Barbara Hepworth

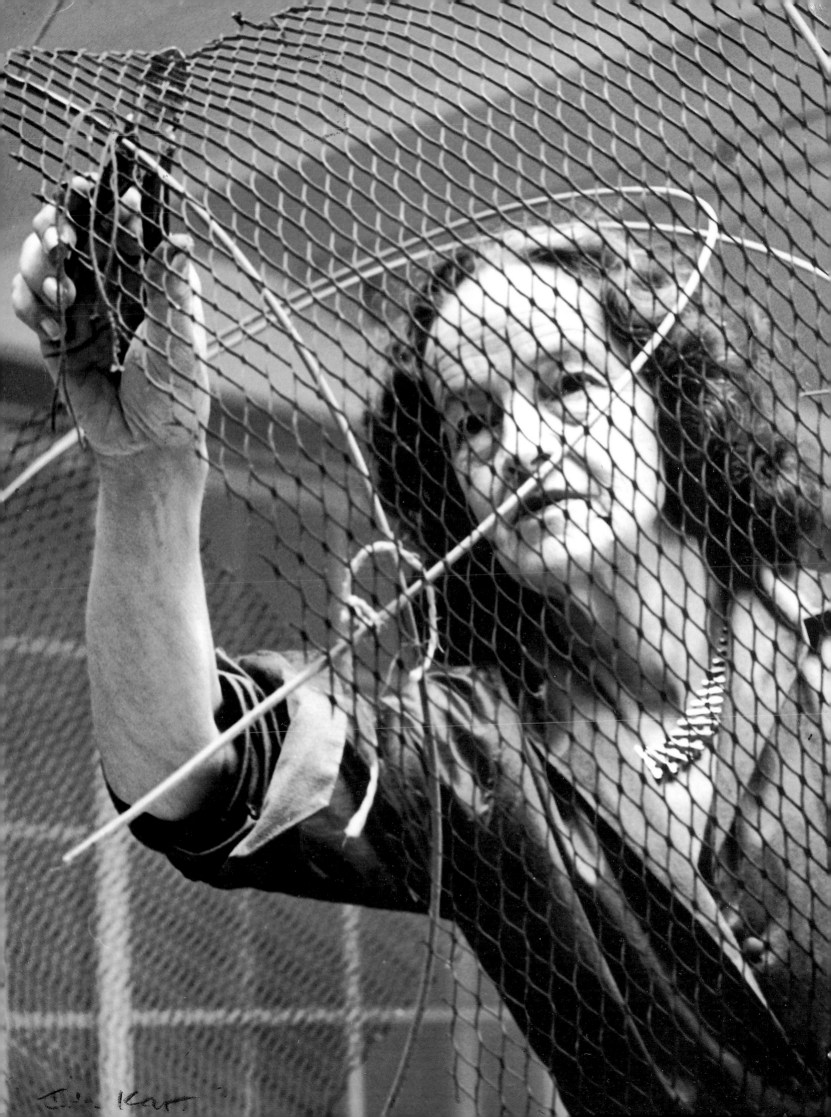

Barbara Hepworth

Works in the
Tate Collection
and the
Barbara Hepworth
Museum St Ives

Matthew Gale and
Chris Stephens

Tate Publishing

Published with the assistance of the Getty Grant Program

Frontispiece: Barbara Hepworth working with aluminium
mesh, 1961, private collection. Photograph by Ida Kar
Frontispiece to catalogue (p.22): Corinthos 1954–5 (no.32)
detail. Photograph by David Lambert

Published by order of the Tate Trustees
by Tate Gallery Publishing Ltd, Millbank, London SW1 4RG

ISBN 1 85437 347 1
A catalogue record for this book is available from
the British Library

Designed by Isambard Thomas
Printed in Hong Kong

20 00004 169

Illustration Credits
The publishers have made every effort to trace all the
relevant copyright holders and apologise for any omissions
that may have been made.

Colour Plates
All colour photographs have been provided by the Tate
Photographic Department (with the exception of no.59,
provided by the Conservation Department).

Black and White Figures
Art Gallery of Ontario, Toronto 63; Birmingham Museums
and Art Gallery 52, 65; Bolton Metro Art Gallery 48;
© Alan Bowness, Barbara Hepworth Estate 4, 8, 10, 15a & b,
20a, b & c, 37, 41, 58, 66, 67, 75; Bill Brandt © Bill Brandt
Archive Ltd 62; British Council Collection 64, 77;
Christie's Images, London 2; Cliché Musée National d'Art
Moderne Paris 17, 39; The Conway Library. Courtauld
Institute of Art 19; Gimpel Fils 61; Henry Moore Foundation
33; John Lewis Partnership 72; Kettle's Yard, Cambridge
35; Leeds Museums and Galleries 14, 31; London
Metropolitan Archives 43; Manchester City Art Galleries 3;
The Pier Gallery Collection, Stromness, Orkney 22, 38, 56;
Private Collection: frontispiece (Photo: Ida Kar), 13, 16, 24,
54; Science Museum/Science and Society Picture Library
49; Scottish National Gallery of Modern Art, Edinburgh 42;
Spink-Leger Pictures, London 47; Tate Archive 1, 5, 21, 23,
27 (Photo: Arthur Jackson), 28, 29, 30, 32 (Photo: John
Piper), 55, 78; Tate Cataloguing Files 45, 46, 57, 76; Tate
Gallery Department 11, 26, 36, 40, 59, 73, 79; Ulster
Museum, Belfast 60; United Nations/DPI, New York 6;
V&A Picture Library 12; © Ville de Paris – C.O.A.R.C. 70;
Wills Lane Gallery, St Ives 44; Yorkshire Sculpture Park,
Wakefield 7.

Preface

Barbara Hepworth has long been regarded as one of the major sculptors of the twentieth century and this is justification enough for a new study. The present volume attempts something quite different from previous monographs and recent critical studies: to refocus discussion on individual works. The scope, which includes examples from almost every year of a career spanning half a century (1925–75), is determined by the Tate Gallery's unrivalled collection of her work.

The Gallery now owns fifty-eight sculptures and nine paintings and drawings by Hepworth, but it was not until halfway through her career that she was first included in the collection. The subsequent expansion in her representation is due above all to her own generosity; she presented sixteen works in her lifetime and bequeathed another two. The Barbara Hepworth Museum, which was established according to the artist's wishes in her St Ives studio and garden after her death, was transferred to the Tate's control in 1980 when a further twenty-eight works were presented. Significant additions to the Gallery's holdings have been made by purchases and gifts from Mr and Mrs J.R. Marcus Brumwell and Ben Nicholson, and the bequests of Miss E.M. Hodgkins and Mrs Helen Margaret Murray.

The comprehensiveness of the Gallery's collection of Hepworth's works is augmented by the long-term loan from her estate to the Barbara Hepworth Museum of a further sixteen works. With the kind agreement of the Trustees of the estate these works, too, have been catalogued. The Museum also displays the artefacts of Hepworth's studio environment in the form of her tools, unfinished works and related paraphernalia. Amongst these are five plasters for bronzes; although at least one was exhibited in the artist's lifetime, they are customarily considered as preliminary versions and, as such, are not included in this catalogue.

The research upon which the present volume is based was conducted as part of the cataloguing of works in the Tate's collection by British artists born in the years 1900–9. The Gallery is deeply indebted to the Getty Grant Program for a two-year grant which made possible the intensive concentration necessary to maintain the thoroughness of its documentation. This volume is not only a demonstration of the value that the Gallery places upon researching its collection but also reaffirms a commitment to the publication of the fruits of such work alongside the growth of electronic publishing. Further funding from the Getty Grant Program, for which we are most grateful, has also supported the publication.

A central purpose of the catalogue entries is to establish, as far as possible, factual information about the making and history of each piece. As such, they intensify consideration both of the physical characteristics of each work under discussion and of its surrounding circumstances, whether personal or public. The technical history of a work, from its earliest stages, and the conservation evidence are integrated with information of dissimilar kinds in perhaps a closer and more illuminating way than has been achieved previously in Tate catalogue entries. The reader's sense of each

sculpture as a vulnerable object that yields observable evidence of every phase through which it has passed is thus enhanced. The history of the public appearance of each object provides one measure of the perceived importance of the work to the artist and its impact on different audiences. In addition, the critical and historical response is considered in order to measure the works' reception. It is one of the established aspirations of Tate catalogue entries that all of this evidence is presented impartially and that the authorial presence is kept to a minimum. Any transgressions into speculation are, it is hoped, clearly signalled.

While each entry is conceived so as to be able to stand alone, the authors' brief to research so many works by a single artist brings enormous advantages for the reader of this volume. The catalogue presents what is in effect a continuous account of Hepworth's development, into which references to major works outside the Tate's care are introduced with relevance and ease. The result is an overview of Hepworth's achievement that transcends the documenting of a particular collection.

The insight that this volume offers into the demands of one sculptor's enterprise is instructive with regard to those of artists of many different persuasions in the modern era. When an artist's reputation is as long established as Hepworth's, an oeuvre may sometimes be imagined to constitute a seamless, even an inevitable sequence. Not the least value of this catalogue is the way in which it enables us to understand how, though impelled by an essentially consistent vision, Hepworth was engaged in a process of continuous exploration, attended by uncertainties as well as by difficulties of many kinds. Many works which now appear as effortless extensions of her formal and expressive vocabulary can be seen to be the outcome of taxing investigation of new territory and of processes not only of intuition but also of concentrated decision-making, at once aesthetic and technical. Numerous works which rightly strike us as admirably resolved represented for her a breaking through that would have been difficult to visualise even a short time previously. Within an overall unity, her development is one of a sequence of phases each with its own distinct pressures and atmosphere. By the end one is astonished to appreciate how far she has travelled; in many ways her professional and artistic journey gives the feeling of having extended over much more than fifty years. One is equally struck by the sheer scale of her undertaking – by her ceaseless industry, by her technical understanding across a range of materials and by the many aspects of nature and human experience with which she sought to imbue the forms she produced.

The introduction which follows seeks to establish a general picture of Hepworth's life and work against which the entries may be seen. The first part provides a biographical overview, and draws out issues closely affecting her work and the course of her reputation. On this foundation, the second half explores the artist's changing concerns, from the role that she sought for art to her political and social commitment. The entries accord central attention to Hepworth's own writings but also go beyond this evidence in order to place her works more effectively within their historical context. The result is to embrace wider issues than has often been the case in past catalogue entries, just as continually emerging archival resources tend to reveal greater complexity in her aspirations than do her necessarily circumspect public statements. This catalogue is offered as a contribution to the continuing development of an understanding of her achievement.

Richard Morphet
Keeper Emeritus, Modern Collection

Acknowledgements

The research undertaken for this publication was part of a cataloguing project of an aspect of the Tate Gallery collection funded by the Getty Grant Program. The volume has also been supported by the Getty Grant Program, to whom we are most grateful. It would have been more limited in scope were it not for the permission from the Trustees of the artist's estate to discuss their works on long-term loan to the Barbara Hepworth Museum St Ives. We would like to express our thanks to Sir Alan Bowness and the Trustees of the Barbara Hepworth Estate for facilitating this.

For their assistance in different ways during the course of our research, we would like to thank the following: Wilhelmina Barns-Graham and Rowan James; Sir Alan and Sarah Bowness; Sophie Bowness; Charles Bravington; Richard Calvocoressi; Christie's; Angela Conner; Penelope Curtis; Patrick Elliott; Margaret Gardiner; the Garnett Passe and Rodney Williams Memorial Foundation, Carlton (Victoria, Australia); Kay Gimpel and Gimpel Fils; Edna Ginesi; Nicholas Guppy; Simon Guthrie; Jack Hepworth; the Hirshhorn Sculpture Garden and Museum, Smithsonian Institution (Washington DC); Brian Ilsley; the late Janet Leach; Pat Leigh; Marlborough Fine Art; Sir Leslie Martin; Mr and Mrs Dicon Nance; Rachel Nicholson and Michael Kidd; Silvie Nicholson; Breon O'Casey; Tom Pearce; Chris Petter of the McPherson Library, University of Victoria (British Columbia); Richard Read; Tommy Rowe; Juan Oliver Fuster of the Pedro Serra Collection, Soller (Majorca); Wendy Sheridan of the Science Museum; Nick Skeaping; Peyton Skipwith of the Fine Art Society; Brian Smith; Brian and Sylvia Wall; John Wells; George Wilkinson.

At the Tate Gallery we would like to thank those in the Conservation departments whose expertise has been invaluable, especially Jo Crook, Sandra Deighton, Jackie Heuman, Derek Pullen, and Calvin Winner, who read entries and answered queries. The inspection and reproduction of works would not have been possible without the imaginative help of the Registrars, the Art Handling Department and the Photographic Department, especially David Clark, Andrew Dunkley, Mark Heathcote, David Lambert, Marcus Leith, and Gill Selby. The Tate Library staff answered repeated requests and, in particular, Meg Duff's Barbara Hepworth Bibliography in Thistlewood 1996 (see abbreviations) provided an invaluable resource. Other colleagues have helped at all stages, especially Jennifer Booth, Judith Collins, David Fraser Jenkins, Jeremy Lewison, Jennifer Mundy and Leslie Parris, who has read all the texts. From the Tate Gallery St Ives, we thank Mike Tooby, Matthew Rowe and Norman Pollard. The support of Belinda Davies in the Development Department and above all Celia Clear at Tate Gallery Publishing helped to secure the publication of the volume. We are especially grateful to our editor, Liz Alsop, for her enthusiasm. Finally, the content of each of our entries has been scrutinised by Richard Morphet, Keeper Emeritus of the Modern Collection, whose enthusiasm has been as boundless as his knowledge of the collection and his eye for exacting detail.

Matthew Gale and Chris Stephens

Introduction

Barbara Hepworth 1903–1975

In mid-1932, Barbara Hepworth wrote to the painter Ben Nicholson about music and art: 'in Bach the visual sense is always delighted because every movement made by the orchestra is beautiful… What a lovely vision – so complete – perfect construction & understanding. If you knew just a little more about the construction you would see the likeness to Picasso – in fact no difference at all hardly.'[1] These comparisons between the structures of music and contemporary art came at a time of enthusiastic exchange between the two artists, as their own work moved towards a viable abstraction. Inspired in part by the example of Parisian artists, such as Pablo Picasso, Constantin Brancusi and Piet Mondrian, the work of Hepworth and Nicholson and their allies would be instrumental in opening up the possibility of an abstract art in Britain in the 1930s. Hepworth's musical analogy is indicative of the priority given to formal abstraction by these artists, but what was termed a Constructive art also encompassed – in a period of critical fragmentation – social and political aspirations which she would maintain into her later career. However, to see the sculptor solely in the context of the 1930s is to accept a misleading picture of her early development.[2] The sculpture of the preceding years emerged from a concern with 'direct carving' and its associated ideals, and it was in the subsequent reconciliation of carving and abstraction that her most characteristic and remarkable work was made.

Hepworth's parallel passions for music and art went back to her childhood. Born in Wakefield, Yorkshire (10 January 1903), she was the eldest of four children in a middle-class West Riding family. Her father, Herbert Hepworth, would become County Surveyor and a local Alderman; the allowance that he gave her was a crucial support in the difficult 1930s and 1940s. At Wakefield Girls' High School, her talents for drawing and the piano were recognised and, in retrospect, she attributed the urge to sculpt to a conjunction of Egyptian art (discovered through a school lecture) and the experience of the landscape.[3] A scholarship to Leeds School of Art (1920–1) was followed by a county scholarship to the Royal College of Art in London (1921–4). At both institutions she was close to Edna Ginesi and the slightly older Raymond Coxon, both painters, and to Henry Moore.

In 1923, Hepworth was one of four sculptors – with John Skeaping, Pamela Harris and Emile Jacot – to reach the final part of the academic Prix de Rome competition which required a 'high relief panel … for the main entrance to a hospital'.[4] The prize was awarded to Skeaping, who had already spent 1920–2 in Italy on a Royal Academy travelling scholarship. Both his and Hepworth's submissions were appropriately orthodox, reflecting the demands of the competition and their training as modellers of grand subjects in clay and plaster. Hepworth went to Florence on a West Riding Travel Scholarship in the autumn of 1924 and visited Skeaping in Rome; an intimate relationship developed during a tour of Tuscany[5] and they were married on 13 May 1925

in Florence. In Italy, both sculptors turned to stone carving and, in so doing, crossed an ideological divide. The academic process of modelling was additive and open to revision, and on completion the model was translated into stone by craftsmen. The 'direct carving' championed by modernists, such as Jacob Epstein and Henri Gaudier-Brzeska in London and Constantin Brancusi and Ossip Zadkine in Paris, opposed this practice with first-hand knowledge of the stone submitted to the reductive process. In Rome, encouraged by medieval and Renaissance examples, Skeaping and Hepworth learnt carving with the *marmista* (marble craftsman) Giovanni Ardini – who was then working for the Croatian Ivan Meštrović. As Hepworth spoke no Italian, Skeaping mediated this experience and advice, and she later valued Ardini's remark that 'marble changes colour under different people's hands'.[6] They returned to London in November 1926 because of Skeaping's ill health. Some measure of Hepworth's development in Italy may be found in a comparison between the bronze *Standing Woman, Right Hand Raised* 1925 (fig.2) and one of her earliest carvings, *Doves* 1927 (fig.3), which shows the sympathy for materials and simplification of planes shared by both artists.

Connections forged through the British School eased the couple's re-establishment in London. George Hill and the sculptor Richard Bedford, curators at the British Museum and the Victoria and Albert respectively, encouraged the interest of collectors such as Edward Marsh and George Eumorfopoulos. The latter bought two Hepworths, including *Doves*, at the couple's studio show in St John's Wood in late 1927. They moved to 7 The Mall Studios in Hampstead in 1928, and held successful joint exhibitions that year and in 1930.[7] These consisted of animal and figure sculptures in stone and wood, such as Hepworth's *Infant* 1929 (no.2 q.v.). With Bedford, Moore, Alan Durst, Maurice Lambert and others, the couple became leading figures in the 'new movement' associated with direct carving. Identification with a loose grouping – which was contrasted with the 'years in the wilderness' of older sculptors like Epstein and Frank Dobson[8] – facilitated the establishment of their reputations. Both because of the ambition of their works and the ingrained prejudice against women artists, Skeaping and Moore received more critical attention than Hepworth, whose shy earnestness meant that she relied upon the work to speak for her. She and Skeaping were members of the London Group in 1930–2 before joining the more modernist Seven & Five Society (later 7 & 5 Society) in 1931.[9] This secured their connection with a developing circle, which included artists like Moore, Paul Nash and Ben Nicholson, and was supported by critics such as Herbert Read and Adrian Stokes. Within this intellectual milieu in Hampstead, Hepworth would find other close friends over the next decade, notably the zoologist Solly Zuckerman, the collector Margaret Gardiner, the physicist Desmond Bernal, the Tate Gallery curator H.S. 'Jim' Ede and later the artist Roland Penrose.

Establishment in Hampstead coincided with important changes in Hepworth's private life. In August 1929, she and Skeaping had a son, Paul, but their marriage was deteriorating. In early 1931, Hepworth met Ben Nicholson, who was also experiencing marital difficulties;[10] in September he joined the group – consisting of Moore, Ivon Hitchens and others – with which she was holidaying at Happisburgh, Norfolk. Shortly after a holiday in the Scilly Isles, where they admired the form of 'rocks all worn by the water',[11] Hepworth and Skeaping separated; they were amicably divorced in 1933 and he remarried in the following year. Hepworth and Nicholson had triplets in October 1934 and were married four years later.

The two artists revealed their move towards abstraction in joint exhibitions in 1932 and 1933 of works in which references to the figure were considerably reduced.[12] In Hepworth's sculptures they survived as incised lines on increasingly organic carvings, though they had already been abandoned with the pioneering penetration of the block for *Pierced Form* 1931 (fig.4), which allowed a reconsideration of the integrity of form and matter. The abandonment of the figure was a brave departure from the work for which Hepworth was already known, not only because it coincided with the collapse of

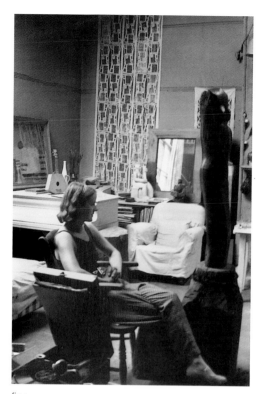

fig.1
Barbara Hepworth in Mall Studios, *c.*1932

the art market following the Wall Street Crash, but also because of the demands of her growing family. It is characteristic of the mood of adventure shared with Nicholson that, in this period – which she recalled as 'turbulent'[13] – Hepworth experimented with different media – collage and photograms – as well as new sculptural forms. In addition, designs for prints and fabrics served to broaden her means of expression while at the same time providing potential sources of income.

The involvement of British modernists with European concerns was given new urgency and solidarity by the combination of economic crisis and totalitarianism in the 1930s. An awareness of the repressions in Nazi Germany was balanced by the excitement over activities in Paris, accessible through the visits of Nicholson and others. In late 1932 Hepworth gave serious thought to the possibility of joining him there permanently.[14] They had stayed in Dieppe in August 1932, and they travelled to Avignon and St Rémy-en-Provence in April 1933. In Paris, they visited the studios of Arp and Brancusi, met Picasso and Zadkine and seem to have established contact with Alberto Giacometti.[15] Probably through Auguste Herbin or Jean Hélion they joined the internationalist group Abstraction-Création.[16] On subsequent trips, they visited Braque in Dieppe (September 1933) and Mondrian's studio in Paris (1935); in 1937 they stayed with Alexander Calder at Varengeville.[17]

In London, Hepworth, Nicholson and Moore were members of *Unit One*, announced by Nash in June 1933 as a united front for progressive artists and architects. The associated exhibition and publication showed a division between abstraction and surrealist tendencies.[18] This gradually became more pronounced, although Moore and Herbert Read attempted to maintain a balance. By 1935, Nicholson and Hepworth were instrumental in restricting the 7 & 5 (as it was now known) to exhibit only abstract work; this was echoed by the touring *Abstract & Concrete* exhibition (1936), organised by Nicolete Gray with the co-operation of Myfanwy Evans's periodical *Axis*, which included continental contributions from Hélion, Mondrian and others.[19] A significant lift to Hepworth's reputation came in 1936, when her *Discs in Echelon* 1935 (no.10 q.v.) was donated to the Museum of Modern Art, New York, while the cause of abstraction was promoted in America by friends such as Calder and G.L.K. Morris. With the authority of Parisian connections and formal radicalism, Hepworth and Nicholson secured a reputation for avant-gardism even if their work seemed to reach only a restricted audience. In the context of political debates brought to a head by the Spanish Civil War, London briefly became a centre for refugees from totalitarian Europe, several of whom were loosely associated with constructivism, including Naum Gabo and László Moholy-Nagy, the architects Walter Gropius and Marcel Breuer, and Mondrian (who arrived in 1938).

This tendency culminated in the publication of *Circle: International Survey of Constructive Art* (1937), edited by Nicholson, Gabo and the architect Leslie Martin, and designed by Hepworth and Sadie Martin. As distinct from the utilitarianism of Russian Constructivism, this publication used 'the Constructive idea' as a broad term by which to gather those 'working in the same direction and for the same ideas'.[20] In the face of political nationalism, Constructive art was positively internationalist; in contrast to artistic realism and Surrealism, geometric forms and new materials were used as the basis for a new art which presaged a new society. Its social aspirations were suggested by the inclusion of contributions from engineers, scientists and educationalists, a tendency echoed in the introduction of Hepworth's first solo exhibition by the physicist J.D. Bernal.[21]

Such utopianism was constricted by the war, and in August 1939 Hepworth and Nicholson evacuated to Cornwall. They stayed for four months with the painters Margaret Mellis and Adrian Stokes at Carbis Bay, the neighbouring town to St Ives, before moving to a house of their own. During this period the Gabos also settled in Carbis Bay. They all came into contact with the potter Bernard Leach and younger

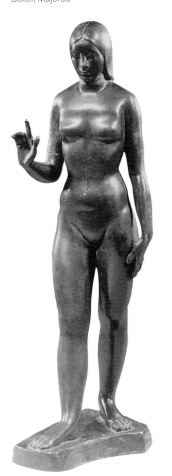

fig.2
Standing Woman, Right Hand Raised, 1925, height 40.7 (16), bronze, no BH number, Pedro Serra Collection, Soller, Majorca

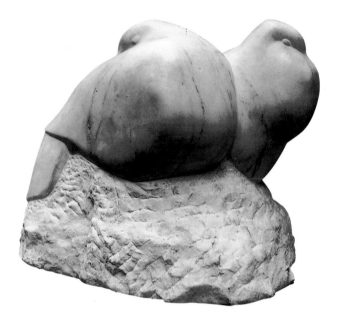

fig.3
Doves, 1927, length 48.2 (19), marble, BH 3, Manchester City
Art Gallery

artists, including Peter Lanyon (briefly Nicholson's pupil), John Wells and Wilhelmina
Barns-Graham. They also renewed contact with the untrained painter Alfred Wallis.
Domestic and wartime demands and lack of space and materials restricted Hepworth
to small sculptures and to painting, but on moving to a larger house, 'Chy-an-Kerris',
Carbis Bay in 1942, she secured a studio. Contacts were maintained with artists and
sympathetic curators and writers, such as Read and E.H. Ramsden; publications and
exhibitions were projected in an attempt to sustain the impetus of what they called
'the movement', although a rift developed between Gabo, who promoted a strict
continuation of his particular view of constructivism, and Nicholson and Hepworth,
who interpreted the Constructive idea more loosely.

Despite the difficulties, Hepworth had two important exhibitions during the war.[22]
They were followed in 1946 by a monograph by William Gibson, a London exhibition and
her own statement 'Approach to Sculpture'.[23] Through Barns-Graham, the couple were
invited to exhibit with the St Ives Society of Artists and Nicholson first showed in 1944
followed by Hepworth a year later. They remained contributors until the formation of the
predominantly modern Penwith Society of Arts in Cornwall in 1949 with Leach, Lanyon,
Barns-Graham, Wells and others. The connections of Hepworth, Nicholson and Leach
helped to attract international attention to the new group. Despite their continuing
aesthetic alliance, Hepworth's and Nicholson's marriage had broken down; in 1949, with
financial help from several friends, she bought Trewyn Studio, St Ives, where she lived
following their divorce two years later.

Seeking to establish her reputation on a level with Nicholson and Moore, Hepworth
believed that her sex had counted against her. Feeling 'quite outraged' at her neglect by
the British Council in 1943, she told Read: 'I have never been included in one of their
exhibitions but up till now I have thought of various reasons for this omission – such as:
1. being a woman; 2. being abstract; 3. young; 4. a wife & mother etc etc'.[24] This was both
an astute assessment of the position and evidence of her determination to overcome
such prejudice. Her wartime retrospectives were a preliminary step, but it was around
1949–50 that her efforts were really rewarded. In that period Hepworth held her first
solo exhibition in New York, followed shortly by an exhibition of new work in London.[25]
In 1950 the British Council presented her work at the Venice Biennale but, despite the
endorsement of Read, the display was dogged by adverse comparisons with Moore's
prize-winning exhibition of 1948. Nonetheless, her contributions of sculptures for the
South Bank site of the Festival of Britain in 1951 – together with retrospectives in
Wakefield and at the Whitechapel Gallery in London, and designs for Sophocles' *Electra*
and Michael Tippett's opera *The Midsummer Marriage* – all served to reinforce
Hepworth's national standing.[26] This position was confirmed by the publication of a
major monograph introduced by Read and augmented by the sculptor's substantial

texts. Dividing her career into six periods, she remarked on the integration of domesticity and society: 'being a woman, every daily event of home and family as well as contemporary events in the world at large have had to be related and resolved within my work.'[27]

The 1950s brought new contacts. On the one hand, for younger abstract artists – including the British Constructionists (Victor Pasmore, Kenneth and Mary Martin and others) and the painters and sculptors of St Ives – Hepworth provided a link to a pre-war commitment to the integration of artistic, political and social concerns. A number of her assistants became prominent sculptors in their own right, notably Denis Mitchell and Brian Wall. In common with the painters around her, she became interested in the free energy of Tachisme, which is evident in her contemporary drawings. Though she admired the work of Reg Butler (fig.54), the spikey neuroticism of the 'geometry of fear' sculptors and their use of industrial materials and machinery were in contrast to her continued idealism and retention of a 'truth to materials' aesthetic. These younger artists found inspiration in the post-war work of Giacometti, linked to Parisian Existentialism, and Hepworth's distance from them was marked by her omission from the exhibition of contemporary British sculpture at the 1952 Venice Biennale.[28]

As Hepworth became increasingly established, her wider recognition led to two changes in her working practice. First, works such as the large *Contrapuntal Forms* 1950–1 (figs.5 & 51) for the Festival of Britain demanded that she take on permanent assistants – including, initially, Denis Mitchell, John Wells and Terry Frost – for preparatory work.[29] Second, in 1956, she began to carve plaster specifically for casting in bronze. The new workshop structure and a broadened repertoire of media brought an upsurge in productivity and scale, and the ambition for monumental works eventually prompted the purchase of the neighbouring Palais de Danse in 1961 as an additional studio. Alan Bowness (the sculptor's son-in-law) opened his conversation with Hepworth in 1971 by observing that there were 'almost as many [works] since 1960 as there were in the preceding thirty-five years'.[30] However, the development of such a workshop exposed Hepworth to suggestions of feminine frailty, and appeared to contradict the primacy of 'direct carving' espoused in the inter-war period.

Nevertheless, she maintained a high output of carved works alongside the editions of bronzes. She visited Greece in 1954, in an effort to recover from the sudden death of her son Paul Skeaping the year before, and the ensuing series of large carvings in rich guarea wood – such as *Corinthos* 1954–5 (no.32 q.v.) – gained particular acclaim; she also resumed working in marble in the late 1950s. Following an exhibition of her carvings travelling through America, the distribution of sculptures became more far-reaching with a contract with Gimpel Fils in London, and subsequent exhibitions in New York and Zurich.[31] Hepworth's international standing was confirmed by the Grand Prix at the 1959 São Paolo Bienal, which initiated a five-year period of unprecedented success. J.P. Hodin's monograph emerged in 1961 and – in direct comparison to publications on Moore – contained the first catalogue raisonné of her work (by Bowness).[32] A second Whitechapel exhibition, in 1962, was followed by a European tour;[33] around this time a particularly strong collection of the sculptor's works was formed at the Rijksmuseum Kröller-Müller at Otterlo by A.M. Hammacher. The period was also marked by official acclaim: honorary degrees, the CBE and the DBE (in 1958 and 1965 respectively). In many ways the crowning achievement was the installation of *Single Form* 1961–4 (fig.6) in 1964 outside the United Nations building, New York, as a memorial to the Secretary-General, Dag Hammarskjöld. In a location of such prominence and at more than six metres high, it was the most important and largest of Hepworth's several public sculptures. She favoured placing her work in the landscape and in the mid-1960s was involved in an abandoned project for a sculpture park, following the example of the Kröller-Müller;[34] instead, a number of her large-scale works were sited on the campuses of new universities.

fig.4
Pierced Form, 1931, height 25.4 (10), alabaster, BH 35, destroyed

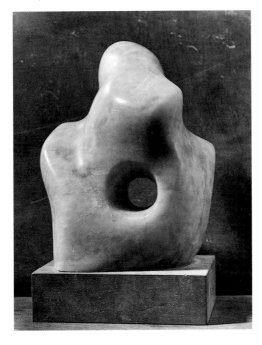

Hepworth worked consistently to maintain her hard-won reputation, facilitating and instigating new publications. In 1965, anticipating a volume on her drawings,[35] she tried but failed to persuade Read to write a second book which 'would reach more people & aid a bigger mono[graph]'.[36] Instead, it was written by Hammacher, and was followed in 1971 by the extension of the catalogue raisonné by Bowness.[37] Hepworth served as a Tate Gallery trustee (1965–72), a position which fitted her belief in the public role of both art and artists and to which she dedicated considerable effort. She donated six works to the Tate in 1964 and a further nine in 1967 prior to her retrospective at the Gallery in the following year. With her long-standing friend Bernard Leach, she was awarded the Freedom of St Ives in 1968 as an acknowledgement of her importance to the town. Still seeking prominence in America, the sculptor transferred to Marlborough Fine Art in 1970, the same year in which her *Pictorial Autobiography* appeared.

A measure of Hepworth's continuing ambition is found in the large-scale bronzes of the 1970s such as *The Family of Man* 1970 (fig.7) and *Conversation with Magic Stones* 1973 (no.75 q.v.). However, her last years were blighted by illness. She had been diagnosed in 1965 as suffering from cancer, which was treated successfully, and broke her hip two years later. She became increasingly immobile and reliant upon her assistants, devising, as Hammacher remarked, 'schemes whereby she could keep a check on their activities, even when she could hardly leave her sickbed'.[38] Despite this gradual decline, she died suddenly when, on 20 May 1975, she was overcome by smoke from a horrific fire at her home in St Ives. According to her wishes, the Barbara Hepworth Museum was established there in the following year. A range of her sculpture and paintings was placed on display in the house and garden alongside a reconstruction of her studios which afforded a sense of her working environment.[39] In 1980, the Museum was presented to the nation under the aegis of the Tate Gallery, establishing an unrivalled collection of her work.

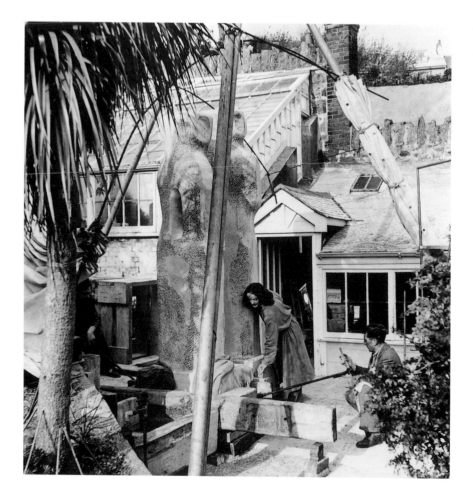

fig.5
Denis Mitchell, Barbara Hepworth and John Wells working on *Contrapuntal Forms* (fig.51 q.v.), Trewyn Studio, 1950

Material Sources and Spiritual Values

Barbara Hepworth's art was determined by a range of strongly held intellectual and ideological, as well as aesthetic, beliefs. These reveal continuities, but they also changed considerably over the fifty years of her career in the light of a mutually enriching exchange with her closest colleagues. Though the examples of Skeaping, Moore and Nicholson were important, as were the writings of Read, Stokes, Ramsden and Hodin, her correspondence shows that she was never acquiescent in her response, but developed her own views through debate. Hepworth's stated understanding of her work was for the most part formalist, placing emphasis on the primacy of the object and the formal qualities instilled in the process of making. She claimed, for instance, that 'carving is interrelated masses conveying an emotion', but she also recognised a movement 'towards an ideal',[40] and it is possible to trace in her broader attitudes, which shifted across her career, a theoretical basis for the work. In approaching these issues, one might identify as a unifying theme Hepworth's persistent concern with the place of the artist in the community, whether a like-minded circle or society at large. Although by no means the only issue or possible interpretation, it seems to have served, for her, as an underlying justification for the relevance of formally hermetic work in the modern world.

The early shift from modelling to carving signalled Hepworth's polemical alignment with avant-garde ideals. The associated belief in 'truth to materials' extended technical issues into the wider realm of individual expression, with one contemporary critic equating direct carving with 'the personal touch'.[41] It brought together disparate issues. Hepworth's academic training converged with a resurgent emphasis on realism in the post-war 'return to order'. She also shared with Epstein and Moore a competing interest in the carvings of the so-called 'primitive' cultures either of the past or outside Europe; Hepworth and Skeaping particularly looked at Chinese, Cycladic and African carvings in the British Museum. A romantic view of apparently less sophisticated societies was combined with what has subsequently been interpreted as a colonialist appropriation of the style of the works without regard to their purpose. While such art provided a convenient precedent for the consideration of modernism,[42] the interest also signalled a deeper aesthetic and cultural rejection of the apparently exhausted state of Western civilisation. Conceptual modifications distinct from European conventions of reality justified the emphasis placed upon expression and then upon non-representational form. In the 1930s and 1940s, neolithic monuments such as Stonehenge achieved a new relevance with the refocusing of this attention on specifically indigenous sources. Paul Nash, John Piper and others had already made this connection, which Hepworth took up in *Circle* and subsequently established as an underlying paradigm for her own work.[43] Her notion of the landscape defined by man's intervention made the equation of her work with the standing stones of West Cornwall a key means of rooting the sculpture in its locality.

The qualities of technique and juxtaposition became crucial in the 1930s, when a move away from realism was encouraged by Hepworth's partnership with Nicholson and by contemporary debates in Paris. There, they discovered the dream-like abstraction of Giacometti and Joan Miró, and the more measured geometry of Mondrian. After a brief enthusiasm for the former, it was towards the purity of the latter that they inclined as part of a concerted alignment with European issues. Such work was promulgated on the privileged creativity of the artist whose personally conceived abstract forms could convey universal values, a process comparable to the refinements of classical music or architecture. Hepworth attempted to clarify this position by comparison to scientific laws, writing: 'It seems to me that we know those laws emotionally & intuitively, learning by experience & trying to live the sort of life that will most easily enable us to express the laws – that is Construction.'[44]

Her belief in constructivism was more than simply aesthetic and, despite her insistence upon the formal harmony of the art object, she was never solely a formalist. She persistently questioned her most fundamental political, social and spiritual beliefs. Though always passionate, she seems to have approached such issues with a marked intellectual rationalism. In the late 1950s Hepworth would recall the highly politicised period of the 1930s.[45] It is indicative of her thought that, despite changes in her attitudes in the intervening twenty years, she returned to the moment in which her political consciousness was defined. The rise of the Left, in particular of Communism, in Britain in the 1930s came as a response to social unease and the ascendancy of Fascism in Europe. Unlike Moore and despite the urging of J.D. Bernal,[46] Hepworth did not join the Communist Party when membership was widespread amongst British artists and intellectuals, though her reluctance may be more indicative of her intense questioning of her own position than of a lack of commitment. She told her friend Margaret Gardiner that she feared she was too individualistic to follow a party line: 'should I want to be free the moment I gave my word to a set thing?' she wondered.[47] The value she set upon such individual freedom provided a further link to Herbert Read, an active member of the Anarchist movement. However, in common with others close to her, she did show with the Communist-dominated Artists International Association in their 1935 exhibition *Artists Against Fascism and War*. This left-wing unification reflected the formation of the Popular Front against Fascism which became more urgent in response to the Spanish Civil War of 1936–9. Hepworth's sympathy for the Republican side in that conflict, the *cause célèbre* of the Left, was marked by her *Project (Monument to the Spanish War)* 1938–9 (fig.8).

Within these debates a discussion of the role of art in society was articulated by artists of diverse persuasions: Social Realists, Surrealists and constructivists. While the Realists argued that a revolutionary art should be popularly accessible, the abstract artists – such as Hepworth, Gabo and Nicholson – proposed a new art for a new society. It was on this basis that they aligned themselves with architects and designers, as well as with scientists (Bernal, Zuckerman and C.H. Waddington, for example), sociologists, such as Karl Mannheim, and educationalists (Hepworth invited W.B. Curry, the headmaster of the progressive Dartington School, to contribute to *Circle*).[48] A comparable heterogeneity was reflected in the international dimension of their approach to both art and politics. The contact between Nicholson and Hepworth and artists in Europe and America is indicative of their fundamental belief in the importance of an international modern movement rather than simply their awareness of foreign developments. The significance of internationalism was made all the more urgent for them by their contact with refugees from Nazism.

Despite her belief in socialism, Hepworth's modernism was also informed by less materialist ideas. Her statement in *Unit One* (1934) had set out a conception of the artistic process and of the work of art which she would maintain throughout her career: 'In the contemplation of Nature we are perpetually renewed, our sense of mystery and our imagination is kept alive, and rightly understood, it gives us the power to project into a plastic medium some universal or abstract vision of beauty.'[49] Thirty years later she still retained her faith in the positive function of such an abstract art: 'the meaning of art,' she asserted, was to 'affirm and continue life in its highest form.'[50] During the 1930s, her attitude appears to have been influenced by Christian Science, which she knew from childhood and to which she was reintroduced by Nicholson. Though he had first encountered it in California during the First World War, Christian Science was shared by a number of their circle: specifically, Winifred Nicholson and Paul and Margaret Nash. The central tenets of the faith are a conception of a spiritual ideal which overrides the corporeal and a consequent belief in the power of positive thought, particularly as a means of healing. Its insistence upon a level of existence superior to the material world provided a basis for an alternative to modern life, in opposition to technological and

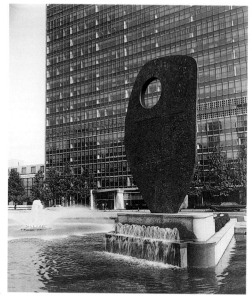

fig.6
Single Form, 1961–4, height 640 (252), bronze, BH 325, United Nations, New York

social advancement, centred around an escape to a more natural environment and way of life. As Winifred Nicholson wrote: 'We lived in white houses with large windows, we ate simple foods – the fruits of the earth. We wore sandals and ran barefoot along the boulevards … unnecessary things were to be done away with.'[51] In its provision of a non-materialist basis for their art, this interest in Christian Science echoed that of earlier modernists, such as Mondrian and Wassily Kandinsky, in other forms of spirituality. However, Hepworth does not seem to have accepted this life unquestioningly and her letters reveal an increasing scepticism which turned to disillusionment by the mid-1940s. Nevertheless, a basis in absolute ideals and the recognition of beauty in all things closely parallels the formal perfection that she continued to seek in her work.

While such a quasi-Platonic belief is not inconsistent with her view of the artist as the upholder of basic values for the benefit of all, a tension remained between Christian Science and Hepworth's socialism. In that regard, it is significant that Nicholson, though always left-leaning, lacked her political commitment and was more insistent upon the primacy of the individual. That difference was revealed during the Second World War, when Hepworth found, amongst the wreckage of the optimistic idealism of the 1930s, a means of fusing her political and more spiritual concerns. This was profoundly influenced by the family's relocation to Cornwall and her apparently growing interest in psychoanalysis.

Though the members of the group to which Hepworth and Nicholson belonged in Hampstead in the 1930s were both successful and well connected, it was during the war that their views can be seen to have had a significant influence on public life. Through their association with a number of prominent figures in the campaign for reconstruction, most particularly the magazine proprietor Edward Hulton, the Nicholson circle provided a cultural aspect to the debate about post-war planning that dominated the domestic political agenda after 1940. Their input was laid out in a series of essays in Hulton's *World Review*, entitled 'This Changing World', edited by Marcus Brumwell, an advertising executive friend of Nicholson and Hepworth.[52] In the series, introduced with a trenchant restatement of modernist confidence by Herbert Read, artists, scientists, architects, sociologists, economists and political scientists set out a programme for the post-war world. Hepworth's contemporary correspondence reveals the degree to which she saw the reconstruction plans – epitomised by the publication of the Beveridge Report in 1942[53] – as the realisation of many of the things for which they had campaigned before the war in *Circle* and elsewhere. In the formulation of what would become the Welfare State, she saw the application of the socialist principle of common endeavour.

In this period Hepworth also developed a related belief in the importance of belonging to an intimate community. This was reinforced by her move to Carbis Bay, though such an ideal might equally have been seen in the close-knit group in Hampstead which Read would recall affectionately as 'a nest of gentle artists'.[54] The mainstay of her ideology became a faith in the coherent interaction of individuals at different social levels: internationally, nationally and locally. This could be embodied in such groups as the Penwith Society. In a sense, this human aspect may be seen as her answer to the problems and threats of modern life, which became even more acute in the wake of the war with the revelation of the Holocaust and the dropping of atomic bombs on Hiroshima and Nagasaki. Increasingly, the question of the artist's role in society would be seen by Hepworth in terms of her involvement in the local community. Speculating on the relationship of artists and society, she wrote to Read in 1942 of an ideal network, 'we must … become a part of a human community instead of being a minority, de-centralise and yet unify ourselves'.[55] Later, she believed in the importance of civic duty and, as well as being a leading figure in the Penwith Society, she launched the St Ives Festival in 1953 and helped to establish the St Ives Trust, a conservation group. In 1968, she was proud to have the freedom of the borough conferred in recognition of her civic role, which continued the tradition of her alderman father.

The origins and extent of Hepworth's interest in psychoanalysis are unclear. Though there is no explicit evidence of her knowledge of Freud's writings, the characteristics of her work and the terms in which she discussed it would suggest an appreciation of his theories. Her proximity to Herbert Read, who was well versed in psychoanalysis, and Adrian Stokes, an enthusiastic follower of Freud, would make such an understanding probable. In particular, from 1930 Stokes underwent seven years of analysis with Melanie Klein, a leading British Freudian analyst, and his essay on Hepworth's carving, written during that period, has been shown to reflect Klein's theory of artistic production.[56] The artist certainly knew the theories of Alfred Adler, whose emphasis on the social dimension of individual psychology would have appealed to her. Her interest was encouraged by her friendship with Adlerian experts in St Ives, Phyllis Bottome and Ernan Forbes Dennis.[57]

However, it was in the work of Carl Jung that Hepworth, like many artists of the period, found a particularly valuable theoretical foundation for her work, especially for the communalism which it embodied. Though Jung features repeatedly in her wartime letters to Read, whose interest was well established, it is unclear when she first encountered his writing.[58] His work had been available in English since 1912 and had been the subject of discussion amongst students at the Royal College in the 1920s.[59] In his proposition of a 'collective unconscious' Hepworth and many of her associates found a basis for their interest in earlier cultures and their influence on the creative process; in *Art and Society*, Read emphasised the centrality of art to any understanding of such cultures.[60] The belief that an unconscious awareness of a community's past is reflected in the form of its objects must be seen to underpin Hepworth's repeated association of her work with the megaliths of west Cornwall. Through Jung, one might see a synthesis of her belief in the community as the basis of socialism and a more spiritual dimension linking that modern community with traditional culture.

The predominant themes of human interaction and community manifested themselves most obviously in the group sculptures, developed from the formal harmony of such pre-war pieces as *Three Forms* 1935 (no.9 q.v.), which recurred in Hepworth's work from 1950 to 1975. There is a sense, also, in which the motif of the figure in the landscape, which by the artist's own account was the subject of many of her works, may be seen as a metaphor for social interaction. Through her citation of local standing stones Hepworth invoked the history of the countryside, an approach typical of a period in which the land was seen as a palimpsest on which its history and that of its

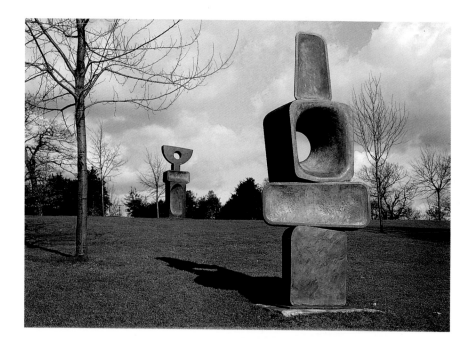

fig.7
Ultimate Form, height 300 (118¼) and *Parent I*, 268.6 (105¾), two of nine bronzes from *The Family of Man*, 1970, BH 513, Barbara Hepworth Estate on loan to Yorkshire Sculpture Park, Wakefield

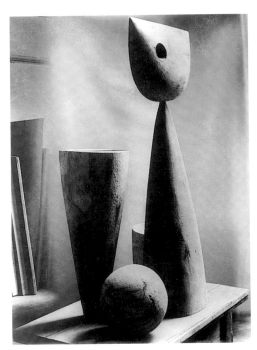

fig.8
Project (Monument to the Spanish War), 1938-9, height 177.8
(70), wood, BH 111, destroyed

inhabitants was repeatedly inscribed.[61] Though she retrospectively related all her work to the natural environment, she especially associated her ideas about the artist and landscape with her move to Cornwall: 'It was during this time that I discovered the remarkable pagan landscape which lies between St Ives, Penzance and Land's End; a landscape which still has a very deep effect on me, developing all my ideas about the relationship of the human figure in landscape – sculpture in landscape.'[62] She explained how the sculptures sought to recapture the experience of continuity between her body and the natural environment: 'I became the object … the figure in the landscape.'[63] A sensation of enclosure within the land offers an explanation for the form of many of her organic, hollowed sculptures. Such a symbolic empathy with landscape echoed its use in the work of Rainer Maria Rilke – one of Hepworth's favourite poets – who saw in nature ready-made equivalents for inner experience.[64] However, she later claimed to see the relationship of her sculpture and the landscape differently; late monolithic carvings were described as 'objects which rise out of the land or sea' and, as such, were compared with the Cornish megaliths.[65] That the figure in the landscape motif related to her ideas about society was confirmed by the artist: from her preoccupation with the landscape image in sculpture, she explained, had developed a 'concern with an image in sculpture of the community in landscape.'[66]

Hepworth's conception of her work in relation to the landscape and to natural laws and processes was validated by a number of diverse texts in circulation at that time. Alongside Jung, a theory of organicism and unconscious artistic production was informed by the reading of d'Arcy Wentworth Thompson's *On Growth and Form* and by the aesthetic offshoot of Gestalt psychology. The latter, most notably expounded by Rudolf Arnheim,[67] argued that human perception tended to form disparate elements into structural wholes which had a coherence greater than the individual units. Such a theory echoed the intention of Hepworth's group sculptures and Arnheim's identification of the tendency towards simple shapes offered a psychological explanation for the works of the 1930s and 1940s. It was also in accord with the informal abstraction of the 1950s, the influence of which may be identified in Hepworth's paintings of 1957–60 and, by association, in such textured bronzes as *Meridian* 1958–60 (fig.69). Her attitude was important to the modernist artists gathered around St Ives, who were seen to be united in their search for a closer conjunction of abstract, or semi-abstract, art and the natural environment. The phenomenon of St Ives, and Hepworth's work specifically, may be seen in the context of the development, in the 1950s, of an organic aesthetic and artistic practice. In London this was centred on the Institute of Contemporary Arts and largely based on Read's writings, but parallel explorations, drawing on similar textual sources, may be identified in the work of contemporary artists working in Europe and North America.

That one of Hepworth's favourite books was *Zen and the Art of Archery* indicates that she also shared the interest in mysticism which informed much of the abstract painting of the 1950s.[68] In Britain, such selfless beliefs as Tao and Zen had been increasingly expounded by such writers as Aldous Huxley since the 1930s. Specifically, Hepworth's interest was preceded by that of Read and echoed the adherence to the Baha'i faith of two of her friends: the potter Bernard Leach and the American painter Mark Tobey. In particular, Leach provided a model of spiritual sensitivity as well as craft-skill and integrity to two generations of artists in St Ives. Hepworth's appreciation of eastern religion was one element in a broad interest in the non-materialist aspects of existence rather than a doctrinal adoption of a particular faith. Besides its emphasis on the development of a natural facility, it is hard to reconcile Zen's insistence upon an unconscious practice of art, which was clearly significant for such painters as Tobey, with the necessarily slower processes and the workshop arrangement of the sculptor.

As well as her own concerns and desires, Hepworth's interest in psychoanalysis and spirituality was also a response to the politics of the post-war era. The sculptor's

international profile coincided with the height of the Cold War: the Korean War was followed by the Vietnam War, while nuclear 'deterrents' were stockpiled by the super-powers, adding further anxiety to such incidents as the Cuban Missile Crisis. The extent to which such events concerned Hepworth is seen in her commitment to the peace movement – through membership of the Campaign for Nuclear Disarmament and the United Nations Association.[69] In 1956, at the time of the Soviet invasion of Hungary and the débâcle for British imperialism of the Suez Crisis, a letter to Read reflected the integration for Hepworth of art and politics: 'How have you got on during these last awful weeks? … I became a pacifist two years ago but all this has pushed me into trying to do more by joining the Labour Party, the Toldas Group & United Nations Ass. etc. One can scarcely look "earlier sculptures" in the face if one remains politically & socially inactive now.'[70] The evocation of the political relevance of pre-war works indicates Hepworth's perception of a continuing struggle; recalling the Spanish Civil War she later remarked: 'With Vietnam people of my age are reliving the same thing. But there's now more passion about it.'[71] The sculptor continued to see art as a force for good in a disjointed world, but a recognition of failed idealism underlies many of her statements, exemplified by her confession in an interview: 'I think that we must all be feeling hideously guilty to have produced a situation which must be an agony for the young people.'[72]

Such social consciousness was associated during the 1950s with Hepworth's return to a more conventional religious faith. In 1944 she had stated her atheism unequivocally,[73] but her carving of a *Madonna and Child* as a memorial to her eldest son in 1954 signalled a renewed Christian aspect to her life.[74] This seems to have been determined by 1958 when she gave a number of works religious titles, notably *Cantate Domino* (no.45 q.v.). In 1966 she insisted that every 'sculpture is, and must be, an act of praise', echoing Nicholson's earlier comparison of painting to religious experience.[75] Hepworth's assertion reflected the strengthening of her faith as an 'Anglican Catholic'.[76] This was especially pronounced after the diagnosis of cancer in 1965 and manifested itself most overtly in *Construction (Crucifixion)* 1966 (fig.9), which she specifically related to her illness.[77] In her last ten years she was a regular communicant at St Ives parish church, while friendships with Fr Donald Harris of St Paul's, Knightsbridge in London, and Moelwyn Merchant, former Dean of Salisbury Cathedral, offered the opportunity to discuss her own Christian reflections. Her speculations on sin and the relationship between the artist and Christianity were, typically, informed by her reading of such Christian writers as Teilhard de Chardin, Søren Kierkegaard and Thomas Traherne.

Spiritual concerns and political internationalism converged in Hepworth's friendship with the charismatic UN Secretary-General, Dag Hammarskjöld, whom she met in 1959. Both were dedicated to work to the exclusion of personal happiness, and shared an appetite for spiritual speculation. In a poem, published posthumously in his diary of meditations on sacrifice, Hammarskjöld contemplated the pre-war sculpture *Single Form*, which he owned, and concluded with a question: 'Shall my soul meet | This curve, as a bend in the road | On her way to form?'[78] Hepworth's exchange with Hammarskjöld went beyond admiration for his integrity to a recognition of this personal isolation. Like him, she sought a spiritual guidance and meaning for her work which could inform its political and social relevance. In the aftermath of his sudden death in 1961, she pursued these themes in a letter to Read: 'I do not think it is a weakness in us that we have to sacrifice friendships for work. I think that in trying to be true to our work we are trying to be true to our friendships.'[79]

The conflict between personal and professional lives was central to Hepworth's position as a woman artist, even as she viewed modernism as an endeavour shared amongst equals. As for many of her generation, she believed that art lay outside considerations of gender: it is 'either good or it isn't'.[80] However, she was not blind to

fig.9
Construction (Crucifixion), 1966, height 366 (144), painted bronze, BH 443, Barbara Hepworth Estate

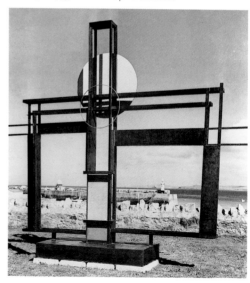

the prejudice to be borne by women artists. In *Circle*, Hepworth addressed this obliquely by stressing that the concern with the 'vital' in art – a current evaluative term – was not a test of strength exclusive to men: 'Vitality is not a physical, organic attribute of sculpture – it is a spiritual inner life.'[81] Nevertheless, in the critical comparisons of her work with that of Moore and Nicholson, she was regularly considered as a follower, explicitly because she was younger and implicitly because of her sex. Rarely was her work measured for its own quality aside from such comparisons, even by those – such as Read – whom she counted amongst her closest supporters. Her early work had confounded Stokes's gendered theory of carving which posited the male sculptor imposing form on the female material; forty years later, he returned to the habitual contrast with Moore and proposed: 'If we conceive nature, particularly landscape, as the mother's body refreshed by the father … we are provided with a deep contrast between their feeling that issues originally from the developed difference of sex. Moore tunnels mountains … In the main line of Barbara Hepworth's work there is no tumult.'[82]

If the sculptor saw art as beyond gender, she nevertheless understood – in a way suggested by Stokes – her experience as a woman as being quite distinct. This was particularly the case in the relation between her work and her responsibility for her family. These Hepworth saw as mutually enriching projects, later emphasising the inspiration derived from her children as well as her prompt return to work after their birth.[83] She had observed in 1943 that youth, motherhood and gender had hindered her reputation and ambition,[84] but, with the establishment of her international standing, she also recognised what she called the 'complementary' relationship between the feminine and masculine in art. This she understood in formal and emotional terms: in an implicit contrast with Moore's hieratic 'Northampton Madonna', which she thought 'smug',[85] she wrote that on seeing a woman carrying a child, 'it is not so much what I see that affects me, but what I feel within my own body. There is an immediate transference of sensation, a response within to the rhythm of weight, balance and tension of large and small form making an interior organic whole. … It may be that the sensation of being a woman presents yet another facet of the sculptural idea.'[86] This is a privileged position, especially as Hepworth believed that 'The sculptor sets out to appeal to all the senses of the spectator, in fact to his whole body, not merely to his sight and his sense of touch.'[87]

When, in the 1970s, the critical debate shifted towards a reassessment of women artists in the light of wider feminist discourses, Hepworth was necessarily – if equivocally, because of her view of complementary contributions – the subject of considerable attention. Although the sculptor asserted that 'one does contribute to art and that's nothing to do with being male or female', Cindy Nemser sought to reposition Hepworth's activity within a feminist history.[88] In contrast to the artist's formalist defence, subsequent accounts have reread her work in the light of feminist and other critical discourses. In these contexts, Hepworth's sculpture tells of different issues – of the place of a woman artist concerned with abstraction from and of the body working within the patriarchal modernist art world – which, though she might not have recognised them, have nevertheless proved enriching.[89] It has become possible to understand Hepworth's early carving in the light of psychoanalytical readings of maternal–infant relations and as 'an act of self-inscription – an identification with the stone',[90] or, in Kristevean terms, as indicative of a transformatory feminine practice.[91] Diverse as these approaches may be, they have served to refocus the discussion of Hepworth's sculpture in terms distinct from the formalist approach which she herself countenanced and even controlled in her lifetime. Thus, the theoretical pluralism of recent years has facilitated a reassessment of Hepworth and challenged the singular view of her work.

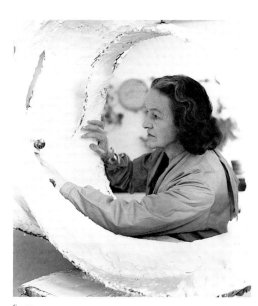

fig.10
Barbara Hepworth working with plaster, 1963

Conventions

All works are listed with their Tate Gallery accession number
and all sculptures are given their 'BH' number, which refers
to the two volumes of the published catalogue raisonné
(Hodin 1961, and Bowness 1971) and to the artist's own
records, copies of which are held by the Tate Gallery
Archive. Accompanying references to reproductions are
made to the catalogue raisonné and other major texts.

Each entry is accompanied by listings relating to the history
of the work. The list of exhibitions is comprehensive, while
the 'Literature' section refers to texts in which the work is
specifically discussed. The selection of places where a work
is reproduced concentrates on early instances and
monographs on the artist. In the exhibition histories of
editioned sculptures, reference is made to the specific cast
under discussion; references to exhibitions in which another
cast was shown or the cast was unspecified bear the
appropriate symbol.

A list of the abbreviations used for exhibitions and
publications is found on pp. 278-9.

All dimensions are given in centimetres (followed by
inches); height is given before width and depth.

b.l./b.r.	bottom left/bottom right
col.	colour
q.v.	*quod vide*: which see
repr.	reproduced
t.l./t.r.	top left/top right
?	unconfirmed information
†	unidentified cast
‡	other cast
\|	line endings in inscriptions
[...]	lost or indecipherable letters
<...>	deletions

Catalogue

1 Torso 1928

T03128 BH 12

Hoptonwood stone 36 × 17 × 10 (14¼ × 6¾ × 4) on poplar
base 4.2 × 30.5 × 18.7 (1⅝ × 13¾ × 7⅜)

*Presented by the executors of the artist's estate,
in accordance with her wishes, 1980*

*Displayed in the artist's studio, Barbara Hepworth Museum,
St Ives*

Provenance: Acquired from the artist by A.J. McNeill Reid,
1928; sold by his widow, Sotheby's *Modern British Drawings,
Paintings and Sculpture*, 22 April 1970 (96, repr.), bought
Gimpel Fils and the artist jointly; acquired in full by the
artist 1972

Exhibited: Beaux Arts 1928 (7); Glasgow 1928 (39);
Whitechapel 1954 (5); *Carving Mountains: Modern Stone
Sculpture in England 1907–37*, Kettle's Yard, Cambridge,
March– April 1998, De la Warr Pavilion, Bexhill-on-Sea,
May–June (19, repr. p.50)

Literature: Read 1952, pp.ix, x–xi, pl.8; Hodin 1961, p.161, no.12;
Jenkins 1982, p.10, repr. p.23; *Tate Gallery Acquisitions
1980–2*, 1984, p.110, repr.

In its simplicity, *Torso* embodies the ideals of the 'new movement' in sculpture, with which the works of Barbara Hepworth, John Skeaping, Henry Moore and others were identified in the 1920s. These ideals were opposed to the practice of craftsmen transferring sculptors' models into stone and adopted instead the technical honesty of direct carving; Michelangelo was cited as a precedent, 'removing the superfluous in a block of stone in order to reach the essential'.[1] Direct carving represented a rebellion against the nineteenth-century academic tradition and was associated with the modernism of Jacob Epstein and Henri Gaudier-Brzeska in Britain and Constantin Brancusi, Ossip Zadkine and others in Paris. Hepworth – by Skeaping's account – began to carve stone in Rome in 1925–6 under his guidance and that of Giovanni Ardini the *marmista* (marble craftsman), whose experience she also recalled.[2]

An instructive comparison may be drawn between *Torso*, carved in Hoptonwood stone (a Derbyshire limestone), and the bronze *Standing Woman, Right Hand Raised* 1925 (fig.2) made during her Italian period. The restraint of this earlier work reflects the monumentality of Quattrocento art which Hepworth later remembered admiring[3] and which was influential on other Rome Scholars such as Thomas Monnington. The modelling technique shows Hepworth's only gradual transition to carving. A sympathy for stone and a retention of the form of the block was established in *Torso*, with the shallow delineation of the limbs serving simultaneously as a demonstration of skill and an acknowledgement of the quality of the material. Although she and Skeaping also carved exotic stones, the use of an indigenous limestone more commonly used for architectural details reinforced a craft sensibility.

Recent interpretations of Hepworth's concentration upon the nude – notably by Anne Wagner[4] – have stressed the conjunction of her experience as woman and her exploration of the female body as a subject. In works such as *Torso* a simple actuality – the broad hips and small breasts common to most of Hepworth's nudes – displaced the conventional idealisation in many comparable works by men. Nevertheless, the objectified and truncated female nude remained a quintessential sculptural theme epitomised by Hellenistic Aphrodites and readdressed by Auguste Rodin's presentation of the fragmentary body as a complete work. Gaudier-Brzeska's slim marble *Torso* 1913, at that time in the Victoria and Albert Museum,[5] exemplified a pre-war attempt to reintegrate this theme with direct carving, and Skeaping also seemed to take up this thread in a naturalistically treated white marble *Torso* also of 1928, which was at one time attributed to Hepworth.[6] In the 1950s, Herbert Read went as far as to suggest that the Tate's *Torso* was 'conceivably a derivative of the lost masterpiece of Praxiteles', the *Aphrodite of Knidos*, but he qualified this with an absorption of Mexican, Egyptian and Renaissance sculpture.[7] Indeed, in the warm grey-brown of the stone and Hepworth's characteristic tendency towards frontality, *Torso* was opposed to classical values. Even an element of stylisation was introduced in the detail of the triangular navel, which recurred in *Contemplative Figure* 1928.[8]

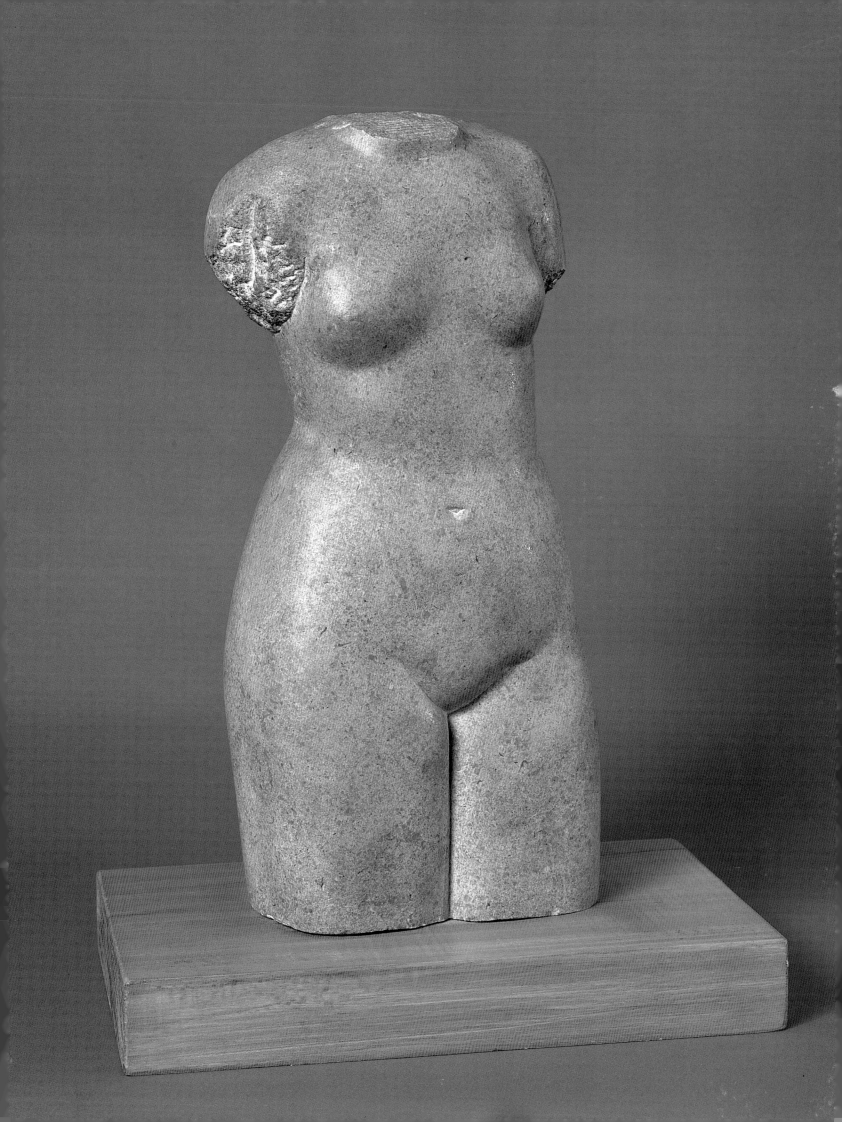

In common with many of her contemporaries Hepworth was also drawn to sources outside the classical European tradition. *Torso* may be specifically compared to the unique *Limestone Statue of a Woman* c.1073–1056 BC from Nineveh which was acquired by the British Museum in the mid-1920s.[9] More broadly, a commonly held interest in Archaic Greek Kouroi may be suggested by Hepworth's possession of a postcard of an example in the Louvre, and by the evident debt of Skeaping's contemporary *Torso of a Boy in Detached Relief* 1928.[10] In March of the same year, by contrast, Eric Gill showed his female torso *Mankind* 1927–8 (fig.11) at the Goupil Gallery; although a product of direct carving in the same Hoptonwood stone, it epitomised an attenuation and idealisation of the female form quite distinct from Hepworth's approach.

Torso must have been completed before June 1928, as it was included in both of Hepworth's and Skeaping's joint exhibitions that summer. The foreword to their Glasgow show drew attention to her 'statuettes and groups in marble and stone … carved directly and freely'.[11] It was at this moment – and as a significant measure of confidence in her work – that the dealer A.J. McNeill Reid acquired the sculpture. While in his collection *Torso* was mounted on a narrow circular base.[12] In contrast to the present rectangular wooden base, which seems to date from the work's reacquisition by the artist, this encouraged viewing in the round.

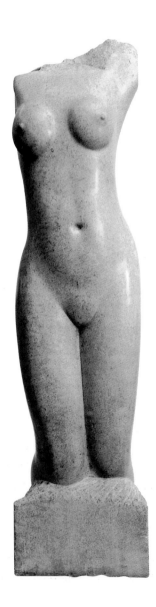

fig.11
Eric Gill, *Mankind*, 1927-8, height 241.3 (95),
Hoptonwood stone, Tate Gallery

2 Infant 1929

T03129 BH 24

Burmese wood 42.5 × 27 × 19 (16¾ × 10⅝ × 7 ½)
on Hoptonwood stone base 11.4 × 29.5 × 20.3 (4½ × 11⅝ × 8)

*Presented by the executors of the artist's estate, in
accordance with her wishes, 1980*

*Displayed in the artist's studio, Barbara Hepworth Museum,
St Ives*

Provenance: Purchased from the artist through Arthur
Tooth & Sons by Sir George Hill 1930; …; Dr H.P. Widdup
(by 1954, Whitechapel Art Gallery), from whom acquired by
Miss Jill Horne (by 1968, Tate Gallery), from whom bought
by Gimpel Fils on behalf of the artist by April 1970

Exhibited: Tooth's 1930 (35); Whitechapel 1954 (7); Tate 1968
(6); *Retrospective* 1994–5 (6, repr. p.14, Liverpool only)

Literature: John Grierson, 'The New Generation in
Sculpture', *Apollo*, vol.12, no.71, Nov. 1930, p.350 (repr.);
Louise Gordon-Stables, 'London Letter', *Art News*, vol.29,
no.6, 8 Nov. 1930, p.23; F. G[ordon] R[oe], 'Let's be Modern',
Connoisseur, vol.86, no.352, Dec. 1930, p.413; Hodin 1961,
p.162, no.24, repr.; Hammacher 1968/1987, p.32, repr. p.33,
pl.18; Jenkins 1982, p.10, repr. p.23; *Tate Gallery Acquisitions
1980–2*, 1984, p.111, repr.; Festing 1995, pp.68, 79, 81, repr.
between pp.40 and 41, pl.17; Anne M. Wagner, "'Miss
Hepworth's Stone *Is* a Mother'" in Thistlewood 1996, pp.54,
69, repr. p.55; *Un Siècle de Sculpture Anglaise*, exh. cat.,
Galerie national du Jeu de Paume, Paris 1996, p.457; Curtis
1998, p.28

Reproduced: Barbara Hepworth, 'Statement' in the series
'Contemporary English Sculptors', *Architectural Association
Journal*, vol.45, no.518, April 1930, p.385; Gibson 1946,
pls.8–9 (as '*Infant* (Burmese wood) 1930'); Read 1952, pl.10;
Pictorial Autobiography 1970/1978, p.16

Hepworth's first son, Paul, was born on 3 August 1929, and *Infant* may be taken to
be 'a likeness' of him.[1] In her autobiography, the sculptor placed a reproduction of
the work alongside a photograph of herself with her baby, and commented: 'My son
Paul was born, and, with him in his cot, or on a rug at my feet, my carving developed and
strengthened.'[2] Nevertheless, *Infant* is set apart from portraiture through the use of the
impersonal title and wood almost black in colour. In a statement of 1930 Hepworth
explained this move away from representation: 'Generalisation, by which I mean an
accumulative assertion of the emotion of a thing, is nearer to the abstract than
particularisation, which is a faithful portrayal of an individual object. My trend is
towards generalisation; but I have not dispensed with representation entirely.'[3] The
accompanying reproduction of *Infant* implies that the sculptor saw it as exemplifying
such a distancing from portrayal.

The pose must have derived from Hepworth's experience and observation of Paul,
the relaxed enclosure of the rounded body conveying an instinctive security. Even the
back is curved, although it was evidently adapted from a recumbent sleeping position
to an unsupported vertical. An imposed formality mitigated against the improbability of
this position – the near-symmetrical legs and feet were tucked around the front of the
body and balanced visually by the upheld arms – and the underlying symmetry was
enlivened by the turned head. While presumably indicative of sleep, the curiously
smoothed eye sockets may suggest the limited sensual experience of early infancy.
The contradiction between repose and the upright position imbues *Infant* with an air
of presentation and authority reminiscent of the traditional iconography of the Christ
child. Such associations have led Anne Wagner, in her discussion of the retrospective
reading of *Infant* in the *Pictorial Autobiography*, to remark: 'We see that the infant Paul
… wriggling on his rug, was not just a talisman or tutelary deity; he was a subject for
art.'[4] In her integration of art and life, Hepworth's view of her son's birth in terms of her
sculptural development presented just the depersonalised aspect suggested in the title.

Like animals, children featured regularly in contemporary sculptures. Henry Moore
and Maurice Lambert both made works on the theme of the mother and child, as
Hepworth did herself in the early 1930s with works such as *Mother and Child* 1934 (no.7
q.v.). However, their concern was with formal and emotional inter-relations and, as such,
they differ fundamentally from the isolation of *Infant*. In Moore's remarkable *Suckling
Child* 1927, this concentration persists even if the mother is reduced, as Wagner has
observed, 'to a mere object, and a purely Kleinian one at that … a single breast'.[5] *Baby*
1932 by another woman sculptor, Gertrude Hermes,[6] is directly comparable with *Infant*
in its isolation, but its foetal repose contrasts with the hierarchical confidence of
Hepworth's work.

Along with the teak *Standing Figure* 1930,[7] *Infant* is one of the earliest of Hepworth's
works in dark heartwood from exotic trees. While contrasting in colour with her
contemporary use of light stones, the hard wood met her preference for direct carving

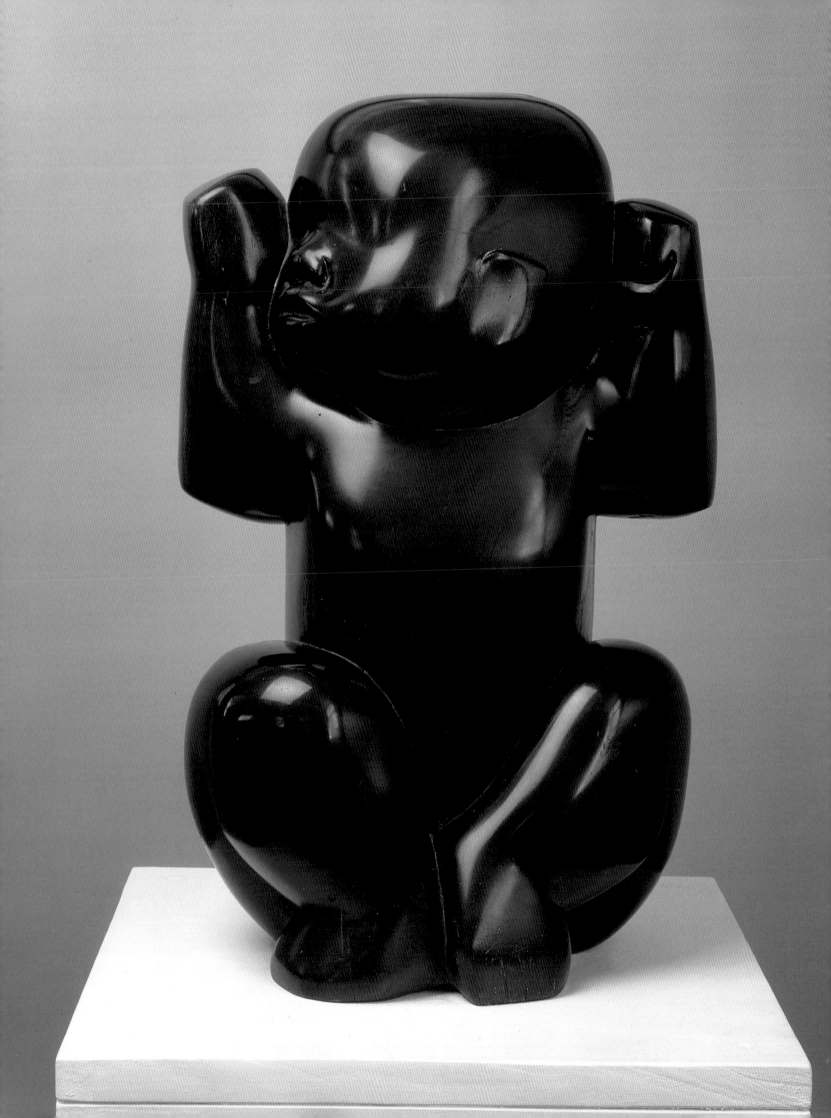

over modelling; she would explain: 'I like the resistance of the hard material and feel happier working that way.'[8] Although the specific wood described by the sculptor as 'Burmese' has not been identified conclusively, it facilitated the cutting of crisp details on *Infant* – the ears, nose and mouth, and the incised lines of the fingers and toes – and the undercutting of the parts of the body. When viewed from the side, the body stacks up in roughly equal rounded masses of the legs, torso and head.

The sculpture's good condition may also be linked to the wood's hardness and maturity, although a radial split (centred on the head and passing down the back and shoulder) probably developed during carving; pigmented woodflour mixed with PVA has replaced earlier putty fills.[9] Although currently displayed without a base for reasons of security, the sculpture has been presented in two ways. The polished base of oatmeal-coloured Hoptonwood stone (with its graded stepped top) first appears in the photograph in the *Pictorial Autobiography* published in 1970, the year in which the sculpture was reacquired by the artist. Prior to that it was shown on a slightly lower wooden block, close in quality to the sculpture itself; this is visible in the earliest published photograph and conveyed the impression of the continuation of the work from the base even though they were clearly separate.[10] A similar impression was created with related wooden works, such as *Standing Figure* 1930.

Both the material and handling of *Infant* suggest Hepworth's interest in what she would describe as 'the warmth, creativeness, humaneness of the negro carvings.'[11] These concerns formed part of the critical debate which surrounded her joint exhibition with Skeaping at Tooth's in 1930. There *Infant* sold immediately to Sir George Hill, a Trustee of the British School in Rome and a Curator in the Coins Department of the British Museum, who also owned *Mask* 1928 and *Sleeping Mask* 1928.[12] The sculpture also attracted positive critical comment. Remarking on some debt to 'the savage arts of Africa', Gordon Roe called *Infant* 'the one really expressive thing in the display, in that it definitely told of an instinctive mental reaction, rather than of a cultural adoption of formulae with a purely technical appeal. Whether active or latent, the love for a child is equally a matter of the past and the present'.[13] Such a perception of the instinctiveness of the work of contemporary women artists was widespread. John Grierson was more searching in an article on Hepworth and Skeaping in *Apollo*, timed to coincide with the exhibition. Writing of their choice of animal and figure subjects he suggested that it 'comes from a quickened consciousness of organic life which I am apt to think is the especial stock-in-trade of the new generation'. Pursuing this further, he added 'I have never seen any reason why fidelity to the essentials of form – to strength, solidity, function, and the like – should prevent an artist being decently imaginative about things'.[14] As well as works by Skeaping, he found 'this greater imaginativeness' in *Infant*. Given his connection with the couple – he had known Skeaping since 1923–4 when they both taught at Armstrong College, Newcastle – it may be presumed that his discussion reflected their views. The notion of 'organic life' characterised the formal modifications associated with modernism, while the 'imaginative' went beyond this to suggest the potential accommodation of abstraction. Indeed, Hepworth herself acknowledged this inclination in the brief statement published in the *Architectural Association Journal* in 1930, where she asserted: 'abstract form, the relation of masses and planes, is that which gives sculptural life; this, then, admits that a piece of sculpture can be purely abstract or non-representational.'[15]

3 Figure of a Woman 1929–30

T00952 BH 27

Corsehill stone on integral marble base 53.3 × 30.5 × 27.9
(21 × 12 × 11); weight 47.5 kg
Incised into back of base 'BH' centre ('H' chipped)

Presented by the artist 1967

Provenance: ?Purchased from the artist by Mr and Mrs
Geoffrey Gorer, from whom purchased by Zwemmer Gallery
by 1950 and sold by them to Nicholas Guppy after 1961, by
whom sold back to the artist March 1965

Exhibited: ?*First Exhibition of the Young Painters Society*,
New Burlington Galleries, March–Apr. 1930 (348, as '*Half
Figure of Woman* by Barbara Hepworth Skeaping'); *London
Group Exhibition of Open-Air Sculpture*, Selfridge's Roof
Garden, June–Aug. 1930 (44, as *Girl*); Tooth's 1930 (34,
repr.); *London Group 29th Exhibition*, New Burlington
Galleries, Oct. 1931 (320, as '*Half Figure* in Hamhill stone');
Neue Englische Kunst, Hamburg Kunstverein, June–July
1932 (34, as *Frau*); Leeds 1943 (74); Wakefield & Halifax,
1944 (3, as *Figure*); *Venice Biennale* 1950 (British pavilion
65, as *Woman*); Whitechapel 1954 (10, as *Woman*); *London
Group: 1914–64 Jubilee Exhibition, Fifty Years of British Art*,
Tate Gallery, July–Aug. 1964 (69, repr., as *Woman: Half
Figure*); Tate 1968 (7, repr. in col. p.10); Plymouth 1970 (2);
*Henry Moore to Gilbert and George: Modern British Art
from the Tate Gallery*, Palais des Beaux Arts, Brussels,
Sept.–Nov. 1973 (45, repr. p.56); *British Sculpture in the
Twentieth Century, Part 1: Image and Form 1901–50*,
Whitechapel Art Gallery, Sept. 1981–Jan. 1982 (101); *Images
of Women*, Leeds City Art Gallery, Oct. 1989–Jan. 1990 (64,
repr. p.49); *Retrospective* 1994–5 (8, repr. in col. p.30);
*Carving Mountains: Modern Stone Sculpture in England
1907–37*, Kettle's Yard, Cambridge, March–April 1998, De la
Warr Pavilion, Bexhill-on-Sea, May–June (20, repr. p.52)

Literature: John Grierson, 'The New Generation in
Sculpture', *Apollo*, vol.12, no.71, Nov. 1930, p.349; Louise
Gordon-Stables, 'London Letter', *Art News*, vol.29, no.6, 8
Nov. 1930, p.23; Hodin 1961, p.162, no.27, repr.; *Tate Gallery
Report 1967–8*, 1968, p.61; Alan Gouk, 'Subject to Stones:
British Sculpture at the Whitechapel I: 1901–1950', *Artscribe*,
no.32, Dec. 1981, p.28, repr.; Nicholas Hely-Hutchinson, 'The
Reluctant Modernist: John R. Skeaping, R.A. 1901–1980',
unpublished MA Dissertation, University of St Andrews,
1982, p.32, pl.20; Jenkins 1982, p.10, repr. p.23; Penelope
Curtis, 'British Modernist Sculptors and Italy', *British Artists
in Italy 1920–80*, exh. cat., Herbert Read Gallery, Canterbury
1985, p.14; Penelope Curtis, *Modern British Sculpture from
the Collection*, Tate Gallery Liverpool, 1988, p.42, repr.; Alan
G. Wilkinson, 'The 1930s: "Constructive Forms and Poetic
Structure"' in *Retrospective* 1994–5, exh. cat., pp.31–2; Curtis
1998, p.29, repr. p.28 fig.28 (col.)

Figure of a Woman embodied a bold assertion of the modernist tendency towards formal experimentation associated with 'direct carving'. It may be seen in the context of Hepworth's contribution to a series of articles on contemporary sculpture in 1929–30; there she stated her preference for carving because of the particular demands of 'an unlimited variety of materials'.[1] Two years later, by which time the arguments for this practice were well rehearsed, she would explain that carving was 'more adapted to the expression of the accumulative idea of experience'.[2] Such experience appears to have been as much accrued in the working as in life. Each block afforded a demonstration of responsive carving techniques; how far these differed between stone and wood may be seen in comparing the robust forms of *Figure of a Woman* with the similarly posed but more sensuously handled sycamore *Figure* 1931.[3]

The appearance of Corsehill stone, a red sandstone, is soft and dry and resembles terracotta in texture and colour. It attracted comment soon after *Figure of a Woman* was first shown: Kineton Parkes remarked upon the 'pleasing material', while John Grierson wrote that in it there was, 'as one expects from a woman sculptor, a more conscious feeling for the colour of the material'.[4] The stone has been scratched in places (on the top of the head and the figure's right hip), and heavy soiling of its porous surface necessitated surface and steam cleaning in 1991.[5] It contrasts with the greyish ochre of the marble base, to which it is fixed (the joint being filled with pigmented plaster) and which bears Hepworth's initials. However, the base did not appear in either the photograph in the Tooth's catalogue (Oct. 1930) or another of the same moment where it is displayed on a square stone block.[6] The sculpture had already been exhibited twice that year: its presence in the Selfridge's Roof Garden exhibition (June–Aug.) is confirmed by the artist's records,[7] and may be the *Half Figure of Woman* shown at the earlier Young Painters' Society. Thus the initialled base may date from the purchase of the work by Geoffrey Gorer, presumably from the 1931 London Group exhibition.

At least three different techniques are demonstrated on the figure itself. Although unpolished, most of it is worked smoothly in order to equate the bulk of the stone with the body and to focus detail on defining areas, such as the column of the neck. The weighty forms allow for the carefully opened cavities between the elbows and the sides. In a way that is more extreme than with *Torso* 1928 (no.1 q.v.), *Figure of a Woman* retains the mass of the block in the lower part, with the concomitant modification of the structure of the torso. This is particularly evident in the rear view, where the broad hips and shoulders are joined by a powerful but boneless back. In contrast to the surface, sharp cutting and incising secured further details. The strong form of the nose and mouth contrasts with less distinct eyes. They are asymmetrical – like those of Skeaping's *Fish* c.1930 (Appendix B q.v.) – the left eye being a careful almond, and the right eye abbreviated to three shallow cuts. To the treatment of planes and the cutting, a third quality was added as the lower surface of the mass of hair shows the tooth marks of the claw-chisel used to rough out the block. The furrows coincide with the direction

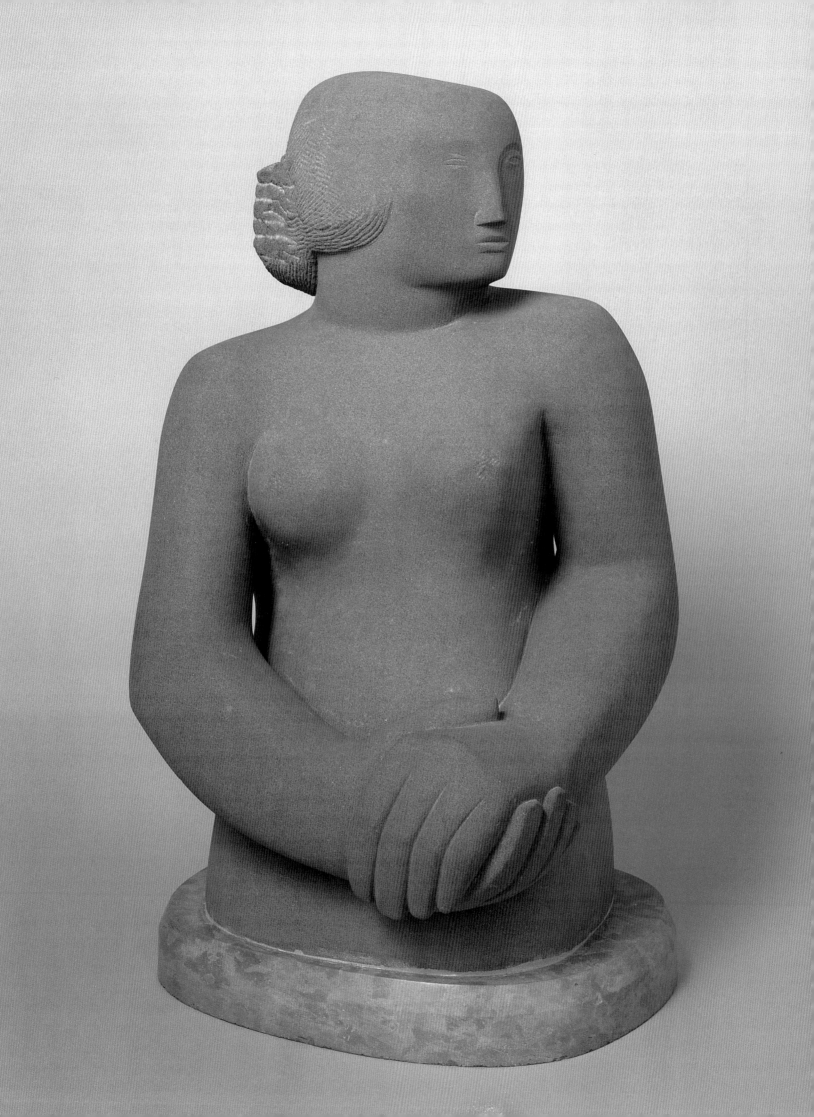

fig.12
Female Nude, Half-Figure, 1929, dimensions and material not known, no BH number, whereabouts unknown

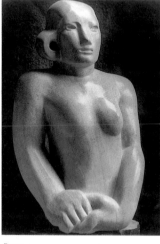

fig.13
John Skeaping, *Half-Length Figure of a Woman*, c.1929-30, dimensions not known, Ancaster stone, whereabouts unknown

fig.14
Henry Moore, *Reclining Figure*, 1929, length 83.8 (33), brown Hornton stone, Leeds City Art Gallery

of the hair as it converges to form a bun. In this detail, the emergence of the figure from the block was embodied in the shift from unformed to formed, from stone to image.

Hepworth had explored this contrast in texture on a number of closely contemporary pieces. Photographs of two of these were published by Penelope Curtis: *Mother and Child* 1929 in brown Hornton stone and *Female Nude, Half-Figure* 1929 (fig.12).[8] In both the heavy-limbed bodies are massive and the hair left with the claw-chisel marks. In the emphasis on the profile *Female Nude, Half-Figure* is especially close to *Figure of a Woman*, although the flatter and more crudely stylised face may suggest that it is earlier. To some extent, the handling of all three works may be related to Michelangelo with whom direct carving was associated in books such as Kineton Parkes's *The Art of Carved Sculpture*; the hair of *Figure of a Woman* may even be compared to the rough hair of his unfinished and similarly posed *Brutus* c.1538.[9] More immediately, the variety of surfaces was also evident in Moore's figures, such as *Reclining Figure* 1929 (fig.14), where the block on the head and the massiveness of the body are especially close to *Figure of a Woman*. In both sculptors' work a response to that of two senior modernists is evident. In 1929, considerable public hostility was aimed at Jacob Epstein's carvings of *Night* and *Day* 1928–9 on the headquarters of London Underground – a project in which Moore had also been involved.[10] Massive block-like forms were already evident in the work of both Moore and Hepworth, and their strength in *Figure of a Woman* may be seen as an assertion of the 'new movement' in sculpture despite this controversy. The scale and balance of Hepworth's forms may also be compared with Picasso's classicising paintings of heavy-handed women, such as *Women at the Fountain* 1921.[11]

Hepworth and her circle were particularly enthusiastic about precedents outside Europe – Mexican, African and Asian sculpture – as well as those excluded from the classical European tradition. The primary source was the British Museum, with which Hepworth and Skeaping were familiar, not least through the curators who collected their work (such as George Hill and Laurence Binyon). The flattened triangular face of *Figure of a Woman* hints at Hepworth's interest in Cycladic sculpture evident in her *Musician* 1929.[12] The locked hands, which recur in the sycamore *Figure* 1931 (BH 34), relate to Mesopotamian sculptures such as the *Statue of Kurlil* c.2500 BC,[13] then newly arrived from Sir Leonard Woolley's excavations at Ur. Such precedents have been identified as the 'locus classicus' of the theme by Charles Harrison, who has noted Moore's later article in *The Listener* in which he expressed his enthusiasm for Sumerian work.[14] These sources encouraged similarly fine carving in hard stone.

Although these themes identify an approach which Hepworth shared with Skeaping and Moore, there remain distinct differences between their works. Alan Wilkinson has contrasted a 'sense of calmness and serenity' (which he associated with classical art) in *Figure of a Woman* with the 'alertness' of Moore's Mexican-inspired *Girl with Clasped Hands* 1930.[15] Penelope Curtis has argued persuasively for a blurring of these distinctions, seeing a residue of Italian influence in both sculptors' works alongside their enthusiasm for extra-European sources.[16] Skeaping's contribution to this dialogue has been minimised through the loss of important works. However, a photograph of his *Half-Length Figure of a Woman* c.1929–30 (fig.13), which was shown at Tooth's in 1930 alongside *Figure of a Woman*, shows a shared formal language. Skeaping made his figure more naturalistically muscled and the face less stylised. As well as providing a wider context for Hepworth's work, these differences highlight its assurance.

Figure of a Woman is representative of Hepworth's use of the anonymous female as the vehicle of expression. She eschewed the idealised classical form which continued to characterise such acclaimed sculptures as Gill's *Mankind* 1927–8 (fig.11) and Frank Dobson's *Cornucopia* 1925–7.[17] This also challenged perceptions of sexual stereotypes, a tendency implicit in the minimal marking of the nipples on *Figure of a Woman* which has the effect of de-eroticising them. The overall solidity of the form resulted in a powerful image of self-assurance.

4 Sculpture with Profiles 1932

TO6520 BH 45

Alabaster 19 × 19 × 14 (7½ × 7½ × 5½) on alabaster base
3.5 × 23.9 × 13.9 (1⅜ × 9⅜ × 5½)

*Bequeathed by Mrs Helen Margaret Murray in memory of
her husband Frederick Lewis Staite Murray 1992*

Provenance: ?Acquired from the artist through Alex. Reid
and Lefevre by Frederick Lewis Staite Murray 1933

Exhibited: Lefevre 1933 (5, as *Composition*); Leeds 1943
(82); *Art in Britain 1930–40 Centred around Axis, Circle, Unit
One*, Marlborough Fine Art, March–April 1965 (35); Tate
1968 (15, repr. p.9); *British Sculpture in the Twentieth
Century*, Whitechapel Art Gallery, Sept. 1981–Jan. 1982 (part
1, 150); *Années 30 en Europe: Le Temps menaçant
1929–1939*, Musée d'Art Moderne de la Ville de Paris,
Feb.–May 1997 (no number, repr. in col. p.304); *Carving
Mountains: Modern Stone Sculpture in England 1907–37*,
Kettle's Yard, Cambridge, March–April 1998, De la Warr
Pavilion, Bexhill-on-Sea, May–June (21, repr. pp.38, 70)

Literature: Gibson 1946, p.6, pls.16–17; Hodin 1961, p.162,
no.45, repr.; Robert Melville, 'Creative Gap', *New Statesman
and Nation*, vol.75, no.1935, 12 April 1968, p.494; Anne M.
Wagner, '"Miss Hepworth's Stone *Is* a Mother"' in
Thistlewood 1996, p.63; Curtis 1998, p.30, repr. fig.28 (col.)

Reproduced: Eric Underwood, *A Short History of English
Sculpture* 1933, opposite p.171, fig.47 (as *Carving in White
Alabaster*); Read 1952, pl.30

fig.15*a*
Two Studies for Sculpture, c.1932, 27.4 x 21.2 (10 3/4 x 8 1/4),
pencil on paper, Barbara Hepworth Estate

During the 1930s Hepworth began what has been perceived as a smooth transition from the concerns of direct carving to those of 'constructive art'. Already in early 1930, she had argued that 'the relation of masses and planes … admits that a piece of sculpture can be purely abstract or non-representational'.[1] By October 1931, she could acknowledge privately that her work was 'tending to become more abstract', and she would later look back on this period as 'pre-"totally constructive"'.[2] A decade later again, she specified that 'achieving a personal harmony with the material' was superseded in 1930 by independence; of *Head* 1930 she wrote that it 'expressed that feeling of freedom, and a new period began in which my idea formed independently of the block'.[3] In his introduction to Hepworth's part of the exhibition shared with Nicholson in late 1932, Herbert Read already felt able to identify the departure from direct carving. Taking it as an achievement secured, he noted: 'Beyond these essentials, so appealing to our immediate senses, there is a fantasy which should awaken subtler delights in the imagination and memory.'[4]

There is little doubt about either the proficiency with which Hepworth carved stone and wood by 1929 or the composition of abstract solids in 1935, but the work of the intervening years was varied, with reversions to earlier conventions alongside innovations which were not followed through in the constructive phase. Indeed, the works reflect an especially experimental and turbulent period for the artist in which a primitivising figurative work, *Kneeling Figure* 1932,[5] could appear after the biomorphic and formally significant *Pierced Form* 1931 (fig.4). Their conjunction must suggest an adjustment either to their chronological relationship or to the idea that Hepworth pursued a single direction. There is supporting evidence in her productivity: after ten sculptures in 1929, output dropped to five in 1930 and three in 1931. This may be related to the birth of her son Paul in 1929 and the emotional upheaval following her encounter with Nicholson in 1931. Nevertheless, Hepworth's surviving correspondence shows that she was also experimenting with printing and with photograms (unique photographs made by laying objects on light-sensitive paper); she obviously felt considerable enthusiasm for both media as well as hoping to derive some commercial success from the results.

Sculpture with Profiles dates from this 'pre-"totally constructive"' period. Its form is loosely figurative, giving 'the impression of being a human bust hidden under a wet cloth'.[6] Anne Wagner has seen it as an expression of a female perception, remarking that 'Hepworth's proposal concerning the female body announces more than its coherence and unity. It is a body which can be as abrupt as it is unified, can seem as stunted as it is continuous. It becomes less a body than an object.'[7] The presence of more than one body in *Sculpture with Profiles* is suggested by a hitherto unpublished drawing (fig.15*a*) of embracing figures. This fits with the dominant themes in Hepworth's work at this time, and has clear parallels with the contemporary work of Picasso and of Ben Nicholson.

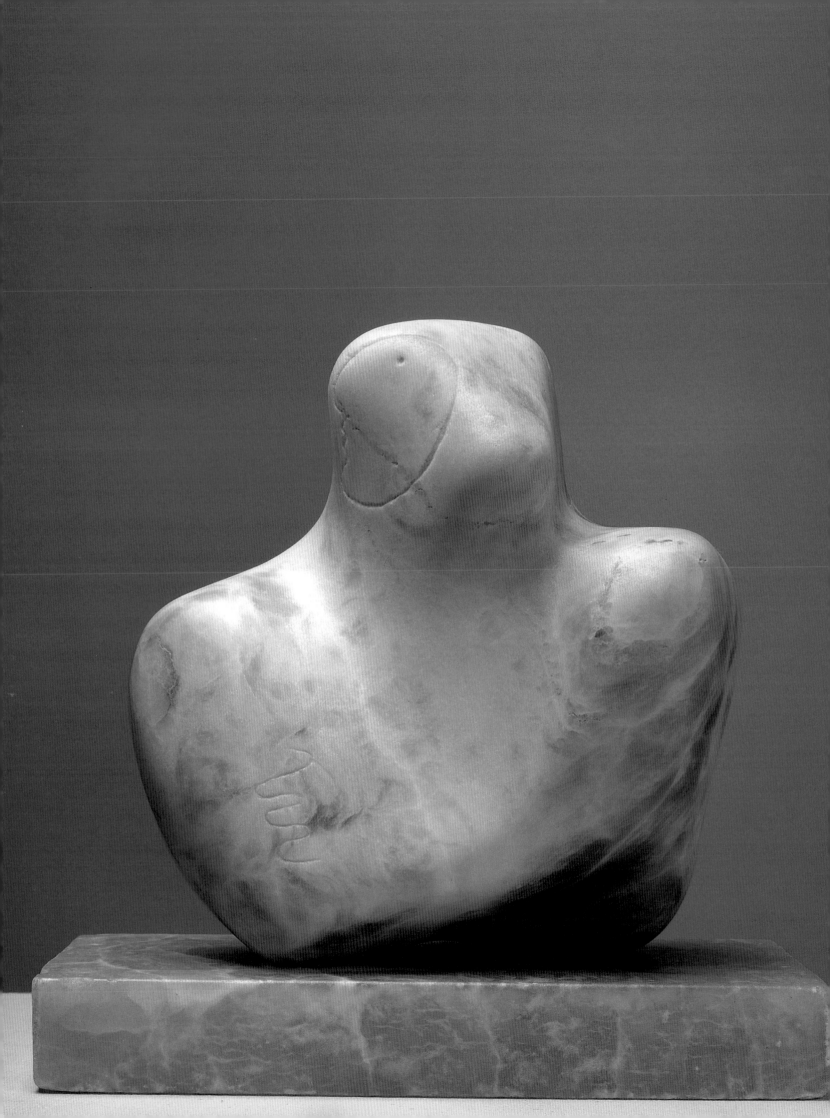

Parts of the sculpture may certainly be read as heads and shoulders. These are particularised by the incised lines although not without contradiction. The three fingers and thumb on the front relate to the shoulder, but a head in profile (with a simple dot eye) is delineated on the left side of the protrusion above, looking towards the rear. It is partnered on the other side by a face in profile (also looking towards the rear), open-mouthed and with an oval and dot eye (fig.15b). A third eye – an almond with circle and dot – appears on the very top of the stone. The related drawing indicates that the pointed protrusions on which the sculpture is balanced may have developed from the elbows of two figures pressed together. Although the translation from the drawing was not literal, the linear process seems to anticipate the conjunction of forms in three dimensions. The embrace suggested by the overlaying drawn profiles could thus be reconceived in the making of the sculpture. At their most immediate, the individual details in *Sculpture with Profiles* evoke at least three senses – touch, speech and sight – two of which were intimately bound to the making of sculpture. In this, as in their apparently free arrangement, they may support Read's identification of 'fantasy' in the sculptor's works. However, these details also suggest private meanings, not least because the profile face closely resembles that of Hepworth herself, hinting at self-identification. This is distinct from the more generalised profiles used on such works as *Profile* 1932 or *Figure* 1933.[8] Instead it has echoes in other practices of 1932–3. In November 1933, writing to Nicholson who was in Paris with Winifred, Hepworth announced '*I am doing photograms!*'[9] One of the results may be the *Self-photogram* of her profile published in *A Pictorial Autobiography*,[10] and this departure seems to relate to discussions the day before with László Moholy-Nagy, one of the discoverers of the technique. As an acknowledgement of inspiration, her profile was also central to such Nicholson paintings as *1932 (profile – Venetian red)*,[11] and came to be combined with gouges into the paint; thus, incised through black into white, she is embraced by a man with a Greek profile in *1933 (St Rémy, Provence)* (fig.16). Both the technique and motif parallel those on *Sculpture with Profiles*. Closer still to the sculpture are her features in Nicholson's 1933 *profile* linocut, where the inclusion of a second floating eye in the head accords with that placed on the top of the sculpture.[12]

The redistribution of figurative parts on *Sculpture with Profiles* also reflects concerns which both Hepworth and Nicholson shared with artists in Paris. The rearrangement of features was a classic Cubist device, with the use of outline close to Picasso's continuous line in paintings of the late 1920s.[13] Braque used a comparable line in his still lifes which were regularly reproduced in *Cahiers d'Art*, and he was the most frequently mentioned artist in Hepworth's letters to Nicholson during the latter's periodic stays with Winifred in Paris. In one of these letters, Nicholson revealed how close he considered this artistic connection to be in claiming: 'I told him [Braque] there was a sculptural movement in England which had sprung from his & Picasso's work.'[14] Hepworth and Nicholson met both Picasso and Braque on their passage through Paris at Easter 1933. The floating details on the sculpture's surface may also be related to Giacometti's most recent sculptures, which reflected contact with Surrealism. He may have been amongst the artists whom Hepworth and Nicholson met on their Parisian trip at Easter 1933, as Alan Wilkinson has suggested.[15] By that time Giacometti had carved his marble *Caress* 1932 (fig.17), an apparently abstract form with – coincidentally, in relation to *Sculpture with Profiles* – outlines of hands incised on either side.

On the same trip, the couple also visited the studios of Brancusi and Arp, meeting Sophie Taeuber-Arp in the latter's absence. Twenty years later Hepworth specifically recalled showing Brancusi photographs of her *Pierced Form* 1931 and *Profile* 1932 both works pierced near the centre. The penetration of the stone has been recognised as a crucial step in Hepworth's work, one followed by Moore in 1932. Hepworth would recall 'the most intense pleasure in piercing the stone in order to make an abstract form and space'.[16] Significantly, she added that she 'was, therefore, looking for some sort of

fig.15b
Sculpture with Profiles, another view

fig.16
Ben Nicholson, *1933 (St Rémy, Provence)*, 1933, 105 x 93
(41⅜ x 36⅝), oil and pencil on board, private collection

fig.17
Alberto Giacometti, *Caress*, 1932, height 49 (19¼), marble,
private collection

ratification of an idea which had germinated during the last two years'. Of Brancusi's studio, she remembered the 'humanism, which seemed intrinsic in all the forms', an abstraction from experience which was implicitly contrasted with the 'poetic idea in Arp's sculptures'.[17] As Alan Wilkinson has noted, the biomorphic form of Arp's works such as *Head with Annoying Objects* 1930–2 proved to be an immediate stimulus to Hepworth.[18] In her alabaster pieces, she had already begun to negotiate a path between the alternatives with which she associated the two Parisian sculptors. In response to the question of the relationship between sculpture and other arts, Hepworth wrote in late 1932: 'The best carvings are necessarily both abstract and representational, and if the sculptor can express his vision in the right medium, the abstract conception of form imbued with that life force, then he is at one with all other artists.'[19]

A number of organic works were related to *Sculpture with Profiles* in the incorporation of figurative incised lines. Although the Tate's work was not included in the 1932 Tooth's exhibition, two of Hepworth's pieces served to demonstrate this development. The nestling mother and child in alabaster entitled *Two Heads* 1932 showed a naturalistic stage, in contrast to the more biomorphic green marble *Profile* 1932.[20] However, with *Profile*, unlike the earlier *Pierced Form*, the relationship of hole to face retained figurative references.

The figurative aspect continued to infuse the works which appeared in the sculptor's second combined exhibition with Nicholson in late 1933 in which *Sculpture with Profiles* was shown. It is likely that the work was acquired there by Frederick Murray, brother of the potter William Staite Murray, a fellow member of the 7 & 5 Society. It was shown as *Composition* although it was simultaneously published by Underwood as *Carving in White Alabaster*. Both early titles draw attention to the abstract, this was emphasised less when the present title came into use in the 1940s. While this may reflect the later critical hostility to abstraction, the change confirms the balance between form and subject which was also achieved in related alabaster works such as the vertical *Figure* 1933 – first shown as *Composition* – and *Reclining Figure* 1932.[21] Both of these were included in the 1933 exhibition with *Sculpture with Profiles*, and both are visible in the photograph of the artist's studio in *Unit One* (fig.19). Such biomorphic bodies also feature in silhouette in Hepworth's collages; that of *Reclining Figure* dominates three similar forms in the collage *Saint-Rémy* 1933 which is also visible in the photograph.[22] Their combination in this context tends to reinforce the impression of a concerted theme.

It was appropriate that Hepworth used soft alabaster for most of these organic sculptures. Of the thirty-eight works for the years 1930–4 listed in Alan Bowness's catalogue, twenty were identified as in alabaster; Henry Moore recalled that the use of this stone in their circle was initiated by Skeaping.[23] It may be suggested that the ease of working allowed a rise in Hepworth's productivity during a period of financial instability; she made ten works in each of the years 1932–4, a total of sixteen being alabaster. For *Sculpture with Profiles* the choice was of a cream stone with heavy butterscotch veining for the sculpture, on a more yellow crazed (and evidently sawn) base. One danger was that alabaster was prone to fracture, as is evident from the now blackened fault at the right side and the crack in the grain of the head. However, it did allow the easy incision of lines, although some of the edges are slightly nibbed; these appeared to be whiter in the earliest published photograph, either through the opacity of the cut or because of some treatment. The balancing of the whole block on the two protrusions (through which it is attached with stainless steel screws to the base) carries echoes of the use of ironstone pebbles collected and worked by Hepworth, Skeaping and Moore during the previous summers.[24]

5 Seated Figure 1932–3

T03130 BH 46

Lignum vitae 35.6 × 26.7 × 21.6 (14 × 10½ × 8½)

Presented by the executors of the artist's estate, in accordance with her wishes, 1980

Displayed in the artist's studio, Barbara Hepworth Museum, St Ives

Provenance: Purchased from the artist by Sir Michael Sadler, 1933; bought from his estate through the Leicester Galleries by Mark Harvey, 1944, from whom bought by Gimpel Fils on behalf of the artist April 1970

Exhibited: Lefevre 1933 (6, as *Composition*); *Selected Paintings, Drawings and Sculpture from the Collection of the late Sir Michael Sadler*, Leicester Galleries, Jan.–Feb. 1944, 1st ed. (160); Whitechapel 1954 (18); *Retrospective* 1994–5 (13, repr. in col. p.27, Liverpool only)

Literature: Hodin 1961, p.162, no.46, repr.; Jenkins 1982, p.10, repr. p.23; *Tate Gallery Acquisitions 1980–2*, 1984, p.111, repr.; Derek Pullen and Sandra Deighton, 'Barbara Hepworth: Conserving a Lifetime's Work' in Jackie Heuman (ed.), *From Marble to Chocolate: The Conservation of Modern Sculpture*, 1995, p.140; Anne M. Wagner, "'Miss Hepworth's Stone *Is* a Mother'" in Thistlewood 1996, p.66

fig.18
Composition, 1933, 28.5 x 44.5 (11¼ x 17½), pencil and collage on wood, private collection

Hepworth carved *Seated Figure* at about the same time as the group of alabaster pieces to which *Sculpture with Profiles* (no.4 q.v.) belongs. It shares with them the combination of abstracted form with linear details, but retains characteristics associated with the artist's carving of wood. The original shape of the block is more in evidence in *Seated Figure*. This is emphasised by the fine quality of the dark grain, which enhances the form of the back, breasts and left arm. Despite originally being exhibited as *Composition* in 1933, the arrangement of the head, encircling arms and one knee raised over a tucked-in leg is immediately legible. Angular edges (such as those defining the hands) are kept to a minimum, as most of the volume was achieved through transitions with subtle modulations and complex contours. This is true of the hole below the arm, which was carved at converging angles from both sides (visible on close inspection), giving the impression that the figure was coiled around it. The incised lines act as signs for naturalistic details: the wave for the foot developed from undulating toes, the contrasting hands (a 'v' for the right, a spiral for the left) indicate their cupping and clenching, and the device of the profile/full face (shown by the mouth crossing the profile) derived from familiar Cubist conventions. This retention of reality was a characteristic of Hepworth's wooden sculptures of that moment – it is true of *Kneeling Figure* 1932 and *Torso* 1932 – as distinct from the greater abstraction in stone.[1]

The sculptor had favoured dark tropical timbers, such as the Burmese wood of *Infant* 1929 (no.2 q.v.), as their density provided the required resistance in carving. It also carried implicit comparisons with the African sculptures whose example had encouraged a break with European conventions. It is notable that Hepworth's wooden pieces of this moment, like African sculptures, tended not to have separate bases; unusually *Seated Figure* has no base at all. The corollary of this choice of material was considerable effort; after sawing the base of the African Blackwood *Torso* 1932, Hepworth confessed: 'it was the hardest work I have ever done.'[2] Lignum Vitae is one of the darkest and hardest of these woods, and Tommy Rowe, one of Hepworth's assistants in the 1960s, reported that exudations made it self-lubricating.[3] *Seated Figure* was originally polished with shellac and remains in good condition apart from some fine surface cracking;[4] these cracks temporarily developed an unidentified fungal growth when the piece was shown in 1993 under changed atmospheric conditions.[5]

There is evidence that Hepworth approached the sculpture simultaneously through carving and drawing. In the carefully staged photograph of her carving shed at 7 The Mall Studios published in *Unit One* (fig.19), the back of the block of Lignum is recognisable on a work table by the open window. It has only been roughed out and further carving – significantly the piercing of the hole – has been projected by the use of white lines on the surface. This stage in the carving may be dated to mid-1933, when the publication of *Unit One* was first proposed, as most of the other pieces in the photograph were shown with *Seated Figure* in the joint exhibition with Nicholson in October of that year rather than the comparable show of 1932. The works include

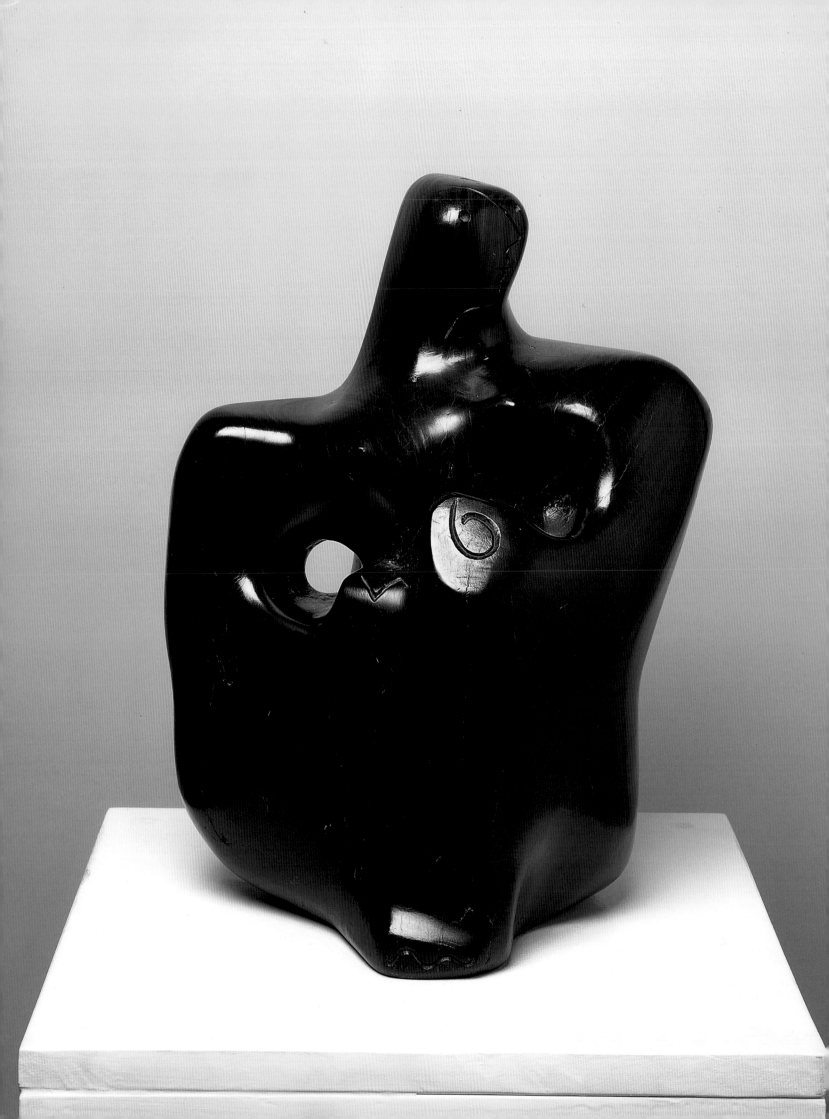

the standing female *Figure* 1933, *Reclining Figure* 1932, and the bone-like *Figure* 1933.[6]

The survival of several sheets of drawings from a sketchbook confirms that Hepworth also worked on the idea away from the block. One, published as *Studies for Sculpture (Profile Heads)* c.1932, places schematic overlapping profiles associated with the sculpture's head alongside more hesitant sketches of the whole.[7] The most worked of these shows the view from behind with the back pierced under the arm, and the legs and hands seen through the shaded hole and through the block itself. This view – rather than the sculpture itself – is related to the silhouette in the collage *Composition* 1933 (fig.18). Together with the adjacent drawing of the front, they show a resemblance to the radically abstracted alabaster *Figure (Mother and Child)* 1933 (fig.21), where the retaining knees cradled the child-pebble. Extending Hepworth's central concern with the female body, both the stone and lignum figures envisage the seated nude as powerful and enclosing.

Three more sheets of studies confirm that drawings played a crucial role in the development of *Seated Figure*. One hitherto unpublished sketch (fig.20*a*) shows the main view of the figure with the sources from which the carved details were reduced: the hands have fingers, the arms and legs are independent of the mass. It is juxtaposed with sectional layers through the block which, perhaps, helped to determine its contours. This suggests a shift from a response through carving to a more carefully planned method. The side view is developed in another unpublished page (fig.20*b*), where the form is described in continuous lines, such as those linking nipple and hand. Two of the sketches on a third sheet, previously published as *Three Studies for Sculpture* (fig.20*c*) show more schematic views of *Seated Figure*, with the rear view again treating the block as if transparent. Through their investigation of each face of the sculpture these drawings provide evidence of a new conceptual process which replaced the reliance upon reality and through which Hepworth was forming an art based upon the transfer of linear rhythms into formal relations in three-dimensions.

Although it is impossible to say at what stage the drawings were used in relation to the carving, Hepworth's practice seems to have been to visualise sculptures through drawings. Writing to Nicholson of other pieces in the previous autumn, she asked: 'do you remember the little drawing of the seated woman & child on the same page as the drawing for the man carving? well I'm doing that one it is v v exciting.'[8] This reinforces the suggestion that the studies pre-dated the carving of *Seated Figure*, and that the

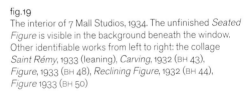

fig.19
The interior of 7 Mall Studios, 1934. The unfinished *Seated Figure* is visible in the background beneath the window. Other identifiable works from left to right: the collage *Saint Rémy*, 1933 (leaning), *Carving*, 1932 (BH 43), *Figure*, 1933 (BH 48), *Reclining Figure*, 1932 (BH 44), *Figure* 1933 (BH 50)

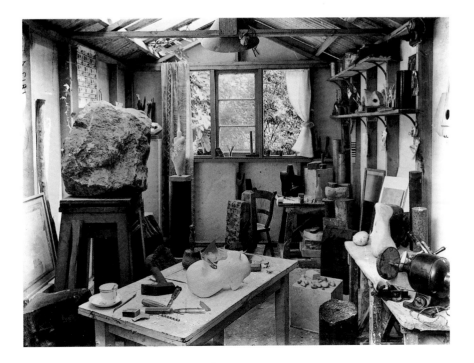

response to the block modified the preconceived linear aim. Further, it suggests that drawings may have been the site in which an inherent thematic unity within Hepworth's work – based around the female figure and the mother and child – was visualised.

As a response to the mass of the material, the cutting of a hole became a recurrent device for Hepworth. In 1930 John Grierson had remarked upon Skeaping boring through the block: 'It gives air and intimacy, and a sort of stereoscopic quality to the composition and … does by this element of variation deepen its power.'[9] With some justification, this has been taken as a sign of Skeaping originating the device,[10] although it is likely that the works to which Grierson was referring were essentially realistic. Nevertheless, penetration of the solid form afforded unexpected qualities, which Hepworth and Moore explored from 1931 and 1932 respectively. Only with Hepworth's lost *Pierced Form* 1931 (fig.4) can her subsequent claim be strictly accepted that her act of piercing resulted in 'an abstract form and space'.[11] In *Seated Figure*, although abstracted into a circular opening, it remained tied to a realistic source and served a function comparable to that in *Figure of a Woman* 1929–30 (no.3 q.v.).

Beyond the use of the hole, *Seated Figure* parallels concerns explored in a number of contemporary works. The nature of the incisions – like those on *Sculpture with Profiles* 1932 (no.4 q.v.) – and the simplification of features are related to the use of scraped profiles in Nicholson's paintings. The treatment of the form – especially the heavy enclosing arms, conical breasts and block-like head – may be compared to Moore's contemporary half-length alabaster *Figure* 1931. He also used puncturing under the arm in his African wood *Composition* 1932. Both of these carvings were reproduced in *Unit One*,[12] where Hepworth reproduced her most abstract works to date, including the lost *Figure (Mother and Child)* 1933 (fig.21).

Sir Michael Sadler bought *Seated Figure* from Hepworth's joint exhibition with Nicholson in 1933.[13] He was intensely interested in contemporary sculpture at that time, also buying Skeaping's *Blood Horse*.[14] Both works appeared in the posthumous exhibition of his collection, but the two differing editions of the catalogue suggests that works were removed from the display; *Seated Figure* was only listed in the first edition.[15] This seems to be confirmed by Sadler's great-nephew, Mark Harvey, who told Hepworth that he bought it when the collection was 'dispersed'.[16] In the process of her correspondence with Harvey, which led to her reacquisition of the work, Hepworth recalled having 'a special feeling for the sculpture'.[17]

figs.20a, *b & c*
Studies for 'Seated Figure', c.1932, each 27.4 x 21.1 (10¾ x 8¼), pencil on paper, Barbara Hepworth Estate

6 Two Forms 1933

TO7123 BH 51

Alabaster on limestone base 26 × 29.6 × 17.3 (10¼ × 11⅝ × 6⅞); weight 7 kg

Purchased from Mr and Mrs J.B. Frankfort (Grant-in-Aid) 1996

Provenance: Purchased from the artist by Dr Henri Frankfort c.1934 and thence by descent

Exhibited: Tate 1968 (18); *Retrospective* 1994–5 (15, repr. in col. p.42)

Literature: Hodin 1961, p.163, no.51, repr.; Alan G. Wilkinson, 'The 1930s: "Constructive Forms and Poetic Structure"' in *Retrospective* 1994–5, exh. cat., pp.46–7; Festing 1995, p.117; Anne M. Wagner, '"Miss Hepworth's Stone Is a Mother"' in Thistlewood 1996, pp.63–4, repr.; Curtis 1998, p.33, repr. p.32 (col.)

The attenuated triangle balanced within a two-pronged fork of stone which constitutes *Two Forms* was formally and conceptually unprecedented in Barbara Hepworth's work in 1933 and would remain unrivalled. The two pieces of cream alabaster – the sculptor's favoured material at that moment – are mounted on a circular base of beige limestone, to which the fork is secured by a dowel. The central triangular form rests on the higher edge within the fork and is pinned there by a second dowel. Both balance and movement (lateral as well as rocking) are thus ensured; but the original fixing has enlarged the hole through wear, causing it to become precarious. Some damage has resulted from this mobility and from the frequent reassembly of the parts; in 1996 the fixing was secured, the surface was cleaned and minor scratches retouched.[1]

The two pieces are perpendicular to one another. The veining of the central form runs along its length, which twists slightly towards the narrower end. The richer and browner veining of the fork, especially noticeable towards the base, runs across the prongs. Both stones carry the calligraphic incisions which Hepworth favoured in 1932–3, but their identity is ambiguous. A single drill hole in the top of the thicker prong is accompanied by an undulating line engraved in its companion. Sally Festing has convincingly identified the latter as the sign for a hand, and added that the central form may be read as a bird.[2] The suggestion that it may be an animal is supported by the circular incised eye and the drill hole on either side of the end of the central stone. It relates to the tendency towards reduced detail found in the preceding years in works such as Hepworth's *Doves* 1927 (fig.3) or John Skeaping's *Fish* c.1930 (Appendix B q.v.). The subject of a held bird had been treated by Skeaping in *Woman and Bird* c.1928 and by Maurice Lambert in *Man with a Bird* 1929.[3] The animal component of *Two Forms* may equally evoke a fish, especially as its movement is comparable to Brancusi's rotating *Poisson d'Or* 1924 owned at that time by Jim Ede, whose Hampstead house Hepworth visited regularly.[4]

Irrespective of such naturalistic subjects, the effect of the central form is, as Alan Wilkinson has observed, 'blatantly phallic'.[5] This suggests connotations for the fork (as hand, legs or vagina) and for the incised and drilled details (as orifices) which result in an unexpected sexuality; the phallic form is found in the contemporary *Carving* 1933 and *Standing Figure* 1934.[6] In *Two Forms*, the sexual quality is given material form in the malleable effect achieved in the alabaster and through the contrast in the direction of the two stones, which serves to emphasise the penetration of one form by the other. On a personal level, this might reflect the excitement of Hepworth's relationship with Ben Nicholson, which she acknowledged as having a direct impact on her work. After visiting Dieppe with him in 1932, she wrote of her new works: 'they are going to be good – It is all that loveliness you have given me dear & all that expression of that new world we seemed to look into the last month.'[7] Their shared approach is seen in the similar use of incisions which became increasingly abstract during 1933. Just as the markings on *Two*

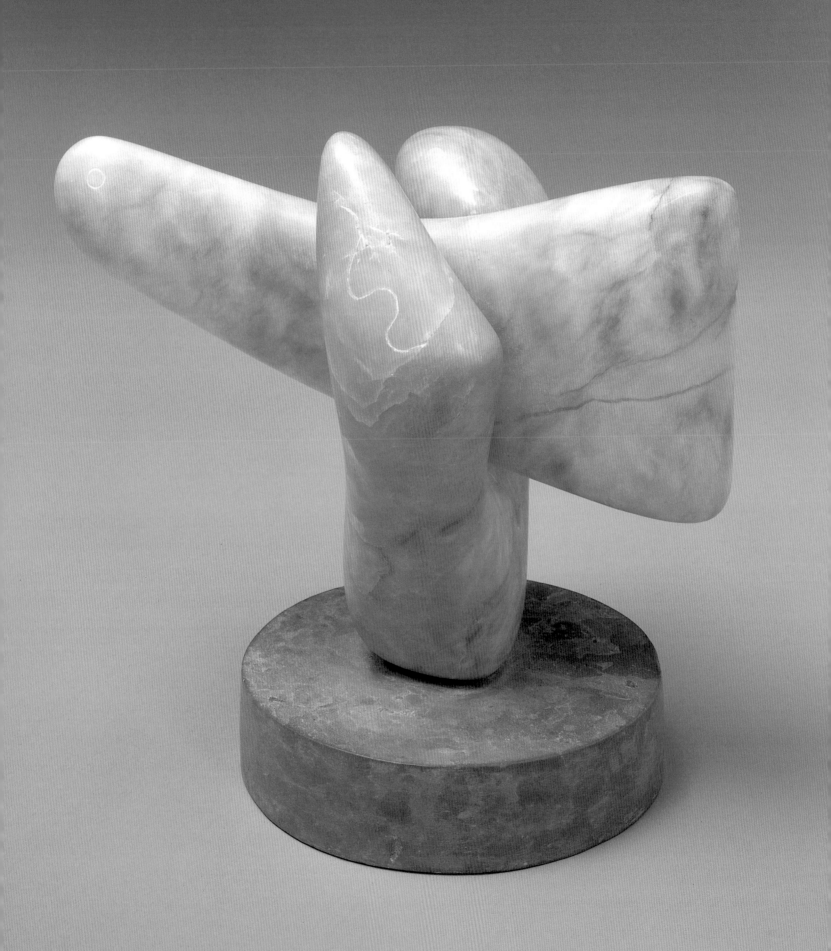

Forms are ambiguous, so Nicholson's scraped lines momentarily become sexualised in the suggestion of a female nude in *1933 (composition in black and white)* and of a vagina in *1933 (painting – hibiscus).*[8]

On another level, the complications of Nicholson's divided time between Hepworth and Winifred Nicholson led to speculations couched in the language of their Christian Science beliefs. Hepworth subscribed to these views, but in one pertinent passage pointed out that '[Christian] Science will not admit the necessity of sex harmony'. She objected:

How can we cut out the most lovely thing that God has created – the quiet strength & urge that makes a flower force its way out of the beaten earth or raise its head after much trampling – that makes all that quiet still movement in the night of things growing – growing to new loveliness and light. It is the rhythm of the seasons & the heart of earth & sea & sands – & the very stillness of understanding as deep as the blue of sky in the night.[9]

Although not directly associated with *Two Forms*, this passage indicates that the sculpture's implicit sexuality related to a wider view of the structure of nature. Elaboration of this is found in Hepworth's public statements, where similar language is used in a theoretical context. In her contribution to *Unit One*, composed in late 1933, she wrote of a train, an aeroplane and pylons 'in lovely juxtaposition with springy turf and trees of every stature. It is the relationship of these things that makes such loveliness'.[10] Hepworth reserved the recurrent term 'lovely' for harmony or harmonious relations, as had been specified in her 1932 statement, 'The Aim of the Modern Artist'.[11] In the year between these texts, she sharpened her theoretical precision partly as a result of her discussions with Adrian Stokes, who favourably reviewed her 1933 exhibition at the Lefevre Gallery and who, as she told Nicholson, began 'collaborating over my Unit One thing – that is he is going to help me!'[12] She claimed that the 'sculptor carves because he must' in 1932, but specifically qualified this point in *Unit One*: 'The predisposition to carve is not enough, there must be a positive living and moving towards an ideal.' That ideal was to be abstract work, which she defined as 'an impersonal vision individualised in the particular medium'. However, she concluded: 'In the contemplation of Nature we are perpetually renewed, our sense of mystery and our imagination is kept alive, and rightly understood, it gives us the power to project into a plastic medium some universal or abstract vision of beauty.'[13] While this conclusion reflects the figurative associations of the alabasters which were reproduced alongside the statement, it also shows a self-conscious move towards what Hepworth saw as an individual abstraction.

Although speaking of an 'impersonal vision', Hepworth's status as a woman artist imbued her recurrent subjects of the female figure with particular resonances. Her transformation of these themes in 1932–3 has recently been seen as an objectification of the female body by Anne Wagner, who considers that in *Two Forms* 'the body has split into parts, amputees or fragments which mime a grotesque and fruitless intercourse'.[14] While such a language of aggression is at odds with the sculptor's, it seems likely that Hepworth viewed her subject as a site of opposing demands. Writing to Nicholson of a visit from the artist Hans Feibusch, she reported his preference for her work over Moore's and added: 'He was most refreshing to me with his ideas about *woman* – he said a woman's idea when it came through was tremendously exciting to him because it was so simple – that men had so much ability & freedom that they made many deviations.'[15] Although reported through the mouth of another, this is evidence of Hepworth's own consideration of the necessity for single-mindedness as a woman artist. She was well aware of the social conventions of status alluded to by Feibusch, in addition to which she had to balance her sculpting against the demands of her three-year-old son, Paul, who was periodically sent away to allow her to 'get the work done'.[16]

Two Forms was made in the period circumscribed by these public statements and private letters of 1932–3. Its sexual quality coincided with that of Salvador Dalí's contemporary Surrealist paintings such as *The Enigma of William Tell* 1933 in which

crutches support extruded body parts.[17] It is unclear whether Hepworth was yet aware of Dalí's work, but her stay in Paris with Nicholson at Easter in April 1933 brought contacts with the fringes of Surrealism – a movement in which Nicholson was briefly interested. Judging from the order in her catalogue of works, Alan Wilkinson has proposed that it was following the trip that Hepworth began to make multi-part sculptures in response to the work of Arp (and before Moore's similar experiments of 1934).[18] In Arp's studio, around which they were shown by Sophie Taeuber-Arp, Hepworth saw the first of his biomorphic plaster sculptures in which varying organic forms were juxtaposed and given such humorous or sometimes worrying titles as *Head with Annoying Objects* 1930–2. It is notable that the latter was subsequently illustrated, as *Concrétion humaine*, in the first number of Myfanwy Evans's periodical *Axis*.[19] Although such concerns were far from her own, Hepworth would later recall the 'poetic idea in Arp's sculptures'.[20] A darker tone was set by Giacometti, with whom Nicholson may have already been in contact in March and may have met with Hepworth in April.[21] Giacometti's overtly phallic *Disagreeable Object* 1931, a drawing of which appeared in the periodical *Le Surréalisme au service de la révolution* in 1931,[22] is especially comparable to the central element of Hepworth's *Two Forms*, although the threatening spikiness of his wooden object is far from the sensuality of her alabaster. Picasso had likewise been working with organic and threateningly sexualised forms. Hepworth recalled visiting his painting studio that spring, where she may well have seen works such as the mutually devouring and phallic *Figures by the Sea* 1931. She would already have known the more abstract and bone-like series of *Drawings for a Monument* 1928 published in *Cahiers d'Art* in 1929.[23]

Two Forms was not exhibited or reproduced at the time. The son of the first owner, Henri Frankfort, informed the Tate that its purchase had been a way in which Hepworth's and Nicholson's friends provided support following the birth of their triplets in October 1934. The artists seem to have opened their studio to friends soon after.[24] Frankfort was one of the British Museum archaeologists amongst whom Hepworth's work of the 1920s had found favour, and later wrote about such abstract multi-part pieces as *Three Forms* 1935 (no.9 q.v.) in the sculpture issue of *Axis*.[25]

7 Mother and Child 1934

T06676 BH 58

Cumberland alabaster on marble base 22 × 45.5 × 18.9
(8⅝ × 7¹⁵/₁₆ × 7⁷/₁₆); weight 11.1 kg

*Purchased from Browse & Darby with assistance from the
Friends of the Tate Gallery 1993*

Provenance: …; Bertha Jones, by whom sold at Sotheby's
Modern British Drawings, Paintings and Sculpture, 1 Nov.
1967 (176, repr.), bought Mrs Edna Cohen, from whom
bought by Browse & Darby

Exhibited: *Unit One*, Mayor Gallery, April 1934 (35, as
'*Composition* (Grey Cumberland Alabaster)'), Walker Art
Gallery, Liverpool, May–June (41, as *Composition*), Platt Hall,
Rusholme, Manchester, June–July (15, as *Composition*), no
cat. traced for: Hanley City Art Gallery & Museum,
Aug.–Sept., Derby Corporation Art Gallery, Swansea,
Belfast Municipal Art Gallery & Museum; ?*St Ives Society of
Artists Summer Collection*, New Gallery, St Ives, summer
1946 (133); *19th and 20th Century Painting, Drawing and
Sculpture*, David W. Hughes, Summer 1968 (22, repr. in col.
[p.17]); *Barbara Hepworth 1903–75*, William Darby, Nov. 1975
(1, repr., mistakenly as 'collection: B. Jones'); *Retrospective*
1994–5 (17, repr. in col. p.48); *Design of the Times; One
Hundred Years of the RCA*, Royal College of Art,
Feb.–March 1996 (no number); *Carving Mountains: Modern
Stone Sculpture in England 1907–37*, Kettle's Yard,
Cambridge, March–April 1998, De la Warr Pavilion, Bexhill-
on-Sea, May–June (24, repr. p.71)

Literature: Hodin 1961, p.163, no.58, repr.; Alan G. Wilkinson,
'The 1930s: "Constructive Forms and Poetic Structure"' in
Retrospective 1994–5, exh. cat., pp.47, 50; Alex Potts,
'Carving and the Engendering of Sculpture: Stokes on
Hepworth' in Thistlewood 1996, p.48, repr. p.50; Anne M.
Wagner, '"Miss Hepworth's Stone *Is* a Mother"', ibid.,
pp.66–7; Claire Docherty, 'Re-reading the Work of Barbara
Hepworth in the Light of Debates on "the Feminine"', ibid.,
p.166; *Un Siècle de Sculpture Anglaise*, exh. cat., Galerie
national du Jeu de Paume, Paris, June–Sept. 1996, p.457

Reproduced: *Unit One* 1934, p.24, pl.5

With the emergence of her multi-part sculptures during 1933–4, Barbara Hepworth initiated (in Britain at least) the abandonment of the convention of the single integral sculptural mass. This paralleled her sometimes hesitating experiments with abstraction and an increasingly internationalist outlook, aspects brought together in her membership of the Parisian group Abstraction-Création from 1933. Already two years earlier – the year of her first holed piece, *Pierced Form* 1931 (fig.4) – she saw that her output was 'tending to become more abstract'.[1] By 1934, when *Mother and Child* was made, this process was being explored theoretically in her writings, especially her contribution to *Unit One*, and reinforced by like-minded supporters.

The theme of the mother and child was arguably Hepworth's most consistent in this period, even if, significantly, many examples were initially exhibited under more anonymous titles such as *Carving* or *Composition*. The sequence of works, in which *Mother and Child* falls towards the end, may be divided roughly into three stages. First, the theme was tackled in a number of direct carvings of the preceding years in which the block was characteristically evident; these included *Mother and Child* 1927 (BH 6).[2] Second, there were the organic alabasters of 1931–2, such as *Two Heads* 1932, in which the integrity of the sculpture and some reference to the body were maintained.[3] The multi-part sculptures begun during 1933 constitute the third phase; they included the lost grey alabaster *Figure (Mother and Child)* 1933 (fig.21) – first exhibited as *Composition* – in which the child was famously pebble-like. Such upright (seated or standing) pairings were supplemented by horizontal arrangements, of which one of the earliest was the undulating abstraction of the blue marble *Two Forms* 1933 (BH 54) – first shown as *Carving*.[4] In the following year, at least three still organic but more referential reclining alabasters were made, including the Tate's sculpture, itself first entitled *Composition*. Very similar to it, because of the child perched on the knee, is *Large and Small Form* 1934 (fig.22); while in the other, much smaller, *Mother and Child* 1934 (BH 57), the child nestles at the mother's side.[5] In all these works, the two parts were, at least by implication, cut from the same block, a practice which had important psychological resonances.

Within this sequence the Tate's *Mother and Child* is materially and formally consistent. As with the other horizontal works of 1934, there is a visible consonance in the form of the child as a miniature echo of the mother. The warm grey alabaster of the child is close in colour to the adjacent knee to which it is fixed, suggesting the continuity of material if not of the veining. The waves of stone, slightly angled across the length (an effect more obvious from above), and the undulating outline of the whole offers a variant of *Two Forms* 1933 (BH 54). The nodule heads follow an established pattern, and both have single drilled eyes which appear to have been originally whitened.[6] The choice of stone can be linked to Henry Moore's recollection that John Skeaping had introduced his friends to Cumberland alabaster, having been sold lumps of the stone ploughed up by a farmer.[7] Hepworth's period of carving alabaster –

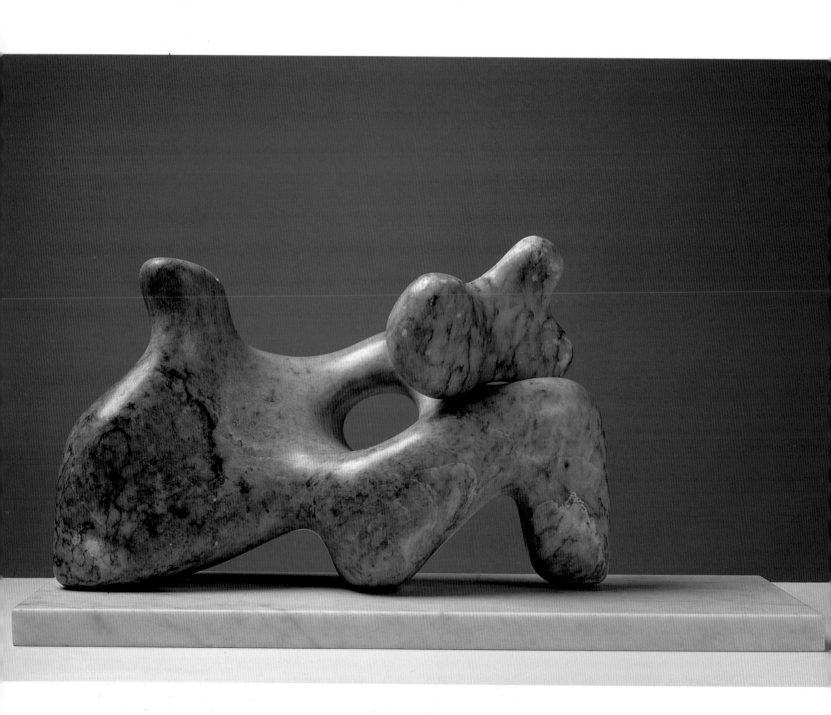

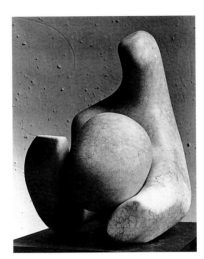

fig.21
Figure (Mother and Child), 1933, height 66 (26), alabaster,
BH 52, destroyed

whether the grey-brown Cumberland or creamier varieties such as that used for
Sculpture with Profiles 1932 (no.4 q.v.) – coincided with Moore's use of it during 1930–4,
for such works as *Four-Piece Composition: Reclining Figure* 1934.[8] The soft stone
of *Mother and Child* has a major fault through the mother's back and foot, while both
heads have suffered stun marks and small scratches; the surface has been cleaned
and the single dowels, from child to mother and from mother to base, re-secured.[9] The
mother's hip is pinned, with the elbow resting on the base and the foot is lifted free;
in the sculptor's photographic albums this gap is deliberately lit.[10]

The same photograph shows the sculpture on a base quite different from that
to which it is now fixed. The front of the first base was roughly broken off to form
a sloping shelf and to allow a textural variety. Furthermore, this base framed the figure
closely at elbow and foot. By the time Bertha Jones sold *Mother and Child* in 1967,
the base had been replaced by one with more conventional edges which was more
generous in the space beyond the elbow and foot. This tendency towards elongation
is carried further in the present base. The fate of the earlier bases is not known, nor is
it known if Hepworth sanctioned the changes. In any case, the effect of the progressive
elongation is to present the mother asymmetrically, placing the emphasis on the child
and fundamentally altering the balance and, consequently, the experience of
the sculpture.

In addition to the juxtaposition of separate elements, Hepworth introduced her still
innovatory piercing in the main stone of *Mother and Child*. This epitomised the tendency
in 1932–4 towards organic abstraction. In common with nearly all its precedents, the
hole appears to be derived formally from the space under an arm. In *Mother and Child*
it achieved an importance comparable to that in the first *Pierced Form*, as it was at the
centre of the composition when the work was still mounted on the original base;
although this is no longer the case, the hole remains crucial to the undulating rhythm.
Like the organic form, the introduction of piercing anticipated Moore's use of these
devices for the treatment of the figure. He would transform this into a figurative
equivalence with landscape in such works as the Hornton stone *Recumbent Figure*
1938 (fig.33). For Hepworth, the piercing of *Mother and Child* went beyond a formal
device. It carried a conceptual value, with the suggestion that the child had come from –
and outgrown – the vacant space in the centre of the mother's body. The psychological
empathy and the physical dependence (and independence) of this relationship were
repeatedly addressed in her exploration of the theme, which became more acute
following her son Paul's birth in 1929. In early 1934, Hepworth became pregnant again
and her triplets were born in October.

Hepworth's 1933 *Mother and Child* works were shown in her exhibition at the end
of that year and elicited Adrian Stokes's review in *The Spectator*.[11] They were close
friends and in the following month the writer helped the sculptor with her contribution
to *Unit One*.[12] In his review, Stokes favoured her sympathy in carving stones, so that
'their unstressed rounded shapes magnify the equality of radiance so typical of stone';
he saw pebbles as 'essential shapes' achieved through smoothing and rubbing. This
served as a preliminary to his discussion of *Composition*, a work identifiable from
his description with the lost *Figure (Mother and Child)* 1933. His discussion of the
hierarchical and implicitly psychological relationship between the two elements was
deliberately couched in more widely applicable terms:

The stone is beautifully rubbed: it is continuous as an enlarging snowball on the run; yet part of the matrix is
detached as a subtly flattened pebble. This is the child which the mother owns with all her weight, a child
that is of the block yet separate, beyond her womb yet of her being. So poignant are these shapes of stone,
that in spite of the degree in which a more representational aim and treatment have been avoided, no one
could mistake the underlying subject of the group. In this case at least the abstractions employed enforce a
vast certainty. It is not a matter of a mother and child group represented in stone. Miss Hepworth's stone *is* a
mother, her huge pebble its child.[13]

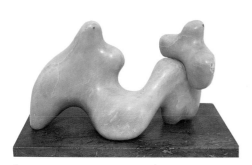

fig.22
Large and Small Form, 1934, length 36.9 (14⅕), alabaster, BH 59, The Pier Gallery Collection, Stromness

Both the discussion of the pebble-like form of the stone and the play between representation and abstraction are applicable to *Mother and Child* 1934. More particularly, the psychological interpretation of the separation of child from mother was of crucial and – the writer implies – universal significance. From Hepworth's response to his assistance over *Unit One* in the following month, it may be assumed that she found his interpretation acceptable. Writing to Nicholson, she claimed:

His [Stokes's] whole life is built on a very sensitive perception of other people's thoughts. His thought is not that of limitation but of this: 'Identity is the reflection of the Spirit, the reflection in multifarious forms of the living principle – love' which sees the individual beauty & differences of flowers stones & people & cares for & loves each identity & understands.[14]

Several scholars have discussed Stokes's article, as much in terms of his own theories of sculpture as for the light it sheds on Hepworth's work. Its revelation and contradiction, in the case of the woman artist, of his explicit gendering of the process of sculpture – whereby the male carver transforms the female matter – has been the focus of Alex Potts. In a broader discussion, Anne Wagner has seen the article in the light of Stokes's course of analysis with Melanie Klein.[15] Both scholars have noted that this had only just begun in 1933, but the psychoanalyst's concentration upon infancy appeared to be especially pertinent to Hepworth's work. In such papers of the late 1920s as 'Early Stages of the Oedipus Conflict' and 'Infantile Anxiety Situations Reflected in a Work of Art and the Creative Impulse', Klein discussed the coincidence of sadistic desire and the Oedipus complex within the infantile psyche.[16] In particular, she posited 'infantile anxiety situations' in the female psyche centred upon the internal organs: a desire to remove the sexual and reproductive organs – to deprive the mother of sex and prevent further children – and a conflicting fear of an assault by the mother on the girl's organs, depriving her in turn of children.

The sculptor's concentration on the mother and child theme and its conflation with the pierced stone takes on particular resonances in the light of Klein's theories. Some of these were hinted at by Stokes, but Wagner has taken the analysis further. Proposing Hepworth's carving as 'an act of self-inscription', Wagner observed that Klein's theories could show them to be thematically more complex than formal discussion had hitherto allowed. She concluded: 'These are bodies made into objects which may present dangers or threats, or themselves be threatened … They add up to a testing and verification of a limited range of fantasmatic fears and hopes concerning the female body's presence, its contents and its voids.'[17]

A decade after completing *Mother and Child*, Hepworth reviewed her own work in a letter to E.H. Ramsden, who was writing an article for *Horizon*.[18] The letter provides some support for Wagner's reading, not least because of its acknowledgement of 'emotion, tension and so on' in the works of the 1930s. In a passage interspersed with sketches, Hepworth acknowledged: 'There was a turbulent period 1933–34 … Ben always kicks up a fuss when he sees the few turbulent photos such as [sketches of the lost *Figure (Mother and Child)* 1933 and *Large and Small Form* 1934 (BH 59)] etc. but I stand by them. They mattered a lot emotionally and sculpturally.'[19] In view of the fact that both sketched works belong to the mother and child sequence of organic alabasters, the memory of turbulent emotion is telling. In retrospect, they may also have been regarded as sculpturally turbulent in contrast to the purity of the ensuing abstractions of the mid-1930s.

8 Three Forms (Carving in Grey Alabaster) 1935

TO3131 BH 66

Grey alabaster on grey marble base 26.5 × 47.3 × 21.7
(10⁷⁄₁₆ × 18⅝ × 8½); weight 10 kg

*Presented by the executors of the artist's estate, in
accordance with her wishes, 1980*

*Displayed in the artist's studio, Barbara Hepworth Museum,
St Ives*

Exhibited: Wakefield & Halifax 1944 (13, as 'Three Forms,
Carved in 1935'); *Art in Britain 1930–40 Centred around Axis,
Circle, Unit One*, Marlborough Fine Art, March–April 1965
(not in cat.); Tate 1968 (25, as 'Three Forms 1934'); Hakone
1970 (1, repr., as 'Three Forms 1934'); *The Non-Objective
World 1924–39*, Galerie Jean Chauvelin, Paris, June 1971,
Annely Juda Fine Art, London, July–Sept., Galleria Milano,
Milan, Oct.–Nov. (68, repr. p.75, as 'Three Forms 1934');
The Thirties: British Art and Design Before the War,
Hayward Gallery, Oct. 1979–Jan. 1980 (6.61, repr. p.170, as
'Three Forms 1934')

Literature: Hodin 1961, p.163, no.66 (as 'Three Forms 1934');
Jenkins 1982, p.10, repr. p.24 (as 'Three Forms 1934'); Wales
& Isle of Man 1982–3, exh. cat., [p.5] (as 'Three Forms 1934');
Tate Gallery Acquisitions 1980–2, 1984, p.112, repr. (as 'Three
Forms 1934'); Michael Tooby, *An Illustrated Companion to
the Tate St Ives*, 1993, p.30 (repr. in col. as 'Three Forms
1934'); Alan G. Wilkinson, 'The 1930s: "Constructive Forms
and Poetic Structure"' in *Retrospective* 1994–5, exh. cat.
pp.53–4 (as 'Three Forms 1934')

Reproduced: H[enri] Frankfort, 'New Works by Barbara
Hepworth', *Axis*, no.3, July 1935, p.16 (as 'Carving in Grey
Alabaster 1935'); Geoffrey Grigson, 'Painting and Sculpture',
The Arts Today, 1935, facing p.106 (as 'Carving 1935')

The elements of *Three Forms* were carved from Barbara Hepworth's favoured alabaster, in this case of the pale grey-brown stone which established the first published title – *Carving in Grey Alabaster* – and set on a rectangular base of dark grey marble. It is comparable to the alabaster used for *Mother and Child* 1934 (no.7 q.v.) and may be some of that sold to John Skeaping by a Cumberland farmer.[1] Hepworth had initiated multi-part juxtapositions in the organic works of 1933, but for such geometric arrangements the defining field of the base was of determining importance for the relationship of solid and void. *Three Forms (Carving in Grey Alabaster)* must have been one of the earliest examples of the more geometrical arrangements, but its exposure has been limited, perhaps because of its extensive damage.

In the photograph in *Axis*, the chip out of the lower edge of the base is clearly visible. The remainder is in good condition, but seems to be still unpolished.[2] The right end of the base is not visible, but is actually slightly angled in contrast to the other vertical faces. This may suggest that the narrow length of marble had served some other purpose, possibly, like the later *Group I (concourse)* 1951 (no.27 q.v.), salvaged from a mantlepiece. It has been noted that a sketch of the work appears amongst other drawings of sculptures apparently sent to friends for safe keeping, perhaps in 1939; it was listed under the Cumbrian address of Sir William Morton, the father of the textile designer Alastair Morton with whom Hepworth and Ben Nicholson were in contact during the war.[3] The annotated price (45 guineas) suggests that it was available for sale and was, as yet, unbroken. Presumably the sculpture was still whole when exhibited at Wakefield in 1944, but at some stage the large stone was broken, low down and on a shallow diagonal. Answering an enquiry from the Tate, Dicon Nance, who was one of Hepworth's assistants between 1959 and 1971, recalled 'repairing and polishing' the work. He noted: 'The sculpture was sadly wrecked, the largest form being broken and the forms loose on the base. I did quite extensive work on the largest form and I think I replaced the old steel pins with bronze as the rust from the steel pins was discolouring the alabaster.'[4] The orange discoloration is especially prominent even though the pins have now been replaced with stainless steel. Unfortunately, Nance did not date the repair, but it is likely to have been before 1965 when the sculpture was exhibited again. The resin used to fill the crack and to reinforce the single dowels holding the smaller forms discoloured (to a yellow) and has since been replaced with clear resin. A further repair was required when the base was broken, on a diagonal under the large form, on return from Japan in 1970. This was fixed with two stainless steel clamps and filled with resin coloured with slate dust. The surface has been cleaned and waxed.[5]

After its first repair, *Three Forms (Carving in Grey Alabaster)* featured in several of Hepworth's major exhibitions, attesting to the importance and rarity of such geometric works of the 1930s. As was her practice, the three elements are different in form: the small sphere is located in the corner, slightly closer to the back than the right edge; the middle element is about two-thirds longer than it is high; the large element has a flat

back. There may be some general proportional sequence as the width of the middle stone is about twice that of the smallest and about half the height of the largest.[6] However, it is likely that such relationships were worked out by eye. This is also true of the spacing, as the two elements ranged to the left are balanced visually by the extreme positioning of the smallest across the wide intervening space. It is notable that the characteristically frontal effect was that shown in the dramatically lit photograph in *Axis*.

That photograph accompanied the article 'New Works by Barbara Hepworth' written in mid-1935 by the archaeologist – and owner of *Two Forms* 1933 (no.6 q.v.) – Henri Frankfort. In his enthusiasm, Frankfort even claimed that Hepworth occasionally 'omitted to fix' an element, adding that: 'It means that she has so exhaustively realised all possible spatial interrelations between the elements … that … each displacement of the mobile element within the work as defined by the slab, results in a fresh harmony.'[7] Although pinned, the ball of *Three Forms (Carving in Grey Alabaster)* gives this impression. As a result, Frankfort was 'tempted to consider these works as living organisms in which (within certain limits which to pass means death) distinct organs each with a character of its own, exist interdependently within a larger unit which is more than the mere sum of its constituents'.

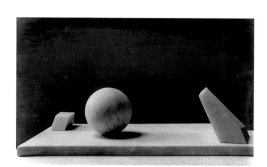

fig.23
Two Forms and Sphere, 1935, base 45.8 x 25.4 (18 × 10), alabaster, BH 63, private collection

Although Hepworth had been arranging organic elements on bases during 1933–4, the geometric forms seem to date from 1935. She would later associate the move to abstraction with the birth of her triplets on 3 October 1934. 'When I started carving again in November 1934', she wrote, 'my work seemed to have changed direction although the only fresh influence had been the arrival of the children. The work was more formal and all traces of naturalism had disappeared, and for some years I was absorbed in the relationships in space, in size and texture and weight, as well as in the tensions between the forms.'[8] Here the conjunction of life and art is stressed, just as in discussion of *Infant* 1929 (no.2 q.v.), showing their harmonious coexistence at a time when Hepworth was aware that a working mother was unusual. The suggestion of a causative relationship between the children and the new formal relationship is notable, and may at least be related to her enforced rest from carving. In its detail, the retrospective account is contradicted by a letter to Nicholson in Paris from the end of 1934. There she clearly summarised the conflicting pressures: 'I am not going on from week to week & month to month being separated from my carving by nurses undernurses & cooks. I am going to work in the New Year. It is 5 months or more since I did any.'[9] This indicates that little was achieved in the second half of 1934 (including the last eight weeks or so of the pregnancy) and that work was not resumed in the month following the birth but in 1935. This was hardly surprising given the demands of the tiny children on the weakened mother,[10] and Nicholson's departure in December to stay with his first wife Winifred and their children. Hepworth told E.H. Ramsden, a decade later, that when she did begin to work again 'all the forms flew quickly into their right places in the first carvings I did after SRS [Simon, Rachel, Sarah] were born in the 3 Forms'; a sketch identifies this as *Two Forms and Sphere* (fig.23).[11]

The clarification of this moment of change in Hepworth's work has a direct bearing on *Three Forms (Carving in Grey Alabaster)* because it has been dated to 1934 by Alan Bowness.[12] This was based upon the artist's memory of it being the first work completed after the triplets' birth; however, it was dated to 1935 in both articles of that year and in the Wakefield exhibition of 1944.[13] If made in 1934, it would have to have been in the first half of the year, when Hepworth was still making such organic works as *Mother and Child* (no.7 q.v.) which was exhibited in *Unit One*.[14] This indicates that *Three Forms (Carving in Grey Alabaster)* must date from 1935 and, from the 1943 account, that it was not the first made on her resumption of carving. Indeed, the unpolished state shown in the photograph published in *Axis* in July 1935 may suggest that it was, as yet, unfinished. The change in date makes the appending of the original title desirable in order to distinguish the work from *Three Forms* 1935 (no.9 q.v.).

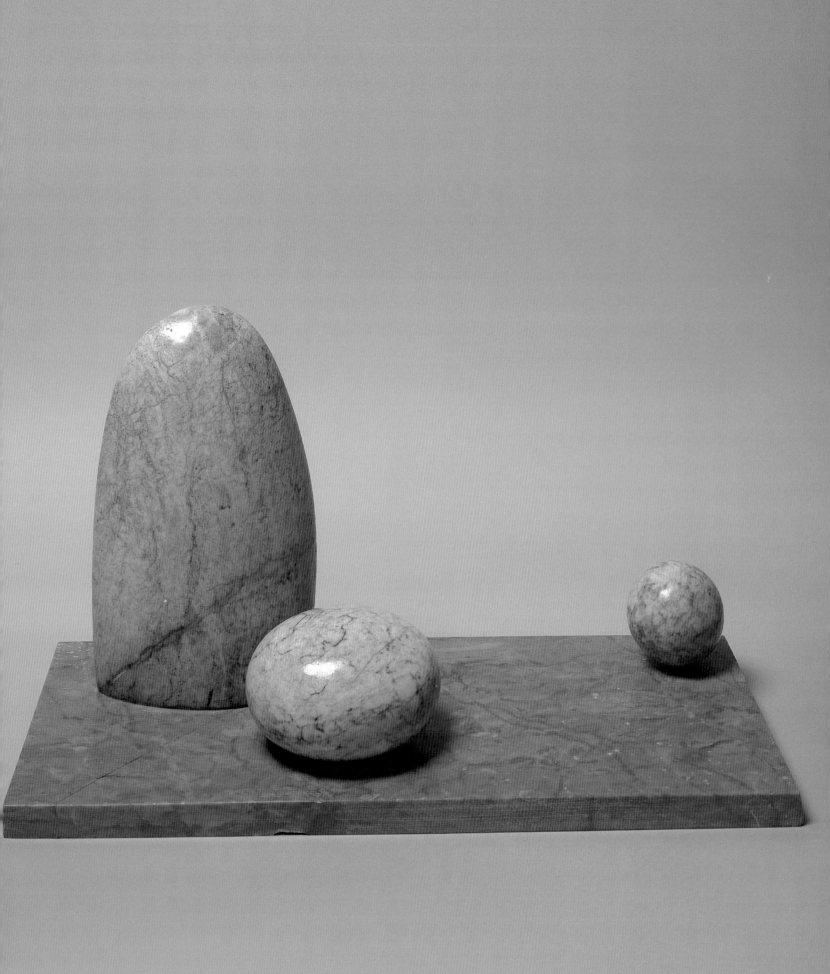

The formal change in Hepworth's work was quite distinct. While remarking on the completeness of the transition from figurative to geometric works, she would, in hindsight, identify a continuity between the phases; she told Ramsden: 'the torso or figure became the Single Form, the Mother & Child or "group" became a Two Form.'[15] She also noted that the early work 'contains all the same ideas of form, emotion, tension & so on in a less mature way than the later'. Her recollection in 1952, of 'relationships in space, in size and texture and weight', is more formal in its analysis of the source and the impact of the juxtapositions.[16]

This transition may be seen in the context of the similar change in Nicholson's work following their contact with Parisian abstract artists. On their visit at Easter 1933, Hepworth and Nicholson had been invited to join the internationalist grouping Abstraction-Création. In their periodical, Hepworth published two photographs of her lost abstract *Pierced Form* 1931 (fig.4) and Nicholson submitted the calligraphic *1932 (painting)*.[17] It is notable that both were isolated in the respective artist's work in their degree of abstraction. In the following year, Nicholson's illustrations included one of his earliest reliefs made in December 1933 in Paris, *1933 (6 circles)* (fig.24), while Hepworth contributed the lost *Figure (Mother and Child)* 1933 (fig.21) and *Reclining Figure* 1932.[18] Perhaps because of the evidently figurative nature of these works, she wondered 'do A-C want to get rid of my carvings?'[19] Both artists were close to Jean Hélion, and after he broke with Auguste Herbin and left Abstraction-Création neither continued to contribute to the Parisian group.

In late 1933, Nicholson experimented with complete abstraction in making shallow reliefs from which hand-drawn circles were cut. They were acknowledged by Hepworth: 'I am very interested in your new work idea (carving out) naturally – I've been longing for it to happen for ages.'[20] The contrast between his reliefs and her 'turbulent' organic works seems to have caused Nicholson to dismiss the latter, as Hepworth later reported.[21] However, the sculptor's text for *Unit One*, written in late 1933, indicates that her position was also changing. While asserting that the work 'must be stone shape and no other shape', she concluded: 'I feel that the conception itself, the quality of thought that is embodied, must be abstract – an impersonal vision individualised in the particular medium.'[22] She was yet to achieve such a position. The balance of 'spatial interrelations' recognised by Frankfort in 1935 in *Three Forms (Carving in Grey Alabaster)* and associated works paralleled Nicholson's disposition of circles in the reliefs. Indeed, the latter evoke plans of Hepworth's carvings, and spatial judgements for both were made by eye, with the geometry implied rather than measured. Nicholson began to use compasses and rulers in the middle of 1934 for the white reliefs, of which he associated one with the birth of the triplets: *October 2 1934 (white relief – triplets)* (fig.25). Hepworth's more severe juxtapositions appear to have followed in 1935.

In contrast to the theory of direct carving from which *Three Forms (Carving in Grey Alabaster)* emerged, a bronze edition of 9 (+ 0, an artist's copy) was cast from the stone original in 1971.[23]

fig.24
Ben Nicholson, *1933 (6 circles)*, 1933, 114.5 × 56 (45 × 22) oil on carved board, private collection

9 Three Forms 1935

T00696 BH 72

Serravezza marble on marble base 20 × 53.3 × 34.3
(7⅞ × 21 × 13½)

Presented by Mr and Mrs J.R. Marcus Brumwell 1964

Provenance: Purchased from the artist by Mr and Mrs J.R.
Marcus Brumwell 1935

Exhibited: *14th 7 & 5 Society*, Zwemmer Gallery, Oct. 1935
(no cat.); *Abstract & Concrete: An Exhibition of Abstract
Painting and Sculpture, 1934 & 1935*, 41 St Giles, Oxford,
Feb. 1936, ?Liverpool School of Architecture, March, Gordon
Fraser's Gallery, Cambridge, May–June (13); *British Art and
the Modern Movement 1930–40*, Welsh Committee of the
Arts Council, National Museum of Wales, Cardiff, Oct.–Nov.
1962 (28); *Art in Britain 1930–40 Centred around Axis,
Circle, Unit One*, Marlborough Fine Art, March–April 1965
(40, repr. p.31); Tate 1968 (26); *Henry Moore to Gilbert and
George: Modern British Art from the Tate Gallery*, Palais des
Beaux Arts, Brussels, Sept.–Nov. 1973 (46, repr. p.61); *Art in
One Year: 1935*, Tate Gallery display, Dec. 1977–Feb. 1978
(no number); *Thirties: British Art and Design Before the
War*, Hayward Gallery, Oct. 1979–Jan. 1980 (6.61, repr. p.170);
*British Sculpture in the Twentieth Century, Part 1: Image and
Form 1901–50*, Whitechapel Art Gallery, Sept.–Nov. 1981
(166); *Retrospective* 1994–5 (20, repr. in col. p.63); *Un Siècle
de Sculpture Anglaise*, Galerie national du Jeu de Paume,
Paris, June–Sept. 1996 (no number, repr. in col. p.97);
*Carving Mountains: Modern Stone Sculpture in England
1907–37*, Kettle's Yard, Cambridge, March–April 1998, De la
Warr Pavilion, Bexhill-on-Sea, May–June (27, repr. p.29)

Literature: Gibson 1946, p.7, pl.26; Hodin 1961, pp.19, 163, repr.
no.72; *Tate Gallery Report 1964–5*, 1966, p.39; 'Recent
Museum Acquisitions: Sculpture and Drawings by Barbara
Hepworth (The Tate Gallery)', *Burlington Magazine*, vol.108,
no.761, Aug. 1966, p.425, repr. p.424, pl.56; Ronald Alley,
'Barbara Hepworth's Artistic Development', Tate 1968, p.13;
Richard Morphet, *Art in One Year: 1935*, display broadsheet,
Tate Gallery, 1977–8, [pp.3,4,5] repr. [p.5]; Dennis Farr,
English Art 1870–1940, Oxford 1978, pp.290–1, pl.108a;
Simon Wilson, *British Art: From Holbein to the Present Day*,
1979, p.144, repr.; Charles Harrison, *English Art and
Modernism 1900–1939*, London and Bloomington, Indiana,
1981, rev. ed. London and New Haven, Conn. 1994, p.269;
Jenkins 1982, p.10, repr. in col. p.25; Penelope Curtis, *Modern
British Sculpture from the Collection*, Tate Gallery Liverpool,
1988, p.51, repr.; Festing 1995, pp.121, 292; Penny Florence,
'Barbara Hepworth: the Odd Man Out? Preliminary
Thoughts about a Public Artist' in Thistlewood 1996, p.28;
Anne J. Barlow, 'Barbara Hepworth and Science', ibid.,
p.100–1. repr.; *Un Siècle de Sculpture Anglaise*, exh. cat.,
Galerie national du Jeu de Paume, Paris, June–Sept. 1996,
p.458; Alan Wilkinson, exh. cat., New York 1996, p.21, repr.

Reproduced: Read 1952, pl.37b

Tripartite groups appeared in Barbara Hepworth's works with the advent of
geometrical abstraction in 1935. *Three Forms* 1935 is the largest and best known of
these, and was probably preceded by two others of the same moment, *Two Forms and
Sphere* (fig.23) and *Three Forms (Carving in Grey Alabaster)* (no.8 q.v.). These latter two
have been placed in 1934, but the sculptor's review of her work in December of that year
makes this unlikely: 'It is 5 months or more since I did any.'[1] *Three Forms (Carving in
Grey Alabaster)* featured in Henri Frankfort's article in July 1935, where the absence
of *Three Forms* 1935 may suggest that it was not yet finished.[2]

In retrospect, Hepworth placed the tripartite works immediately after the watershed
in her sculpture caused by the birth of her triplets on 3 October 1934. In 1952, she
recalled that her works had become 'more formal and all traces of naturalism had
disappeared, and for some years I was absorbed in the relationships in space, in size
and texture and weight, as well as in the tensions between the forms'. Perceiving the
continuity with her subsequent work, she added an anthropomorphic reading: 'This
formality initiated the exploration with which I have been preoccupied continuously
since then, and in which I hope to discover some absolute essence in sculptural terms
giving the quality of human relationships.' This was further qualified by the statement
that 'the only fresh influence had been the arrival of the children'.[3] Ten years earlier, she
had told E.H. Ramsden that *Two Forms and Sphere* was the first work made after their
birth;[4] this seems to have been implied for each of the tripartite works, including *Three
Forms* 1935.[5]

All three of these works display the concern with 'relationships in space, in size
and texture and weight'. The rectangular bases define the relations between the
three elements. The location of these was necessarily triangular, as Hepworth
avoided a purely linear option, and the variations in size laid open potentially complex
interrelations. In each case, a pair of forms – which in both Tate works included the
largest – was ranged to the left and balanced by pushing the third far out (as if on
a fulcrum) and activating the intervening space. The relative equality between the
elements in *Three Forms* 1935 means that this space is less exaggerated than in the
related works, but, even so, the sphere is distinctly isolated.

The irregularity of the elements in each of these tripartite works was highlighted by
the inclusion of a sphere. It acts as a compositional measure, matched against angular
forms in *Two Forms and Sphere* and against ovals in *Three Forms (Carving in Grey
Alabaster)* and *Three Forms* 1935. It also sets up the proportional relationship with its
more irregular fellows. The diameter of the sphere in *Three Forms* 1935 is 12 cm (4¾ in).
This is the same as the depth of both the medium size element and the larger oval, and
variety is achieved in the other dimensions.[6] Even there, the height of the large oval is
equivalent to the length of the central element. Although the base has been replaced,
the present spacing follows the original and is similarly regulated. This may be seen
from the location of the largest element which is as far from the front of the base as the

sphere is from the back – ensuring the open space on the right – and its distance from the right edge is equivalent to the length of the middle element.[7] This precision must be seen in the light of a significant adjustment – presumably made by Hepworth herself – to the position of the largest element: holes in the original base indicate that it was relocated about 1 cm (⅜ in) further back. This alteration must have been of critical importance as it required drilling very close to the original holes and risked leaving the plugged holes visible. Shallow divots were taken out of the marble around the new holes in order to bed the element into the base; the same method has been used to locate the other two solids. Such 'spatial disposition' encouraged Frankfort to stress the role of the base in this group of works as 'by no means an accessory, but, on the contrary an essential part of the carving'.[8]

The elements in *Three Forms* 1935 are larger in relation to the base than in the associated works, and the rectangle is broader. The result is calmer than the frontal arrangement across the shallow stone of *Three Forms (Carving in Grey Alabaster)* and more stable in the round. It is enhanced by the carving of all parts from the same white Serravezza marble, the luminosity of which lends a sense of permanence and classical form. It recalls Adrian Stokes's perception of the radiance of Hepworth's 'unstressed rounded shapes', and his definition that 'all successful sculpture in whatever material has borrowed a vital steadiness, a solid and vital repose'.[9] The contemporary critical term 'vital' – even if usually gendered as Katy Deepwell has observed – signalled the ambition and achievement in Hepworth's work.[10] In all these qualities, especially in the luminosity of the marble and the use of proportions, *Three Forms* 1935 evokes a sense of classicism modified by modern vitality. It is in this respect that Frankfort could compare Hepworth's work to the Apollo of Olympia.[11] Such comparisons reveal a fundamental departure from the primitivising references of the 1920s.

The degree of abstraction represented by *Three Forms* 1935 is closely comparable to that in Ben Nicholson's white reliefs. Although the structure remained essentially pictorial, his adoption – under the influence of Hepworth's carving – of shallow relief at the end of 1933 went some way to meet her increasing definition of her work by the plane of the base. Their converging concerns were a function of their shared interests, contacts and work spaces in the Mall Studios. During 1933–4, Nicholson had the advantage of regular periods in Paris (seeing his first family) where he was in contact with the artists of Abstraction-Création alignment, of which the couple were members. Hepworth's pregnancy and the birth of the triplets severely limited the time she could dedicate to carving in 1934, although she later claimed that their arrival 'gave us an even greater unity of idea and aim'.[12] Nevertheless, *Three Forms* 1935 parallels such reliefs by Nicholson as *October 2 1934 (white relief – triplets)* (fig.25) or the large mahogany *1935 (white relief)*.[13] There, the balancing of a compass-drawn and a hand-drawn circle exactly echoes Hepworth's combination of the sphere and the oval solids.

Among the members of Abstraction-Création, Hepworth's contributions of carvings contrasted with the enclosure of space by plane and line which typified the international constructivism of Naum Gabo, Antoine Pevsner, Alexander Calder and Katarzyna Kobro. In this respect, Hepworth maintained a latent relation to the techniques of Brancusi and (to a lesser extent) Arp, as well as to the direct carving ideals of the 1920s. The shift to abstraction expressed in her work, and that of Henry Moore, raised the question of reconciling a craft heritage with new forms. A.M. Hammacher has alighted upon this disparity exposed around 1936–7, commenting that while 'space became a point of departure' for Gabo's constructions and their carvings, 'neither Moore nor Hepworth found themselves able to relinquish their relationship with wood and stone, a relationship which had proved so fruitful'.[14] The solution, exemplified by *Three Forms* 1935 and by Moore's more organic *Three-piece Carving* 1934, was the juxtaposition of abstract forms on a definite field.[15] This seemed to owe something to Paul Nash's paintings of juxtaposed solids, and *Three Forms* 1935 has been compared to Nash's

fig.25
Ben Nicholson, *October 2 1934 (white relief - triplets)*, 1934, 120.7 × 61 (47½ × 24), oil on carved board, private collection

fig.26
Paul Nash, *Equivalents for the Megaliths*, 1935, 45.7 × 66 (18 × 26), oil on canvas, Tate Gallery

Equivalents for the Megaliths 1935 (fig.26) with its concentration upon illusionistic cylinders.[16] Rather than the Surrealistic disjuncture taken up by Nash and Moore, Hepworth sought the contemporary 'equivalent' for prehistoric carving in geometrical solids, relying on the sphere in *Three Forms* 1935 and related works such as *Two Forms and Sphere, Two Segments and Sphere* 1935–6 and *Conoid, Sphere and Hollow II* 1937.[17] As well as the defiant balance, the attraction of the sphere lay in the same purity of form found in the circles of Nicholson's reliefs.

The works of Hepworth and Nicholson during this period are also united by the predominance of white, which achieved an ideological significance amongst modernists. It was a sign of the 'perfection, purity and certitude' of the era according to the Dutch constructivist Theo van Doesburg in 'Vers la Peinture Blanche', a pamphlet which Nicholson may have been given by Hélion in late 1933.[18] In particular, the preference for white was associated with the clarity and proportional harmony of contemporary architecture, and especially that of Le Corbusier. In 1933, Jim Ede recommended that Hepworth and Nicholson visit his acquaintance 'La Roche in a Corbusier house in Paris' on their Easter holiday, presumably as much for the Cubist paintings as the building.[19] At the same time, the architect Wells Coates – whom Hepworth and Nicholson knew through Unit One – was completing the modernist Isokon Flats in Lawn Road, Hampstead (1932–4) of which one was occupied by Adrian Stokes. In 1934, the presence of such modernist architecture in London was further reinforced by the arrival of Walter Gropius from the Bauhaus; Hepworth reported that Ben Nicholson's architect brother Christopher met him later that year.[20]

However, in writing of the association of architecture with the use of white in Nicholson's reliefs, Charles Harrison has argued that 'the whiteness of the white reliefs should be perhaps taken as the distillation of a particular set of interests in the apperceptive world of painting, rather than as a reflection of an aspect of the history of design'.[21] Hepworth certainly shared the 'pursuit of an extreme clarity' which Harrison associates with Nicholson's memories of visiting 'the white-painted studios of Arp or Brancusi in 1932–3'. For her part, Hepworth added a potent memory of Mondrian's studio which 'made me gasp with surprise at its beauty … everything gleamed with whiteness'.[22] She had also shared the important visits to the studios of Brancusi and Arp. A 'miraculous feeling of eternity' struck her in Brancusi's studio, where 'humanism … seemed intrinsic in all the forms'.[23] The immediate impact seems to have been exercised in Hepworth's organic abstractions of 1933–4 which drew upon Arp's work, but by 1935 she was responding to Brancusi's referential ovoid and oval forms (fig.39) by converting them into the more impassive abstraction of such works as *Three Forms* 1935. Like Brancusi, Hepworth allowed herself greater variety in her choice of coloured materials than did Nicholson in his reliefs.

Three Forms 1935 was conceived while Hepworth was a member of Abstraction-Création and came to represent an achievement of 'Constructive' art. She was amongst those responsible for introducing such an art to Britain with the exhibitions of the 7&5 in 1935 and *Abstract and Concrete Art* in 1936 (fig.27) organised by Nicolete Gray; *Three Forms* 1935 featured in both. The validity of Constructive art raised considerable debate, and encouraged the editors of the 'survey' publication, *Circle* (Gabo, Nicholson and the architect Leslie Martin), to solicit contributions from progressive scientists. The physicist Desmond Bernal was one of these and, in the same year, he wrote the foreword for Hepworth's exhibition, in which he drew attention to the 'surfaces of slightly varying positive curvature' and the exactitude of the 'placing and orientation' of forms.[24] In an undated letter, perhaps in relation to these observations, Hepworth wrote to Bernal of the intuitive experience of the artist and defended Constructive art as 'the one way of freeing every conceivable idea to its fullest intensity'.[25] More specifically she added, with accompanying sketches of *Three Forms* 1935: 'When you criticised my carving & said this was wrong [arrow to sphere] & should have been this [arrow to dotted-in cylinder]

you were quite right, sculpturally, spatially & constructively.' Given her differentiation of the roles of artist and scientist, such an unequivocal acceptance of Bernal's sculptural judgement seems astonishing, but it may reflect a dissatisfaction with an earlier work (despite the proportional relationships it used) by comparison with the standards of her work at the time. So much is implied by her concluding remarks:

if I solve the spatial form, ten to one I make a good carving, because I perfect the lines, form & tension & it lives. I might improve the one [form] you criticised, but my state of mind at the time I did it was not sufficiently clear, consequently the other 2 shapes have not the perfection that was required to solve the third shape.

It is interesting that the subject of this debate is the most superficially 'scientific' form – the sphere – which presumably lacked the surface variety that Bernal perceived in the sculptor's more recent elements. For her part, Hepworth accepted the application of 'laws' associated with Constructive art, that a scientist could define and she could only grasp intuitively when her state of mind was – in language toned by her Christian Science beliefs – 'sufficiently clear'.

At the time of this debate, *Three Forms* 1935 must already have been in the collection of Marcus and Irene Brumwell, friends and collectors of both Hepworth and Nicholson. Thirty years later, having donated the work to the Tate, Marcus Brumwell agreed that it was bought soon after being exhibited at the end of 1935, estimating: 'Shall we say 1 December 1935'.[26] During that period it remained in remarkably good condition, limited to surface dirt. However, on return from exhibition in Brussels in January 1974, the base was found to have been broken as the result of a 'sharp blow sustained unevenly'. The crack, which had chipped in the aperture, ran through one of the dowel holes for the medium-size element and under the larger element. The impossibility of achieving a strong but invisible repair prompted the replacement of the original base with a new marble; this is slightly colder in colour. The iron dowels holding each form (three for the largest) were replaced with stainless steel as they had left rust marks, and the surface was cleaned and waxed.[27]

fig.27
Exhibition installation, *Abstract and Concrete Art*, 41 St Giles, Oxford, 1936. Photograph by Arthur Jackson

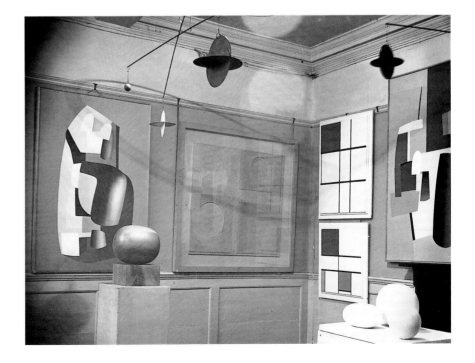

10 Discs in Echelon (version 4) 1935, cast 1959

T03132 BH 73, version 4; cast '1/4 A'

Solid bronze bolted to bronze base 34.8 × 50.5 × 27.4
(13¹¹⁄₁₆ × 19⅞ × 10¾)

Cast numerals and incised inscription in front face of
base 'A 1/4' l. and '1/4 A' r.

*Presented by the executors of the artist's estate, in
accordance with her wishes, 1980*

Exhibited: New York 1959 (2†); Zurich 1960 (1†); *British Art
and the Modern Movement 1930–40*, Welsh Committee of
the Arts Council, National Museum of Wales, Cardiff,
Oct.–Nov. 1962 (125); *Art in Britain 1930–40 Centred around
Axis, Circle, Unit One*, Marlborough Fine Art, March–April
1965 (39†, repr. p.31); Tate 1968 (27‡); *Conferment* 1968 (no
cat., Guildhall, as 'prototype'); Plymouth 1970 (33); Hakone
1970 (2‡, repr. as lent by '1/4 Janet Leach'); *Unit 1*,
Portsmouth City Museum and Art Gallery, May–July 1978
(BH 3† as lent by 'Barbara Hepworth Museum'); AC Scottish
tour 1978 (2†); *The Seven and Five Society 1920–35*,
Atkinson Art Gallery, Southport, Aug.–Sept. 1979, National
Museum of Wales, Cardiff, Sept.–Oct., The Minories,
Colchester, Oct.–Nov., Michael Parkin Gallery, London,
Jan.–Feb. 1980, Newlyn-Orion Gallery, Newlyn, Feb.–March
1980 (no number‡, repr. [p.19]); Wales & Isle of Man 1982–3
(2‡); *Two Sculptors and Two Potters: Barbara Hepworth,
Henry Moore, Hans Coper, Lucie Rie*, Cleveland Gallery,
Middlesborough, Oct.–Nov. 1986 (12‡, as '1935 brass'); New
Art Centre 1987 (5‡, repr. as '1959, Cast 1 of an edition of
four'); *10 Decades: Careers of Ten Women Artists Born
1897–1906*, Norwich Gallery, Norfolk Institute of Art and
Design, Norwich, March–May 1992 (no number‡)

Literature: Hodin 1961, p.163, no.73 (as 'Version 4'); Charles
Harrison, *English Art and Modernism 1900–1939*, London
and Bloomington, Indiana, 1981, rev. ed. London and New
Haven, Conn. 1994, p.269; Jenkins 1982, p.10, repr. p.24;
Wales & Isle of Man 1982–3, exh. cat., [p.5]; *Tate Gallery
Acquisitions 1980–2*, 1984, pp.112–13, repr.; Festing 1995,
p.251; Claire Doherty, 'Re-reading the Work of Barbara
Hepworth in the Light of Debates on "the Feminine"' in
Thistlewood 1996, p.171; Alun R. Graves, 'Casts and
Histories: Material Evidence and Hepworth's Sculptures',
ibid., pp.179–82

The conception and production of the Tate's *Discs in Echelon* are separated by twenty-five years, so that the work may be considered to belong to two periods in Barbara Hepworth's career: 1935, when the original was carved in wood, and 1959, when the present bronze cast was made. The title announces the work's formal simplicity, with the off-set relation of the two discs on the rectangular base being described by the artist's first use of the unexpected military term. In fact, the discs are more complex than would first appear, and differ slightly from each other. They present almost flat faces to each other with the outward sides being more rounded. In elevation, a crisp edge at the upper shoulder is broadened and rounded as it descends and the underneath has a flat plane in order to facilitate fixing. Profound differences attended the change of material and means of production of these subtle forms, as four castings in three materials were made from the carving. These changes were associated with a fundamental alteration of Hepworth's approach as she moved from carving direct to working with a studio of assistants.

The original *Discs in Echelon* was carved in 'darkwood' – possibly rosewood – during Hepworth's Constructive period in 1935.[1] It was amongst her contributions to the important *14th 7&5 exhibition* in October 1935, and, with the more anonymous title *Carving*, was reproduced shortly after in Myfanwy Evans's periodical *Axis*.[2] In that year it was bought by a Sheffield collector, W.B. Bennett, who presented it to the Museum of Modern Art in New York in 1936. Prior to being sent to America, a plaster cast was taken from the wood and exhibited in 1937.[3] This was unprecedented in Hepworth's practice up to that moment, and serves as a measure of the work's success in her eyes. The plaster seems to have been made as a preliminary to the unique aluminium cast of the same year, although this remained unexhibited in the artist's possession until acquired by her dealers in 1959.[4] The Tate's copy belongs to the edition of four solid bronzes cast in 1959; four hollow bronzes were cast in 1964 both sets being cast from the plaster in the artist's collection.[5]

During the 1950s, and especially following the success of her prize at the São Paolo Bienal (1959), Hepworth secured her position as one of the handful of major sculptors of her generation. This strengthened the demand for her work and she began to work consistently for bronze in 1956. The adoption of this quintessential medium of academic sculpture contravened her early rejection of such conventions, as well as her belief in the relationship between form and material. It raised fundamental problems for her, as she acknowledged in a letter to Herbert Read in which she reflected on the pressures to produce bronzes able to survive in the 'travelling circus' of contemporary art. For new works, Hepworth's procedure was to carve plaster for casting, a process which she believed more direct than modelling clay; she emphasised this distinction to Read: 'whilst I endeavour to remain constant to "truth to material" I really query the plaster versus clay controversy.'[6] At the same time, she began to cast small editions of earlier works in bronze; in the particular case of *Discs in Echelon* the cast was a logical

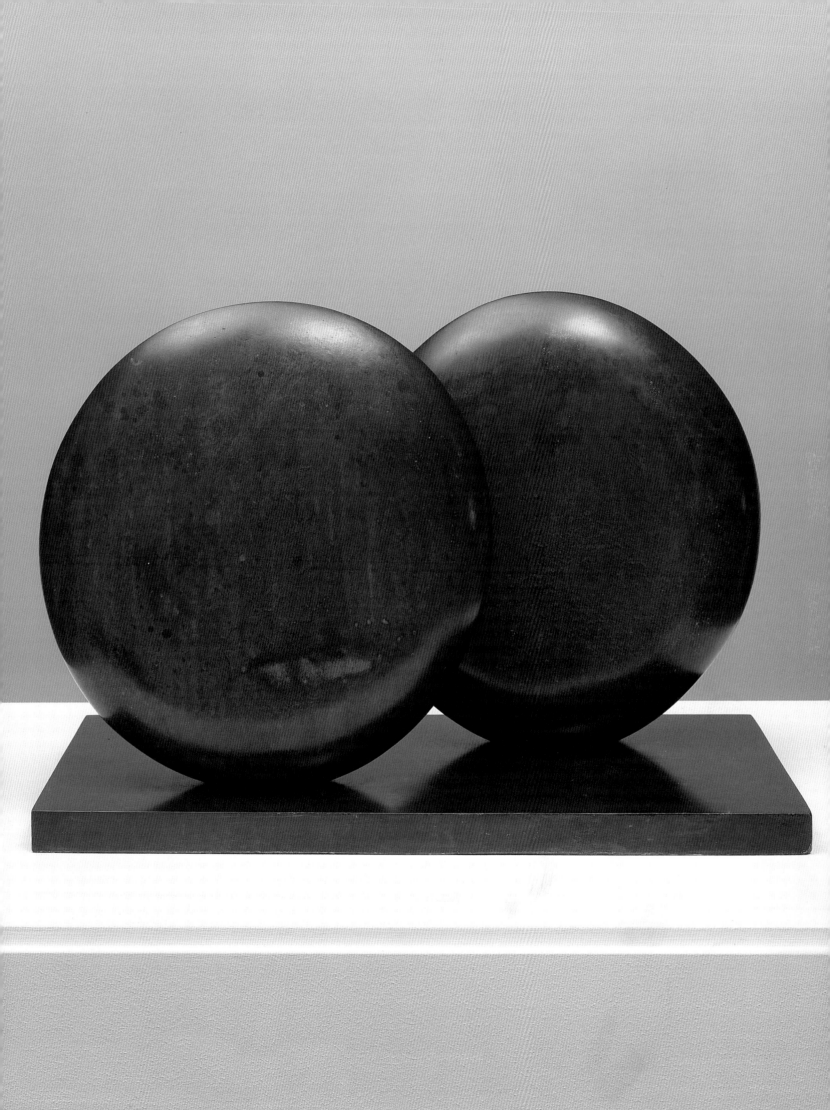

consequence of the experiment with aluminium. The employment of assistants facilitated these processes, as they increasingly worked alongside and instead of Hepworth on the more laborious and mundane aspects of preparing and finishing.

Hepworth chose to cast the edition of four *Discs in Echelon (version 4)* locally, possibly because of a combination of control over the process and financial reasons. The sculptor Brian Wall, who was an assistant at the time, recalled that it was cast by Holman's of St Just.[7] The simplicity of the forms was matched by the simplicity of the technique employed: the two discs and the base were solid sand casts – a process in which the dampened sand is packed around the form and removed to leave a void into which the molten bronze is poured. However, the result was crude and finishing was labour intensive, as the pitted and blackened surface which resulted from contact with the sand had to be filed down.[8] The discs were cast the right way up and air trapped in the molten liquid left defects towards the top. These were plugged by drilling and filling each with a dowel of metal derived from the excess cut from the same cast to achieve as close a match in colour as possible. The assistants to whom this work fell – Brian Wall, Breon O'Casey and Tommy Rowe – found that the bronze had been bulked out with domestic chrome-covered brass taps. The more brittle chrome had to be drilled out and plugged as it broke the files used to finish the rough cast surface.[9] Derek Pullen has observed that, in cooling, the metals would have 'tended to solidify separately'; the resulting differences were accentuated by the patination process and are especially visible in the lighter patches on the rear of the right disc.[10]

The quality of the finish resulted in a curious correspondence, which suggested that the foundry returned a preliminary cast for inspection. They wrote:

Reading between the lines we assume the casting was not the required finish expected, but trust you will be able to bring it to your standard for any future use. Our man was very worried as it was not possible to get the pattern out of the sand without tearing, and then try and build up the mould. Actually the pattern should have been made with loose pieces. Also instead of green sand finish, we would blacken and dry the face of the mould in future.[11]

To this was added, by way of reassurance: 'we have often made brass fender tops for Cornish Ranges.' The 'green sand finish' would have given a rougher surface, and may also explain the inconsistencies in the Tate's cast, visible in the shiny areas of the shoulders of the discs.[12] The patina is a subtle combination of shiny and dull areas of brown, reminiscent of the finish of Japanese bronzes or pottery glazes. However, uneven weathering may have contributed to the effect, as it seems likely to have been the cast displayed and photographed in the artist's garden.[13] The stamping of the Tate's copy with '1/4 A' may suggest that it was the first cast and the one retained by the artist; its shortcomings may have been tolerated in these circumstances. A 'prototype' is listed in the artist's album as shown at the Freedom of St Ives Conferment in 1968; while this is likely to have been the plaster, it is possible that it was the first bronze cast.[14]

The supposition that the Tate copy was the first cast is reinforced by Hepworth's reply to the foundry: 'I think that if I can improve my design for you and with your experience of my requirements, we ought to be able to get the sort of finish which would be economically possible for me to manage.'[15] This suggests that further work was done; in particular, different finishes seem to have been achieved. One other cast was in the collection of the late Janet Leach by 1964. It has a 'blackish' finish;[16] and bears no number, although it is listed as '1/4' in the artist's album. The cast listed as '4/4', which the artist gave to her son Simon Nicholson, was highly polished – a condition confirmed by his widow Silvie Nicholson;[17] this is the cast frequently reproduced as representative of the edition. Of the other casts listed in the artist's album, '2/4' was in a private collection and '3/4' was given by her in 1968 to the Rijksmuseum Kröller-Müller, Otterlo; however, the Kröller-Müller catalogue notes it as '0/4'.[18]

At the very least, it is clear that the numbering of the edition was confused and inconsistent. On acquisition, the Tate's cast was identified with '4/4', which had been

fig.28
Darkwood Spheres, 1936, length 45.8 (18), wood, BH 80,
destroyed

bought back jointly by Hepworth and her dealers Gimpel Fils when her son sent it to auction.[19] This identification now seems unlikely, not only because of the discrepancy in the numbering, but also because, as already observed, Simon Nicholson's cast was notably shiny. In 1965, Hepworth exchanged with her dealers a cast from the new hollow edition of *Discs in Echelon* (BH 73, version 5) for her share of this cast;[20] She had proposed destroying two of the solid casts in November 1964, but seems to have been dissuaded by Janet Leach's objections: 'This sculpture is my fondest possession and I question that anyone, even you, has the moral right to destroy work after its completion.'[21]

The decision to have the bronze cast locally may have been prompted by pressure of time. Six months after the correspondence with Holman's, one of the solid casts was shown in New York. There it served as a work from the 1930s and must have been directly comparable to the original wood in the Museum of Modern Art. The uneven quality of casting may account for the inability to sell the remaining examples from the edition until 1968. It also seems to be the reason for the orthodox hollow cast edition of 1964 by Hepworth's regular foundry Morris Singer Ltd.

One further consequence of the St Just casting was the tremendous weight of the solid cast. Hepworth gave the resultant difficulties with transportation as a reason for the 1964 cast. In 1994, the Tate's cast was dropped during transfer to the Barbara Hepworth Museum in St Ives and suffered considerable damage. Deep gouges and scratches resulted in the upper shoulders of both discs which have now been successfully restored.[22]

In contrast to the bronze of the late casts, the materials used for the early versions of *Discs in Echelon* were indicative of Hepworth's personal modernism in the 1930s. The unusual aluminium cast apparently made in 1936 was the epitome of this. The dealer Kay Gimpel remembered the artist remarking retrospectively that it was a 'cruel material', although it is unclear whether this related to its handling, its final appearance or wider associations.[23] At the time, aluminium implicitly evoked the machine aesthetic of contemporary design, which shaped such stream-lined vehicles as Sir Malcolm Campbell's Bluebird in which the land speed record was set in September 1935. The darkwood original of *Discs in Echelon* did not evoke such associations, although it carried the idea of direct carving into Constructive art. Richly dark, it contrasted with the white modernism of *Three Forms* 1935 (no.9 q.v.). Other related works were carved in such woods, notably *Two Forms* 1935 in snakewood and *Darkwood Spheres* 1936 (fig.28).[24] While the vertical element of the former is closely comparable to that of the discs, the latter sculpture shows the achievement of a geometrical purity in the alignment of two spheres of different sizes. Such variety was characteristic of Hepworth, who had used white stones and exotic woods side by side in the early 1930s thus echoing Brancusi's practice of making versions of the same work in different materials.

By 1935, the different material strands in Hepworth's work had been pulled together in a unified concentration upon formal abstraction. While emphasising the continuity of carving in her work, she would recall that she 'had developed a deliberate conception of form and relationship'.[25] The technique was reconciled with what she called the 'absolute reverse of all that was arbitrary' by providing subtle variety on increasingly idealised forms. When Hepworth exhibited the plaster of *Discs in Echelon* in 1937, the physicist Desmond Bernal observed that in such works 'the greatest thought has been given to exact placing and orientation' of the similar forms. He added: 'The separate surfaces are made to belong to one another by virtue of their curvatures and their precise distances apart much as two sheets of a geometrically defined single surface.'[26] Bernal's scientific authority was welcome support in the face of earlier criticism, which most commonly associated the purity of Hepworth's work with a draining of emotion and meaning. Two years earlier J.M. Richards reviewed the 7&5 exhibition – in which the

original *Discs in Echelon* and *Three Forms* 1935 featured – in the supportive periodical *Axis*. Nevertheless, his assessment of Hepworth's composition of 'convex shapes' was equivocal:

The earlier one is still organic in the derivation of its forms, as are Henry Moore's; the latter one is not. A revealing contrast, but in this case, though the artist is following Ben Nicholson's successful lead, the necessary vitality does not seem to have survived the change. The later work appears empty compared with the earlier. Her third exhibit, in wood, is the most satisfactory of the three.[27]

For Richards, therefore, Hepworth's forms were distilled to the point of emptiness. In addition, the key notion of 'vitality' – widely used in art criticism of the 1930s as a measure of a work's success – was used to divide Hepworth from her male peers. This position had been stated more nakedly by Hugh Gordon Porteus in the preceding issue of *Axis*: 'Take away from Barbara Hepworth all that she owes Moore, and nothing would remain but a solitary clutch of Brancusi eggs, with a few Arp scraps.'[28] Beyond the apparent vitriol, Porteus continued in more measured and generous style to discuss the subtlety of Hepworth's touch:

Considered singly, her objects often lack power – partly, perhaps, because of the proximity of a Moore! But consider the superb poise of her new twin monoliths; and, as between the units of her rotunder pieces, note the precise apprehension of surface tension. Her objects are related together in a manner diametrically opposed to that of Moore. Where Moore's forms are linked by an intangible bond of sympathy, attraction of opposite magnetic poles, Barbara Hepworth's are as deliberately based on similarity of forms, magnetic repulsion. Each unit is a highly individualised, haughty, feminine, enclosed lump, spurning its neighbour with a tacit *noli me tangere*.

The discussion of 'sympathy' and 'magnetic repulsion' evokes some of the qualities of *Discs in Echelon*, even if Porteus's combination of comprehension and criticism is somewhat obstructive.

Such uneven comparisons to Moore and Nicholson were to haunt the discussion of Hepworth's work until the 1950s and beyond. She took the opportunity to clarify the term by which she was divided from them with her assertion that 'Vitality is not a physical, organic attribute of sculpture – it is a spiritual inner life.'[29] In 'L'Art contemporain en Angleterre' in *Cahiers d'Art* (1938), Herbert Read illustrated the original *Discs in Echelon* as newly acquired by the Museum of Modern Art in New York and claimed that it exemplified 'quelque chose dans le tempérament anglais – non pas … notre puritanisme, mais plutôt notre transcendantalisme'.[30]

Despite such arguments it is only recently that Hepworth's uneven critical reception has been exposed to scholarly assessment, by Katy Deepwell and others, and the sculptor's achievement disentangled from the perception that her individual practice was a faint echo or reflection of her male contemporaries.[31] In the process of this revision Claire Doherty has reread Hepworth as an exemplar of a Kristevean 'sculpture féminine'. In place of her perceived passivity, Doherty has seen Hepworth's practice as 'highly electric' and suggested that *Discs in Echelon* in particular encouraged the spectator's inspection 'generating either a desire to eliminate the imperfections or a need to halt the unbearable tension'.[32]

11 Ball, Plane and Hole 1936

T03399 BH 81

Teak on ?oak base 21 × 61.1 × 30.5 (8⁵⁄₁₆ × 24 × 12);
weight 4.7 kg

Purchased from Waddington Galleries (Grant-in-Aid) 1982

Provenance: Acquired from the artist by Leslie and Sadie
Martin (later Sir Leslie and Lady Martin); anon. sale
Sotheby's *Important Impressionist and Modern Paintings
and Sculpture*, 31 March 1982 (105, repr. in col.) bought
Waddington Galleries

Exhibited: *1937 Exhibition: Unity of Artists for Peace,
Democracy and Cultural Development*, AIA, 41 Grosvenor
Square, April–May 1937 (90, 91, 93 or 94); Lefevre 1937 (4);
British Art and the Modern Movement, Welsh Committee of
the Arts Council of Great Britain, National Museum of
Wales, Cardiff, Oct.–Nov. 1962 (58, as '*Sculpture c.*1935');
*British Sculpture in the Twentieth Century, Part I: Image and
Form 1901–1950*, Whitechapel Art Gallery, Sept.–Nov. 1981
(168); *Retrospective* 1994–5 (23, repr. in col. p.54); *Home
and Away*, Tate Gallery Liverpool, Nov. 1995–April 1997 (no
catalogue)

Literature: Hodin 1961, p.164, no.81; Jenkins 1982, p.10, repr.
p.24; *Tate Gallery Acquisitions 1982–4*, 1986, p.197, repr.;
Alan G. Wilkinson, 'The 1930s: "Constructive Forms and
Poetic Structure"' in *Retrospective* 1994–5, exh. cat., p.56;
Festing 1995, p.117; Penelope Curtis, 'Hepworth, Nicholson
et Moore, 1934–1939: l'imagination picturale' in *Un Siècle de
Sculpture Anglaise*, exh. cat., Galerie national du Jeu de
Paume, Paris 1996, p.85, repr.

Ball, Plane and Hole was made during the period in the mid-1930s in which Barbara Hepworth came to be closely identified with Constructive art. Her contemporary wooden sculptures, such as the original of *Discs in Echelon* 1935,[1] retained a quality of craftsmanship in which geometry was mellowed by subtly carved surfaces and volumes. In this respect, *Ball, Plane and Hole* is rather unusual, as two of the four elements were sawn and all were simply held by screws. This momentarily introduced the simplest techniques of construction into Hepworth's repertoire, with a result that remained closer to the cage-like wooden structures of Eileen Holding than to the explorations of machined plastic and metal by constructivists such as Naum Gabo and Antoine Pevsner.

The elements of *Ball, Plane and Hole* were simply assembled: a pair of brass screws secure each of the rectangular elements from under the base. The ball is held to the wedge by a concealed brass screw. Hepworth may have carved the ball from a cylinder (as there is a slight unevenness at its mid-point). It is not perfectly spherical, perhaps as a result of the expansion of the wood. The wedge was cut along its sides and ends; it has been damaged and repaired on its outermost corner. The pronounced curve along its length, so that each end is lifted from the base, may have been achieved by carving. Because of its thinness the base has an appreciable concave warp both across its width and along its length.[2] There is an associated crack along the grain from the right end which reopened after an old repair; a 'crack stopper' hole has been partially drilled from underneath at its furthest point 'to release any stress concentration'.[3] The hole was filled with wood flour mixed with epoxy adhesive. The wood was listed as teak in the catalogue of Hepworth's Lefevre show in 1937, but the architect Sir Leslie Martin – the sculpture's first owner – has noted that she referred to it as oak in a letter of 11 April 1959;[4] only the base is now judged to be oak. The sculptor's letter identified three woods (lignum vitae, mahogany and oak) but referred to three different sculptures; this has been misread as referring to *Ball, Plane and Hole* alone.

For such a formally simple work, *Ball, Plane and Hole* has a multiplicity of associations. The title draws attention to the relationship of solid and void, and to the spatial qualities of the passage of the three-dimensional ball through a plane to leave a hole. The work evokes 'the playful quality of children's toys' as Alan Wilkinson has observed and, as such, relates to Ben Nicholson's interest in games.[5] Its form also evokes the 'little wooden ball … knocked up from a sloping platform' which constituted the Yorkshire game of 'knurr and spell' recalled by Henry Moore.[6] However, Hepworth's teasing visual paradox of balancing the ball on the wedge also seems to reflect her interest in the work of Alberto Giacometti, whom she may have met in Paris in 1932 and whose sculptures both she and Nicholson continued to admire. In 1936, Nicholson reiterated this admiration in a letter to Herbert Read, at a time when Giacometti's *Woman* and *Man* 1928–9 were included in the *Abstract and Concrete* exhibition in Oxford.[7] Giacometti had also made a number of wooden 'board-game' sculptures, and

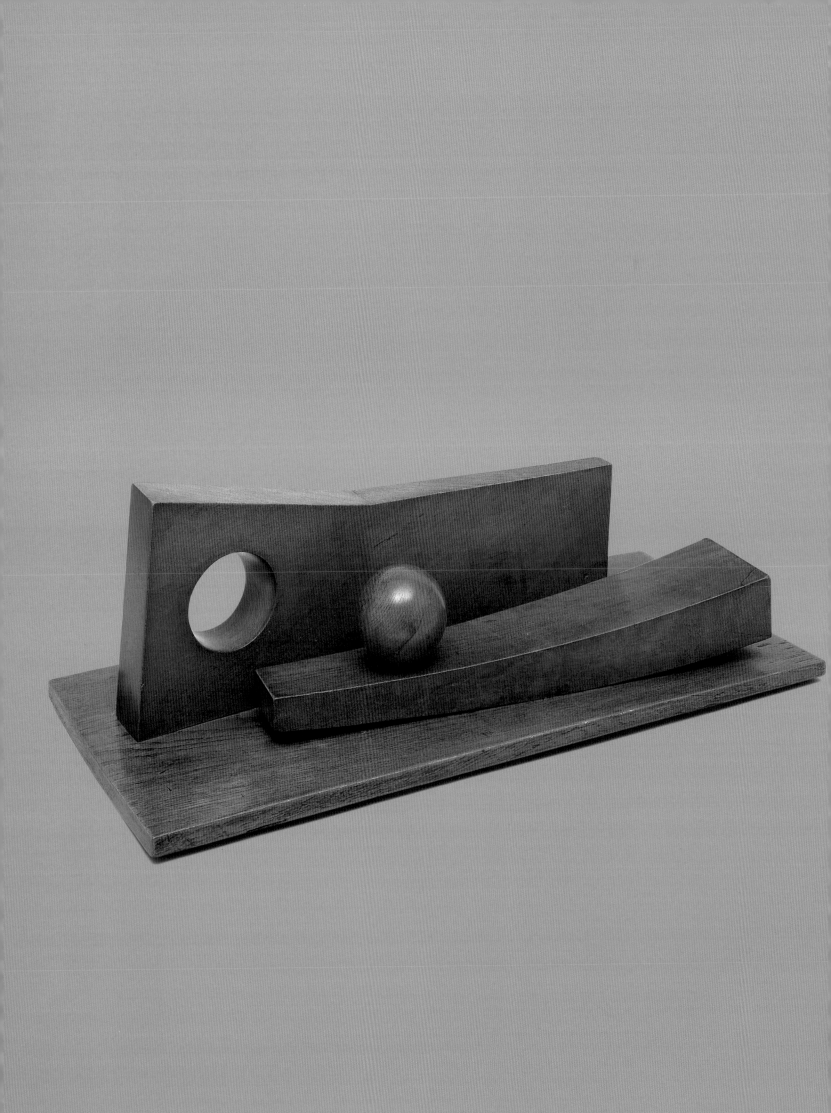

especially comparable to *Ball, Plane and Hole* is his *Circuit* 1931, in which a ball is routed in a groove.[8] Many of his works carried a sexual charge, and this has also been perceived in Hepworth's sculpture. Both Sally Festing and Alan Wilkinson have recognised in *Ball, Plane and Hole* a combination of 'constructive form, with the sexual imagery of the hole and ball'.[9] It suggests a Constructive distillation of the eroticism of the earlier *Two Forms* 1933 (no.6 q.v.).

Positions within contemporary artistic debates in Britain shifted during 1935–6, and as biomorphic abstraction became associated with the dream imagery of Surrealism (to which Giacometti had been allied), so the constructivists emphasised the social function of their own more geometric work. Definitions hardened following the popular success of the *International Exhibition of Surrealism* of 1936 to which the publication of *Circle: International Survey of Constructive Art* in 1937, under the editorship of Gabo, Nicholson and Martin, served as a response.[10] There Hepworth herself characterised the artist's rebellion against 'the world as he finds it' as a choice, suggesting: 'he can give way to despair and wildly try to overthrow' the existing order 'or he can passionately affirm and re-affirm and demonstrate in his plastic medium his faith that this world of ideas does exist'.[11]

The refinement of Hepworth's points of reference during this period may be seen in a comparison of her two large stone works completed before and immediately after *Ball, Plane and Hole*. Although angular and abstract, the four-feet-high carving in blue Ancaster stone *Two Forms (Two Figures)* 1935 retained some echo of Giacometti's work in the sympathetic bending together of elements;[12] it was bought by Roland Penrose, one of the co-ordinators of Surrealism in Britain. In the following year, all such associations were stripped away in the Constructive *Monumental Stela* 1936 (fig.29), made in the same stone but six feet high. The formal vocabulary was very similar to *Ball, Plane and Hole*, especially in the layered use of flat planes and the cylindrically pierced hole, and it was closely related to that of Nicholson's contemporary white reliefs. With its reference to the stelae (tombstones) of ancient Greece, *Monumental Stela* was an assertion of the classical possibilities for Constructive carving on a scale unprecedented in Hepworth's work. Significantly, it was illustrated in *Circle*.[13] Situated outside, both these stone carvings suffered bomb damage: *Two Forms (Two Figures)* is listed as 'destroyed' and after the war Hepworth had *Monumental Stela* cut up by Bernard Meadows (who had taken over her studio).[14] As a result of these losses, *Ball, Plane and Hole* is an important survival of Hepworth draining any tendencies towards Surrealism from her Constructive work.

Ball, Plane and Hole was exhibited at the AIA exhibition and at Lefevre in 1937, the year of *Circle*. It is visible in an installation photograph of the former.[15] Sir Leslie Martin has confirmed that he and his wife Sadie Speight bought it after these exhibitions as they always bought 'directly from the artists themselves who were, of course, our friends'; they had first sought out Hepworth and Nicholson following the *Unit One* exhibition three years earlier.[16] In his preface to the Lefevre catalogue, another friend and contributor to *Circle*, the physicist J.D. Bernal, grouped *Ball, Plane and Hole* with works which 'bring out the theme of complementary forms, each solid structure being contrasted sharply with a hollow smaller, or larger, than itself'.[17] Through the exchanges between Hepworth and Bernal on qualities of form – as seen in the discussion of *Three Forms* 1935 (no.9 q.v.) – and the Martins' support, *Ball, Plane and Hole* exemplified the converging sculptural, scientific and architectural interests which were central to *Circle*.

fig.29
Monumental Stela, 1936, height 182.9 (72), blue ancaster stone, BH 83, destroyed

12 Single Form (Eikon) 1937–8, cast 1963

T00697 BH 329; cast 7/7

Bronze with integral base 148 × 28 × 32 (58¼ × 11 × 12⅝);
weight 77 kg

Cast inscription in top face of base 'Barbara Hepworth |
1937–38 7/7' back left; cast foundry mark on back of base
'MORRIS | SINGER | FOUNDER | LONDON' t.l.

Presented by the artist 1964

Exhibited: Zurich 1963–4 (18†, repr. in col.); *Profile III:
Englische Kunst der Gegenwart*, Städtische Kunstgalerie,
Bochum, April–June 1964 (63); *Spring Exhibition 1964*,
Penwith Society of Arts, St Ives, spring 1964 (sculpture 1†);
Gimpel Fils 1964 (18†, repr. in col.); BC European tour
1964–6 (2‡); *Little Missenden Festival Exhibition*, Little
Missenden, Oct. 1965 (no cat.†); New York 1966 (13†, repr.);
5ᵉ Internationale Beeldententoonstelling Sonsbeek '66,
Arnhem, May–Sept. 1966 (98†); *Contemporary Sculpture*,
Gimpel Fils, Feb.–March 1967 (23†); Tate 1968 (32);
Conferment 1968 (no cat., St Ives parish churchyard ‡);
Plymouth 1970 (8); Hakone 1970 (3‡, repr.); *Henry Moore to
Gilbert and George: Modern British Art from the Tate
Gallery*, Palais des Beaux Arts, Brussels, Sept.–Nov. 1973
(47, repr. p.61); AC Scottish tour 1978 (3‡); Bretton Hall 1980
(7‡); *Sculpture du XXᵉ Siècle 1900–1944: Tradition et
Rupture*, Fondation Maeght, Saint-Paul de Vence, July–Oct.
1981 (104‡, repr. p.124); Wales & Isle of Man 1982–3 (3‡)

Literature: *Tate Gallery Report 1964–5*, 1966, p.39; Edwin
Mullins, 'Barbara Hepworth', Hakone 1970, exh. cat., unpag.;
Bowness 1971, p.34, no.329; Jenkins 1982, p.10, repr. p.24;
Wales & Isle of Man 1982–3, exh. cat., [p.6]

Like the Tate's bronze version of *Discs in Echelon*, the original *Single Form* and the cast – to which the subtitle (*Eikon*) was appended – are separated by twenty-five years. This made a crucial difference to Barbara Hepworth's conception of the work and to the materials used. The original plaster *Single Form* (BH 104) was made in 1937–8 and sent to Paris in 1938.[1] There it remained until 1961, when it was returned to Hepworth. Two years later she had it cast in an edition of seven (+ 0, artist's copy); a copy was given to the Tate and another (4/7) was acquired by the Rijksmuseum Kröller-Müller in Otterlo in 1967.

The title suggests the simplicity of the tall shaft raised on its plinth. In common with the majority of Hepworth's sculptures, it presents a definite front face. The shaft is essentially triangular in plan, although the sides of the triangle curve outwards and the back is quite rounded, especially at the base. The form expands gradually as it ascends, reaching its greatest breadth about two-thirds of the way up before diminishing again. Just above this stage, the spine widens to become the top plane, meeting the front face in a slightly curved horizontal edge. The subtle modulation of this form is contrasted with the deliberate roughness of the base: this reproduces the deeply chiselled gouges in the wooden block on which the original plaster is mounted, complete with a larger scoop out of the upper part of the right side.

The decision to use plaster for the original of *Single Form (Eikon)* was unusual for Hepworth in the 1930s. It is possible that it was envisaged as a preparation for a cast, such as the single aluminium cast made in 1936 from a plaster of *Discs in Echelon* (no.10 q.v.). Alternatively, it may have been seen as a potentially dispensable work, as it was sent to an unspecified Parisian exhibition in 1938,[2] at a time of high political tension – from the Nazi annexation of Austria (the Anschluss) in March, to the Munich Agreement over the partition of Czechoslovakia in September. Just as the material of the original is unusual, so is the fact that it was painted a bright cobalt blue worked with a stippled finish. This was unprecedented in Hepworth's practice at a time in which white was the quintessential colour of Constructive art, although it anticipates the treatment of *Sculpture with Colour (Deep Blue and Red)* 1940 (no.14 q.v.). On the one hand, the stippling, if applied in 1937–8, may indicate that the plaster was a substitute for a veined stone; Hepworth had recently carved the large-scale *Monumental Stela* 1936 (fig.29) in blue Ancaster stone. On the other hand, the fact that the blue was transformed into green patination when the bronze was made may suggest that the colouring was part of that process of visualisation in 1963. In that case, the work would originally have been exhibited as white and might thus be associated with the purity of such carvings as *Three Forms* 1935 (no.9 q.v).

Hepworth made several closely related works in 1937–8, all with very similar formal qualities despite their different materials. They have an affinity with the smaller of the elements in the white marble *Two Forms* 1937 (fig.30). All were subsequently called *Single Form*, but some were originally exhibited under more individual titles which serve

fig.30
Two Forms, 1937, height 66 (26), marble, BH 96, private
collection on loan to University of East Anglia, Norwich

to distinguish them. Of the four works completed in 1937, two – *Stela* carved in marble and *Single Form in Lignum Vitae* – were under two feet high.[3] They had flat angled tops, and were broad in relation to their height, allowing a dramatic curving diminution towards the base. Two taller and more attenuated pieces were carved in English hardwoods: *Single Form in Sycamore* and *One Form in Plane* also known as *One Form (Single Form)*.[4] At five and a half feet high the latter must have been impressive. In scale and conception as a rising form, these works approach those of Brancusi, such as his *Bird in Space* 1925 a version of which was illustrated in *Circle*.[5] At that time, Brancusi was taking verticality to an extreme in the *Endless Column* at Tirgu-Jiu in Romania, which is almost thirty metres (ninety feet) high.

All four 1937 versions of *Single Form* were shown (with their differentiating titles) in Hepworth's solo exhibition in October 1937. J.D. Bernal wrote of them in his introduction:

the others, which we may call the four Menhirs though each has its distinctive individuality, gain immensely from being studied together. Though at first similar, comparison brings out subtle differences of entasis and change of section. They may indeed be considered to introduce a fourth dimension into sculpture, representing by a surface the movement of a closed curve in time.[6]

Bernal's points of reference are significant. The expansion of the forms certainly evoke the entasis used on classical columns. This was a very slight outward curvature in the centre of the shaft, which served to counter the visual illusion of narrowing which results from the use of straight lines. As this refinement was practised most famously by the architects of the Parthenon in the fifth century BC, Bernal's allusion served as a legitimising reference to classicism for those sceptical of abstraction. This was more explicit when he compared her work to 'Helladic' [sic] statues of Apollo. In the particular case of the *Single Form* works, Bernal's additional allusion to scientific laws directly addressed accusations of excessive severity made against Hepworth's Constructive art. As a physicist himself – he is noted as a Fellow of the Royal Society – his reference to the fourth dimension and 'the movement of a closed curve in time' carried particular weight, even if made in rather vague terms.

Reinforced by this confident statement of the formal complexity of her work, Hepworth had two further wood versions of *Single Form* underway by the end of the year. These were in holly (fig.31) and sandalwood.[7] Medium-sized by comparison to the earlier wooden versions (under three and four feet high respectively), they were broader and presented flatter faces. The proportions of the plaster from which *Single Form (Eikon)* was cast lie somewhere between the destroyed *One Form in Plane* and the holly version; its height is closest to the five and a half feet of the former. This may suggest that the plaster was begun before the last two wooden versions.

Although William Gibson called Hepworth's 1937 exhibition an 'oasis in this desert of the commonplace' not everyone was enthusiastic.[8] The art historian Anthony Blunt reached a withering conclusion: 'To praise Miss Hepworth's sculptures seems to me like saying that a man is a good orator because the shapes which his mouth makes when he speaks are aesthetically satisfying.'[9] Together with such Euston Road painters as Graham Bell and William Coldstream, Blunt was amongst those who sought a political role for art through Social Realism and who saw abstraction as escapism. Their position had explicit links to the official Socialist Realism of the Soviet Union, at a time when Hitler was condemning modernism as 'Entartete Kunst' (Degenerate Art). Those favouring Social Realism had little time for Surrealism, and the opposition worked out in exhibition reviews came to a head in a series of debates between these two groups at the Artists International Association in March 1938.[10] Although this did not involve the Constructive artists, the wider debate of artistic relevance had to be taken into account by all those seeking to justify their own work. Indeed, Hepworth's statement in *Circle*, published in late 1937, explicitly rebutted the criticism of the realists; she stated that Constructive art 'is no escapism, no ivory tower, no isolated pleasure in proportion and space – it is an unconscious manner of expressing our belief in a possible life'.[11]

The article in *Circle* was Hepworth's longest discussion of the role of sculpture. Like Bernal's contemporary text, it offered a defence of the formal and affirmative radicalism of Constructive art by relating it to wider scientific, cultural and social issues. The apprehension of these formal qualities was recognised as part of everyday life:

The consciousness and understanding of volume and mass, laws of gravity, contour of the earth under our feet, thrusts and stresses of internal structure, space displacement and space volume, the relation of man to a mountain and man's eye to the horizon, and all the laws of movement and equilibrium – these are surely the very essence of life, the principles and laws which are the vitalization of our experience, and sculpture a vehicle for projecting our sensibility to the whole of existence.[12]

The privileged position of sculpture in this scheme was underwritten by the reference to its physical occupation of space, most significantly related to the natural. This is particularly evident in Hepworth's summary of Constructive work: 'It is an absolute belief in man, in landscape and in the universal relationship of constructive ideas.'[13] This parallel anticipated the artist's later concentration on the relation of her work to the figure in the landscape. Hepworth had a number of the *Single Form* works photographed outdoors; as well as practical reasons of lighting this suggests a deliberate dialogue with nature. In 1943, writing of a photograph of the *Single Form* in holly which belonged to Herbert Read, the sculptor was emphatic about the relationship to the landscape: 'I took this photograph myself down at Herbert's place in Bucks because when I conceived Single Form it was born of this particular sort of landscape.'[14] As she went on to say that 'all my sculpture comes out of landscape', this appears to read contemporary conditions of working in Cornwall onto those of London in 1937–8. Read only settled in Buckinghamshire in late 1937, the time at which he acquired the sculpture.

The comparisons made for Hepworth's work in the late 1930s were not so much with the experience of landscape as with man's contribution to it in the form of the Neolithic menhirs in which carving and abstraction were conveniently combined. This was used by Bernal in relation to the *Single Form* group and in the coincidence of Hepworth's pierced sculptures with the famous ring-shaped Men-an-tol stone in Cornwall (fig.32).[15] The comparison was suggested by Hepworth herself, through the inclusion of photographs of Stonehenge immediately after her article in *Circle* of which she and Sadie Speight were responsible for the layout.[16] That this was a current concern is confirmed in Hepworth's letter to Ben Nicholson thanking him for material about the stone circle at Avebury which he had sent from his father's house at Sutton Veny. Significantly, this coincided with John Piper's article 'Prehistory from the Air' which published aerial photographs of Neolithic sites and compared them to contemporary abstraction.[17]

For both Hepworth and Bernal, the presumed functions of menhirs offered a precedent for a social function for the new art. Hepworth wrote of the individual artist in clearly political terms related to the contemporary debates:

It is the sculptor's work fully to comprehend the world of space and form, to project his individual understanding of his own life and time as it is related universally in this particular plastic extension of thought, and to keep alive this special side of existence. A clear social solution can only be achieved when there is a full consciousness in the realm of thought and when every section constitutes part of the whole.[18]

In the aspiration for social change, Hepworth summarised one of the reasons for the conjunction of arts and sciences in *Circle* which was part of a broader concern within the avant-garde. The precedence of art in this process of change was less widely shared, but Hepworth would become more involved during the war years in strategies for political and social planning for the future.

Many of these concerns were articulated by Herbert Read, the major spokesman for modernism – or, as Hepworth put it ironically, 'the infamous encourager (perhaps conjurer) of all this nonsense'.[19] He had written a foreword to Hepworth's part of her joint exhibition with Nicholson in 1932. However, as Katy Deepwell has shown, his

fig.31
Single Form, 1937-8, height 78.7 (31), holly, BH 102, Leeds City Art Gallery

support for her work remained ambivalent because he clearly favoured that of Henry Moore, to whom she was habitually compared.[20] Both Read and Moore made contributions to *Circle* in which they spoke for an accommodation between Constructive art and Surrealism for which Hepworth had little time. However, Read's ownership of her *Single Form* in holly wood indicated his enthusiasm for her particular affirmative abstraction.

The production of the bronze cast of *Single Form (Eikon)* in 1963 occurred in a context quite distinct from that of the late 1930s. One indication of this change lies in the addition of the Greek subtitle, which follows Hepworth's practice begun in the mid-1940s. The Greek spelling of 'eikon', meaning 'an image', draws attention to a potential figurative content as distinct from the specifically religious 'icon'. The sculptor had already made this link in a letter to E.H. Ramsden, in which she illustrated the continuities in her work with sketches of early and recent pieces; in this scheme, *Single Form* was seen to have derived from the vertical alabaster *Figure* 1933.[21]

By 1963, Hepworth's reputation had been secured in a series of retrospectives and awards. As a memorial to Dag Hammarskjöld, the owner of *Single Form* in sandalwood, 1937–8, she was making a work for the United Nations building in New York; presumably deliberately called *Single Form* 1961–4 (fig.6), it derived from the wood carving *Single Form (September)* 1961 (no.55 q.v.). At the same time, the abstract art of the 1930s – and her role as a pioneer – was the subject of renewed interest, as shown by the exhibition *Art in Britain 1930–40 Centred around Axis, Circle, Unit One* in 1965 to which she contributed the plaster of *Single Form* amongst other works.[22] Casting became a way of meeting the demand for her pre-war work at exhibitions and in public collections; a bronze edition of *Single Form in Lignum Vitae* was made in 1962.

The standard hollow sand cast of *Single Form (Eikon)* was made in 1963 by Morris Singer Ltd. Like the original, the bronze shaft and base are separate units, with the joint being aligned by a bronze rod passing through a metal bar in the base and secured by a central Whitworth thread bolt.[23] The patination has been worn off the upper part of the spine; the base, the top of which is similarly worn, has a slightly darker patination. The front is rather pitted in places, following the plaster, and the sides have received several noticeable scratches as a result of handling. There is also an area of slightly yellowed early restoration about two-thirds of the way up the shaft, which is visible from behind. In 1992 old retouchings were removed and the whole cleaned before the scratches were retouched.[24]

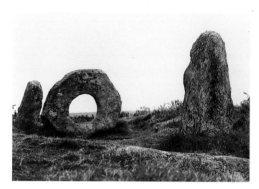

fig.32
The neolithic stones of Men-an-Tol, Cornwall. Photograph by John Piper

13 Forms in Echelon 1938

T00698 BH 107

Tulip wood on elm base 108 × 60 × 71 (42½ × 23⅝ × 28); weight 58.2 kg

Presented by the artist 1964

Exhibited: *Abstract and Concrete Art*, Guggenheim Jeune, April 1939 (24, as *Two Forms (Tulip Wood)*); Leeds 1943 (96); Wakefield & Halifax 1944 (22); *Summer Exhibition*, Penwith Society of Arts, St Ives, summer 1951 (80); Whitechapel 1954 (32); North American tour 1955–6 (3, repr.); New York 1956–7 (3); São Paolo Bienal 1959 (2, dated 1939); BC South American tour 1960 (1); *British Art and the Modern Movement 1930–40*, Welsh Committee of the Arts Council, National Museum of Wales, Cardiff, Oct.–Nov. 1962 (128, repr. p.33); BC European tour 1964–6: Copenhagen (3), Stockholm (4); *Art in Britain 1930–40 Centred around Axis, Circle, Unit One*, Marlborough Fine Art, March–April 1965 (45, repr. as *Two Forms*); Tate 1968 (34, repr. p.14); Plymouth 1970 (10, repr.); *British Sculpture in the Twentieth Century*, Whitechapel Art Gallery, Sept. 1981–Jan. 1982 (part 1, 170); *Un Siècle de Sculpture Anglaise*, Galerie national du Jeu de Paume, Paris, June–Sept. 1996 (no number, repr. in col. p.98)

Literature: 'Art Out-of-Doors', *Architectural Review*, vol.85, no.509, April 1939, pp.201–2, repr. p.202, pl.1; Hodin 1961, p.165, no.107, repr.; *Tate Gallery Report 1964–5*, 1966, p.40; 'Recent Museum Acquisitions: Sculpture and Drawings by Barbara Hepworth (The Tate Gallery)', *Burlington Magazine*, vol.108, no.761, Aug. 1966, pp.425–6, repr. p.424, pl.57; George Heard Hamilton, *Painting and Sculpture in Europe 1880–1940*, Harmondsworth 1967, p.236, pl.141; 6th ed. 1993, pp.361–3, repr. p.362, pl.218; Charles Harrison, *English Art and Modernism 1900–1939*, London and Bloomington, Indiana, 1981, rev. ed. London and New Haven 1994, p.269, repr. p.270, fig.141; Jenkins 1982, p.10, repr. p.26; Alan G. Wilkinson, 'The 1930s: "Constructive Forms and Poetic Structure"' in *Retrospective* 1994–5, exh. cat., p.64; Alun R. Graves, 'Casts and Histories: Material Evidence and Hepworth's Sculptures' in Thistlewood 1996, p.179

Reproduced: Read 1952, pl.59 (as 1939)

In retrospect, Barbara Hepworth recalled the paradox of the difficult years 1938–9: 'Lacking money, space and time, I became obsessed by ideas for large works.'[1] She claimed that she had already made three works over ten feet high which were subsequently destroyed; the largest of these was, in fact, the six-feet-high *Monumental Stela* 1936 (fig.29). Nevertheless, through its size, *Forms in Echelon* falls between such pre-war aspirations to monumentality and her preoccupation with a place for her work in the landscape. This move was intimated when the sculpture was first reproduced superimposed on a photograph of a garden;[2] other works were shown collaged on photographs of terraces around an International style house in order to suggest a context distinct from the gallery. The idea may have been stimulated by the positioning of Henry Moore's *Recumbent Figure* 1938 (fig.33) on the terrace of the architect Serge Chermayeff's house.[3] For her part, Hepworth was reported to believe 'that all good sculpture was, and still is, designed for the open air', and her comment on *Forms in Echelon* (culled from an interview) concentrated on the effect: 'The sculpture has an upward growth but the curves of the two monoliths make a closed composition which, in the open, with light all round, they [sic] create a quietness, a pause in the progress of the eye.'[4] This desire to see *Forms in Echelon* outside was reaffirmed fifteen years later when it was positioned next to the Neolithic stones of Men-an-Tol for Dudley Shaw Ashton's 1953 film on the artist.[5]

What distinguishes *Forms in Echelon* from many of the contemporary works is the differentiation of organic forms which extended the variety found within the *Single Form* group of 1937–8 (no.12 q.v.). Both of the elements are slim in section and come to prow-like edges. The outside faces are curved, while those turned inwards are noticeably flat, perhaps retaining the sawn plane of the original block. Although the element with the cylindrical hole is higher and generally more massive, the 'upright growth' of each rises to a high point at the right (when seen from the side) creating an echoing – rather than a reflected – pair. A related form appeared poised on a cone in Hepworth's contemporary five-part *Project (Monument to the Spanish War)* 1938–9 (fig.8). The elements of *Forms in Echelon* appear to be responsive to each other, securing a sense of enclosure which went beyond the similar pairings in the stone *Two Forms (Two Figures)* 1935 and the white marble *Two Forms* 1937 (fig.30).[6] Because of this relationship, they cannot strictly be said to be in 'echelon', as they are not staggered in the way used for *Discs in Echelon* 1935 (no.10 q.v.); significantly, the work was first shown simply as *Two Forms (Tulip Wood)*.

The carving admirably displays the richly coloured tulip wood. There are paler flashes in the edges to the rear, and the grain is especially rhythmical in the flat faces. However, the highly polished surfaces show many minor indentations sustained during handling. The slenderness of the blocks may have helped to minimise splitting, although it has occurred in the hole of the larger element (relating to the knot below) and in the top (relating to burring in the wood). A long split from the top of the smaller element was

filled before the work left the artist's possession. In her official photograph,[7] the two elements appear to be shown on a plinth, suggesting that they were free-standing and their relationship was adjustable. The present base may date from the early 1960s, when a similar base was made for *Image II* 1960 (no.51 q.v.). It consists of three horizontal layers of wood, the middle one of which is set at right angles in an effort to prevent warping. Unfortunately, this precaution was counteracted by metal bands screwed underneath which restricted the wood's movement and resulted in buckling; the end strips have since been slotted to allow movement as the wood expands and contracts.

Forms in Echelon was one of two Hepworths included in *Abstract and Concrete Art* at Peggy Guggenheim's gallery in 1939; the catalogue of the exhibition was published in the *London Bulletin*.[8] The threat of war saw the closure of the gallery in June (to be replaced by unfulfilled plans for a Museum of Modern Art under the directorship of Herbert Read) and the relocation of Hepworth and Nicholson to St Ives, where they stayed with Adrian Stokes for the latter part of the year. A sketch of *Forms in Echelon* features on a sheet of drawings of sculptures made around this time seemingly as a record of their distribution for safe keeping.[9] It was listed under Stokes, with the annotation '100' (?guineas), suggesting that it was in St Ives; it was certainly available for Hepworth's wartime exhibitions. As several of her other large-scale sculptures were destroyed in the war, *Forms in Echelon* served as an important example of her scope and ambition. This was implicitly acknowledged by Hepworth herself, as she chose to feature it in the series of retrospectives preceding its donation to the Tate in 1964.

fig.33
Henry Moore, *Recumbent Figure*, 1938, length 132.5 (52¼), green Hornton stone, Tate Gallery, photographed on original site at Serge Chermayeff's house

14 Sculpture with Colour (Deep Blue and Red) 1940

T03133 BH 117.2

Painted plaster and string 8.7 × 10 × 9.8 (3⅝ × 3¹⁵⁄₁₆ × 3⅞)
on plaster base 1.4 × 15.1 × 10.5 (5½ × 6¹⁵⁄₁₆ × 4⅛);
weight 0.670 kg

Inscribed on underside ?by another hand in pencil
'Bucha[…]', in black crayon an arrow pointing to the right
and stamped '99/11'

*Presented by the executors of the artist's estate, in
accordance with her wishes, 1980*

*Displayed in the artist's studio, Barbara Hepworth Museum,
St Ives*

Provenance: Purchased from the artist by Mary Buchanan
1941, from whom purchased by Wilhelmina Barns-Graham,
c.1949, by whom sold to an unknown London art dealer
1959; …; ?Galerie Charles Lienhard, Zurich; …; Peter
Gimpel, from whom acquired by the artist at an unknown
date

Exhibited: *Retrospective* 1994–5 (30, repr. in col. p.67)

Literature: Gibson 1946, p.9, pl.42; Hodin 1961, p.165, no.117,
version 2, repr.; Jenkins 1982, p.12, repr. p.28 (col.); *Tate
Gallery Acquisitions 1980–2*, 1984, p.113, repr.; Alan G.
Wilkinson, 'The 1930s: "Constructive Forms and Poetic
Structure"' in *Retrospective* 1994–5, exh. cat., pp.67–8;
Festing 1995, pp.150,167, repr. between pp.104 and 105, pl.34;
Martin Hammer and Christina Lodder, 'Hepworth and Gabo:
A Creative Dialogue' in Thistlewood 1996, pp.117, 122–3, repr.
p.118; Emma E. Roberts, 'Barbara Hepworth Speculatively
Perceived within an International Context', ibid., p.193; Curtis
1998, p.36, repr. fig.36 (col.)

Reproduced: Read 1952, pl.61a; *Pictorial Autobiography*
1970/1978, p.42, pl.112

The main form of *Sculpture with Colour (Deep Blue and Red)* is carved from solid plaster and made up of two conoids joined together with an irregular section of approximately half of the upper conoid removed. Much of the internal space of one half of the form is hollowed out, but only a shallow section of the other. The inner surface is painted ultramarine while the outside has a thin coat of white paint. The need to paint the white plaster and extensive repairs along the edges indicate the vulnerability of the material. The opening of the work is crossed by strings which, in 1980, were described by Tate Gallery conservators as originally orange discoloured to brown.[1] They are embedded in individual holes on one rim and converge on a single hole inside the other; a small plug blocking the latter is evident on the outer surface. The main form is attached to its plaster base by means of a screw and the whole is attached to a plywood board. In two albums of photographs compiled by the artist in 1940 as a record of her work, the sculpture was illustrated without a base.[2]

Sculpture with Colour (Deep Blue and Red) is listed in Alan Bowness's catalogue of Hepworth's oeuvre as the second of six progressively larger versions of the same work.[3] Of these, the first five (all numbered BH 117) are of plaster and are described as 'original maquettes' for the sixth, which was carved from wood (BH 118). This idea of the series as a progression towards the final, largest sculpture is reinforced by their listing in order of size: their heights are given as 4, 5, 6, 9, 14 and 18 inches, respectively. In 1952, the artist described the plasters as maquettes for a 'sculpture with colour' which she was not able to carve until 1943.[4] The first monograph on Hepworth – written in 1943 though published in 1946 – and the catalogues of her exhibitions at Temple Newsam, Leeds, in 1943 and at Wakefield and Halifax in 1944 all list the two largest plaster versions: the first belonging to Peter Watson and the second from Helen Sutherland's collection.[5] As both the book and the exhibitions were prepared in close consultation with the artist, this may suggest that she then saw the two larger plasters as complete works in themselves and only the three smallest versions as maquettes. This is borne out by the fact that the smaller ones are closer to each other in scale than previously thought: when it was sold in 1980, the height of the third version was given as 5½ inches, the same as that in the Tate.[6]

On 7 May 1940 Hepworth, presumably referring to version 1 of *Sculpture with Colour (Deep Blue and Red)*, wrote to E.H. Ramsden that she had just 'achieved a good new sculpture'.[7] Bowness dates the first three versions to 1940, the fourth to 1941 and the fifth to 1942. A note appended to the entry for the wooden version in her 1943 and 1944 catalogues also dates the fourth and fifth to 1941 and 1942, respectively, but Gibson gives both as 1941;[8] in fact the fourth was initialled by the artist and dated '1940'. Hepworth's later statement, and associated sketch, in a letter to Ramsden dated 4 April 1943 that she had 'carved a larger version in wood (painted) of sculpture with blue & red' allows us to date the wooden version fairly accurately.[9] That she dated it 1941–3 in her

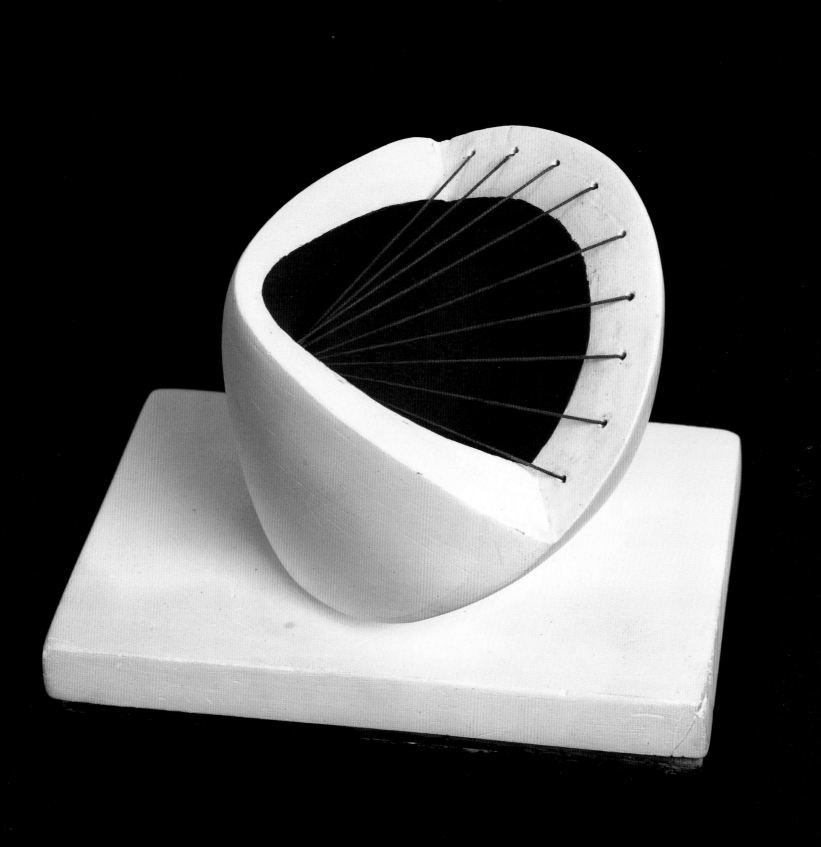

1946 Lefevre Gallery catalogue seems to demonstrate that by then she saw the series as a continuous project.

Sculpture with Colour (Deep Blue and Red) was made at Dunluce, the house in Carbis Bay, near St Ives, to which Hepworth and Nicholson had moved on 27 December 1939. Prior to that, since their evacuation from London in late August 1939, they had been staying nearby with Adrian Stokes and Margaret Mellis. The relative scarcity and small scale of Hepworth's work between 1939 and 1943 has been seen as the result of the restrictions placed upon her by domestic responsibilities, the lack of a proper studio and a shortage of materials. Certainly, Hepworth implied that her choice of plaster may have reflected that situation when she wrote to Ramsden, in connection with *Sculpture with Colour*, 'Material is almost impossible to get hold of – maybe that in itself will produce new ideas and vitality'.[10] Of the first two years of the war she would later recall: 'I was not able to carve at all; the only sculptures I carried out were some small plaster maquettes for the second "plaster with colour", and it was not until 1943, when we moved to another house, that I was able to carve this idea.'[11]

Hepworth began work soon after she arrived in Cornwall, but it is apparent from her contemporary correspondence and later reminiscences that she was largely frustrated in the attempt. It is interesting, therefore, that she chose to make several, almost identical versions of a single piece. The production of small-scale multiple editions of one work was a characteristic of Nicholson's practice in the early 1940s, as demonstrated, for example, by nine versions of *1940–42 (two forms)*.[12] In his case it may be seen, like his reversion to landscape motifs, as an attempt to produce more saleable work at a time when the art market had all but collapsed and the family's financial situation was especially precarious. It is clear that the paintings Hepworth made during the war also sold relatively easily and it may be that her production of multiple small sculptures was similarly aimed at ensuring sales. The reproducibility of the work of art was also central to the ideology of Naum Gabo who, after following Hepworth and Nicholson to Cornwall, worked in close proximity to Hepworth from 1939 to 1946. For him, the making of numerous versions of a single piece reflected art's adoption of industrial practices. This belief was intimately linked to his Constructive working processes which contrasted with Hepworth's retention of the more individualistic practice of carving.

Despite the association of this series of works with wartime conditions, Hepworth had already made at least two sculptures in plaster. Though now painted, *Single Form* 1937–8 (BH 104) – later cast as *Single Form (Eikon)* (no.12 q.v.) – may have been shown in Paris in 1938 as a pure white form. The following year, she would recall in 1952, she 'did the maquette for the first sculpture with colour, and when I took the children to Cornwall five days before war was declared I took the maquette with me, also my hammer and a minimum of stone carving tools.'[13] This maquette, listed by Bowness as *Sculpture with Colour, White, Blue and Red Strings* (BH 113), was reproduced in the 1952 monograph as *Sculpture with Colour (Blue and Red)*.[14] Though Bowness associated it with BH 117 and 118, it actually provided the basis for *Sculpture with Colour (Oval Form) Pale Blue and Red* 1943 (fig.34). It was for this reason that Hepworth described the sculpture for which the Tate's work was a maquette as 'the second "*Sculpture with Colour*"'.[15] The first is formally different, being more elongated in shape, including black and red strings and a pale blue interior which anticipated later works such as *Pelagos* 1946 (no.20 q.v.).

The sculptures with colour embody two significant departures in Hepworth's work: her use of colour and the inclusion of strings. The latter must be compared to Henry Moore's strung works – in particular his *Stringed Relief* 1937 and *Bird Basket* 1939,[16] which also incorporated red string – and, more pertinently, to Gabo's employment of nylon thread. *Linear Construction in Space No.1* (fig.35) was the first work in which Gabo used thread rather than incised lines. Though the earliest version of this work has

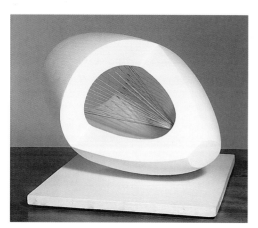

fig.34
Sculpture with Colour (Oval Form) Pale Blue and Red, 1943, height 40.6 (16), painted wood with strings, BH 113, private collection

often been dated 1938, Gabo's cataloguers have argued that it was more probably made in 1942, post-dating Hepworth's sculptures with colour. They also report Miriam Gabo as claiming that the first model for the piece was three or four inches long and made with red thread, making it especially comparable to the small Hepworth plaster maquettes. However, they note that there is no further evidence for such a work and do not include it in their catalogue.[17]

A.M. Hammacher related Hepworth's use of strings to her interest in mathematical models and stated, presumably drawing upon the artist's own testimony, that she had studied them 'in Paris and London in her youth but let the idea lie dormant until she could use it emotionally, not mathematically'.[18] Martin Hammer and Christina Lodder, discussing *Sculpture with Colour (Deep Blue and Red)* in relation to Gabo's use of such models, have compared it specifically to a 'Spindle cyclide'.[19] Hepworth and Gabo's interest in mathematical models was shared with many artists during the 1930s. Their use of them for artistic purposes reflected a desire for a modernist synthesis of science and art, as most notably reflected in the heterogeneous contents of *Circle*, edited by Gabo, Nicholson and Leslie Martin in 1937. For Hepworth in the 1940s this interest in science became increasingly coupled with a belief in the importance of organic forms in art.

While she incorporated colour into many of her sculptures after 1939, the use of the strong hues seen in *Sculpture with Colour (Deep Blue and Red)* is unusual. It is in sharp contrast to the predominance of white in her work in the second half of the 1930s and echoed Nicholson's move away from white reliefs towards coloured paintings and reliefs in the same period. In this, both artists reveal their debt to Mondrian, whom they had met in the early 1930s and who was a close neighbour in Hampstead between September 1938 and their departure the following August, when they had tried to pursuade him to accompany them to Cornwall. Hepworth's incorporation of colour may also be related to the proximity of Adrian Stokes, whose *Colour and Form* had been published in 1937. The book was concerned specifically with colour in painting but employed imagery from sculptural theory: 'Colour', wrote Stokes, 'is the ideal medium for the carving conception'.[20] Significantly, he went on to assert that colour related to the inside of the form and so may be seen as its vital character: 'Carving colour gives the interior life, the warmth, to composition … the simultaneous life of the blood'.[21] Colour was certainly used by Hepworth to emphasise the contrast between the exterior and interior surfaces of a work and, in a later interview, she associated it with medieval sculpture. She recalled the unearthing of an Anglo-Norman capital by wartime bombing: 'I was able to see how the cavities of the reliefs had once been coloured with a bright terracotta red, and this was exactly the kind of effect that I too had been seeking from 1938 onwards, in some of my own works'.[22] The sculptures with colour represent the first appearance of the opening-up of the forms which would become such a characteristic of her work from the 1940s onwards.

Hammacher associated Hepworth's use of colour and strings with her growing consciousness of the landscape, quoting from her retrospective statement: 'The colour in the concavities plunged me into the depth of water, caves, of shadows deeper than the carved concavities themselves. The strings were the tension I felt between myself and the sea, the wind or the hills'.[23] This statement would be echoed by John Wells in discussing his *Relief Construction* 1940 (fig.40), which sprung from his relationship with Hepworth, Nicholson and Gabo during the war.[24] Hepworth certainly imagined *Sculpture with Colour* on a large enough scale to be sited in the landscape. On completing the wooden version in 1943, she told Ramsden that she 'should love to make it larger against the sea and sky as we have it here'.[25] Her album of work, compiled c.1960, includes a photograph of the wooden version superimposed on a blue sky with clouds.[26] Nevertheless, her production of the first maquette for a sculpture with colour in London would seem to dissociate the idea from her relocation to Cornwall. Writing in 1950 or 1951, the artist listed *Sculpture with Colour* along with two other works related to

fig.35
Naum Gabo, *Linear Construction in Space No.1*, 1938/42, height 30.4 (12), perspex with nylon thread, Kettle's Yard, Cambridge

her environment – *Wave* and *Pelagos* (no.20 q.v.) – as one of the only three of her works which were not anthropomorphic. But then, she added, 'this was an_eye, a God's eye if you like'.[27]

This version of *Sculpture with Colour (Deep Blue and Red)* was sold to Mary Buchanan, a friend of the artist and wife of the St Ives novelist George Buchanan, in the autumn of 1941. Hepworth wrote to Nicholson on 11 October, 'Mary Buchanan sent me a cheque and asked for model quickly'.[28] At the end of the decade the artist Wilhelmina Barns-Graham, also a friend of Hepworth's, acquired it from Mrs Buchanan along with a small version of Gabo's *Spiral Theme* (fig.36).[29] The similarity between the different versions has caused some confusion over the provenance of this work. Barns-Graham recalls selling it to a London art dealer and believes she later saw it at Gimpel Fils. Annotations in Hepworth's records suggest that it was at one time at the Galerie Charles Lienhard, Zurich, which had a co-operative relationship with Gimpel Fils, and that it was in the collection of Peter Gimpel by 1968.[30] Of the other versions, number 1 was given by Ben Nicholson to their daughter Sarah and damaged when a bronze cast was made of it in 1964. The third was given by the artist to the architects Maxwell Fry and Jane Drew, who sold it at Sotheby's on 24 March 1980 (lot 259); the fourth, originally purchased by Peter Watson, was later acquired by Nicholson and passed on to their other daughter, Rachel; the fifth was bequeathed by Helen Sutherland to Nicolete Gray. The wooden version was given to the Carnegie Institute and sold by them in 1980; it, too, is now in the Hepworth family collection. In 1968 a bronze cast was made of this work in an edition of nine and exhibited at Gimpel Fils in October 1972.[31]

15 Drawing for 'Sculpture with Colour' (Forms with Colour) 1941

T07010

Gouache, oil and pencil on paper 21.7 × 39.2 (8½ × 15⅜)

Inscribed in pencil 'Barbara Hepworth 1941' b.r.
Inscribed on back of mount in pencil 'Drawing for
"Sculpture with Colour" | Barbara Hepworth 1941'; inscribed
on backing board in another hand 'To be returned to |
JOHN SUMMERSON | 38 Eton Rise | Haverstock Hill |
London NW3'

Accepted by the Commissioners of the Inland Revenue in
lieu of tax and allocated 1995

Provenance: Purchased from the artist by Sir John
Summerson by 1943

Exhibited: Leeds 1943 (107, as *Forms with Colour*)

Forms with Colour is one of a considerable number of two-dimensional abstract works made by Barbara Hepworth during World War Two. Though often referred to as drawings, these may be described more accurately as paintings. In 1946, Hepworth distinguished them from her working sketches, which she characterised as 'scribble[d] sections of form or lines on bits of scrap paper or cigarette boxes': 'I do spend whole periods of time entirely in drawing (or painting, as I use colour) when I search for forms and rhythms and curvatures for my own satisfaction. These drawings I call "drawings for sculpture"; but it is in a general sense – that is – out of the drawings springs a general influence.'[1] A manuscript list in the possession of Gimpel Fils and apparently copied from the artist's own records shows that the title 'Drawing for "Sculpture with Colour"' was assigned to several similar paintings. For this reason the Tate Gallery and Hepworth's executor, Sir Alan Bowness, have sought to distinguish this work by adding the title under which it was originally exhibited.

Past commentators have shown scant interest in Hepworth's wartime paintings and, after 1950, the artist herself marginalised them in her retrospectives. However, during the 1940s they appeared to be important to her: in 1941 she told Ben Nicholson she was 'thinking of having a show of drawings in Leeds, Oxford and London', and of the sixty-one works in her 1943 retrospective at Temple Newsam, Leeds, thirty were paintings.[2] They were clearly successful as the artist reported in October 1941 that she had sold '12 in as many weeks'.[3] In the early 1940s, Hepworth and Nicholson were forced to find new ways of earning more money. It was for this reason that he began to paint landscapes and to produce small-scale versions of abstract paintings and it may be that Hepworth's prolific production of her paintings was also partly stimulated by their relative saleability. Many of her close friends, most of whom visited her in Carbis Bay during the war, bought them, including Margaret Gardiner, C.S. Reddihough, Alastair Morton, John Wells, Tim Bennett, E.H. Ramsden and Margot Eates, Leslie Martin and her parents. Her sister Elizabeth and her husband, the architectural historian John Summerson, bought *Forms with Colour*.

In the first years of the war restrictions on Hepworth's time, materials and studio space meant, she later recalled, that she 'could only draw at night and make a few plaster maquettes'.[4] Apart from the different versions of *Sculpture with Colour (Deep Blue and Red)* (no.14 q.v.), the only works she produced at that time appear to be the paintings such as *Forms with Colour*, which, she told Alastair Morton, she found 'so quick and easy!!! technically I mean'.[5] She saw these as substitutes for sculptures: 'If I didn't have to cook, wash-up, nurse children ad infinitum', she wrote to a friend, 'I should carve carve carve. The proof of this is in the drawings. They are not just a way of amusing myself nor are they experimental probings – they are my sculptures born in the disguise of two dimensions.'[6]

Despite her insistence on the pictures' independence, some of them were linked to particular sculptures in the first book on Hepworth's work. Specifically, Gibson

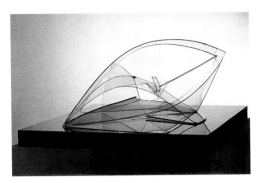

fig.36
Naum Gabo, *Spiral Theme*, 1941, height 35 (14), plastic,
Tate Gallery

described one work, *Oval Form* 1942,[7] as 'one of three drawings from which she evolved the *Sculpture in Beechwood* of 1943' – the work now known as *Oval Sculpture* (no.16 q.v.).[8] In the same year, the artist admitted that occasionally some drawings could be related to a particular sculpture but, she added, 'I like to think of the drawings as a form of exploration and not as a two-dimensional representation of a particular three-dimensional object. They are abstract in essence – relating to colour and form but existing in their own right.'[9] They were, she would write later, her 'own way of exploring the particular tensions and relationships of form and colour which were to occupy [her] during the later years of the war'.[10]

The physical qualities of *Forms with Colour* reflect the conditions in which it was made. It is painted on a poor-quality support, described by conservators as a very fibrous thin laminate board, which is laid on a thicker board. Both gouache and an oil-based paint – most probably for household use – were applied and have crackled badly where one has been laid over the other. On acquisition by the Tate Gallery, a number of loose fragments of paint had to be consolidated.[11] The primary support had been securely stuck to the secondary board with household paint before the artist signed it; an X-Ray was taken as the work was considered too vulnerable to be parted from the board. Though there was no sign of an inscription on the reverse, numerous additional compositional lines were revealed. These were not visible in a photograph of the painting taken under raking light, so it may be assumed that they are on the reverse and relate to a similar design. The impenetrability to X-Ray of the small green area indicates that it is a colour rich in heavy metal, such as viridian.[12] Hepworth's choice of colours was dictated to some extent by chance and their availability. In a letter to Nicholson, then in London, speculatively dated 13 October 1941, she asked him to bring her '2 peculiar colours … perhaps a queer green?'[13]

These wartime pictures are characterised by forms made up of a pattern of intersecting straight and curved lines drawn on a ground of pale pigments with an area of strong colour. Traces of erased lines in *Forms with Colour* suggest that the design was not planned beforehand. Some of the works consist of a single linear form, while others, like *Forms with Colour*, contain two, three, or on occasion four such forms located within discrete rectangular compartments. As in this work, there is often one larger and other subordinate forms; in a few some of the compartments are empty. The use in the main form of intersecting straight lines to produce a parabolic curve creates a sense of three-dimensional space and the different tones of grey give the illusion of successive planar layers. In this way they invoke comparison with sculpture, specifically, the strung works of Naum Gabo, such as *Linear Construction in Space No.1* (fig.34), versions of which were produced at this time.[14] One may also draw comparisons between Hepworth's use of strong colour to provide a focal centre for the linear structure and the central elements of Gabo's *Spiral Theme* (fig.36) – first made in Cornwall in 1941 – and his *Construction in Space with Crystalline Centre*, made between 1938 and 1940 and photographed against St Ives Bay by Hepworth in 1942.[15]

While *Forms with Colour* cannot be related to a specific sculpture, one can see parallels in Gabo's *Spiral Theme* construction, which had a considerable impact soon after it was first made in 1941. Herbert Read wrote, for instance, that it represented, 'the highest point ever reached by the aesthetic intuition of man'.[16] The lower section of Gabo's construction is a slightly arched transparent plastic plate, the plan of which is approximately three quarters of a circle. It is incised with radiating lines and above it arc curves around a central straight line. *Forms with Colour* and Hepworth's later *Forms in Movement* both display allusions to a structure similar to the Gabo.[17] All three works are based on the circle, contain striations and use an arc along a straight line as a space-creating device.

The paintings made by Hepworth in the 1940s may be divided into different categories. In one type, which started earlier, the forms are angular and have the

fig.37
Drawing for Sculpture, 1941, 24.1 × 35.5 (9½× 14), gouache
and pencil on paper, private collection

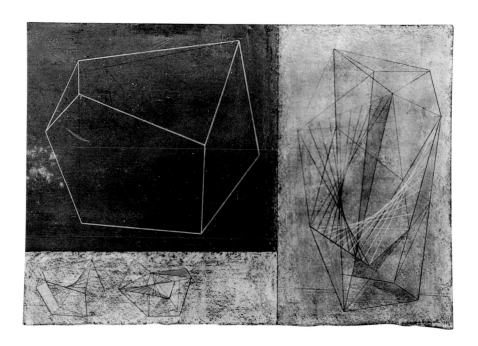

appearance of multi-faced solids, like crystals. *Drawing for Sculpture* 1941 (fig.37) is
typical of these in the use of straight lines to create the suggestion of space and planes.
Several, such as *Red in Tension* 1941, also include a small area of strong colour.[18] The
lines in a second type are more curvilinear, appearing to relate to spheres and ovoids
rather than polyhedral forms. *Forms with Colour* appears to be one of the earliest of
these. From those paintings available in reproduction, it seems that Hepworth did not
stop making drawings of one sort to begin another, as polyhedral works post-date
circular ones. On the whole, however, the forms became more generally oval. From 1943
to 1945, she was more able to carve and so made fewer paintings, though a
considerable number date from 1946. Three-sided curvilinear forms feature among
these later pictures – seen, for example, in *Drawing for Stone Sculpture* 1946 – and
associate them with the work of a number of artists in Cornwall after the war, such as
Peter Lanyon and John Wells.[19] Several of the post-war pictures also include longer
forms of more than one section that were related to landscape, most obviously
Landscape 1946.[20]

The main motif of *Forms with Colour* is based upon the linear relationship between
two partially overlapping circles, which creates the illusion of a three-dimensional
object. Although not literal, it seems likely that the two subsidiary forms are this same
imagined solid as if seen from different positions, with the coloured area changing hue
from each point. A number of Hepworth's other subdivided drawings can be seen to
include different views of a single form. A precedent, published in *Axis* in 1936, appears
to be an abstract composition influenced by Ben Nicholson; however, this was actually
Hepworth's sculpture *Two Forms* 1935 seen from the front, side and above.[21] Similarly,
Drawing for Sculpture 1941 seems to consist of a number of views of the irregular
polyhedron which Hepworth used in *Two Forms* 1934–5 (fig.78) and would later reuse
as the magic forms in *Conversation with Magic Stones* 1973 (no.75 q.v.).

The wartime paintings are amongst Hepworth's most purely abstract works. A clue
to her intention may be offered by her contemporaneous praise of Herbert Read's
poetry, which she admired 'largely because of the extreme purity of his forms – the total
absence of the spectacular'.[22] The paintings coincide with an important point in the
history of constructivism in Britain and, specifically, in Hepworth's attitude to it. Despite
the widely accepted idea of a neo-romantic domination of British culture during the
1940s,[23] the war saw a renewed effort by Nicholson and Hepworth to promote abstract
art and associated ideas. This was seen in Nicholson's uncompromising 'Notes on

Abstract Art' of 1941 and several exhibitions, most particularly the London Museum's *New Movements in Art* 1942, in which Hepworth exhibited a version of *Sculpture with Colour (Deep Blue and Red)* and three 'drawings for sculpture with colour'.[24] Plans were made for a second edition of *Circle* and for a book on constructivism, while British constructivist work was shown in various exhibitions and appeared in a number of periodicals, including the American *Partisan Review*.[25] Reviewing the London Museum exhibition, Read was able to assert, 'as far as constructivism is concerned … the column is advancing'.[26]

It was not only in the field of the visual arts that the group to which Nicholson and Hepworth belonged was exercising an important influence. The ideas which had informed *Circle* in 1937 were developed by artists, critics, sociologists, economists and, most especially, scientists in the series 'This Changing World' in *World Review*, edited by J.R.M. Brumwell with advice from Nicholson. This was an important forum for the theorising of the post-war planning and reconstruction for which Edward Hulton, proprietor of *World Review*, was a leading campaigner. Within those debates, modernists like Hepworth and Nicholson were able to revive the optimism of the 1930s which had been lost in the first two years of the war. Her correspondence with Herbert Read and E.H. Ramsden shows that Hepworth, especially, saw in the popular calls for widespread social change the potential realisation of the society for which they had hoped. These wartime works may be seen in terms of this constructivist resurgence and the attempt to protect modernist values until the end of the war. Hepworth would later explain how her continued abstraction related to social aims: 'I do not think these abstract forms were escapism; I see it as a consolidation of faith in living values, and a completely logical way of expressing the instrinsic "will to life" as opposed to the extrinsic disaster of the world war.'[27]

Despite this rallying of the constructivists, these works come from a period when Hepworth sought to distance herself from constructivism as a movement, preferring the more general epithet 'Constructive'. In January 1940 Nicholson told Read of 'Barbara's desire to be disassociated from "russian Constructivism" [sic], and from all "isms"'. [28] Three years later he reiterated the point: 'Barbara & I are both v keen now to be disassociated from Constructivism. Constructive is a different matter not a label but covering all the things one likes in all art past & present.'[29] For Hepworth, the term 'Constructive' appears to have meant both a formal element in the work of earlier artists she admired – such as Masaccio, Raphael or Mondrian, for example – and a more abstract quality. She used it to indicate a positive force for good and as an equivalent to Nicholson's preferred term for a successful work of art, 'alive'. It was in this more general sense that she saw abstract art as a positive contribution towards social reconstruction. Increasingly, these ideas would become, for her, associated with the organic processes of nature and the landscape. An organic reading was placed upon these paintings when she gave a number titles such as *Crystal* or *Stone and Flower*. This was in response to a commission for a few drawings to illustrate Kathleen Raine's volume of poetry *Stone and Flower: Poems 1935–43*.[30] Hepworth indicated to Herbert Read that the works had been made in response to the poems and that this had been an established practice. She wrote that a drawing which belonged to him – most probably *Forms in Red: Drawing for Sculpture with Colour* 1941 – was 'very much a part of my reading of Rilke's First Elegy'.[31]

16A Oval Sculpture (No.2) 1943, cast 1958

T00953 BH 121.2 (illus. opposite)

Plaster 29.3 × 40 × 25.5 (11½ × 15¾ × 10¹/₁₆)
on veneered wooden base 3.5 × 32.7 × 30 (1⅜ × 11¾ × 11⅞);
weight 14.4 kg

Presented by the artist 1967

16B Oval Sculpture (No.2) 1943, cast 1958

L00943 BH 121.2 (illus. p.86)

Plaster 29.3 × 40 × 25.5 (11½ × 15¾ × 10¹/₁₆)
on solid oak base 3.5 × 32.7 × 30 (1⅜ × 11¾ × 11⅞)

*On loan from the Trustees of the artist's estate to the
Barbara Hepworth Museum, St Ives*

*Displayed in the artist's studio, Barbara Hepworth Museum,
St Ives*

Exhibited: *Retrospective* 1994–5 (32, repr. in col. p.72,
Tate Gallery's version)

Literature: Patrick Heron, 'Introduction', Wakefield, York &
Manchester 1951, exh. cat., pp.4–5; E.H. Ramsden, *Sculpture:
Theme and Variation*, 1953, p.42; Hodin 1961, p.165, no.121;
Tate Gallery Report 1967–8, 1968, p.62; Jenkins 1982, p.10,
repr. p.26; Alan G. Wilkinson, 'Cornwall and the Sculpture of
Landscape: 1939–1975', *Retrospective* 1994–5, exh. cat.,
pp.81–2

Following her first original bronzes two years previously, in 1958 Hepworth elected to make casts of selected earlier carvings as a means of increasing her output and, presumably, of further disseminating her work. She chose the first work to be cast – her 1943 *Oval Sculpture* in planewood with painted interior (fig.38), which belonged to her friend Margaret Gardiner – because it had begun to split and she was anxious to preserve it. Brian Wall, an assistant of Hepworth's at that time, has recalled her borrowing the sculpture from Gardiner and bringing the renowned plaster caster 'Mac' Mancini from the Mancini-Tozer foundry in Wimbledon to St Ives for the purpose. Mancini, according to Wall, was horrified when he saw the complexity of the piece to be cast and insisted it would be too difficult. Nevertheless, he made a cast of it – along with a number of other carvings – in Hepworth's Trewyn Studio using a forty-piece mould.[1] Two plaster casts were made: one belongs to the Tate Gallery and the other remains in the artist's estate and is on display in the Barbara Hepworth Museum, St Ives. A polished bronze version was cast in the following year at the Susse Frères foundry in Paris and issued in an edition of four as *Oval Sculpture (No.3)*.[2]

The Tate's plaster is in sound condition, though there is considerable evidence of its vulnerability to dirt and mechanical damage. Areas of the surface have been painted with an off-white, semi-gloss paint and there are numerous abrasions and chips, particularly along the edges of the holes. Two chips near the smallest opening have been repaired with a grey filler. Tool marks – specifically of file and riffler – are visible on the inner surfaces. The version in the estate was not painted and small rust spots, which probably result from the oxidation of flecks of iron in the plaster, reveal the effect of the damp sea air. In both versions, the plaster is highly polished giving it a bone-like sheen. Lines marking the divisions of the sections of mould are visible at various places on the sculpture. Testing with a magnet suggests that there is no armature and it is likely that the plasters are solid.[3]

Apparently 'evolved' from three abstract drawings of 1942,[4] the wooden original of *Oval Sculpture* was among the first works carved by Hepworth after her move to Chy-an-Kerris, a large house overlooking the sea at Carbis Bay, in July 1942. There she and Nicholson had enough space for them both to have studios. In September 1943 she asked Nicholson, then in London, to call a timber merchant as she had 'a permit for English hardwood', but soon afterwards lamented: 'the outlook for my wood looks bad. I can get the wood but seasoned wood is extinct. Newly felled timber will split like hell'.[5] Despite these hindrances, 1943 was important for her as she was invited at the beginning of the year to show with Paul Nash in an exhibition at Temple Newsam, Leeds, from April to June. However, the only wartime sculpture she showed was the wooden version of *Sculpture with Colour (Deep Blue and Red)* (no.14 q.v.), which suggests that no other carvings were ready for exhibition.

Oval Sculpture is, essentially, an ovoid, the outer surface of which is pierced in four places to open up the curving space of its interior. It demonstrates the increasing

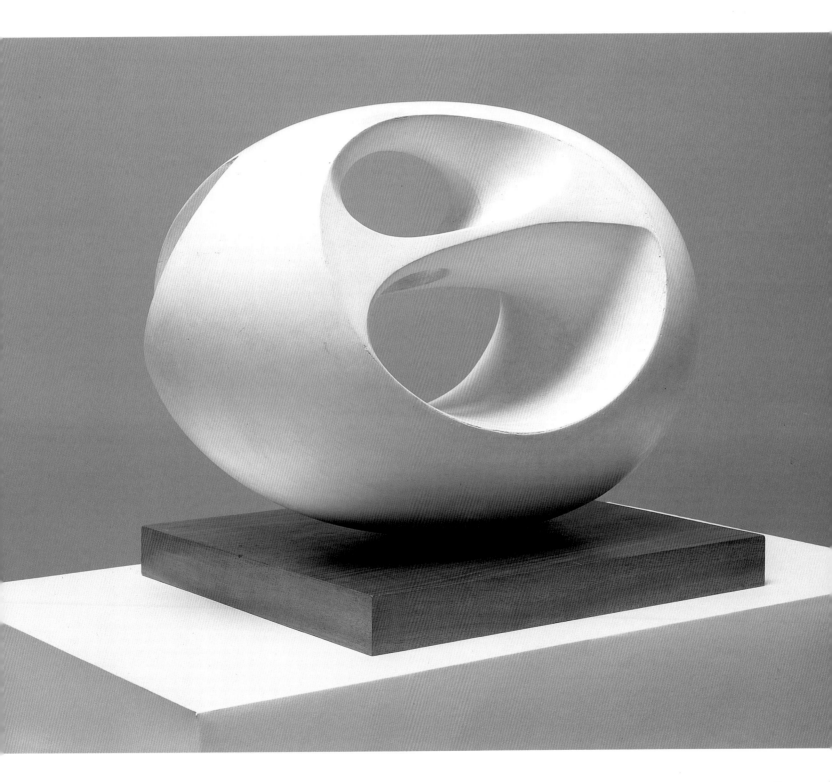

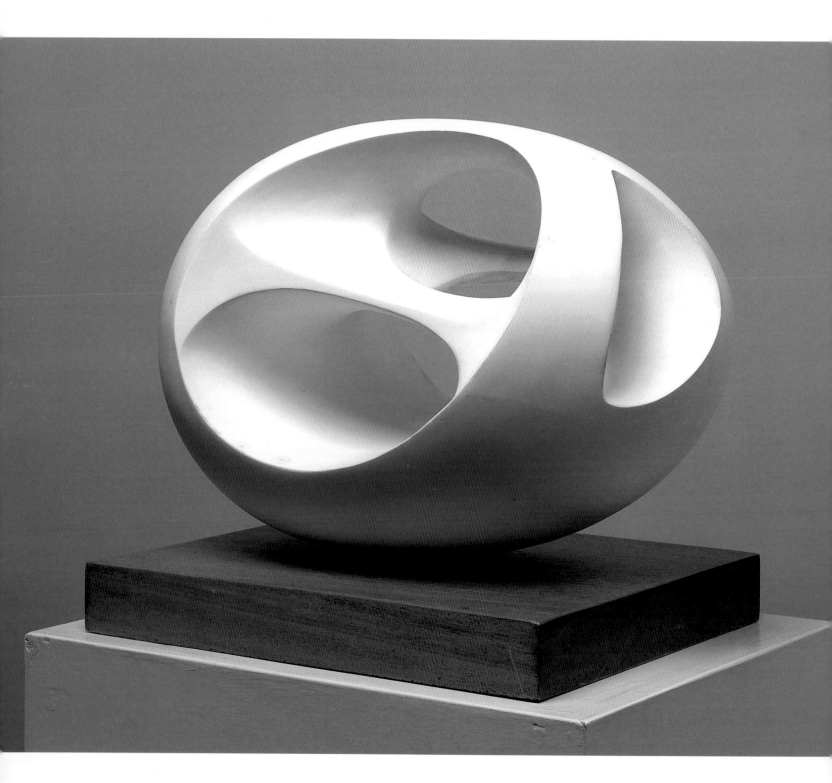

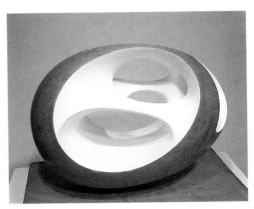

fig.38
Oval Sculpture, 1943, base length 42 (16½), painted wood, BH
121, The Pier Gallery Collection, Stromness

complexity of Hepworth's piercing of the block at that time. The sculpture epitomises a number of works of the mid-1940s which are ovoid in form by artists associated with St Ives. Naum Gabo, Peter Lanyon and John Wells all employed such forms and Sven Berlin has described how they were a cause of the considerable anxiety over mutual influence which culminated in a rift between Hepworth and Gabo.[6] In 1946 Hepworth told E.H. Ramsden that the row with Gabo had 'started 3 yrs ago when he accused me of stealing the OVAL! and since that time I havn't [sic] seen <u>any</u> of his work'.[7] The 'open curvilinear rhythms of Hepworth's *Oval Sculpture*' have been specifically related to Gabo's paintings of the 1940s,[8] though it might be argued that her interest in light and interior space had developed from her first piercing of the block in the early 1930s. Similarly, one might see a precedent for her use of the oval in the pre-war carving *Conicoid* 1939, which was exhibited the year before *Oval Sculpture* was made.[9] Subsequently, Hepworth produced a number of ovoid pieces, many of which were shown with *Oval Sculpture* in her exhibition at the Lefevre Gallery in October 1946. At that time she discussed her interest in such shapes: 'The carving and piercing of such a form', she wrote, 'seems to open up an infinite variety of continuous curves in the third dimension, changing in accordance with the contours of the original ovoid and with the degree of penetration of the material'.[10] Around the same time, in a letter repudiating her association with constructivism and, speculatively, the term 'Constructive', she told Ramsden, 'I could, for the rest of my life, take an egg form and in <u>different</u> materials carve an infinite number of sculptures all giving [a] different sort of "life"'.[11]

Hepworth identified the ovoid in earlier works also: 'The first carvings were simple realistic oval forms of the human head or of a bird', she wrote.[12] Her insistence on the relationship between figurative motifs and abstract shapes echoes Brancusi's use of the ovoid as an archetypal form derived, in part, from the human head. Hepworth had visited the Romanian sculptor's Paris studio in 1933 and it seems inconceivable that her use of the oval was not informed by his work. Specifically, *The Beginning of the World c.*1920 (fig.39), an egg-like carving in marble, had been in the collection of H.P. Roché, who had bought paintings by Nicholson in 1930. In a 1944 discussion of the work of Henry Moore, Herbert Read cited the egg – juxtaposed with the Brancusi – as an exemplar of the organic form. He contrasted the organic approach and constructivism as two opposing forms of sculpture. Quoting d'Arcy Thompson's theory of the determination of form by natural processes, Read wrote: 'The egg is not an arbitrary shape; it is determined, as we say, by physical laws.'[13]

While Alan Wilkinson's description of *Oval Sculpture* as one of Hepworth's first 'direct references to the landscape and seascape of Cornwall' may seem unlikely, the sculpture does signal the resurgence of a more generalised organicism as the central theme of her work.[14] In December 1946 Hepworth wrote to Ramsden that she was 'deeply impressed by your article on "Oval Sculpture"';[15] it is not clear to which article she referred, but Ramsden had published a piece on Hepworth in the September/October issue of *Polemic*. While not dealing with specific works, this short essay's proposition, pertinent to *Oval Sculpture*, is that a 'vital' work of art is grounded in Nature and is, 'evolved in accordance with laws analogous to those of Nature and owe their being to a like necessity'. 'Is it not', Ramsden wrote, 'by the interpenetrations of the material, the convergence and recession of the planes, the dissolving curves of the interior and exterior surfaces, the stringing and the inner tensions of the configured whole that a sense of the cosmic rhythm of life … is evoked'.[16]

That the oval might have had more specific, subconscious significance for the artist is suggested by a scheme of her iconography which she drew for Read in 1947. The drawing demonstrates the translation, through the medium of emotion and feeling, of what she describes as 'known symbols' to 'unknown symbols' and vice versa. On the left-hand side she listed 'figures hands eyes trees etc' as examples of known symbols, and on the other: 'curves, spirals ovoids – foetus errotic [sic], prenatal dream, childhood

– primitive etc?'[17] The conjunction of the ovoid form with themes relating to the foetus and childbirth indicates Hepworth's knowledge of psychoanalytic theory to which she was exposed through Read, whose *Education Through Art* drew heavily on Jung's writings,[18] and Adrian Stokes – a leading exponent of Melanie Klein. In Klein's theory the making of a work of art is seen as reparation for infantile attacks in fantasy on the mother's womb.[19] A work in the shape of an egg – the form and contents of the womb – may be seen to embody that desire for renewal in its organic completeness and its allusion to mechanisms of regeneration. Hepworth would acknowledge this reparative dimension in later years when she cited *Oval Sculpture* as an example of her making a work to resolve internal anxieties: 'There's an oval sculpture of 1943. I was in despair because my youngest daughter … had osteomyelitis … I thought the only thing I can do to help … is to make some beautiful object.'[20]

While such two-part sculptures as *Large and Small Form* 1945 may appear to address the theme of generation,[21] *Oval Sculpture*'s concern with it appears to be confirmed by Hepworth's deliberations over the titling of it and similar works. Before her 1946 exhibition, Ramsden provided her with Greek titles for some works. Of one piece, possibly the ovoid *Sculpture with Colour (Eos)* 1946,[22] Hepworth wrote that it had the 'feeling of Genesis … "the beginning" would be the right idea … "Origin" … "source" … "Eiréne"'. The subsequent discussion is accompanied by a sketch of *Oval Sculpture*: 'Is there a word for "evolution", she asked, 'I could cut out the spirit and call it "penetration" but that implies a physical act in some way & I don't like it. The form is evolving & the idea.'[23] None of these options were eventually adopted, and the use of a more generalised title stressed the formal aspect of the sculpture. In its employment of an archetypal organic form to express a natural, passive process of growth, *Oval Sculpture* may be seen to establish the tenor of Hepworth's work for the subsequent few years.

fig.39
Constantin Brancusi, *The Beginning of the World*, c.1920, height 17 (6¾), marble on polished metal disc, whereabouts unknown. Photograph by the artist

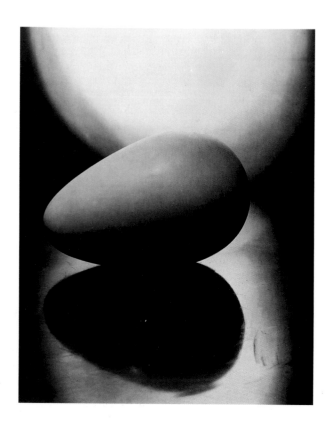

17 The Artist's Hand 1943–4, cast 1967

T03154 BH 434; cast 2/7

Bronze 5.8 × 18.6 × 9.2 (2⅜ × 7⁵⁄₁₆ × 3⅝) on a teak base 3 ×
22.4 × 12.2 (1³⁄₁₆ × 8¾ × 4¹³⁄₁₆)

Cast foundry mark 'CIRE P[ERDU] | Morris Singer |
FO[UNDRY] | LON[DON]' and cast inscription '2/7' on
end of wrist

*Presented by the executors of the artist's estate, in
accordance with her wishes, 1980*

*Displayed in the artist's studio, Barbara Hepworth Museum,
St Ives*

Exhibited: Marlborough 1979 (26†, repr. p.13, as *Barbara
Hepworth's Hand (1943–4)*, London only)

Literature: Bowness 1971, p.44, no.434; *Tate Gallery
Acquisitions 1980–2*, 1984, p.125, repr.; Robert and Nicholas
Robins, 'Hands and the Artist: Barbara Hepworth', *Journal of
Hand Surgery*, vol.13-B, no.1, Feb. 1988, p.104, repr.

Reproduced: *Pictorial Autobiography* 1970/1978, p.47, pl.133

The original plaster for *The Artist's Hand* was not included in Alan Bowness's 1961 catalogue of Hepworth's work; it was dated 1943–4 in his second volume in relation to the 1967 bronze cast.[1] Though it is now bolted to its base at the ball of the thumb and the tip of the middle finger, the sculpture has previously been reproduced in a vertical position and without a base.[2] Photographs in the artist's album show that the palm may also be viewed, giving the piece a more iconic status than its current, more incidental, recumbent setting.[3] A later sculpture of a hand – *Hand I (vertical)* 1949–50 – was also designed to be shown vertically.[4]

In making a sculpture of a hand, Hepworth followed the precedent of Rodin, whose late work includes numerous bronzes of a single or several hands at rest and in action. The hand was an established sculptural subject and it may be that the casting of *The Artist's Hand* was, in part, stimulated by the 1965 exhibition *La Main: Sculptures* at the Galerie Claude Bernard, Paris, to which Hepworth lent a cast of her *Hand II (horizontal)* 1949–50.[5]

That *Hand II* is her first known bronze since leaving the Royal College might be indicative of the fact that Hepworth saw the human hand as of great significance. For her it was, generally, an indicator of human vitality and, specifically, a symbol of the creative sensibility of the artist. Consequently, hands feature repeatedly in her work. The artist John Wells, recalling his time as Hepworth's assistant (summer 1949, 1950–1), has described how she worked incessantly, even making plaster casts of his hand in the evenings. It was, he said, 'part of her training'.[6] The plaster *Hand I (vertical)* and the bronze *Hand II (horizontal)* both date from that period. The former has not been reproduced and it appears that the latter was originally modelled in clay on the hand of surgeon Norman Capener, a friend of the artist. In summer 1950 Hepworth employed the sculptor Hubert Dalwood to cast a hand. This may have been the bronze *Hand* that she exhibited in the Institute of Contemporary Art's *1950: Aspects of British Art* in December that year. Reviewing the exhibition, David Sylvester wrote that she did 'nothing to enlarge our experience of reality' because her '*Hand* is so sensitive a fragment of observation of surface appearance that we lose sight of the fact that a hand is a strong and efficient piece of machinery'.[7]

In many of Hepworth's hospital drawings of 1947–9 special emphasis is laid on the figures' hands and eyes. In *Concentration of Hands No.1* 1948 and *Hands Operating* 1949 the hands are the principal, or only, focus of the composition.[8] The artist later described how she saw a delicate operation on a hand as an 'example of the difference between physical and spiritual animation' and how the contrast of 'the inanimate hand asleep and the active, conscious hand' made her 'look in a new light at human faces, hands when people are talking'.[9] One of her assistants reported that, *c.*1960, she made drawings with her right hand of a nodule being removed from the palm of her left hand under local anaesthetic.[10]

The concentration on eyes and hands echoes Hepworth's conception of sculpture as appealing to both visual and haptic senses. 'Our sense of touch', she said in relation to sculpture, 'is a fundamental sensibility … the ability to feel weight and form and assess its significance.'[11] The touch of a hand is implied in a number of works, for example *The Cosdon Head* 1949 (fig.52), in which a Giacometti-like incised hand introduces a sensual note. Around the time that she made the plaster cast of *The Artist's Hand*, Hepworth made *Hand Sculpture* 1944, a small abstract carving derived from the example of László Moholy-Nagy in *The New Vision*.[12] The production of a piece designed to be held reiterates the relationship between sculpture and touch.

The artists' hands were used as symbols of their creativity in the publication *Unit One*. David Lewis has described how Hepworth's dominated her outward appearance: 'I remember watching how she felt every surface, not with her fingers but with her palms.'[13] In the late 1950s and early 1960s, they were photographed a number of times by the portrait photographer Cornel Lucas, caressing sculptures and holding tools.[14] Hepworth also discussed her hands in relation to her work:

My left hand is my thinking hand. The right is only a motor hand. This holds the hammer. The left hand, the thinking hand, must be relaxed, sensitive. The rhythms of thought pass through the fingers and grip of this hand into the stone.

It is also a listening hand. It listens for basic weaknesses of flaws in the stone; for the possibility or imminence of fractures.[15]

The Artist's Hand was cast from her left hand.

Her hand is given an alternative significance by Margaret Gardiner, who has recounted how, before the war, Hepworth had been upset by a palmist who refused to read her palm: 'What horror had that woman imagined that she saw in her hand, what terrible fate? "If only she'd told me", said Barbara, "then I could have laughed it off. But now – why did she refuse".'[16]

18A Landscape Sculpture 1944

LOO944 BH 127

Broadleaf elm and strings 27 × 65.4 × 27 (10⅝ × 25¾ × 10⅝)
on veneered base 3.6 × 35.5 × 27.7 (1⅜ × 14 × 10¹¹⁄₁₆)

On loan from the artist's estate to the Barbara Hepworth Museum, St Ives

Displayed in the artist's studio, Barbara Hepworth Museum St Ives

Provenance: …; Mr & Mrs S. Kaye; …; Gimpel Fils and artist jointly; acquired in full by the artist 1972

Exhibited: Lefevre 1946 (13); Wakefield, York & Manchester 1951 (22); ?*Design and Sculpture by Consagra, Hoflehner, Mullen, Perez, Piper, Ramous and Hepworth*, MacRoberts and Tunnard, Feb.–March 1961 (12, as '*Landscape* 1944'); *Eröffnungs-Ausstellung*, Gimpel & Hanover Galerie, Zurich, Nov. 1962–Jan. 1963 (26, repr.); Zurich 1963–4 (3a); *Profile III: Englische Kunst der Gegenwart*, Städtische Kunstgalerie, Bochum, April–June 1964 (59, repr.); Gimpel Fils 1964 (3a); *St. Ives: Twenty Five Years of Painting, Sculpture and Pottery*, Tate Gallery, Feb.–March 1985 (57, repr. p.166); *St Ives*, Hyogo Prefectural Museum of Modern Art, April–May 1989, Museum of Modern Art, Kamatura, May–June, Setagaya Art Museum, July–Aug. (42, repr. in col. p.67)

Literature: E.H. Ramsden, *Sculpture: Theme and Variations*, 1953, p.42, pl.92; Hodin 1961, p.165, no.127, repr.

Reproduced: Read 1952, pls.73a–d

18B Landscape Sculpture 1944, cast 1961

TOO954 BH 127; cast 7/7 A

Bronze 27.1 × 65.5 × 26.8 (12½ × 25¾ × 10½)
on a bronze base 3.9 × 35.2 × 27.6 (1½ × 13⅞ × 10⅞)

Cast inscription on upper surface of base 'Barbara Hepworth 1944 7/7ₐ' rear right-hand corner and cast foundry mark on back of base, 'CIRE PERDU | Morris | Singer | FOUNDERS | LONDON', l.

Presented by the artist 1967

Exhibited: *Penwith Society of Arts in Cornwall Spring 1962*, Penwith Gallery, St Ives, spring 1962 (65); Whitechapel 1962 (5†, repr.); *Sculptors Today and Tomorrow*, Bear Lane Gallery, Oxford, May–June 1962 (27); *Penwith Society of Arts 1st Summer Exhibition*, Penwith Gallery, St Ives, summer 1962 (162†); *British Art Today*, San Francisco Museum of Art, Nov.–Dec. 1962, Dallas Museum of Contemporary Arts, Jan.–Feb. 1963, Santa Barbara Museum of Art, March–April (111, as *Landscape Sculpture I* 1944); *Formes*, Université de Paris, Jan.–Feb. 1963 (55, repr.); John

Landscape Sculpture characterises Hepworth's attempts in the mid-1940s to synthesise Constructive forms and techniques with the theme of landscape. As such, it anticipates one of the principal aspects of her post-war sculpture and reveals her desire to revise her practice in the aftermath of the war.

The work was carved from elm, reflecting the shortage of material other than locally grown timber. The main form is pierced at each end, the holes narrowing towards the back. It is traversed by nine strings, which have discoloured. These emerge from holes along the edge of the right-hand opening, converge on a single hole on the left, pass down through the wood and back up across the left hand aperture to a further sequence of small holes, from where they cross back to the right hand side, through the opening and terminate in a single hole at the back. The knotted ends of the strings are all visible. Though the sculpture appears flat in photographs, the form curves towards the front as if pulled by the strings and the back has an angular 'elbow' near the right-hand end. At the time of this work, Hepworth identified three sizes of sculpture: 'the small intimate "hand sculpture" … the "arm" sculpture … [and] the large sculpture, the size of the human figure'.[1] That this work belongs to the second category is reflected in this elbow form. The heart of the wood runs the length of the sculpture, passing approximately from the left-hand hole to the point on the right at which the strings converge. Though it has a slightly dry appearance, the timber has no significant splits. Filler has been applied to a knot in the left-hand opening and around the strings. The back of the sculpture has been bleached on the right-hand end by the sun but a group of dark markings towards the left, at the front, is a natural discoloration. The earliest published photographs of the work show that its original wooden base was as long as the sculpture;[2] the shorter one on which it now sits was probably added by the artist when she reacquired the work.

After her relocation to Cornwall at the outbreak of war, Hepworth increasingly discussed her work in relation to the landscape. She longed to see a large version of *Sculpture with Colour (Deep Blue and Red)* 1940 (no.14 q.v.), the first wartime piece, sited outside and a number of the carvings after 1943, such as *Pelagos* 1946 (no.20 q.v.), allude specifically to the environment. Of the war years Hepworth later recalled: 'It was during this time that I gradually discovered the remarkable pagan landscape … which still has a deep effect on me, developing all my ideas about the relationship of the human figure in the landscape.'[3] At the same time, she also sought to relate her earlier work to a similar source. Discussing a photograph of her *Single Form* 1937–8 (fig.31), taken against young birch trees, she said in 1943: 'I took this photo myself … because when I conceived Single Form it was born of this particular sort of landscape – all my sculpture comes out of landscape.'[4] *Landscape Sculpture* was one of several works which were photographed by the artist in her Carbis Bay garden.[5]

E.H. Ramsden, who was especially close to Hepworth in the 1940s, was able to associate the work with a specific place. She described it as 'a transcription of the felt

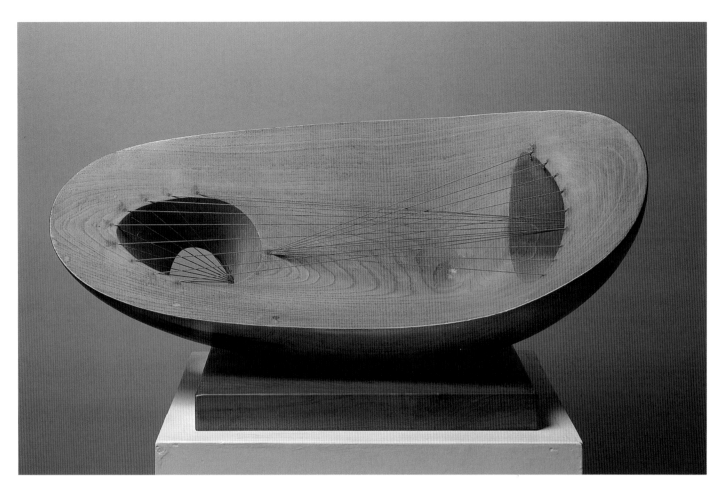

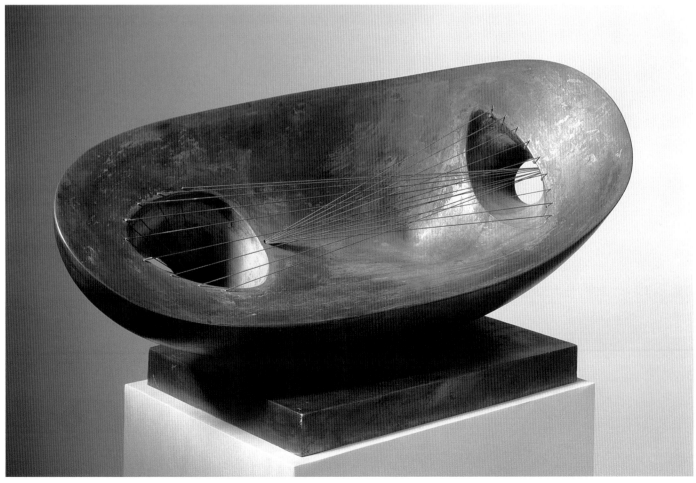

Lewis 1963 (2†); Zurich 1963–4 (3b†, repr.); Toronto 1964 (3); BC European tour 1964–6: Copenhagen (5‡), Stockholm (6‡), Helsinki (4‡), Oslo (4‡), Otterlo (4‡), Basel (4‡), Turin (5‡, repr.), Karlsruhe (4‡), Essen (4‡); *Little Misenden Festival Exhibition*, Little Missenden, Oct. 1965 (no cat.†); *Sculpture Contemporaine et Art Africain*, Lacaste, France, July–Sept. 1966 (33); Tate 1968 (43, listed but not exhibited); *Conferment* 1968 (no cat.‡, St Ives parish churchyard); AC tour 1970–1 (2†, repr.); *Decade 40s: Painting, Sculpture and Drawing in Britain 1940–9*, AC tour 1972–3, Whitechapel Art Gallery, Nov. 1972, Southampton City Art Gallery, Dec.–Jan. 1973, Carlisle Public Library, Museum and Art Gallery, Jan.–Feb., DLI Museum and Arts Centre, Durham, Feb.–March, Manchester City Art Gallery, March–April, Bradford City Art Gallery, April–May, Aberdeen Museum and Art Gallery, May–June 1973 (155); *Henry Moore to Gilbert and George: Modern British Art from the Tate Gallery*, Palais des Beaux Arts, Brussels, Sept.–Nov. 1973 (48, repr. p.61); AC Scottish tour 1978 (4†); Wales & Isle of Man 1982–3 (4†); *Masters of the 19th and 20th Centuries*, Marlborough Gallery, New York, Nov.–Dec. 1986 (17‡)

Literature: E.H. Ramsden, *Sculpture: Theme and Variation*, 1953, p.42; *Tate Gallery Report 1967–8*, 1968, p.62; Jenkins 1982, p.10, repr. p.26; Michael Tooby, *An Illustrated Companion to the Tate St Ives*, 1993, p.39, repr. in col.

"pull" existing between two hills, in Uny Lelant, near the Cornish coast'.[6] Uny Lelant is close to Chy-an-Kerris, the house in Headland Road, Carbis Bay, which Hepworth shared with Ben Nicholson and where the sculpture was carved. Ramsden's account echoed Hepworth's own explanation of her use of stringing in many works of the 1940s. 'The strings', the artist wrote, 'were the tension I felt between myself and the sea, the wind or the hills'.[7] This conceit was later employed by the artist John Wells when discussing his *Relief Construction* 1940 (fig.40) which, he said, 'express[es] (unconsciously perhaps) my deep awareness of the living tensions of the environment of the [Scilly] Islands'.[8] Wells was a member of the small group of constructivists exhibiting in Britain during the war and, later, a prominent member of the circle of artists in St Ives. *Landscape Sculpture* follows his relief in its use of lateral strings diverging from round or elliptical forms. This was a characteristic of a number of Wells's pieces of the 1940s and derived from his knowledge, largely in reproduction, of modernist paintings and constructions of the 1930s. A comparable use of linear elements may be seen in Hans Erni's work and, put to a different use, in the landscape-based paintings of John Tunnard. After the war, the association of abstract form with landscape became a characteristic not only of Hepworth's work but also of the group of artists in St Ives centred on her and Nicholson.

Landscape Sculpture was one of several earlier works which Hepworth cast in bronze in the late 1950s and early 1960s; other examples include *Oval Sculpture* 1943, cast in 1958 (no.16 q.v.) and *Single Form (Eikon)* 1937–8, cast 1963 (no.12 q.v.). Cast in an edition of seven, the artist's copy (7/7) is in the collection of the Tate Gallery. Like the original, the bronze is traversed by nine strings which have discoloured. It is distinguished, however, by the green patination of its internal face which places an emphasis on the contrast between outer and inner surfaces. Fine, swirling scratches covering the back of the form may be the result of cleaning with a mild abrasive, but smaller incised marks appear to have been deliberate. The bronze, which was cast at the Morris Singer Foundry, may be solid, but the age of the strings makes the sculpture fragile despite its weight.

fig.40
John Wells, *Relief Construction*, 1940, 32.1 × 42.2 × 4.5 (12⅝ × 16⅝ × 1¾), mixed media, Tate Gallery

19 Tides I 1946

TO2008 BH 139

Part-painted holly wood 33.5 × 63 × 29 (13¼ × 24⅞ × 11⅜)

Presented by Ben Nicholson OM 1975

Provenance: Acquired by Ben Nicholson early 1950s

Literature: Hodin 1961, p.166, no.139; *Tate Gallery Acquisitions 1974–6*, 1976, pp.105–6, repr.; David Orchard, *The Techniques of Wood Sculpture*, 1984, p.73, repr.; David Lewis, 'St Ives: A Personal Memoir 1947–55' in *St. Ives: Twenty Five Years of Painting, Sculpture and Pottery*, exh. cat., Tate Gallery, 1985, p.36, repr.; Penelope Curtis, *Modern British Sculpture from the Collection*, Tate Gallery Liverpool, 1988, p.52, repr.; Festing 1995, p.172; Alun R. Graves, 'Casts and Continuing Histories: Material Evidence and the Sculpture of Barbara Hepworth' in Thistlewood 1996, pp.173–5, repr.; Curtis 1998, p.36

In 1946 Barbara Hepworth wrote: 'I prefer the foreign hardwoods with their great variety of colour and surface finish. The war stopped all imports of foreign timber and I have been seasoning my own logs from trees felled in the Cornish woods.'[1] It was such expediency that, at the beginning of the same year, had led her to carve this work from a piece of holly – a wood notoriously prone to splitting.

The dramatic splits in *Tides I* appeared while the artist was still working on the piece. She wrote to Ben Nicholson, staying in London, in early 1946: 'On Sat. night I'd smoothed up my new wood carving [sketch] & applied colour to see what it looked like – I thought it one of my best and went to bed smiling. Sun. morn. I found 3 ENORMOUS cracks in it – This morning 3 more. I can only think that I smoothed it too soon and blocked the pores.'[2] The artist reworked the idea later in 1946 in plane wood and the result was *Tides II* (fig.41), which was shown at her exhibition at the Lefevre Gallery in October of that year as *Tides*. The two works were differentiated as *Tides I* and *Tides II* in Alan Bowness's catalogue of the artist's work.[3] *Tides I* has often been reproduced upside down. If it is orientated correctly, with the largest split on the left-hand side and the three parallel splits to the right, one can see that *Tides II* was a fairly close replication of it. It is, therefore, revealing that the second version was painted white within the concavities of the front face and pale blue in the holes which penetrate through to the back.

Though most of the surface of *Tides I* has a smooth finish, there are areas where fine chisel and gouge marks are evident around the main curves of the form. A small area of the outer surface has not been finished and was, presumably, the face on which the sculpture sat while being carved. Tate Gallery conservators have suggested that pale grey paint was applied to the wood after it had split.[4] This would suggest that either the artist continued to work on it or that Ben Nicholson added another coat of paint while it was in his possession. The wood has darkened under the painted area, giving the pigment a cool effect. Flecks of a dark blue can be seen in the paint layer and there are streaks of purple and blue paint on the back of the sculpture which were presumably applied accidentally. On acquisition by the Tate Gallery it was found that, since being carved, the wood had been subject to boring by woodworm of a size consistent with a seaside location. Tate Gallery conservators have reported that the work has been waterlogged in the past and suggested that it was damp at the time of carving.[5]

The condition of *Tides I* may be accounted for by its history. It would seem that the artist abandoned this work shortly after it split and discarded it in the garden of Chy-an-Kerris, her home in Carbis Bay. David Lewis has described the circumstances of its later rediscovery. After Hepworth and Nicholson had divorced, Lewis helped Nicholson tidy the garden at Chy-an-Kerris before he moved into St Ives. 'One afternoon I went at the docks and nettles with a billhook', Lewis wrote,

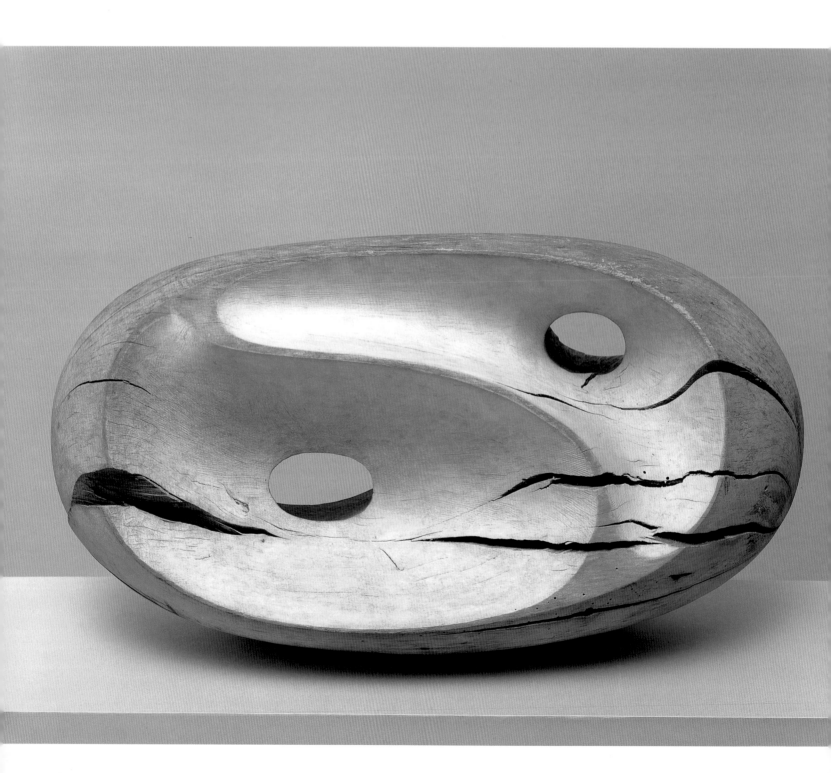

fig.41
Tides II, 1946, length 47 (18⅝), painted wood, BH 140, private collection

Deep in the weeds under a granite wall I found a wood carving of Barbara's. One can only assume that Barbara had thrown it out four years earlier, but who knows for sure. Anyhow, there it was, sodden from rain, cracked and worm-eaten, with moss in its inner cavities where paint colour had flaked. Ben said: 'David, you found it, you should keep it.' I said: 'Ben, that's very generous, but surely it's Barbara's. She should decide what's to be done with it.' But Ben and Barbara were not on speaking terms, so the sculpture was put in a box.[6]

Tides I remained in Nicholson's collection until after Hepworth's death. In 1966 he sent her photographs of it, prompting her to observe, 'It is so much more beautiful than the second version! The photo might persuade people to put up with cracks in wood.'[7] Before giving the work to the Tate, Nicholson told the director, Norman Reid, that he believed it to be one of the finest examples of Hepworth's work and explained that he was presenting it 'in response to a request made by Dame Barbara in her lifetime' on the condition that no attempt was ever made to fill the splits in the wood. Reid gave a guarantee to that effect.[8]

The wave-like serpentine curve that characterises *Tides I* may be the source of the work's title. However, the sinuous division of its face and the piercing of each section is also reminiscent of the Yin-Yang symbol. In ancient Chinese philosophy the concept of Yin-Yang represents the two contrasting forces of life in a harmony of opposites, by which existence is seen as a dynamic process of complementary, interdependent principles alternating in space and time such that cosmic time is seen as rhythmic. Within the harmony of Yin-Yang all things are related so that man is in unity with Nature. The infinite repetition of the tides – of which Hepworth would have been especially aware living by the sea – might be seen to encapsulate the essence of such a natural rhythm. Though she described herself at that time as an atheist,[9] there was considerable interest in Eastern philosophy and religion amongst artists in St Ives during the 1940s. In particular, her close friend Bernard Leach had had direct contact with Eastern thought since the early years of the century and was a practising Baha'i. Taoist philosophy – to which the concept of Yin-Yang is fundamental – was of particular current interest to younger artists such as Bryan Wynter and Sven Berlin with whom Hepworth associated. It is likely that she would have been conscious of the similarity of *Tides* to the Yin-Yang symbol and one might, therefore, speculate that the title was intended to have more metaphysical resonances. The concepts of harmonious interdependency and the unity of man and nature were certainly consistent with her personal philosophy.

20 Pelagos 1946

T00699 BH 133

Part-painted elm and strings 43 × 46 × 38.5 (14½ × 15¼ × 13)
on an oak base; weight 15.2 kg

Presented by the artist 1964

Provenance: Purchased from the artist by Duncan
Macdonald 1946, and bought back from the estate of his
widow, Mrs Elizabeth Macdonald, by the artist 1958

Exhibited: Lefevre 1946 (21); *XXV Venice Biennale*,
June–Oct. 1950 (British pavilion 74); Wakefield, York &
Manchester 1951 (27, repr. p.22); Whitechapel 1954 (45, pl.H);
São Paolo Bienal 1959 (4, repr.); BC South American tour
1960 (3, repr.); Whitechapel 1962 (3, repr.); Tate 1968 (45,
repr. in col. front cover); *Conferment* 1968 (no cat., Guildhall);
*St. Ives: Twenty Five Years of Painting, Sculpture and
Pottery*, Tate Gallery, Feb.–March 1985 (73, repr. in col. p.69);
Retrospective 1994–5 (38, repr. in col. p.76 and front cover)

Literature: David Lewis, 'Sculptures of Barbara Hepworth',
Listener, vol.44, no.1122, 27 July 1950, p.122; David Lewis,
'The Sculptures of Barbara Hepworth', *Eidos*, no.2,
Sept.–Oct. 1950, p.28, repr. p.29; Read 1952, pp.x–xi, repr.
pls.82a–83b; E.H. Ramsden, *Sculpture: Theme and
Variation*, 1953, p.42; Edouard Roditi, *Dialogues on Art*, 1960,
pp.92–3; Hodin 1961, pp.15, 166, no.133, repr.; Whitechapel
1962, exh. cat., p.10; Shepherd 1963, [p.38], pl.6; *Tate Gallery
Report 1964–5*, 1966, p.40; 'Recent Museum Acquisitions:
Sculpture and Drawings by Barbara Hepworth (The Tate
Gallery)', *Burlington Magazine*, vol.108, no.761, Aug. 1966,
p.426, repr. p.424, pl.58; Hammacher 1968/1987, p.105, pl.76
(col.); Ronald Alley, 'Barbara Hepworth's Artistic
Development', Tate 1968, pp.16–17; Herbert Christian
Marillat, *Modern Sculpture: The New Old Masters*, 1974, p.54,
repr. between pp.142 and 143, pl.105; Peter Selz, *Art in Our
Times: A Pictorial History 1890–1980*, 1981, p.376, pl.1016
(col.); Jenkins 1982, p.14, repr. p.27; Penelope Curtis, *Modern
British Sculpture from the Collection*, Tate Gallery Liverpool,
1988, pp.52–3, repr.; Alan G. Wilkinson, 'Cornwall and the
Sculpture of Landscape: 1939–1975' in *Retrospective*
1994–5, exh. cat., pp.81, 83–4, 86, 109; Andrew Causey,
'Liverpool and New Haven: Barbara Hepworth', *Burlington
Magazine*, vol.136, no.1101, Dec. 1994, pp.860–1, repr. p.860;
Festing 1995, p.168; Derek Pullen and Sandra Deighton,
'Barbara Hepworth: Conserving a Lifetime's Work' in Jackie
Heuman (ed.), *From Marble to Chocolate: The Conservation
of Modern Sculpture*, 1995, p.140, repr.; David Thistlewood,
'Barbara Hepworth: Absolutist and Relativist Interpretations'
in Thistlewood 1996, p.5; Martin Hammer and Christina
Lodder, 'Hepworth and Gabo: A Creative Dialogue', ibid.,
p.120, repr.; Penelope Curtis, 'What is Left Unsaid', ibid.,
p.159; Claire Doherty, 'Re-reading the Work of Barbara
Hepworth in the Light of Debates on "the Feminine"', ibid.,
p.168; Emma E. Roberts, 'Barbara Hepworth Speculatively
Perceived within an International Context', ibid., p.187; *Un
Siècle de Sculpture Anglaise*, exh. cat., Galerie national du
Jeu de Paume, Paris 1996, p.458; Alan Wilkinson, exh. cat.,
New York 1996, p.26, repr.; Curtis 1998, p.34

One of her best-known works, *Pelagos* epitomises Hepworth's post-war sculpture.
In its combination of organic form, natural material and the constructivist
technique of stringing, it may be seen as a successful synthesis of the different forces
in her earlier works. In 1950 David Lewis, then Hepworth's secretary, described *Pelagos*
as one of 'the two final sculptures' of the period of experimentation that had started
with *Two Forms and Sphere* in 1935 (fig.23).[1] Later, Michael Shepherd identified it as, 'a
key work representing her distilled experience up to that time'.[2] The importance which
the artist and others have attached to the piece is demonstrated by its illustration on the
covers of *The Studio*, at the time of its first exhibition, and of the catalogues of
Hepworth's two Tate retrospectives: in London in 1968 and Liverpool in 1994.[3] That
Pelagos was bought soon after completion by the artist's dealer, Duncan Macdonald of
the Lefevre Gallery, might be further indication that it was seen as the outstanding
piece in the one-person exhibition that marked the beginning of her post-war success.

The form of *Pelagos* derives from the hollowing out of the middle of the wood to
make two spiralling arms. This has been described in terms of the hole that
characterised Hepworth's earlier work having 'mastered the interior and even broken it
open'.[4] The interior space was painted pale blue with a very matt finish. David Lewis
used *Pelagos* to demonstrate the continuity in her work and to distinguish her
preoccupation with light and space from Henry Moore's organicism.[5] Though apparently
spherical when seen in reproduction, the sculpture's shape is in fact ovoid. The form
allows sufficient movement so that there are considerably fewer radial splits than in
many of Hepworth's other wooden pieces. However, there are numerous small cracks,
some of which have necessitated the repainting of the interior, possibly by the artist.
There are also areas of the exterior which have been filled.

Pelagos has often been paired with *Wave* 1943–4 (fig.42): both are hollowed-out
wooden forms, their interiors painted pale blue and both are said to relate to the
landscape. Writing of a later work, Hepworth suggested that she no longer thought the
specific colour of such interiors to be significant. In a letter to the director of the
Scottish National Gallery of Modern Art, dated 13 March 1975, she remarked,

As regards the pale blue – 20 years ago I used Ripoline and this lasted superbly, but 10 years ago when I did
some restoration due to careless handling I had to resort to Dulux (matt) with a little cobalt pure artists'
colour. Alas I have discovered on all sides that this has no staying power and even on big works like the
Crucifixion the fading has been absolute. I can't help feeling that a pure white matt ground … would not only
last but project my point of view. I am much more concerned with the way the colour is applied and the brush
strokes than with the actual colour, which used to be pale blue.[6]

Though the use of colour had been a feature of Hepworth's sculpture since 1939, this
would suggest that the matt finish, which contrasts with the high polish of the wood,
was of equal concern. The tension between the interior and exterior became a
dominating feature of Hepworth's sculpture and reached a highpoint with the pieces
carved in guarea in the 1950s, such as *Corinthos* 1954–5 (no.32 q.v.).

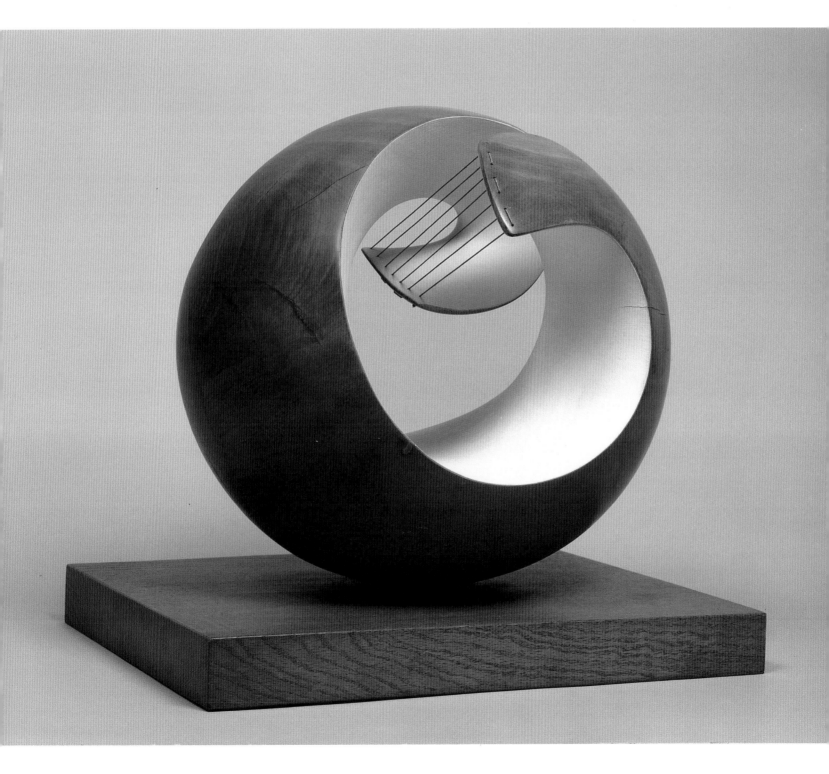

The titles of this work and of *Wave* are also comparable. *Pelagos*, like many of Hepworth's titles of the period, is a Greek word suggested by E.H. Ramsden and means 'the sea', its wave-like form has been noted.[7] Specifically, the artist associated it with the view of St Ives Bay from her house, Chy-an-Kerris, where it was carved. 'I had a studio room', she wrote later, 'looking straight towards the horizon of the sea and enfolded (but with always the escape for the eye straight out to the Atlantic) by the arms of the land to the left and the right of me. I have used this idea in *Pelagos*.'[8] She elaborated, establishing a land–body duality as the underlying basis for her sculpture in general: 'the lighthouse and its strange rocky island was an eye; the Island of St Ives an arm, a hand, a face. The rock formation of the great bay had a withinness of form.'[9] Later, with a possible allusion to the paintings of Alfred Wallis, she reiterated the non-visual aspect of the source:

I could see the whole bay of St Ives, and my response to this view was that of a primitive who observes the curves of coast and horizon and experiences, as he faces the ocean, a sense of containment and security rather than of the dangers of an endless expanse of waters. So *Pelagos* represents not so much what I saw as what I felt.[10]

The artist's statements validate Kate Doherty's recent reading of the work in terms of 'allusions to the womb and to the sheltering, caring function of the mother'.[11] Implicit in Doherty's discussion is a knowledge of Melanie Klein's idea of art as a reparative process, with which Hepworth may have been familiar through her friendship with Adrian Stokes. The sculptor suggested that in her work 'known symbols', such as 'figures hands eyes trees etc', were transformed through emotion and feeling to 'unconscious (or unknown) symbols'.[12] That these included not only formal elements – 'curves, spirals ovoids' – but also more specific signifiers – 'foetus, errotic [sic], prenatal dream, childhood – primitive etc' – invited a psychoanalytic and perhaps specifically Kleinian interpretation of her use of oval and enfolding forms.

A sense of wholeness and integration is implicit in Read's discussion of *Pelagos*: 'our senses are projected into the form, fill it and partake of its organization … it becomes a mandala, an object which in contemplation confers on the troubled spirit a timeless serenity.'[13] The mandala, a sacred diagramatic representation of the universe in Tantric Hinduism and Buddhism, was an important feature of Jungian theory. Jung proposed that the mandala was a necessary step in the process of individuation – the integration of the conscious and unconscious into a whole individual. While there is no concrete evidence of Hepworth's knowledge of Klein, her interest in Jung is apparent from her letters to Read and others. Read's debt to Jung was especially pronounced in *Education Through Art*, which was enthusiastically praised by Hepworth.[14] In the book Read made special mention of the mandala and Jung's interpretation of it. Hepworth analysed her own children's drawings in a manner close to Read's researches and commented on one group which, clearly recalling the mandala, consisted 'of egg forms within eggs, folded again & again into a purse & hidden in a secret place'.[15] Her desire for a sense of harmonious integrity is indicated too by her interest at that time – also shared with Read – in Gestalt psychology.

The 'radiating and parallel lines' of the stringing of *Pelagos* and *Wave* have recently been related to the post-war persistence of constructivist modernisation.[16] However, more contemporaneous critiques perceived *Pelagos* as a negotiation of constructivist and organic aesthetics. In 1952, Herbert Read referred to it as a 'constructive image', but added that it conveyed 'life-enhancing values' directly because, 'the wood is carved into a tense form which suggests the unfolding point of life itself'.[17] In contrast, it was described by one critic in terms of 'an association not with nature but with some of the engineering accompaniments of civilization; ventilator shafts, hangars and fly-over roadways'.[18] The duality of the work's constructivist and organic aspects reflects Hepworth's wartime move away from the dogmatic Constructivism that she associated with Naum Gabo, Antoine Pevsner and their erstwhile colleagues in Russia. In 1944, the

artist contrasted Herbert Read's description of constructivism as related to the machine with her more organic understanding of the term. Earlier she had written: 'Constructivism does not do away with imagery – in fact it contains the most easily understood use of images which are undoubtedly organic in so far as they are the basic forms of the rhythm of landscape, primary construction, the human figure and so on. They are more elemental than the personal imagery of an individual.'[19]

Hepworth's adaptation of earlier abstract theory to accommodate her growing interest in psychology and engagement with the landscape and nature was central to her work from the 1940s onward. *Pelagos* is the outstanding example of the integrated, organic forms that resulted from this change in her approach to sculpture.

fig.42
Wave, 1943-4, length 47 (18½), painted wood and strings, BH 122, private collection, on loan to Scottish National Gallery of Modern Art, Edinburgh

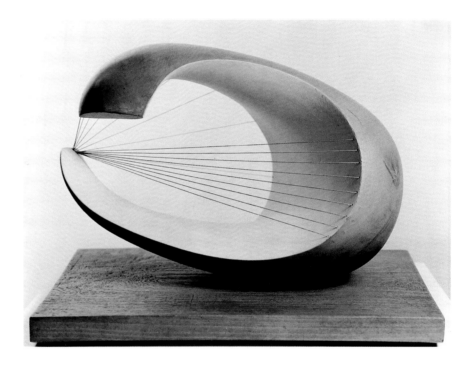

21 Projects for Waterloo Bridge 1947

L00948; L00949; L00950

Oil, watercolour, crayon and pencil on paper,
each 46.4 × 59 (18¼ × 23¼)

*On loan from the artist's estate to the Barbara Hepworth
Museum, St Ives*

*Displayed in the artist's studio, Barbara Hepworth Museum,
St Ives*

Exhibited: Wakefield, York & Manchester 1951 (49, 50, 51 as
'*Drawings for Sculpture for Waterloo Bridge 1946–7*')

Literature: J.P. Hodin, 'Portrait of the Artist, No. 27: Barbara
Hepworth', *Art News and Review*, vol.2, no.1, 11 Feb. 1950, p.6;
Read 1952, section 5

Hepworth's designs for sculptures for London's Waterloo Bridge, over the River Thames, were her first participation in the public sculpture boom that followed the Second World War. Though none of the competitors' proposals was realised, her inclusion among the six major British sculptors invited to participate reflected her growing reputation.

Plans for the reconstruction of Waterloo Bridge were initiated in 1923 when John Rennie's original (1811–17) showed signs of major structural weakness. It was not until 1934, however, that the demands of growing road and river traffic forced the London County Council (LCC) to consider various proposals for a new bridge. Sir Giles Gilbert Scott's elegant design for a five-span bridge was accepted and the demolition of the old crossing began at the end of 1936. The foundation stone of the new structure was laid on 4 May 1939 and construction continued, despite the outbreak of war, so that the bridge was partially opened to traffic in August 1942 and in full use from 21 November 1944.

In common with a number of major architectural schemes of the inter-war years, Scott's original design (fig.43) made provision for sculptures.[1] However, nothing was done before the bridge's completion. In 1942 the LCC announced that, though the bridge was in use, 'in view of the war certain works … are being postponed … Figure groups in stone will eventually be designed for the two masonry blocks at each end of the bridge.'[2] At an unspecified time after the bridge's final opening in 1944, Sir Charles Wheeler was invited to design four such groups. His 'model and drawings' for sculptures representing *The Four Winds* were accepted by the LCC Town Planning Committee on 30 September 1946.[3] However, following further consultation with Scott, that decision was revoked and the committee resolved that 'designs for the figure groups … should be chosen on the basis of competition between sculptors of high repute'.[4] Six sculptors, approved by Scott, agreed to participate: Hepworth, Frank Dobson, Jacob Epstein, Eric Kennington, Henry Moore and Wheeler, who was asked to submit a new proposal. All but Hepworth had experience of comparable monumental commissions. Competitors would receive £150 each for their submissions, which were to include estimated costs of drawings, models and carving (the cost of stone, transport and erection was to be defrayed by the promoters). To ensure anonymity, entries were to bear no signatures or other identifying marks and the artist's name was submitted in a sealed envelope. The winning design would be chosen by three assessors: Scott, the sculptor Sir William Reid Dick and Sir Philip Hendy, Director of the National Gallery. This proposal was accepted by the committee at their 9 June 1947 meeting and a deadline for submissions was set for the following 13 October.

The competitors were 'required to submit a model to a scale of 1½ in.:1 foot [1:8] of one of the groups, and a drawing of each of the other three groups to the same scale … A short report describing the subjects' could also be submitted. The 'figure groups' had to be of Portland stone, in keeping with their pedestals. 'The choice of subject and the

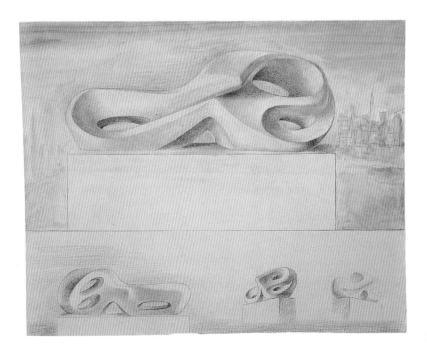

fig.43
Giles Gilbert Scott, *Design for Waterloo Bridge*, 1934,
56 × 122 (22 × 48), pencil on paper, London Metropolitan
Archive

method of treatment' was left to the artists' discretion, though it was emphasised that the blocks were 'not designed for the ordinary type of sculpture superimposed on the top of the pedestals as independent units'.[5] Rather, the sculpture was 'intended to form a carved and modelled top to the masonry blocks, having a simple and compact outline with a low horizontal sculptural treatment. The silhouette, as seen from a distance, should form part of the lines of the bridge design'.[6] In keeping with these instructions, all of the surviving entries consist of horizontal figure forms. Dobson's reclining nudes symbolised President Roosevelt's Four Freedoms, while Kennington took the patron saints of the four nations of the United Kingdom as his theme.[7] Wheeler's second design has not been traced and Moore and Epstein were unable to complete their entries within the four-month deadline.

In November the assessors wrote to the Clerk of the Council: 'We cannot but feel that the result of the competition was disappointing and we do not consider that any of the four schemes submitted can be adjudged suitable for the position that they are intended to occupy. We greatly regret, therefore, that we are unable to make any award'.[8] They suggested that the competition be extended to 'two or three additional sculptors … and that a further six months be allowed … [which] might also allow Mr Epstein and Mr Moore to complete their entries. If this course is adopted we should greatly appreciate the opportunity of submitting names of sculptors suitable for this type of work'.[9] As a consequence, on 2 February 1948 it was decided 'that no action be taken … to provide sculpture' for the bridge.[10]

The *Projects for Waterloo Bridge* are the three drawings which Hepworth submitted in conjunction with a scale model as stipulated by the conditions of the competition. Each comprises a view of an imagined sculpture with smaller images showing it from three other viewpoints. In common with the other entries, all of the designs are suggestive of a recumbent figure. Each is distinctive, however: one may be described as more rectilinear (21A), another rises sinuously to a point (21B) and the third is more organic (21C). The artist carved two small maquettes in Portland stone in relation to this project (BH 144.1 & 2) and from the first of these she developed the 1/8 scale model for submission (fig.44).[11] It appears to have been at this time that Hepworth became dissatisfied with this working method. She recorded that, to her, the forms 'looked slightly absurd as maquettes since every curved surface and every pierced hole had been thought out in relation to the scale of human beings'.[12] This problem is reflected in the fact that she seems to have made at least one full-size study: Ben Nicholson, describing the scale of the project, told Helen Sutherland that their 'living room wall was only just long enough to take Barbara's sketch for one of the designs'.[13]

The plinths on which the sculptures were to sit rise up from the middle of the double flights of stairs that link Waterloo Bridge to the street below. They are 335.6cm (122 in) long and 106.6cm (42 in) deep; from the bridge the top is slightly above eye level, but from the stairs they tower over the viewer. Each competitor was sent a scale elevation

(1:8) of them and was instructed that their designs should 'include a portion of the pedestal blocks down to the line "A-A" on the drawing, 3 feet below the existing top'.[14] This is the portion in Hepworth's drawings which, in the main images, is depicted as if seen by a pedestrian on the bridge. The subsidiary views appear to show the sculpture as seen from behind and as if approached from either direction along the pavement.

The pedestals are stepped at the top and the artists were allowed to remove the top course of stone in their designs, though they were advised that this was not possible on the north-west block which had been incorporated into the adjacent terrace. The step is only included in the second of Hepworth's drawings, in which the two square windows on the right-hand side suggest the form of the abutting Lancaster House. If the pointed sculpture may be thus associated with the north-west corner, it is not possible to identify with certainty the positions for which the other designs were intended, not least because extensive post-war building has obscured the views to which Hepworth alludes in her drawings. The first design, of the rectilinear form, may be for the south-western sculpture as the tower on the right-hand edge may be the Victoria Tower of the Houses of Parliament. However, there is a faint outline of a dome topped with a cross on the left which suggests St Paul's Cathedral in the opposite direction. This would identify the site of the drawing as one of the eastern corners of the bridge looking towards the City of London. In which case, the tower may be that of Southwark Cathedral on the south bank of the river. If, as one might expect, the larger part of each form was to be at its landward end, the rectilinear form would be placed at the north-east corner, beside Somerset House, the model would be located at the south-west corner and the more organic design at the south-east. That the carved maquette is especially similar to the Lancaster House figure and so may be more likely to be sited opposite it, at the northern end of the bridge, might also militate against this scheme. However, in 1947 the view of the south-western plinth would have been dominated by the Shot Tower which stood immediately behind it (and is visible in Scott's elevation, fig.43). Though it is possible that the backgrounds are more suggestive than accurate, Hepworth recorded that she spent a lot of time considering her design on site.[15] It may be, therefore, that the absence of such a prominent feature from the three drawings indicates that the maquette was intended for the plinth beneath the tower.

Though the motif of the reclining figure had featured in Hepworth's treatment of the *Mother and Child* theme in 1934 (no.7 q.v.), it was especially prominent in post-war British sculpture through the success of Henry Moore's work. Hepworth's four designs are more abstract than Moore's sculpture, but the basic definition of the figure by means of a twisting, organic form may be compared to his *Recumbent Figure* 1938 (fig.33), with which she was undoubtedly familiar. Her choice of the reclining figure was clearly determined by the stipulation of 'a low horizontal sculptural treatment' and is appropriate to the shape and scale of the plinths.[16] This may cast doubt on Bowness's identification of the vertical, rectilinear figures of *Drawing for Stone Sculpture* 1947 as 'one of the ideas' for the Waterloo Bridge competition.[17] Nevertheless, though the style of that drawing is closer to such later works as *Two Figures (Heroes)* 1954 (no.30B q.v.), its form does accord with Hepworth's reported concerns for the design. A few years later she recalled spending 'many hours contemplating the architectural and sculptural scale of the site in relation to the thousands of people who passed over or under the bridge'.[18] It is probable that pressures on Hepworth would have prevented experimentation with widely varying ideas: shortly after receiving the invitation to compete, with the school holidays in prospect, she complained to E.H. Ramsden, 'they only give four months for the competition. It does not allow time for anything to go wrong. What a hazard life is for women.'[19] Nicholson recorded that the project 'kept her busy night and day all summer'.[20]

Despite their site-specificity, the designs are consistent with her carvings of the period. In her works of 1946, a number of which were in Portland stone, the organic

fig.44
Model for sculpture for Waterloo Bridge, 1947, length 42 (16½), portland stone, BH 144.3, private collection

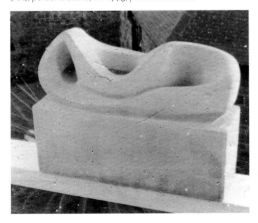

ovoid of such pieces as *Oval Sculpture* 1943 (no.16 q.v.) developed into a more twisted, though still enwrapping, form. The title of *Involute* 1946 announced this new complexity.[21] Other works suggest that the horizontality of the Waterloo designs may be related to the artist's engagement with landscape. The hollowed, slightly spiralling form of *Pendour* 1947, a wood carving similar to those of the bridge works, is implicitly linked to a place by its title.[22] Though he described them in 1950 as 'music turned into stone, pure harmonies, *orphic sculpture*', J.P. Hodin later related the Waterloo Bridge designs to the theme of landscape and their urban context. He believed that with them Hepworth had achieved a balance between her two preoccupations: sculpture and landscape, and sculpture and architecture. This led, he suggested, to 'the inclusion within the sculpture of lyrical qualities born from the sensations of nature and designed as a contrapuntal poetic element to express the essence of modern architecture'.[24]

Coming at a time of change and reappraisal in her work, the Waterloo project must have appealed to Hepworth's interest in the artist's role in society as well as in the question of sculpture in the modern city. This was especially the case with this scheme as plans were underway for the redevelopment of the South Bank site adjacent to the bridge's southern end. In 1951 the area would host the Festival of Britain, but its designation in 1946 as the site for a National Theatre had already established it as a symbol of the cultural regeneration of the bomb-damaged city. One may see the theme of regeneration reflected in the enfolding form of the designs. A litany of terms in a letter to E.H. Ramsden reveals the preoccupation in Hepworth's sculptures at that time: 'the beginning' … 'Origin' … 'source' … 'Eiréne' … 'evolution'.[25] A similar concern with birth and generation might be suggested by these designs' balance between the abstraction of such works as *Oval Sculpture* and allusion to the female body.

In their literal depiction of a finished sculpture, the drawings are unique in Hepworth's oeuvre. Some earlier carvings – *Seated Figure* 1932–3 (no.5 q.v.), for example – were developed from small linear sketches and some of her wartime abstract paintings, which she described as drawings for sculpture, included suggestions of alternative views of the same imagined solid. However, though the degree of finish was determined by the nature of the competition, the three Waterloo designs offer an unprecedented insight into the completeness of her conception of a sculpture prior to carving. Nevertheless, she recognised the need for flexibility during the working process, when, in 1946, she stated: 'Before I can start carving the idea must be almost complete. I say "almost" because the really important thing seems to be the sculptor's ability to let intuition guide him over the gap between conception and realization without compromising the integrity of the original idea.' She added, 'I rarely make drawings for a particular sculpture; but often scribble sections of form or lines on bits of scrap paper or cigarette boxes when I am working.'[26]

Nevertheless, the drawings share the same technique as most of her other pictures. The support was prepared with a gesso-like ground, which is probably Ripolin Flat white household paint. The forms were drawn in pencil with some ochre shading and the pencil hatching was scratched back in some places. Ultramarine watercolour or oil glaze was washed around them, with turquoise crayon being used to finish off with hatching around the silhouettes.

Though unrealised, the project for Waterloo Bridge appears to have stimulated Hepworth's interest in monumental sculpture. In May 1948 she told Ben Nicholson that she was considering renting a field from a neighbour, Ethel Hodgkins, 'in order to do one large sculpture'. 'I want to do one of three tons', she wrote alongside a small rough sketch of a sculpture similar to the bridge proposals and considerably higher than a man.[27] That work was never carved, but a major commission for the Festival of Britain's South Bank site in 1949, resulting in *Contrapuntal Forms* 1950–1 (fig.51), soon realised her ambition for public sculpture.

22 Two Figures with Folded Arms 1947

T00269

Oil and pencil on gessoed hardboard laid on plywood panel
35.6 × 25.4 (14 × 10)

Inscribed in pencil 'Barbara Hepworth 11/47' b.l. and on back
of panel 'Barbara Hepworth | (Gregory)' centre

Purchased from the executors of E.C. Gregory (Grant-in-Aid) 1959

Provenance: Purchased from the artist through the Lefevre
Gallery by E.C. Gregory 1948

Exhibited: Lefevre 1948 (41); Wakefield, York & Manchester
1951 (79); Whitechapel 1954 (98); *The Gregory Collection*,
ICA, July–Aug. 1959 (15); *Gregory Memorial Exhibition*,
Leeds City Art Gallery, March–April 1960 (12, pl.6); Tate 1968
(204); *Retrospective* 1994–5 (102, repr. in col. p.89)

Literature: Read 1952, p.x, pl.98; *Tate Gallery Report
1959–60*, 1960, p.19; Hodin 1961, p.21, pl.e; C, F & B 1964,
p.278; Jenkins 1982, p.15, repr. p.43; Alan G. Wilkinson,
'Cornwall and the Sculpture of Landscape: 1939–1975' in
Retrospective 1994–5, exh. cat., pp.88–90

After the war Barbara Hepworth produced a considerable number of pictures of the female nude. These form part of a larger group of images from the late 1940s, the volume of which is indicated by her exhibition of paintings at the Lefevre Gallery in 1948. Of the sixty-two pictures shown, twenty-one were nudes and thirty-one were hospital pictures (e.g. no.23A and B q.v.). According to Alan Bowness, the earliest of these figure drawings, amongst which he included *Two Figures with Folded Arms*, were made 'at the end of 1947 and in 1948'.[1] Ben Nicholson told Helen Sutherland towards the end of November 1947 that Hepworth had 'done some lovely new dwgs & recently some v interesting nude dwgs – we have found a particularly beautiful model here'.[2]

While *Pelagos* 1946 (no.20 q.v.) was seen as the summation of Hepworth's constructivist sculpture, her return to figuration may reflect a period of doubt in her work and a desire to introduce a more human element. In a letter dated 6 March 1948, she told Herbert Read that, though she felt no 'difference of intention or of mood' whether working 'realistically' or in the abstract, she believed that the realistic mode replenished 'one's love for life, humanity and the earth', while the abstract 'releases one's personality and sharpens one's perceptions'.[3] Her questioning of non-figuration, which was also marked by an increasing organicism in her sculpture, reflected a broader reassessment of modernism after the war.

Like many of Hepworth's two-dimensional works of the period, *Two Figures with Folded Arms* may be considered both a painting and a drawing. It is executed in graphite pencil (ranging from H to 4B) over a ground of oil paint on gesso. The white gesso, which is thought to have been prepared with traditional size, was roughly applied to the 2.5 mm thick hardboard with a brush. A pink-grey oil imprimatura was applied over the gesso and then scraped – probably with a razor blade – so that the ridges of the brushmarks were removed, leaving paint in the grooves. Long, straight scratches, consistent with the use of a razor blade, may be seen around the legs of the right-hand figure. Some areas were rubbed completely flat, for example between the legs of the two women and, in places, the gesso has been abraded so much that the board is visible. The figures were drawn with a strong outline over the thin painted layer and shading was added with finer pencils. The subversion of normal practice by drawing over paint was a well-established characteristic of the work of Ben Nicholson. A rough gesso ground had also been a feature of his painting for many years and was popular among artists in St Ives, such as Sven Berlin, just after the war. Adjustments to the right-hand figure's left leg indicate that the initial drawing may have been executed rapidly and strengthened later. Incision with a point was used to reduce the strength of the drawn line, as seen, for example, between the buttocks of the left-hand figure. The work is in a stable condition, though in 1994 a small piece of loose impasto in the centre had to be consolidated. Tate Gallery conservators have speculated on the effectiveness of the attachment of the hardboard to the original plywood base board, to which a white wash was applied by the artist.[4]

In common with other contemporary works by the artist, *Two Figures with Folded Arms* shows two views of the same model. Despite Bowness's assertion that Hepworth preferred her models not to take up artificial positions, it would seem that in a number of cases, as here, the artist depicted her subject in a single pose from two viewpoints. Bowness also states that, because of the artist's desire for 'the model to move about naturally', she tended to use 'trained dancers on holiday, rather than professional artists' models'.[5] This is said to place an emphasis on the rhythm of the figure's movement, echoed in the rhythmic line of Hepworth's drawing style, and so highlight the pictures' relationship to her abstract work. However, *Two Figures with Folded Arms* is marked by a static, monumental quality. The strong linear element, the solidity of the figures and the style of the eyes may be seen to reflect the debt to *Quattrocento* Italian painters that Herbert Read identified in the contemporaneous hospital pictures.[6]

In Hepworth's later paintings the figures became intertwined in a Cubist-like multi-faceted conglomeration. These two- and three-figure pictorial compositions may be seen to come very close to her contemporary sculpture, such as *Bicentric Form* 1949 (no.25 q.v.), in which the form derives from the amalgamation of two bodies. Hepworth's increasing concern with the relationship between two figures was seen most notably in the sculpture *Contrapuntal Forms* (fig.51), which she made for the South Bank site of the Festival of Britain in 1951.

Works such as *Two Figures with Folded Arms* should not be seen as studies for sculpture but as independent and complete works. They followed on from the abstract compositions, such as *Forms with Colour* (no.15 q.v.), which Hepworth had begun to make in 1941 and which continued into the later 1940s. It seems likely that the diversification of her practice into two dimensions was intended to maximise her potential market. It may also have been stimulated by her great admiration for Henry Moore's wartime pictures, most particularly the Shelter Drawings and his depictions of Yorkshire coal miners. The production of paintings enabled Hepworth's friends to purchase work without the expense of acquiring a sculpture. As with the wartime pictures, a number of the figure drawings were sold to members of her immediate social circle. *Two Figures with Folded Arms* was purchased by E.C. (Peter) Gregory, director of the publishers Lund Humphries, whose collection also included *Seated Nude*, a painting of the same size, date and, possibly, the same model as the Tate's picture.[7] The inscription in the artist's hand on the back of *Two Figures with Folded Arms* may suggest that it was purchased before it was shown at the Lefevre Gallery in April 1948 and a letter to Herbert Read, written shortly before the exhibition, confirms that a number of works had already been sold.[8]

23A Fenestration of the Ear (The Hammer) 1948

T02098 (illus. opposite)

Oil and pencil on board 38.4 × 27 (15⅛ × 10⅝)

Inscribed in pencil 'Barbara Hepworth 4/48' t.l.

Purchased at Sotheby's (Grant-in-Aid) 1976

Provenance: Given by the artist to be sold at Treason Trial
Defence Fund Sale, Cathedral Hall, Cape Town, South
Africa, 31 Jan.–1 Feb. 1958 (230), bought Heinrich Nathan, by
whom sold Sotheby's *Modern British Drawings, Paintings
and Sculpture*, 10 Nov. 1976 (146, repr.), bought Waddington
and Tooth Galleries for Tate Gallery

Exhibited: New York 1949 (2, as *Fenestration (the
beginning)*); *Contemporary British Painting 1925–50*,
Pennsylvania Academy of Fine Arts, Dec. 1950–Jan. 1951
(14, as *Fenestration (the beginning)*); Whitechapel 1954
(108, as *Fenestration of the Ear*); *Three British Artists:
Hepworth, Scott, Bacon*, Martha Jackson Gallery, New York,
Oct.–Nov. 1954 (10, dimensions reversed in cat.); North
American tour 1955–6 (20, as *Fenestration of the Ear*,
dimensions reversed in cat.); New York 1956–7 (20, as
Fenestration of the Ear); *St. Ives: Twenty Five Years of
Painting, Sculpture and Pottery*, Tate Gallery, Feb.–March
1985 (75, repr. p.172); *Barbara Hepworth: 'The Fenestration
of the Ear'*, Tate St Ives study display, June–Sept. 1993
(no number)

Literature: *Tate Gallery Acquisitions 1976–8*, 1978, p.80–4,
repr.; Jenkins 1982, p.15, repr. p.43; Michael Tooby, *An
Illustrated Companion to the Tate St Ives*, 1993, p.44,
repr. col.

23B The Scalpel 2 1949

T07009 (illus. p.114)

Oil and pencil on board 49.2 × 72.7 (19⅜ × 28⅝)

Inscribed in pencil 'Barbara Hepworth | 1949' b.r. and on
back '51 | Barbara Hepworth | "The Scalpel" | 1949 | oil &
pencil' centre

*Accepted by the Commissioners of the Inland Revenue in
lieu of tax and allocated 1995*

Provenance: Purchased from the artist by her parents, Mr
and Mrs H.R. Hepworth, thence by descent to Lady
Summerson

Exhibited: Lefevre 1950 (51); Whitechapel 1954 (128)

Around the middle of 1947 Barbara Hepworth was invited to observe an operation
at the Princess Elizabeth Hospital in Exeter by Norman Capener, the surgeon
who had earlier treated her daughter Sarah's osteomyelitis. The artist made numerous
subsequent visits to operating theatres in Exeter and in London at the National
Orthopaedic Hospital and the London Clinic, where she made rapid pencil sketches and
notes in a sterile pad. These resulted in a significant number of hospital pictures made
between 1947 and 1949, which were shown at the Lefevre Gallery in April 1948 and in
New York the following year. They stimulated considerable critical interest and were
seen as a radical departure in the artist's work indicative of a more general shift in art
production after the war. The extent of Hepworth's commitment to her two-dimensional
work after the London exhibition is indicated by the fact that in the same year she set
to work on a '6ft × 5 canvas'.[1]

Some of the works are pencil or chalk drawings, but many, including *Fenestration of
the Ear (The Hammer)* 1948 and *The Scalpel 2* 1949, were executed in pencil and oil
paint on a gesso-like ground. In this way, they may, like Hepworth's contemporaneous
nudes (e.g. nos.22 & 24 q.v.), be seen as both paintings and drawings. Both the Tate's
works have a primary support of thin composite board; the later one is faced with a thin
layer of paper and the earlier has a reverse chamfer, suggesting that it was the central
remnant of a picture mount. The support of *The Scalpel 2* lacks mechanical strength,
and its liability to fracture because of its brittle nature has led to some minute losses of
ground and paint. It appears to have been trimmed after the work was completed.
Fenestration of the Ear has similar losses along its edges and has three corners
crumpled by impact which were consolidated in 1977.[2]

Though the grounds of these works are generally described as gesso, the artist told
Birmingham Museum and Art Gallery Conservation Department: 'I have always made
my own grounds by building up several layers of the best flat paint procurable, and each
surface I rubbed down or scraped down until I got the hardness and depth that I
required. The paint that I used during the years in question 1948–1951 was Ripolin flat
white'.[3] The ground of *Fenestration of the Ear* has been identified by Tate Gallery
conservators, drawing on this account, as combining Ripolin Flat white (an alkyd resin-
based household paint), white lead and chalk. The ground of *The Scalpel 2* appears to
be of a similar nature and the same techniques were used in both works. A thin oil glaze
was painted over the ground: a soft blue-grey in *Fenestration of the Ear* and, in *The
Scalpel 2*, a rich golden brown. This layer was then rubbed and scraped with a blade so
that areas of white ground became more visible and the texture of its brushwork was
accentuated. In the case of *Fenestration of the Ear* the pencil drawing was applied over
this rough ground and the cobalt blue area at the top and brown towards the bottom
painted last. However, the basic design of *The Scalpel 2* appears to have been sketched
in first, possibly with a pencil and certainly, in places, with a blade. Areas of brown paint
were then abraded or removed according to the composition and blue and green

fig.45
Fenestration of the Ear (The Beginning), 1948, 26 × 37 (10½ × 14½), oil and pencil on board, private collection

fig.46
Fenestration of the Ear (The Lamp), 1948, 35.5 × 45.8 (14 × 18), oil and pencil on board, Leeds City Art Gallery

fig.47
Fenestration of the Ear (The Microscope), 1948, 34.3 × 43.8 (13½ × 17¼), oil and pencil on board, Spink-Leger Pictures, London

colouring added in places. The detailed drawing was, thus, the final stage of the process, though adjustments were clearly made: some lines and shading have been partially rubbed away, some hard pencil line has been strengthened and pencil was used to block out areas where too much ground was visible.

The appearance of the hospital pictures, in common with their materials, has an archaic quality that reflects the artist's admiration for the painters of the early Renaissance. They are characterised by a solid figure style, reminiscent of Masaccio's frescos in the Brancacci Chapel combined with a concentration on the elongated, thin eyes of Giotto. A Masaccio-like aspect had been seen recently in Henry Moore's wartime drawings, which Hepworth greatly admired, and she had earlier told Herbert Read of her love for Masaccio's 'virility, humanity and vision'.[4] Read, in his turn, identified in the 'austere humanism' of the hospital pictures' style the artist's consciousness of abstract form.[5] In many of the works – *The Scalpel 2* for instance – this quality is emphasised by the formality of the composition. A sense of human identity is also established by the artist's concentration on the figures' hands and eyes.

Hepworth explained that the formal harmony was not simply an artistic device but symbolic of the common purpose of the doctors and nurses. 'From the moment I entered the operating theatre', she wrote,

I became completely absorbed by two things: first, the extraordinary beauty of purpose and co-ordination between human beings all dedicated to the saving of life, and the way that unity of idea and purpose dictated a perfection of concentration, movement and gesture, and secondly by the way this special grace (grace of mind and body) induced a spontaneous space composition, an articulated and animated kind of abstract sculpture very close to what I had been seeking in my own work.[6]

For Hepworth, the idea of a common purpose, which the compositional formality symbolised, had a social as well as an interpersonal dimension. These images may be seen to embody the principles of the collective society which was an increasing concern for her during the 1940s. It has been suggested that the hospital drawings were celebrations of the National Health Service, which had been planned since 1944 and was inaugurated on 5 July 1948.[7] It was argued that the NHS, a central plank of the Welfare State which was established by the 1945–50 Labour government, must have been of great importance to Hepworth, a staunch Labour supporter who had long campaigned for better social provision. These concerns would have been imbued with an even more poignant significance as a result of the emotional and financial strain of her daughter's protracted and serious illness.

An earlier Tate Gallery catalogue entry has identified *Fenestration of the Ear (The Hammer)* as one of a series of six pictures produced in April and May 1948 from sketches made of that operation at the London Clinic.[8] A sketchbook used by Hepworth during those sessions survives in the Science Museum.[9] Though no other similar book is known to exist, a reference to having traced 'one of these old notebooks' in a letter from Hepworth to the owner suggests that there were others.[10] It was argued in the catalogue that the Tate's picture was exhibited in America in 1949 and 1950–1 under the wrong title. As the other works in the series have subtitles, the gallery accepted the suggestion of the artist's executor, Sir Alan Bowness, that this piece should be known as 'The Hammer' for ease of identification.

The exhaustive entry demonstrated the documentary accuracy of the fenestration pictures. The fenestration operation was performed from 1924 until the early 1950s as the treatment for Otosclerosis, the principal cause of hearing loss among middle-aged people. The operation – since superseded – involved the making of a new window (fenestra) in the inner ear. The Tate's picture, however, shows an early stage, known as the mastoidectomy, when access to the inner ear is gained through the mastoid bone. The figure on the left of the group was identified as the surgeon E.R. Garnett Passe, one of the foremost practitioners of the fenestration operation. On the right is Dr John Seymour, his assistant surgeon, and the central

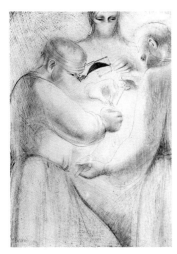

fig.48
Fenestration of the Ear (The Magnifying Glass), 1948, 38 ×
27.3 (15 × 10¾), oil and pencil on board, Bolton Art Gallery

female figure is his private theatre sister, Margaret Moir, who coincidentally later became Hepworth's secretary.

One of the six works in this series, listed in the artist's catalogue as '*Fenestration of the Ear No.6* (little one) blue drapery 1948', was never photographed and its current whereabouts is unknown. However, for the earlier catalogue, Miss Moir listed the other five in the order of the processes they depict. The first in that scheme is *Fenestration of the Ear (The Beginning)* (fig.45); the second is the Tate's; the third, *Fenestration of the Ear (The Lamp)* (fig.46); *Fenestration of the Ear (The Microscope)* (fig.47) is the fourth and *Fenestration of the Ear (The Magnifying Glass)* (fig.48) the fifth.

Annotations made by the artist in the Science Museum sketchbook suggest a different sequence of events. A note on page 27, probably made at the time and possibly based on a discussion with the surgeon, lists '3 stages' of the operation: '1st by eye (mastoid op) | 2nd with magnifying glass – making skin flap | 3rd with microscope making new hole'. It may be, therefore, that if the works are to be listed according to the sequence of the operation's processes the fourth and fifth works should be interchanged. However, it is not certain that the artist intended such a narrative structure as the works were not executed in that order. *The Hammer*, *The Lamp* and *The Magnifying Glass* are all dated April 1948 and *The Beginning* and *The Microscope* May. Unexplained numbers on the reverse of the artist's photographs of the paintings may suggest an alternative order: *The Hammer* is numbered 33, *The Microscope* 35 and *The Beginning* 36. The other two are not numbered, but as they are dated April they may be supposed to be 32 and 34. If one were to number *The Magnifying Glass* 32 and *The Lamp* 34 the series could be seen to develop in pairs. Both *The Magnifying Glass* and *The Hammer* are vertical compositions and offer an elevated view of three-quarter length figures in similar poses. *The Lamp* and *The Microscope* are horizontal, include three closely related figures (there is a fourth in the latter picture) and feature the tubular form of the canvas-encased drill used by the surgeon. *The Beginning* is unlike the others in that it shows the scene as viewed from a different position and includes a sketchily rendered head, which, it has been suggested, may be a self-portrait.[11] That the six fenestration pictures were never shown together may be further indication that Hepworth did not consider them a homogeneous series.

Some of the other works in the series can be related to sketches. To some extent, however, none is as close to a study as *The Hammer*, which was clearly based upon the drawing on page 18 of the surviving sketchbook (fig.49). Though necessarily rendered with great economy, the drawing established the basic figure composition and the details of the surgical instruments. A number of further studies of the detail of the surgeon's hammer and gouge may indicate Hepworth's particular interest in this stage of the operation. It has been proposed that she was attracted to it by its similarity to her own practice of carving.[12] The sequence of drawings in the sketchbook suggests that they depict more than one operation; this is consistent with Margaret Moir's recollection that Hepworth, 'came to the London Clinic on several occasions in the space of two or three weeks, each time a Fenestration Operation was being performed … She did brief sketches during these visits, at all stages of the operation'.[13] The length of these visits is uncertain, but at the beginning of March 1948, presumably around the time of her visits to the London Clinic, Hepworth wrote to Herbert Read from Cornwall, 'I was in "the theatre" for ten hours one day last week.'[14] That over forty pages have been removed from the front and back of the Science Museum sketchbook might indicate that it had contained drawings of other subjects.

No other documentary narrative comparable to the *Fenestration of the Ear* has been identified among the hospital pictures. While some bear the names of specific operations, the works, more commonly, have general titles; in this, *The Scalpel 2* may be seen as typical. The painting might be considered as a reworking of a smaller painting of the previous year – *The Scalpel* (fig.50). Both consist of three half-length figures –

fig 49
Page from hospital sketchbook, 1948, 25.8 × 20.6 (10⅛ × 8⅛),
pencil on paper, Science Museum

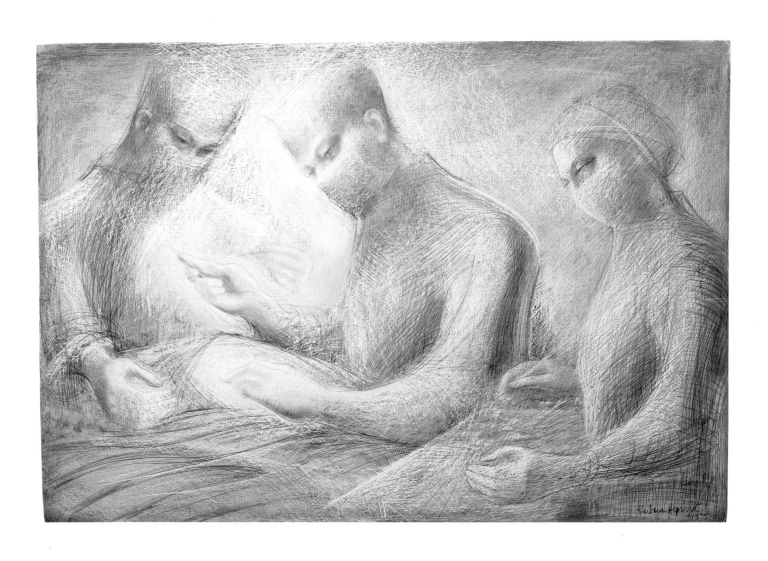

two male doctors and a female nurse – ranged horizontally across the composition. However, in contrast to the symmetry of the first version, the focal point of *The Scalpel 2*, the eponymous instrument, was moved to the left-hand side. The highly burnished area of ground between the two male figures and the gaze of all three figures draws the viewer's eye across.

It may be more useful to associate the Tate's work with other images of three figures arranged formally. In contrast to the *Fenestration of the Ear* series, most of the hospital pictures have an iconic quality which is accentuated by the formality of their composition. While the whole body of works encompasses studies of detail and more complex figure groups, the majority are of two or three people in harmonious arrangements. The stiff poses and slightly rhetorical gestures combine with the *Quattrocento* compositional order to emphasise the works' abstract quality and suggest a symbolic level of meaning. This hieratic feeling prompted Philip Hendy to identify a sacramental quality in the hospital pictures.[15] In this way, the artist elevated the subject and presented compositional harmony as a symbol of social co-operation.

fig.50
The Scalpel, 1948, 38 × 53.3 (15 × 21), oil and pencil on board, private collection

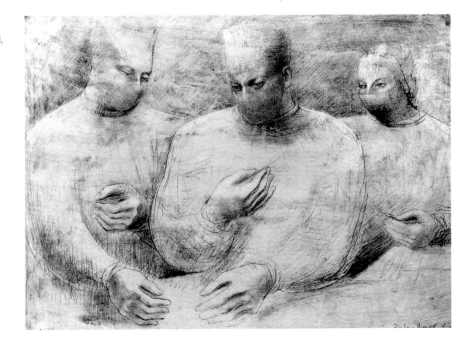

24 Seated Woman with Clasped Hands 1949

L00951

Oil and pencil on board 47 × 35.5 (18½ × 14)

Inscribed in pencil 'Barbara Hepworth 1949' b.r. and on backing board '"Seated Woman with clasped hands" | 1948 oil + pencil | X6611'

On loan from the artist's estate to the Barbara Hepworth Museum, St Ives

Displayed in the artist's studio, Barbara Hepworth Museum, St Ives

Exhibited: New York 1949 (?23 *Seated Figure* or 32 *Seated Woman*); *Six English Moderns: Piper, Sutherland, Hepworth, Tunnard, Moore, Nicholson*, Cincinatti Art Museum, Feb. 1950 (no number); Whitechapel 1954 (122)

Towards the end of 1947 Hepworth returned to drawing the nude figure for the first time since the 1920s. Though they adopt the appearance of working drawings in their use of multiple viewpoints and studies of detail, the results may be seen as finished pictures. In conjunction with the contemporaneous hospital paintings, such as *Fenestration of the Ear* 1948 (no.23A q.v.), they were considered to be a significant departure for the artist and reflect the diversity of her output immediately after the war. As well as being works in their own right, they also contributed to the development of her abstract sculpture into a semi-figurative mode.

Seated Woman with Clasped Hands is typical in Hepworth's employment of a textured gesso-like white ground; this is most probably Ripolin white, a household paint favoured by the artist, in common with Ben Nicholson and, earlier, Christopher Wood. As in *Two Figures with Folded Arms* 1947 (no.22 q.v.), Hepworth applied a grey oil glaze, which was then scraped down to leave a residue of paint in the grooves of the ground, creating a surface of modulating texture and colour. A warmer off-white was then applied to a roughly square area a little smaller than the support and the artist drew over this. The discrete portions of the picture – the main figure, and studies of head and hands – are isolated by the rubbing away of the colour between them in some areas and by the application of grey wash in other places. The basic drawing appears to have been made quickly in fine pencil and some lines, those of the elbow and the profile of the main figure for instance, were strengthened later; a double outline can be seen in various places as a result. Grey wash was used for shading the contours of the figure and traces of what may be conté crayon are discernible along the back of the arm and leg. The sharp, hard continuous pencil line, seen most clearly in the study of the hands on the right-hand side, is typical of Hepworth's drawing at that time and reflects her debt to Ben Nicholson's particularly linear graphic style.

The inclusion of more than one viewpoint in the picture is a characteristic of the figure paintings of the late 1940s and is also seen in *Two Figures with Folded Arms*. In *Seated Woman with Clasped Hands* this resembles the established form of study drawings – examinations of details in relation to a larger image. Hepworth's reported insistence on the model's moving 'about naturally, pausing or resting at certain moments, but never taking up an artificial position' indicates the artist's desire to see the pictures as naturalistic examinations of the human form.[1] However, they were also more contrived. In a number of similar works different views of a single model interlock to produce a Cubist-like multi-faceted figure. Hepworth's semi-figurative sculptures of the late 1940s and early 1950s, such as *Biolith* 1948–9[2] and *Bicentric Form* 1949 (no.25 q.v.), can be seen to have developed from these conglomerate figures, which come to stand for an interaction between two individuals. The process of drawing may thus be seen as part of her formulation of a new sculptural style in which the human figure was brought together with her abstract forms.

Barbara Hepworth 1949

25 Bicentric Form 1949

N05932 BH 160

Blue marble 158.7 × 48.3 × 31.1 (62½ × 19 × 12¼);
weight 400 kg

*Purchased from the artist through the Lefevre Gallery
(Cleve Fund) 1950*

Exhibited: Lefevre 1950 (1, as *Biocentric Form*); *Venice Biennale* 1950 (British pavilion 83); Tate 1968 (57); *St. Ives: Twenty Five Years of Painting, Sculpture and Pottery*, Tate Gallery, Feb.–March 1985 (78); *Retrospective* 1994–5 (41, repr. in col. p.102, Liverpool only)

Literature: J.P. Hodin, 'Barbara Hepworth', *Les Arts Plastiques*, vol.4, no.3, July–Aug. 1950, pp.207–8; David Lewis, 'The Sculptures of Barbara Hepworth', *Eidos*, vol.2, Sept.–Oct. 1950, p.30, repr. p.25; Barbara Hepworth, 'Rhythm and Space', Read 1952, section 5, repr. pls.135–7b; J.P. Hodin, *The Dilemma of Being Modern*, 1956, pp.133–4; Hodin 1961, pp.20, 167, no. 160, repr.; C, F & B 1964, p.278; Jenkins 1982, p.15, repr. p.27; Joanne Prosyniuk (ed.), *Modern Arts Criticism: A Biographical and Critical Guide to Painters, Sculptors, Photographers and Architects from the Beginning of the Modern Era to the Present*, II, 1992, p.263 (as *Biocentric Form*); Michael Tooby, *An Illustrated Companion to the Tate St Ives*, 1993, p.45, repr. (col.); Festing 1995, pp.184, 196; Curtis 1998, p.37

Bicentric Form is one of several monumental figure sculptures made by Hepworth at the end of the 1940s and in the early 1950s. Their semi-abstract style, a synthesis perhaps of her more pure abstraction and the figure drawings of the preceding years (e.g. no.22 q.v.), came to characterise her work of the period. That the works coincided with an especially successful moment in her career helped to ensure their prominence in the establishment of her reputation. *Bicentric Form* was a central feature of her exhibition at the Venice Biennale in 1950, displayed at the entrance to the British pavilion, and the comparable, though larger, two-figure *Contrapuntal Forms* 1950–1 (fig.51) was her major contribution to the Festival of Britain in the following year. Hepworth's success was also reflected at that time by her acquisition of a new studio, Trewyn, in the heart of St Ives in September 1949. From that date all of her sculptures were made there (e.g. fig.5) or, later, in a neighbouring studio; it is most likely that *Bicentric Form* was one of the works which she began in Carbis Bay and completed at Trewyn. It was the first of her works to be acquired by the Tate and remained the only example of her sculpture in the collection until 1960.

The artist told the Tate Gallery that *Bicentric Form* 'was carved during a period when my main interest was in the fusion of the "two form" idea, so that it would be fair to describe [it] as a fusion of two figures into one sculptural entity. I think, from a purely abstract point of view, it was a logical and inevitable development from the separate forms in association'.[1] Earlier, she had explained how that synthesis of figures was related to the nude drawings she had been producing since 1947, such as *Two Figures with Folded Arms* 1947 (no.22 q.v.). She wrote in 1952 that the drawing of groups of figures led her 'to renewed study of anatomy and structures as well as the structure of integrated groups of two or more figures. I began to consider a group of separate figures as a single sculptural entity, and I started working on the idea of two or more figures as a unity, blended into one carved and rhythmic form'. *Bicentric Form*, she specified, was one of many carvings on that theme.[2]

It is unclear whether the two figures from which *Bicentric Form* was developed were seen by the artist as two distinct individuals or two views of a single person. Many of the pictures to which she related the sculpture were, as with *Two Figures with Folded Arms*, multiple aspects of the same model. Alan Bowness has suggested that the sculpture may be associated with the drawing *Interlocking Forms* 1950, which also shows two images of the same figure.[3] The contemporaneous sculpture *Biolith* 1948–9 was clearly based upon a Cubist-like double view of the head of the model identified as Lisa. However, one could also relate *Bicentric Form* to such drawings as *Three Groups (Blue and Yellow Ground)* 1949, in which male and female figures face each other in an embrace.[4] Intimacy between male and female was an aspect of other works of the period: both *Two Figures* 1943 and *Contrapuntal Forms* are clearly gendered and, it has been suggested, the Giacometti-like incised hand of *The Cosdon Head* 1949 (fig.52) may be seen as an intimate caress.[5] While such works have been considered in light of

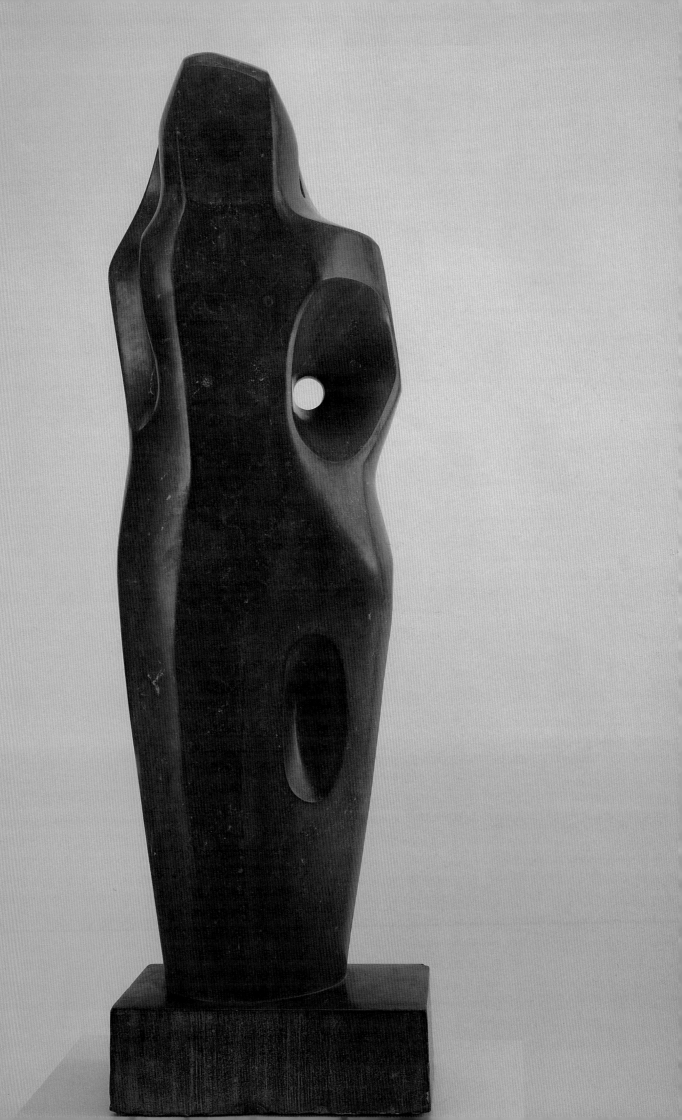

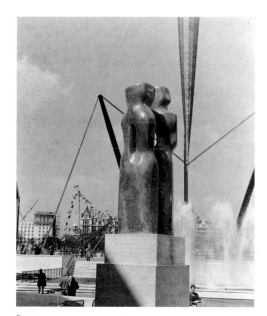

fig.51
Contrapuntal Forms, 1950, height 305 (120), blue limestone, BH 165, Harlow Art Trust, photographed on original site at the Festival of Britain

the complexity of the artist's own personal relationships at that time, in particular the gradual collapse of her marriage to Ben Nicholson, she also viewed human interaction in more general and symbolic ways.[6]

The physical and spatial relations between figures was a dominant concern in much of Hepworth's work and especially at that moment. The development from the balance of abstract forms in works such as *Discs in Echelon* 1935 (no.10 q.v.) to the association of human figures represents a significant shift in emphasis. The change, which must be seen as part of a return to figuration by many artists after the Second World War, was witnessed most dramatically in her depictions of operating theatres (no.23 q.v.). The artist suggested that these studies demonstrated how formal harmony was significant of co-operative action and, by extension, of social cohesion. The idea of a collective society and, specifically, the question of the artist's role within it was a major concern of Hepworth's. In her work the relationship between a figure and the landscape, or between two or more figures, can be seen to address these issues. As their titles suggest, the organic synthesis of two entities into one in *Bicentric Form* or the harmonious deportment of a group as in *Contrapuntal Forms* illustrate the themes of intimate and social co-operation.

At the time of *Bicentric Form*'s exhibition at the Venice Biennale, David Lewis, then Hepworth's secretary, identified the group of works to which it belonged as 'unmistakably archetypal'. He wrote: 'Their lithic forms are synonymous with the most ancient of man's symbols, the monolith, lonely and foreboding, a form which she has arrived at intellectually and unconsciously, the latter, absorbed from the cromlechs and stone circles and granite obelisks of the Cornish landscape of Penwith, affirming its rectitude.'[7] A similar affinity to ancient standing stones has been identified in *Contrapuntal Forms*, where 'the perceived timeless and changeless past of England' combined with the futurism of the Skylon (fig.51) exemplified an ambiguity that ran through the Festival of Britain and which played 'a crucial role in reformulating the history of the modern nation'.[8] The conjunction of ancient and modern symbolised 'a Janus-faced nation' which was both progressive and regressive, constructing, it is argued, 'an image of England … as an impossible unity'. As with the larger work, the combination in *Bicentric Form* of the megalith and the theme of interaction might be thought to define what has been described as 'the socialist history of the nation … as an unconflicted and inevitable linear progress'.[9]

While his reading of *Bicentric Form* as a single figure is in contrast to Hepworth's description, Lewis echoed her in discussing the works in terms of man's existential state. Like the ancient stones, he said,

these carvings stand as solitary testimony to man's contemporary failure to achieve harmony between his universe and his being, between the changing and the unchangeable; like them, in the still security of their solitariness, bound by immutable laws, they testify towards the achievement of that essential relationship, the only ultimate solution.[10]

The association of Hepworth's figures with the 'archetypal' and the suggestion that her response to the ancient monuments of Cornwall was 'unconscious' reflect the widespread interest in the theories of Carl Jung among artists in St Ives after the war. Parallels were drawn between their use of landscape and earlier traditions through the Jungian concept of the 'Collective Unconscious', a shared memory that operates across different generations and cultures. The belief in such an idea underlies Lewis's proposition that Hepworth's absorption of ancient monuments, as reflected in the work, possessed a certain 'rectitude' because it was unconscious. This was part of a wider strategy to establish an art form that was at once figurative and absolute – a dialectic also proposed by Herbert Read – as a humanist answer to the relationship of man to the universe.[11] Such a use of primitive cultures and abstract ideas is a feature of many attempts to counter modern alienation, particularly after the war when the absolutes upon which the abstraction of the 1930s had been based were under scrutiny.

fig.52
The Cosdon Head, 1949, height 61 (24), blue marble, BH 157, Birmingham Museums & Art Gallery

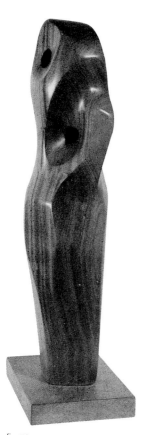

fig.53
Bimorphic Theme, 1948-9, height 78.8 (31), mahogany, BH 152, private collection

Hepworth's return to figuration received a mixed reception. Patrick Heron, writing in the *New Statesman*, welcomed the 'human form' which he saw 'press[ing] through the skin of the lop-sided sphere'. Hepworth, he said, was 'enhancing, not diluting, the quality and power of her own abstraction. The addition of an element of representation has resulted in her abstract rhythm being elevated from a geometrical to a poetic condition'.[12] In contrast, John Berger insisted that, despite its human forms, her work still lacked a human presence, illustrating his point with the recollection that when '*Contrapuntal Forms* arrived at the South Bank for the Festival [of Britain], the workmen who unloaded them spent a long time searching for an opening or a hinge because they believed that the real figures must be inside'.[13] Hepworth's showing at the 1950 Venice Biennale, which was dominated by *Bicentric Form* and *Biolith*, was received with similar equivocation. Following Moore's success in 1948, there was little interest in her display, and the idea of her as his follower was established.

The origin of *Bicentric Form* in two figures is reflected by its dual aspect. The figure and its integral base were carved from a single piece of marble of varying colour. Vertical traces of cutting on the base show that its sides mark the parameters of the original block. There are numerous faults in the stone, including a long crack across one 'face', and several chips have been lost from around the edges. There are two areas of about 10 mm of buff-coloured fill on the head. The sculpture's form may, to some extent, have been dictated by the conditions within which it was made. The scale and intractable materials of many of the works of that period, and the success and growing reputation which they reflect, forced Hepworth to take on assistants for the first time. To cope with the volume of work in the run-up to the Venice Biennale and the Festival of Britain in 1951 she employed the artists John Wells (1949, 1950–1) and Terry Frost (1950–2). In 1949 she also took on Denis Mitchell, who remained her senior assistant until 1959 and became a successful sculptor himself as a result. The planar style of *Bicentric Form* became a characteristic of many of Hepworth's stone carvings and may have been influenced by her need to give the assistants directions by drawing on the stone, which imposed an inevitable linearity on the resultant design.

Bicentric Form appears to be a reworking of the slightly earlier carving in mahogany, *Bimorphic Theme* 1948–9 (fig.53). The smaller scale (78.7cm high) and different material gives the earlier piece a sinuous elegance that contrasts with the emphasis on planes and mass in the Tate's work. This may reflect the fact that the wood would have been carved by Hepworth herself and used, perhaps, as a guide for her assistants when carving the more resilient stone. The similarity and differences between the two works may thus indicate her attempts to develop a successful workshop practice.

26 Apollo 1951

LOO945 BH 167

Painted steel rod 154 × 105 × 86 (60⅝ × 42½ × 33⅞)
set in concrete base 17.5 × 38.5 × 35.5 (6⅞ × 15⅛ × 14)

On loan from the artist's estate to the Barbara Hepworth Museum, St Ives

Displayed in the artist's garden, Barbara Hepworth Museum, St Ives

Literature: Hodin 1961, p.167, no.167; Festing 1995, pp.201–2

Reproduced: *Pictorial Autobiography* 1970/1978, pp.61–2, pls.169, 171

In 1951, at the invitation of the theatre producer Michel St Denis, Hepworth designed a production of Sophocles' *Electra* at the Old Vic theatre, London. The play ran from March until April 1951 and starred Peggy Ashcroft in the title-role. Hepworth would return to theatrical design four years later when she worked on Michael Tippett's opera, *The Midsummer Marriage,* at Covent Garden. For *Electra*, as well as a pure white set and costumes in primary colours, the artist produced this sculpture from bent steel. Its title suggests that the work served as a representation of the god Apollo, who does not actually appear in the drama, but whose presence is a recurrent theme. In particular, in the penultimate scene, when Orestes and Pylades go to murder Clytemnestra, Electra beseeches the god to aid their venture. It seems likely that it is Ashcroft's portrayal of this entreaty that is recorded in one of the published photographs.[1] Others show the sculpture located stage left, at the front, sitting on a larger base than now, so that it rose considerably above head height.[2] The original base appears to have been oblong in plan with the corners scooped out, so slightly reminiscent of the fluting of a classical column.

Apollo was made by Denis Mitchell from Hepworth's bent-wire maquette, using two mild steel rods, which define a volume whilst also appearing as a drawing in space.[3] The work's combination of three-dimensionality with the linearity of its components make photographs especially deceptive. Nevertheless, one may see the rods as describing a form which, though entirely abstract, is reminiscent of the incised profiles in such earlier carvings as *Sculpture with Profiles* 1932 (no.4 q.v.). This graphic element seems to have derived from Picasso's appropriately classical paintings and drawings; the material also recalls his wire sculptures, such as the *Design for a Monument to Guillaume Apollinaire* 1928, but these tended to be in a rectilinear form that is in contrast to the marked gestural quality of *Apollo*.[4] The freedom of form most closely resembles the images which Picasso produced by drawing in the air with a torch for the photographer Gjon Mili, photographs of which were reproduced in *Life* magazine in January 1950.[5] Hepworth later developed a graphic conception of sculpture with the works associated with *Meridian*, such as *Garden Sculpture (Model for Meridian)* 1958 (no.46 q.v.), which relate to her gestural paintings and interest in Tachisme.

The use of steel was unprecedented in Hepworth's oeuvre and reflects her response to the latest sculptural forms and practices. In the early 1950s a number of British sculptors, influenced by Giacometti's post-war figures, produced spiky metal sculptures. In particular, Reg Butler, a former blacksmith, had made works from welded and forged iron since 1948, most notably *Birdcage* 1951 (fig.54). Though these methods might be related to constructivist techniques, the resultant sculptures are very far from the sinuous elegance of Hepworth's work. She knew and admired him: 'I like Reg Butler's work a lot. We've had some good talks here in the garden', she told Herbert Read in 1952. She distinguished his work from that of younger artists whom she saw as his followers: 'His figures have a nervous energy which is sculpturally valid. Many of the younger people are just quite simply neurotic in their approach and create a nervous

disintegration.'[6] The sculptures, which Read characterised with his phrase 'the geometry of fear', certainly appear a long way from Hepworth's persistent belief in art's affirmative function.[7]

The ends of the rods of *Apollo* are gathered into a small steel support; though visible in earlier photographs, this is now covered by the coarse sand aggregate concrete into which the sculpture has been cast. The two rods are welded together where they pass over each other at the top. They were painted with red primer, followed by a dull silver top coat. They have probably been repainted several times, and in 1980 Tate Gallery conservators noted extensive blistering and losses of paint, especially towards the base. In 1989 and again in 1997 the flaking paint was stripped and the metal was repainted with two coats of primer and three of silver paint.[8]

Though Hepworth later produced many works from sheet metal, only *Form in Tension* 1951–2 repeated the use of steel rods and they were later removed and the work retitled *Poised Form* (no.28 q.v.). She did make a second version of *Apollo* which, despite the apparent improvisatory nature of its manufacture, is almost indistinguishable in reproduction. Originally in the collection of Elizabeth MacDonald and in New York for a time, that version was exhibited in London in 1988.[9] According to Tommy Rowe it was repaired, restored and given a new base by Denis Mitchell after Hepworth's death.[10]

fig.54
Reg Butler, *Birdcage*, 1951, 412 × 198, iron, English Heritage on loan to South Bank Centre, photographed on original site at the Festival of Britain

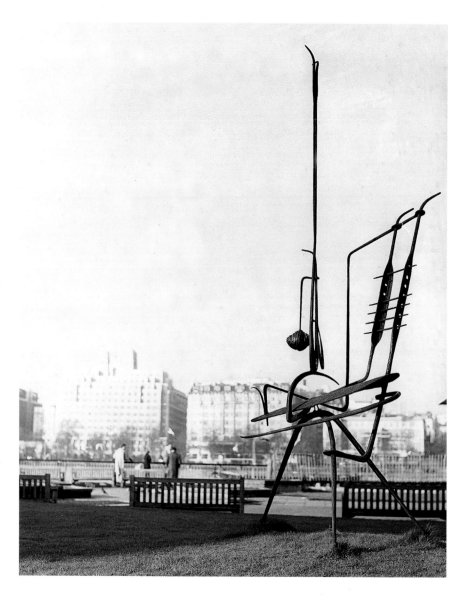

27 Group I (concourse) February 4 1951 1951

TO2226 BH 171

Serravezza marble 24.7 × 50.5 × 29.5 (9¾ × 19⅞ × 11⅝)

Bequeathed by Miss E.M. Hodgkins 1977

Provenance: Purchased from the artist by Miss E.M. Hodgkins *c.*1952

Exhibited: Lefevre 1952 (1, as *Group (Concourse), february 4th 1951*); Whitechapel 1954 (145, repr., as '*Group I – concourse (twelve figures 10")*'); BC European Tour 1964–6, Otterlo (8, repr.); Tate 1968 (58, repr. p.23); *Conferment*, 1968 (no cat., Guildhall); Hakone 1970 (4, repr.); *British Sculpture in the Twentieth Century*, Whitechapel Art Gallery, Sept. 1981–Jan. 1982 (part 2, 70); *St. Ives: Twenty Five Years of Painting, Sculpture and Pottery*, Tate Gallery, Feb.–March 1985 (79, repr. in col. p.68); *Forty Years of Modern Art 1945–1985*, Tate Gallery, Feb.–April 1986 (no number); *Retrospective* 1994–5 (42, repr. in col. p.97)

Literature: David Baxendall, 'Some Recent Carvings by Barbara Hepworth', *Apollo*, vol.56, no.332, Oct. 1952, p.118, repr.; Robert Melville, 'Exhibitions', *Architectural Review*, vol.62, no.672, Dec. 1952, pp.412–13; Hodin 1961, p.167, no.171, repr.; Shepherd 1963, p.39, pl.7; Ronald Alley, 'Barbara Hepworth's Artistic Development', Tate 1968, exh. cat., pp.22–3; *Tate Gallery Acquisitions 1976–8*, 1979, pp.84–9; Jenkins 1982, p.15, repr. p.29; Edward Lucie-Smith, *Sculpture Since 1945*, 1987, p.23, repr. p.22, pl.25; Alan G. Wilkinson, 'Cornwall and the Sculpture of Landscape: 1939–1975' in *Retrospective* 1994–5, exh. cat., pp.90, 97; Festing 1995, p.204

Reproduced: Read 1952, repr. pls.149a & b

This is the first of three similar works which can be seen as the culmination of Hepworth's figure studies of the late 1940s and early 1950s. They reflect the artist's dominant concern of those years: the formal arrangement of figures and its symbolism of a more general harmonious human interaction. They may thus be thought to bring together the formalist values of her abstract sculpture and her socio-political concerns of the 1940s. All three works in the series are entitled 'Group', but each has a different subtitle: in addition to the Tate's these are *Group II (people waiting)* 1952 and *Group III (evocation)* 1952 (figs.55 and 56). Though the number and style of the figures vary, each work is made from the same Serravezza marble and each includes one horizontal element. None of the bases are quite rectangular and that of *Group III* incorporates a raised area.

Denis Mitchell, who worked on the Group sculptures as Hepworth's assistant, recalled that the three works were carved from an old mantlepiece removed from Trewyn, the house next to her St Ives studio, by its new owner.[1] One edge of *Group III* appears to retain the profile of the mantlepiece and this may also be the origin of the curved notch in the front face of the base of *Group I*. Hepworth, according to Mitchell's account, 'was very thrilled' to be given the marble, 'as at that time she had great difficulty in getting materials'.[2] In the 1930s white marble had offered the purity that she desired for her most abstract pieces, such as *Three Forms* 1935 (no.9 q.v.). Later on, in the 1960s, she would produce a significant number of marble carvings – *Image II* 1960 (no.51 q.v.), for instance – but in between those two moments there are only a handful. In 1964 she claimed a special relationship with white marble, the quintessential medium of classical sculpture, which she associated with the Mediterranean sun.[3] In contrast, it is striking that, despite the problems of getting materials, Hepworth did not use local stone until her later slate pieces, such as *Two Figures (Menhirs)* 1964 (no.61 q.v.); she never carved the granite of which St Ives is largely built.

Mitchell recalled that Hepworth was unwell at the time of making *Group I* so that he had to 'keep taking it into her studio to be told what to do next and then [determine] the arrangement'.[4] The distribution of the figures in *Group I* was the subject of thorough consideration in an earlier Tate Gallery catalogue entry.[5] There it was pointed out that the photographs of the work in Hepworth's 1952 monograph show two different configurations: the figure in the back right-hand corner and the one to its left were interchanged and a number of other elements rotated on their axes – most markedly the two at the front.[6] When the work was acquired by the Tate the figures were in the same places as they appear in the second photograph, though again some had been rotated; they remain in that state. Despite earlier speculation, there is little doubt that the artist's arrangement was considered definitive.[7] This may be confirmed by the fact that the individual figures in another of the series, *Group III*, each have a number incised on their underside which corresponds to a numbered outline on the base. Terry Frost, who also worked on *Group I*, told the Tate:

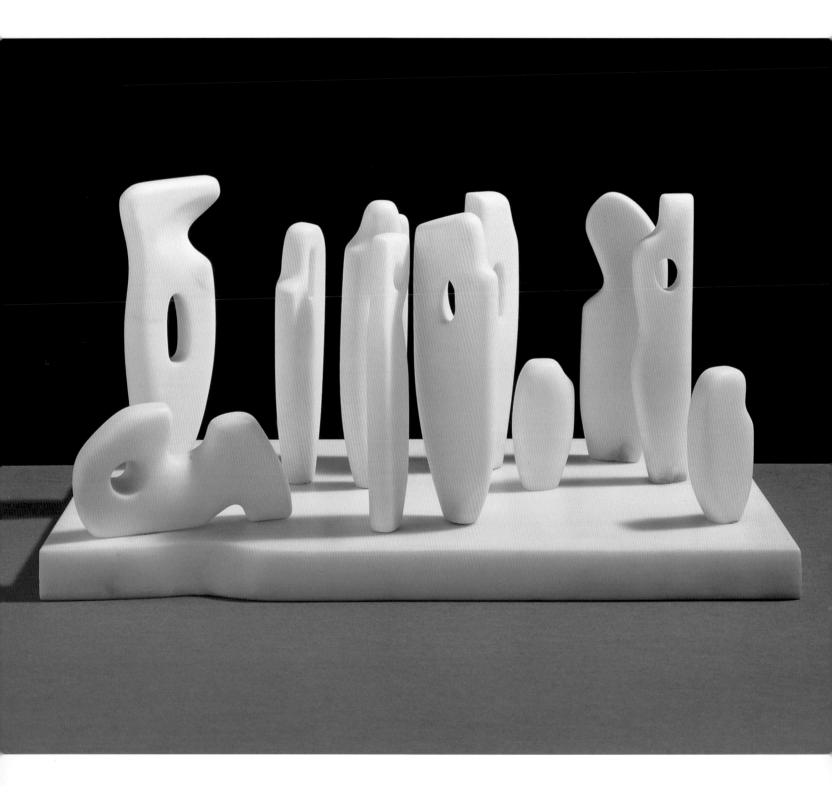

I am certain … that Barbara moved the elements quite a lot. I know I sat in the evening with her at one time talking about them and we looked at all the possibilities … At first the elements were interchangeable of that there is no doubt; but knowing Barbara I can't imagine her wanting them moving once they were well and truly pinned.[8]

The positioning of the figures must have been decided upon fairly early in the production process as a photograph of the work, taken when they were roughed out and still bore the artist's pencil markings, shows an arrangement close to the final composition (fig.57). The right-hand figure of the foremost pair and that in the back right-hand corner were swapped around, as were the two small forms, and most of the figures were rotated; otherwise the basic layout remained the same. The photograph appears to show pencil dots on the base which may have been potential locations for the figures. It is thus clear that the form of each figure and their positions across the base were planned before the individual details were finished. The artist's executor, Alan Bowness, has suggested that the presence in Hepworth's estate of two unfinished figures for this work may indicate that she 'had problems' with them.[9] Stains from the rusting of the steel pins on which they stood offer one explanation for their abandonment.

Bowness believes that the 1952 photograph which shows a different arrangement was taken before the sculpture was complete. Though the individual elements appear finished, this may be borne out by the fact that the second vertical figure from the left is now pierced right through where, in the 1952 photograph, it was only slightly hollowed out. Bowness also reported that Dicon Nance, an assistant to Hepworth in the 1960s, recalled twice making repairs to the sculpture. One occasion was prior to her 1968 Tate retrospective and the other, Bowness suggests, was in preparation for her show at the Kröller-Müller in 1965. As Miss Hodgkins, the owner of the sculpture, was a friend of the artist and had been a close neighbour in Carbis Bay, it would have been easy for it to be taken back. According to Bowness, Nance remembered that when *Group I* returned to the studio, 'the pieces were loose and some had been put in incorrect positions … [Hepworth] realized that the work, when restored, did not look like the [1952] photographs, but she was not worried about this'. It was at that time that the original steel nails, which had secured the pieces but had rusted, were replaced with stainless steel pins and were further secured with a synthetic resin.[10] A number of the vertical elements and the adjacent area of the base had become stained by the rusting of the nails. The bottom of one figure has also split slightly, possibly as a result of the expansion of the corroding steel. A yellow stain by the foot of the 'reclining figure' may be old adhesive as that element is secured by only one pin, located in the larger section of its underside. Stains near to the tops of a few figures were probably always present in the stone.

The suggestion that the artist had a clear idea of where each piece should be located is confirmed by her 1952 description of *Group I* in terms of 'twelve separate forms each bearing a specific and absolute position in relation to the others'.[11] In this way Hepworth identified a common theme running between the abstract pieces of the mid-1930s, such as *Three Forms* 1935 (no.9 q.v.), and the Group series. That theme, she said, was 'the exploration … in which I hope to discover some absolute essence in sculptural terms giving the quality of human relations'.[12] The assembly of figures was a motif to which she would return throughout her career, notably with *The Family of Man* 1970 (fig.7). Between 1947 and 1949 Hepworth had made a series of paintings of surgical operations (nos.23A & B q.v.) in which, she explained, harmonious spatial compositions were indicative of co-operative endeavour and social cohesion. Two of those paintings were, like *Group I*, entitled *Concourse*.[13] In an article on the second of these paintings, *Group I* was described, presumably with Hepworth's approval, as a 'sculpture derived from the ideas of the drawings'.[14] No obvious link between the carving and the pictures is apparent beyond the fact that they both show a coming together of figures – the definition of 'concourse'.

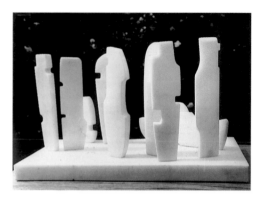

fig.55
Group II (people waiting), 1952, 25.4 × 50.8 × 292 (10 × 20 × 11 ½), marble, BH 181, private collection

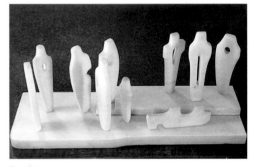

fig.56
Group III (evocation), 1952, 22.8 × 52 × 20.3 (9 × 20½ × 8), marble, BH 182, The Pier Gallery Collection, Stromness

fig.57
Group I in progress, 1951

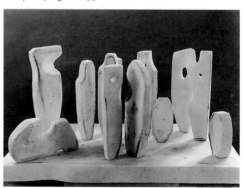

As the earlier Tate catalogue explains, Hepworth associated *Group I* with her visit in May 1950 to the Venice Biennale, in which she was showing. The year after she made the sculpture she recalled her visit:

Every day I sat for a time in the Piazza San Marco … the most significant observation I made for my own work was that as soon as people, or groups of people, entered the Piazza they responded to the proportions of the architectural space. They walked differently, discovering their innate dignity. They grouped themselves in unconscious recognition of their importance in relation to each other as human beings.[15]

This echoed her discussion of the hospital pictures, but the larger space of a city free from motor traffic enabled the analogy of spatial and human relationships to be expanded. In the same essay, Hepworth remarked that she 'was fortunate enough to watch from the balcony opposite San Marco the deeply moving ceremony of the procession of Corpus Christi round the Piazza'. She may have been attracted to the conception of the Piazza as the focus of civic life and a precedent for the depiction of that theme was available in Gentile Bellini's *Processione in Piazza San Marco* 1496, in which the orderly clusters of figures may be compared with *Group I*.[16]

It seems probable that, while in Venice, Hepworth would have seen Giacometti's *Piazza* 1947–8 in the collection of Peggy Guggenheim at the Palazzo Venier.[17] With Herbert Read – a friend of both Hepworth and Guggenheim – in Venice for the Biennale, it is likely that sculptor and collector would have met. In any case, Giacometti's sculptures of figures crossing an open space, like *Piazza*, were already a considerable influence on a number of younger British artists. However, the intention behind Giacometti and Hepworth's works is very different. While Giacometti shows individuals isolated from one another in an apparent comment on urban alienation, Hepworth's aim is typically affirmative. She sees them instinctively entering into an integrated whole – both human and social – and recognised 'particular movements of happiness springing from a mood among people'.[18] The smoothness of her forms and purity of their colour and material is equally distinct from the textured bronze of Giacometti.

Though the dispersal of organic forms across a horizontal plane in *Group I* has also been compared to both Yves Tanguy's biomorphic paintings of the 1940s and 1950s and to the standing stones in the Cornish landscape,[19] one might say more generally that the sculpture has a marked theatrical character. In particular, the focus on a pair of figures positioned at the front edge with others ranged behind them gives it the appearance of a stage set. Hepworth worked on designs for a number of theatrical productions, the first of which, Sophocles' *Electra*, was staged at the Old Vic, London, in March 1951. She later described the set as 'pure white' and recalled the director, Michel St Denis, moving three-inch figures around a model of it.[20] If the date in the title of *Group I* signifies that of its completion, she would have been carving it at around the same time as working on the designs for *Electra*.

Group I (concourse) February 4 1951 is the only work by Hepworth to bear such a precise date. It was used in the catalogue for the work's first showing and Alan Bowness told the Tate Gallery that the artist insisted on its inclusion in his 1961 catalogue raisonné of her work.[21] The titling of works with a date was a practice of Ben Nicholson's and the initialling of the month with the lower case in the 1952 catalogue is an especially Nicholsonian device. It has not, hitherto, been possible to establish the date's significance for Hepworth, though Bowness has speculated that it 'is more likely to be personal and private than simply the date of completion'.[22] If that is the case, the sculpture could have been made after 4 February, though it seems probable that the date and the production would be proximate in time. The date may be related to the dissolution of the artist's marriage to Nicholson, which would give its style a particular resonance. The two separated at the beginning of December 1950 and their divorce was finalised on 3 April 1951. The production of a work concerned with human interaction in the middle of that process might thus take on a special poignancy.

28 Poised Form 1951–2, reworked 1957

TO3134 BH 172

Blue Purbeck marble 117 × 45.5 × 38 (46 × 17⅞ × 15) set in
a white painted concrete base 17 × 52 × 72.5 (52¾ × 20½ ×
28⁹⁄₁₆)

*Presented by the executors of the artist's estate, in
accordance with her wishes, 1980*

*Displayed in the artist's garden, Barbara Hepworth
Museum, St Ives*

Exhibited: Lefevre 1952 (2, as *Form in Tension*); *2a
Rassegna Internazionale di Scultura all'Aperto*, Villa
Mirabello, Varese, Aug.–Sept. 1953 (64, repr., as *Form in
Tension*); Whitechapel 1954 (146, as *Form in Tension*)

Literature: Hodin 1961, p.167 no.172, repr. (as *Form in
Tension*)

Reproduced: Read 1952, pls.156–157b (as *Form in Tension*)

A stone monolith, *Poised Form* was originally exhibited in a different state: as *Form in Tension*, it was shown between 1952 and 1954 ringed by two steel rods (fig.58). Alan Bowness has said that the artist reworked the piece as she 'was not happy about the combination of marble carving and metal rings, so she removed them [the rings] after the Whitechapel exhibition'.[1] The artist's album of her work states that the sculpture was reworked in 1957, though it was reproduced in its original form in 1961.[2] A comparison of *Poised Form* with photographs of *Form in Tension* demonstrates that the circular concavity on one face was added when the rings were removed; it was presumably at that time that the stone was set in a new concrete base.

The Blue Purbeck marble from which *Poised Form* was carved – actually a pale grey limestone – is rich in small fossil deposits which give the surface a varying appearance. The original faces of the sculpture have a smooth finish, while the concavity shows claw-marks. On its acquisition by the Tate, the work was found to bear the scars of prolonged display in the artist's garden: the surface had been stained by snails and bird lime and there was algal growth in the fissures in the block. The surface had also been finely scored, perhaps as a result of cleaning with wet and dry abrasive paper. The sculpture was cleaned to remove grease, ingrained dirt and salts were removed and a biocide was applied to kill the algae; the fissures in the stone were filled.[3]

The combination of carved stone and metal in *Form in Tension* is unusual in Hepworth's work. The stone is close in appearance to that used for *Contrapuntal Forms* (fig.51), the monumental figure group commissioned for the Festival of Britain (1951). In contrast, the wrought iron may be compared with its use by younger British sculptors. Hepworth especially admired 'nervous energy which is sculpturally valid' in the work of Reg Butler who visited her in St Ives around this time.[4] She adopted bent iron rod in *Apollo* 1951 (no. 26 q.v.), a work conceived for the 1952 Old Vic production of Sophocles' *Electra*. This, however, was distinct from the rods of *Form in Tension* as it was painted a silvery colour. It seems likely that the two versions of *Apollo* and *Form in Tension* were produced around the same time, which may be borne out by the artist's dating of this work as 1951–2. It is not clear why the artist gave *Form in Tension* this expansive dating, though in the catalogue of her 1952 exhibition all the carvings were listed under 'Sculptures, 1951–2'. If the works were listed chronologically, *Form in Tension*, which was second after *Group I* 1951, may have been completed in 1951. On the other hand, the two dates may suggest that the iron rods were added slightly later.

Unusually for that period, Hepworth developed *Form in Tension* from a maquette, which is made of plaster and lead wire and is listed in her catalogue as *Maquette for Garden Sculpture*.[5] The central form is different in the model as a result of the nature of the material: it is more matt in finish, lighter in weight and has a more organic shape than the stone. In addition, it has three metal elements which arc around the main form, the lowest of which was omitted from *Form in Tension*. The use of a maquette marks a distinction from Hepworth's carvings in its suggestion of a Constructive production

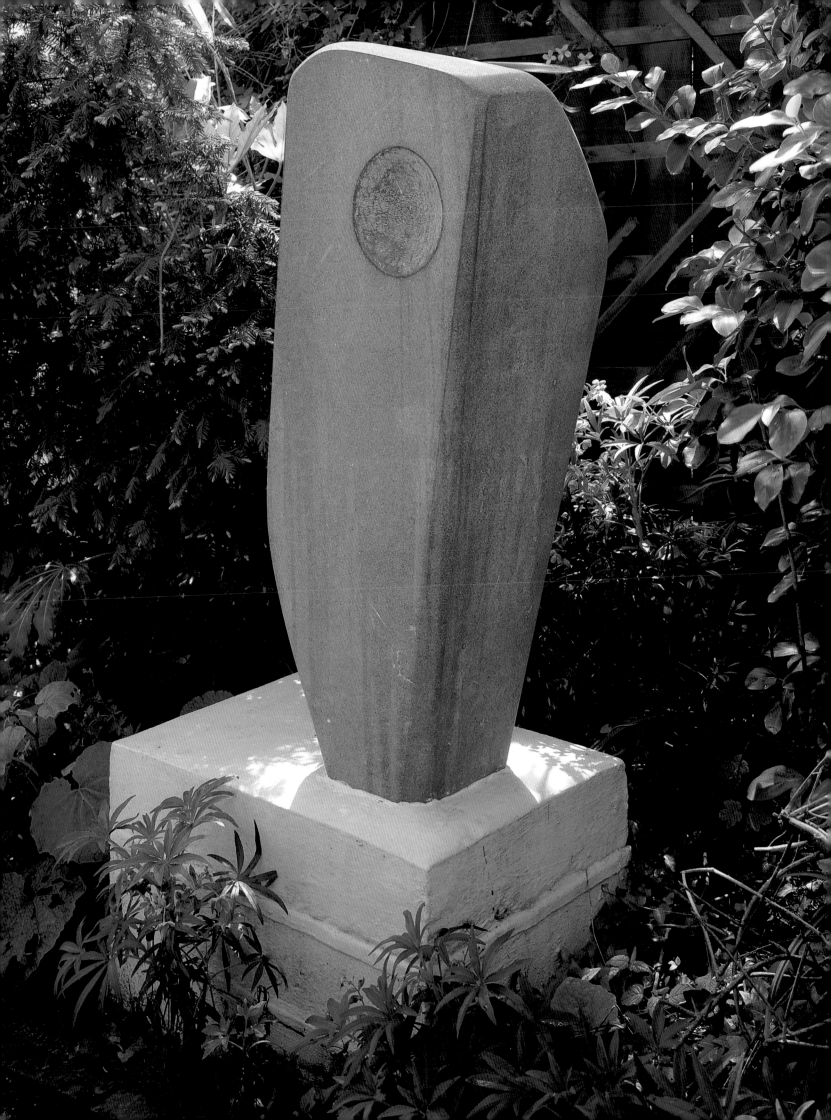

process.[6] Its title may reflect the original conception of *Form in Tension*, which was exhibited outside at Varese in 1953, was displayed in Hepworth's garden and was one of the first works to be photographed with St Ives parish church as a backdrop.[7] It seems likely, however, that the artist called the model *Maquette for Garden Sculpture* in view of those photographs. It may also be significant that Priaulx Rainier, the South African composer to whom Hepworth gave the maquette, helped her to design the garden.

It has been suggested that *Form in Tension* and its maquette might be compared to images of atomic structures in which electrons orbit, diagrammatically, a nucleus.[8] The atom and atomic power were dominant concerns at the beginning of the 1950s. Forms based upon atomic structure were a leitmotif of much of the design at the South Bank site of the Festival of Britain, where Hepworth's *Contrapuntal Forms* was a major feature. It has been observed that 'the atom was a heavily loaded sign' at a time when anxieties over the war in Korea were heightened by the explosion of two nuclear bombs in the Nevada desert in January 1951 and the first testing of the hydrogen bomb in the Pacific in the following May.[9] The delicate balance of the leaning block, alluded to by the title *Poised Form*, may be seen to contrast with the 'tension' of the original sculpture and its title.

fig.58
Form in Tension, 1951-2, height 142.2 (56), blue Purbeck marble and steel, reworked as *Poised Form*

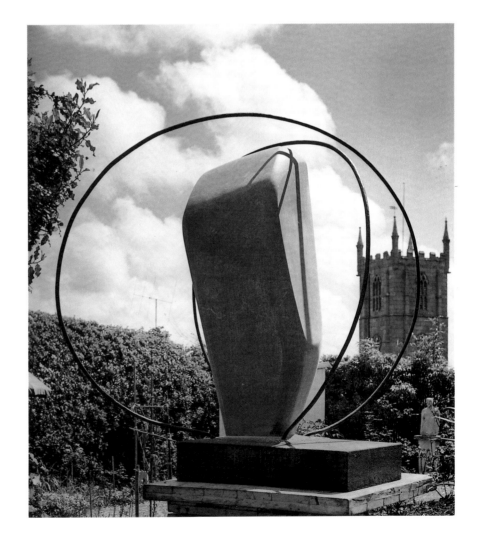

29 Image 1951–2

L00946 BH 173

Hoptonwood stone 150 × 33.5 × 34 (59¹⁄₁₆ × 13³⁄₁₆ × 13³⁄₈)
on a concrete base 10 × 51 × 46 (4 × 20⅛ × 18⅛)

On loan from the artist's estate to the Barbara Hepworth Museum, St Ives

Displayed in the artist's garden, Barbara Hepworth Museum, St Ives

Exhibited: Lefevre 1952 (3); *2e Biennale voor Beeldhouwkunst*, Middelheimpark, Antwerp, May–Sept. 1959 (54); *Sculpture in the Open Air: London County Council Third International Exhibition of Sculpture*, Holland Park, May–Sept. 1954 (13); *Documenta: Kunst des XX. Jahrhunderts*, Museum Fridericianum, Kassel, July–Sept. 1955 (223, pl.103); *Exposition internationale de sculpture contemporaine*, open-air exh., Musée Rodin, Paris, 1956 (catalogue not traced); *Spring Exhibition*, Penwith Society of Arts, St Ives, spring 1956 (48); Newcastle 1956 (17, as 'collection British Council'); *Contemporary British Sculpture*, AC open-air tour, Leamington Spa, May–June 1958, Shrewsbury Festival July–Aug., Cardiff, Aug. (14, pl.1); *Modern Sculpture*, Leeds City Art Gallery, Oct.–Nov. 1958 (22, pl.15); São Paolo Bienal 1959 (7) and BC South American tour 1960 (6); ?*Italia '61*, Turin, 1961 (catalogue not traced); BC European tour 1964–6: Copenhagen (7), Stockholm (8), Helsinki (7), Oslo (7), Otterlo (7), Basel (6), Turin (7, repr.), Karlsruhe (6), Essen (6); Tate 1968 (59, repr. p.22)

Literature: Hodin 1961, p.167, no.173, repr.; Hammacher 1968/1987, p.115

Reproduced: Read 1952, pls.155a–b; David Lewis, 'The Artists of West Penwith', *Go*, March–April 1953, p.43

Image may be seen as an archetypal Hepworth carving. Its essential shape – a curved, three-sided column that broadens as it rises before narrowing slightly at the top – follows that of the *Single Form* pieces originated in the 1930s (e.g. no.12) and would recur in one of the figures of *Conversation with Magic Stones* 1973 (no.75 q.v.).

The fossils which characterise Hoptonwood stone are denser towards the left-hand side and an especially prominent one cuts across the most forward of the top corners. A majority of Hepworth's stone carvings from the decade after the war were from indigenous materials and this reflects the scarcity of more exotic stones and her financial restrictions. There are several lighter areas which are natural variations in the stone. The sculpture was cleaned in 1998 as prolonged exhibition out of doors had resulted in orange staining from an overhanging Magnolia tree and lichen and algal growth over much of the surface. Early photographs suggest that the current concrete base is not original.

The artist related *Image* to the motif of the figure in the landscape, the predominant theme of her work since the early 1940s. Landscape provided a point of departure for two types of sculpture. The majority are enfolding forms, such as *Pelagos* 1946 (no.20 q.v.), in which the morphology reflects her conception of the earth wrapping around the body. In contrast, she saw *Image* in terms of a single figure standing in the landscape. In 1958 she related it to later works which she produced after her visit to Greece, such as *Corinthos* 1954–5 (no.32 q.v.). She believed that in West Penwith, as in Greece, the sea's proximity created a particular quality of light in which,

the vertical power of a human figure is … accentuated. In this pure light the solitary human figure, standing on hill or cliff, sand or rock, becomes a strong column, a thrust out of the land, as strong as the rock itself and powerfully rooted: but the impression overall is one of growth and expansion, a rising form which reaches outwards and upwards, an *image*, or symbol of the span of time. This is my own reaction to the effect of light and space on a figure seen in West Penwith in Cornwall.[1]

In 1943 she had, similarly, described the more starkly abstract *Single Form* motif as 'born of [a] particular sort of landscape'.[2] Her addition of the term 'eikon', Greek for 'image', to the bronze of *Single Form* 1937–8 (no.12 q.v.) reflects this continuum. In 1954, Hepworth explained that *Image* was an attempt to synthesise her experience and 'a particular quality of the landscape'. She concluded, 'In this way the forms and piercings, the weight and poise of the sculpture also become evocative – a fusion of human experience and myth'.[3] The reference to myth implied her awareness of the history and past culture of a landscape and alluded to the megaliths of Penwith. These had been associated with her work since J.D. Bernal's introduction to her 1937 Lefevre exhibition and continued to be registered in later pieces such as *Two Figures (Menhirs)* 1964 (no. 61 q.v.).[4]

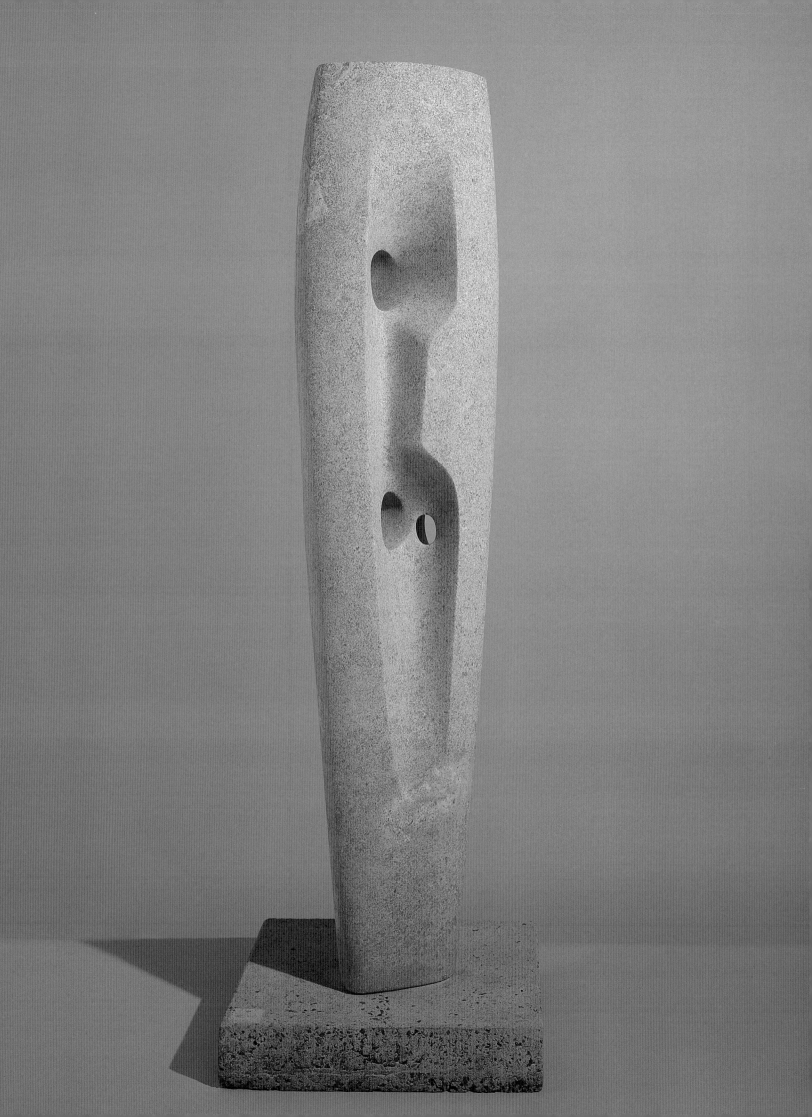

30A Family Group – Earth Red and Yellow 1953

T02228 (illus. opposite)

Oil and pencil on hardboard 29.8 × 22.2 (11¾ × 8¾)
on an oil-painted hardboard support 33.5 × 27.7 (13¼ × 10⅞)

Inscribed in pencil 'Barbara Hepworth 20/6/53' running up
right-hand side b.r.

Bequeathed by Miss E.M. Hodgkins 1977

Provenance: Acquired from the artist by Miss E.M.
Hodgkins by April 1954

Exhibited: Whitechapel 1954 (193); Tate 1968 (208);
Conferment 1968 (no cat., Public Library); *Retrospective*
1994–5 (110, repr. in col. p.130)

Literature: *Tate Gallery Acquisitions 1976–8*, 1979, pp.89–90,
repr.

30B Two Figures (Heroes) 1954

T03155 (Illus. p.136)

Oil and pencil on hardboard 183 × 120.5 (72 × 42)

Inscribed in pencil 'Barbara Hepworth | 1954' t.l.; inscribed
on the back in pencil over two areas of white paint 'Barbara
Hepworth | Two Figures (heroes) | oil Jan 1954 | 72" × 48"'
and 'dedicated to | Paul & John | pilot and navigator, killed
February 13th 1953'

*Presented by the executors of the artist's estate, in
accordance with her wishes, 1980*

*Displayed in the artist's studio, Barbara Hepworth Museum,
St Ives*

Exhibited: Whitechapel 1954 (198); *Three British Artists:
Hepworth, Bacon, Scott*, Martha Jackson Gallery, New York,
1954 (not in cat.); North American tour 1955–6 (3, repr.); New
York 1956–7 (31)

Literature: Jenkins 1982, p.15, repr. p.41 (col.); *Tate Gallery
Acquisitions 1980–2*, 1984, p.125, repr.

Painting, in a diversity of forms, was a facet of Barbara Hepworth's output from 1940. She produced a considerable number in which a frieze-like array of figures are represented by a matrix of intersecting straight lines punctuated by areas of strong colour. *Family Group – Earth Red and Yellow* 1953 and *Two Figures (Heroes)* 1954 are two examples of this type, which was concentrated around 1952–4 but seems to have begun in 1947 with *Drawing for Stone Sculpture* and continued until 1956 with *Figures (Sunion)*.[1] A comparison of the two examples owned by the Tate – one under a foot high and the other life size – serves to emphasise the wide range of scale covered by this body of work. Though the size of *Heroes* is unusual for a painting by Hepworth it was not unprecedented: in October 1948 Ben Nicholson reported that she was 'working on her 6 ft × 5 canvas and will be probably for many months'.[2] That work was presumably abandoned.

The Tate's paintings were made, in large part, using a similar technique, which Hepworth had developed in the 1940s for her nude studies (no.22 q.v.) and hospital pictures (no.23A and B q.v.). In both, a thick white-oil ground – probably of household paint – was brushed on to the smooth face of the hardboard to give a hard, textured surface. A thin glaze of brown oil paint was applied and then scraped down, in some areas to the white ground, and so much so in *Family Group* that only a halo of colour was left around an almost white composition. The main design was drawn over the paint in black pencil, probably with the aid of a ruler; sections of the resulting grid were filled in with strong colours – red, black, blue, grey – and a pale grey was washed over some sections. In *Two Figures*, the coincidence of scraped areas with the pencil design demonstrates that both were modified as the artist worked on the painting. That it was framed before it was executed is indicated by splashes on the frame and the absence of paint beneath it.

While *Family Group* is in good condition, *Two Figures*, though sound, has suffered from its past treatment. George Wilkinson, one of Hepworth's last assistants, recalled that after the artist's death the painting was found in the confined space behind the old stage of the former Palais de Dance that had served as her studio since 1961; her executors had the film of dirt which covered it removed.[3] Since the establishment of the Barbara Hepworth Museum, *Two Figures* has been on display in her studio and has suffered from the humid conditions that result from the damp Cornish atmosphere. Local cleavage and flaking of paint is visible, particularly in the black areas; some has been retouched – presumably by the artist – and some is more recent. Abrasion has caused the loss of a small area of paint on the lower right-hand side and small splashes of white paint on both the frame and the picture surface are possibly the result of decorators working in the studio at some time in the past.[4]

The technique of intersecting lines relates to Cubism, in particular to the later Cubism of Georges Braque. The predominance of long verticals is especially reminiscent of his *La Musicienne* 1918, which Hepworth could have seen reproduced in

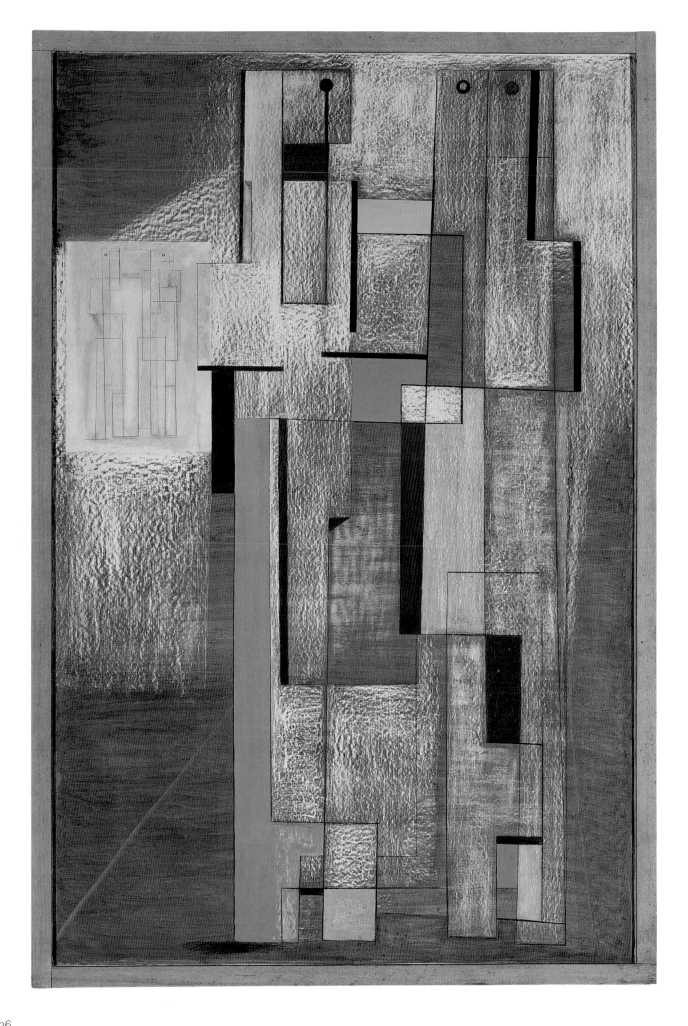

the special Cubism number of *L'Art d'Aujourd'hui* in May 1953.[5] The suggestion of a continuous line also recalls Paul Klee's conception of drawing as taking a line for a walk, which enjoyed significant popularity in St Ives in the early 1950s. In post-war Britain both Braque and Klee had come to stand for a more rooted modernism, and their influence on Hepworth may be related to her search for a form of expression that was both human and modern. Her use, in a figurative composition, of the primary colours and rectilinearity associated with Mondrian's abstraction may reflect such a humanising intention. The adaptation of Klee's line to a post-Cubist style, with the filling in of defined areas with strong colour and heavy pencil shading, was particularly characteristic of Ben Nicholson's painting after 1947, though his forms are more fluid than Hepworth's. The scraping down of oil glazes over a textured white ground was, similarly, a familiar technique of his. Her style may also relate to contemporary sculpture, in particular to the work of Robert Adams and Henry Moore, which themselves had their roots in Cubism. In Adams's *Figure* 1949 the human body is defined by interlocking angular forms, though in three dimensions. Moore had used such forms in the 1930s, but they reached a very public peak in his *Time-Life Screen* 1953–4.[6]

The theme of the family recurred in several of Hepworth's paintings of this type.[7] Human relations at different levels – individual, familial and social – were a dominant theme of her painting and sculpture. While works such as *Group I* 1951 (no.27 q.v.) were concerned with crowds of people in public spaces, others like *Bicentric Form* 1949 (no.25 q.v.) dealt with more intimate exchanges by the fusion of bodies in a way that anticipated *Two Figures*. The artist related the idea back to her pre-war abstract work: 'It is an extension of the same idea which started in November 1934, but extended gradually from within outwards; through the family group and its close knit relationship out to the larger group related to architecture.'[8] Thus the classic Cubist interpenetration of forms becomes a symbol of the cohesion of people: of the family unit in *Family Group* and of the two 'heroes' of *Two Figures*.

At that time, the family was an especially emotive theme for Hepworth whose marriage to Ben Nicholson had collapsed in December 1950. The tension between their need to work and the demands of a large family had been a significant factor in the breakdown of their relationship and was a source of great anxiety for her. It has been suggested that it was at the level of this awareness of the conflict between professional and domestic labour that she engaged with the debates around women's art and the problems specific to female artists.[9] In 1953, however, her relations with Nicholson were friendly enough that together they considered purchasing a house opposite her studio for the children.[10] Such a context may suggest a different interpretation of her assertion of a cohesive family. That theme is even more poignantly present in *Two Figures* which, as the inscription on the back makes clear, was dedicated to Paul Skeaping, the artist's son by her first husband, John Skeaping. Paul was an RAF pilot flying patrols over Malaya and died, along with his navigator, in an air crash in Thailand in February 1953. Though it is most likely that it was accidental, it has been suggested that they were the victims of a terrorist bomb.[11] Since the age of nine, Paul had lived with his father, but he spent extended periods with Hepworth in Cornwall. Her close friend Margaret Gardiner recorded that his death was 'a lasting grief' to the artist, who, in addition to *Two Figures*, carved a *Madonna and Child* for St Ives parish church in his memory.[12]

The left-hand person in *Two Figures* appears to hold a smaller picture, the forms of which echo the main image. The emphasis placed upon this detail by the thorough scraping away of the paint suggests that it is an important element of the work. The motif of a picture-within-a-picture has been used in the past as a means of including figures otherwise absent from the scene depicted; in particular portraits of the dead often appear in family groups. If Hepworth used this traditional device, the painting might serve, like *Family Group* and many of the other similar works, to reinforce the importance of family ties.

31 Two Forms (White and Yellow) 1955

T02227

Oil and pencil on wood panel 42.5 × 15.2 (16¾ × 6)
on an oil-painted hardboard support 51.8 × 23.8 (20⅜ × 9⅜)

Inscribed in pencil 'Barbara Hepworth 3/55' b.r. and on the
back of the mounting board in pencil over an area of white
paint 'Barbara Hepworth | "Two Forms" | (white and yellow) |
1955 | oil & pencil | 17" × 6"', and 'TOP' centre top

Bequeathed by Miss E.M. Hodgkins 1977

Provenance: Purchased from the artist through the Penwith
Gallery, St Ives, by Miss E.M. Hodgkins 1955

Exhibited: *Summer Exhibition*, Penwith Society of Arts, St
Ives, 1955 (71); *Conferment* 1968 (no cat., Guildhall)

Literature: *Tate Gallery Acquisitions 1976–8*, 1979, p.89, repr.

Though similar in technique to her other paintings, the style of *Two Forms (White and Yellow)*, with its contrast of geometrical shapes against a ground of varying density, is unique in Hepworth's work. The white gesso-like ground is thicker than in other paintings and extends over the sides of the board to give an uneven edge. Over this a very matt black paint was applied unevenly and then scraped with a razor blade to give the swirling effect of differing intensities of pigment. In places the colour is like coal, in others the white ground shows through and the whole surface is covered in fine scratches, most noticeably a series of arcs between the two squares. For the top square cadmium yellow was painted over the black, resulting in a varied effect: the yellow appears slightly green where the stronger areas of black show through. The lower square was achieved by scraping off the black completely to reveal the white beneath. The traces of black within that square are, therefore, the residue left in the grooves of the textured ground. The dark lines that sub-divide the square were drawn with a black pencil.

By 1955 Parisian Tachisme was a major concern among British artists and the work of the American Abstract Expressionists, though hardly seen in Britain, was equally the subject of great interest. The loose application of the black paint may be indicative of Hepworth's interest in contemporary abstract painting, but *Two Forms* nonetheless reflects her thorough grounding in earlier modernist styles and practices. The simple square had been central to abstract painting since Malevich's *Red Square and Black Square* 1914–16, which Hepworth had known in reproduction from Alfred Barr's *Cubism and Abstract Art,* published in 1936.[1] The off-set of the lines in the lower square towards one corner recalls Mondrian's painting, with which Hepworth was particularly familiar. She had first met Mondrian in 1934 and they were neighbours in Hampstead for a year from September 1938. She and Nicholson owned one of his paintings – *Composition No.2 with Red and Blue* 1937, though it is in *Composition with Blue* 1937, then owned by their friend Marcus Brumwell, that the off-setting device is especially marked.[2] Hepworth's use of a thick black pencil for the linear forms is a technique typical of Nicholson's painting; she had employed his transgressive practice of drawing over paint since 1947.

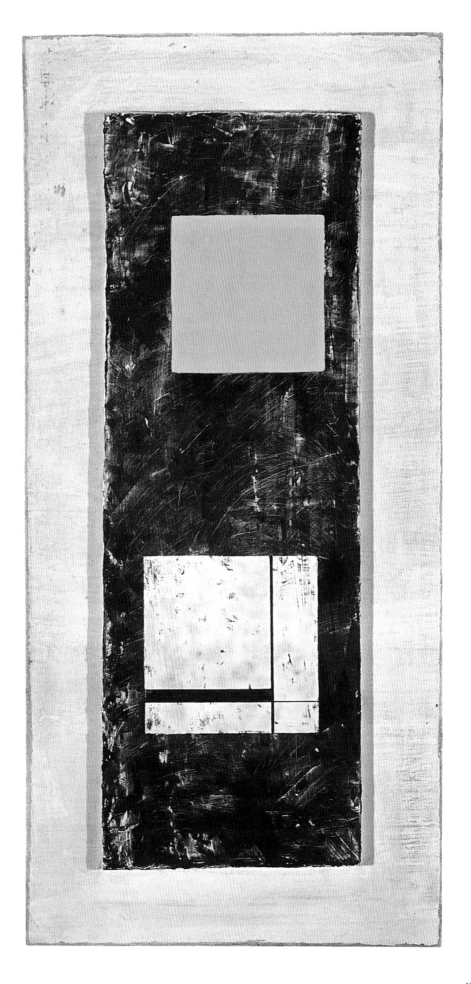

32 Corinthos 1954–5

T00531 BH 198

Nigerian guarea; 104 × 106.7 × 101.5 (41 × 42 × 40) on a
painted wooden base 7 × 65.5 × 56 (2¾ × 25¾ × 22);
weight 410 kg

*Purchased from the artist through the Whitechapel Art
Gallery (Grant-in-Aid) 1962*

Exhibited: *Summer Exhibition*, Penwith Society of Arts, St
Ives, 1955 (97); *The Seasons*, CAS, Tate Gallery, March–April
1956 (54, as *Corinthos (The Seasons)*); *Modern Sculpture*,
Leeds City Art Gallery, Oct.–Nov. 1958 (27); Whitechapel
1962 (8, repr.); *Arte d'oggi nei musei*, XXXII Venice Biennale,
May–Oct. 1964 (London, Tate Gallery 18); Tate 1968 (69); *St.
Ives: Twenty Five Years of Painting, Sculpture and Pottery*,
Tate Gallery, Feb.–March 1985 (131, repr. p.190)

Literature: Hodin 1961, pp.21, 168, no.198, repr.; C, F & B 1964,
pp.279–80; Robert Melville, 'Creative Gap', *New Statesman
and Nation*, vol.75, no.1935, 12 April 1968, p.494; Jenkins
1982, p.16, repr. p.29; Penelope Curtis, *Modern British
Sculpture from the Collection*, Tate Gallery Liverpool, 1988,
p.53, repr.; Alan G. Wilkinson, 'Cornwall and the Sculpture of
Landscape: 1939–1975' in *Retrospective* 1994–5, exh. cat.,
p.98; Curtis 1998, p.37

Corinthos was the first and largest of a number of sculptures, named after ancient Greek sites, that Barbara Hepworth carved from 'scented' guarea between 1954 and 1956. Though acknowledged as one of her major works, its exhibition history has been relatively restricted by its size. Its scale is especially remarkable for a work carved from a single piece of wood, described by the artist as 'the very largest tree trunk that I have ever been able to procure from anywhere, really monumental in size'.[1]

Guarea, from which the sculpture was carved, is a tropical hardwood. Her friend, Margaret Gardiner, had family connections with Africa and, when Hepworth accepted the offer of a sample, she arranged for a Nigerian plantation owner to send a single tree trunk.[2] On returning from her Greek holiday in August 1954, Hepworth received a message that seventeen tons of wood had arrived from Nigeria at Tilbury docks. A tortuous process of transportation to Cornwall and manhandling through the narrow streets of St Ives followed and the butt was cut into logs ranging in size from three-quarters to two tons, which were stored in various locations around the town.[3] Though the timber is said to have been a gift, Hepworth's comment to Ben Nicholson in October 1954 that she had 'tied up £250 in this new wood from Nigeria' suggests that she had to pay something for it.[4] Relieving the scarcity of non-indigenous stones and woods since the beginning of the Second World War, this consignment enabled Hepworth not only to produce a series of dramatic large works, but also to lay some wood by to be worked on later. *Pierced Form (Epidauros)* 1960 (no.53 q.v.) is the product of this later campaign of work. According to Alan Bowness's catalogue raisonné of her work, she produced seven guarea pieces in 1954–6 and six between 1960 and 1963, of which one was unfinished;[5] she was able to give wood to several of her assistants – works in guarea appear in a number of their catalogues, for example Denis Mitchell's *Oracle* 1955[6] – and there was a large amount left over. The guarea was especially welcome as, in both stone and wood, Hepworth preferred her materials to be hard. It was, she later enthused, the 'most beautiful, hard, lovely warm timber … I was never happier'.[7]

When acquired by the Tate, the sculpture was found to have 'countless' splits and cracks.[8] The majority were very fine and in a concentric crazing pattern around the heart of the wood and the larger ones had been filled with guarea splints and coloured. Dicon Nance, Hepworth's former assistant, has said that the hollowing out of the timber in works such as *Corinthos* helps it to dry evenly and so reduce splitting, which may explain the concentration of the cracks around the heart of the wood at the ends; there are no splits on the outermost surfaces.[9] In 1964 *Corinthos* was taken off display because it appeared to be splitting further in the dry atmosphere of the gallery. In February of that year Hepworth told the Tate's director, Norman Reid, that she had set aside some guarea in case these 'shakes' should change while the sculpture was on display in Venice.[10] The wood was originally polished by hand and then with 'White Silica Polish and nothing else',[11] though it was noted in 1964 that the polish had acquired a matt appearance and deteriorated. The wood is a lighter colour towards the top where it

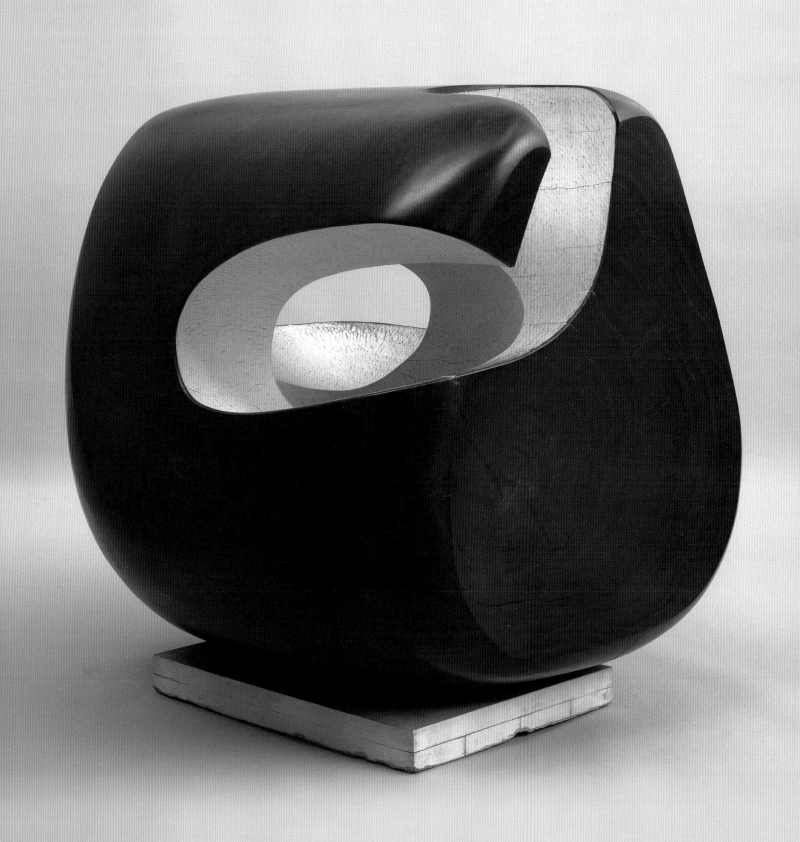

has been bleached by the light. Hepworth originally painted the interior with 'Ripolin Flat' – a household paint which she used for many years – but she added 'Dulux Flat' at the time of her 1962 retrospective.[12] In 1986 this paint was found to be yellowing.

The size and weight of the sculpture make it especially susceptible to damage. In 1964 it sustained three bruises on its way to Venice, each about 51 × 6 mm (2 × ¼ in). Hepworth advised the Tate:

I have found the most successful way of dealing with [bruises] is by the use of a steamiron. I have a small Murphy iron and as soon as the steam is ready I hold it just above the surface of the bruise and the moisture percolates the wood and pulls the fibres up.
This treatment does, of course, leave a slight roughness afterwards which has to be delicately smoothed down with the finest emery; 00 or flour.[13]

When Dicon Nance carried out this treatment in March 1965, the artist reassured the gallery that the resultant area of paler wood would tone down with time,[14] though the restoration was not considered fully satisfactory. In October 1992 an accident in the Tate Gallery store involving a large steel sculpture caused six gouges, between 60 and 90 mm (2⅜–3½ in) long, 5 mm (⅜ in) wide and 3–4 mm (¼ in) deep, in one side of *Corinthos*. These were filled and a smooth finish was achieved by the application of a combination of waxes which could be easily burnished. This mixture was layered with wood dyes of differing tones to match the variations of colour across the surface of the sculpture. At the same time the most obvious earlier fills, which, having caused some compression damage, were now breaking up and had become lighter than the wood, were removed and similarly treated.[15]

Corinthos was probably begun at the very end of 1954 or beginning of 1955: Hepworth told A.M. Hammacher in February 1955 that the first guarea piece was 'taking shape', but she had made no mention of it in her letters of the preceding months to Herbert Read, either in a letter discussing her holiday in Greece, or when she sent him a photograph of her *Madonna and Child*.[16] Though she had first employed Greek words in her titles in the 1940s with works such as *Pelagos* (no.20 q.v.), *Corinthos* is the first of a series of sculptures named after ancient Greek sites. Her friend Margaret Gardiner had taken Hepworth – exhausted after the trauma of her son's death the year before and the preparations for her Whitechapel retrospective – on a Greek cruise in August 1954. They visited several places on the mainland, including Athens and Delphi, and a number of the Aegean islands, such as Crete, Patmos and Santorini. Hepworth told the Tate Gallery that *Corinthos* was 'carved immediately on my return from Greece 1954–5. I think it summarised my experience there'.[17]

The relationship between the work and Hepworth's experience of Greece, and Corinth in particular, is unclear. One might relate the sculpture to the topography around the city and Bryan Robertson has asserted that it's tunnelled form 'embodies a memory of sailing through the Corinth canal and entering the Greek world for the first time'.[18] Hepworth and Ben Nicholson had been fascinated with Greece for many years and early works, such as *Single Form* 1937–8 (no.12 q.v.), had been discussed in classical terms. Though Nicholson first visited the country a few years after Hepworth, he had previously given Greek titles to his paintings and his *1954, May (Delos)* was in her collection.[19] She was conscious of their association with Greece and wrote to him from Athens: 'I wish you were here. It just seems wrong to see it without you, for everytime I look I think of the way you would see it.'[20]

Hepworth's description and memoirs of her trip suggest that she was drawn both to the historical and cultural associations of Greece and to her own sensuous experience of the landscape. The cruise included a series of scholarly lectures on ancient Greece and the sites to be visited. The artist published a selection of the notes in her Greek sketchbook and, though there is no specific discussion of Corinth, much of her attention was devoted to the colours, forms and sensations of the places she visited.[21] This sensuous dimension may help to explain why she carved works with Greek

associations from a Nigerian hardwood rather than the quintessentially classical marble; the original of *Coré* 1955-6 (no.33 q.v.) represents an isolated attempt to unite marble and her Greek experience. Hammacher has noted Hepworth's sensual response to the guarea: he recalled that, in addition to her description of it as 'beautiful, hard … warm', she told him that the smell of the wood was 'overpowering' at first, though it became 'more gentle and amenable'. Presumably echoing the artist, he went on to describe the guarea pieces as, 'these almost animal wood sculptures with their sonorous boom' and quoted Hepworth as saying, 'Sculpture, to me, is primitive, religious, passionate, and magical – always, always affirmative.'[22]

In her references to the places she visited in Greece there is a recurrent religious or spiritual theme; she was especially moved by Delphi, where, she said, she found physical and spiritual ease.[23] It may also be significant that all of the places recorded by sculptures are noted for their ancient theatres; in a later publication, Hepworth accompanied her description of her trip with photographs of three different theatres.[24] Greek theatre had featured in her work previously: Read had compared the nurses in her hospital drawings to a Greek chorus and in 1951 she had designed a production of Sophocles' *Electra*.[25] In her commentary on the inspiration of Greece, Hepworth's description of watching people respond bodily to the ancient architecture in a landscape setting suggests a comparison between the form of the theatre and her conception of the figure enwrapped in the land.[26] She had sought to capture this experience in the 1940s with works such as *Pelagos* 1946 (no.20 q.v.), so that the return to abstract wood carving and the use of a painted interior in *Corinthos* may be seen as a refrain of that moment.

Though a sense of this enfoldment is demonstrated in other guarea works, such as *Curved Form (Delphi)* 1955 (fig.60), *Corinthos* is perhaps the apogee of Hepworth's fascination with the hollowed-out form and the resultant tension between interior and exterior. It is remarkable for the contrast between the two, the almost complete outer surface giving little clue to the expansive white internal space made up of a double spiral movement through the wood (fig.59). The artist warned the Tate Gallery that photography was problematic: 'It is a very difficult one to do well, due to the relation of inside and outside carving, i.e. if you get all the outside, you hardly see the inside.'[27] The painting of the interior dramatises the effect of the light falling through the sculpture. David Lewis had earlier held up the articulation of space by the passage of light through her sculpture as the feature which distinguished it from the work of Henry Moore.[28] As she worked on the carving, the artist was conscious of this effect; in February 1955, she wrote to Hammacher, presumably about *Corinthos*: 'one of the logs is taking shape – a great cave is appearing within it and I have tunnelled right through the 48 inches and daylight gleams within it. It is terribly exciting to have such enormous breadth and depth. When I have finished perhaps I shall be able to get inside it.'[29]

Her statement is reminiscent of interpretations that have been made of her earlier work. It has been suggested that, 'pieces such as *Pelagos* 1946 [may be] read for their allusions to the womb and to the caring, sheltering function of the mother' and, as such, may be seen as embodying a positive feminine syntax.[30] Doherty's suggestion implies the influence, which others have identified in Hepworth's work, of Melanie Klein's theory of art as an act of reparation for attacks on the mother's womb in infantile fantasy. As with *Pelagos*, one may see a parallel between that psychoanalytic reading of the work in terms of the body and Hepworth's attitude to the figure enwrapped by the landscape. That the internal space of *Corinthos* is to be entered by the eye is apparent from the artist's technique; the viewer is drawn in by the gradual transition from the smooth wooden exterior to the contrasting white-painted chiselled surface inside. The articulation of form through this contrast of colour and texture is a characteristic of almost all of the guarea pieces and may be seen as reflecting Hepworth's interest in a Jungian dualism. In particular, her concept of the masculine and feminine as distinct but complimentary traits seems to have been informed by Jung's 'animus' and 'anima'

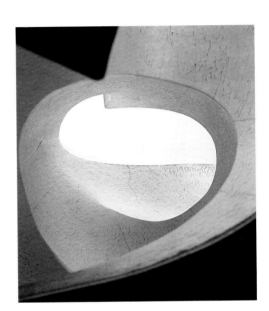

fig.59
Corinthos, detail

archetypes, which represented the feminine qualities in a man and the masculine side of a woman. That she associated this concept with the interiors and exteriors of sculptural forms is demonstrated by her *Curved Form with Inner Form (Anima)* 1959.[31]

Quoting the artist, Edwin Mullins has seen in these 'post-Greece landscapes' the first expression of 'a humanist philosophy', which Hepworth had arrived at during her 1954 trip. Her comments suggest that various aspects of that experience contributed to an elevation of mankind: 'In Greece I noticed the wonderful stance of man. I thought of Greek philosophy, of the majesty of Greek tragedy, and of a certain strength of the human mind which causes people to become bigger when you see them.'[32] In this the guarea carvings may be seen to represent the highpoint of Hepworth's development of a humanist sculpture in which the figure in the landscape was conceived in terms of a continuous, enfolding form. Later, the motif would be seen increasingly in terms of figures located in space, as exemplified by *The Family of Man* 1970 (fig.7). Greece, the artist said, 'was a confirmation, not a transformation'.[33]

33 Coré 1955–6, cast 1960

TO3135 BH 208 (bronze version); cast 1/7

Bronze 74 × 40 × 30 (29⅛ × 15¾ × 11⅞)
on a slate base 5 × 45.8 × 35.5 (2 × 18 × 14)

Incised inscription on back '1/7' b.l.

*Presented by the executors of the artist's estate, in
accordance with her wishes, 1980*

*Displayed in the artist's garden, Barbara Hepworth
Museum, St Ives*

Exhibited: *Northern Artists*, AC tour, Manchester City Art
Gallery, July–Aug. 1960, Graves Art Gallery, Sheffield,
Aug.–Sept., Laing Art Gallery, Newcastle-upon-Tyne,
Sept.–Oct., Bolton Art Gallery, Oct., Bradford City Art
Gallery, Nov., Carlisle Public Library and Art Gallery, Dec.
(27†, as '*Figure (Coré)*, 1960'); Zurich 1960 (2†, repr.);
Sculpture 1961, Welsh Committee of the Arts Council tour,
National Museum of Wales, Cardiff, July–Sept. 1961, Glynn
Vivian Art Gallery, Swansea, Sept., National Library of Wales,
Aberystwyth, Oct., University College, Bangor, Nov. (17†,
repr.); Whitechapel 1962 (not in cat.‡); *British Sculpture
Today*, Ashgate Gallery, Farnham, July 1962 (42†); *Summer
Exhibition*, Penwith Society of Arts, St Ives, summer 1962
(116†); John Lewis 1963 (3†); *Englische Maler und
Bildhauer*, Gimpel Hanover Galerie, Zurich, Aug.–Sept. 1963
(41†, repr.); Zurich 1963–4 (4b†, repr.); Gimpel Fils 1964
(4b†); *Nine Living British Sculptors*, Lalit Kala Akademi/BC
tour of India 1965, Delhi, Calcutta, Madras, Bombay (23†);
Little Missenden Festival, Little Missenden, Oct. 1965 (no
cat.); *5ᵉ Internationale Beeldententoonstelling Sonsbeek
'66*, Arnhem, May–Sept. 1966 (97†); *British Sculpture: The
Collection of Leicestershire Education Authority*,
Whitechapel Art Gallery, Dec. 1967–Jan. 1968 (24‡); Tate
1968 (76‡); *Open Air Sculpture Exhibition*, Syon Park,
May–Sept. 1968 (no cat.‡); Plymouth 1970 (35); *Growing Up
with Art: The Leicestershire Collection for Schools and
Colleges*, AC tour, Whitechapel Art Gallery, Sept.–Oct. 1980,
Henry Thomas Gallery, Carmarthen, Nov.–Dec., Midland
Group, Nottingham, Dec. 1980–Jan. 1981, Cooper Gallery,
Barnsley, Feb.–March, Kirkcaldy Art Gallery, March–April,
D.L.I. Museum and Arts Centre, Durham, April–May,
Atkinson Art Gallery, Southport, June–July 1981 (74‡, repr.
p.18); New Art Centre 1987 (7†); *St Ives Exhibition*, New Art
Centre, Sept.–Oct. 1988 (16‡)

Literature: *Tate Gallery Acquisitions 1980–2*, 1984, p.114, repr.

In common with other bronzes cast from earlier carvings, *Coré* spans two historical moments and so embodies two sets of concerns. It would appear that the plaster was taken from the marble original in 1959 and the bronze was cast the following year. Hepworth told Herbert Read in December 1959: 'I have had to despatch to various foundries all the bronzes needed for my show with Charles Lienhard [in Zurich] next year – &, with the prize money from São Paolo, I have been able to do this without a fearful feeling of anxiety.'[1]

Other than student work and *Hand II* 1949–50, *Curved Form (Trevalgan)* 1956 (no.34 q.v.) was Hepworth's first bronze and, like many others, was cast from an original plaster.[2] In 1958 she started making casts of early carvings such as *Oval Sculpture* (no.16 q.v.) and *Discs in Echelon* (no.10 q.v.), but *Coré* appears to have been the first to be cast from a more recent work. Hepworth's return to casting in 1956 had been in response to the growing demand for her work and a similar expansion of her market seems to have stimulated another increase in her production around 1959–60. In 1959 she won the Grand Prix at the São Paolo Bienal and showed in New York for the first time, and the following year her South American tour was followed by her first Zurich exhibition. The casting of more bronzes was not simply to produce a greater number of works, but also to answer the practical demands of showing internationally. She explained to Read that 'the travelling circus' of biennales and British Council tours 'shriek for more and more bronzes' because 'the transporters smash all carvings'. She expressed a concern that the demands which were placed on the sculptor, for which she blamed society, would lead to over-production and sub-standard casts.[3] The number of exhibitions in which the bronze of *Coré* was shown, which is in contrast to the dearth of critical comment, illustrates the demand for such pieces. This is also demonstrated by the fact that the edition was sold out in 1968, four being sold in the summer of that year, when one was also presented to the Whitworth Art Gallery, Manchester.

The original *Marble Form (Coré)* 1955–6 reflects, in its title and material, the influence of Hepworth's visit to Greece a year earlier.[4] The coincidence of her return from holiday in August 1954 and the arrival of a large consignment of tropical hardwood had stimulated a series of large wood carvings, of which *Corinthos* 1954–5 (no.32 q.v.) was the first. For *Coré* she used a material with more obvious Hellenic associations, white marble. Marble had been relatively rare in her output since the 1930s owing to the difficulty of acquiring it; *Pastorale* 1953 is the only marble work of the period larger than *Coré*.[5] 'Core' or 'Kore' is the name for a type of ancient Greek female figure sculpture, the male being 'Koros'. Hepworth's reference to that source is typically elliptical as the rigid verticality of the Archaic figures is in contrast to the organic curves of her work. However, she adopted the same material as her ancient predecessors and the concave circle on the right-hand side and the crescent on the left of *Coré* may be seen as schematic signifiers for a face. Though her Greek notebooks reveal, above all, her

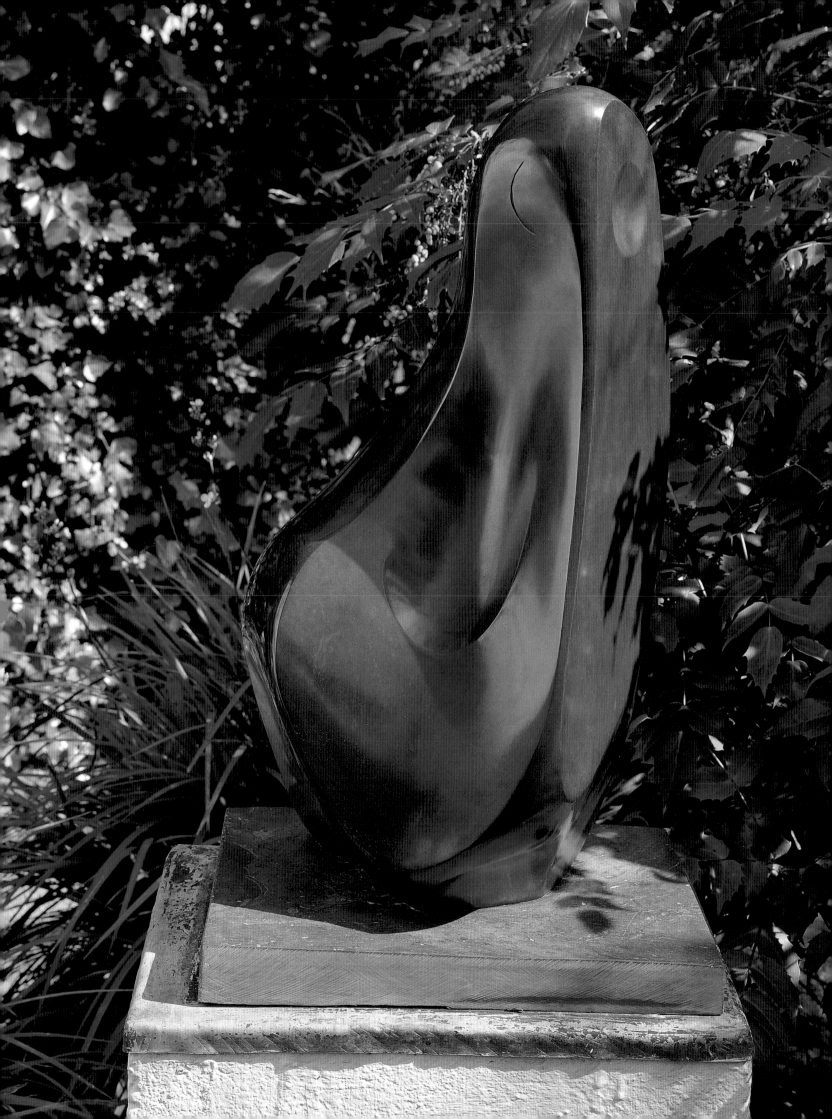

fascination with the sensuous experience of the landscape, she was also attracted by the tradition of sculpture that united her and the classical sites she visited. They also show that the sculptures she saw were often fragmentary: 'Santorin … Six lovely Archaic 7th Century sculptures. Parts of Kore and Koros. Fine marble and great scale.'[6]

The bronze of *Coré* is unpatinated, hollow and attached to its base by bronze fastenings. Some casting faults are discernible: there is slight pitting in the circular concavity and several plugs towards the top. Individual casts were given different finishes: while the Tate's retains a dark brown colouring, which was protected by a wax coating, possibly for outdoor display, at least one other cast (3/7) was highly polished and the photograph in the artist's album shows another with an uneven, mottled finish.[7] This may result from the fact that much of the finishing and patinating of bronzes, especially the earlier ones, was carried out in the studio. In common with other sculptures on display in Hepworth's garden, on acquisition *Coré* was found to have been marked by snails, bird lime, and leaf and algae deposits. It was cleaned in 1983 and given a protective lacquer coating, but in 1989 this layer was found to be flaking. The laquer was removed and wax was applied as a protective coating and buffed to give a rich, even finish.

34 Curved Form (Trevalgan) 1956

T00353 BH 213; cast 5/6

Bronze 90.2 × 59.7 × 67.3 (35½ × 23½ × 26½)
on teak base 7 × 50 × 53.5 (2¾ × 19⅝ × 21); weight 160 kg

Cast numerals on upper edge of left side '5/6'

Purchased from the artist 1960

Exhibited: Gimpel Fils 1956 (12†); New York 1956–7 (no
number); *Sculpture 1850–1950*, London County Council
Exhibition, Holland Park, May–Sept. 1957 (15†, repr.); *Het
Beeld in de Stad* (Sculpture in the Town), Antwerp,
June–Aug. 1958 (32, repr. pl.6); *Pittsburgh Bicentennial
International Exhibition of Contemporary Painting and
Sculpture*, Carnegie Institute, Pittsburgh, Dec. 1958–Feb.
1959 (207‡, as *Trevalgan*); *Modern Sculpture*, Leeds City Art
Gallery, Oct.–Nov. 1958 (32, repr. pl.6); São Paolo Bienal
1959 (14†, repr.); New York 1959 (15†, repr.); BC South
American tour 1960 (13, repr.); *Recent British Sculpture:
Robert Adams, Kenneth Armitage, Reg Butler, Lynn
Chadwick, Hubert Dalwood, Barbara Hepworth, Bernard
Meadows, Henry Moore, Eduardo Paolozzi*, BC tour of
Canada, New Zealand, Australia, Japan and Hong Kong
1961–4, National Gallery of Canada, Ottawa, April–June
1961, Montreal Museum of Fine Arts, Aug.–Sept., Winnipeg
Art Gallery, Sept.–Oct., Norman Mckenzie Art Gallery,
Regina College, Nov., Art Gallery of Toronto, Jan.–Feb. 1962,
Public Library and Art Museum, London, Ontario,
Feb.–March, Vancouver Art Gallery, March–April, Auckland
Institute and Museum, July, Dominion Museum, Wellington,
Aug.–Sept., Otago Museum, Dunedin, Oct., Canterbury
Museum, Christchurch, Nov.–Dec. 1962, Western Australia
Art Gallery, Perth, Jan.–Feb. 1963, National Gallery of
Victoria, Melbourne, July–Aug., Art Gallery of New South
Wales, Sydney, Sept.–Oct., Queensland Art Gallery,
Brisbane, Nov.–Dec. 1963, Newcastle War Memorial Cultural
Centre, Jan. 1964, Albert Hall, Canberra, Feb., Bridgestone
Art Gallery, Tokyo, and other Japanese venues, including
Museum of Modern Art, Kyoto, July–Aug., City Hall Art
Gallery, Hong Kong, Aug.–Sept. 1964 (33‡, repr.);
Whitechapel 1962 (21†, repr.); *Contemporary British Painting
and Sculpture*, Albright-Knox Art Gallery, Buffalo, NY,
Oct.–Nov. 1964 (20‡, as *Curved Form*); *Nine Living British
Sculptors*, Lalit Kala Akademi/BC tour of India 1965, Delhi,
Calcutta, Madras, Bombay (24‡, repr.); BC European tour
1964–6: Copenhagen (10‡, repr.), Stockholm (11‡, repr.),
Helsinki (10‡, repr.), Oslo (10‡, repr.), Otterlo (14‡), Basel
(9‡), Turin (11‡, repr.), Karlsruhe (9‡), Essen (9‡); *British
Sculpture 1952–1962*, Brooke Park Gallery, Londonderry,
April 1967, Ulster Museum, Belfast, May–June 1967 (22†,
repr.); *Britisk Skulptur 1952–62*, BC tour of Norway,
Stavanger, Sept. 1967, Bergen, Sept.–Oct., Trondheim,
Oct.–Nov., Tromsø, Nov. (22‡, repr.); Tate 1968 (79);
Collectors Choice, Gimpel Weitzenhoffer, New York, March
1969 (38‡); *Eight British Sculptors*, BC exh., United Arab
Republic, 1969 (18‡); *Yedi Ingiliz Heykeltrasi (Seven British
Sculptors): Robert Adams, Kenneth Armitage, Lynn
Chadwick, Hubert Dalwood, Barbara Hepworth, Bernard
Meadows, Henry Moore*, BC & Turco-British Association
tour, 1970, Ankara, Istanbul (18‡, repr.); Plymouth 1970 (24†);
Hakone 1970 (6, repr. in col.); *A Right to Vote*, Westminster
Hall, Palace of Westminster, July 1978 (no cat.); *The Pier
Gallery, Stromness, Orkney*, Tate Gallery, Sept.–Oct. 1978,
Aberdeen Art Gallery and Museum, Nov. 1978–Jan. 1979,

As a medium, bronze re-emerged within Barbara Hepworth's practice in 1956 with the making of *Curved Form (Trevalgan)* specifically for casting. She had been trained in modelling at the Royal College, and at least one student work in bronze survives (fig.1), but in the 1920s she had eschewed the process as part of her commitment to a modernist perception of the technical honesty of carving. In the 1950s, the situation changed. The demand for Hepworth's work increased substantially as her reputation was secured and she recognised that bronzes were more likely to survive the pressures of the 'travelling circus' of exhibiting around the world.[1] Metal sculpture was being made more generally, with iron rivalling bronze in the work of the younger generation of British sculptors, such as Reg Butler and Lynn Chadwick; their exhibition at the Venice Biennale in 1952, introduced by Herbert Read, met with critical success. The presiding presence of a work by Henry Moore outside the British pavilion raised complaints from Hepworth which Read met with the explanation: 'if you had had a large sculpture to balance Henry's that would be the ideal solution.'[2] As Penelope Curtis has remarked, this may be interpreted as encouragement towards the use of bronze which Moore had espoused with such critical and commercial success.[3] It was not until 1956 that Hepworth followed suit, beginning with *Curved Form (Trevalgan)*. Paradoxically, she subsequently found herself having to justify her use of bronze to Read. In so doing, she stressed the carving of the plaster which was then cast – as distinct from modelling in clay – and asserted that she endeavoured 'to remain constant to "truth to material"'.[4]

New materials facilitated Hepworth's development of a working method by which the conflict between carving and casting would be reconciled. At the same time as using sheet metal for sculptures such as *Orpheus* 1956 (no.38 q.v.), she adopted expanded aluminium as the armature for plasters prepared for casting. Expanded aluminium is a tight mesh which is strong and flexible, and is produced in sheets which are easily cut up. It is responsive to manipulation, and provides an ideal key for plaster (frontispiece). For Hepworth's purposes, building up the plaster was swift by comparison to carving wood or stone. That this was the process used on *Curved Form (Trevalgan)* has been confirmed by one of her assistants at the time, the sculptor Brian Wall.[5] The flexibility of the material allowed the application of curves to the sides and a twist to their alignment. While the sides may remain close to the thickness of the aluminium, more plaster was layered on the lower parts of the sculpture around the off-centre pierced hole. Hepworth later compared the whole process to 'covering the bones with skin and muscles', adding: 'But I build it up so that I can cut it. I like to carve the hard plaster surface.'[6]

The texture of the carving, in combination with that of the application of the plaster, is retained in the bronze of *Curved Form (Trevalgan)*. The treatment of the surface would become more highly wrought as Hepworth adjusted to the process. In addition, casting opened the possibility of colour. The brown-green patination chosen for *Curved*

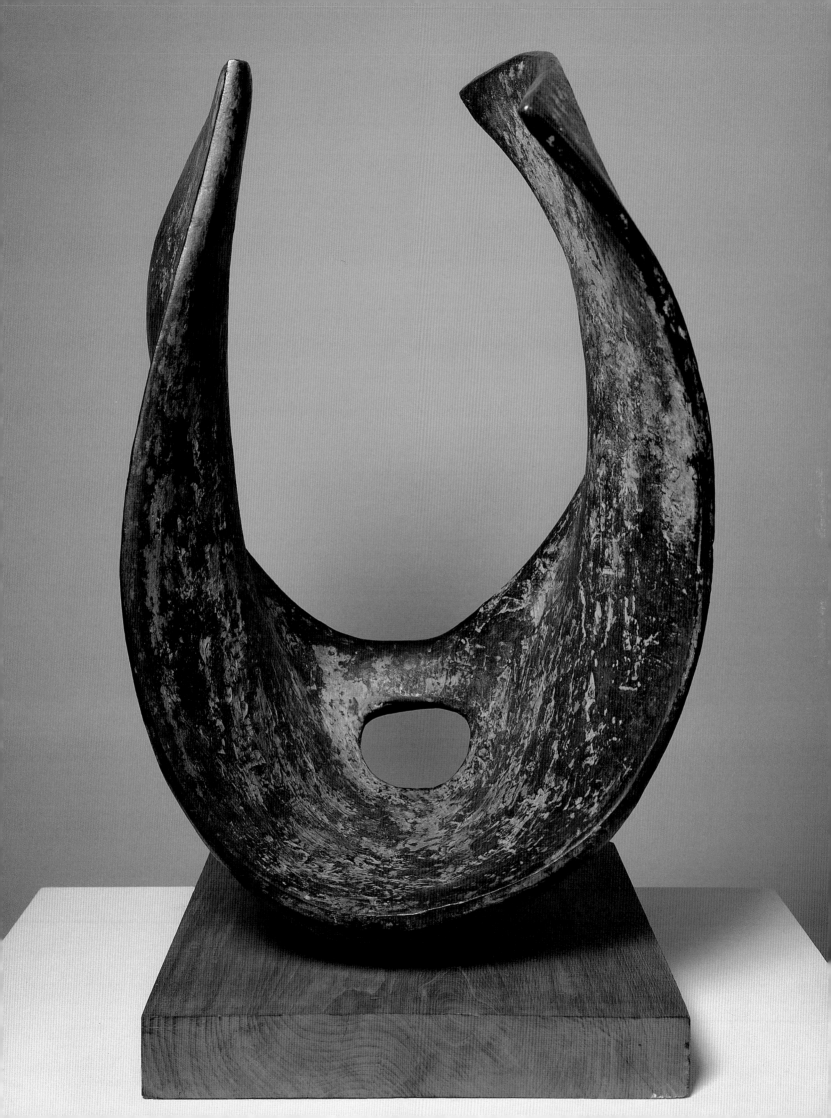

Glasgow Art Gallery and Museum, Jan.–Feb. 1979 (24, repr. p.36); Bretton Hall 1980; *Retrospective* 1994–5 (53, repr. in col. p.103)

Literature: *Tate Gallery Report 1960–1*, 1961, pp.21–2; Hodin 1961, pp.20, 169, no.213, repr.; C, F & B 1964, p.279; *Pictorial Autobiography* 1970/1978, p.75; Frank Davis, 'Substance and Shadow', *Art and Antique Weekly*, 14 June 1975, pp.16–17; Edinburgh 1976, exh. cat., unpag.; Jenkins 1982, p.17, repr. p.30; Alan G. Wilkinson, 'Cornwall and the Sculpture of Landscape: 1939–1975' in *Retrospective* 1994–5, exh. cat., pp.99, 102–4; Festing 1995, pp.225–6; Curtis 1998, p.40, repr. fig.42 (col.)

Form (Trevalgan) was applied judiciously in response to the form; it anticipates the green which the artist favoured for most of her subsequent bronzes. The edition was made by a standard lost wax method at the Art Bronze Foundry in Fulham, which was the first of a number of founders with whom Hepworth placed work. Two bolts from the small opening in the underside of the sculpture hold it to the base; on other casts this was granite (for outdoor display) but the artist fitted a wooden base on acquisition by the Gallery. The bronze has been cleaned, and, but for a scratch to the back right edge, it remains in good condition.[7]

Curved Form (Trevalgan) echoes the form of the wood carving of the previous year *Curved Form (Delphi)* 1955 (fig.60). The latter had similarly raised sides, enclosing a hollowed-out interior with an off-centre hole. Although the guarea wood necessitated more bulk – and part of the interior was strung – it is telling that the crucial step towards new materials and techniques undertaken in *Curved Form (Trevalgan)* benefited from the guidance of a pre-conceived form.

If the vessel-like enclosure of both works reflected their respective methods of manufacture, Hepworth also drew attention to the relation to the landscape in her choice of subtitle. When she included *Curved Form (Trevalgan)* in the exhibition *Sculpture 1850–1950* she wrote in the catalogue:

This 'Curved Form' was conceived standing on the hill called Trevalgan between St. Ives and Zennor where the land of Cornwall ends and the cliffs divide as they touch the sea facing west. At this point, facing the setting sun across the Atlantic, where sky and sea blend with hills and rocks, the forms seem to enfold the watcher and lift him towards the sky.[8]

This text might suggest a literal reading of the forms of the sculpture as echoing the division in the cliff. The similarity to *Curved Form (Delphi)* encourages this, as the oracle at Delphi was associated with a cleft in the mountain. However, the suggestion of enfolding indicates a more complex response, which Hepworth enlarged upon when she told the Tate that Trevalgan and Nanjizal (no.44 q.v.) 'are Cornish place-names which inspired me to do the works. Trevalgan is a hill overlooking the Atlantic … Both sculptures are really my sensations *within* myself when resting in these two places'.[9] The final qualification established the work as activated by the place rather than depicting it. The use of local names – Trevalgan is about two miles west of St Ives – in the titles of works from the early 1950s suggested a rooting in the locality. This association with the landscape was also conceptual. In 1952, she wrote:

I was the figure in the landscape and every sculpture contained to a greater or lesser degree the ever-changing forms and contours embodying my own response to a given position in the landscape. What a different shape and 'being' one becomes lying on the sand with the sea almost above from when standing against the wind on a high sheer cliff with seabirds circling patterns below one; and again what a contrast between the form one feels within oneself sheltering near some great rocks or reclining in the sun on the grass-covered rocky shapes which make the double spiral of Pendour or Zennor Cove; this transformation of essential unity with land and seascape, which derives from all the sensibilities, was for me a voyage of exploration. There is no landscape without the human figure: it is impossible for me to contemplate pre-history in the abstract. Without the relationship of man and his land the mental image becomes a nightmare.[10]

These ideas, explored in the carvings of the 1940s, seem also to have infused Hepworth's bronzes of the late 1950s. What she termed 'a different shape or "being"' was the result of an equation between body and landscape, an experience of immersion and identification through 'the form one feels within oneself'. This was an approach to the reconciliation of subject and abstraction in relation to landscape which Hepworth shared with others working in West Penwith, as demonstrated through the works and titles of Ben Nicholson and Peter Lanyon. In 1953, when Dudley Shaw Ashton made his film about Hepworth – with music by Priaulx Rainier – it was entitled *Figure in Landscape*.

Curved Form (Trevalgan) was widely exhibited. A cast (1/6 was bought by the Albright (subsequently Albright-Knox) Art Gallery in Buffalo and submitted to the Pittsburgh International in 1958–9. In 1960, both the Tate and the British Council bought casts (5/6 and 4/6 respectively), the latter being exhibited around the world as a result. Another cast (3/6) is in the Pier Arts Centre, Stromness. In a curious incident, the last cast was stolen from the foundry and – on the assumption that it would be melted down – an additional cast (6/6) was taken in March 1960.[11] This successful work was followed by closely related bronzes, such as *Involute II* 1956 (no.35 q.v.) and, on a smaller scale, *Corymb* 1959 (no.49 q.v.).

fig.60
Curved Form (Delphi), 1955, height 106.7 (42), guarea and strings, BH 199, Ulster Museum, Belfast

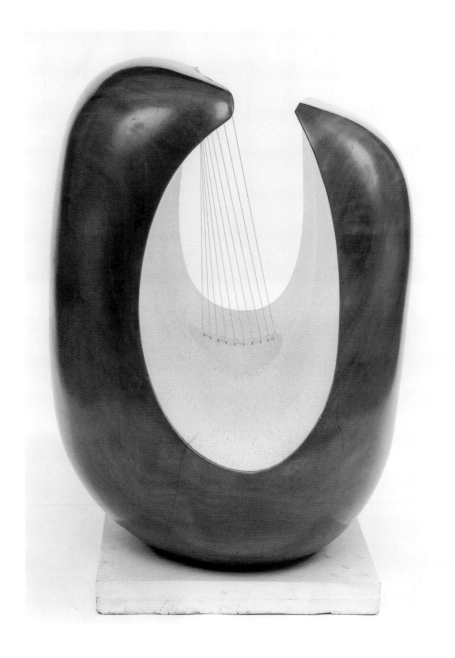

35 Involute II 1956

T03749 BH 218; cast 4/6

Bronze on bronze base 41 × 42 × 36 (16⅛ × 16½ × 14⅛);
weight 33.4 kg

Transferred from the Victoria and Albert Museum 1983

Provenance: Purchased from the artist through Gimpel Fils
by the Department of Circulation, Victoria and Albert
Museum 1960 (Circ.249-1960)

Exhibited: *Contemporary British Art*, AC tour, Castle
Museum, Nottingham, May–June 1957, Southampton Art
Gallery, June–July, Bute Park, Cardiff, July–Aug., Penlee
House, Penzance, Aug.–Sept., Imperial Gardens,
Cheltenham Festival, Sept.–Oct. (not in cat.); Gimpel Fils
1958 (3†); *Modern Sculpture*, Leeds City Art Gallery,
Oct.–Nov. 1958 (34); *A Private Exhibition of Contemporary
British Paintings, Sculptures and Drawings*, British
Embassy, Brussels, summer 1958 (15); New York 1959 (16†);
Zurich 1960 (3†, repr.); *Sculpture 1961*, Welsh Committee of
the Arts Council, National Museum of Wales, Cardiff,
July–Sept. 1961, Glynn Vivian Art Gallery, Swansea, Sept.,
National Library of Wales, Aberystwyth, Oct., University
College, Bangor, Nov. (18†, repr.); Belfast 1962 (3†, repr. as
1959); Whitechapel 1962 (20, repr.); Gimpel Fils 1972 (3†);
AC Scottish tour 1978 (8†, repr.); Wales & Isle of Man
1982–3 (8†)

Literature: Hodin 1961, pp.22, 169, no.218, repr.; W.J. Strachan,
Open Air Sculpture in Britain: A Comprehensive Guide,
1984, p.230, no.541, repr. p.231; *Tate Gallery Acquisitions
1982–4*, 1986, p.198, repr.; Alan G. Wilkinson, 'Cornwall and
the Sculpture of Landscape: 1939–1975' in *Retrospective*
1994–5, exh. cat., p.102

Following the three-feet-high *Curved Form (Trevalgan)* (no.34 q.v.), Barbara Hepworth made a number of smaller sculptures in 1956 specifically to be cast in bronze; *Involute II* was one of these. It is formally close to the larger work, although the sides turn over to form an enclosure. Both stand on curved undersides which, despite the bulk of material in the hollow, make them appear light. They were achieved by applying plaster to an armature of bent expanded aluminium sheet; these were then sent for casting. It may be a measure of the experimentation with techniques that such works went through several transformations. The benefit of this system was that each stage could be issued in an edition to meet the considerable demand for Hepworth's work. As the title suggests, *Involute II* derives from the larger *Involute* 1956.[1] It was cast in an edition of seven, and it is notable that the plaster was exhibited at Gimpel Fils in June 1956, suggesting that the bronzes were cast or finished in the second half of the year. By contrast to the smooth surface of *Involute*, *Involute II* was heavily textured, showing the crests and crevices of the plaster.

The bronzes are associated with two carvings: *Involute I* 1946 in white stone and its larger version *Involute II* 1946 in pink Ancaster stone.[2] The renewed emphasis on abstract forms in the mid-1950s made such works of a decade earlier suitable points of departure. The stones embody the inward rolling indicated by the title, as the spiralling lines of the edges of the outer surfaces guide the eye into three openings. This line became characteristic of Hepworth's piercing of the block. The carvings were implicitly associated with the volutes of architectural capitals, but their bronze successors were perhaps more akin to the spiral membranes of snail shells. The enclosing sides allowed a more open centre, which was dynamic and light. The result is also wave-like, and may be compared to the earlier carving *Pelagos* 1946 (no.20 q.v.). The bronzes follow the stones, with the main plane turning over to form an eccentric arch and another spiralling over at an angle. The sheet of aluminium from which the form was cut must have been roughly T-shaped; this necessitated it being cut into three pieces in order to be cast.

The bronze was sand-cast, probably at the Art Bronze Foundry in Fulham where *Curved Form (Trevalgan)* was also cast in 1956. The varied surface allowed for the uneven patination. The Tate's cast is in Hepworth's favoured green; it bears no inscription or number but, according to the artist's album, it is 4/6.[3] A cast remaining with the estate is pattinated blue; it has a lower base, which is stamped 2/6. The Tate's cast is in generally good condition, but shows signs of weathering. Before its transfer to the Gallery, it was involved in travelling exhibitions of the Department of Circulation at the Victoria and Albert Museum. Some losses were retouched while it was at the Museum; there are further losses of patination within the hollow of the main plane especially where the top of the fixing has been exposed. The welded joint where the subsidiary spiral touches the main curve is in danger of opening, as it has done on the estate's cast. In 1963, the sculptor gave another cast (5/6) to the Cornwall Education Committee, through which it was made available to local schools.

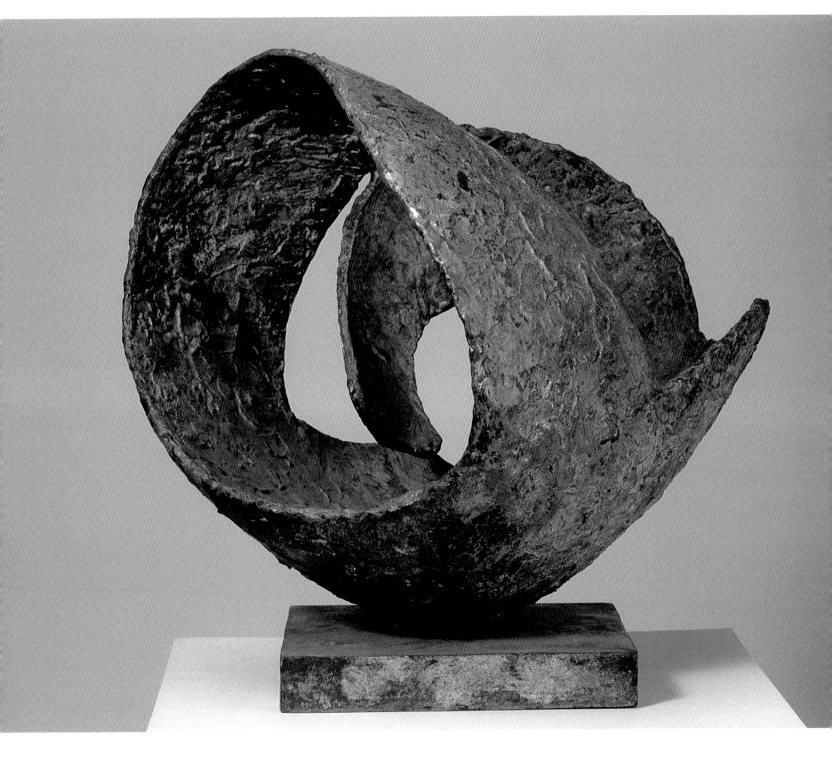

36 Forms in Movement (Pavan) 1956–9, cast 1967

T03136 BH 453; cast 0/7

Bronze on bronze base 77.5 × 108 × 58.5 (30½ × 42½ × 23)

Cast inscription on top of base 'Barbara Hepworth 1967 0/7'
back l., and cast foundry mark on back of base 'Morris
Singer FOUNDERS LONDON' t.r.

*Presented by the executors of the artist's estate, in
accordance with her wishes, 1980*

*Displayed in the artist's garden, Barbara Hepworth
Museum, St Ives*

Exhibited: Tate 1968 (78‡); *Sculpture Exhibition: City of
London Festival*, Financial Times foyer, June 1968 (22†);
New York 1969 (15†, repr., as *Pavan*); Gimpel Fils 1975 (11‡,
repr.)

Literature: Edwin Mullins, 'Barbara Hepworth', Hakone 1970,
exh. cat., unpag.; Bowness 1971, p.453, no.46; Jenkins 1982,
p.17, repr. p.30; *Tate Gallery Acquisitions 1980–2*, 1984,
pp.114–15, repr.; Alan G. Wilkinson, 'Cornwall and the
Sculpture of Landscape: 1939–1975' in *Retrospective*
1994–5, exh. cat., p.99; Festing 1995, p.224; Curtis 1998, p.39

During 1956 Barbara Hepworth experimented with two new materials for making sculpture: armatures of expanded aluminium for works such as *Curved Form (Trevalgan)* (no.34 q.v.) and sheet metal for works such as *Orpheus* (no.38 q.v.). *Forms in Movement (Pavan)* uses both of these techniques: it was cast from a work made with expanded aluminium, the form of which was based upon the copper *Forms in Movement (Galliard)* 1956 (fig.61). The demands being made on Hepworth for more sculptures and on a larger scale were met by these new practices, both of which facilitated the production of editions.

The multiplicity of slightly differing works with associated titles is characteristic of the editioning of Hepworth's sculpture at this moment. The *Pavan* group is typical, with the Tate's work coming from the fourth stage. Informed by the artist, Edwin Mullins observed that the first stage was *Forms in Movement (Galliard)* 1956.[1] The combined strength and flexibility of the copper allowed Hepworth to bend it in order to describe space without filling it. The strips of metal had curved profiles and were stacked into the three loops of a seemingly continuous whirling line building from the centre at which they are attached. The span is 76 cm (30 in); an edition of six was made by Hepworth and her assistants. The broadening of the upper curve and its flattened edge reappear in the related works. The slightly larger *Curved Form (Pavan)* 1956 had the same formal character but the use of 'metalised plaster' – plaster over an aluminium armature – may account for the more weighty horizontal emphasis.[2] Both works were exhibited at Gimpel Fils in mid-1956, where the latter appeared as '*Forms in Movement (Pavan)*'.[3] It was included in Hepworth's *Exhibition on the Occasion of the Conferment of the Honorary Freedom of St Ives*; a second version was made for the collector Tom Slick.[4]

As the third stage in the series, a concrete version was made and called *Forms in Movement (Pavan)*.[5] This was 114.3 cm (45 in) wide and is usually dated to 1956. However, Dicon Nance recalled working on it when he became an assistant to Hepworth in 1959. He described the process, beginning with the armature which was: 'expanded steel "metal lathing" as it is called in the building trade, and the cement was applied in small quantities over several days. This made a surprisingly strong and homogeneous structure.'[6] Significantly, he added: 'Like all Barbara's versions…there was no attempt at making a replica with all the attendant measurements. Each form, though basically as the original, was judged on its own, especially if there was a change in scale.'

It was from the concrete that the edition of seven bronzes – and the artist's copy (0/7) which came to the Tate – was cast in 1967. It remains unclear why Hepworth waited to have it cast, but the concrete had become brittle and was irretrievably damaged and destroyed in the process. The cast of *Forms in Movement (Pavan)* retained the roughened surface of the concrete and the flat edges resulting from the armature. It also contrasted the high flattened curve to the left and the two lower loops to the right. All three are fixed to a circular bronze plate, positioned on the base to the

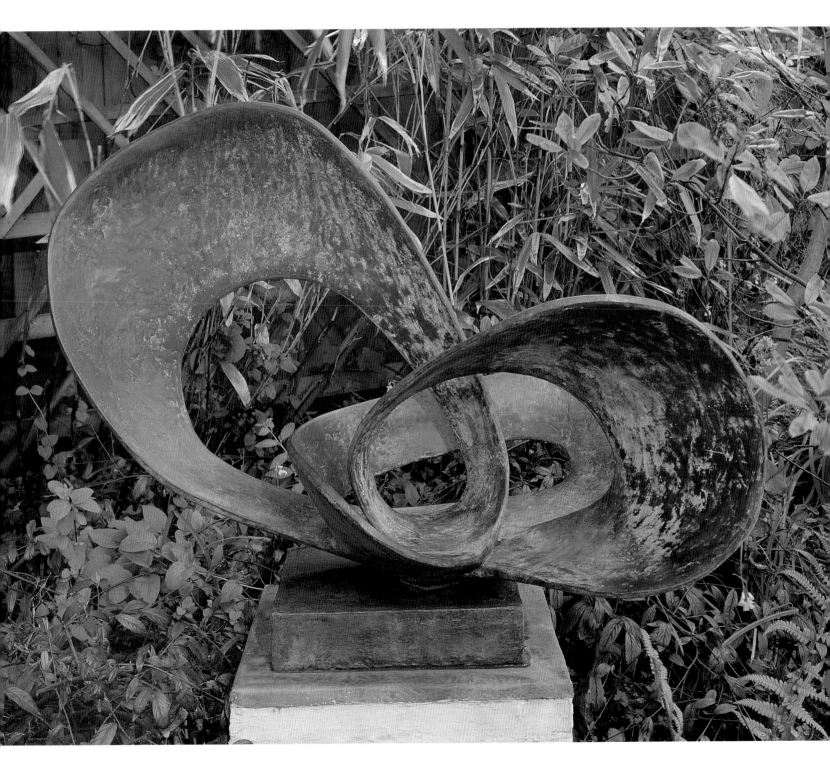

right of centre. The green patination of the Tate's copy has been slightly worn down to the raw bronze on the upper surfaces and, because of its location in the artist's garden, has suffered from bird lime and the accumulation of water in its central cradle. The surface is cleaned and coated with wax annually.[7]

In the late 1960s, Hepworth claimed that 'Man's discovery of flight has radically altered the shape of our sculpture, just as it has altered our thinking.'[8] Remarking on *Forms in Movement (Galliard)*, Mullins added that 'the exultant spirit … emerged more radiantly still once she was able to merge the theme of dance with that of flight.'[9] In this way he alluded to the subtitles which Anglicise the complementary sixteenth-century dances, galliarde and pavane; Alan Wilkinson has explained: 'A galliard is a quick and lively dance in triple time; a pavan is a grave and stately dance.'[10] Fauré and Ravel had composed modern pavans, which may have come to Hepworth's attention. A suitably processional dance is implied in the frieze of abstracted figures in the drawing *Monolith – Pavan* 1953.[11] This also suggests how the interest in dance elided with Hepworth's interest in social interaction and a sense of communal activity. The sculptures convey the rhythmic quality of movement and explore space in a formal way which is distinct from the drawing.

The *Pavan* group of sculptures may be compared to those of Hepworth's contemporaries. The elegant metal sheet of *Forms in Movement (Galliard)* contrasts with the black wrought surfaces of the iron sculptures of younger British sculptors such as Reg Butler. Instead, it has parallels with Gabo's *Spheric Theme* which was conceived in 1936–7, although the dating of the metal versions is open to question.[12] Gabo had cut and curved sheets into related concentric conoids so that the outer edge, forming a line similar to the seam of a tennis ball, implied the surface of a sphere. Hepworth similarly used the sheet metal to describe space, although the geometrical regularity of the curves used by Gabo contrasts with her more free-flowing loops appropriate to the gesture of the dance. In Hepworth's concrete and bronze versions, the roughened surface makes the contrast more noticeable.

fig.61
Forms in Movement (Galliard), 1956, length 76.2 (30),
copper, BH 212, Gimpel Fils

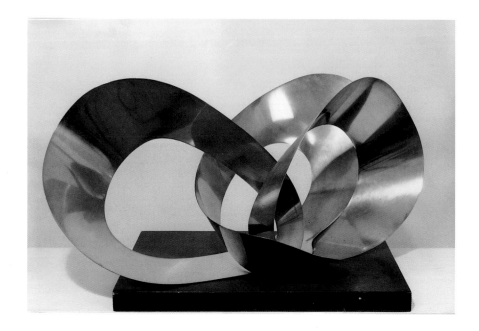

37 Stone Sculpture (Fugue II) 1956

LOO947 BH 220

Limestone 123 × 46 × 38 (48⅜ × 18⅛ × 15)
on ?granite base 11 × 52.5 × 42.5 (4⁵⁄₁₆ × 20¹¹⁄₁₆ × 16¼)

*On loan from the artist's estate to the Barbara Hepworth
Museum, St Ives*

*Displayed in the artist's garden, Barbara Hepworth
Museum, St Ives*

Exhibited: *5e Biennale voor Beeldhouwkunst*,
Middelheimpark, Antwerp, May–Sept. 1959 (46);
Whitechapel 1962 (22, repr.)

Literature: Hodin 1961, p.169, no.220, repr.

Reproduced: *Pictorial Autobiography* 1970/1978, p.75, pl.201

In the catalogue of her 1962 Whitechapel exhibition, Barbara Hepworth wrote:

the necessary equilibrium between the material I carve and the form I want to make will always dictate an abstract interpretation in my sculpture – for there are essential stone shapes and essential wood shapes which are impossible for me to disregard. All my feeling has to be translated into this basic framework, for sculpture is the creation of a *real object* which relates to our human body and spirit as well as our visual appreciation of form and colour content. Therefore I am convinced that a sculptor must search with passionate intensity for the underlying principle of the organization of mass and tension – the meaning of gesture and the structure of rhythm.[1]

This served as a reiteration of the basic carving principles by which Hepworth had worked since the 1920s and had demonstrated in works in the exhibition like *Stone Sculpture (Fugue II)*. The emergence from the block suggested by the rough hewn base (in fact, a separate piece of granite) was characteristic of the sculptor's search for the 'essential stone shapes'.

A series of photographs, taken by Bill Brandt, of the sculptor posed as if carving the block (fig.62) shows it approaching the final rough state. The overall profile and the concavity in the face have been achieved, and the holes made but not yet given their full breadth; it is not yet mounted on its base. The visible working of the stone demonstrates Hepworth's practice of carving with a point chisel in parallel lines. On completion of a sequence of channels, further reduction of the mass was achieved by carving away the intervening ridges in another series of parallel cuts. The photographs show that on the lower part cuts have also been made at right angles to achieve the face. The reductive process was very gradual, and this makes it likely that the smooth plane to the left (running almost the full height) is not a finished surface but the dressed face of the original block, to which the sculpture is closely worked. As the next stage, a claw chisel would be used to take the rest of the rough surface back to the deepest cut made with the point. Once the desired form was achieved, further work on the surface of the stone was undertaken with files and increasingly fine grades of emery paper, finishing with a rubbing down with the paper lining of a cigarette packet. In this process the crisp lines of the edges of the forms which describe the planar transitions and openings would be secured.

The blue limestone of *Stone Sculpture (Fugue II)* is riddled with small fossils which, because of the different densities, must have made carving difficult. They are also to be seen in the very similar stone used for *Poised Form* 1951–2 (no.28 q.v.) and a dressed block at present used as the pedestal for *Shaft and Circle* 1972 (no.73 q.v.). The status of *Stone Sculpture (Fugue II)* as a quintessential carving of the period was suggested by Hepworth's appearance with it in the photograph used as the frontispiece for her 1961 catalogue raisonné.[2] Such early photographs show the fine finish achieved on the sculpture, but weathering as a result of its position in the artist's garden has since exaggerated cracks in the top, across the reverse and within the opening at the back.

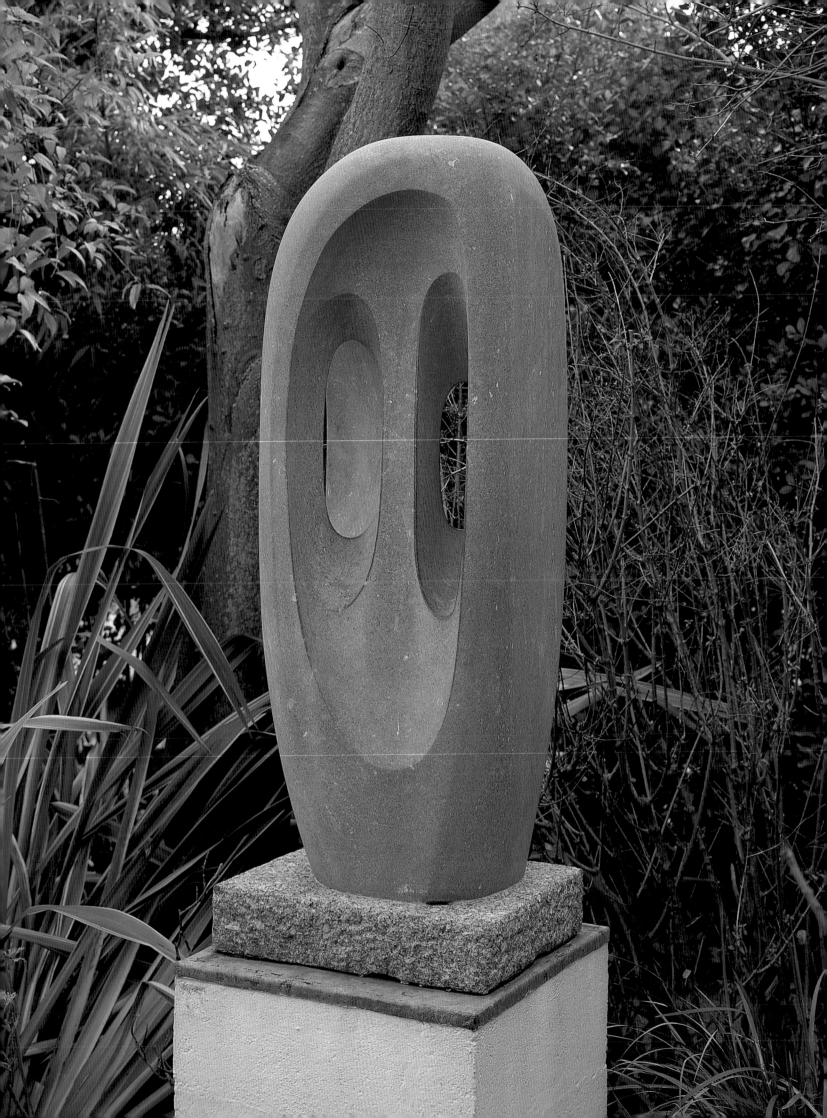

Exposure has made the stone susceptible to staining from water and lichen growth; this has also allowed the filler between the sculpture and the base to come loose and water to seep in.

Hepworth's initial experiments with bronze casting in 1956 overtook such carvings as *Stone Sculpture (Fugue II)* and may account for its limited appearance in exhibitions. It epitomised the gradual process which she maintained alongside the production of editions beginning with *Curved Form (Trevalgan)* 1956 (no.34 q.v.). The sculpture's rhythmic quality is alluded to in the musical title. This also draws attention to the mahogany *Wood and Strings (Fugue)* 1956 with which it shared the device of divergent oval openings.[3]

fig.62
Barbara Hepworth carving *Stone Sculpture (Fugue II)*, 1956, Bill Brandt Archive Ltd. Photograph by Bill Brandt

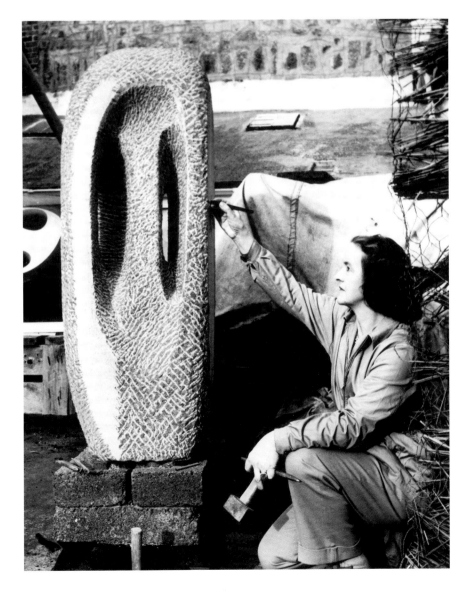

38 Orpheus (Maquette 2) (Version II) 1956, edition 1959

T00955 BH 222 version II; edition no. 2/3

Brass and cotton string on original teak base
114.9 × 43.2 × 41.5 (45¼ × 17 × 16¼)

Presented by the artist 1967

Exhibited: Whitechapel 1962 (25†, repr.); Tate 1968
(82, repr. p.30); Gimpel Fils 1975 (14‡)

Literature: Hodin 1961, p.169, no.222; Bowness 1966, p.23,
repr. p.22, pl.8; *Tate Gallery Report 1967–8*, 1968, p.62;
Hammacher 1968/1987, p.138; Jenkins 1982, p.17, repr. p.30;
Penelope Curtis, *Modern British Sculpture from the
Collection*, Tate Gallery Liverpool, 1988, p.53, repr.; Festing
1995, pp.224–5; Curtis 1998, p.39

Curled into an open conic shape and held by strings, *Orpheus* signalled a departure in Barbara Hepworth's working practice in 1956. Rather than the work being hewn from a block, the process of cutting shapes from flat sheets of metal allowed the description and enclosure of space. It had the advantage of being easily transferable from the artist's models to a larger scale to be worked on with and by her assistants. Its success was carried into the exactly contemporary *Stringed Figure (Curlew)* (no.39 q.v.). This crucial addition to Hepworth's battery of techniques was also explored in the contemporary *Forms in Movement (Galliard)* 1956 in sheet copper (fig.61), a work associated with *Forms in Movement (Pavan)* 1956-9 (no.36 q.v.).

The technique and conception date from 1956, but *Orpheus (Maquette 2) (Version II)* was made in 1959, as the last in a group of related works. The sequence was associated with the commission from the electronics firm Mullard Ltd for Mullard House at Torrington Place in Bloomsbury; the result was *Theme on Electronics (Orpheus)* 1956 for which the poised metal rises nearly four feet from the base.[1] In that year Hepworth made two preparatory works: *Orpheus (Maquette 1)* (BH 221) where the metal part is 42 cm (16½ in) high, and the larger 61 cm (24 in) high *Orpheus (Maquette 2)* (BH 222).[2] The purpose of the intermediate stage remains unclear, but both of the maquettes were issued in editions of eight. The second edition was shown at Gimpel Fils in June 1958[3] and its success may have encouraged the production of the larger – 94 cm (37 in) top to base – *Orpheus (Maquette 2) (Version II)* in an edition of three in the following year. The artist's copy (2/3) came to the Tate and another (1/3) went to the National Gallery of Australia. Although its size places it between the second maquette and the Mullard work, the production of this third edition after the commission makes the term 'maquette' as ambiguous as the additional qualification 'version II'. The records at Gimpel Fils, derived from the artist's own lists, add it to the sequence as '*Maquette for Stringed Figure (Orpheus) III* 1959'.[4]

Like the associated works, *Orpheus (Maquette 2) (Version II)* was made from brass sheet with strings. The Mullard version had a motor so that it rotated on its cylindrical plinth. The form of each version was the same. A pointed sheet rises and describes a curve on the right so that the highest corner almost stands above the centre of the base; the more extreme bulge of the left side was contained within this height, with its lower point turned upwards, as if lifted off the base by the network of strings between them. The sharp corners have been filed off. The back of the narrowing support is reinforced with three graduated and chevroned plates as it reaches the base; these do not extend all the way across the width, so that the additional thickness is not apparent along the inner rising edge. The sheet from which the form was cut was essentially triangular. To achieve the upper acute corners, the top edge of the triangle must have described a concave curve. At the bottom corner a small triangle was cut out of the left side to achieve the uneven pair of points, effectively creating a 'W'; as the right point was embedded in the base, so the left was lifted free.

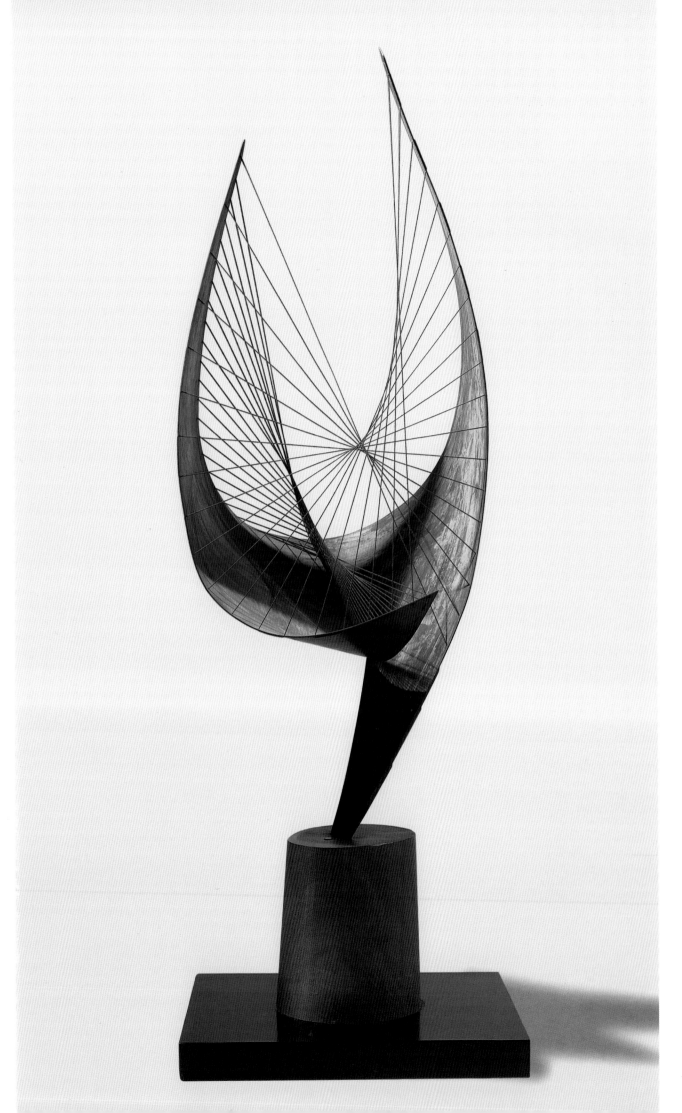

The production of the editions was largely undertaken by Hepworth's assistants. She took on the young sculptor Brian Wall in 1955 for his experience with metal and he worked for her until 1960. He has explained the constraints of the laborious process.[5] The shape of the brass sheet was planned in cardboard, but the curvature was achieved by 'cold rolling' (running a piece of wood over the surface to make it curl) as Hepworth did not want the metal to be heated. Wall stated that the sheet was cut by tapping or drilling holes and filing between, however, the unevenness of the inner junction between the lower points on the Tate's version appears to be compatible with the use of metal cutters. As well as working the sculptures, Wall recalled patinating the metal. The interior face of the Tate's version has a loosely brushed green patination; the outside retains the soft pinkish brown of the brass.

The creation of the 'W' shape allowed the stringing to be attached to four edges. Reddish brown fishing line was used and originally held the curve in tension,[6] but this has slackened considerably (indicating the set of the metal) so that some of the vertical strings rest upon those below. The front set passes from side to side; a second set runs from the left end of the back edge into the centre, where it is attached to the uplifted corner. In both cases, the illusion of a parabolic curve results from the crossing lines of the stringing, threaded in sequence to descend from one edge as it ascends the other. The string is 'stitched' through holes drilled in the metal so that it is visible on the outside and demonstrably continuous within each set. Variety is achieved by the different spacing between the holes, which appear to have been made by eye rather than measurement. Along the front right, for instance, they are all approximately spaced at 4.2 cm (1⅝ in), but the strings passing to the left are spaced so that they vary from 3 cm (1⅛ in) at the top to 6.5 cm (2½ in) below. These adjustments crucially maintain the relative angle between the strings at a constant and result from the point at which these lines cut through curvature of the planes. The effect of the stringing may be linked to the converging lines regularly present in Hepworth's drawings since works such as *Drawing for 'Sculpture with Colour' (Forms with Colour)* 1941 (no.15 q.v.); the device is present in the similarly titled *Curved Form (Orpheus)* 1956.[7]

The *Theme on Electronics* of the main title may have been expressed in the structural lightness of the sculpture for which engineering and electronics were used quite literally to make it rotate. This had consequences in the work which, rather unusually for Hepworth, was conceived completely in the round. Although the opening remains the privileged face, the contrast between plane and void, and the alteration of the effect of the strings in parallax were animated by rotation. Hepworth had used concrete for the motor-driven *Turning Forms* 1950 for the Festival of Britain of 1951,[8] but the lightweight metal of the Mullard work seems appropriate to the association with electronics. More generally, the commission extended her interest in the contact between art and science which was encapsulated in the addition of the subtitle *Orpheus*, one of Hepworth's Greek allusions which had become more frequent after her trip to the Aegean in 1954. The mythical poet was famous for pacifying wild beasts when playing his lyre, and there seems to be a simple visual link between the musical instrument and the stringed sculpture. Music had always been of special importance to Hepworth, not least because of its formal abstraction; in the Mullard work, it served as a link between technology and art.

The formal change in Hepworth's work represented by the use of sheet metal and stringing may be associated with similar concerns amongst her contemporaries. Her use of string for *Sculpture with Colour* 1940 (no.14 q.v.) followed Henry Moore in the balance of lines across an open solid, but the finer conjunction of plane and string in *Orpheus* relates more closely to the example of Naum Gabo's use of nylon thread and perspex structures in *Linear Construction in Space No.1* 1938–42 (fig.35); in particular, both created parabolic curves with the stringing. As such the sculpture represents Hepworth's proximity to a constructivist description of space rather than her more

characteristic carving of mass. Her interest in this approach was also demonstrated in the Gaboesque curved and spoked elements of her designs for Michael Tippet's ballet *The Midsummer Marriage,* 1954.[9] More generally, Gabo's belief in the reproducibility of his work following the original concept – seen in the seventeen versions of *Linear Construction in Space No.1* between 1940 and 1970 – offered a precedent for the various versions of Hepworth's 1950s' constructions.

At that time, Hepworth's role as a pioneer of pre-war modernism came to be recognised especially amongst emerging artists. The British Constructionists, who saw themselves as inheritors of the constructivist tradition, looked to her work – and that of Ben Nicholson – as an endorsement of their abstraction; Kenneth Martin and Victor Pasmore secured a reproduction of the sculptor's white marble *Two Forms* 1937 (fig.30) for the front cover of their 1951 publication *Broadsheet.*[10] After her important retrospective at the Whitechapel in 1954, she showed a wood carving alongside them in *Statements: A Review of British Art in 1956* and contributed the strung sheet metal *Winged Figure* to a similar group exhibition at the end of 1957: *Dimensions: British Abstract Art 1948–57.*[11] Although *Orpheus (Maquette 2) (Version II)* did not demonstrate the geometry favoured by the Constructionists, Hepworth's experiments with rotating sculptures may be seen to be invigorated by such developments as Kenneth Martin's mobiles. During the same period, her work also bore a relation to that of the more expressive sculptors shown together in the British pavilion at the 1952 Venice Biennale under the auspices of Herbert Read. Hepworth admired the open iron constructions of Reg Butler and Lynn Chadwick in particular. It is notable that the latter's series *The Inner Eye* 1952 has parallels with her *Orpheus* group, as Chadwick set a cage of metal across an opening and against a rising sheet of metal; he also made the sculpture in several different sizes.[12] In adopting sheet metal, Hepworth placed her work of 1956 within these varying currents in contemporary sculpture.

39 Stringed Figure (Curlew) (Version II) 1956, edition 1959

TO3137 BH 225 version II; edition no. 1/3 A

Brass and cotton string 53 × 75.5 × 49 (20⅞ × 29¾ × 19¼)
on wood veneer base 4.7 × 45.7 × 35.5 (1⅞ × 18 × 14)

Incised on brass plate '1/3A' r.

*Presented by the executors of the artist's estate,
in accordance with her wishes, 1980*

*Displayed in the artist's studio, Barbara Hepworth Museum,
St Ives*

Exhibited: Whitechapel 1962 (24†, repr.); BC European tour
1964–6: Copenhagen (11‡), Stockholm (12‡, repr.), Helsinki
(11‡), Oslo (11‡), Otterlo (15‡), Basel (10‡, repr.), Turin (13‡,
repr.), Karlsruhe (10‡, repr.), Essen (10‡, repr.); Tate 1968
(83); AC tour 1970–1 (5†, repr.); Gimpel Fils 1972 (7‡);
Gimpel Fils 1975 (16‡); New York 1977 (1‡); Osaka 1978 (2†);
Retrospective 1994–5 (54, repr. in col. p.140)

Literature: Hodin 1961, pp.22, 169, no.225, repr.; Jenkins 1982,
p.17, repr. p.32 (col.); *Tate Gallery Acquisitions 1980–2*, 1984,
p.115, repr.; Festing 1995, pp.224–5; Claire Doherty, 'Re-
reading the Work of Barbara Hepworth in the Light of
Debates on "the Feminine"' in Thistlewood 1996, p.169, repr.
p.168; Curtis 1998, p.39

Reproduced: *Pictorial Autobiography* 1970/1978, p.76,
pl.202 (with the artist)

The recumbent *Stringed Figure (Curlew) (Version II)* is close in many ways to the upright *Orpheus (Maquette 2) (Version II)* (no.38 q.v.) of that moment. The same techniques and materials were used as those developed for the commission for *Theme on Electronics (Orpheus)* 1956.[1] It also belonged to a series of editions in different sizes. This reflects both the artistic and commercial success of both pieces, and the ease of production facilitated by the presence of assistants in Hepworth's studio.

Under the impetus from the Mullard commission, Hepworth produced a number of sheet brass maquettes and larger sculptures. Editions of nine were issued of *Stringed Figure (Curlew) (Maquette I)* (BH 224), which was 33 cm (13 in), and the larger (56 cm / 22 in) *Stringed Figure (Curlew) (Maquette II)* (BH 225).[2] Although both are dated to 1956 and placed in ascending size in the artist's album, the records of her dealers, Gimpel Fils, indicate that the smaller work was made in 1957, perhaps as a result of the popularity of the earlier edition.[3] The Tate's example, *Stringed Figure (Curlew) (Version II)*, was larger still and was made in an edition of three, another of which (3/3) is in the Carlsberg Foundation in Denmark. The Gimpel Fils records place it in 1959. Unlike the *Orpheus* group, there was no apparent culminatory work in the *Curlew* series.

The sculptures were made in the same way as the *Orpheus* group. A cardboard template determined the shape of the brass sheet; for *Curlew* this was a right-angled triangle with the acute corners forming the enclosing wings. Two cuts into the left side of the triangle allowed a section to be turned inwards and facilitated a tighter curling of the form. Hepworth's assistant Brian Wall has described how the curvature was achieved by 'cold rolling' the brass, which was roughly patinated green on the inner surface.[4] The fact that each sculpture was handmade accounts for differences in effect; the version illustrated in the catalogue raisonné has more pointed and closed wings.[5]

The scheme of the stringing with red-brown fishing line was more straightforward than that for *Orpheus*, as the two webs on *Curlew* simply closed off the openings. The one at the back was threaded around the whole of the side, forming the characteristic parabolic profile; the intervals between the holes are all approximately 3.5 cm (1⅜ in). The stringing at the front only occupied the central section of the wings and was interrupted by the turned-in strip; the intervals are more varied – 4–4.5 cm (1⅞₆ – 1¾ in) – suggesting that adjustments were made by eye. The string initially kept the metal in tension, but the form has settled, and the string may have been replaced. The sculpture was riveted into the wooden base through a steel spacer plate and a flat brass plate. The rivet holes gradually enlarged, allowing a rocking movement; this has been prevented by the introduction of larger rivets.

The *Curlew* and *Orpheus* groups share many points of comparison. Hepworth used stringing on *Sculpture with Colour* 1940 (no.14 q.v.) but the formation of the parabola relates closely to Naum Gabo's *Linear Construction in Space No.1* 1938–42 (fig.35). This scheme appeared in Hepworth's drawings of the 1940s and resurfaced in those made at the same time as the sculptures, such as *Stringed Figure* 1956.[6] In the 1940s, Gabo

had identified sources for his Constructive art in nature,[7] and it may be in a similar context that Hepworth's reference to a wading bird in her subtitle, *Curlew*, may be seen. This suggests a comparison with John Wells's *Sea Bird Forms* 1951,[8] at that time in the collection of their mutual friend Ethel Hodgkins. The play of abstract forms in Wells's painting is dominated by a swooping asymetrical curve opening to points which closely resemble the effect achieved by Hepworth in sheet metal. The use of brass sheet may also reflect the context of contemporary abstraction, but Claire Doherty has placed a gendered interpretation on the technique, noting that such works 'explore the currents and connections in space, rejecting the weight and solidity of the work of her male forebears'.[9]

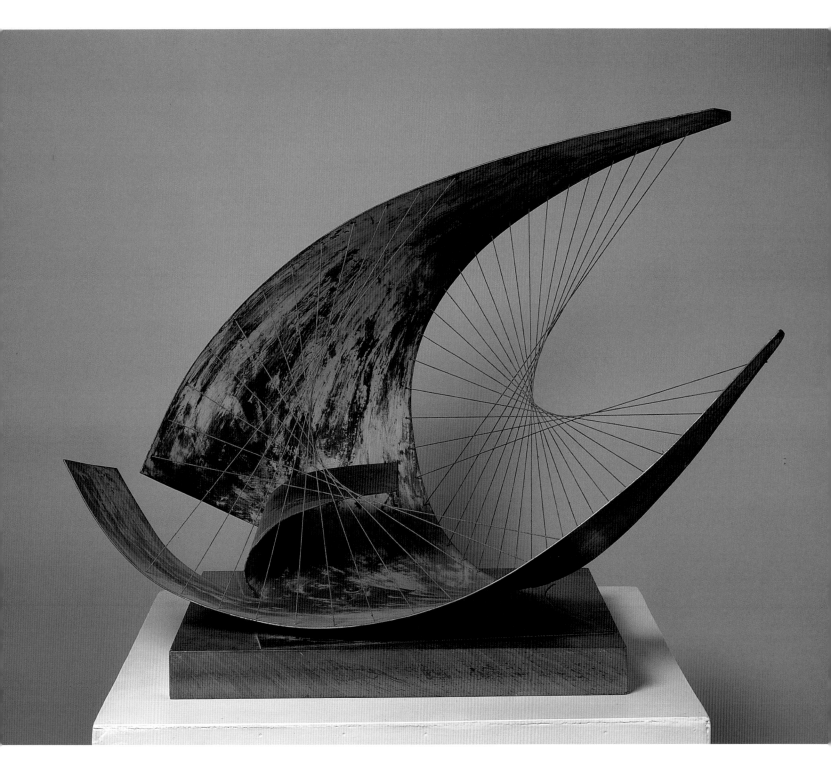

40 Spring, 1957 (Project for Sculpture) 1957

LO0953

Oil and ink on board 61.3 × 44.7 (24⅛ × 18¾)

Inscribed on back of backing board in pencil over white ground 'TOP', t., and 'Barbara Hepworth | Spring 1957 (project for Sculpture | oil 24" × 18" 1957' centre; in another hand 'Gimpel' t.r., and '220-0694 | 270-3679' t.l.

On loan from the artist's estate to the Barbara Hepworth Museum, St Ives

Displayed in the artist's studio, Barbara Hepworth Museum, St Ives

Exhibited: Penwith Society of Arts in Cornwall: A Selection of Paintings and Drawings, Sculpture and Pottery, St Ives, AC tour 1957–8, Laing Art Gallery, Newcastle-upon-Tyne, Nov.–Dec. 1957, Ferens Gallery, Hull, Dec. 1957–Jan. 1958, Leicester Art Gallery, Jan.–Feb., Museum and Art Gallery, Mansfield, Feb.–March, Birmingham City Art Gallery, March–April, Brighton Art Gallery, April–May, Hereford Art Gallery, May–June, Museum and Art Gallery, Kettering, June–July, Bolton Art Gallery, July–Aug., Cooper Art Gallery, Barnsley, Aug., Turner House Museum, Penarth, Sept., Arts Council Gallery, Cambridge, Oct.–Nov. (16 as Spring 1957); IVᵉ Exposition Internationale de Sculpture Contemporaine, Musée Rodin, Paris, June 1971 (not in cat.)

A hollow implement – possibly a straw – was used to apply the interlacing lines of Spring 1957 (Project for Sculpture). Barbara Hepworth used this individual technique for a considerable number of contemporary pictures, which combine drawing and painting and in which the speed of the gesture appears paramount; these include Périgord 1958 (no.48 q.v.). The flow of black ink facilitated the process which may be related to her interest in Tachisme, the gestural abstraction being explored in Paris in the 1950s.

Close inspection reveals the preparation of the board in anticipation of this burst of activity. In common with the majority of her drawings, a dry gesso-like ground was applied in long horizontal strokes affording a slightly textured surface. Further long scratches were made before the Indian red paint was worked in. The effect of a central glow was achieved by rubbing away the paint to reveal the white below, and then a number of hurried lines were made in pale blue. Though indistinct, these established the pattern of upward loops and nest of lines at the base. The black ink followed and elaborated this lead, adding the more agitated lines at the centre where the speed of application is indicated by the way in which the ink is pressed out to either side of the line. The semi-circular and puddled end-point to the line at the middle right confirms the shape of the implement.

In a letter of 3 March 1965, Hepworth told the Tate that the related drawing Périgord was connected to her sculpture Meridian 1958–60 (fig.68), for which Garden Sculpture (Model for Meridian) 1958 (no.46 q.v.) was an intermediary state.[1] The loose line has some echo in the folded strands of the sculpture, but the drawings pre-dated the commission, which came in late 1958. The subtitle of Spring, 1957 (Project for Sculpture) was one commonly used by the sculptor even when not linked to a specific three-dimensional work. The suggestion of natural phenomena as a source of inspiration is found in the titles of this and other closely related drawings, notably Figures (Summer) Yellow and White 1957 and Wind Movement No.2 1957.[2] As Group (Dance) May 1957 shows, however, the spontaneity of gesture allowed by working with paint almost certainly preceded any subject matter, making these pictures amongst Hepworth's least premeditated works.[3]

A label on the reverse indicates that the drawing was shown at the IVᵉ Exposition Internationale de Sculpture Contemporaine, Musée Rodin in 1971. Although Hepworth was amongst the British contingent, only her boxwood Single Form (Antiphone) 1953 is listed in the catalogue.[4]

41 Torso II (Torcello) 1958

T03138 BH 234; cast 5/6 A

Bronze 88.3 × 50 × 36 (34¾ × 19⅝ × 14³/₁₆)

Cast inscription on top of base '5/6A | BH | 1958' front right;
cast foundry mark on left-hand face of base 'Susse Fondeur
Paris' b.l.

*Presented by the executors of the artist's estate, in
accordance with her wishes, 1980*

*Displayed in the artist's garden, Barbara Hepworth
Museum, St Ives*

Exhibited: Gimpel Fils 1958 (10†, as *Torso (Torcello)*);
Modern Sculpture, Leeds City Art Gallery, Oct.–Nov. 1958
(39†, as *Torso, Torcello*); *Moments of Vision*, Rome-New
York Art Foundation, Rome, July–Nov. 1959 (no number†,
repr. [p.30]); New York 1959 (23†, repr.); *Summer Exhibition*,
Penwith Society of Arts, St Ives (49†); *Northern Artists*, AC
tour, Manchester City Art Gallery, July–Aug. 1960, Graves
Art Gallery, Sheffield, Aug.–Sept., Laing Art Gallery.
Newcastle-upon-Tyne, Sept.–Oct., Bolton Art Gallery, Oct.,
Bradford City Art Gallery, Nov., Carlisle Public Library and
Art Gallery, Dec. (26†, as *Torso (Torcella)*); *Malerei und
Plastik aus Leeds*, Stadthaus Unterer Galerie, Dortmund,
May–June 1961 (25); *Sculpture 1961*, Welsh Committee of
the Arts Council tour, National Museum of Wales, Cardiff,
July–Sept. 1961, Glynn Vivian Art Gallery, Swansea, Sept.,
National Library of Wales, Aberystwyth, Oct., University
College, Bangor, Nov. (22†, repr.); Whitechapel 1962 (30†,
repr.); *International Exhibition and Sale of Contemporary Art*,
O'Hana Gallery, Nov. 1962 (18†); *Autumn Exhibition 1962*,
Penwith Society of Arts, St Ives, autumn 1962 (no number);
John Lewis 1963 (4†); *Little Missenden Festival*, Little
Missenden, Oct. 1965 (no cat.); *Collectors' Choice XIV*,
Gimpel Fils, June 1967 (25†, repr.); Gimpel Fils 1972 (8‡);
Gimpel Fils 1975 (19‡, repr.); Bretton Hall 1980 (5†, repr. p.15)

Literature: Hodin 1961, pp.22, 169, no.234, repr.; Bryan
Robertson, 'Preface', Whitechapel 1962, exh. cat., p.7;
Hammacher 1968/1987, p.138, repr. p.130, pl.106; Jenkins
1982, p.17, repr. p.31; *Tate Gallery Acquisitions 1980–2*, 1984,
pp.115–16, repr.; Festing 1995, p.229; Curtis 1998, p.41, repr.
fig.43 (col.)

Diversity characterised Hepworth's experiments with metal sculptures in 1956–8.
She made sheet metal pieces, such as *Orpheus* 1956 (no.38 q.v.) and the larger-scale sheet metal *Winged Figure I* 1957.[1] She also made plasters for casting in bronze, of which *Torso II (Torcello)* is one. It is the second of three *Torso* sculptures from 1958 which are closely linked and demonstrate a new solidity in the handling of bronze. They decreased in size, as the Tate's falls between *Torso I (Ulysses)* (fig.63) – the tallest at 130.8 cm (51⅛ in) – and *Torso III (Galatea)* (fig.64) which is only 55.3 cm (21¾ in) high. They were shown together at Hepworth's second exhibition at Gimpel Fils in June 1958. A fourth work, *Figure (Archaean)* 1959 also known as *Archaic Form*, is closely related and carries the torso theme to a monumental scale.[2]

The process that Hepworth had developed in 1956 for making plasters for bronzes was adapted for the *Torso* group. In *Curved Form (Trevalgan)* 1956 (no.34 q.v.), the form was determined by a shape cut from a sheet of expanded aluminium and then covered with plaster. The results were sinuous. The method had the advantage of speed and flexibility, as the aluminium was sufficiently strong not to need additional support. For the *Torsos*, as her assistant Brian Wall recalled, the expanded metal was folded over to make a hollow framework which provided greater solidity.[3] This brought a transformation from the single sheets to works which appeared robust. At the same time their presence was of a different order from the mass of wood or stone, as was evident in the more amorphous and organic development of form.

Like the earlier pieces, the casts bear the enlivening traces of the application of the plaster. However, those of 1958 appear to be the first that the sculptor began to cut and carve. This would be a central justification for the use of bronze: Hepworth drew a distinction between her rejection of modelling in clay – which is kept damp and malleable for revision – and her method of working plaster when dry and hard on an armature. In a letter to Herbert Read, she equated her process with sculpting unique works in stone or wood, and she evoked the ideal of 'truth to material'.[4] However, elsewhere she lamented the quality of casting which necessitated that she had 'casts delivered here in the rough state. My aesthetic requirements are such that I cannot stand deviations in casting – nor the varying qualities of trade production…I am now inventing bronzes which will virtually become carvings!!'[5] This modification meant that the metal was handworked by the artist or her assistants and was necessarily time-consuming, but Hepworth would also write (conflating bronze and plaster): 'I only learned to love bronze when I found that it was gentle and I could file it and carve it and chisel it'.[6] The signs of filing and cutting score the surface of *Torso II (Torcello)* and contribute to the variations between rough and smooth in concavities and on protuberances. There are even traces of claw chisels.

All of the *Torsos* were cast at the Paris foundry Susse Frères. Unusually the casting of the Tate's copy may be dated precisely, to September 1959 when, on the sale of 4/4, the sculptor asked Gimpels to order it.[7] However, Hepworth confessed that each cast

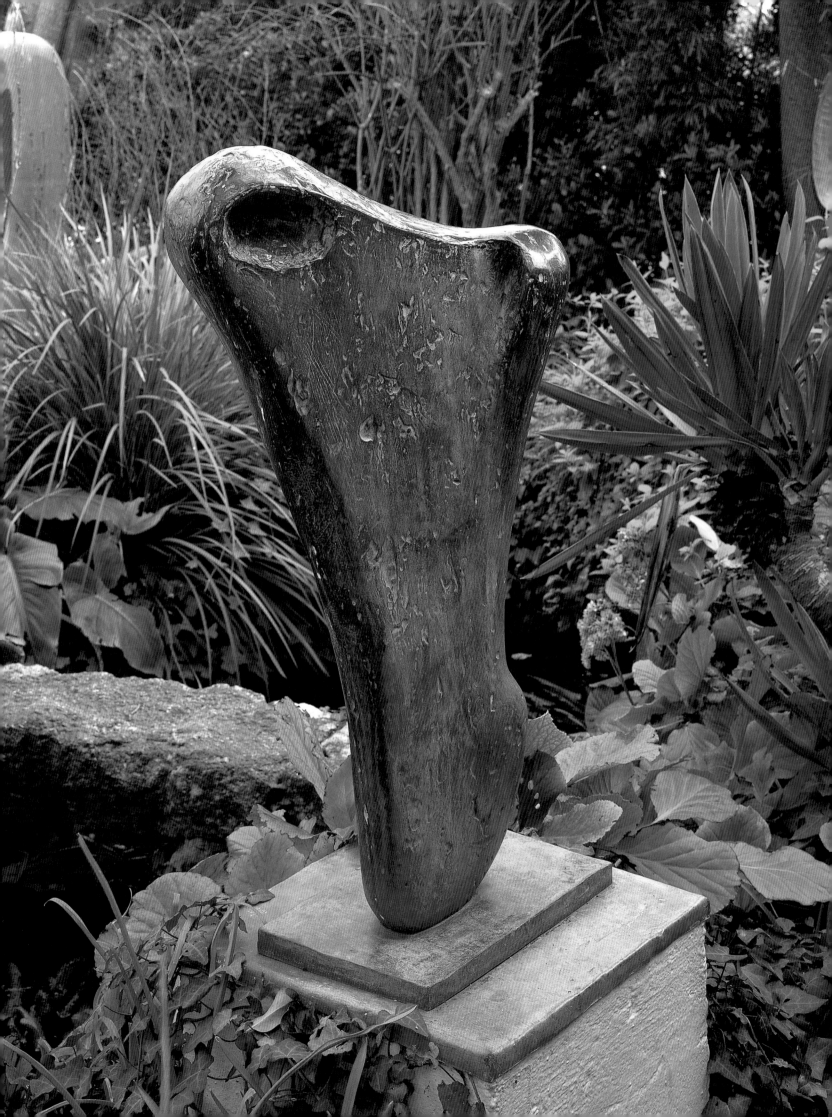

fig.63
Torso I (Ulysses), 1958, height 130.8 (51½), bronze, BH 233, Art Gallery of Ontario, Toronto

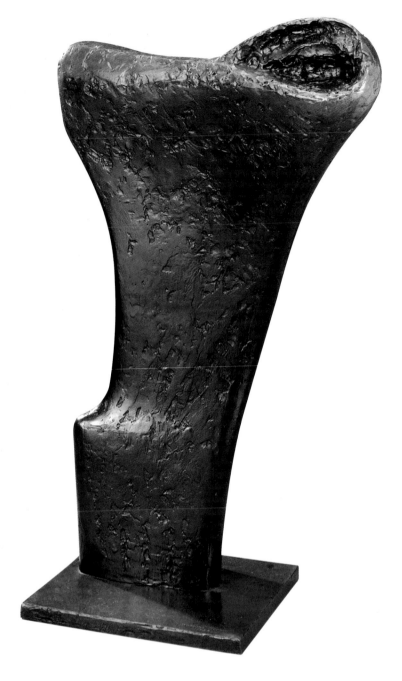

fig.64
Torso III (Galatea), 1958, height 55.2 (21¾), bronze, BH 235, British Council

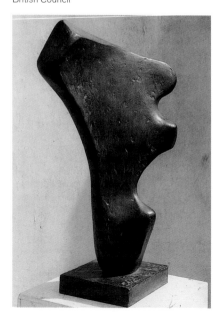

had to be 'vetted for any discrepancies' on return to the studio and that *Torso II (Torcello)* in particular had to be 'corrected as well as patinated'.[8] The Tate's cast has been polished by weathering and handling in its public position in the artist's garden; this has worn away much of the green patination and allowed a certain amount of algal growth. Nevertheless, it is in good condition, and has been solvent-cleaned prior to the application of a protective wax coating.[9]

The *Torsos* are more organic than the immediately preceding works. They present a flattened wedge-shape which is reminiscent of a scapula. Michael Shepherd recognised a bony quality in *Torso I (Ulysses)*, and Edwin Mullins described the series as 'images that are part bone, part stone and part gesture…conceived as figures poised in their landscape'.[10] This coincides with the title's indication of the truncated body. In the first and second sculptures a distinct step suggests a hip, and the upper corners suggest shoulders. The broad forms of *Torso I (Ulysses)* were condensed for *Torso II (Torcello)*. The rough cavity in the upper right corner of the former was softened on the latter, where a related indentation on the other side hints at the making of a hole there. This was not taken up in the antler-like *Torso III (Galatea)* but came to fruition in the piercing of *Figure (Archaean)* 1959.

The subtitles of the three *Torsos* have Mediterranean associations which have been related to Hepworth's important trip to Greece in 1954.[11] *Ulysses* – the Roman equivalent for Odysseus – evokes the Greek hero condemned to wander after the Trojan Wars, as narrated in Homer's *Odyssey*. Perhaps stimulated by this, Shepherd recognised in it an 'atmosphere of the heroic' and Hammacher identified a 'tragic or elegiac undertone' in the group.[12] However, the subtitles do not follow a consistent theme. *Galatea* was a mythical sea nymph – famously portrayed by Raphael in the Villa Farnesina in Rome – and *Torcello* is the name of the island north of Venice known for its Byzantine Basilica and mosaics. The link therefore appears to be with the sea, also evoked by *Archaean* which refers to the earliest of geological periods. It is notable that Hepworth had the three large sculptures photographed against the sea.[13]

In a wider context, the *Torsos* also bear comparison with other sculptures including Henri Matisse's series of four progressively schematised female *Backs*. Although dating from the early part of the century they were newly rediscovered in the 1950s, and considerable publicity surrounded the acquisition of casts by the Tate in 1955–7.[14] The asymmetry created by the raised left arm is comparable to the extrusion of Hepworth's *Torsos*; there is also a similar concentration upon the cut and carved surface. This treatment in the *Torsos* may likewise be compared to that of Henry Moore's contemporary works – which were almost exclusively modelled for bronze and similarly evocative of their inspiration from bones – especially the form and handling of his *Warrior with Shield* 1953–4 (fig.65). The evocation of classical precedents and conflicts by both sculptors carried implicit references to the Cold War which had circumscribed the *Unknown Political Prisoner* competition of 1953, on which Moore was a judge and Hepworth a prizewinner.[15] Although a political interpretation cannot be imposed upon Hepworth's *Torsos* in particular, she remained sensitive to the repercussions of contemporary events. Overt political commitment was present in the work of the 1930s, and from that period the isolation of *Single Form* 1937–8 (no.12 q.v.) may be seen to anticipate the more wrought and figurative *Torsos*. In late 1956, when the suppression of the Hungarian uprising succeeded the Suez Crisis, Hepworth wrote to Herbert Read with the 1930s in mind:

how have you got on during these last awful weeks? It has made one feel somewhat sick inside. I became a pacifist two years ago but all this has pushed me into trying to do more by joining the Labour Party, the Toldas group & United Nations Ass. etc. One can scarcely look 'earlier sculptures' in the face if one remains politically & socially inactive now.[16]

fig.65
Henry Moore, *Warrior with Shield*, 1953-4, height 152.4 (60), bronze, Birmingham Museums & Art Gallery

42 Forms (West Penwith) 1958

T00700

Oil and pencil on hardboard 64 × 63.1 (25³⁄₁₆ × 24⅞)

Inscribed on back in black paint 'Barbara Hepworth | 1958 oil | forms (West Penwith)' centre and in pencil '[...]ara Hepworth' (partially obscured by label), bottom

Presented by the artist 1964

Exhibited: Gimpel Fils 1958 (16); São Paolo Bienal 1959 (Drawing 11); BC South American tour 1960 (5); *Recent British Sculpture: Robert Adams, Kenneth Armitage, Reg Butler, Lynn Chadwick, Hubert Dalwood, Barbara Hepworth, Bernard Meadows, Henry Moore, Eduardo Paolozzi*, BC tour of Canada, New Zealand, Australia, Japan and Hong Kong 1961–4, National Gallery of Canada, Ottawa, April–June 1961, Montreal Museum of Fine Arts, Aug.–Sept., Winnipeg Art Gallery, Sept.–Oct., Norman Mckenzie Art Gallery, Regina College, Nov., Art Gallery of Toronto, Jan.–Feb. 1962, Public Library and Art Museum, London, Ontario, Feb.–March, Vancouver Art Gallery, March–April, Auckland Institute and Museum, July, Dominion Museum, Wellington, Aug.–Sept., Otago Museum, Dunedin, Oct., Canterbury Museum, Christchurch, Nov.–Dec. 1962, Western Australia Art Gallery, Perth, Jan.–Feb. 1963, National Gallery of Victoria, Melbourne, July–Aug., Art Gallery of New South Wales, Sydney, Sept.–Oct., Queensland Art Gallery, Brisbane, Nov.–Dec. 1963, Newcastle War Memorial Cultural Centre, Jan. 1964, Albert Hall, Canberra, Feb., Bridgestone Art Gallery, Tokyo, and other Japanese venues, including Museum of Modern Art, Kyoto, July–Aug., City Hall Art Gallery, Hong Kong, Aug.–Sept. 1964 (40); Hakone 1970 (46, repr.)

Literature: *Tate Gallery Report 1964–5*, 1966, p.41

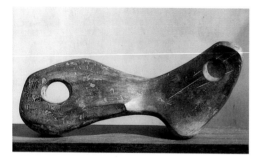

fig.66
Reclining Form (Trewyn), 1959, length 63.5 (25), bronze, BH 262, Barbara Hepworth Estate

On the smooth side of a nearly square sheet of hardboard, Hepworth painted three forms reminiscent of reclining figures for *Forms (West Penwith)*. The technique was swift. A cream layer, applied in rough vertical strokes, took up colour from the underlying scraped-down paint: blue and orange, purple and grey are evident, the latter especially in the top left corner. The figure elements were superimposed in white, which was applied with a thick brush (perhaps 5 cm / 2 in) in continuous angular strokes and again picked up colour. Blue was dragged through the top form, and grey through the lower two; conté crayon may also have been used here. The speed of the work (if not the result) is comparable to the contemporary *Périgord* (no.48 q.v.), but on *Forms (West Penwith)* the free technique was brought under control by the carefully ruled pencil lines. This device had been seen in Hepworth's more geometrical drawings of the 1940s.

The forms of head and shoulders are quite distinct to the right of the upper two figures and the left of the lower. They recall earlier realistic drawings of reclining female nudes propped on one elbow, especially *Three Reclining Figures (Prussian Blue)* 1951.[1] *Forms (West Penwith)* may also be related to the organic sculptures of 1933–4, especially the reclining *Mother and Child* 1934 (no.7 q.v.), in which a similar rhythmic silhouette was used as a sign for the body. In a way only implied in the sculpture, the 1958 drawing made an equation between figure and landscape through these forms and the reference in the subtitle to the peninsula of westernmost Cornwall. This recalls Hepworth's observation of a process of coalescence in drawings a decade before: 'If I go out to draw the landscape, I sometimes find my pencil turning to draw an idea for an abstract carving – the landscape is transformed into that on the spot.'[2] Such a combination is closely related to her identification with the figure in the landscape. There is also a parallel with Henry Moore's related equation of body and landscape (fig.33). However, the relative scarcity of reclining figures in Hepworth's work may be a measure of how far they were identified with Moore.

Along with *Périgord*, the drawing was amongst the works in Hepworth's 1964 gift to the Tate, which included the important carving *Pelagos* 1946 (no.20 q.v.). Shortly after, she stressed the coincidence of the pencil lines in the drawing with the strung elements in such abstract metal sculptures as *Winged Figure I* 1957, writing that it: 'related to all my stringed figures and wing figures of the period; but it would not be true to say that it was for any particular sculpture.'[3] She also acknowledged a formal relation to the notably bone-like bronzes *Figure (Oread)* 1958 and *Reclining Figure* 1958.[4] To these may be added *Reclining Form (Trewyn)* 1959 (fig.66), named, significantly, after her own studio.

43 Reclining Figures (St Rémy) 1958

L00952

Oil, ink and pencil on canvas 46 × 104.4 (18⅛ × 41⅛)

Inscribed on backing board in red crayon in another hand
'BARBARA HEPWORTH | RECLINING FIGURES ST
REMY 1958' top centre, and 'SIGNED ON BACK OF
CANVAS' lower centre

*On loan from the artist's estate to the Barbara Hepworth
Museum, St Ives*

*Displayed in the artist's studio, Barbara Hepworth Museum,
St Ives*

Exhibited: Gimpel Fils 1958 (Drawings for Sculpture 15);
?New York 1959 (not in cat.)

Literature: J.P. Hodin, 'Barbara Hepworth: A Classic Artist',
Quadrum, no.8, 1960, p.80, repr.

Reclining Figures (St Rémy) was first shown in Barbara Hepworth's solo exhibition at Gimpel Fils in mid-1958 alongside *Forms (West Penwith)* 1958 (no.42 q.v.). In both paintings abstracted figurative forms were worked in a mixture of media which allowed a variety of techniques. A layer of ultramarine oil paint appears to have been laid on the canvas of *Reclining Figures (St Rémy)* – remaining visible at the corners – upon which white was applied energetically with a broad brush (25 mm / 1 in) dragging up the blue and mixing with it. The central area, identifiable with the reclining figures of the title, was rubbed back to blue and defined by smudges of Indian red and sweeps of white. The thickness of the white allowed a series of stepped scrapes made with a palette knife (to the left and in the centre); it has also resulted in surface cracking in the upper and lower centre. Pencil was used to add the horizontals, verticals and enclosing lines especially at the right end. These defining lines relate to the ruled pencil lines on *Forms (West Penwith)*. The canvas is floated, unglazed, on a hessian-covered backing board which appears to be the original framing. Two Gimpel Fils labels on the reverse indicate that it was sent to New York, probably for the solo exhibition in 1959.

Although an established theme in sculpture – especially for Henry Moore (fig.33) – the reclining figure was relatively limited in Hepworth's work. The pose was used in her life drawings, notably *Three Reclining Figures (Prussian Blue)* 1951 in which the combination of blue, white, earthy reds and browns anticipated *Reclining Figures (St Rémy)*.[1] The disparate paintings of the late 1950s may be linked to the *Projects for Waterloo Bridge* 1947 (no.21 q.v.) for which Hepworth proposed abstracted recumbent sculptures. Associated forms emerged in such sculptures as *Reclining Form (Trewyn)* 1959 (fig.66), which show a shift from an urban location to a concern with the place of the body in the landscape. Perhaps as a result of the fluency of the media, *Reclining Figures (St Rémy)* is extreme in the compression of the bodies into an hour-glass form.

These post-war works look back to such sculptures of the early 1930s as *Mother and Child* 1934 (no.7 q.v.), both in the abstracted form and in the rhythmic outline. These characteristics and the French subtitle had already been used for the collage *Saint Rémy* 1933,[2] in which silhouettes derived from Hepworth's contemporary figurative sculptures were cut out from various papers. The title presumably refers to the visit that she made with Ben Nicholson to St Rémy-en-Provence at Easter 1933. In 1952, the sculptor recalled the trip in terms circumscribed by her later concerns: 'I began to imagine the earth rising and becoming human.'[3] She made drawings of Roman ruins and anthropomorphic hills, such as *St Rémy, Mountains and Trees* 1933.[4] The union of land and figure is echoed in *Reclining Figures (St Rémy)* where the fusion of two bodies is implied. As such, the painting touches upon issues of human interrelationships and responses to surroundings which were explored in sculptures such as *Bicentric Form* 1949 (no.25 q.v.). The happiness of Hepworth's 1933 holiday remained a key point in her relationship with Nicholson, making the reference particularly poignant at the time of their estrangement following his marriage to Felicitas Vogler in 1957.

44 Figure (Nanjizal) 1958

T00352 BH 236

Yew 246.9 × 45.7 × 33 (98¼ × 18 × 13) on wood base
10 × 91 × 60 (4¼ × 35¾ × 23¾)

Purchased from the artist (Grant-in-Aid) 1960

Exhibited: Gimpel Fils 1958 (12); *Modern Sculpture*, Leeds
City Art Gallery, Oct.–Nov. 1958 (40, repr. pl.14); Tate 1968
(89); *Forty Years of Modern Art 1945–1985*, Tate Gallery,
Feb.–April 1986 (no number)

Literature: *Tate Gallery Report 1960–1*, 1961, p.21; Hodin 1961,
pp.20, 169, no.236, repr.; C, F & B 1964, p.279; Edwin Mullins,
'Barbara Hepworth', Hakone 1970, exh. cat., unpag.; Jenkins
1982, p.17, repr. p.31; Festing 1995, p.238

By the late 1950s, when *Figure (Nanjizal)* was made, Barbara Hepworth was one of the few modernist sculptors still committed to carving wood. Of her contemporaries many, like John Skeaping, had returned to naturalism or, like Henry Moore, worked almost exclusively for casting; the new generation of sculptors concentrated on metal. In 1956, Hepworth herself began to explore the possibilities of bronze casting; *Figure (Nanjizal)* and related works were, therefore, affirmations of the continuing validity of carving. It was in this context that she regarded herself as a teacher in the workshop. She told Alan Bowness: 'I was keen to hand on this carving technique which is now so hard to acquire.'[1] By these means Hepworth maintained the balance between modernism and craftsmanship which was a key characteristic of art associated with St Ives.

The desire to carve was limited by the availability of seasoned wood, supplies of which had not recovered since the war. In 1954, Hepworth received a shipment of Nigerian guarea from which works such as *Corinthos* 1954–5 (no.32 q.v.) were carved immediately. The elegant attenuation and honey colour of the yew of *Figure (Nanjizal)* contrasted with the massive richly coloured boles of guarea. The yew lent itself to a rising form of impressive twisting height, which is enhanced by the fine figuring of the grain. Although maintaining the integrity of the trunk – including a stump-like protrusion – Hepworth hollowed out an opening to about half the depth and almost to the full height. This removed the heart wood which was off-centre in the sculpture; it was difficult work as yew is notoriously hard.[2] Glimpses through to this hollow were afforded by two narrower openings in the closed side. These points of entry were emphasised by the directional cross-grain carving into the centre of the wood. Towards the top, as the outer planes twist round and curve in, two smaller but broader openings were cut in a similar way. The chiselling of the interior was relieved by the smoothing of the junctions between planes – especially around the apertures. The interior has a matt grey appearance, as if the result of liming or a similar treatment; it was, characteristically, contrasted with the polishing of the outside.

As well as the sense of spatial enclosure and release achieved for the eye rising over these forms, the hollowing out had practical benefits. According to Hepworth's assistant Dicon Nance – an expert wood craftsman – it afforded more even drying of the timber and helped to reduce splitting.[3] This seems to have been the case with *Figure (Nanjizal)*, which only has notable splits descending from the opening to the left of the stump, and within both the lowest and the highest parts of the hollow. The upper split has been filled, as have a number of other areas of damage to the exterior. Instead, what is most noticeable is the dark staining of the grain on the exterior surfaces, which occurs in apparently random concentrations, particularly below the stump and – less dramatically – around the middle-range openings. This appears to be exuded by the wood. The effect is unfortunately distracting and presumably accounts for the sculpture's omission from exhibitions since 1968.

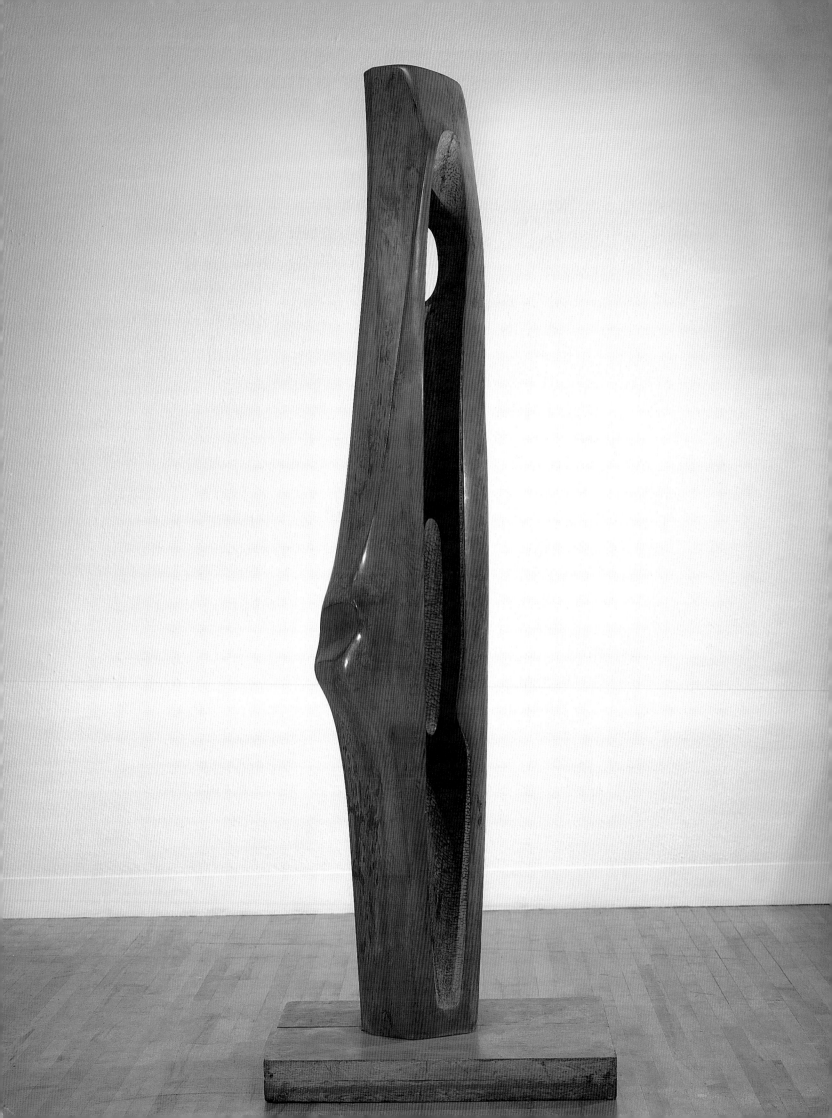

Nanjizal is the name of a bay on the extremity of Cornwall, just to the south of Land's End. Soon after the sculpture was acquired by the Tate, the artist wrote of it in relation to this 'superb cove with archways through the cliffs'. Coupling it with the bronze *Curved Form (Trevalgan)* 1956, also named after a local site, she added: 'Both sculptures are really my sensations *within* myself when resting in these two places'.[4] The choice of Cornish place-names – which balanced the use of Greek names for the guarea pieces – reflects the importance Hepworth placed on locating herself and her work in the landscape. Just as with *Trevalgan* (no.34 q.v.), the 'sensations within' took precedence over a portrayal of nature, as an identification between body and landscape gave rise to the associated abstract work. The openings in *Nanjizal* may echo the 'archways' in the cliffs but are not literal.

The rising form of *Figure (Nanjizal)* was shared with other sculptures such as the walnut *Figure (Requiem)* 1957 which is 216 cm (85 in) high.[5] Taken together they suggest a deliberate contrast between carvings in English woods and Hepworth's massive guarea pieces. The tendency towards verticality was a theme shared amongst her assistants and colleagues in St Ives, such as Denis Mitchell who in 1959 made the elegant bronze *Turning Form*.[6] They may also be seen in the context of Moore's totemic bronzes – *Upright Motive No.1 Glenkiln Cross* 1955–6, for example – and the columnar works of William Turnbull, such as *Janus 2* 1959.[7] As distinct from such mythic references, the upward thrust of Hepworth's works of the late 1950s takes on a combination of figurative and spiritual aspects, as suggested by *Figure (Requiem)* and *Cantate Domino* 1958 (no.45 q.v.). They also reflect a contemplative mood following the death of her son, Paul Skeaping, in 1953, as well as the regenerative experience of Greece the following year. In the sculptures, such spiritual aspirations became conflated with Hepworth's perception of and absorption with the landscape.

45 Cantate Domino 1958

T00956 BH 244; cast 6/6

Bronze 209.8 × 55 × 50.5 (82½ × 21⅝ × 19⅞)
on bronze base 7.6 × 52.9 × 50.2 (3 × 20⅞ × 19¾);
weight 265 kg

Cast inscription and numerals on upper surface of base
'HEPWORTH 1958' and '6/6' l.

Presented by the artist 1967

Exhibited: Gimpel Fils 1958 (13‡); *Modern Sculpture*, Leeds
City Art Gallery, Oct.–Nov. 1958 (42†, repr. pl.9); *5ᵉ Biennale
voor Beeldhouwkunst*, Middelheimpark, Antwerp,
May–Sept. 1959 (49†); São Paolo Bienal 1959 (19†); New
York 1959 (25†, repr.); *British Artist Craftsmen: An Exhibition
of Contemporary Work*, exhibition toured through USA by
Smithsonian Institution, Washington DC, 1959–60 (10, repr.);
BC South American tour 1960 (18†); *6ᵉ Biennale voor
Beeldhouwkunst*, Middelheimpark, Antwerp, July–Oct. 1961
(142); Whitechapel 1962 (35†, repr.); *Artists Serve the
Church: An Exhibition of Modern Religious Work*, Coventry
Cathedral Festival, Herbert Art Gallery, Coventry, 1962
(131‡); BC European tour 1964–6, Otterlo (17‡, repr.); Tate
1968 (91, repr. p.34); Bretton Hall 1980 (2‡, repr.p.9)

Literature: 'Barbara Hepworth's New Sculpture', *Times*, 3
June 1958; Hodin 1961, pp.22, 170, no.244, repr.; Norbert
Lynton, 'London Letter', *Art International*, vol.6, no.7, Sept.
1962, p.47; Shepherd 1963, [p.39], repr. pl.12; *Tate Gallery
Report 1967–8*, 1968, p.62; Edwin Mullins, 'Barbara
Hepworth', Hakone 1970, exh. cat., unpag. repr.; Judith Rich,
'Barbara Hepworth', *Guardian*, 17 Jan. 1973, p.8; Michael
Davie, 'By-laws bar Dame Barbara's tombstone', *Observer*,
25 May 1975; Hammacher 1968/1987, p.130, repr. p.129, pl.104;
Jenkins 1982, p.17, repr. p.31; Festing 1995, pp.225, 238, 305,
repr. between pp.280 and 281, pl.54

Reproduced: *Pictorial Autobiography* 1970/1978, p.103

The title, *Cantate Domino* ('O Sing unto the Lord'), indicates the overtly religious nature of this work. This fits with a wider pattern in Barbara Hepworth's output in the 1950s, associated with both personal and public issues, and was made manifest in the rising form of the sculpture. *Cantate Domino* is based on two diamond shapes formed in depth by flat planes so that they are open front and back. More bulky towards the base, the structure opens out at the upper points. This almost exactly matches the slightly shorter *Ascending Form (Gloria)* 1958 (fig.67) which has an additional back plate.

The sculpture was made for casting following Hepworth's established method of constructing an armature of flat independent planes in expanded aluminium to which plaster was applied. Brian Wall, who was an assistant at the time, recalled that the outline was established first, then the inner strip passing between the diamonds, and finally the deep U-shape between the upper arms.[1] A cast was made at the Art Bronze Foundry in Fulham and exhibited in 1958; further casting was underway in March 1959.[2] The inner strip was joined to the left-hand side in the process of casting; according to Wall, Hepworth was unhappy about the closure of this gap.[3] The weight of the upper section caused structural problems. A welded joint at the waist of one copy (1/6) was found to be broken on arrival for Hepworth's first New York exhibition in late 1959; this may have been the cast repaired at the foundry on return from the *British Artist Craftsmen* exhibition which toured America.[4] Wall also recalled repairing a cast. The artist's copy, which came to the Tate, spent eight years in the studio garden (1959–67) and its chalky surface over brown may result from the oxidisation of the bronze or from Hepworth's reputed use of sour milk in order to achieve a white patination.[5]

Remarking on the thrust of the composition, Michael Shepherd wrote that:

the resilience of the metal, and the organic spring which recalls the uncurling tendrils from a seed, unite with the upwards stretch like that of upstretched open hands. Thus a multiplicity of references from figurative associations, together with the work's own essential and abstract nature, come together to form an independent spiritual unity.[6]

This figurative interpretation was also taken up by Mullins. He calls it 'even more exultant' than *Ascending Form (Gloria)*, adding that they 'represent a free stylisation of the human hand raised in supplication and praise'.[7] In this way the reflected forms may evoke hands in prayer, such as those in Albrecht Dürer's famous *Praying Hands*, 1508.[8]

Although Hepworth did not specify such an interpretation, Mullins's assessment – culled from conversations with her – does reflect her view of the spirituality of her work and sculpture in general. Writing to Herbert Read of the sculptures in the British Museum, she asserted: 'Only a society in a state of affirmation can produce sculpture – a primitive society or one fighting for its existence…on the basis of active belief in both the virility of nature & the spiritual ascendancy of man.'[9] The latter she equated with 'a religious sensibility', adding: 'In an art [sculpture] which is intrinsically bound up with the understanding of natural forces, & an art which depends on virility of life & movement

fig.67
Ascending Form (Gloria), 1958, height 190.5 (75), bronze, BH 239, Barbara Hepworth Estate

even for its comprehension, you have to look for a dynamic inter-play in society itself.' Such an understanding of sculpture, as resulting from the conjunction of social and spiritual energies in a period of crisis while drawing on the latent forces of nature, was central to Hepworth's faith in the relevance of art. This confidence was strengthened in adversity, as she later told Mullins that outside events supplied 'the moral climate in which my sculpture is produced'.[10]

In *Cantate Domino* the response was specifically religious, as the title is the opening phrase of Psalm 98. Hepworth may also have recognised in this text her concerns with the landscape: 'Let the sea roar, and the fullness thereof; the world and they that dwell therein; Let the floods clap their hands; Let the hills be joyful together before the Lord'.[11] This conjunction was reinforced by photographs of the sculpture seen in front of the tower of St Ives parish church and in the countryside.[12] Soon after completion, it was exhibited in the 'Altar Furniture and Religious Sculpture' section of *British Artist Craftsmen*; once acquired by the Tate, Hepworth wrote to the Director Norman Reid: 'It was intended to be reserved as a Headstone for my grave in St Ives … I only mention this because I have always considered this a religious work.'[13]

Other works combined references to religious music with vertical forms, notably *Ascending Form (Gloria)* and the contemporary carving *Figure (Requiem)* 1957.[14] They were the most abstract manifestation of a renewed spirituality in her work following the death of her son, Paul Skeaping, in 1953 and the definitive separation from Ben Nicholson in 1957. In 1954, she carved a *Madonna and Child* for St Ives parish church which served as a memorial to her son.[15] Its realism may be measured against Hepworth's earlier disenchantment with Henry Moore's *Northampton Madonna* 1943–4, which she had criticised as using 'sentiment as a substitute for strength'.[16] By contrast, *Cantate Domino* used a formal language which was integral to the stylistic concerns of her contemporary sculpture. In 1969–70 (when the tanker Torrey Canyon spilled oil along the Cornish coast) she told Mullins:

My sculpture has often seemed to me like offering a prayer at moments of great unhappiness. When there has been a threat to life – like the atomic bomb dropped on Hiroshima, or now the menace of pollution – my reaction has been to swallow despair, to make something that rises up, something that will win. In another age…I would simply have carved cathedrals.[17]

These public crises were the subject of much post-war sculpture and provide a further context for *Cantate Domino*. In Rotterdam, Ossip Zadkine's *The Destroyed City* 1946–53 addressed themes of suffering and regeneration through a figure with uplifted arms. This appears to be indebted directly to Rodin's *Prodigal Son* c.1889 – which Read illustrated in *The Art of Sculpture* in 1956; both adopt the pose which is sometimes recognised in Hepworth's sculpture.[18] Soon after, Naum Gabo built the *Bijenkorf Construction* 1956–7, also in Rotterdam. This took to a monumental scale his submission for the *Unknown Political Prisoner* competition in 1952, which raised up finely tapering bows.[19] Hepworth knew this work as she was a fellow prizewinner in the competition. Beyond the formal similarity the asymmetry and organicism of *Cantate Domino* establishes a human dimension and scale more personal than Gabo's work.

In making the selection of works to be submitted to the São Paolo Bienal in 1959, the British Council's Lilian Somerville preferred *Cantate Domino* to the contemporary carving *Figure (Nanjizal)* (no.44 q.v.), which Hepworth herself was keen to send.[20] The bronze may have been chosen for the practicalities of travel; in any case, Hepworth's award of the International Prize followed and a cast (3/6) was acquired for the Museu de Arte Moderna São Paolo. Another cast is in the Middelheimpark in Antwerp (4/6). As Hepworth told Norman Reid, she intended *Cantate Domino* for her grave but local by-laws ensured that 'it was pointedly refused on account of it being too high', the limit being two feet six inches.[21] The artist's cast had passed to the Tate before this decision was reversed; her grave is marked with a simple stone and a cast of *Ascending Form (Gloria)* is now placed at the entrance to Longstone Cemetery, Carbis Bay.

46 Garden Sculpture (Model for Meridian) 1958

TO3139 BH 246; cast 3/6

Solid bronze 150.5 × 86.5 × 54 (59¼ × 34 × 21¼)
on bronze base 9.8 × 45 × 37.4 (3⅞ × 17¾ × 14¾)

Cast inscription on top face of base 'Barbara Hepworth
1958 3/6' and cast foundry mark on right-hand face of base
'CAST BY | MORRIS SINGER Co. | LONDON S.W.8' t.l.

*Presented by the executors of the artist's estate, in
accordance with her wishes, 1980*

*Displayed in the artist's garden, Barbara Hepworth
Museum, St Ives*

Exhibited: Zurich 1960 (8‡, repr.); Gimpel Fils 1961 (1‡, repr.);
Contemporary British Sculpture, AC open-air tour, Cannon
Hill Park, Birmingham, April–May 1961, Manor Gardens,
Eastbourne, May–June, The Abbey, Cirencester, June–July,
Castle Grounds, Nottingham, July–Aug., Inverleith House,
Edinburgh, Aug.–Sept., Lister Park, Bradford, Sept. (12, repr.
on back cover, as *Garden Sculpture (Meridian)*);
Whitechapel 1962 (36†, repr.); *British Art Today*, San
Francisco Museum of Art, Nov.–Dec. 1962, Dallas Museum
of Contemporary Arts, Jan.–Feb. 1963, Santa Barbara
Museum of Art, March–April (113†, as *Garden Sculpture
(Meridian)*); BC European tour 1964–6: Copenhagen (14,
repr.), Stockholm (15, repr.), Helsinki (14, repr.), Oslo (14,
repr.), Otterlo (19, repr.); Tate 1968 (92); Gimpel Fils 1972 (9‡).

Literature: Hodin 1961, p.170, no.246 (as *Meridian, Model for
State House*); Jenkins 1982, pp.17, 18, repr. p.31; *Tate Gallery
Acquisitions 1980–2*, p.116, repr.

Winning the Grand Prix of the São Paolo Bienal in late 1959 came as an official acknowledgement of Barbara Hepworth's international importance. It coincided with a period of enormous productivity in her studio, in which carvings were emerging side by side with plasters for casting in bronze. A series of large and important commissions for public sculptures further heightened this activity. These culminated in *Winged Figure* 1961-2 (fig.72) in London and *Single Form* 1961–4 (fig.6) in New York, but began with *Meridian* 1958–60 (fig.69) installed at State House in High Holborn, London. *Garden Sculpture (Model for Meridian)* is the result of one of the intermediary stages towards this final sculpture; it is bound up with the process but also an independent aspect of it.

The commission came about during late 1958 through the British Council's Lilian Somerville, who also organised the submission to the São Paolo competition. She expressed relief about the commission: 'for once these architects do not want symbolism or a subject or a theme but an *abstract* sculpture.'[1] Indeed Harold Mortimer, the project architect with Trehearne & Norman Preston & Partners, had set aside a position for a contemporary sculpture beside the main entrance to the new office development.[2] He was furnished with a list of potential sculptors (including Lynn Chadwick) whose studios he visited before offering Hepworth the commission.[3] The sculptor studied the plans and visited the site, where one storey was already built.[4] She made 'lots of drawings' in the studio in which she proposed to set flowing line in contrast to the 'hardness of the architecture'.[5] In a contemporary interview, Hepworth spoke of the 'immediate formal impact' on seeing the site: 'With this commission I felt no hesitation whatsoever. By next morning I saw the sculpture in my mind quite clearly. I made my first maquette, and from this, began the armature for the working model.'[6] Later she reiterated: 'mercifully, I did get an immediate idea. I thought the building needed some kind of growing form, and I went straight ahead.'[7] She apparently explained to Mortimer her choice of title, which refers either to an imaginary arc of longitude (quintessentially the Greenwich Meridian) or to the highest point in the arc of the sun; unfortunately he was unable to remember its significance in 1981. Ben Nicholson had entitled one of his paintings *1953, August 11 (meridian)*.[8]

Hepworth's assistant, Brian Wall has recalled that she made the initial idea in pipe cleaners dipped in plaster. From this linear but three-dimensional beginning, Wall made the 43 cm (17 in) *Maquette for State House (Meridian)* in plaster; it and *Maquette (Variation on a Theme)* were subsequently cast in bronze editions of nine.[9] Enlargements of both maquettes were then made. The resultant unfinished plaster, *Variation on a Theme*, in which the central coiled form is suggestively figurative, remains in the artist's studio; it exemplifies the surface quality achieved in plaster and faithfully transferred to bronze.[10] The Tate's *Garden Sculpture (Model for Meridian)* closely followed *Maquette for State House (Meridian)*, but was one third the height of the final work. Following Hepworth's practice, it was made with an armature of expanded

fig.68
Plasters for *Meridian*, 1958 and *Garden Sculpture (Model for Meridian)* in studio, 1958

aluminium to which plaster was applied. This was more energetically worked than contemporary pieces, such as *Cantate Domino* (no.45 q.v.), with the surface showing the heavy encrustation of the plaster reminiscent of the work of Giacometti. Following the unfolding line of the maquette, the planes are set side-on and unravel in an elongated spiral to establish a triangular outline. They curve and turn in space and coil forwards at the centre. The handling of the planes and of the surface relates to the organic inspiration of the work, and may be associated with the energetic linearity of related drawings such as *Périgord* 1958 (no.48 q.v.). A photograph in the artist's album shows the plaster positioned against a curved board with a numbered grid.[11] This was the means for enlarging to the monumental work, and anticipated the form of the curved back wall at State House, which the artist specified should be of Cornish granite.[12] A further photograph shows both the plasters for *Garden Sculpture (Model for Meridian)* and for *Meridian* (fig.68); the size of the final work required a larger studio, and Hepworth was lucky to secure the former Lanham's Sale Rooms near her Trewyn Studio which had been recently vacated by the Penwith Society.

The plaster for the full-size sculpture was complete by February 1959 and cast as a unique bronze by Susse Frères in Paris.[13] In early November 1959, Hepworth herself

went to Paris 'for a party & the finish of Meridian'. She was there for about two weeks, later writing to Herbert Read: 'Paris was a complete exhilaration for me after 21 years…I had a good time with Charles Lienhard, Joray [publisher of Hodin 1961], Seuphor, Arp & Soulages – & I worked v. hard at the foundry. The large bronze is finished'.[14] In January 1960, Mortimer had the guarding wall heightened on Hepworth's suggestion 'to make Meridian look perfect' (fig.69).[15] The sculpture was unveiled in March 1960 by Sir Philip Hendy, Director of the National Gallery, at a ceremony under the auspices of Sir Herbert Read.

Already in 1958, Hepworth had qualified the 'fantastic experience' of the Holborn job by remarking on its small financial return and the fact that 'it is going so much slower than I anticipated'.[16] As recompense, each stage of the process was cast. During 1959 casts of *Maquette for State House (Meridian)* were already selling.[17] Her Swiss dealer Charles Lienhard suggested 'casting the five foot model of "Meridian" as suitable for a garden'.[18] The edition of *Garden Sculpture (Model for Meridian)* began to be cast at Morris Singer in March 1960 and was first shown in Zurich later that year.[19] In advising her London dealers 'it is pretty hefty', Hepworth also remarked with pride: 'It is not the sort of sculpture to go in a corner because it is so exciting all the way round & seeing through it'.[20] This emphasised a fundamental quality which distinguished it from the larger work backed by its wall. One cast (5/6) went to New College, Oxford.

fig.69
Meridian, 1958-60, 462.2 (180), bronze, BH 250, Pepsi Cola Corporation. Photographed on original site.

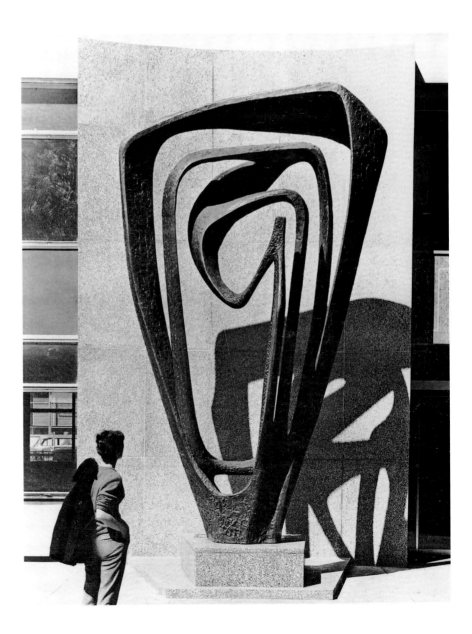

The artist's cast of *Garden Sculpture (Model for Meridian)* which came to the Tate has, appropriately, been sited in her garden. It has a pale green patination, slightly worn at the edges, and has also suffered from exposure to handling, accumulation of leaves and rain, and bird lime. Its vicissitudes started early. In 1961, on receiving it Hepworth remarked that 'there seems to have been considerable warping on one of the inner limbs and there are two very large lumps of bronze which simply don't exist on the cast…The biggest fault is on the left-hand inner limb which is very thin'.[21] Despite this, the cast was needed for an Arts Council tour; a replacement was cast six months later.[22] As a protective coating, this cast was lacquered in 1974, but this was found to acquire a white bloom, possibly as a result of the breakdown of the polymer coat. The lacquer proved stubborn when removal was attempted in 1993, only 70 per cent was removed and the surface was protected with a wax coating.[23]

Despite their formal relationship *Meridian* and *Garden Sculpture (Model for Meridian)* represent different positions in Hepworth's thinking about sculpture. Large-scale modernist sculpture was in demand during the construction boom of the 1950s and 1960s, amongst which the works of Henry Moore were very much in evidence. Hepworth's use of bronze from 1956 onwards was predicated upon meeting the demand for her work and the possibility of securing public commissions. She also maintained her forthright opinions of the social contribution of sculpture, stating in relation to *Meridian* that 'the architect must create a valid space for sculpture so that it becomes organically part of our spiritual perception as well as our three dimensional life. To do less is to destroy sculpture and admit to an impoverished architecture'.[24] Interestingly, this assertion echoes debates around the relationship between the two arts in the 1930s with which Hepworth had been involved through her large-scale works, such as *Forms in Echelon* 1938 (no.13 q.v.). Hepworth presumably felt that the guarding wall behind *Meridian* provided just such a 'valid space' within the otherwise rectilinear architecture. The context for *Garden Sculpture (Model for Meridian)* was evidently on a more domestic and human scale than the monumental work. It coincided with wider interests reflected in Hepworth's work, found especially in the freedom of drawings already being made in 1957–8, such as *Périgord* (no.48 q.v.). It also carried her abiding concern with the relationship between sculpture and the natural world. While *Meridian* offered Hepworth the opportunity to make a sculpture on a scale unprecedented but long desired,[25] *Garden Sculpture (Model for Meridian)* retained the linear form within the scope of gesture, and located the sculpture in the landscape.

47 Sea Form (Porthmeor) 1958

T00957 BH 249; cast 4/7 A

Bronze on bronze base 83 × 113.5 × 35.5 (32¾ × 44¾ × 14)
on wood veneer base 4.1 × 45.7 × 35.4 (1⅝ × 18 × 13¹⁵⁄₁₆)

Cast numeral with incised inscription on back of base
'4/7 A' b.l.

Presented by the artist 1967

Exhibited: *5ᵉ Biennale voor Beeldhouwkunst*,
Middelheimpark, Antwerp, May–Sept. 1959 (50‡); New York
1959 (26‡, repr.); *Sculpture: Ten Modern Masters*, Laing
Galleries, Toronto, Nov. 1959 (5‡); São Paolo Bienal 1959
(20‡); BC South American tour 1960 (19†);
Beeldententoonstelling Floriade, Museum Boymans-van
Beuningen, Rotterdam, March–Sept. 1960 (42†);
Contemporary British Sculpture, AC tour 1960, Cannon Hill
Park, Birmingham, May 1960, Cannon Hall, Barnsley,
May–June, Ashburne Hall, Manchester, June–July,
Avonbank Gardens, Stratford-on-Avon, July–Aug., Inverleith
House, Edinburgh, Aug.–Sept., Cheltenham Festival of Art
and Literature, Sept.–Oct. (16†, repr.); Zurich 1960 (9‡, repr.);
Gimpel Fils 1961 (2†, repr.); *Summer Exhibition*, Penwith
Society of Arts, St Ives, summer 1961 (123†); *Recent British
Sculpture: Robert Adams, Kenneth Armitage, Reg Butler,
Lynn Chadwick, Hubert Dalwood, Barbara Hepworth,
Bernard Meadows, Henry Moore, Eduardo Paolozzi*, BC tour
of Canada, New Zealand, Australia, Japan and Hong Kong
1961–4, National Gallery of Canada, Ottawa, April–June
1961, Montreal Museum of Fine Arts, Aug.–Sept., Winnipeg
Art Gallery, Sept.–Oct., Norman Mckenzie Art Gallery,
Regina College, Nov., Art Gallery of Toronto, Jan.–Feb. 1962,
Public Library and Art Museum, London, Ontario,
Feb.–March, Vancouver Art Gallery, March–April, Auckland
Institute and Museum, July, Dominion Museum, Wellington,
Aug.–Sept., Otago Museum, Dunedin, Oct., Canterbury
Museum, Christchurch, Nov.–Dec. 1962, Western Australia
Art Gallery, Perth, Jan.–Feb. 1963, National Gallery of
Victoria, Melbourne, July–Aug., Art Gallery of New South
Wales, Sydney, Sept.–Oct., Queensland Art Gallery,
Brisbane, Nov.–Dec. 1963, Newcastle War Memorial Cultural
Centre, Jan. 1964, Albert Hall, Canberra, Feb., Bridgestone
Art Gallery, Tokyo, and other Japanese venues, including
Museum of Modern Art, Kyoto, July–Aug., City Hall Art
Gallery, Hong Kong, Aug.–Sept. 1964 (34‡, repr.);
Whitechapel 1962 (38†, repr.); *Modern Sculpture from the
Joseph H. Hirshhorn Collection*, Solomon R. Guggenheim
Museum, New York, Oct. 1962–Jan. 1963 (207‡, repr. p.153);
54:64: Painting and Sculpture of a Decade, Calouste
Gulbenkian Foundation exh., Tate Gallery, April–June 1964
(78); *Barbara Hepworth*, Toronto Art Gallery, Nov. 1964 (5‡);
Nine Living British Sculptors, Lalit Kala Akademi/BC tour of
India 1965, Delhi, Calcutta, Madras, Bombay (25‡, repr.); BC
European tour 1964–6: Copenhagen (15), Stockholm
(16),Helsinki (15), Oslo (15, repr.), Otterlo (20), Basel (13,
repr.), Turin (17, repr.), Karlsruhe (13, repr.), Essen (13, repr.);
British Sculpture 1952–62, Brooke Park Gallery,
Londonderry, April 1967, Ulster Museum, Belfast, May–June
(23†); *Britisk Skulptur 1952–62*, BC tour of Norway,
Stavanger, Sept. 1967, Bergen, Sept.–Oct., Trondheim,
Oct.–Nov., Tromsø, Nov. (23); Tate 1968 (93, repr. p.31); *Eight
British Sculptors*, BC exh. United Arab Republic 1969 (19‡,
repr.); *Yedi Ingiliz Heykeltrasi (Seven British Sculptors):
Robert Adams, Kenneth Armitage, Lynn Chadwick, Hubert*

The textures of Barbara Hepworth's bronzes of 1958 are notably varied between the heavy encrustation of *Garden Sculpture (Model for Meridian)* (no.46 q.v.) and the density of *Torso II (Torcello)* (no.41 q.v.). On the whole, the surface of *Sea Form (Porthmeor)* was smoothly worked in keeping with the stretched organic form. There are rough areas around the enclosing sides, but the folded-over lip-like forms have been burnished to shiny edges. This may have been exaggerated by handling or wear. In any case, it serves to enhance the contrast between the drier inner surface and the seeming elasticity of the peripheries.

The sculpture was made in the way established in Hepworth's studio by this time. An armature of expanded aluminium was built to take the plaster specifically for bronze casting. The organic quality of *Sea Form (Porthmeor)* shows how far Hepworth and her assistants were able to develop the process away from the original metal sheet still evident in *Curved Form (Trevalgan)* 1956 (no.34 q.v.). The malleability of the aluminium is seen in the turned-over edges and puncturing with holes. The function of the strong rising diagonal within the form is not clear; it seems likely to be a welding joint, indicating that the sculpture was cast in two parts.

The casting was underway at the Art Bronze Foundry, Fulham, in early 1959.[1] The unusual thickness of the bronze – *c*.6 mm (¼ in) – may indicate that there were problems with the process. The base is rather thinner, and the two are held together by bolts through a central bronze bar, which were replaced in 1988; the veneered plywood of the blockboard base was repaired at the same time.[2] It is possible that the patination of the bronze was carried out at the studio. It was treated so that it was almost black both inside and on the back, and then covered with energetic dappling in green and white. The effect is crusty and contrasts with the smoothness of the sculpture's edges. The original white plaster, which is visible in a photograph of the sculptor's upstairs studio in January 1959 (fig.71), was painted with a broken green, presumably as a preliminary to the patination. The plaster was shown at the St Ives Guildhall when the sculptor received the Freedom of the Borough in 1968 and is now one of several such preparatory pieces on display at the Barbara Hepworth Museum.[3]

In combination with the form and patination, the title may identify the sculpture as a response to Porthmeor Beach in St Ives. Although Hepworth's studio turns towards the harbour rather than this Atlantic coast, Porthmeor was the site of artists' studios, including those occupied by Ben Nicholson and Terry Frost. To Herbert Read the sculptor described the 'extraordinary feeling being poised above the changing calligraphy of tide & water movement, sand & wind movement & the pattern of men's & birds' feet'.[4] It has been observed that the sculpture is 'in part based on her observation of breaking waves, and the pattern left on the beach by waves and tides'.[5] In his assessment, Michael Shepherd held back from a literal equation between the surf and the form of the sculpture, writing that with 'its lipped edges, its amoebic or cellular organic forms, and its white-plastered metal as if salted from long immersion in

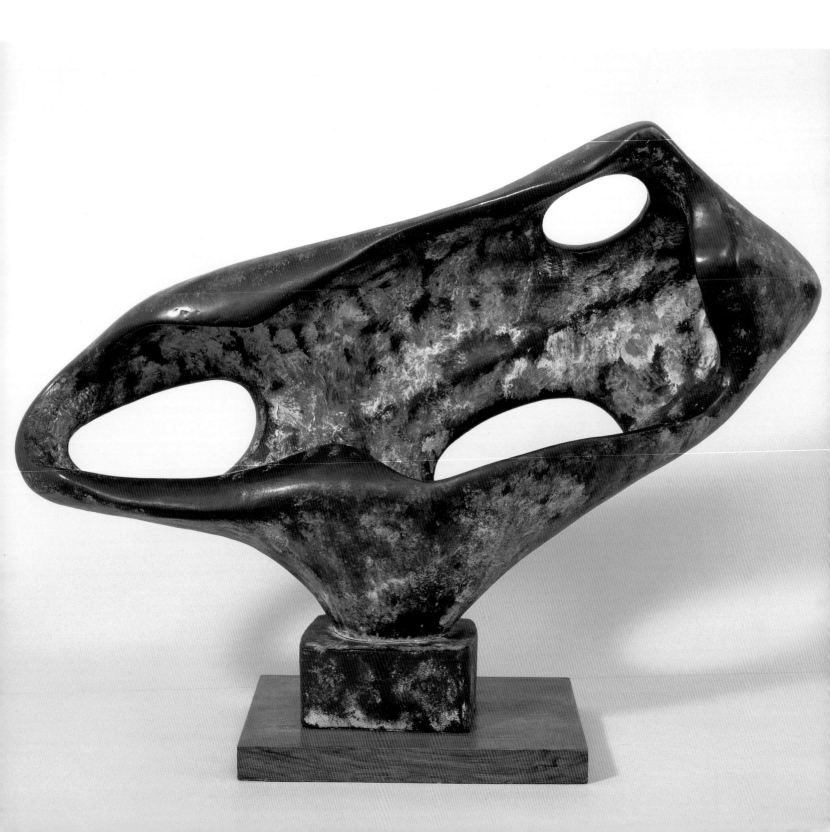

Dalwood, Barbara Hepworth, Bernard Meadows, Henry Moore, BC & Turco-British Association tour, 1970, Ankara, Istanbul (19‡); *A Tribute to Samuel J. Zacks from the Sam & Ayala Zacks Collection*, Art Gallery of Ontario, Toronto, May–June 1971, National Gallery of Canada, Ottawa, Aug. (84‡, repr.); Hakone 1970 (8, repr.); *Henry Moore to Gilbert and George: Modern British Art from the Tate Gallery*, Palais des Beaux Arts, Brussels, Sept.–Nov. 1973 (49, repr. p.62); *Sculptors and their Drawings: Selections from the Hirshhorn Museum Collection*, Lyndon Baines Johnson Library, Austin, Texas, Oct. 1974–Jan. 1975 (no number†, repr.); Washington 1981 (†no cat.); *St. Ives: Twenty Five Years of Painting, Sculpture and Pottery*, Tate Gallery, Feb.–March 1985 (135, repr. p.192); *British Art in the Twentieth Century: The Modern Movement*, RA, Jan.–April 1987 (152‡, repr. in col. p.245); *Comparisons: An Exercise in Looking*, Hirshhorn Museum and Sculpture Garden, Smithsonian Institution, Washington DC, Dec. 1990–April 1991 (no number†, repr. in brochure); Canada 1991–2 (6, repr. p.30); *Retrospective* 1994–5 (58, repr. in col. p.87, Liverpool only); *Porthmeor Beach: A Century of Images*, Tate St Ives, April–Oct. 1995 (no number)

Literature: Hodin 1961, pp.22, 170, no.249, repr.; Bryan Robertson, 'Preface', Whitechapel 1962, [p.7]; Shepherd 1963, [p.39], pl.13; *Tate Gallery Report 1967–8*, 1968, p.63; Hammacher 1968/1987, pp.138, 152, 167, repr. p.137, pl.116 (col.); *Pictorial Autobiography* 1970/1978, p.76, repr. p.77; H.H. Arnason, *A History of Modern Art*, rev. ed., 1977, p.547, pl.950; Jenkins 1982, p.17, repr. p.34; Penelope Curtis, *Modern British Sculpture from the Collection*, Tate Gallery Liverpool, 1988, p.54, repr.; Alan G. Wilkinson, 'Cornwall and the Sculpture of Landscape: 1939–1975', *Retrospective* 1994–5, exh. cat., p.104; Festing 1995, p.226; Claire Doherty, 'Re-reading the Work of Barbara Hepworth in the Light of Debates on "the Feminine"' in Thistlewood 1996, pp.169, 171; Emma E. Roberts, 'Barbara Hepworth Speculatively Perceived within an International Context', ibid., p.195; Curtis 1998, p.40

seawater, [it] seems to belong to the living world of the sea'.[6] However, Hepworth herself appeared to condone the association: 'I had…become bewitched by the Atlantic beach. The form I call Porthmeor is the ebb and flow of the Atlantic'.[7]

In laying stress on tidal movement, Hepworth hinted at her wider view of sculpture expressing the experience of being within the landscape. The processes of nature were concerns shared with other artists working in St Ives. They gave impetus, for instance, to Terry Frost's abstractions of movement on water, such as *Green, Black and White Movement* 1951, and Bryan Wynter's more cosmic works, such as *Mars Ascends* 1956.[8] Hepworth's *Sea Form (Porthmeor)* emerges from a similar focus on cyclical events. When she reproduced the sculpture in her *Pictorial Autobiography* it was placed opposite her acknowledgement of a shared endeavour in St Ives with Frost and Wynter, as well as Denis Mitchell and Patrick Heron; it was also juxtaposed with a photograph of Bernard Leach's hands throwing a pot.[9] This indicates that the formal qualities of *Sea Form (Porthmeor)* may also be seen in a wider context of contemporary visual culture, especially within design in the late 1950s; comparisons may be drawn with the work of other studio potters, such as James Tower, who worked with asymmetric forms, or Hans Coper, who used heavily textured surfaces. Perhaps because of this contemporary style, *Sea Form (Porthmeor)* was very widely exhibited. A cast (6/7) was acquired by the British Council in 1961, shortly after it was included in the successful São Paolo Bienal display (1959) and subsequent South American tour. Other casts are in the Hirshhorn Museum, Smithsonian Institution, Washington (2/7), Yale University Museum (1/7), the Art Gallery of Ontario (3/7), and the Gemeentemuseum in The Hague (7/7).

Confrontation with the sea was a theme implied in Hepworth's contemporary *Torso* group (no.41 q.v.), and had a long pedigree in the history of painting back to Gustave Courbet and Caspar David Friedrich. However, Claire Doherty has specifically refuted these literal connections, writing of *Sea Form (Porthmeor)*:

the allusions to the landscape of St Ives are neither delicate nor romantic, but reveal a fascination with the re-creation of a natural form in sculpture. The viewer is provoked to question: What relationships are initiated in the spaces between the solid forms? What meanings are generated when a natural form is imitated by the mark of the chisel or cast in bronze?[10]

Instead, asserting that the form encourages an exploration which 'is never prescribed, but variable, motivated and intrigued', Doherty posited Hepworth's work as an example of a gendered 'sculpture féminine'. This was exemplified by such qualities as 'the play on notions of nature and the natural, the opening up of spaces between solid forms, the deconstruction of stability'.[11]

48 Périgord 1958

T00701

Oil, ink and pencil on board 48.3 × 36.2 (19 × 14¼)

Inscribed on the back in black paint over an area of white
'Barbara Hepworth | oil 1958 | Perigord | 19 × 14' centre and
in pencil '[...]epworth' (partially obscured by label) bottom

Presented by the artist 1964

*Displayed in the artist's studio, Barbara Hepworth Museum,
St Ives*

Exhibited: Gimpel Fils 1958 (17); São Paolo Bienal 1959
(Drawing 15); BC South American tour 1960 (Drawing 9);
*Recent British Sculpture: Robert Adams, Kenneth Armitage,
Reg Butler, Lynn Chadwick, Hubert Dalwood, Barbara
Hepworth, Bernard Meadows, Henry Moore, Eduardo
Paolozzi*, BC tour of Canada, New Zealand, Australia, Japan
and Hong Kong 1961–4, National Gallery of Canada, Ottawa,
April–June 1961, Montreal Museum of Fine Arts, Aug.–Sept.,
Winnipeg Art Gallery, Sept.–Oct., Norman Mckenzie Art
Gallery, Regina College, Nov., Art Gallery of Toronto,
Jan.–Feb. 1962, Public Library and Art Museum, London,
Ontario, Feb.–March, Vancouver Art Gallery, March–April,
Auckland Institute and Museum, July, Dominion Museum,
Wellington, Aug.–Sept., Otago Museum, Dunedin, Oct.,
Canterbury Museum, Christchurch, Nov.–Dec. 1962,
Western Australia Art Gallery, Perth, Jan.–Feb. 1963,
National Gallery of Victoria, Melbourne, July–Aug., Art
Gallery of New South Wales, Sydney, Sept.–Oct.,
Queensland Art Gallery, Brisbane, Nov.–Dec. 1963,
Newcastle War Memorial Cultural Centre, Jan. 1964, Albert
Hall, Canberra, Feb., Bridgestone Art Gallery, Tokyo, and
other Japanese venues, including Museum of Modern Art,
Kyoto, July–Aug., City Hall Art Gallery, Hong Kong,
Aug.–Sept. 1964 (39)

Literature: *Tate Gallery Report 1964–5*, 1966, p.41

Reproduced: Hodin 1961, pl.n

'*Périgord* could be said [to have] belonged to the family of drawings connected to the big *Meridian* of State House in Holborn', the artist told the Tate Gallery shortly after donating the drawing.[1] The sculpture *Meridian* 1958–60 (fig.69) was Hepworth's first major public commission since the Festival of Britain, and the preparation involved drawings, maquettes and the medium-sized *Garden Sculpture (Model for Meridian)* (no.46 q.v.). As the commission was secured in late 1958 and associated drawings – such as *Wind Movement No.2* – are dated to 1957, the 'family of drawings' appears to have been underway before the monumental sculpture was envisaged.[2] This coincides with the view that 'My drawings in the main relate to general phases of sculpture in the exploratory sense.'[3]

The orange board on which the cream ground of *Périgord* was applied is visible in the corners and in the scratches made with a five-toothed tool. Central scratches sketch out circles into which some blue seems to have been worked. Over this preparation are the more energetic black lines. Ink was applied with a hollow instrument – like a reed or straw – which allowed it to puddle at the inception but ran out to leave dragged parallel lines. Although broken, the lines give the impression of being continuous as they build outwards. The rubbing of the surface (to the right) and the flash of lilac paint appear to be afterthoughts. A hollow instrument was also used for *Spring, 1957 (Project for Sculpture)* (no.40 q.v.).

Similar preparations and tools characterise the bursts of activity in related drawings, such as the organic *Figures (Summer) Yellow and White* and *Group (Dance) May 1957*.[4] These carry the rhythmic qualities related to sculptures such as *Forms in Movement (Pavan)* 1956-9 (no.36 q.v.) and *Meridian*. The practice is notable for its contrast to the control of Hepworth's earlier abstractions (e.g. no.15 q.v.). While this may relate to the new freedoms of her sculptural techniques with plaster for bronze, it may also be linked to the example of others. Despite the collapse of their marriage, Hepworth and Ben Nicholson had continued to be close until 1957, and it is possible that the title *Périgord* refers to his painting *1955 (Périgord)* rather than to the region of south-west France.[5] The sculptor's unravelling line has similarities to the controlled pencil in the still-life. J.P. Hodin would remark on her 'nervous animated drawings … suggesting vegetative growth', and the energy of Hepworth's line may also be seen in relation to the 'action painting' of the Abstract Expressionists, which was first seen in Britain in *Modern Art in the United States* and shown at the Tate Gallery in January 1956.[6] Several of the artists associated with St Ives responded to the impetus from France and America. It is significant that, at the time of *Meridian*, Hepworth confirmed her interest in this gestural current, writing to Herbert Read about Tachisme:

of all the 'pulses' of creation this has moved me more profoundly than any other. The whole vitality of this stream of painting is incredibly close to research being done by physicists at the moment, & by medical research into the 'source of vitality' of healing of wounds etc. … it seems to me very bound up with the aesthetic perceptions of such fundamental rhythms & impulses of growth & form.[7]

49 Corymb 1959

LOO940 BH 270; cast 1/9

Bronze 26.5 × 34.2 × 24.2 (10⁷⁄₁₆ × 13½ × 9½)
on bronze base 1.8 × 21.5 × 17 (1¹⁄₁₆ × 8½ × 6¹¹⁄₁₆)

Cast numeral on top of base '1/9' front left

*On loan from the artist's estate to the Barbara Hepworth
Museum, St Ives*

*Displayed in the artist's garden, Barbara Hepworth
Museum, St Ives*

Exhibited: Zurich 1960 (16†, repr.); Gimpel Fils 1961 (10);
?Aldeburgh Festival 1961 (no catalogue traced); Belfast
1962 (1†, repr.); Whitechapel 1962 (50†, repr.); *British
Sculpture Today*, Ashgate Gallery, Farnham, July 1962 (42a);
Autumn Exhibition, Penwith Society of Arts, St Ives, autumn
1962 (no number†); *Christmas Exhibition*, Penwith Society
of Arts, Dec. 1965–Jan. 1966 (sculpture 1†); Tate 1968 (100,
not shown); *St Ives Group: 2nd Exhibition*, Festival Gallery,
Bath, June 1969 (sculpture 3†); *Retrospective* 1994–5 (62†,
repr. p.148)

*C*orymb 1959 was executed in the early years of Barbara Hepworth's experimentation with making plasters specifically for casting in bronze. The development of a satisfactory personal process was a gradual one, but the fundamentals were established with *Curved Form (Trevalgan)* 1956 (no.34 q.v.) reputedly the first such sculpture. The system used was to cut and bend a sheet of expanded aluminium to the desired form – probably following a cardboard model – and then apply plaster.[1] The texture of application and of subsequent cutting and carving was captured in the cast.

Although *Corymb* is small by comparison to the capacious *Curved Form (Trevalgan)*, they are formally related. The simple curving sides of the earlier work had been shifted slightly so as not to stand in direct opposition; this was exaggerated in *Corymb*. The pair of rising forms are more twisted and splayed apart, with their uppermost corners curled in so that the outer corners can turn away and open up the centre of the sculpture. These outer corners are on quite thin but textured planes; they are given added support by a step out to smoother bracing planes which reinforce them up to the topmost corners. Into the dynamic centre, Hepworth interposed a very similar curving form laid horizontally as a counterpoint. Its wings curve away to points. The joint by which they are attached to the uprights necessitated a sharp change of direction in the curvature of the plane. At its narrowest, the gap is bridged by three metal rods and the plugging of the joints has become more apparent with the passage of time and the exposure of the work in the artist's garden. The lowest hole on the horizontal element is now especially evident, as it has discoloured brown in contrast to the green of the patination.

The title is a botanical term. A 'corymb' is one of several types of 'indeterminate' inflorescence (or cluster of flowers) in which the lower buds are borne on longer stems (pedicels) giving the cluster a flat head of flowers. Hepworth had long been a keen gardener and the walled studio garden at Trewyn, where her works are sited, provided the opportunity to extend this enthusiasm. Although some coincidence of form may be found between a corymb and the sculpture, it is possible that a more general idea of inflorescence linked the two.

The absence of a signature or foundry stamp is typical of other works that Hepworth had cast at the Art Bronze Foundry in Fulham; these include *Curved Form (Trevalgan)*. Of the edition (9 + 0), another (2/9) is now in the Städtisches Museum, Leverkusen.

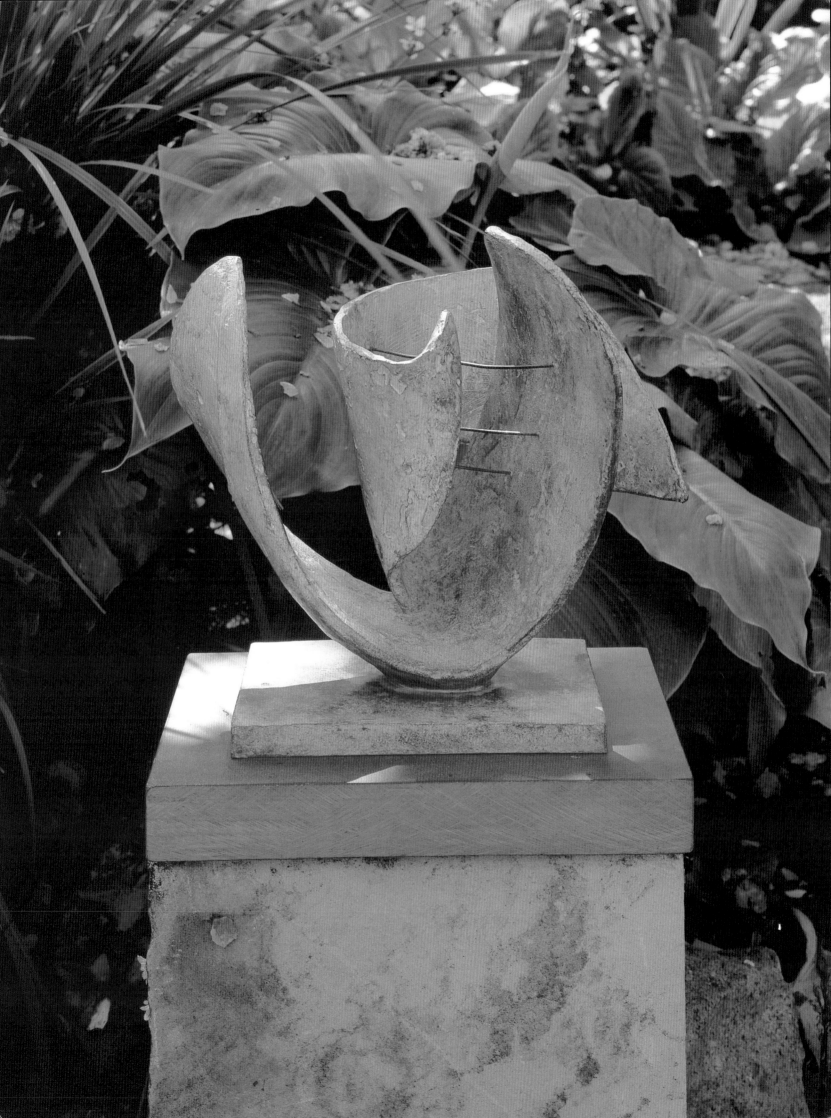

50 Figure (Nyanga) 1959–60

TO1112 BH 273

Elm 84.5 × 57 × 29 (33¼ × 22½ × 11½) on black lacquered
plywood base 6 × 53.5 × 35.5 (23⅜ × 21 × 14);
weight 34.6 kg

Presented by the artist in memory of Sir Herbert Read 1969

Exhibited: Zurich 1960 (18, repr.); Gimpel Fils 1961 (11, repr.);
Whitechapel 1962 (51, repr.); BC European tour, 1964–6:
Copenhagen (19), Stockholm (20), Helsinki, (19), Oslo (19),
Otterlo (24, repr.); *Reliefs, Sculpture*, Marlborough London
Gallery, Sept.–Oct. 1966 (31, repr.); Tate 1968 (101, repr. p.33);
Retrospective 1994–5 (63, repr. in col. p.78)

Literature: Hodin 1961, p.170, no.273, repr.; Bryan Robertson,
'Preface', Whitechapel 1962, exh. cat., p.10; Shepherd 1963,
[p.40], pl.15; *Tate Gallery Acquisitions 1968–9*, 1969, p.13;
Jenkins 1982, p.18, repr. p.34; Curtis 1998, p.41

Figure (Nyanga) was carved from elm which was much prized for large-scale sculptures, as Barbara Hepworth later demonstrated with *Hollow Form with White* (no.62 q.v.). It has a warm honey colour and a broad grain. This is especially dramatically exposed on the reverse of the half log, where the fine pattern of the grain indicates the limits of the heart wood and the intrusion of sapwood. The core of the trunk runs down the other face, establishing a column of fine knots, one of which has been carefully filled with appropriately angled grain. Characteristically the front is the most complex face, although a pronounced curvature in the form is exaggerated by the undercutting of the reverse and the twisting rhythm of the left side. The hole near the top uses a spiralling form which follows the natural line of the grain to draw the eye in, it then penetrates the wood with a slightly conical opening to the rear; this may have suggested Michael Shepherd's observation of the passage from 'calm curve to strong counter-rhythm'.[1] The smooth interior of the hole is slightly whitened with paint, which sets up a contrast with the rich colouring of the main waxed surfaces. The transition from one surface treatment to the other is gradual on the rear face, a process also practised on such guarea carvings as *Corinthos* 1954–5 (no.32 q.v.). A very substantial crack runs down the back face.[2] This presumably opened during the process of carving, as – like the knot on the front – it has been filled with wood with carefully matching grain. The thickness of the block makes it prone to splitting, although the sculptor claimed that this could be avoided if allowed to acclimatise: 'I have had no trouble with the wood all this decade.'[3] It is held on the shallow box base with a steel bolt and a locating pin, which prevents its swivelling. As indicated by Dicon Nance, the base is recognisable as one of those made by his brother, the craftsman Robin Nance;[4] it appears to be one of the earliest examples of a type regularly used by the sculptor, and found under works such as *Pierced Form (Epidauros)* 1960 (no.53 q.v.).

It was not Hepworth's general practice to make drawings for carvings, preferring to respond to the form of the block. Nevertheless, she suggested that several drawings bore 'a close relationship in thought' to the carving, while adding: 'As you know, I very rarely draw a sculpture direct; but the research is there.'[5] The drawings to which she referred were contemporary with the carving but generally relate to the generation of form through linear progressions found in the stringed sculptures of 1956–8, such as *Orpheus* (no.38 q.v.).[6] Through its main title a figurative element is suggested in *Figure (Nyanga)*, which may encourage a literal reading of the form as a head or torso.

In the introduction to Hepworth's 1962 Whitechapel retrospective, Bryan Robertson specified that '*Nyanga* is a private act of attrition for the more inhuman incidents in Africa and at Sharpsville [sic]'. The sculptor herself confirmed this context for the work in her letter to the Tate: 'I was much involved in thought about Africa and the United Nations and my many friends who were doing what they could…From time to time, a deep involvement on my part, in human suffering and human dignity has brought a certain poignancy into the works…[as] happened in the 30s and in the 40s.'[7] The

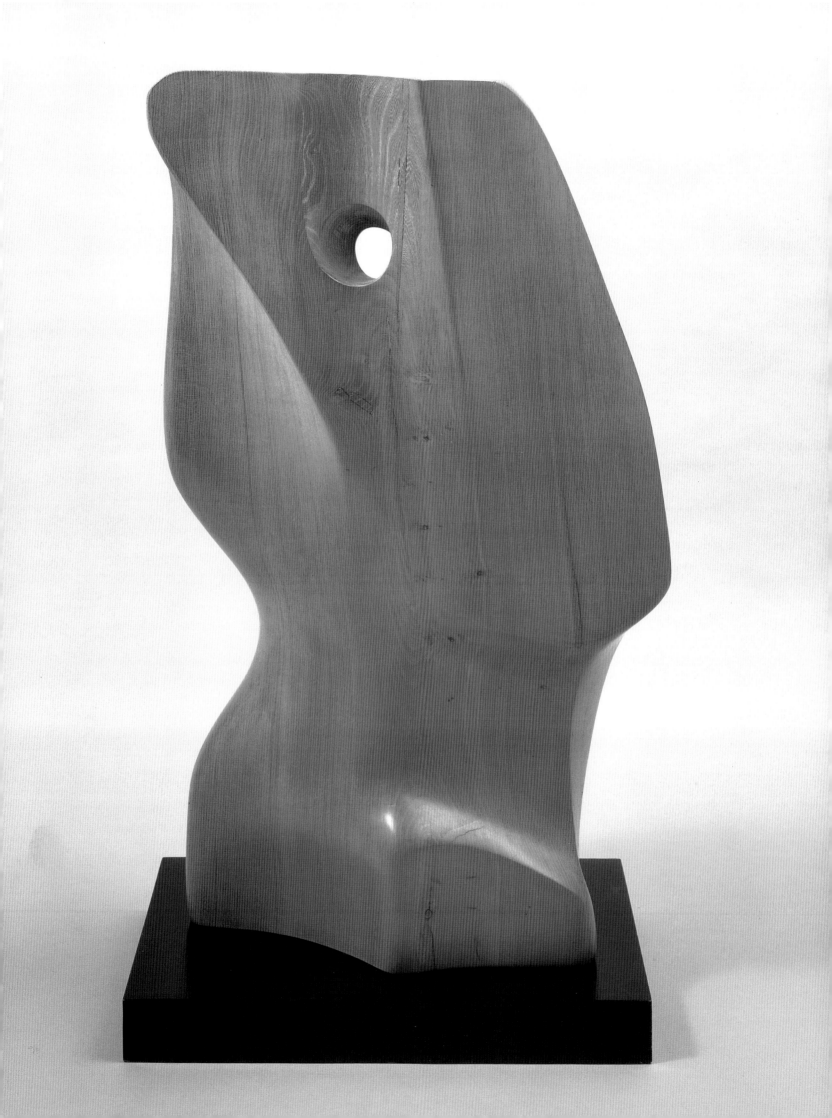

incident at Sharpeville township was the massacre by the South African authorities of seventy-one blacks objecting to the 'Pass Laws' limiting freedom of movement on 21 March 1960. Albert Luthuli, president of the African National Congress, was awarded the Nobel Peace Prize in December as a symbol of international solidarity with the campaign of peaceful protest. This focused international attention on the official Apartheid system of racial segregation and initiated three decades of protest.

The sculptor expressed her political commitment to peace and social reconstruction through support for such organisations as the United Nations Association and the Campaign for Nuclear Disarmament. It seems likely that she also associated the sculpture retrospectively with the efforts of Dag Hammarskjöld, the Secretary General of the United Nations and a close friend, to establish peace in Central Africa. The independence of former French colonies was achieved in 1958; Gabon was amongst them, and Nyanga is its southernmost province. In 1960, neighbouring Congo passed directly from Belgian colonial rule to civil war as Katanga province seceded. United Nations peace-keeping troops were deployed and, in mid-1961, they mounted a controversial action to reintegrate Katanga. Hammarskjöld had misgivings and was travelling to negotiate with the rebel leader Moise Tschombe when he was killed in an air crash on 18 September 1961 near Ndola in neighbouring Northern Rhodesia (now Zambia). Hepworth had been deeply inspired by Hammarskjöld's ideas and was shocked by his death; she made *Single Form* 1961–4 as a memorial to him in New York.

Through the special circumstances of its donation, *Figure (Nyanga)* also became associated with Hepworth's friend the poet and critic Sir Herbert Read, who died on 12 June 1968. The sculptor told the Tate: 'As you perhaps realise, this was one of the sculptures Herbert Read had a very deep affection for, from the moment I carved it.'[8] His opportunity to see it soon after completion arose when he addressed the Penwith Society of Arts on 23 September 1961, on the occasion of the opening of their new gallery. He brought news of participation in the CND 'sit-down' in Trafalgar Square on 17 September in protest against intercontinental missiles. This action occurred the day before Hammarskjöld's death, binding the two events together. Following Read's visit, Hepworth wrote of being 'sick and desolate inside me over D.H.' She also indicated that she had encouraged Read to choose a work for his house at Stonegrave, but commented, 'I felt at a loss when you said you did not like texture in bronze – & I expect I shut up like the proverbial clam.'[9] His objection gave rise to a debate between them over the merits of bronze, in which Hepworth had to defend her production of plasters for casting – to meet demand and for strength on travelling exhibitions – in the light of her pre-war commitment to 'truth to materials'. That the sculptor dedicated a wood carving to his memory seems to take account of this debate.

Hepworth's *Figure (Nyanga)* was the first of four gifts celebrating Read's life; the others were Naum Gabo's *Linear Construction No.2* 1970–1, Ben Nicholson's *March 63 (artemission)* 1963 and Henry Moore's *Upright Form (Knife Edge)* 1966. Responding to the sale of the poet's archive to the University of Victoria, British Columbia, both Hepworth and Nicholson promised their papers to the Tate Gallery Archive. She and Moore also celebrated Read's memory by jointly donating Patrick Heron's *Portrait of Herbert Read* 1950 to the National Portrait Gallery.[10]

51 Image II 1960

T00958 BH 277

White marble 75 × 77.5 × 48 (29½ × 30½ × 18⅞)
on mahogany base 7.7 × 71.2 × 56.2 (3 × 28 × 22⅛);
weight 448 kg

Presented by the artist 1967

Exhibited: Zurich 1960 (21, repr.); Gimpel Fils 1961 (14, repr.);
Whitechapel 1962 (49, repr.); Tate 1968 (105, repr. in col.
frontispiece); *Henry Moore to Gilbert and George: Modern
British Art from the Tate Gallery*, Palais des Beaux Arts,
Brussels, Sept.–Nov. 1973 (50, repr. p.62)

Literature: Shepherd 1963, [p.40], pl.20; Bowness 1971, p.29,
no.277, pl.19

Image II is a massive roughly pyramidal block of white marble. Its solidity is lightened by the undercutting of the lower edges and the piercing through the heart of the stone. The undercutting is also achieved by running the bevels into broad planes; these are circumscribed by crisp lines which hold the form until being allowed to melt away. Shallow concave surfaces on each face enhance the retention of light within the classical purity of the material. The quality of the hole is typical of Hepworth's work. The profile is subtly worked so that a spiral emerges from a plane to lead the eye into the cylindrical shaft; the emergence on the other side is similar, though modified by a bevelled edge. One effect of this is to introduce light through the centre of the solid.

In a contemporary interview, Hepworth discussed her current methods in relation to those developed in the pre-war period. She recalled how at the time she had begun 'to burrow into the mass of sculptured form, to pierce it and make it hollow so as to let light and air into forms'.[1] Speaking more of her contemporary work, she added: 'I believe that the dynamic quality of the surfaces of a sculpture can be increased by devices which give one the impression that a form has been created by forces operating within its own mass as well as from outside … the piercing of mass is a response to my desire to liberate mass without departing from it.' These beliefs seem to be enacted in *Image II* and related marble pieces. In an ensuing interview with J.P. Hodin, Hepworth showed how the relationship between surface and interior, and between material and light were central to her work. She indicated that when she perceived the 'special accord' of inside and outside:

as for instance a nut in its shell or a child in the womb … then I am most drawn to the effects of light. Every shadow cast by the sun from an ever-varying angle reveals the harmony of the inside and outside. Light gives full play to our tactile perceptions through the experience of our eyes, and the vitality of forms is revealed by the interplay between space and volume.[2]

The complexity of the form of *Image II*, through which such vitality is achieved, reflects the methods of carving. The output of Hepworth's workshop reached new heights as she produced works for exhibitions in New York in late 1959 and Zurich in October 1960 which followed her success in winning the Grand Prix at the São Paolo Bienal.[3] All sculptures were prepared to some degree by assistants, who in that period were generally young artists: Denis Mitchell, Brian Wall, Tommy Rowe, Breon O'Casey and Tom Pearce.[4] *Image II* was carved in the yard outside the studio and, according to Tom Pearce, took between two and three months.[5] The procedure followed an established pattern: notes and lines drawn on the stone greeted the assistants at the start of the day's work. These would identify the high-points of the carving and the direction in which Hepworth wanted it to be cut.[6] Tommy Rowe has recalled the gradual removal of layers of material. Parallel lines were cut across the stone with a point chisel, which would leave a series of shallow v-shaped furrows; the next set of parallel cuts followed the ridges between the first until the surface was reduced to the required level. The ridges could then be removed with a claw chisel.[7] A comparable process is visible in the photograph of *Stone Sculpture (Fugue II)*

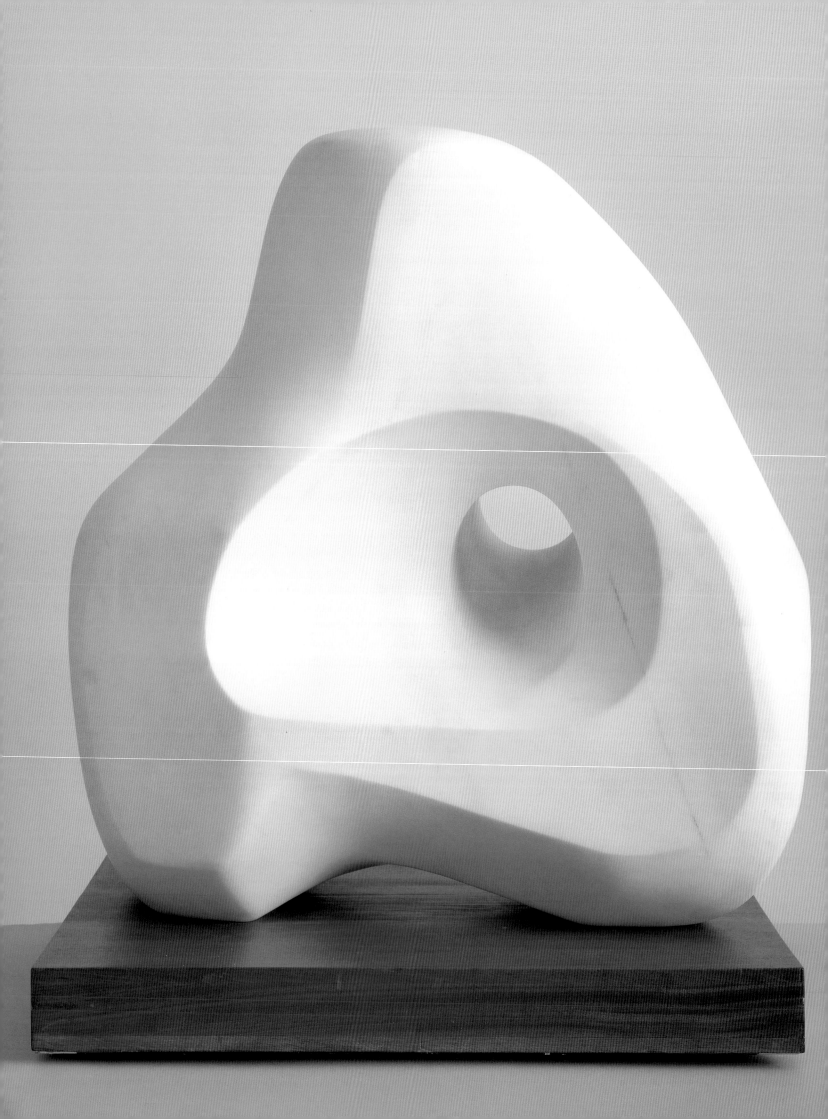

1956 in progress (fig.62). Hepworth did not generally countenance the use of mechanical tools, so that holes had to be cut rather than drilled. This was the case for *Image II*, ensuring the very lengthy and gradual emergence of the form.[8] The sculptor discussed her carving procedures in similar terms in her later interview with Alan Bowness.[9]

This painstaking process was unusual amongst Hepworth's contemporaries, so that such works as *Image II* exemplified her maintenance of a carving tradition within the production of modernist abstraction. After her assumption of casting in 1956, she placed considerable emphasis on balancing the number of bronzes and carvings in her exhibitions. Despite its substantial weight, *Image II* was included in this capacity in her first Swiss exhibition in late 1960. On its return, it burst through its insubstantial crate. Hepworth told her London dealers that it had been loose in the crate without additional packing material, and sustained bruising on 'the head' as well as the splitting of the base. She added: 'I have felt quite sick … The tragedy is that I cannot rest until I have re-carved and re-worked the sculpture. How successful I shall be, I do not know.'[10] The whole surface had to be cut back to remove the bruised areas, and it may be in this connection that Tommy Rowe recalls having to 'pure up the lines'.[11] Planning to show the sculpture in London in May, Hepworth kept the Gimpels informed, writing: 'I thought at first that the sculpture was a total loss and I am only too thankful that I have been so successful in restoring it.'[12] The only evidence for the recarving is a comparison between the photographs of the sculpture in the Lienhard catalogue and in its present state. Although taken from an identical viewpoint, the changed fall of light makes a difference difficult to discern, except perhaps that the outer edge to the left of the concavity leading to the opening originally appears to have been a flat plane.

The restoration of the work must have been extensive, as the stone now appears to be in generally good condition. Nevertheless, there is a long linear fault in the front face to the right of the hole, areas of damage to the right side, and some yellowing of the stone on the left. Faults had been filled with plaster, which discoloured with time; this has since been replaced with fine filler toned with watercolour. The surface was cleaned in 1993. The mahogany base has warped and split because of its inflexibility to atmospheric change caused by metal bars screwed from underneath; these have been slotted to allow for some adjustment.[13]

The consignment of marble from which *Image II* was carved was probably that mentioned in anticipation by Hepworth in May 1959.[14] She regarded with relish the prospect of carving it, and several similarly organic works were completed for exhibition in Zurich. These included *Icon II* 1960 and *Talisman II* 1960 both of which used a closely related formal vocabulary of concave planes and spiralling holes.[15]

Although, like these works, *Image II* reused an earlier title it relates less obviously to the tall Hoptonwood stone *Image* 1951–2 (no.29 q.v.) than to her abstract stone carvings of the 1930s. In particular, it carries some of the same resonances of modernist purity in the use of the white marble as those found in *Three Forms* 1935 (no.9 q.v.). A similar reference to classical precedents was implicit in the use of the stone, prompting Michael Shepherd to relate *Image II* to the sculptor's experience of Greece in 1954. His observation that it 'takes us back to the first pierced form' acknowledges the formal relationship to the watershed work *Pierced Form* 1931 (fig.4). Such references to the work and ideals of the 1930s coloured other assessments. It is significant that Read believed that Hepworth's statement from *Unit One* (1934) still held true and he quoted it in his introduction to her 1959 New York exhibition: 'the quality of thought that is embodied, must be abstract – an impersonal vision individualised in the particular medium.'[16]

It was in the context of representing an overview of her sculpture, that Hepworth donated *Image II* to the Tate in 1967. Alongside the early *Figure of a Woman* 1929–30 (no.3 q.v), a number of works were included to show her range of media from the sheet metal *Orpheus* 1956 (no.38 q.v.) and the bronze *Sea Form (Porthmeor)* 1958 (no.47 q.v) to the elm *Hollow Form with White* 1965 (no.62 q.v.).

52 Figure for Landscape 1959–60

T03140 BH 287; cast 1/7

Bronze on bronze base 260 × 125 × 67.5 (102⅜ × 49¼ × 26½)

Cast numerals on top of base '1/7' and 'Barbara Hepworth |
1960' back right, and cast foundry mark on back of base
'FOUNDERS | MORRIS | SINGER | LONDON' t.r.

*Presented by the executors of the artist's estate, in
accordance with her wishes, 1980*

*Displayed in the artist's garden, Barbara Hepworth
Museum, St Ives*

Exhibited: Whitechapel 1962 (60†, repr.); *Netherlands Art
Foundation*, Keukenhof and Breda, summer 1962; BC
European tour 1964–6, Otterlo (26‡, repr.); New York 1966
(3†, repr.); Tate 1968 (108‡, repr. p.35); *Sculpture Exhibition:
City of London Festival*, St Paul's Churchyard, June 1968
(18†); *Inaugural Exhibition*, Hirshhorn Museum and
Sculpture Garden, Smithsonian Institution, Washington DC,
Oct. 1974–Sept. 1975 (630, repr.); Washington 1981 (no cat.)

Literature: Bowness 1971, p.30, no.287, pls.28–9; Herbert
Christian Merillat, *Modern Sculpture: The New Old Masters*,
1974, p.113, repr. between pp.142 and 143, pl.2 and on front
cover; Nancy Cusick, 'Three in Washington DC', *Women
Artists News*, vol.7, no.3, Fall 1981, p.9; *Tate Gallery
Acquisitions 1980–2*, 1984, p.117, repr.; W.J. Strachan, *Open
Air Sculpture in Britain: A Comprehensive Guide*, 1984, p.98,
no.191, repr. p.99; Curtis 1998, p.47

At over two and a half metres high (eight and a half feet) *Figure for Landscape* is a substantial presence. It was made during a period in which Barbara Hepworth undertook a series of commissions for bronzes which were architectural in scale and setting; they included *Meridian* 1958–60 (fig.69) and *Single Form* 1961–4 (fig.6). Although sharing some of their monumental character, *Figure for Landscape* remained within the physical limitations of manufacture in her workshop and – as the title announces – within the context of nature.

Around the time of making the sculpture, Hepworth discussed the long-standing associations between her work and landscape. She explained to Edouard Roditi that a sculpture 'is for a specific landscape. My own awareness of the structure of the landscape … provides me with a kind of stimulus. Suddenly an image emerges clearly in my mind, the idea of an object that illustrates the nature or quality of my response.'[1] This related to her view of the figure's emergence from and integration with the landscape. She recalled glimpsing an isolated priest on the Greek island of Patmos:

This single human figure then seemed to me to give the scale to the whole universe, and this is exactly what a sculpture should suggest in its relationship to its surroundings: it should seem to be at the centre of the globe, compelling the whole world around it to rotate, as it were, like a system of planets around a central sun.[2]

Hepworth also saw some of this quality in the relationship of the Neolithic stones to the landscape of Cornwall: 'Any standing stone in the hills here is a figure, but you have to go further than that … To resolve the image so that it has something affirmative to say is to my mind the only point.'[3] These conceptual threads – of placement within a specific location and a compelling relationship to it – evolved in Hepworth's earlier works, such as *Curved Form (Trevalgan)* 1956 (no.34 q.v.), which offered an abstract response to the feeling of being in a particular landscape. That these ideas are channelled into *Figure for Landscape* is acknowledged in the explicitly figural reference of the title, even as the vertical form evokes that of such abstractions as *Single Form (Eikon)* 1937–8 (no.12 q.v.). The quality of an enclosed but rising form suggests the emergence of the sculptural object from the landscape to which she also alluded.[4]

This enclosure continues the artist's preferred hollowing to allow light to enter the solid form. It is significant that Hepworth described this process as conveying 'a sense of being contained by a form as well as of containing it'.[5] In relation to the over life-size *Figure for Landscape* such an analogy extends the interpretation of her pre-war sculpture in the light of Melanie Klein's psychoanalytic theory of art.[6]

The hollowing of the sculpture was a standard practice for Hepworth's carvings, but *Figure for Landscape* was the first in which this wrapping was attempted in plaster for bronze. The exactly contemporary marble *Image II* (no.51 q.v.) and guarea *Pierced Form (Epidauros)* (no.53 q.v.) show her stylistic diversity and how far forms were modified in response to the materials. The particular balance in *Figure for Landscape* also suggests comparisons with the work of others. The equation of landscape and figure was a

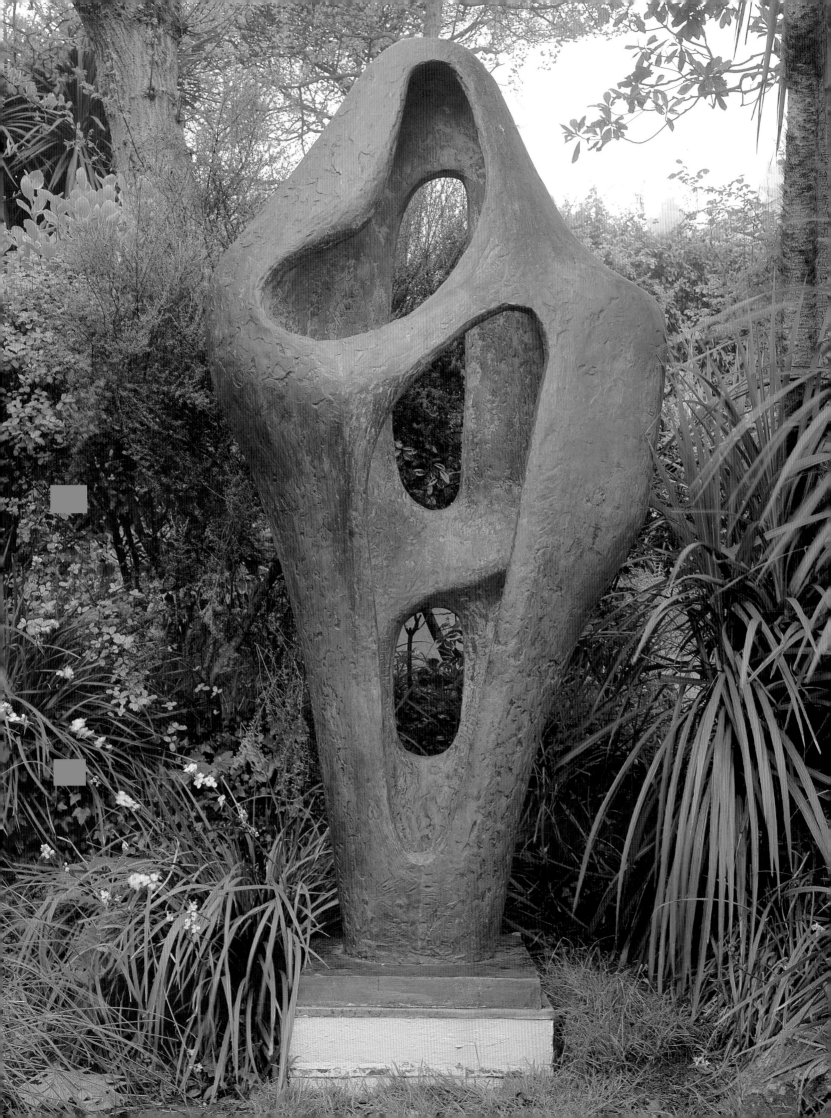

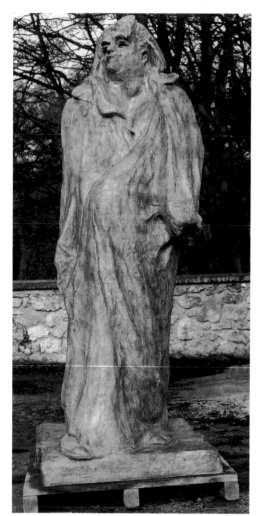

fig.70
Auguste Rodin, *Balzac*, 1892–7, height 301 (118½), bronze,
Ville de Paris-C.O.A.R.C., in the course of restoration

central concern of Henry Moore, for whom it took on a specifically female embodiment in the hollowed shell of *Reclining Figure (External Form)* 1953–4.[7] However, the monumental aspect also evokes Auguste Rodin's famous *Balzac* 1892–7 (fig.70), in which the figure is wrapped in a gown. This similarity encouraged Herbert Merillat to remark that the Hepworth was 'definitely human in contour, suggesting a mummy case'.[8] More pertinent to the opening of the interior is Arp's abstract *Ptolemy I* 1953 in which space is held by diagonally encircling forms; an illustration of Arp's sculpture served as a frontispiece for Herbert Read's *The Art of Sculpture* (1956) of which Hepworth was a joint dedicatee (with Moore and Gabo).[9] Hepworth herself continued to experiment with the themes and processes undertaken in *Figure for Landscape*, in *Sea Form (Atlantic)* 1964 and *Rock Form (Porthcurno)* 1964.[10] Each explored the identification of figure and landscape through the penetration of an upright, vaguely figurative, mass by openings rather than the enclosure used for the earlier sculpture.

In making *Figure for Landscape*, plaster was applied to an expanded aluminium armature, following the method established since 1956. Amongst her assistants, Brian Wall recalled making the armature and Tommy Rowe remembered helping Hepworth to apply the plaster.[11] It appears to have had two curved cross-braces to provide additional strength: the broad strut which intrudes above the lower hole in the back and the diagonal strip that bridges the front opening. The plaster was generously and vigorously applied, securing a richly textured surface that was then carved; this was the process that the artist explained in a contemporary letter to Herbert Read.[12] The shoulders of the form particularly show this carving; this may have been achieved with the help of the recently developed 'surform', a multi-toothed plane, samples of which were supplied to the sculptor by the inventor.[13] In profile, the back appears to be quite flat so that, in common with many of Hepworth's sculptures, the primary effect is frontal.

The casting of the bronze was subject to delay. The sculptor had to distribute works to different foundries in order to get them completed during the run-up to her 1960 Zurich exhibition.[14] In September 1959 she had asked Morris Singer Ltd if they had time to cast an unspecified 'large bronze say 6–7 feet, to be ready by the end of next March'. By November their schedules prevented casting 'my seven foot figure'.[15] As she told Read: 'There remains but one now – a 7ft figure – which so far I haven't been able to persuade anybody to do for me, as the foundries are booked up'.[16] Eventually Morris Singer Ltd cast it in 1961, 1/7 being completed by September.[17] This was the artist's copy – which came to the Tate – and it was patinated green, with greater intensity on the inner faces. Although it was listed in her solo exhibition in London, it was feared that it would not fit in the gallery, and their records note it as 'not shown'.[18] Nevertheless, it did appear in subsequent exhibitions and in 1968, the year it was displayed on the steps of the Tate Gallery outside the artist's major retrospective, two further casts passed into public collections: the San Diego Society of Arts (5/7) and the Stavanger Kunstfasening, Norway (6/7). Earlier casts are in the Hirshhorn Museum and Sculpture Garden, Smithsonian Institution, Washington DC (2/7) and Exeter University (4/7).

The size of the plaster had dictated that the hollow cast bronze had to be made in two parts. An inspection of the Tate's sculpture in 1983 revealed that the parts were bolted together with several bronze and five mild steel bolts which had rusted. Timber formers under the flared-out base had also rotted and they, together with remains of moulding sand from inside the sculpture, were removed.[19] The old drainage hole in the bottom of the sculpture had probably been blocked to arrest the appearance of iron staining from the inner bolts; a new drainage hole was made. The sculpture has weathered as a result of its position in the artist's garden; the perennial problems remain handling and leaf deposits, weather and bird lime. As a result of the 1983 inspection the surface was cleaned in preparation for the application of two coats of lacquer, the second including a matting agent. Lacquer proved hard to detect on a subsequent inspection and small areas of bronze disease have been noted.[20]

53 Pierced Form (Epidauros) 1960

T03141 BH 290

Nigerian guarea 74 × 67.6 × 36 (29⅛ × 26⅝ × 14¼) on
lacquered wood base 4.4 × 45.7 × 35.5 (1¾ × 18 × 14)

*Presented by the executors of the artist's estate, in
accordance with her wishes, 1980*

*Displayed in the artist's studio, Barbara Hepworth Museum,
St Ives*

Provenance: Given by the artist to Simon and Silvie
Nicholson c.1963; returned to the artist's estate 1975

Exhibited: Gimpel Fils 1961 (21, repr.); Whitechapel 1962 (54,
repr.); Hakone 1970 (11, repr.)

Literature: Norbert Lynton, 'London Letter', *Art International*,
vol.6, no.7, Sept. 1962, p.47; Shepherd 1963, p.40, pl.22;
Bowness 1971, p.30, no.290, pl.30; Jenkins 1982, p.17, repr.
p.34; *Tate Gallery Acquisitions 1980–2*, 1984, p.117, repr.;
Festing 1995, p.251

With *Pierced Form (Epidauros)*, and the contemporaneous *Curved Form (Oracle)*, Hepworth returned to a theme and a material which had preoccupied her between 1954 and 1956.[1] In 1954 she had received seventeen tons of guarea, a tropical hardwood, from Nigeria and carved a series of huge works named after ancient Greek sites, such as *Corinthos* 1954–5 (no.32 q.v.). These did much to further her reputation, but in the intervening period she increased her output by producing original bronze sculptures and casts of earlier carvings. Though she had continued to carve in wood and stone, producing works such as *Figure (Nanjizal)* 1958 (no.44 q.v.), there seems to have been a concerted effort at the end of the decade to make a greater number of unique carvings. A letter to Herbert Read in December 1959 demonstrated the pressures on her; following the success of her exhibitions at the São Paolo Bienal and in New York and having just completed the large bronze *Meridian* 1958 (fig.69), she told him that she had despatched all the plasters for bronzes for her Zurich exhibition in the following autumn. As a respite she planned 'a long spell of quiet carving in the garden'.[2] Her desire to carve may reflect an anxiety that the casting of metal sculptures represented an abandonment of the doctrine of 'truth to materials' that had been the basis of her earlier work. It is in contrast to Henry Moore's production of the period: between 1955 and 1964 only three works of his prolific output – albeit major pieces – were carved: one in stone and two in wood.[3] Hepworth carved a total of six guarea pieces between 1960 and 1963, one of which – *Two Forms in Echelon* 1961 – was unfinished.[4]

The use of Greek place-names as subtitles to these works originated from the cruise taken by Hepworth and her friend Margaret Gardiner in the summer of 1954. They made a brief visit to Epidauros, on the east coast of the Peloponnese, and Mycenae on 26 August. The connection between the places in the titles and the guarea works is unclear. It is likely to be based on personal associations and a generalised idea of the sculptures' relationship to the human figure in an architectural and landscape setting. That Hepworth's response to Epidauros was primarily sensual is demonstrated by her diary entry for her visit there. Though preoccupied by colour, smell and sound (the theatre there is particularly noted for its acoustics), she was also aware of the structural geometry of the building which invites comparison with the pierced form of the sculpture: 'EPIDAUROS | Olive, hill and figures | and the quality of sound. | Grey stones | grey hills | Soft grey trees – deep green conifers – rustle of | the wind above. | Absolute acoustics | Cross and upwards acoustics | Growth of olives | Serenity of landscape | Sacred grove and well. | Epidauros – a funnel? twice the breadth × 2 = height? | Facing quiet hills far mountain | Hill behind the sea.'[5]

Epidauros had two specific associations with which Hepworth may have been sympathetic. Firstly, its archaeological site has the best-preserved and one of the largest of all the ancient Greek theatres. These appear to have been of especial interest to Hepworth and Greek drama was a well-established concern; in particular, she had

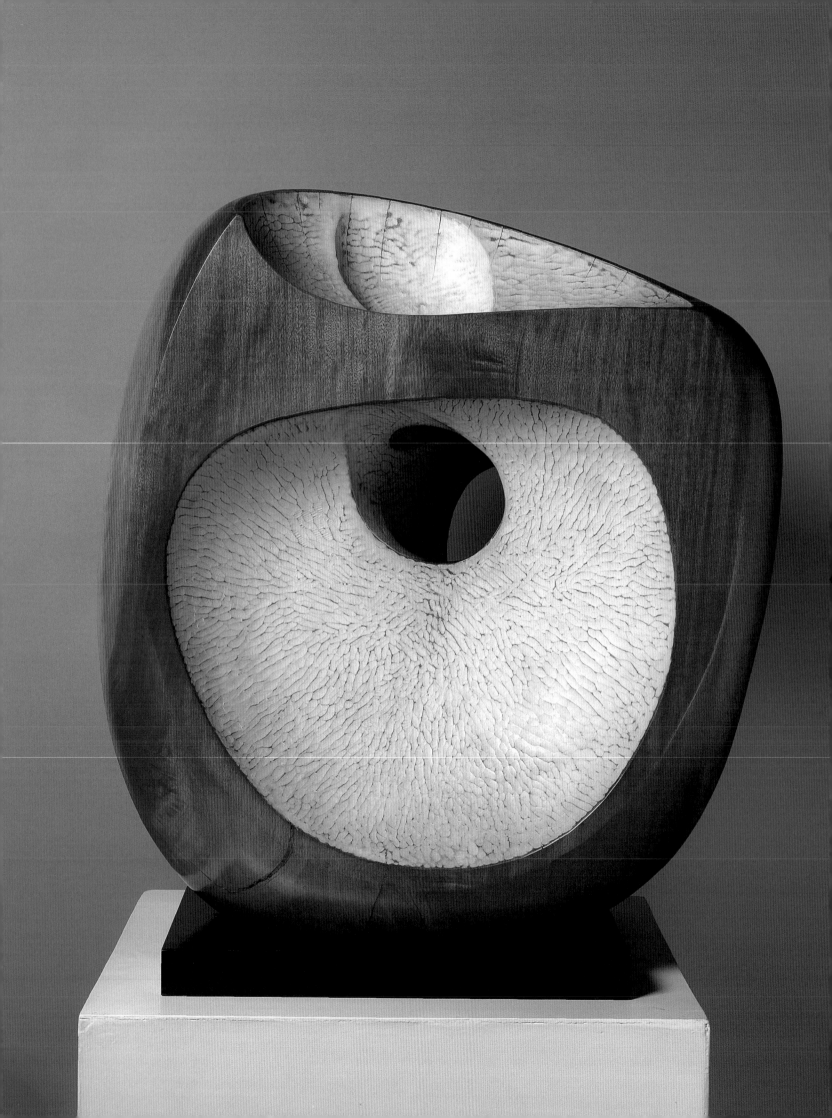

designed a production of Sophocles' *Electra* at the Old Vic in 1951. The curved form of *Epidauros* around a central hole might be compared to the shape of the theatre – an arc of stepped seating around a circular stage. Secondly, the ancient city was famed for its temple of Asclepius, the god of healing, and was a curative centre from the fourth century BC. Good health and medicine, often with a spiritual basis, had been of interest to the artist since she had shared Ben Nicholson's faith in Christian Science in the 1930s. It was most notably represented in a more materialist form in her hospital pictures of 1947–9, such as *Fenestration of the Ear* (no.23A q.v.), in which medical practice provided a metaphor for social organisation. Coincidentally, Hepworth's visit to Greece had a therapeutic motive, as it was intended to help her to recover from the death of her son, Paul, in 1953 and from the exhaustion resulting from a heavy programme of work.

In common with almost all of the guarea pieces, *Pierced Form* is characterised by the juxtaposition of its polished exterior surfaces and the white-painted chiselled interior. The chisel marks of the white area converge towards the central hole and gather around it, creating an effect of organic growth. Their accentuation by the sanding of the paint on the ridges especially emphasises this apparent centripetal movement. In relation to this work, Tommy Rowe, one of the assistants who helped to carve it, recalled that Hepworth liked to minimise the amount of carving necessary and he thought it likely that the almost flat front of the sculpture was the face of the original wooden block.[6] The edges of the white areas are bevelled – a characteristic of Hepworth's later carvings.

Contrasting texture and colour and the articulation of space by the fall of light are central features of almost all of the guarea works, but they may be divided into two categories. Some, such as *Corinthos*, have an internal space tunnelled out, while in others, including *Pierced Form (Epidauros)*, the white area is more open and frontal. Nevertheless, the piercing of the form by a spiralling hole is common to both types. In *Epidauros*, the intersection of vertical and horizontal spiralling holes maximises the play of light and shadow within the form. A similar use of light in the comparable painted wooden carvings of the 1940s, such as *Pelagos* 1946 (no.20 q.v.), had previously been used by David Lewis to set Hepworth's work apart from that of Henry Moore.[7] A photograph of her studio in January 1959 (fig.71) shows two of the guarea works from 1955 – *Curved Form (Delphi)* (fig.60) and *Oval Form (Penwith Landscape)*[8] – alongside *Pelagos*, which Hepworth had bought back in 1958. The guarea works of 1954–6 and 1960–3 thus appear as a refrain of that earlier moment.

On acquisition by the Tate Gallery, over thirty longitudinal splits in the wood were recorded. These mostly radiate around the curved back of the form, though two through the front face are especially prominent. They had been filled with brown filler in the polished surfaces and filled and painted in the white areas. A particularly large split, front left, had been fastened with screws which were capped with dowels. Many of the splits in the back had carefully worked slivers of matching timber, suggesting that they appeared soon after completion. Smears of old adhesive were removed from the painted area and PVA and woodflour were applied to the cracks.[9] The back of the sculpture has been considerably lightened by prolonged exposure to sunlight. Steel bolts fasten it to a laquered wooden base of a type often seen with Hepworth's later work. These bases, which are reinforced with metal pipes to prevent warping, were made by Robin Nance, a well-known St Ives cabinet-maker and elder brother of Hepworth's assistant, Dicon.

Perhaps because of the extensive splitting, a bronze version of *Pierced Form (Epidauros)* was cast, with some modifications, in 1961 (BH 303).[10] While the outer surfaces were worked to give them a texture typical of her bronzes, the chiselled inner surface was replaced with a heavy, glutinous-looking finish. Hepworth had first achieved this effect in *Winged Figure I*, by applying car body filler with a spatula, though

here it would have been worked in the plaster.[11] The proportions of the bronze version are different to the original wood: the hole is larger, the horizontal section of the front surface narrower, as is the base, and the edge of the main concavity is more angular. Norbert Lynton lamented the loss of sensuality in the reworking in bronze: 'The problem that faces [Hepworth] today', he wrote in 1962, 'is how to translate the personal and sexual qualities of her carvings into alternative material and processes. One way *not* to achieve this is to repeat a carving in bronze, as in the case of *Pierced Form (Epidauros)*.'[12] One of the casts of *Epidauros II* is sited on the Malakoff, a small square on the eastern approach to St Ives that looks over the town and harbour and across the bay to Godrevy Lighthouse.

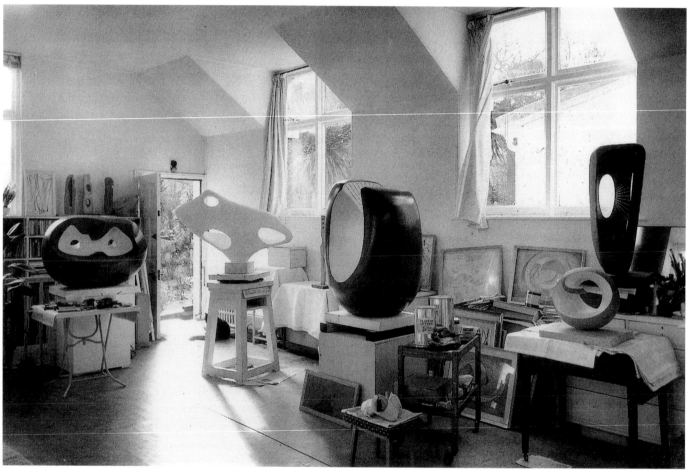

fig.71
Interior of Trewyn Studio, Jan. 1959. Identifiable sculptures from left to right: *Oval Form (Penwith Landscape)* 1955 (BH 202), *The Unknown Political Prisoner* 1952 (BH 186) on bookcase, plaster for *Sea Form (Porthmeor)* 1958, *Idol* 1955–6 (BH 206) beneath window, *Curved Form (Delphi)* 1955 (BH 199), *Pelagos* 1946, *Pierced Form (Toledo)* 1957 (BH 232)

54A Maquette, Three Forms in Echelon 1961

T03142 BH 306 (illus. p.208)

Brass and string on a wooden board and shelf
68 × 52.1 × 21.7 (26¾ × 20½ × 8¹⁵⁄₁₆)

Inscribed in pencil on shelf 'Three forms in echelon 1961
Barbara Hepworth' r.

*Presented by the executors of the artist's estate, in
accordance with her wishes, 1980*

*Displayed in the artist's studio, Barbara Hepworth Museum,
St Ives*

Exhibited: Whitechapel 1962 (69, repr.); Tate 1968 (116)

Literature: Bowness 1971, p.32, no.306; Jenkins 1982, p.18,
repr. p.35; *Tate Gallery Acquisitions 1980–2*, 1984, pp.118–19,
repr.

54B Maquette, Three Forms in Echelon 1961, cast 1965

T00959 BH 306.B; cast 2/9 (illus. p.211)

Bronze 67.9 × 50.8 × 9.5 (26¾ × 20 × 3¾)

Cast inscription on base 'B.H. 1961 | 2/9' r.

Presented by the artist 1967

Exhibited: *Summer Exhibition*, Penwith Society of Arts, St
Ives, summer 1965 (no number†); ?*Autumn Exhibition*,
Penwith Society of Arts, St Ives, Aug.–Oct. 1965 (sculpture
16, version not indicated); New York 1966 (4, repr.†); Gimpel
Fils 1966 (1†); Tate 1968 (116); Hakone 1970 (12‡, repr.); AC
Scottish tour 1978 (15†); Marlborough 1979 (21†, repr. p.11,
London only); Wales & Isle of Man 1982–3 (13†); Canada
1991–2 (11, repr. p.34)

Literature: *Tate Gallery Report 1967–8*, 1968, p.63; Bowness
1971, p.32 no.306, repr. p.33; Jenkins 1982, p.18, repr. p.35

These works, both entitled *Maquette, Three Forms in Echelon*, relate to Barbara Hepworth's proposals for a public sculpture on the John Lewis Department Store in Oxford Street, London. She worked on the proposal for five months in 1961, between an invitation to make designs on 24 May and their submission on 13 October. Of the Tate's two maquettes, that made in brass and wood may be the scale model, while the bronze was probably cast from the more liberal plaster. Despite Hepworth's considerable care, her proposal was rejected. The commission was salvaged by the selection of *Winged Figure I* 1957 as a model for enlargement, resulting in the placement of *Winged Figure* 1961–2 (fig.72) on the building.[1]

Details of the rejected commission are contained in the correspondence between the then Chairman of John Lewis Partnership, O.B. Miller, and the artist. This material, held in the Partnership Archive, has been extensively quoted by David Fraser Jenkins in a previous Tate Gallery catalogue.[2] The John Lewis Building was designed by Slater and Uren Architects and begun in 1956, in order to replace the old building bombed in the war. Large walls clad in Portland stone adjoin each end of the main frontage, and these were identified as sites for decoration. When construction began Jacob Epstein was approached to make a design for the west façade, but he declined through pressure of work;[3] he was completing his bronze *St Michael* for Coventry Cathedral and the War Memorial for the TUC building in London. In 1959, six younger artists were invited to submit suggestions for the east façade on Holles Street visible from Oxford Circus. Proposals by Ralph Brown, Geoffrey Clarke, Anthony Holloway, Stefan Knapp and Hans Tisdall were exhibited in *Mural Art Today*; William Mitchell's design was not included.[4] None was deemed suitable by the panel of advisers, which included the architects Sir Hugh Casson, J.M. Richards and R.H. Uren and the Director of the Royal College of Art, Robin Darwin. Nevertheless, the change of direction from the choice of Epstein to that of younger artists reflected the reinvigoration of public art in the late 1950s. It is notable that Geoffrey Clarke's *Spirit of Electricity* 1961 was closely related to his John Lewis submission.[5]

When O.B. Miller made his invitation to Hepworth in May 1961, he specified that it was her monumental *Meridian* 1958–60 (fig.69) – a work scaled up from *Garden Sculpture (Model for Meridian)* (no.46 q.v.) and unveiled fourteen months before – that prompted the approach. Quoting the purpose of the Partnership, he proposed that a work might express 'the idea of common ownership and common interest in a partnership of thousands of workers "of which the purpose is to increase the happiness of its own members while giving good service to the community"'.[6] Hepworth accepted the following day. Although eager to work on a monumental scale, it is likely that her immediate enthusiasm was also fired by the sense of shared endeavour for which the Partnership stood. The opportunity to contribute to this particular organisation extended both Hepworth's concern with the place of the artist in society and her political sense of post-war community.[7] Although deriving from a more personal involvement, this may be

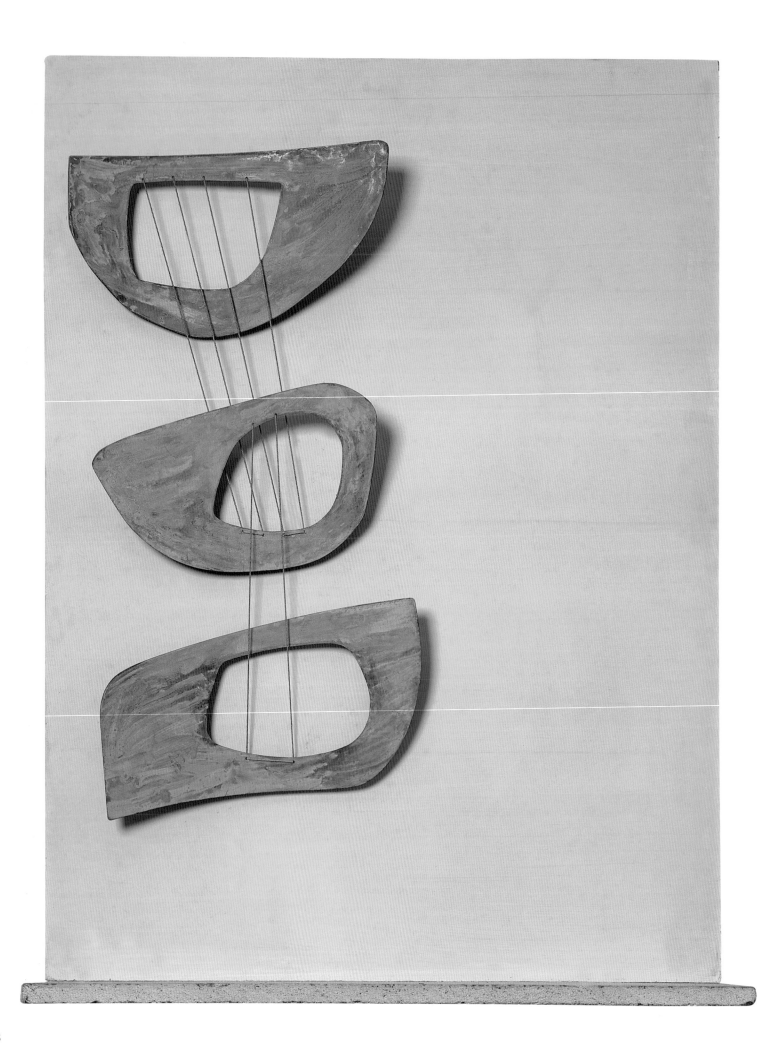

seen to be elevated to an international context in the overlapping commission for the United Nations in New York which resulted in *Single Form* 1961–4 (fig.6).

The sculptor visited the site in the week following the invitation, sought plans and specifications, and told Miller: 'for the next three or four weeks I shall be developing my idea.'[8] This suggests that, as she claimed for *Meridian*, she quickly settled upon a solution. The site had a number of restrictions; it was visible obliquely from Oxford Street with the left half favoured, the plane of Portland stone was 51 × 40 feet (15.544 × 12.192 m) – the equivalent of four floors – but had a canopy at the foot covering the entrance, and the architects did not want to exert an 'excessive structural load' on the façade. In early October maquettes at 1:24 scale were ready 'as soon as the plaster is dry'.[9] Rather surprisingly, the sculptor had hoped to have them cast in bronze – a measure, perhaps, of her confidence in the solution.

A letter and a more technical 'Specification', both dated 10 October 1961, accompanied the submission to Miller on 13 October. In the letter Hepworth described two models: 'One is my working maquette which has the "impulse" in it – but which is exaggerated in its forms and curves for aesthetic reasons. The other is mathematically correct, but at 1:24 scale does not give a true feeling.'[10] Only the plaster was sent. It is not clear whether containing the 'impulse' indicated that it was the first model, but it seems to have been the basis for the bronze *Maquette (Three Forms in Echelon)*. Jenkins has identified the Tate's brass and wood *Maquette* with the mathematically accurate reduction of which photographs were sent.[11] The backing planes are 1/24 of the dimensions of the wall, and the forms are set to the left in anticipation of the view from Oxford Street. On the brass and wood version, the bottom shelf is a scale reduction of the entrance canopy, and horizontal pencil lines are discernible running through the forms' points of attachment; these lines are represented by a row of pins on the surviving plaster.[12] Hepworth made a sketch of the forms on a photograph of the architects' perspective which reveals that the lines coincide with the floors of the building. On the 'mathematical' *Maquette*, the metal elements were made of thin brass sheet with sweeping curved edges. The central form is linked to the others by strings threaded through the metal, in a manner used in such works as *Orpheus* 1956 (no.38 q.v.); two strings converge from the lowest element, four diverge to the highest. The sheets are held by screws, the filed-down heads of which remain visible in the green patinated faces; they are held proud of the wood backing by spacing nuts which suggests how the final sculpture would have floated in front of the façade. The rather make-shift construction (simply screwed and painted white) and battered condition (brown staining and chipping) confirms its status as a working model.

Anticipating the acceptance of her submission, Hepworth discussed further arrangements in her letter of 10 October. She had already consulted 'the manager of my foundry' – presumably Eric Gibbard of Morris Singer Ltd – and preferred bronze to the potential corrosion of the lighter aluminium favoured by the Partnership.[13] The Specification carried more technical notes for the bronze forms (to be patinated 'a very light grey green'), which were estimated at 12–15 cwt (about 0.5–0.7 metric tonnes) weight and linked by rigid 20-foot lengths of 1-inch (609.6 × 2.5 cm) bronze rod. Instructions for lighting and display for viewing the maquette – so that the base was at eye level – were included. Hepworth noted in the letter: 'my next step would be to do a 1/3 scale model from which I would build the full size forms for casting.'[14] In fact, it seems that work had already begun on such models – which would be about 84 cm (33 in) high – as plasters for the middle and upper forms (together with an expanded aluminium armature for the latter) can be seen in the plaster studio at Trewyn (fig.73). Although the central holes are rather larger in proportion to the wings, they are clearly the 1:3 scale models. This may have been the result of thinking ahead, a tendency for which Hepworth had to be cautioned when working on the United Nations *Single Form* before receiving the commission.[15]

fig.72
Winged Figure, 1961-2, height 587 (231), aluminium, BH 315, John Lewis Partnership

In another letter, of 11 October, Hepworth supported the submission with the further explanation: 'I am convinced, from an abstract point of view, that the "Three forms in echelon" with radiating strings rising upwards is my interpretation of the John Lewis Partnership, its Members and the Public'.[16] As Jenkins has noted,[17] this capitalisation suggests that the three concepts were equatable with the three forms and that by these means the artist implied that the work addressed Miller's original proposal that the work deal with 'the idea of ... a partnership of thousands'.

Hepworth was understandably deflated by Miller's response. After consulting a colleague, he wrote: 'To neither of us does the design seem to integrate successfully with the building, nor to create the impression of an organic unity that will be recognised by people qualified to judge as an outstanding example of your own work'. He regretted imposing the constriction of a theme and asked whether 'merely being asked to decorate this building in this particular place would be likely to result in something very different'.[18] This stimulated a lengthy, point by point, defence of the work which has been quoted in full by Jenkins.[19] Hepworth stated 'I would like to say that I think the forms would be a very good foil to the building' and suggested that the result was 'an illusion of light and space, as well as thrusting forms and curves which would work when looking upwards at the building – when naturally the forms begin to blend one with the other'. They were also conceived to be seen from a distance. This point led to the 'organic unity' of the sculpture: 'I feel that these three forms belong to each other completely and have a formal relationship which does not allow the slightest deviation in placing or alteration in curvature'. Finally, Hepworth believed it typical of her work:

The way I work, is to get at an idea subconsciously and then pursue that formally, with quite a considerable belief, within myself, that the formal content will speak back to the public. In this case, the harmony and relationship of the three rising forms, would, I suspect, provoke some interest subconsciously in the harmonious relationship which exists in the Partnership.

fig.73
Expanded aluminium armature and plasters for *Three Forms in Echelon*, Trewyn Studio

However stout the defence, it was to no avail and *Three Forms in Echelon* was rejected. Two days later, Hepworth took up the proposal suggested by Miller of an alternative derived from an existing work, specifically mentioning *Winged Figure* 1957. She conceded that 'if the terms of reference are removed, the whole nature of the site is changed, in so far as one becomes entirely free to place a form within the area'.[20] *Winged Figure*, which constituted the ninth proposal for the building, was accepted almost immediately by Miller.[21] In the ensuing agreement, it was to be enlarged to 18 feet (5.87 m) and cast in aluminium. The plaster was unveiled in St Ives in August 1962 and the cast was installed on the building in Oxford Street on Sunday, 21 April 1963, almost two years after the original invitation.

Although the building of *Winged Figure* was a substantial undertaking, the sculptor herself acknowledged that the rejection of *Three Forms in Echelon* was 'rather a shock'. She also told Miller that 'it is a project which I would wish to carry out on some scale one day',[22] and this faith in the scheme was confirmed by the position allocated to the brass *Maquette* in her studio, where it has been placed high up to allow the appropriate angle of viewpoint. In 1965, she cast the plaster in a bronze edition of nine (+ 0) and presented one (2/9) to the Tate soon after; her friend Prof. W. Moelwyn Merchant gave another cast (7/9) to Exeter University. The differences between this version and the brass presumably derive from the plaster being 'exaggerated ... for aesthetic reasons'.[23] The back plane is slightly narrower and the shelf below substantially so. The three forms are arranged more vertically and are roughly textured in a way which modifies the clean outline of the edges. They have a shiny golden patination, and the stringing is replaced by bronze wire which does not pierce the surface. Rather than spacers, the bronze elements have wedges behind which allow for their attachment to the backing panel to which they are welded. Shallow concavities were let into the panel as the housing for each form and reciprocal mounds appear on the reverse. All the parts were simply sand-cast.

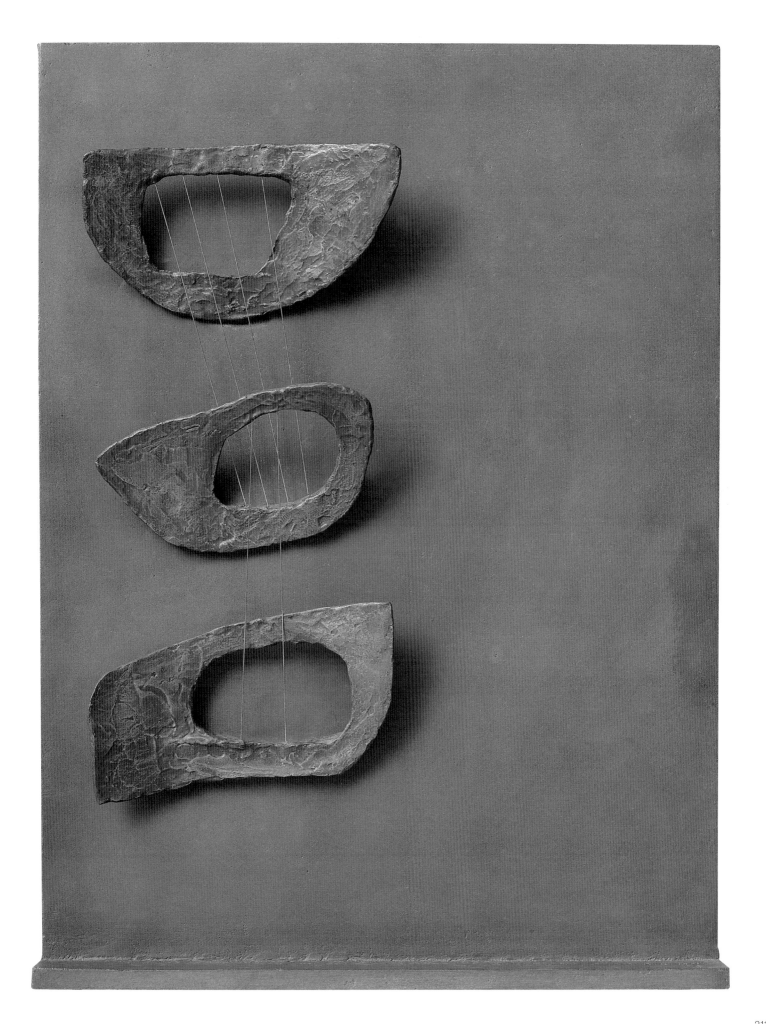

55 Single Form (September) 1961

T03143 BH 312

Walnut 82.5 × 50.8 × 5.7 (32½ × 20 × 2¼)
on veneered base 3.5 × 35.6 × 27.8 (1⅜ × 14 × 10¹⁵⁄₁₆)
on black lacquered base 6 × 38 × 30.5 (2⅜ × 15 × 10⅞)

*Presented by the executors of the artist's estate, in
accordance with her wishes, 1980*

*Displayed in the artist's studio, Barbara Hepworth Museum,
St Ives*

Exhibited: Whitechapel 1962 (73, repr.); Tate 1968 (122, repr.
p.36); *St. Ives: Twenty Five Years of Painting, Sculpture and
Pottery*, Tate Gallery, Feb.–March 1985 (136, repr. in col. p.71)

Literature: W.J. Strachan, *Towards Sculpture: Drawings and
Maquettes from Rodin to Oldenburg*, 1970, pp.67–8, repr.
p.68, pl.108; Hammacher 1968/1987, p.164, pl.141; Bowness
1971, pp.10 and 32, no.312, repr. p.55, pl.3 (col.); Jenkins 1982,
p.18, repr. p.35; *Tate Gallery Acquisitions 1980–2*, 1984, p.120,
repr.; Michael Tooby, *Tate St Ives: An Illustrated Companion*,
1993, p.84, repr. (col.); Festing 1995, p.254

In many respects *Single Form (September)* has become enmeshed with Barbara Hepworth's friendship with Dag Hammarskjöld, the Secretary-General of the United Nations (1953–61), who was killed in an air crash on 18 September 1961. Its subtitle evokes this moment, and the sculptor subsequently associated the choice of wood with her friend's appreciation of carving. In form, the sculpture is also connected with the twenty-one-feet high (6.4 m) *Single Form* 1961–4 (BH 325) (fig.6), commissioned as a memorial to Hammarskjöld at the United Nations in New York by the Jacob and Hilda Blaustein Foundation.

Single Form (September) was carved from an especially striking piece of figured walnut. On the face, the heart wood rises diagonally to the left, while a dark rippled patterning crosses on the opposing diagonal. This face is slightly convex and carries a perfectly circular depression in the upper right-hand corner; its geometric precision acts as a counterpoint to the profile of the work as a whole. The sides are flat and narrow, crisply distinguished from the main faces. Although the walnut is thin for such an expanse, the graining of the curved reverse differs subtly from the front in displaying the concentric rings of the heart wood alongside the rippling. The treatment of the wood may be compared to the scooped-out *Stringed Figure (Churinga)*, which was carved in the previous year from a similar piece of walnut; the nearly identical dimensions and comparable grain suggest that it may be from the same block.[1] Although in good condition, *Single Form (September)* has some bleaching on the lower left and right of the back; a rectangular fill (at the lower left of the reverse) and a number of plugs in the knots were probably undertaken by the artist before it was polished with shellac. Some of the splits have opened over time, and since acquisition by the gallery these have been filled with PVA and wood flour and the whole has been wax-polished.[2] The veneered base – to which the sculpture is screwed – was matched to the colour of the walnut; the lower lacquered base is of a type made by the St Ives cabinet maker Robin Nance and recognisable under other Hepworths, such as *Pierced Form (Epidauros)* 1960 (no.53 q.v).

The moment at which *Single Form (September)* was carved has not been pinpointed precisely in relation to Hammarskjöld's death. Hepworth's assistants Breon O'Casey and Tommy Rowe recalled her carving it in the dance hall of the Palais de Dance, which the sculptor had acquired as a studio by March 1961.[3] Certainly it belongs formally with a number of bronzes all dated to 1961, of which the last was the three-metre-high *Single Form (Memorial)* (BH 314) (fig.74), said to have been undertaken following news of the crash.[4] These works were included in Hepworth's exhibition at the Whitechapel in May 1962. There the bronzes *Curved Form (Bryher II)* and *Single Form (Chûn Quoit)* were listed before *Single Form (September)*; this order was followed in the catalogue of the artist's work.[5] While the relationship of the Tate's sculpture to the stringed concave plane of *Curved Form (Bryher II)* seems to rely upon the upright form and central circular hole, the formal relation to *Single Form (Chûn Quoit)* is more obvious as it is

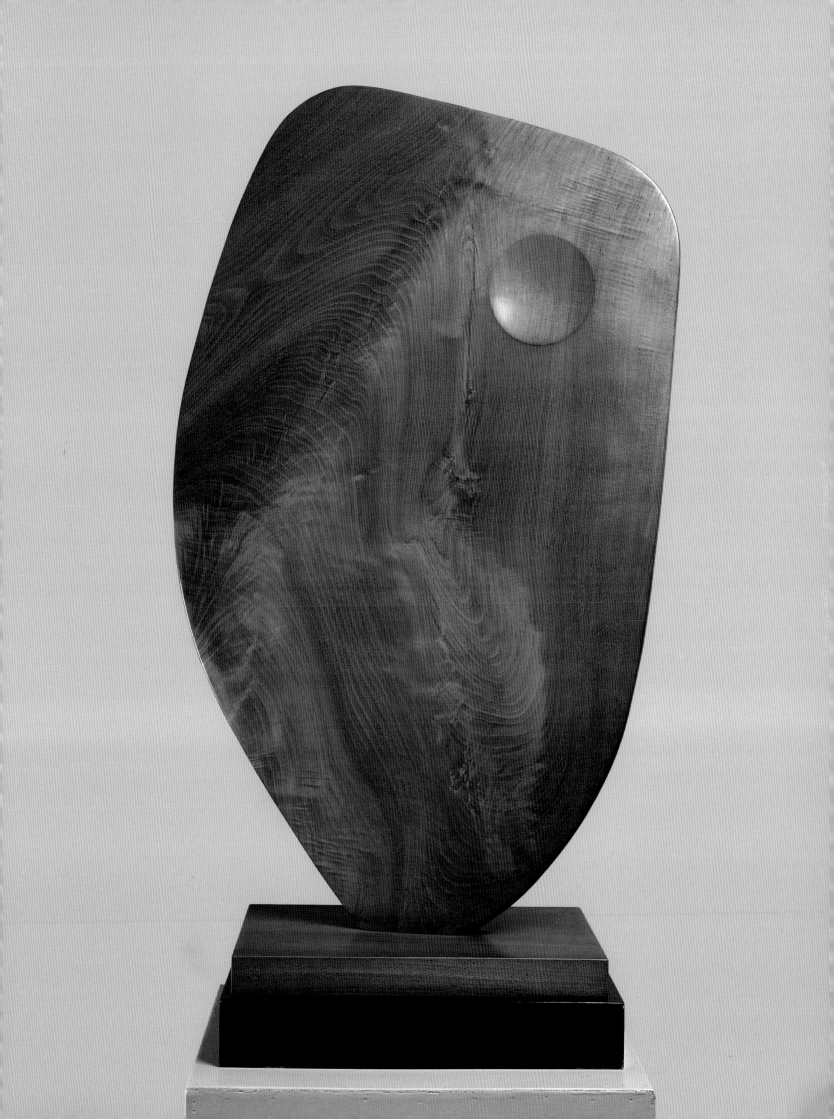

close in size and shape and bears an inscribed circle. The textured and weighty bronze contrasts with the finely balanced wood.

It has been noted that both associated bronzes are named for local places.[6] Bryher is one of the Scilly Isles, and Chûn Quoit, a Neolithic tomb towards St Just-in-Penwith. Alan Wilkinson has proposed a link between the sculpture and the form of the tomb.[7] Although the subtitle of the Tate's sculpture evokes a moment rather than a place, Hepworth's propensity for seeing her sculpture in the landscape remains important. This may be associated with an element of mystery, as the earlier walnut *Stringed Form (Churinga)* derives its subtitle from ritual objects amongst Australian Aborigines. Significantly, a Churinga refers to both the concept of individual identity within the society and, specifically, the flat oval sacred objects in which it is embodied. Although the sculptor's use of titles is sometimes ambiguous, this association fits with the formal development of the single upright monolith within her work.

These works came to be associated in retrospect with Hammarskjöld and his death in September 1961. Hepworth told Alan Bowness: 'when I heard of his death, in a kind of despair, I made the ten-foot high *Single Form (Memorial)*. This is the same theme as *September*, but the hole is moved over and now goes through the form. *Memorial* was made just to console myself, because I was so upset.'[8] The large sculpture must certainly have been produced at considerable speed, not only because Hepworth had other major projects underway at the same time – such as the submission of the *Maquette (Three Forms in Echelon)* (no.54A & B q.v.) for the John Lewis Partnership – but also because it was shown in the plaster version at the Whitechapel in May 1962. There, as the sequence of the catalogue indicates, it served as the culmination of recent work. It seems to have been amongst the sculptures to which Bryan Robertson referred in his preface: 'They are dynamic, and instinct with a compressed energy which is quite new ... In each case, the articulation is even more refined and subtle than in earlier forms, and completely synthesized with an expanding sense of form itself.'[9]

In her conversation with Bowness, the sculptor reiterated the sequence of works building towards *Memorial*, stating that 'Dag Hammarskjöld wanted me to do a scheme for the new United Nations building in New York ... We talked about the nature of the site, and about the kind of shapes he liked.'[10] Hepworth implied a direct connection between him and *Single Form (September)*, noting 'we discussed our ideas together but hadn't reached any conclusion' and adding: 'It was such a beautiful piece of wood, and I knew Dag loved wood. He already had two carvings of mine in his collection, and maybe this would have ended up with them.'[11] The sculptor last saw the Secretary-General in London in June 1961. It may be her statement about his love of wood that encouraged Sally Festing to refer to *Single Form (September)* as 'the sublime piece of walnut ... that Dag had so much praised'.[12]

Hepworth's recollections give a glimpse of Hammarskjöld's concern – despite his other responsibilities – with the artistic environment at the UN as part of the spiritual enrichment of those using the building. An aspect of this is evident in his establishment of a Meditation Room as Roger Lipsey has pointed out.[13] Of Hepworth's carvings, he bought the pre-war sandalwood *Single Form* 1937–8 from her 1956 New York exhibition; he kept it in his UN office and composed a poem related to it which was published posthumously in his book *Markings* 1964.[14] He also owned the recent lignum vitae *Hollow Form (Churinga III)* 1960.[15] The sculptor found in him a kindred spirit, sharing political views on the responsibility of the artist in the community and more broadly the individual within society. Hepworth described Hammarskjöld's 'pure and exact perception of aesthetic principles, as exact as it was over ethical and moral principles. I believe they were, to him, one and the same thing'.[16]

Whether or not Hammarskjöld saw *Single Form (September)*, the consequences of his friendship with Hepworth led to the commission for the *Single Form* 1961–4 at

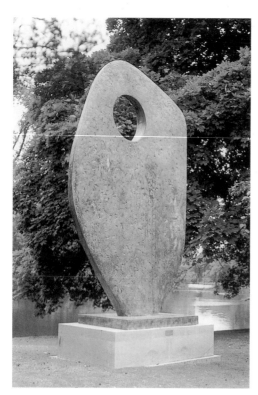

fig.74
Single Form (Memorial), 1961, height 312.5 (123), bronze, BH 314, Wandsworth Borough Council, London

the United Nations. She recalled this as a surprise, noting that the new Secretary General, U Thant, 'told me about the last walk he'd had with Dag around the pond, when Dag had said that I was developing an idea which he wanted very badly'.[17] This memory appears to be slightly romanticised. Hammarskjöld had proposed sculptures for the building before his death but, despite their friendship, he was considering Henry Moore as well as Hepworth.[18] In 1960, another mutual friend Herbert Read had, according to his biographer, 'alerted Moore to the fact that … Hammarskjöld, if approached correctly, might like to commission a sculpture for the UN building in New York'.[19] Moore had already carved the Travertine *Reclining Figure* 1957–8 for the UNESCO building in Paris. Perhaps aware of this, Hepworth was 'purposeful' in pursuit of the commission.[20] Penelope Curtis has enlarged upon the sculptor's own comments to Bowness, detailing the different stages of the UN work, from the initial plan to make an eight-foot-high carving to the mock-up erected in June 1962. Hepworth declined to visit the site, with which she was already familiar, arguing: 'Knowing how Dag was thinking about world ideas and about ideas in sculpture, when I last saw him in June last year, I feel that it is my duty to keep my ideas dedicated and untrammelled for the final work … I can only do it by being single-minded'.[21] As the official commission was not ratified by the UN until September 1962, *Single Form (Memorial)* had been exhibited at the Whitechapel without its subtitle or a dedication (although Robertson's preface had made a point of mentioning the concordance between the sculptor's ideas and those of the late Secretary-General); these were made public when the sculpture was shown in Battersea Park the following summer.[22] The casting of the full-size version at Morris Singer Ltd – took ten months, and it was unveiled in New York on 11 June 1964. Both of the larger versions had to be reconceived because of the increase in size and for structural reasons. The face of the culminatory work bore the division into six parts which facilitated casting, and which was approximately equivalent to the sections reassembled in *Six Forms (2 × 3)* 1968 (no.67 q.v.); both the horizontal divisions and the internal structure were envisaged with the help of a maquette (fig.76). Significantly, the two-tier base of *Single Form (September)* recalls the structure of the fountain outside the UN.

Such a commission was of fundamental importance both to Hepworth's career and to the perception of sculpture as a public medium for the transmission of ideas. Angela Conner, who assisted on making the plaster, recalled it as 'the first major modern work in a public space in New York'.[23] Six years after its inauguration, Edwin Mullins proposed a reading of its rhetoric: 'it is a torso, it is a profile with an eye, it is an expanse of space in which the sun rises, it is a blade, it is a human hand … raised flat in a sign of authority, or of salute, or as a gesture of allegiance'.[24] Dore Ashton proclaimed Hepworth's work to be 'a vision of the cosmos'.[25] She explored one of the literal readings in seeing the pierced circle as a symbolic eye, related to 'the Western window of the soul, but also the Eastern and primitive eye which mythologically survives all history'; Ashton also believed that the sculpture proved 'that there can be a poetry of exchange between nature and metropolis'.[26] This connection has been seen differently by Penny Florence, who raised the question: 'What kind of geopolitical and historical gesture is constituted in the transposition of a piece finely balanced between a modern female subject in a remote landscape and prehistory into the quintessential modern cityscape of New York?'[27] An answer lies in the relation of the sculptor to the dedicatee or, more precisely, in the transcription of that relationship into the arena of world politics, so that modernism and the ideals of internationalism were reasserted at a time of Cold War tensions. It may be in this connection that the simple structure of Hepworth's implicitly political sculptures of the late 1930s, such as Hammarskjöld's sandalwood *Single Form*, was remade in the broader upright *Single Form* sculptures of twenty-five years later.

56 Square Forms 1962

T03144 BH 313; edition no. 9/9

Bronze on bronze base 34.3 × 19 × 8.9 (13½ × 7½ × 3½)

Stamped on front of base '9/9' b.l.

Presented by the executors of the artist's estate, in accordance with her wishes, 1980

Displayed in the artist's studio, Barbara Hepworth Museum, St Ives

Exhibited: John Lewis 1963 (14†); Zurich 1963–4 (11†, repr.); Gimpel Fils 1964 (11†, repr.); *5 British Sculptors (work and talk)*, IBM Gallery, New York, March–April 1965 (18‡); Tate 1968 (123‡); Gimpel Fils 1972 (21‡); Gimpel Fils 1975 (35‡, repr.); New York 1977 (10‡); *Retrospective* 1994–5 (66, repr. in col. p.146, Liverpool only)

Literature: Bowness 1971, p.32, no.313, repr. p.33; Jenkins 1982, p.17, repr. p.35; *Tate Gallery Acquisitions 1980–2*, 1984, p.120–1, repr.

*S*quare Forms was made of seven elements projecting from a rectangular column screwed to a square base and selectively patinated green. There are five overlapping squares which, like the base, each measure *c*.89 mm (3½ in); the base is 23 mm (⅞ in) thick, the planes *c*.5 mm (³⁄₁₆ in). The core of the cluster is held by a vertical rectangle (equivalent to a square and a half) held in the column in a mortise joint. In front of it, a small rectangle (half a square) lifts up a square (the third from the front); another square (the second), immediately in front, is let into a shallow joint cut away from the top edge of the column. The other squares are stacked up and displaced upwards or to the side. They are simply riveted together face to face;[1] rivets are discernible in the overlap between the highest square and that below. Apart from the column, all the main surfaces show the results of diagonal saw cuts in from the corners. This is also seen on the base. Breon O'Casey has recalled that, as an assistant, he trimmed the squares off the bases of an edition of bronze sculptures; Hepworth recognised their potential and salvaged the off-cuts.[2] An edition of nine was issued; they were cut and riveted individually rather than being cast.

Hepworth's contemporary works of 1960–2 were, like *Figure for Landscape* 1959–60 (no.52 q.v.), predominantly organic in appearance, but *Square Forms* saw the reintroduction of a more geometrical approach. She had used such forms in the 1930s with the Constructive carving *Monumental Stela* 1936 (fig.29) in which shallow rectangular planes appeared to be similarly shifted in progressive dispositions. It is notable that the sculptor specifically remarked upon the ambition of such lost pre-war works, telling Alan Bowness in 1970 that more recently she had the 'space and time and money for materials' to realise them on a large scale.[3] The use of this geometry on such a scale was also recalled when Hepworth reconceived *Square Forms* as *Square Forms with Circles* 1963 at nearly eight times the size.[4] This enlargement differs in some details (the vertical rectangle is off-set further to one side) and has the roughened surface typical of Hepworth's monumental bronzes but here also developed out of the process of manufacture. A circular depression was cut into the face of the uppermost square, and an incised circle appears on the other side – suggesting potential removal – and on the equivalent face of the next highest element. These circles became conical piercings in *Squares with Two Circles* 1963 (no.59 q.v.). The artist also took up this simplicity in ensuing drawings, especially the linear *Square and Circle* 1963.[5]

As well as Hepworth's sculptures from the 1930s, this modified geometry and the effect of shallow overlapping planes relates to the reliefs of Ben Nicholson, both from that period and from the late 1950s. Especially notable is his *October 2 1934 (white relief – triplets)* 1934 (fig.25), where the top square is off-set and punctured by a circle. His reliefs of the 1950s are more often constituted of quadrilateral and rhomboidal planes, such as those found in *1957, April (Lipari)*.[6] Significantly, these reliefs made a virtue of the dense texture and uneven absorbency of the materials to achieve a mottled surface which may be compared to that favoured by Hepworth on her bronzes.

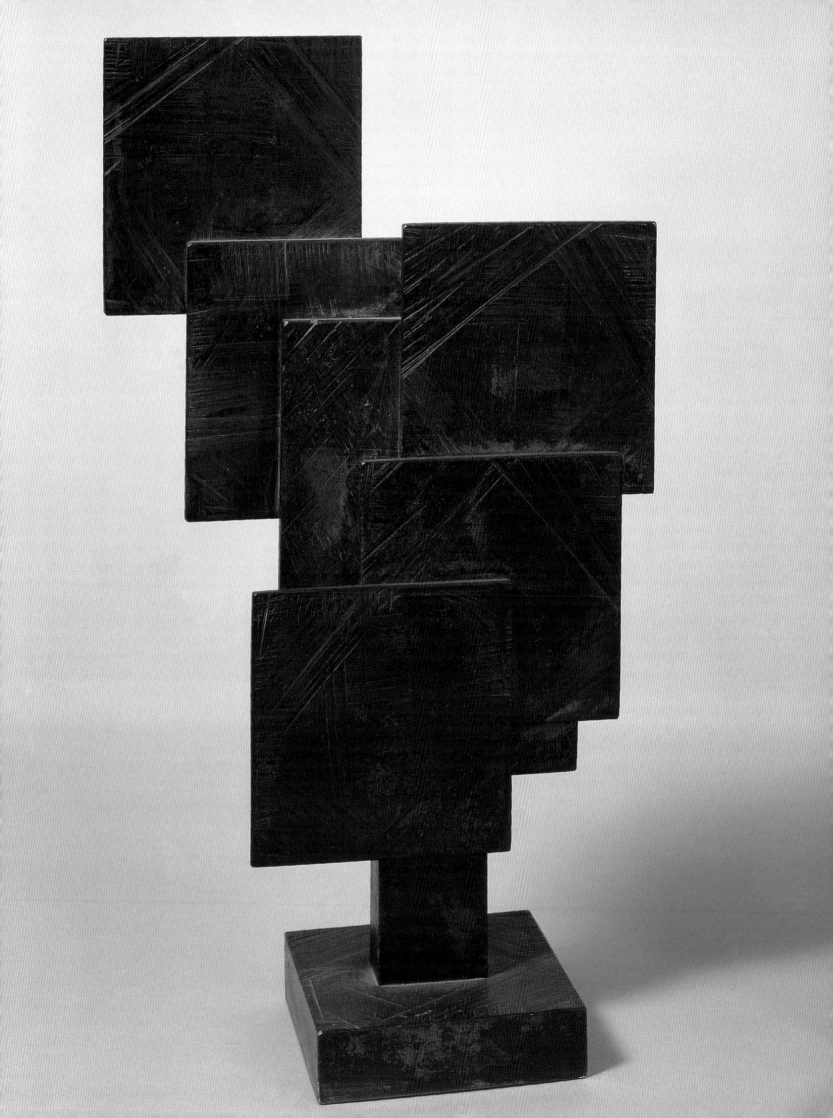

57 Bronze Form (Patmos) 1962–3, cast 1963

T03145 BH 321; cast 0/7

Bronze 65.4 × 95 × 24.1 (25¾ × 37⅜ × 9½)
on bronze base 4.9 × 25.7 × 19.8 (1¹⁵⁄₁₆ × 10⅛ × 7¾)

*Presented by the executors of the artist's estate, in
accordance with her wishes, 1980*

*Displayed in the artist's garden, Barbara Hepworth
Museum, St Ives*

Exhibited: Zurich 1963–4 (13†, repr.); *Profile III: Englische
Kunst der Gegenwart*, Stadtisches Kunstgalerie, Bochum,
April–June 1964 (62†); *Spring Exhibition 1964*, Penwith
Society of Arts, St Ives, spring 1964 (sculpture 2†, as
Patmos); Gimpel Fils 1964 (13†, repr.); *Summer Exhibition
1964*, Penwith Society of Arts, St Ives, summer 1964
(sculpture 3†); *Artists in Cornwall*, Leicester University Arts
Festival, 1965 (13†); *Little Missenden Festival*, Little
Missenden, Oct. 1965 (no cat.); New York 1966 (8†, repr.);
Sculpture Contemporaine et Art Africaine, Galerie Lacloche,
Paris, July–Sept. 1966 (32†, cat. not traced); AC tour 1970–1
(11†, repr.)

Literature: Bowness 1971, p.34, no.321, pl.65; Jenkins 1982,
p.17, repr. p.36; *Tate Gallery Acquisitions 1980–2*, 1984, p.121,
repr.

Extruded and wrapped over an open cavity, *Bronze Form (Patmos)* is one of the
bronze sculptures in which Hepworth achieved most elasticity. The yawning
openings in the front are echoed on a reduced scale by those in the essentially flat
back. The taut bridges of material enhance the sense of movement also found in the
energetic handling of the surface. This is contrasted with the smooth cylinder on which
the form is poised.

The technique employed had been devised for the first bronzes of 1956. The plaster
was carried on an armature of expanded aluminium which was easily manipulated into
an organic form. This plaster version appears in the photograph in the catalogue
raisonné, and was exhibited at the Penwith Society's *Autumn Exhibition 1968*.[1] The
bronze edition (7 + 0) was made at the Art Bronze Foundry in Fulham; according to the
artist's records she retained 0/7, which came to the Tate. The main form appears to have
been cast in at least two pieces, as a seam is visible along the top. The cylindrical collar
was cast separately, and both elements are held to the lower base by steel bolts.
Hepworth chose a green and white patination; the high points are characteristically
polished. Exposure in the artist's garden has resulted in damage by the elements. In
1983, the sculpture was lacquered but problems with patchy wear were recognised and,
in 1989, most of the lacquer was removed and the surface was waxed.[2]

The handling of *Bronze Form (Patmos)* is closely comparable to *Sea Form
(Porthmeor)* 1958 (no.47 q.v.) and *Oval Form (Trezion)* 1961–3, which share the horizontal
emphasis and the potential or actual enclosure.[3] The rolled-over form may relate to the
observation of the sea, although it also occurs in *Figure for Landscape* 1959-60 (no.52
q.v.) where the cavity is barred by a similar protective diagonal similar. The balance on
the truncated cone of the collar echoes an earlier sandalwood carving, *Hand Sculpture
(Turning Form)* 1953, on which the implied rotation appears to have been made actual
by introducing a spindle.[4] Something of the rolled solidity of this wooden form is present
in the small alabaster, related by title to the Tate's work: *Curved Form (Patmos)* 1960.[5]

The title, *Bronze Form (Patmos)*, is notable in two respects. It was the only title in
which Hepworth drew attention to the use of bronze, as if it was especially linked to the
conception of the form. It was also unprecedented in the use of a Greek place-name for
a work in this material, with the exception of *Epidauros II* 1961 which derived from
Pierced Form (Epidauros) 1960 (no.53 q.v.) one of the guarea works habitually named
after Greek locations.[6] The reference to the Dodecanesian island has been associated
with the theme of the sea as well as with the sculptor's visit in 1954.[7] In notes relating to
that trip which Hepworth prepared for publication not long after casting the bronze, she
recalled her impressions of the view from the monastery at Patmos: 'an unbelievable
panorama of indigo sea and deeply sculptured islands – Turkey lying far on the horizon
in mist – purple and brown with little crowns of cloud round the summits.'[8] The memory
of the visit was sharp, as Hepworth also told Edouard Roditi:

I saw a single black-robed Greek Orthodox priest standing beneath me in a snow-white courtyard, with the blue sea beyond and, on the curved horizon, the shores of other islands. This single human figure then seemed to me to give the scale to the whole universe, and this is exactly what a sculpture should suggest in its relationship to its surroundings.[9]

Hepworth viewed the landscape as enfolding, and this relates to the enclosing quality of *Bronze Form (Patmos)*. Such concerns with the sensual and aesthetic placement of the figure in the landscape, which were central to her undertaking, assumed a wider spiritual dimension in relation to the island on which St John had his Revelation. In the saint's iconography he is frequently shown as diminutive within the landscape and this may have coloured the sculptor's account of the priest in relation to the setting. As Hepworth made clear about other works, the actuality implied by her subtitles referred less to a literal portrayal than to a shared sense of the experience of the place.

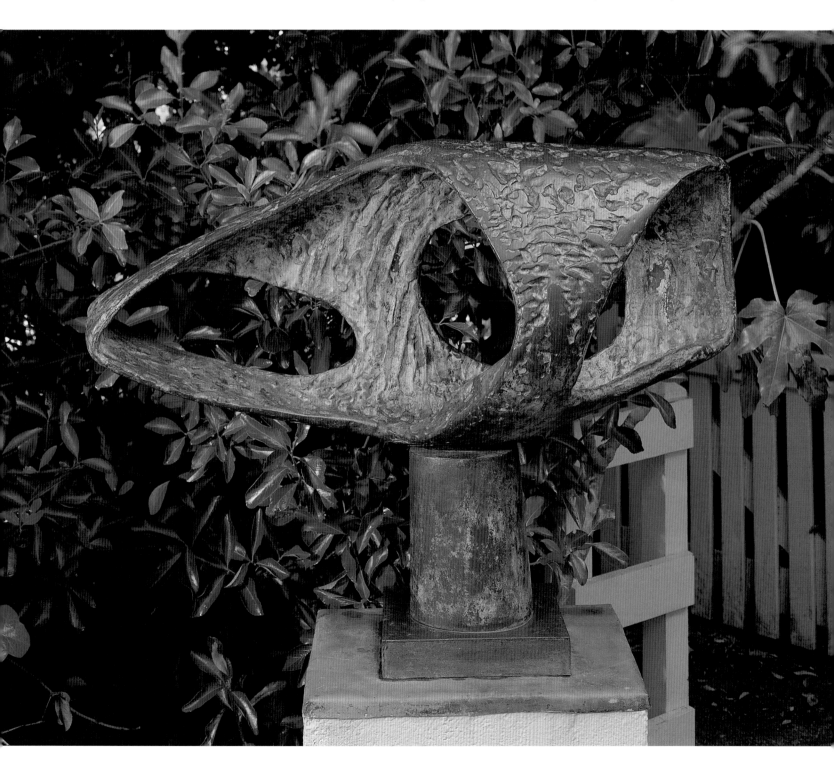

58 Sphere with Inner Form 1963, cast 1963

T03146 BH 333; cast 0/7

Bronze 90 × 90 × 88.5 (38⅜ × 35½ × 34⅞)
on bronze base 7.5 × 59.5 × 59.5 (3 × 23⅜ × 23⅜)

Cast numerals on rear of base '0/7' t.r.

*Presented by the executors of the artist's estate, in
accordance with her wishes, 1980*

*Displayed in the artist's garden, Barbara Hepworth
Museum, St Ives*

Exhibited: Gimpel Fils 1964 (29†, repr.); *Summer Exhibition
1964*, Penwith Society of Arts, St Ives, summer 1964
(sculpture 4†); *Contemporary British Sculpture*, AC open-air
tour, Cannon Hill Park, Birmingham, April–May 1965,
Brighton University, May, Abington Park, Northampton,
June, Castle Grounds, Nottingham, July, Bowes Museum,
Barnard Castle, July–Aug., Hillfield Gardens, Gloucester,
Sept. (7†, repr. pl.1); BC European tour 1964–6: Otterlo (36‡,
repr.), Basel (26‡), Turin (34‡, repr.), Karlsruhe (26‡), Essen
(26‡); New York 1966 (10†, repr.); Tate 1968 (132‡); Bretton
Hall 1980 (10‡)

Literature: Bowness 1971, p.35 no.333, pls.78–9; *Tate Gallery
Acquisitions 1980–2*, 1984, p.121–2, repr.

Enclosure was one of Barbara Hepworth's favoured themes, and in *Sphere with
Inner Form* it is condensed to considerable formal simplicity. The sphere's smooth
thin shell, punctured by circular and oval openings, covers the crusty inner form, which is
also pierced. The warm brown patina of the outer surfaces contrasts with the green of
the interior faces and the inner form. On more than one occasion Hepworth expounded
upon the significance of this enclosure which recurred in such works as *Oval with Two
Forms* 1971 (no.72 q.v.). Especially pertinent to *Sphere with Inner Form*, she drew
attention to the relationship between 'an inside and an outside of every form … a nut in
its shell or of a child in the womb, or in the structure of shells or of crystals, or when one
senses the architecture of bones in the human figure'.[1] There are formal links between
these examples, but they also belong to a chain of ideas associated with protection and
fruition. This leads back to the organic figure carvings of the early 1930s, especially the
lost *Figure (Mother and Child)* 1933 (BH 52) (fig.21) in which the child nestles within the
encircling presence of the mother. Such relationships in Hepworth's sculpture have
been read in the light of Melanie Klein's focus on the enclosing form as womb, and her
theory of art as a reparative activity.[2] That psychoanalytic ideas informed Hepworth's
later work is suggested by the Jungian subtitle of *Curved Form with Inner Form (Anima)*
1959 which evokes the female aspect within the male.[3] The enfolding curve of *Curved
Form with Inner Form (Anima)* – which is based upon *Wave* 1943–4 (fig.42) – is open at
the sides, the rough inner form contrasts with the smooth exterior and is pierced and
roughly four-sided in elevation. In all these respects it anticipated *Sphere with Inner
Form* of four years later.

Like Hepworth's other bronzes, the plaster was made around an expanded
aluminium armature. The sphere is visible in progress in a photograph of the artist at
work taken by the American film-maker Warren Forma, and associated with his
documentary *Five British Sculptors Work and Talk* (1964).[4] The bronze was hollow-cast
at the Art Bronze Foundry, Fulham, from 1963; the artist's copy (0/7) and another (7/7)
were ordered in early 1965.[5] The sphere was cast in at least two pieces, as the welded
joint is visible passing over the top, but there were problems with the edition. Hepworth
complained that one was 'badly grazed' and had 'a nasty crack in the centre of the base'
requiring repair in the studio.[6] The artist's cast, which came to the Tate, has a crack
where the central weld meets the base, another crack in the base and a hole on the
edge of the casting.[7] These and other faults were repaired in the studio with lead alloy
filler, a material which is consistent with reports of the use of car body filler. Further
repairs have used polyester filler. These problems appear to have been echoed in the
subsequent corrosion of the bronze, resulting in deposits of copper salts on the inner
surfaces. Although this is compounded by outdoor display in the artist's garden, the fact
that the location was not the cause is confirmed by a similar development on the other
1965 cast (7/7), now owned by the Whitworth Art Gallery of the University of
Manchester. Samples of the salts were analysed at the British Museum in 1985, which

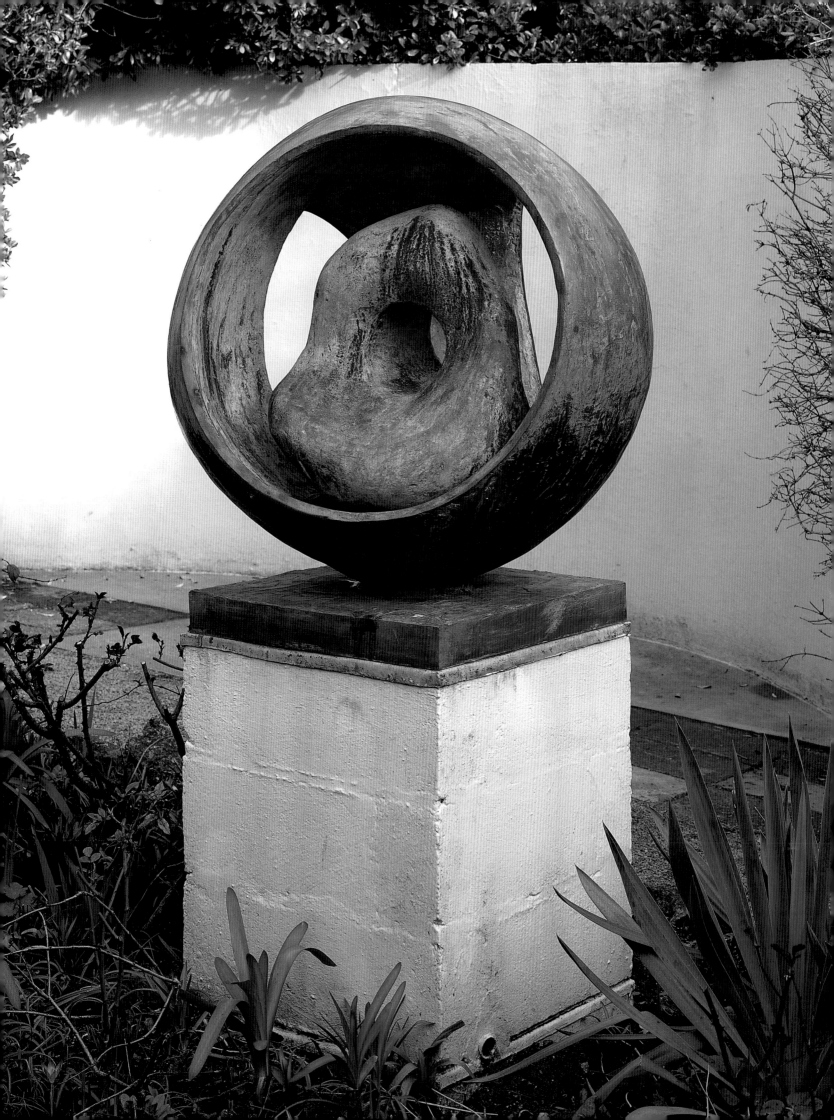

identified the presence of gypsum as a result of the casting process; the conclusion was that the sculpture was not undergoing 'active corrosion' but that 'localised corrosion is occuring at the alloy–gypsum interface'.[8] The conjunction of the two forms tends to encourage the collection of water and detritus, and to block the drainage hole which carries rainwater away through the base and the plinth.

Hepworth donated a cast (6/7) of this work to be auctioned for the benefit of the Institute of Contemporary Art in 1966.[9] Another cast (4/7) is among the extensive Hepworth holdings at the Rijksmuseum Kröller-Müller, Otterlo, The Netherlands.

59 Squares with Two Circles 1963

T00702 BH 347; cast 1/3

Bronze on bronze base 306.1 × 137.2 × 31.8
(120½ × 54 × 12½)

Cast inscription on top of base 'Barbara Hepworth' and '1/3'
back left, and cast foundry mark on front of base 'Morris |
Singer | FOUNDERS | LONDON' t.r.

Purchased from the artist (Grant-in-Aid) 1964

*On long-term loan to Yorkshire Sculpture Park, Bretton
Hall, Wakefield from 1980*

Exhibited: *54: 64: Painting and Sculpture of a Decade*,
Calouste Gulbenkian Foundation, Tate Gallery, April–June
1964 (79, as *Monolith (Square and Two Circles)*, the plaster
repr.); BC European tour 1964–6: Otterlo (40‡, repr.); Tate
1968 (137); Bretton Hall 1980 (23); *A Century of Modern
Sculpture: The Patsy and Raymond Nasher Collection*,
Dallas Museum of Art, April–May 1987, National Gallery of
Art, Washington DC, June 1987–Jan. 1988 (36‡, repr. pp.82
in col., 160)

Literature: *Tate Gallery Report 1964–5*, 1966, p.41; 'Recent
Museum Acquisitions: Sculpture and Drawings by Barbara
Hepworth (The Tate Gallery)', *Burlington Magazine*, vol.108,
no.761, Aug. 1966, p.426, repr. p.424, pl.59; Bowness 1971,
pp.12–13, 36, no.347, pls.6 (col.), 92–4; W.J. Strachan, *Open
Air Sculpture in Britain: A Comprehensive Guide*, 1984,
p.200, no.462, repr.; Nan Rosenthal, 'Sculpture in the
Constructivist Tradition', in Steven A. Nash (ed.), *A Century
of Modern Sculpture: The Patsy and Raymond Nasher
Collection*, exh. cat., Dallas Museum of Art, 1987, pp.79–81,
161

Reproduced: *Pictorial Autobiography* 1970/1978, pp.103, 108

Soon after the completion of *Squares with Two Circles*, Barbara Hepworth told the Tate that she 'was interested in the proportion of the sculpture in relation to the human figure, and the apertures are placed in relation to human vision'.[1] The sculpture is over three metres high; the lower opening is centred at *c*.134 cm (53 in) and the upper at *c*.236 cm (93 in). On a number of occasions, it has been displayed on a further plinth, raising the lower hole to eye level.

Squares with Two Circles is one of Hepworth's largest monolithic bronzes, combining rectilinearity with lightness by the device of the short rectangular column. Variety is introduced in the slight modifications of the geometry: from the side it is apparent that the form tapers as it rises and that the faces are slightly convex. The corners of the quadrilaterals are not precise right-angles, so that 'despite the sculpture's geometric syntax, a sense of the natural and vital is preserved'.[2] This is combined with the restrained handling of the surface which is burnished down to retain only shallow pitting. A hierarchy of zones was established on the related *Maquette for Monolith* 1963.[3] This was made more obvious through the surface and patination of *Squares with Two Circles*. One face is light green above and dark green below, and the other is brown and green in similar dark tones. While the former is made up of the simple disposition of two horizontal quadrilaterals, the inclusion of the column into the composition of the latter allowed for the build-up of vertical planes, one sliding into the other with an additional step at the left. The holes, which are conical in form and more polished than the faces, provide the continuity between the horizontal and the vertical formats. The integration with the landscape – one of Hepworth's abiding concerns – is made actual by these openings, through what she termed the viewer's 'sense of participating in the form'.[4] This has encouraged Nan Rosenthal to write of the establishment in an outdoor setting of a 'balanced nature/culture dialogue'.[5]

The simplicity of *Squares with Two Circles* recalls the purity of the works of the 1930s, a connection to which Hepworth drew attention in her discussion of the sculpture with Alan Bowness. She related it particularly to the six-feet-high carving *Monumental Stela* 1936 (fig.29), reportedly destroyed after being 'damaged … by shrapnel', noting: 'it's haunted me ever since, and when I was able to make *Squares with Two Circles* I kept thinking about it. The back view has the curve that was in the earlier work. I don't often express preferences about my own work, but I must admit it's a particular favourite of mine, perhaps because of the earlier connection'.[6] Although united by a common abstract conception, the 1930s' sculpture was more crisply geometrical in keeping with the contemporary aspirations towards aesthetic and social improvement voiced through *Circle* (1937), the Constructive publication to which Hepworth contributed. In their articulation of space through the accumulation of shallow planes these interrelated works were comparable to Ben Nicholson's reliefs of both periods, but a connection has also been made between the monolith of *Squares with Two Circles* and Neolithic stones. In countering the suggestion that her circles

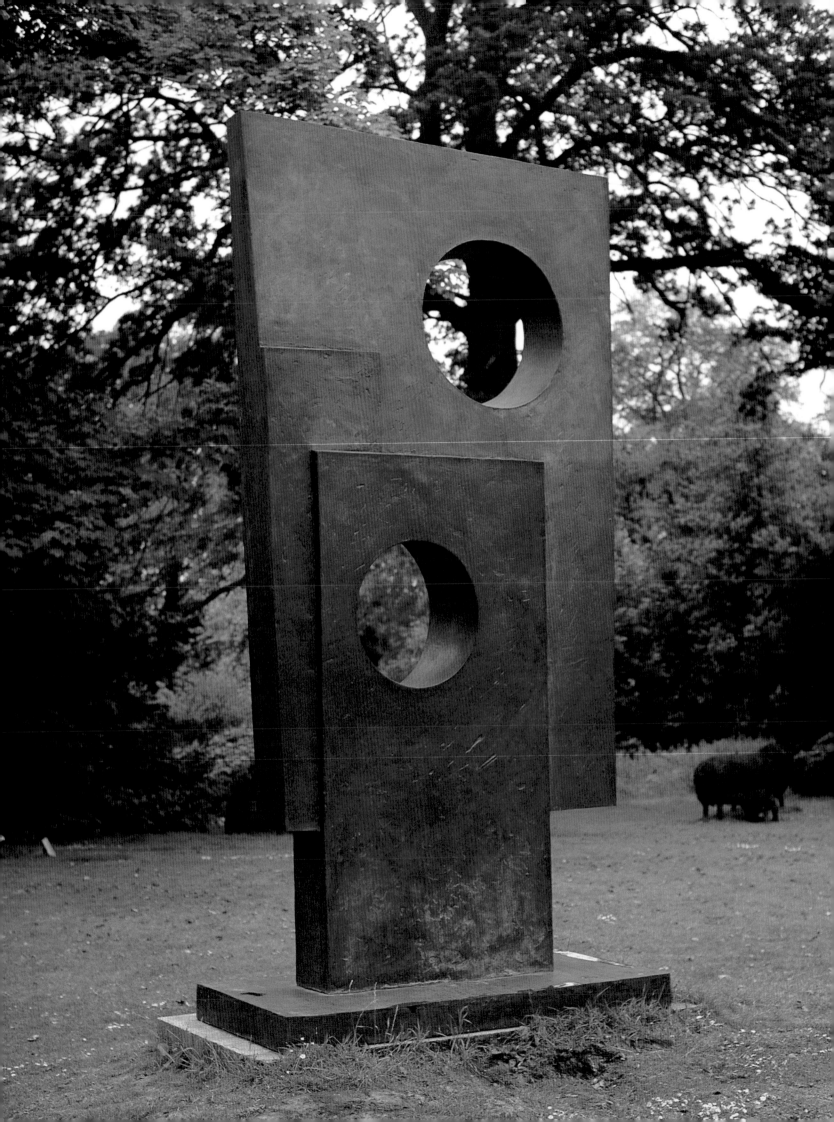

were 'just plonked down', Hepworth indicated that their 'slanted' form would be apparent if 'you climbed through the circles of *Squares with Two Circles*';[7] in fact, the circles funnel outwards in opposite directions. When Alan Bowness linked this comment to the practice of climbing through the local ring-shaped Men-an-Tol stone (fig.32), the sculptor observed that the experience of such stones had ratified her ideas that 'you're making an image, a fetish, something which alters human behaviour or movement'.[8]

The work was made at a time and on a scale associated with Hepworth's series of commissions around 1960, including *Meridian* 1958–60 (fig.69) and *Winged Figure* 1961-2 (fig.72) in London, and *Single Form* 1961–4 (fig.6) in New York. As well as establishing her sculpture in urban public places during a period of particular demand for such monuments, these successes allowed her to finance the enlargement of her own work. She contrasted the response to a site required by a commission with the freedom of her own choice, telling Warren Forma: 'I always imagine the sort of setting I would like to see them in, because I firmly believe that sculpture and forms generally grow in magnitude out in the open with space and distance and hills'.[9] Such imagined placement may be associated with Hepworth's interest in the mid-1960s in the establishment of a sculpture park, comparable to the Rijksmuseum Kröller-Müller at Otterlo.[10] As well as a concern with the site, the interview with Forma expressed Hepworth's new engagement with large-scale public commissions in the year following the unveiling of the Dag Hammerskjöld memorial in New York, and when further American commissions may have seemed a prospect. After the Tate and the Kröller-Müller acquired the first two casts of *Squares with Two Circles* in 1964, the third was sold to the Dallas collectors Patsy and Raymond Nasher in 1968 and the artist's copy (0/3) went to the University of Liverpool.

Although further public commissions did not immediately follow, the sculpture was the first of a series of large works made with essentially flat geometrical planes which culminated in *Four-Square (Walk Through)* 1966 (no.65 q.v.) and *Two Forms (Divided Circle)* 1969 (no.69 q.v.). All were made by cutting the shapes from sheets of expanded aluminium reinforced by angled aluminium corner strips, a structure visible in the photograph of *Four-Square (Walk Through)* in progress (fig.75); the plaster was applied to this preparatory armature and the result cast in bronze. Apart from a small amount of corrosion along a weld in the supporting column, the Tate's cast of *Squares with Two Circles* remained in fine condition for an outdoor work until 1998. On 5 January the sculpture was severely damaged in a storm and repair to major faults along the weld seams was entrusted to the Morris Singer Foundry, where it had originally been cast.[11] The repairs, which necessitated repatination, were completed in the autumn of 1998.

60 Pierced Form 1963–4

T00704 BH 350

Pentelicon marble 126.4 × 97.2 × 22.9 (49¾ × 38¼ × 9)
on wooden base 14 × 99 × 61 (5½ × 39 × 24); weight 625 kg

Presented by the artist 1964

Exhibited: Gimpel Fils 1964 (36, repr. as 1963); *British Sculpture in the Sixties*, CAS exh., Tate Gallery, Feb.–April 1965 (46, as 1963); Tate 1968 (139); Hakone 1970 (16, repr.)

Literature: *Tate Gallery Report 1964–5*, 1966, p.42; 'Recent Museum Acquisitions: Sculpture and Drawings by Barbara Hepworth (The Tate Gallery)', *Burlington Magazine*, vol.108, no.761, Aug. 1966, p.426, repr. p.427, pl.60; Bowness 1971, p.36, no.350, pls.7 (in col.), 95–6

Reproduced: *Pictorial Autobiography* 1970/1978, p.92, pl.256

At the time of presenting *Pierced Form* to the Gallery, Barbara Hepworth claimed with considerable justification: 'I am one of the few people in the world who know how to speak through marble.'[1] In a contemporary interview, she enlarged upon this, asking J.P. Hodin in conversation: 'Do you know that I love marble specially because of its radiance in the light, its hardness, precision and response to the sun?'[2] These qualities were associated with her practice of carving stone outdoors as well as with the resonance of the final result. However, the combination of formal abstraction and craftsmanship was increasingly rare as the new generation of sculptors, epitomised by Anthony Caro, turned to the description of space through brightly painted industrial steel elements.

Hepworth's association of marble with precision and radiance may be related directly to the handling of *Pierced Form*. The block is appreciably massive, being more than four feet high and three feet wide. A consistent grey veining enlivens the white by running diagonally through it; a pronounced line of potential fracture follows this grain from the right of the hole to the bottom left corner. Spots of natural iron staining have yellowed the lower right quarter of the front. The faces are both completely flat and the forms are defined by crisp edges, while the surfaces are finished differently. The highest polish is reserved for the top front edge, the oval funnel of the hole and the bevel of the sides. A secondary polish is achieved on the sides and the hole itself. However, the expanse of the faces has been left with a sanded finish, where the quality of the fine crystalline structure is appreciable as is the intensive chiselling of the stone. Tommy Rowe, who worked on this block in the lower studio in the former Palais de Danse, has remembered that he and Dicon Nance cut away the top right corner by drilling a series of holes.[3] This had to be done surreptitiously while Hepworth was away, as she generally forbade the use of mechanical tools, preferring to work gradually, rhythmically and (necessarily) laboriously. By its placement, the stone is deliberately contrasted with the rugged base, to which it is held by three bronze bolts. The base is a heavy block of wood, the front and back of which have simply had the bark removed to reveal the knotted surface; a comparable base was used for *Marble with Colour (Crete)* 1964.[4] Apart from cracks in the wood, *Pierced Form* is in good condition.[5]

The carving was based upon an earlier bronze maquette: *Pierced Form (Amulet)* 1962.[6] Following Hepworth's practice, the original plaster of this piece would itself have been carved. Two details are notable. First, the rough base of the maquette already appears to anticipate that of the marble. Second, the subtitle 'amulet' – meaning a talisman or charm – was one which Hepworth used in the preceding year for the small bronzes *Reclining Solitary Form (Amulet)* and *Upright Solitary Form (Amulet)* 1961.[7] In a way comparable to *Pierced Form (Amulet)*, they set the hole within a wider depression.

In her interview with Hodin, Hepworth listed a dozen marble works that she liked 'best'. Significantly, these included *Pierced Hemisphere* 1937 and *Head (Icon)* 1959, which she also cited in relation to *Pierced Form* 1963–4.[8] She told the Tate: 'As regards

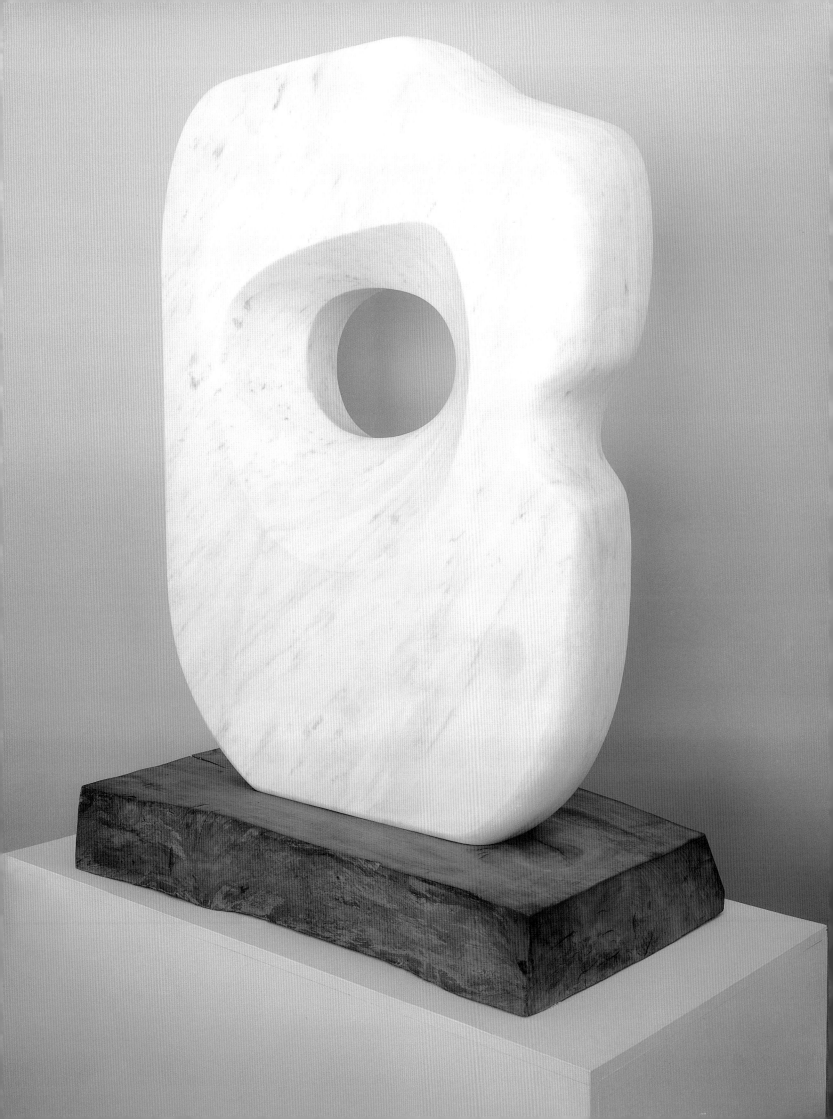

Pierced Form (Pentelicon) it is related formally I think with the earlier *Pierced Hemisphere* and I think related tactilely [sic] to the Heads 242 and 251 in the Hodin book, as you perceived.[9] The latter is *Head (Icon)* and the former is the alabaster *Head (Chios)* 1958.[10] Apart from *Pierced Hemisphere*, these are vertical blocks and, apart from *Head (Chios)*, they are of white marble. All these works are pierced, and the insistence on 'heads' suggests that the hole in *Pierced Form* might be read as an eye. However, what it shares with *Pierced Hemisphere* is a distance from any literal figurative reference. While it is characteristic of Hepworth's work of the early 1960s, it is significant that the sculptor gave *Pierced Form* 1963–4 to the Tate at the same time as one of her classic Constructive carvings of the 1930s, *Three Forms* 1935 (no.9 q.v.), was given by the collectors Marcus and Irene Brumwell with her encouragement. This was a further sign of the emphasis on continuity between early and recent production.

In broader terms, Hepworth's carvings were discussed – at least from the 1950s – as embodying a conjunction of two critical notions. The atmosphere of St Ives encouraged comparisons to the Mediterranean which were common in discussions of the art produced there. In Hepworth's particular case, it was combined with the classical echo of carving white marble that evoked the work of ancient Greece. *Pierced Form* is cut from Pentelicon marble quarried outside Athens. Pre-war critics – notably J.D. Bernal in relation to *Single Form (Eikon)* 1937–8 (no.12 q.v.) – had already drawn classical parallels for her work and this was taken up by Hodin. Remarking of his 1964 conversation with Hepworth, he wrote: 'We … spoke about the Mediterranean around which every idea, concept and form, art, myth and religion, philosophy and science of Europe was born, without which we could not exist even for an instant.'[11] The artist herself shared this view. She said of his comparison of St Ives to the Mediterranean: 'how right to start with the marble, to continue with light and to finish up with the sound of the whole, its music.'[12] In discussing the 'meaning of sculpture in our time', she drew attention – rather more guardedly – to a conceptual continuity:

Today when we are all conscious of the expanding universe, the forms experienced by the sculptor should express not only this consciousness but should, I feel, emphasize also the possibilities of new developments of the human spirit, so that it can affirm and continue life in its highest form. The story is still the same as that of the Greek or of any other culture.[13]

61 Two Figures (Menhirs) 1964

T00703 BH 361

Slate on wood base 82.5 × 63.8 × 32 (32½ × 25⅛ × 12⅝)

Purchased from the artist (Grant-in-Aid) 1964

Exhibited: Tate 1968 (144); *Sculpture for the Blind*, Tate Gallery, Nov.–Dec. 1976 (no number)

Literature: *Tate Gallery Report 1964–5*, 1966, p.41; 'Recent Museum Acquisitions: Sculpture and Drawings by Barbara Hepworth (The Tate Gallery)', *Burlington Magazine*, vol.108, no.761, Aug. 1966, p.426, repr. p.427, pl.61; Edwin Mullins, 'Barbara Hepworth', Hakone 1970, exh. cat., [p.32], repr. [p.18]; Bowness 1971, pp.8, 38, no.361, pl.99; Jenkins 1982, p.19, repr. in col. p.37; Penelope Curtis, *Modern British Sculpture from the Collection*, Tate Gallery Liverpool, 1988, p.54, repr.

Barbara Hepworth asserted on more than one occasion that 'there is no landscape without the figure'. Indeed, shortly after *Two Figures (Menhirs)* was acquired by the Tate Gallery, she noted this on a copy of the associated catalogue entry.[1] The title links the human presence and the landscape of megaliths, just as the sculpture suggests the interaction between two people.

Two Figures (Menhirs) is made of slate from the Delabole quarry in north Cornwall. The narrower angled slate with the vertical slot is appreciably thicker than the broader more symmetrical form stepped in front of it.[2] The artist told the Tate that 'the two forms were carved from the same piece'.[3] She also noted that the 'fossil leaf' prominent in the broader element 'only appeared after the final polishing'. However, her assistant Tommy Rowe, who worked on a number of slate sculptures, has recalled that such fossils 'ripped the teeth of the hacksaw' when the stone was cut and would, therefore, have been evident from the outset.[4] The darkened areas on the back of the other piece are natural to the stone, but made more apparent by the high polish. Both elements have sustained a number of minor scratches. In 1987 they developed a bloomed coating which was cleaned with a mild abrasive cream, they were then rinsed and wax-polished. Each form is fixed to the base by a pair of threaded steel rods. The wooden base has splits along the back and front edges.[5]

Delabole slate was the only locally available stone that Hepworth carved. There are a number of conflicting stories about how this came about, but most contrast it with a softer black Welsh slate salvaged from a billiard table. Hepworth's assistant Tom Pearce recalled that he had bought the billiard table at an auction, and sold one sheet of the slate bed to Denis Mitchell and the rest to Hepworth.[6] Although Pearce was uncertain if this was her first use of slate, Dicon Nance has recalled that Hepworth began making slate sculptures from a billiard table. This was subsequently used mainly for bases, as Delabole slate proved harder and less black.[7] The former County Architect H.C. Gilbert, who designed several buildings in St Ives in the 1950s and 1960s, has suggested that it was he who recommended Delabole slate to Hepworth on the basis of his experience of it as a finishing material.[8] He remarked that it was less friable than other slates, and that 'heart slate' could offer a substantial thickness of stone without stratification. In relation to *Two Figures (Menhirs)*, Hepworth herself told Alan Bowness: 'I found out that if they quarried very deeply in the slate quarry here at Delabole (in Cornwall) they could get a reasonable thickness for me, and a very fine quality … The slates from these deep beds are very beautiful.'[9] As she habitually carved orthodox materials, the use of building slate was a significant departure even if encouraged by its local availability.

What Edwin Mullins called 'the exquisitely graceful' *Two Figures (Menhirs)* 1964 was amongst the first slate sculptures.[10] The earliest seems to have been the wide pierced monolith *Carving (Mylor)* 1962–3; this was also one of the most substantial.[11] A number of other slate works featuring ranged uprights followed on a similar scale, these

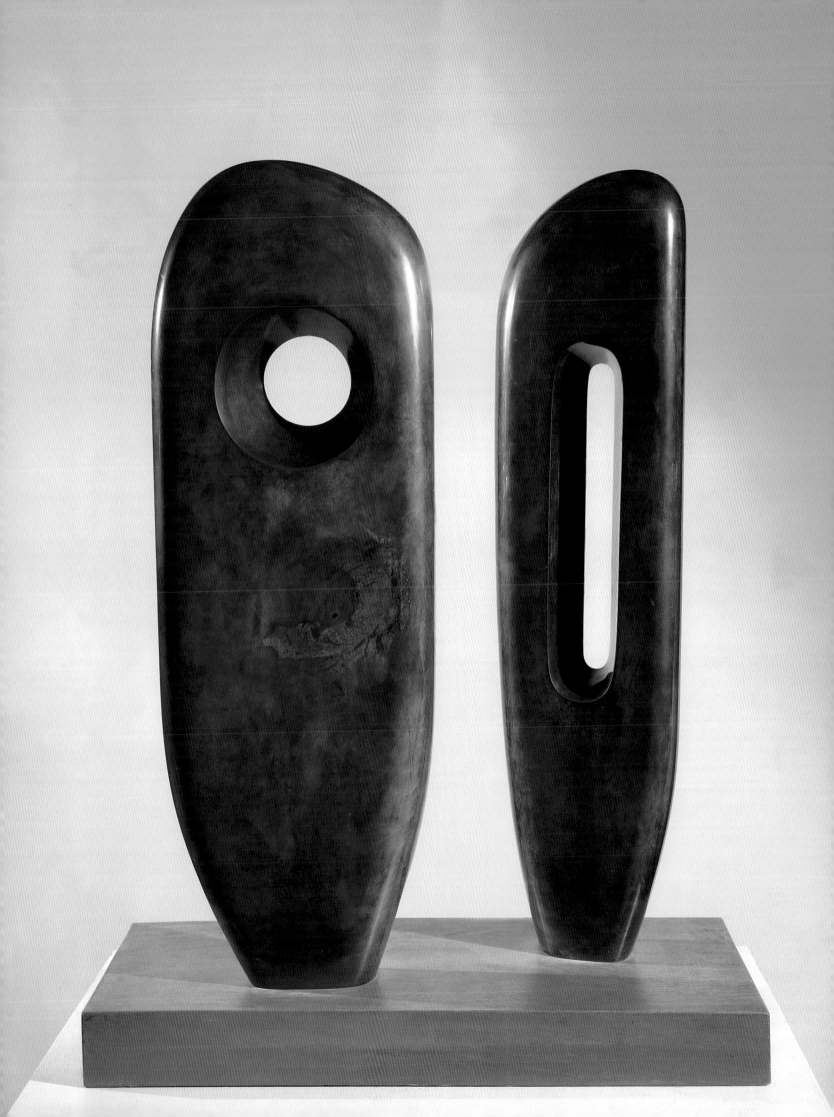

included the graduated *Three Standing Forms* 1964 and the crested *Two Figures* 1964 (BH 366).[12] The material tended to dictate the thin elongated form.

Alongside this material continuity, *Two Figures (Menhirs)* translated into slate the long-standing theme of the pair of abstracted forms which may be traced back to the 1930s. With the strung redwood carving *Two Figures* 1943 (BH 120), such forms were explicitly signalled as figurative.[13] From this general concern a sporadic series of works emerged bearing the subtitle 'Menhirs' and juxtaposing two upright forms. The first of these sculptures was *Two Figures (Menhirs)* 1954–5 (BH 197) which was carved in teak.[14] The sculptor commented that its elements 'are just two presences bound together by their nature in eternal relationship'.[15] They are distinguished by the circular holes in oval hollows cut into the left-hand element and vertical slots cut into that on the right; these features would reappear in the series. A decade after this work – and in the same year as the Tate's sculpture – Hepworth reworked this in *Menhirs 1964* (BH 340); it maintained the distinction between the two elements even as the piercing was reduced to circles.[16] A refinement of this is found in the contrasting apertures of the Tate's *Two Figures (Menhirs)*. The series was continued in painted teak in the following year, with *Two Personages (Menhirs)* 1965 (BH 377).[17]

It is not clear what connection Hepworth envisaged between the teak of these associated works and the consistent reference to the standing stones. She had been interested in the sculptural and environmental effect of such Neolithic stones even before moving to St Ives, as photographs of Stonehenge were reproduced after her article in *Circle*.[18] Menhirs are found across West Penwith and, though granite, may be linked to the use of local slate for *Two Figures (Menhirs)* 1964. Penelope Curtis has stated that the 'title refers to the ancient monuments in Cornwall' and has seen the sculpture as evidence of 'an increasing sense of ritual magic in [Hepworth's] later sculpture'.[19] She also speculated upon the similarity to the elements of *Group I (concourse)* 1951 (no.27 q.v.), suggesting that Hepworth's perception that the posture of figures responded to architecture also pertained in this pairing. Certainly, the *Menhirs* series as a whole appears to have embodied the sculptor's concern with the timeless persistence of the figure within the landscape; as Hepworth commented: 'Any standing stone in the hills here is a figure.'[20] At the same time, the paired uprights of the sculptures reflect her desire to express the harmonious interaction of two individuals, seen most explicitly in her two-part monumental carving for the Festival of Britain, *Contrapuntal Forms* 1950-1 (fig.51).

62 Hollow Form with White 1965

T00960 BH 384

Elm 134.5 × 58.5 × 46.5 (53 × 23 × 18¼)
on lacquered wood base 7.7 × 63.5 × 63.5 (3 × 25 × 25)

Presented by the artist 1967

Exhibited: Gimpel Fils 1966 (10); *Henry Moore to Gilbert and George: Modern British Art from the Tate Gallery*, Palais des Beaux Arts, Brussels, Sept.–Nov. 1973 (51, repr. in col. p.63)

Literature: *Tate Gallery Report 1967–8*, 1968, p.63; Bowness 1971, p.40, no.384, pl.126

*H*ollow Form with White is typical of Barbara Hepworth's work in several respects. The hollowed-out oval was one of the most characteristic forms of her sculpture. In carving, the artist often liked to remove as little from a piece of wood as possible and this work was made with such an economy of means. The sculpture is essentially a large log of elm with the ends rounded and pierced across the grain in three directions. The heart of the wood was removed to form the central cavity. Hepworth's use of elm relates to the size of the sculpture as, before the outbreak of Dutch Elm Disease in Britain in the 1970s, it was the largest indigenous wood available to the sculptor, growing to a diameter of up to eight feet. The broad grain that is a striking feature of *Hollow Form with White* results from the timber's rapid growth and makes it especially suitable for large pieces.

In Hepworth's practice the hollowing out of the timber often had a practical as well as an aesthetic purpose, as it helps the wood to dry out more quickly and evenly and so minimises the risk of its splitting. Despite this, the sculpture has sustained numerous sizeable splits – up to 7 mm (1/4 in) wide – that radiate from the core: there are eight from the top, seven or eight from the bottom and at least one extends the full length of the block. These, along with a knot-hole near the the top, were filled with appropriately grained timber, probably retained by the artist for the purpose. Some fills may have been made in the studio, others were certainly done after the work was acquired by the Tate. In 1969 Hepworth enquired of the gallery's director, 'how is the Hollow Form with White elm wearing since Dicon Nance repaired it for you?'[1] The problem of the splitting may have been compounded by the painting of the interior. Nance, Hepworth's assistant and a wood expert, has explained that paint keeps the wood from drying out, effectively prolonging the seasoning process and so increasing the chance of splitting.[2]

Hollow Form with White was the last of a range of sculptures presented by the artist to the Tate Gallery in 1967. These included *Figure of a Woman* 1929, *Oval Sculpture* 1943, *Landscape Sculpture* 1944, *Orpheus* 1956, *Cantate Domino* and *Sea Form (Porthmeor)* 1958, *Image II* 1960 and the bronze of *Maquette for Three Forms in Echelon* 1961. The selection appears to have been consciously chosen to cover the span of Hepworth's career to fill what were seen by the artist and the director, Norman Reid, as gaps in the gallery's holdings. A similar group of works had been acquired in 1964.

In 1966 a bronze was cast from *Hollow Form with White* in an edition of six with a green patina substituted for the white paint of the interior. It was given the title *Elegy III*, relating it to two wood carvings of the 1940s, *Elegy* 1945 and *Elegy II* 1946.[3] Both of these were pierced oval sculptures and the second was carved in elm. In the recovery of the earlier title one might see a melancholic reiteration in 1966 of Hepworth's belief in the affirmation of abstract form in contrast to the destruction of war. The carving of wooden sculptures with the intention of casting them almost immediately was a phenomenon of the 1960s and is also illustrated by the bronze *Vertical Form (St Ives)* 1968/1969 (no.66 q.v.), which was cast in 1969.

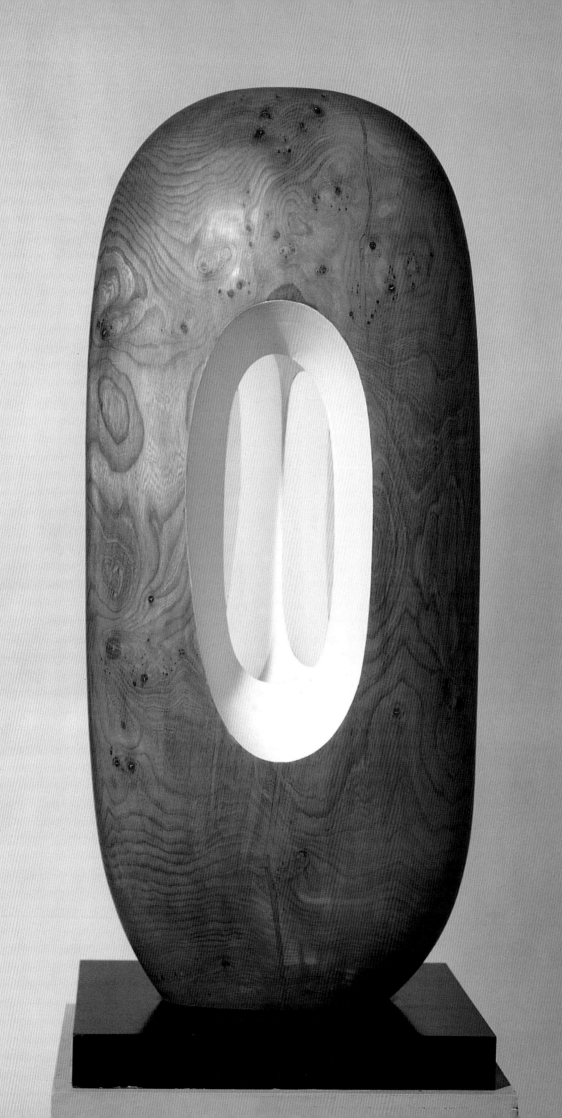

63 River Form 1965, cast 1973

L00939 BH 568; cast 0/3

Bronze 79 × 193 × 85 (31⅛× 76 × 33½)
on bronze base 9 × 114.2 × 69 (3½ × 45 × 27⅛)

Cast inscription on back of base 'Barbara Hepworth 0/3 |
CAST 1973' t.r. and cast foundry mark 'Morris | Singer |
FOUNDERS | LONDON' t.l.

*On loan from the artist's estate to the Barbara Hepworth
Museum, St Ives*

*Displayed in the artist's garden, Barbara Hepworth
Museum, St Ives*

Exhibited: New York 1974 (4†, col. repr. p. 20); Zurich 1975
(21†, repr. p.45); Edinburgh 1976 (14†, repr.); Marlborough
1979 (57†, col. repr. p.47); *Masters of the 19th and 20th
Centuries*, Marlborough Gallery, New York, May–June 1983
(19†, col. repr.)

Literature: *St. Ives: Twenty Five Years of Painting, Sculpture
and Pottery*, exh. cat., Tate Gallery, 1985, p.193

In the mid-1960s, Barbara Hepworth reverted to a smoothed and simplified form for the carvings emerging from her workshop. They had the effect of announcing the quality of the material and the integrity of the block (concerns expressed in the 1920s and 1940s), while moving away from the contrast between polished and gouged surfaces favoured for guarea pieces such as *Pierced Form (Epidauros)* 1960 (no.53 q.v.). At the same time, the piercing and hollowing characteristic of her style allowed the integration of inside and outside, object and environment. All these factors were demonstrated in the original American walnut carving *River Form* 1965 and in the contemporary elm sculptures *Hollow Form with White* 1965 (no.62 q.v.) and *Oval Form with Strings and Colour* 1965.[1] Casts of all three were made – the latter as *Spring* (no.64 q.v.) – with the pronounced graining of the fine exteriors translated into bronze with a smooth dark finish. According to David Brown and Ann Jones, the walnut *River Form* began to split shortly after completion.[2] This deterioration may have encouraged the edition (3 + 0) a decade later; the copy in the artist's garden is 0/3, another cast (1/3) is on loan from the artist's estate to Kensington Town Hall in west London.

Over the decade to 1965, Hepworth had developed a heavily textured surface for her sculptures by which she carried the carving of the plaster into the bronze. She differentiated casts of carvings from those derived from plasters by working the metal to follow the quality of the wood. The bronze of *River Form* has a sleek exterior and an equally smooth interior; Morris Singer Foundry confirmed the sculptor's stipulations on finish as a 'nice teak colour patina on the outside, blue in the large carved out area and satin in the three holes'.[3] The perceptible narrowing towards the right reflects the form of the original tree trunk, which Hepworth usually liked to maintain in the carving. The sculpture's position in the artist's garden has allowed weathering and the effect of bird lime which has caused the green discolouration of the top (despite regular waxing). A substantial amount of rainwater collects in the interior which, though enhancing the sculpture with reflections, may be associated with the blue discoloration of the faults at either end. The three holes are quite burnished and splay towards the exterior from spiralled openings, two turning clockwise and one (on the right) anticlockwise. They do not serve as drains, but their form suggests the eddying effect of water appropriate to the title. Although Hepworth sometimes made reference to natural phenomena, the unspecific title is rather isolated in her oeuvre.

The enclosure of an open interior was a characteristic form which Hepworth had favoured since the 1930s. It has been associated with psychoanalytic theories of the sheltering maternal figure, especially with the addition of an enclosed form such as found in *Sphere with Inner Form* 1963 (no.58 q.v.). Dore Ashton observed that the works 'edge away from specificity, reminding us that analogy and metamorphosis are more important to Hepworth, who generally seeks the rhyming scheme of the universe in much the way of one of her early mentors, Brancusi'.[4] The formal purity of *River Form* may be seen as an example of this continuity with pre-war concerns.

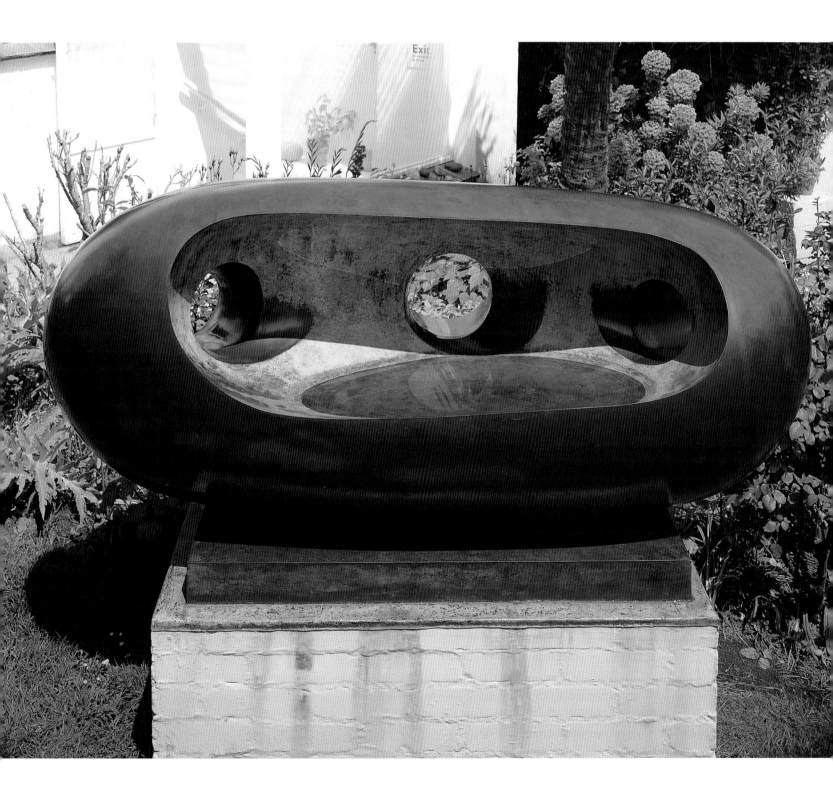

64 Spring 1965, cast 1966

L00936 BH 430; cast 0/6

Bronze with strings 75.5 × 57 × 52 (29¾ × 22⁷⁄₁₆ × 20½)
on bronze base 7.6 × 50.5 × 50.5 (3 × 19¾ × 19¾)

Cast inscription on top of base 'Barbara Hepworth 1966';
cast numerals '0/6' front left; cast foundry mark on back
of base 'Morris | Singer | FOUNDERS | LONDON' t.l.

*On loan from the artist's estate to the Barbara Hepworth
Museum, St Ives*

*Displayed in the artist's garden, Barbara Hepworth
Museum, St Ives*

Exhibited: *Autumn Exhibition*, Penwith Society of Arts,
St Ives, Aug.–Sept. 1967 (sculpture 2‡); Tate 1968 (170‡);
L'Art Vivant 1965–68, Fondation Maeght, Saint-Paul de
Vence, April–June 1968 (114); *Sculpture Exhibition: City of
London Festival*, Daily Mirror, 33 Holborn, July 1968 (no
number); ?Syon Park, summer 1968 (cat. not traced);
?Penwith Society of Arts, St Ives, 1968 (not in spring,
summer or autumn cats.); *Conferment* 1968 (no cat., St Ives
parish churchyard); New York 1969 (6, repr. [p.14]); Hakone
1970 (22‡, repr.); AC tour 1970–1 (13†, repr.); Marlborough
1970 (7†, repr. p.17); Zurich 1975 (3, repr. p.17); Edinburgh
1976 (6†, repr.); Bretton Hall 1980 (16, repr. p.23); *British
Artists in Italy 1920–80: Rome and Abbey Scholars*, Herbert
Read Gallery, Canterbury College of Art, Sept.–Oct. 1985
and tour (32‡, repr. p.46)

Literature: Bowness 1971, p.44, no.430, repr. pls.10 (in col.),
159

Barbara Hepworth cast *Spring* 1966 from the original elm carving of the previous year: *Oval Form with Strings and Colour* 1965.[1] Just as with the walnut original of *River Form* 1965 (no.63 q.v.) and the Tate's *Hollow Form with White* 1965 (no.62 q.v.) in elm, the carving displays on its smooth outer surface the broad graining of the wood. All have the tapering form of the original bole of wood. *Oval Form with Strings and Colour* has concave hollows cut from front and back which intersected at the heart of the sculpture to create an oval opening; threads crossed from the outer to the inner ovals. As well as expressing Hepworth's perennial exploration of the duality of interior and exterior, the carving out reduced the mass of drying wood and therefore the risk of cracking. As the title indicated, the interior of *Oval Form with Strings and Colour* was painted (blue), a practice initiated with such carvings as *Pelagos* 1946 (no.20 q.v.).

The forms were carried over to the bronze *Spring*, although some effects were modified in the process. The grained exterior of the wood became the smooth surface with mottled brown patination; the green now evident on the top being caused by weathering and bird lime. The painted interior was rendered as blue-green patination. It is likely that these modifications, which are found in the similar transfer of *Hollow Form with White*, were anticipated at the time of carving as the cast followed almost immediately. The forms did not change; at 53 × 39 cm (20 3/4 × 15 3/8 in) the height of the larger aperture is close to the depth of the whole sculpture; the smaller opening is 47.5 × 30 cm (18 3/4 × 11 13/15 in). The stringing – in two crossed-over series – also follows the original. From the top right of the front outer rim, it passes through the left edge of the central oval to cross to the left outer rim of the back; there, in order to make the return, it is threaded along the rim – in the same way as found on *Pelagos*. The second series of strings traces a reciprocal course from opposite sides, so that the two groups cross as they converge towards the core of the sculpture. Not surprisingly, the threads have bleached and sagged as a result of being displayed outdoors. Of the edition (6 + 0), the artist's copy was retained for display in the studio garden. Another entered the Arts Council collection (1/6) and that shown in the artist's 1970 exhibition in Japan (4/6) was purchased by the Museum of Modern Art, Kyoto.

In conjunction with the title, the ovoid form of *Spring* suggests Hepworth's long-standing concerns with the cycles of nature and the promise of rebirth. She shared these themes with Brancusi, whose studio had so impressed her in 1933 and whose work drew upon the egg's formal purity and conceptual complexity. In Hepworth's lost early work *Figure (Mother and Child)* 1933 (fig.21), the sheltered child had been ovoid in shape. In 1946, at a time when she first exhibited the carved version of *Oval Sculpture* 1943 (no.16 q.v.), she recognised in her early work the 'simple realistic oval forms of the human head or of a bird'.[2] *Oval Form with Strings and Colour* continued this passage from realism to abstract form. With its bronze version, *Spring*, and a similar work in Swedish green marble, *Oval with Black and White* 1965, the ovoid was simultaneously explored in three different materials.[3]

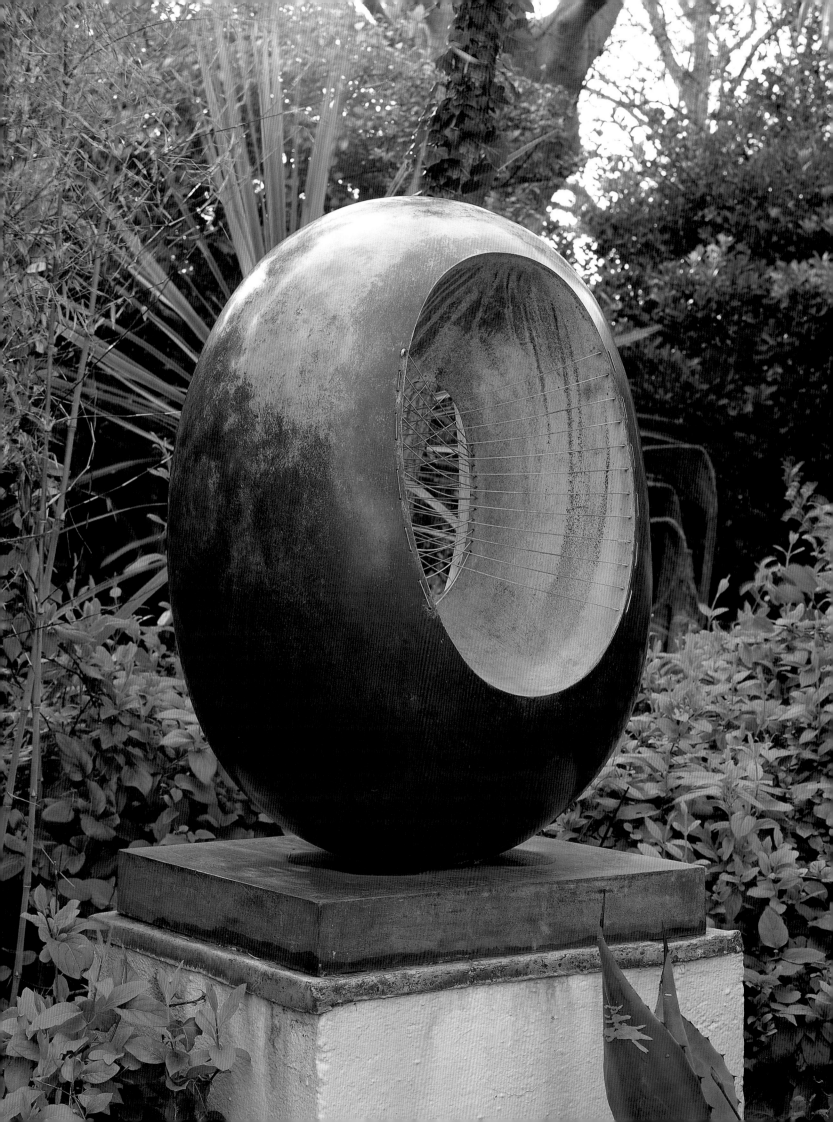

65 Four-Square (Walk Through) 1966

LOO937 BH 433; cast 0/3

Bronze on bronze base 429 × 199 × 229.5
(168⅞ × 78⅜ × 90⅜)

Cast inscription on top of base 'Barbara Hepworth | 1966'
and '0/3' front right; cast foundry mark front of base 'Morris |
Singer | FOUNDERS | LONDON' t.l.

*On loan from the artist's estate to the Barbara Hepworth
Museum, St Ives*

*Displayed in the artist's garden, Barbara Hepworth
Museum, St Ives*

Exhibited: Tate 1968 (172, repr. in col. p.32); *Exhibition of
British Sculpture*, Coventry Cathedral, June–Aug. 1968
(19, as *Four Square walkthrough*); *Masters of Modern
Sculpture*, Marlborough Gallery, New York, May–June 1978
(35, repr.); Marlborough 1979 (21†, repr. p.33)

Literature: Edwin Mullins, 'Scale and Monumentality: Notes
and Conversations on the Recent Work of Barbara
Hepworth', *Sculpture International*, no.4, 1967, p.20 (repr.
under construction); Norbert Lynton, 'Hepworth at the Tate',
Guardian, 3 April 1968, p.12; Edwin Mullins, 'Barbara
Hepworth', Hakone 1970, exh. cat., unpag., repr.; Bowness
1971, pp.12–13, 44, no.433, repr. pls.160–1; Festing 1995,
pp.278–9; Derek Pullen and Sandra Deighton, 'Barbara
Hepworth: Conserving a Lifetime's Work' in Jackie Heuman
(ed.), *From Marble to Chocolate: The Conservation of
Modern Sculpture*, 1995, pp.142–3, repr. p.142 (col.); Curtis
1998, p.46, fig.60 (col.)

Reproduced: *Pictorial Autobiography* 1970/1978, 2nd ed.,
1978, p.128

'Barbara Hepworth's environmental sculpture,' Edwin Mullins observed in 1970, 'is never impersonal, or merely architectural in function. It is … conceived as something the spectator may inhabit … so that he may feel the sculpture to be an actual extension of himself.'[1] *Four-Square (Walk Through)* 1966 is the most extreme example of this approach in Hepworth's work, inviting unprecedented interaction. As the title indicates, the sculpture is there to be walked on and passed through in a way which is unmatched even with the otherwise related *Three Obliques (Walk In)* 1968 and *Two Forms (Divided Circle)* 1969 (no.69 q.v.).[2] This represents a notable departure in the mid-1960s, which the sculptor herself saw as relating to the confirmation of her international reputation.

In hindsight, Hepworth found roots for the achievement of monumental works in pre-war carvings such as *Monumental Stela* 1936 (fig.29) and *Project (Monument to the Spanish War)* 1938–9 (fig.8). These abstractions were prominent points of reference in the second volume of the catalogue raisonné but they had been exceptional, as physical and financial conditions meant that afterwards Hepworth 'felt inhibited for a very long time over the scale on which I could work'.[3] Around the time of her Venice Biennale exhibition of 1950, more figurative elements emerged in large works such as *Bicentric Form* 1949 (no.25 q.v.) and with *Contrapuntal Forms* 1950–1 (fig.51) for the Festival of Britain, 1951. However, the scale was limited by the physical restrictions of carving stone, and it was only when Hepworth added bronze to her repertoire in 1956 that the possibility of work on a grand scale opened up. The impact was felt in ensuing public commissions, such as *Meridian* 1958–60 (fig.69), and the United Nations' *Single Form* 1961–4 (fig.6). Other large-scale works of the early 1960s, notably *Squares with Two Circles* 1963 (no.59 q.v.), anticipated *Four-Square (Walk Through)* in the adoption of geometrical forms through the piercing of rectangular slabs.

The inclination towards monumentality in Hepworth's work may be seen in the context of an increased demand for publicly sited art and a widespread belief in the importance of British sculpture; in 1967 one critic could refer to 'Britain, birthplace of modern sculpture'.[4] Hepworth secured a number of public commissions, but was also aware of finding herself between the dominant personality of Henry Moore and the generation of the 'geometry of fear'. Although she admired the work of Reg Butler, Lynn Chadwick and others, she did not respond to their use of welded iron. Instead, some of her concerns with the interaction of sculpture and its environment related to those of the Constructionists Victor Pasmore and Kenneth and Mary Martin. In the 1960s, others were using sectional steel from construction sites – enlivened with bright colours – to introduce a new abstract quality to sculpture. Hepworth's former assistant Brian Wall was experimenting with these practices. However different in effect, her *Four-Square (Walk Through)* 1966 may be compared with this new tendency typified by Anthony Caro's *Early One Morning* 1962 or the American David Smith's *Cubi XXVII* 1965, whose work Hepworth must have known and which received renewed attention following his

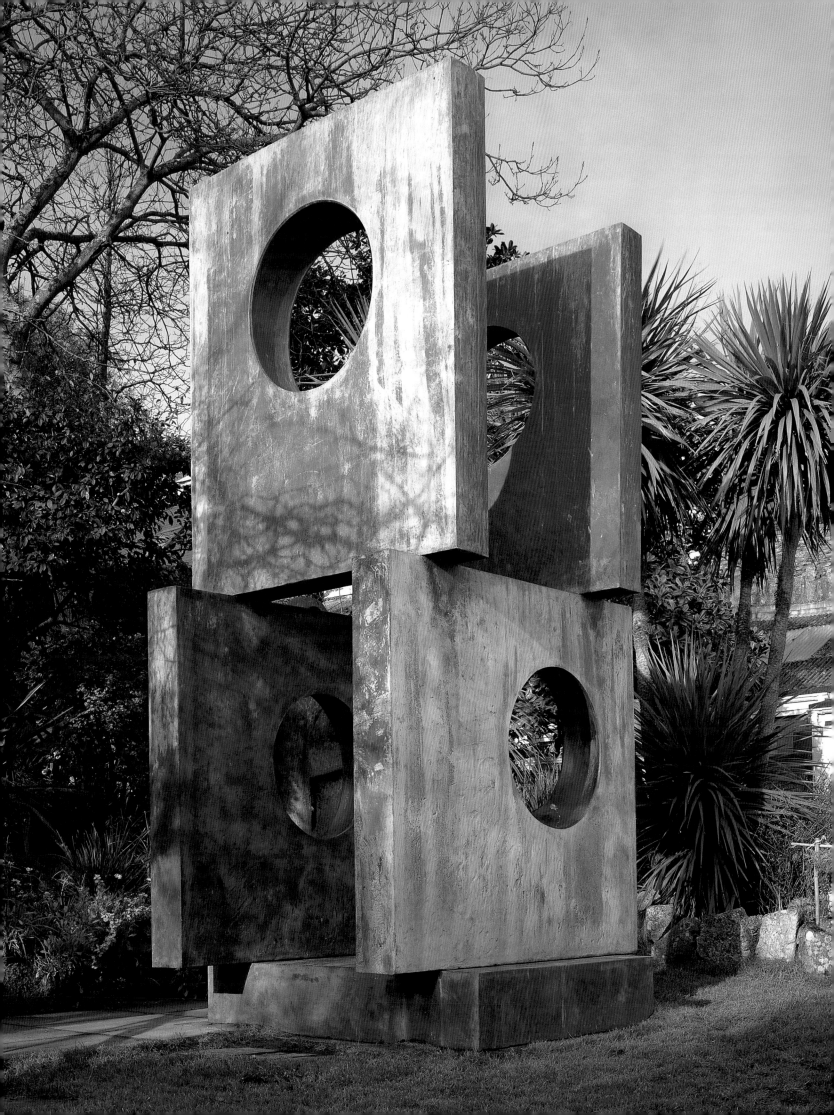

untimely death in 1965.[5] In particular, all sought to define space on an architectural scale through rectilinear abstract elements.

Although Mullins reported that Hepworth 'never works from a maquette: "you can't blow things up"', at least three different small-scale works anticipate *Four-Square (Walk Through)*.[6] These are the slate works, *Maquette for Large Sculpture: Four-Square (Four Circles)* 1966 (BH 407) and *Four-Square (Four Circles)* 1966 (BH 416) and the bronze cast of the latter, *Four-Square (Four Circles)* 1966 (BH 428).[7] The size of the slate maquettes – the first is 28 cm (11 in) and the second 60.5 cm (24 in) which Mullins called 'table-sized' – suggests a process of scaling-up.[8] Both of the maquettes establish some of the fundamental relationships. This included the rectangular form of the elements, the slippage between those of each pair – so that they project over the base to different extents – and the notable difference in height in the upper pair.

If some details were anticipated at the maquette stage, the making of *Four-Square (Walk Through)* was a considerable logistical undertaking requiring it to be reconceived on the large scale. The sculpture was made in plaster applied to an armature of angled and expanded aluminium, as demonstrated by a photograph of it in progress (fig.75). A slight convexity of the broad planes – perhaps resulting from the weight of plaster on the aluminium – softened the geometry. Each element must have been cast separately at the foundry when the edition (3 + 0) was made. The artist retained 0/3, which was erected in the place of a rose bed in her studio garden; another cast (2/3) was lent to Churchill College, Cambridge.

The metal armature meant that the size of the elements was determined in advance, with slight variations resulting from the thickness of the plaster applied on top. Although the title might suggest otherwise, there are five elements none of which is square; indeed, uniformity is only suggested, as each element is individual. The overlaying of rectangles of contrasting orientation begins with the base, which is broader across the entrance although the interior area is rectangular in the direction of passage.[9] The sculpture may be entered from either end; if approached from the artist's studio, it is bridged by the shorter of the upper elements (to the right of the photograph). The lower uprights are different widths and thicknesses.[10] That on the left projects forward of the base by 21.2 cm (8⅜ in); that on the right only projects by 15.5 cm (6⅛ in) but extends further beyond. This establishes the lower rectangles in the 'echelon' displacement favoured by the artist since the 1930s, such as *Discs in Echelon* 1935 (no.10 q.v.). This formation is also true of the upper tier.[11] The low element is a horizontal rectangle which overhangs to the left by 31 cm (12³⁄₁₆ in) but not at all to the right. The higher element is vertical, overhanging slightly to left and right (21 and 11.8 cm; 8¼ and 7⅓ in respectively). The recurrence of measurements close to two metres – approximately six and a half feet – suggests a relationship with a notional idea of the reach of a man of average height.

The holes served the vital purpose of alleviating this architectural passage. As well as articulating the light and the space, they afforded further interaction for the visitor; Hepworth herself posed for a photograph leaning in one of the holes.[12] These must also have been determined at the armature stage as they are angled and tapered rather than simple cylinders. That in the left-hand element, for example, is a horizontal oval on the outside and diminishes to an interior circle.[13] It is off-set with the diminution noticeably funnelling the view towards one end of the sculpture.[14] A similar effect is achieved in its companion in the right element. There the outer opening is a vertical oval diminishing towards the inside face.[15] It is set towards the top and off-centre,[16] and the hole is funnelled towards the same end.

The working of the plaster surface allowed Hepworth to distinguish between the finish of the different elements. Thus the sides of the base have finely grained swirls made, perhaps, by a broad brush working the wet plaster, while its top face is more deeply scarred with long sweeps of a toothed tool providing the grip appropriate for

walking on. The upright elements contrast with this scouring and are closer to the surfaces achieved on Hepworth's other bronzes through the use of spatulas for applying plaster and then by carving back. However, the inner faces of the openings are smoothly worked; they are introduced by a bevel and are concave in section. The patination enhanced these distinct areas. The green of the major surfaces has been particularly exaggerated by weathering on the outside of the right element. The interiors to the openings are now reddish, and it has been suggested that these areas were originally highly polished and lacquered to maintain the sheen.[17] This proposal would seem to be substantiated by earlier photographs and the discovery in Hepworth's studio of a jar of dried yellow lacquer labelled 'Four-square (Walk through)'.[18] A similar treatment is found on *Two Forms (Divided Circle)* (no.69 q.v.).

All of these physical aspects of the sculpture related to Hepworth's anticipation of the response of the viewer. She agreed with Alan Bowness that she wanted 'people to feel the apertures' of her work, and went on to acknowledge in relation to *Four-Square (Walk Through)*: 'I wanted to involve people, make them reach to the surfaces and the size, finding out which spiral goes which way, realising the differences between the parts.'[19] In 1967, shortly after the completion of the work, Mullins reported:

fig.75
Preparatory armature for *Four-Square (Walk-Through)*, 1966

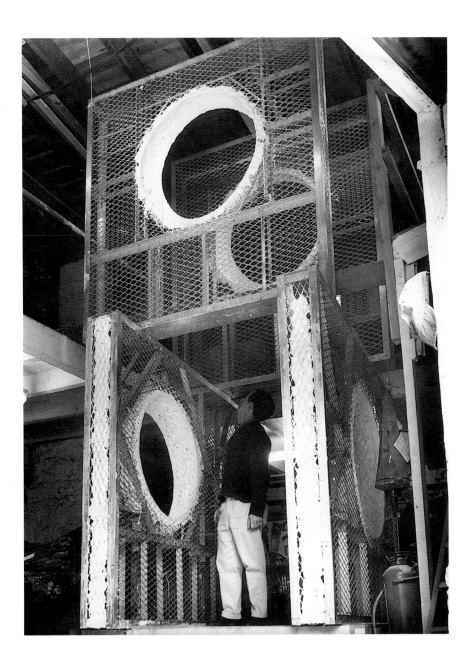

This piece emphasises her insistence that the whole body must be engaged in response to sculpture. 'This engagement helps to orientate us – give us an image of security and a sense of architecture.' On another occasion [Hepworth said] 'You can't look at sculpture if you don't move, experience it from all vantage-points, see how the light enters it and changes the emphasis.'[20]

Three years later, the same author observed that Hepworth's monumental sculpture 'is essentially humanist and intuitive, and indisputably to do with the human body. The organic principle has remained uppermost.'[21] Seeking to reconcile this with the recent rectilinear works, he added that under close inspection 'any apparent geometrical precision really is an illusion: each straight line is really a curve; no two rectangles are quite alike.'[22] Certainly the measurements suggest that forms were established by eye for *Four-Square (Walk Through)*, as do the 'barely noticeable swellings of their sides.'[23]

If Hepworth's unique invitation to 'walk through' one of her sculptures captured both a sense of the human scale and a wider 'humanism', she admitted that the monumentality of *Four-Square (Walk Through)* and associated works was born of a confrontation with mortality. Bowness raised the question of her simultaneous fight against cancer in 1965–6. Referring once again to the pre-war sculptures, she acknowledged: 'Yes of course it was [related]. It was the same in 1938. If war is imminent, or you're very ill or something's threatening, you want to put something down for big work while you can. I was in an absolute fever of ideas, without much hope of fulfilment.'[24] This conjunction of monumentality and mortality was more explicit in the contemporary *Construction (Crucifixion)* 1966 (fig.9), a work which Bowness called 'an unexpected development'. In reply, Hepworth related it to her drawings and added 'I had been very ill, and I wanted to do it.'[25]

Hepworth's use of bronze for *Four-Square (Walk Through)* was characteristic, and massive geometrical slabs had already been used for *Squares with Two Circles* 1963 (no.59 q.v.). In form, both looked back to the pre-war *Monumental Stela* 1936. Nevertheless, the 1960s' works were felt by Ben Nicholson to be uncomfortably close to his own reliefs, and Margaret Gardiner recalled unreasonable complaints of plagiarism.[26] During this period, he had also ventured on to a monumental scale with his temporary *Wall* for the 1964 Kassel Documenta.[27] He may have expressed his views directly to his ex-wife, as Hepworth wrote to him in 1966: 'My small squares which you do not like so much are basically ideas for very large works to go on a hillside – and to walk through. Quite a different idea – to see through to the sky, night and day.'[28] This defence alights on the crucial difference between the two monumental schemes. Where Nicholson's 1964 *Wall* enlarged the play of his layered reliefs and was protected by a pool, *Four-Square (Walk Through)* welcomed the participation of the visitor, to move through and touch, and to use its prospects to frame nature and the outside world. Space was to be experienced in a way which, curiously, Hepworth never explored again in quite the same terms.

66 Vertical Form (St Ives) 1968, cast 1969

T03150 BH 495; cast 0/9

Bronze 47 × 25.7 × 10 (18½ × 10 × 4) on walnut base
6 × 27.3 × 16.5 (2⅜ × 10¾ × 6½) on secondary parana
pine base 4 × 29.7 × 18.8 (1⅝ × 11¾ × 7⅜)

Cast numerals on back '0/9' b.

*Presented by the executors of the artist's estate, in
accordance with her wishes, 1980*

*Displayed in the artist's studio, Barbara Hepworth Museum,
St Ives*

Exhibited: Marlborough 1970 (29‡, repr.); AC tour 1970–1
(16‡); Hakone 1970 (39‡, repr.); *Autumn Exhibition 1971*,
Penwith Gallery, St Ives, Sept.– Nov. 1971 (sculpture 4);
Winter Exhibition 1971, Penwith Gallery, St Ives, Dec.
1971–Feb. 1972 (sculpture 5)

Literature: Bowness 1971, p.50, no.495, repr.; *Tate Gallery
Acquisitions 1980–2*, 1984, p.123, repr.

The solid bronze *Vertical Form (St Ives)* 1969 was cast by the Morris Singer Foundry from Hepworth's *Vertical Wood Form* 1968 and issued in an edition of nine.[1] Its basic form is of a half ovoid, tapering towards the bottom, with its ends flattened off and two identical ovals scooped from its face. A circular hole through the left of these disturbs the otherwise striking symmetry of the piece. The bronze is unpatinated and highly polished in a manner seen in numerous works of the period; however, at least one other cast had a more burnished finish with the high polish reserved for the inner face of the hole.[1] Though some of her earliest bronzes had had a high polish, Hepworth's work became more lavish in the late 1960s. This new richness took a variety of forms: she painted metal in such works as *Construction (Crucifixion)* 1966 (fig.9); carved a range of coloured marbles, slate, alabaster and even quartz, for *Four Hemispheres* 1970; and used precious metals, notably in *Sun and Moon* 1966, for presentation to the Queen.[3] The artist considered a high polish in haptic as well as visual terms: in 1960 she told her dealer that she refused to lacquer such works *as Vertical Form* because they were 'made to be touched' and the lacquer, though invisible, could be felt.[4] This sensuous approach was well established and had been reflected in the emphasis she placed on the hand as a sensory tool. Perhaps as a result of its lack of a protective coating, the front surface of *Vertical Form* is covered with very fine vertical scratches resulting from past polishing with a slight abrasive; it has been waxed.[5] The sculpture is secured to the upper base with two steel bolts.

The original *Vertical Wood Form* is of lignum vitae, a very hard wood which had been especially favoured by the artist since the 1920s. It may be coupled with *Horizontal Form*, which is the same size, though horizontal, and has a similar shape.[6] Like the vertical piece, *Horizontal Form* was also carved from lignum and the pattern of the grain suggests that the two works may have been opposing halves of a single block. This would be consistent with the artist's preference, especially at that time, for an economy of means and materials. *Vertical Wood Form* and the bronze cast from it reflect the gradual simplification of some of Hepworth's sculpture during the 1960s. In particular, she abandoned the spiralling hole seen in such works as *Pierced Form (Epidauros)* 1960 (no.53 q.v.) for a simple cylindrical opening. This represents a significant shift in intention as the twisting internal space was vital to the play of light and shade that characterised sculptures such as *Corinthos* 1954–5 (no.32 q.v.). The more geometric piercing reduces such effects but unites the spaces in front of and behind the sculpture. It may be thought to echo the first piercing of the block by Hepworth and John Skeaping *c*.1930, which was seen at the time as giving the works 'air, intimacy and a sort of stereoscopic quality'.[7] At the same time, the formal simplification asserts the sculpture's monolithic quality. The artist related this aspect of her work to the image of a figure standing erect in, or rising up from, the landscape.

The use of a place name as the subtitle for *Vertical Form (St Ives)* was a device employed by Hepworth from the early 1950s and especially common in her later work. It

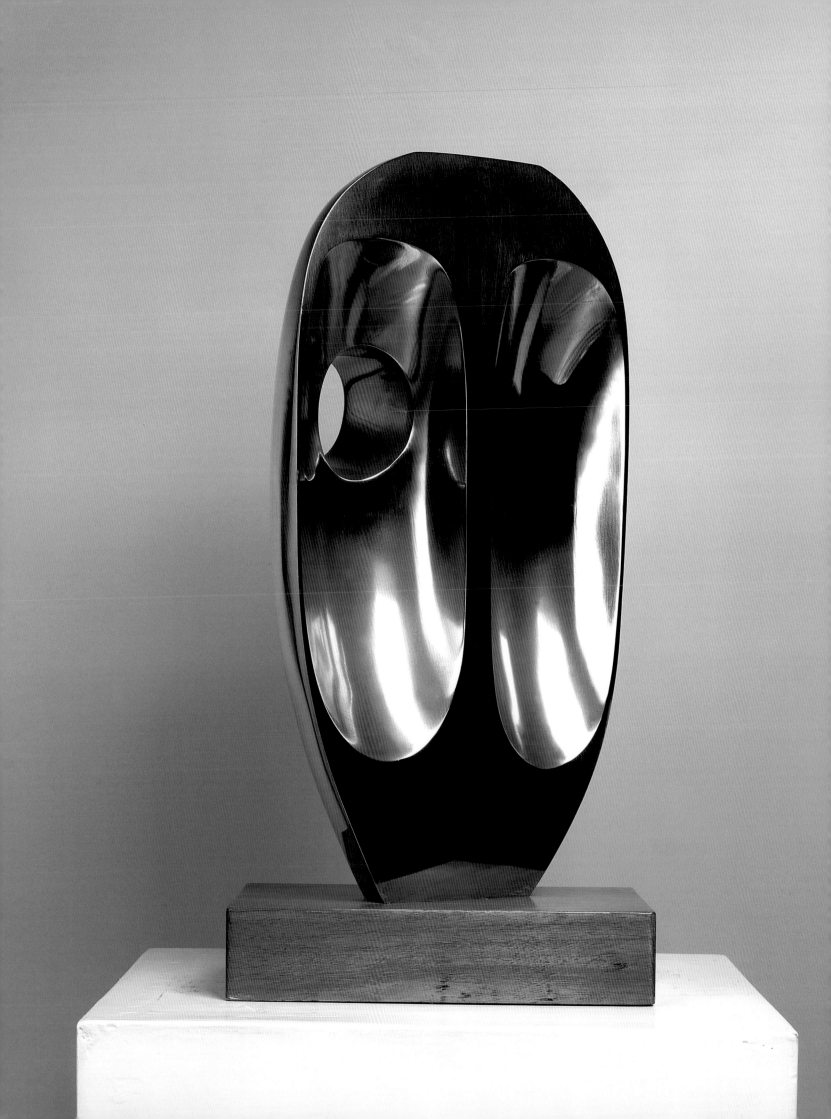

was a practice she shared with Ben Nicholson and, through their influence, it became common among younger artists in St Ives. The relationship between the individual pieces and the places is not clear, though in the case of *Curved Form (Trevalgan)* 1956 (no.34 q.v.) the artist related the form of the sculpture to her experience of that specific landscape. She had lived and worked in St Ives since August 1939 and by 1969 her reputation and that of the town were intimately linked. In 1968 the freedom of the Borough of St Ives was conferred on her and the potter Bernard Leach and she may have named the sculpture 'St Ives' to mark that honour. She recorded how 'deeply touched' she had been by the gesture, which she saw as 'two of St Ives' somewhat elderly children [being taken] into the fold'.[8] As the doyenne of the town's internationally famous community of artists, Hepworth had, for many years, been a major force in the Penwith Society of Arts in Cornwall and in the St Ives Trust, an architectural preservation group. Since the 1940s, an organic community and civic responsibility had been central to her theory of society and the artist's position within it. During the war, she told Herbert Read that artists should 'become a part of a human community instead of being a minority, decentralise and yet unify'.[9] She would reiterate this belief nearly thirty years later and demonstrate how she believed she had achieved such social integration in St Ives. 'It is hard to be aware of natural forces and processes in the city,' she wrote,

[but they] become very potent if one begins really living and putting down roots, and I am so fortunate here to have a garden and space and buildings where I can make such a mess and be tolerated. And so one isn't an oddity, but just another chap…St Ives has absolutely enraptured me, not merely for its beauty, but the naturalness of life…The sense of community is, I think, a very important factor in an artist's life.[10]

67 Six Forms (2 × 3) 1968

T03147 BH 467; cast 7/9

Bronze on bronze base 57.6 × 87.5 × 43.8 (22⅝ × 34¾ × 17¼)

Cast inscription on top face of base 'Barbara Hepworth
1968 7/9' left-hand rear corner and cast foundry mark on
back face 'Morris | Singer | FOUNDERS | LONDON' t.r.

*Presented by the executors of the artist's estate, in
accordance with her wishes, 1980*

*Displayed in the artist's garden, Barbara Hepworth
Museum, St Ives*

Exhibited: *Conferment* 1968 (no cat.‡, Guildhall); New York
1969 (9†, repr.); *A Selection of 20th Century British Art*,
Cunard–Marlborough London Gallery on board *Queen
Elizabeth II*, May 1969 (no number†, repr. in col.); *St Ives
Group*, Widcombe Manor, Bath, 1969 (no cat.†); *Winter
Exhibition 1969*, Penwith Gallery, St Ives, Oct.–Dec. 1969
(sculpture 4†); Marlborough 1970 (13†, repr.); Plymouth 1970
(51, repr.); Hakone 1970 (28‡, repr.); *Ten Sculptors – Two
Cathedrals*, The Cathedral Close, Winchester, July–Aug.
1970, The Cathedral Close, Salisbury, Aug.–Sept. (no
number‡); Austin 1971 (2†); Folkestone 1974 (2†, repr.); AC
Scottish tour 1978 (22†); Marlborough 1979 (32, repr. p.29);
Bretton Hall 1980 (17†, repr. p.27); Wales & Isle of Man
1982–3 (22‡); *Sculpture in a Country Park: An Outdoor
Exhibition in the Gardens of Margam*, Welsh Sculpture Trust,
Cardiff, June 1983–June 1984 (no number‡, repr.);
Retrospective 1994–5 (76‡, repr. p.113); New York 1996 (no
number‡, repr. in col. p.49)

Literature: Bowness 1971, p.47, no.467, pl.13 (col.);
Tate Gallery Acquisitions 1980–2, 1984, p.122, repr.

The eponymous six forms were hollow-cast, and the base sand-cast, in an edition of
nine by the Morris Singer Foundry, who by 1968 made all of Hepworth's bronzes.
The individual elements are bolted together. Indentations in their main faces result from
Hepworth's carving of the original plaster and are coloured with a green patina. The rest
of the work is a consistent dark bronze colour, though an early colour photograph
(perhaps of another cast) shows it to be generally more golden and the inside of the
hole in the bottom left-hand form was especially highly polished.[1] The artist instructed
the foundry that the finish 'should be very lightly touched by liver of salts, with a touch of
colour in texture, and a dark base'.[2] When acquired by the Tate, *Six Forms (2 × 3)* was
lacquered, presumably for outside display, some lacquer had been removed by abrasion
and, in common with the other works in the artist's garden, in 1983 the sculpture was
lacquered and wax-polished. That coating was partly removed in 1989 and the surface is
waxed annually.[3]

 Six Forms (2 × 3) is one of the multi-part sculptures that proliferated in Hepworth's
work in the late 1960s. Though the superimposition of elements was a feature of the
work of several sculptors in the late 1950s and early 1960s – William Turnbull for
example – Hepworth claimed that it had been a concern of hers since the 1920s. In
relation to her early comparable pieces, such as *Three Forms* 1935 (no.9 q.v.), the works
of the 1960s show a greater complexity in their individual forms and in their
arrangement. While their constituent elements tended to be either geometric or
biomorphic, in the case of *Six Forms* the irregularity makes the sculpture appear
especially fragmentary. A similar stacking up of elements was seen in larger, more
totemic pieces such as *Three Forms Vertical (Offering)* 1967 and culminated in the
figures of *The Family of Man* 1970 (fig.7).[4] By a comparison with her *Project (Monument
to the Spanish War)* 1938 (fig.8), she related her return to the theme in the 1960s to
contemporary anxieties over the Vietnam War.[5] According to Edwin Mullins, Hepworth
associated *Six Forms (2 × 3)* with the landscape. She described, he said, 'how the
angles at which the pieces are set, and the patterning on the bronze itself, were related
to the experience of a boat-trip in the Scilly Isles, off the coast of Cornwall, and in
particular the swirling motion of going round and round in the boat'.[6]

 The six, apparently randomly shaped, elements of this work are actually fragments of
a larger piece. The varying thicknesses and curvatures demonstrate that they can be
rearranged and reorientated to make a homogeneous sculpture similar, but not
identical, to the series of monolithic sculptures that culminated in *Single Form* 1961–4
for the United Nations in New York (fig.6). The two pieces in the middle go to form the
top third of the six-part monolith: the upper section being turned around to be the top
right-hand corner. The tapering bottom of the single form is made up from the top left-
and right-hand sections of *Six Forms*, both turned around and the latter inverted. The
bottom left-hand constituent of *Six Forms* must be turned around to provide the left-
hand side of the middle section of the unified object, while the orientation of that at

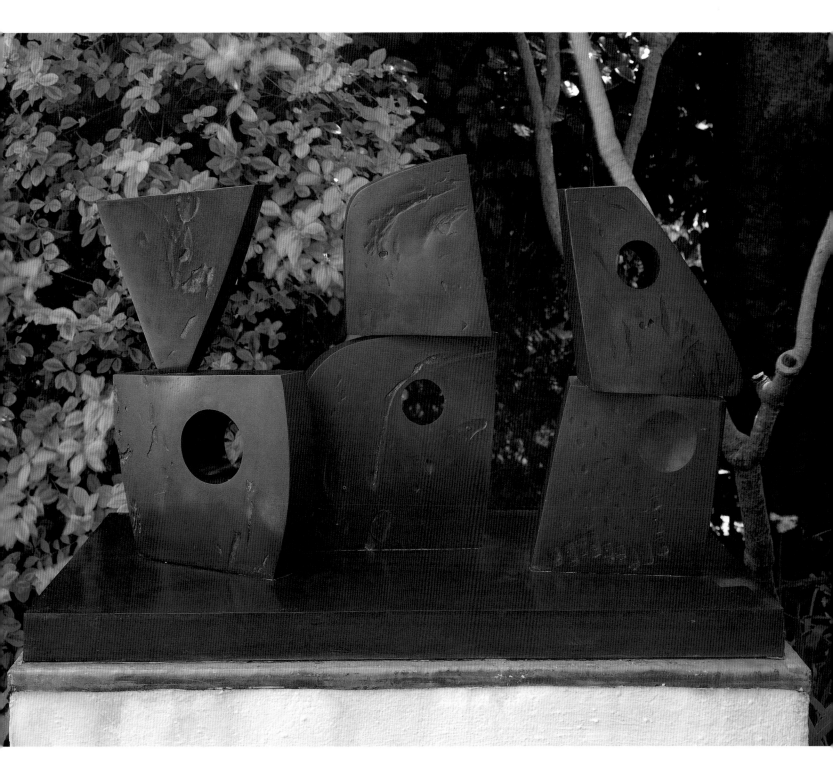

bottom right need not change. The holes and concave circle of *Six Forms* do not relate to the unitary work.

The resultant piece is close to, but not an exact scale model of, *Single Form*. Similarly, the six subdivisions echo in angle and disposition, but do not precisely replicate, the design of incised lines on the UN sculpture (fig.6). These lines mark the sections in which *Single Form* was cast and were incorporated into the design by the artist to facilitate its construction. One may relate *Six Forms (2 × 3)* to the different works in which Hepworth saw the evolution of *Single Form* and to the means of casting such a large work. By her account, in 1961 she made three works mindful of a vague scheme for a monument at the United Nations building in New York that she had discussed with the Secretary-General, Dag Hammarskjöld, a friend.[7] They were *Curved Form (Bryher II)*, *Single Form (Chûn Quoit)* and *Single Form (September)* (no.55 q.v.).[8] When it was finally suggested, following Hammarskjöld's death, that a piece might be commissioned by the UN as a memorial to him, she produced the ten-feet-high (312.5 cm) *Single Form (Memorial)* 1961–2 (fig.74). This was scaled up and adjusted slightly to produce the final twenty-one-feet (640 cm) *Single Form*. The various works show slight variations in form as well as the dramatic differences in scale. Of the different versions of the concept, *Single Form (September)* is closest to the object generated by the reassembly of *Six Forms*. As well as their proximity in size, both have a similarly shallow curve on the left-hand side, in contrast to the more rounded edge of the Battersea Park and New York sculptures.

The UN's *Single Form* was cast in seven pieces: six for the sculpture itself and a seventh as an underplate for insertion into the plinth. However, a blue-painted plaster model in the artist's estate of a similar work in three horizontal sections suggests that she considered different ways of subdividing the form (fig.76). The model incorporates a tubular metal framework which, if compared with a photograph of the plaster for *Single Form* under construction, appears to be a proposed armature for the larger work.[9] It is not clear whether the structure would have been for the plaster or the finished bronze, as the artist later explained that, like the plaster, the bronze was 'reinforced like a battleship, criss-crossed, to take all the strains'.[10] That the conception of the final sculpture in three horizontal sections persisted is suggested by a letter from Hepworth to the foundry shortly before the completion of the casting of the bronze. 'I feel more and more', she wrote, 'that I ought to see the whole thing assembled and not pass the pieces assembled horizontally in three parts.' In response, the founder reassured the artist: 'We are taking every precaution to ensure the form is exactly as your model.'[11] Though it is not clear whether he referred to a maquette or the full-scale plaster, it seems likely that, prior to working on the commission, Hepworth would have made a maquette for the project that anticipated its division into six pieces.

The constituent parts of *Six Forms (2 × 3)* could have originated from the fragmentation of such a model, and the discrepancies between it and the Hammarskjöld memorial might result from practical decisions made during the scaling-up and production processes. Such an imaginative reworking of an earlier piece would be consistent with Hepworth's economy of production and may be compared to the incorporation of earlier carvings in a bronze such as *Hollow Form with Inner Form* (no.68 q.v.) of the same year. That the object resulting from the arrangement of *Six Forms* is closest to *Single Form (September)*, the genesis of the memorial, would also support the notion that it originated at an early stage in the project.

fig.76
Two views of maquette for *Single Form* 1961-4, height 24 (9½), painted plaster and metal, Barbara Hepworth Estate

68 Hollow Form with Inner Form 1968

T03148 BH 469; cast 0/6

Bronze on bronze base 123 × 66 × 66 (48½ × 26 × 26)

Cast inscription on top of base 'Barbara Hepworth 1968 0/6'
back left and cast foundry mark on rear of base 'Morris |
Singer | FOUNDERS | LONDON' r.

*Presented by the executors of the artist's estate, in
accordance with her wishes, 1980*

*Displayed in the artist's garden, Barbara Hepworth
Museum, St Ives*

Exhibited: New York 1969 (21†, repr.); *10^e Biennale
Middelheim*, Middelheimpark, Antwerp, June–Oct. 1969
(69†, repr.); *First International Exhibition of Modern
Sculpture*, Hakone Open-Air Museum, Japan, Aug.–Oct.
1969 (13†, repr.); Marlborough 1970 (15†, repr.); Plymouth
1970 (52); Hakone 1970 (29‡, repr. in col.); *Ten Sculptors –
Two Cathedrals*, The Cathedral Close, Winchester,
July–Aug., The Cathedral Close, Salisbury, Aug.–Sept. 1970
(no. number†); Austin 1971 (4†); Edinburgh 1976 (8†, repr.);
Marlborough 1979 (31, repr. p.57); Bretton Hall 1980 (19†,
repr. p.24)

Literature: Bowness 1971, p.47, no.469, pls.179–80; *Tate
Gallery Acquisitions 1980–2*, 1984, pp.122–3, repr.; W.J.
Strachan, *Open Air Sculpture in Britain: A Comprehensive
Guide*, 1984, p.197, no.45, repr.

Reproduced: *Pictorial Autobiography* 1970/1978, p.124,
pl.336

The contrast of the interior and exterior of forms is one of the dominant themes of
Hepworth's sculpture. However, the problems she experienced in taking a mould
from her *Oval Sculpture* 1943 (no.16A & B q.v.) in 1958 had demonstrated that to pursue
the theme in cast works demanded different techniques to the tunnelling out of
carvings. Alternatives included the use of expanded aluminium to produce enfolding
forms like *Involute II* 1956 (no.35 q.v.) or the placing of one form inside another.

Cast in an edition of six (and an artist's copy), the bronze *Hollow Form with Inner
Form* results from the conjunction of two carvings. The internal element was cast from
the teak *Single Form* 1963–8 and the encircling larger element from *Hollow Form*
1963–8.[1] Given their separation in Alan Bowness's catalogue of Hepworth's work, it
seems likely that the expansive dating of these two derives from their association with
the bronze. The wooden *Hollow Form* has a very particular history. Dicon Nance has
recalled that it originated from a log of elm with dry rot in its middle which he was asked
to clean out until only solid wood remained.[2] Such was the extent of the infestation that
only the thin outer section survived. The date 1963–8 presumably joins the time of that
carving with the casting of the bronze. The determination of sculptural form by practical
demands was typical of Hepworth's carving, as seen in *Figure (Nanjizal)* 1958 (no.44 q.v.)
for example, but the fact that *Hollow Form* was destroyed unexhibited might suggest
that the artist did not consider it a work of art in its own right. It was reproduced in her
catalogue raisonné with the teak *Single Form* inside it, as if its status was simply as a
prototype for the bronze. In contrast, *Single Form*, though also unexhibited, was sold
and subsequently cast in bronze in an edition of 7 + 0 entitled *Single Form (Aloe)*.[3]

The origin of the bronze is revealed in its basic shape of a cylinder with the edges
rounded off. This minimal intervention into the form of the original log may be seen in
numerous wood pieces, including *Hollow Form with White* 1965 (no.62 q.v.) and *Makutu*
1969 (no.71 q.v.). The diagonal open section in the external element of *Hollow Form with
Inner Form* and another smaller opening in the right-hand side may originate from
Nance's carving out of the timber; the left-hand side is also pierced with a cylindrical
hole. The broad chisel marks of the original wood animate the internal surface of the
bronze, which has a pale blue-green patina. In the contrast between this and the
discrete inner form, which, like the outer face of the larger element, is dark brown, the
artist perhaps sought to replicate the contrast of the original teak set against the lighter
elm. The two parts were hollow-cast and are fastened to the base with stainless steel
screws, which replaced the steel originals. On acquisition by the Tate the unpatinated
surfaces were waxed. In 1983 lacquer was applied to the whole sculpture and later
(1989) removed and replaced with a protective coating of wax.[4]

Six Forms (2 × 3) (no.67 q.v.), of the same year, was also produced by the
reconstitution of an earlier piece. This may reflect the demands placed upon Hepworth
in what was a busy and highly significant year for her. While her achievement was
marked by a retrospective at the Tate Gallery in the spring of 1968, her contribution to

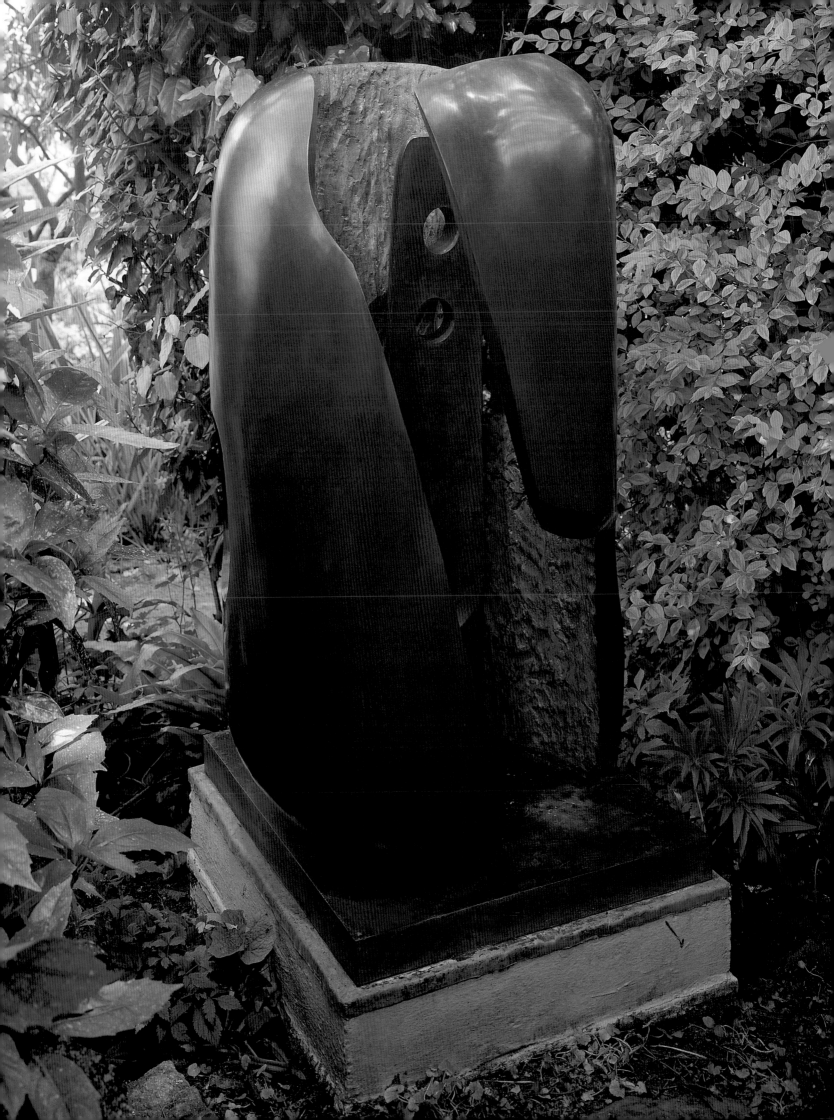

civic life as well as her national status was recognised by her local community when they conferred on her the Freedom of the Borough of St Ives. However, the period was also marked by illness, as at that time she was weakened by three years of treatment for cancer and suffered a broken hip that forced her to rely upon walking sticks. As a result she became more dependent on her assistants for the completion of sculptures. The ever increasing market for her work coupled with these imposed frailties may have contributed to the need to make new works from old. However, the combination of individual works to produce a further conglomerate piece was not unprecedented: in 1956 she had shown her *Reclining Figure I (Zennor)* (BH 204) and *Reclining Figure II* (BH 205), both 1955–6, within the hollowed spaces of *Oval Form (Penwith Landscape)* 1955–6 (BH 203) as *Three Forms: The Seasons* 1956.[5] She would subsequently return to the setting of small elements within an enfolding larger form with stone pieces such as *Oval with Two Forms* 1971 (no.72 q.v.). In fact, the concept first appeared in her work in a number of sculptures like *Figure (Mother and Child)* 1933 (fig.21), and the maternal theme, or a related allusion to nesting, may be thought to run through all such pieces. Hepworth's siting of *Hollow Form with Inner Form* amongst the foliage of her garden, where it remains, enhanced the sense of refuge suggested by the sculpture.

69 Two Forms (Divided Circle) 1969

TO3149 BH 477; cast 0/6

Bronze on bronze base 237 × 234 × 54.3 (93½ × 92 × 21¼)

Cast inscription on front face of base 'Barbara Hepworth 1969 0/6' l. and cast foundry mark 'Morris | Singer | FOUNDERS | LONDON' r.

Presented by the executors of the artist's estate, in accordance with her wishes, 1980

Displayed in the artist's garden, Barbara Hepworth Museum, St Ives

Exhibited: Marlborough 1970 (19†, repr. in col. on cover); *Open-Air Sculpture II*, Gimpel Fils exhibition in Syon Park, summer 1970 (11‡, repr. in col. on cover); Plymouth 1970 (54‡); Hakone 1970 (31‡, repr. in col.); New York 1971 (9†, repr.); *Masters of the 19th and 20th Centuries*, Marlborough Fine Art, summer 1972 (31†, repr. in col. p.63); Edinburgh 1976 (9†, repr. in col.); Bretton Hall 1980 (22‡, repr. p.26)

Literature: Bowness 1971, p.48, no.477, repr. pls.15 (in col.), 189–90; 'News and Notes: Hepworth Sculpture in Dulwich', *Studio International*, vol.181, no.933, May 1971, pp.197–8; Jenkins 1982, p.19, repr. p.39; *Tate Gallery Acquisitions 1980–2*, 1984, p.123, repr.; W.J. Strachan, *Open Air Sculpture in Britain: A Comprehensive Guide*, 1984, p.47, no.51, p.113, no.225, repr. pp.48, 113; J[ackie] Heuman, 'Perspectives on the Repatination of Outdoor Bronze Sculptures' in Phillip Lindley (ed.), *Sculpture Conservation: Preservation or Interference?*, Aldershot 1997, pp.124–5, repr. [p.221], pls.XXVIII, XXIX (col.)

The 1960s was a period of 'tremendous liberation', Barbara Hepworth told Alan Bowness: 'I at last had space and money and time to work on a much bigger scale. I had felt inhibited for a very long time over the scale on which I could work … It's so natural to work large – it fits one's body.'[1] The decade began with the large-scale *Figure for Landscape* 1959–60 (no.52 q.v.), encompassed works designed to include the viewer, such as *Four-Square (Walk Through)* 1966 (no.65 q.v.) and *Three Obliques (Walk In)* 1968, and ended with *Two Forms (Divided Circle)*.[2] This work falls between the monolithic and the environmental sculptures in that its bifurcated form seems to draw the viewer in while the narrow spacing between the two halves denies a passage through. The ambiguity may be related to Hammacher's belief that Hepworth's 'conception of space … is indeed to be found in the openings (the no-door, the door-*angst*) towards the infinity of emptiness'.[3] This quality, combined with the apparently precarious angle of the two forms, gives the sculpture a sense of dramatic tension.

Two Forms (Divided Circle) is an unexpectedly asymmetrical work. Its slightly awkward quality is enhanced by the disposition of the individual elements: set at an angle to each other and stepped one slightly behind the other. Unlike many of Hepworth's sculptures, with *Two Forms (Divided Circle)* it is not possible to identify a single frontal face as both display the narrow and wider ends of the two openings. One of the semi-circular sections is pierced by a cylindrical hole which, on one side, is set within a semi-circular concavity. In the neighbouring form, the hole spirals from a circle to an oval. Early photographs show these recessed areas to have been highly polished and, even though the Tate's work has tarnished, the internal surfaces more golden in colour than the thin green patination of the exterior. Traces of lacquer, which had deteriorated, suggest that the artist wanted to retain the shine on the inner surfaces even while out of doors. Microscopic analysis revealed these to contain yellow ochre and cadmium yellow pigments, which were presumably intended to tone the polished bronze.[4] Tate Gallery conservators and the artist's executors have discussed whether these areas should be repolished and lacquered.[5] The base has a stippled blue/black patina. The two semi-circles taper towards the bottom and their outer edge. While the sides are smooth, their larger, slightly convex, faces bear the texture of the carving of the original plaster. As well as evenly distributed curving lines, there are rectilinear groups of dots, perhaps made with a claw chisel, and a fine regular texture, as if sacking had been pressed on to the wet plaster. All three elements of the sculpture are hollow-cast and the two main forms are welded to the base.

Reflecting developments in the environmental art of the 1960s, Hepworth explained that with the large sculptures of the second half of the decade she sought to involve the viewer in the work. She insisted that one's whole body should be engaged with the sculpture as it 'helps to orientate us – give us an image of security and a sense of architecture'.[6] She included this work among those under discussion: 'You can climb through the *Divided Circle* – you don't need to do it physically to experience it.'[7] The

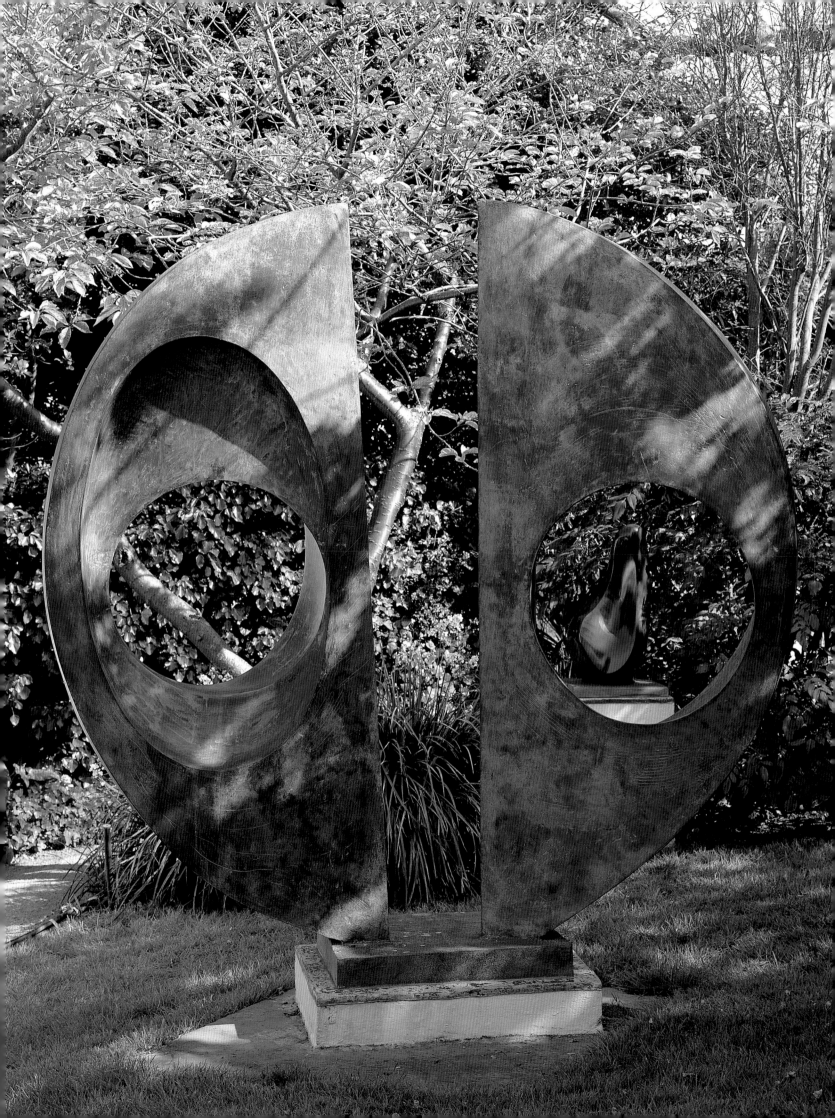

artist told Ben Nicholson how she conceived of these works in physical and visual terms. 'So much depends, in sculpture, on what one wants to see through a hole!' she wrote. 'Maybe in a big work I want to see the sun or moon. In a smaller work I may want to lean in the hole … It is the physical sensation of piercing and sight which I want.'[8] Though she had already made several monumental pieces, the artist related these large works to her diagnosis of cancer in 1965 and the consequent desire to do 'big work while you can'.[9]

She insisted that she did not work from maquettes as sculptures could not simply be scaled up.[10] Nevertheless, as with works such as *Four-Square (Walk Through)*, she made a smaller version of *Two Forms (Divided Circle)*. At 36.9 cm (14½ in) high, *Maquette for Divided Circle* was cast in polished bronze in an edition of 9 + 0.[11] Similar reworking of a single concept was common in her later work, as were small-scale, multi-part sculptures.

Just as numerous paintings and sculptures of the mid-1960s were based on the square, so the semi-circle recurs in Hepworth's works of 1969–72. Specifically, it was the basis for her 1970 design for a mural sculpture at the head offices of the Cheltenham & Gloucester Building Society in Cheltenham.[12] *Theme and Variation* 1970 consists of superimposed semi-circular panels of bronze, of varying sizes, cascading or fanning out in three different configurations over the building's entrance. In 1969, Hepworth was glad to be one of 'a few sculptors of repute' who were invited to consider the commission as she had 'several ideas in mind for wall sculptures'.[13] She had been frustrated a few years earlier by the rejection of her *Three Forms in Echelon* 1961 (no.54A & B q.v.) for a similar scheme for the John Lewis store in London. She started work at the beginning of 1970, her design – which drew on her 1969 Aegean Suite of prints[14] – was accepted in June and the building was opened in September 1972. In 1970 she also commissioned Breon O'Casey and Brian Ilsley, then working together as jewellery makers in St Ives, to produce a small version in silver on walnut.[15] This is entitled *Maquette, Theme and Variations* but, in keeping with similar table-top versions of larger works, was most likely to have been an independent reworking of the same concept.[16] In these works Hepworth used the semi-circular form to create the illusion of a rocking motion in a manner which echoed Terry Frost's paintings based upon the movement of boats in St Ives harbour, such as *Green, Black and White Movement* 1951.[17]

A cast of *Two Forms (Divided Circle)*, purchased by the Greater London Council, is displayed in Dulwich Park (5/6) and another is in the collection of Bolton City Art Gallery (4/6).

70 Touchstone 1969

TO2016 BH 496

Irish black marble 63 × 30.5 × 37 (24¾ × 12 × 14⅝)
on oak base 9 × 43 × 53 (3½ × 17 × 20⅞)

Bequeathed by the artist 1975 and acquired 1976

Exhibited: Marlborough 1970 (35, repr.); New York 1974
(5, repr.)

Literature: Bowness 1971, pp.14, 50, no.496, pl.204;
Tate Gallery Acquisitions 1974–6, 1976, p.106, repr.

Towards the end of her career, Hepworth's use of a wide variety of stones from diverse sources reintroduced the polychromatic quality that had been noted in her exhibitions with John Skeaping in the 1920s. In particular, she began to carve green, sepia and black marbles from Ireland and Sweden in addition to the more familiar white varieties from Italy and Greece. An earlier Tate Gallery catalogue entry has suggested that single stone forms such as this may be seen as reinterpretations of her early figurative work in similar materials. Specifically, it related *Touchstone* to *Torso* 1927, which is of a similarly fossil-rich Irish black marble.[1] Such a return to, or echo of, earlier pieces was a characteristic of her work and outlook in the late 1960s and early 1970s. Beyond her own circumstances this nostalgia reflected a broader reassessment of modernist art in Britain before the war.

Touchstone was most probably carved from a block of Galway Shell Black marble. In June 1966, Hepworth asked Irish Marble Ltd. of Galway to send her samples and a price list. The company's brochure explained that their black variety – Galway Black and Galway Shell Black – was not a true marble but a 'semi-crystalline limestone which polishes well'. From the edge of Galway Bay, the Black was 'mainly free from white spots and the Shell Black has a heavy white fossil content which, when polished, produces magnificent patterns of sea fossil, oysters and crustaceans interspersed with filigree shapes of fossilised sea plants'.[2] She wrote that she was 'delighted' with the Jet Black Galway Marble and their Dark and Light Green Connemara Marbles. She requested some pieces of the Jet Black, 'two to three feet high and a nice shape', and added: 'Should you have any scantlings of the Shell Black I would be happy to work them.'[3] This suggests that, despite the added difficulty of carving an inconsistent piece of stone, the pattern of white specks that characterises this work was deliberately sought after.

The form of *Touchstone* is that of a rectangular block with opposing corners cut away. Despite this symmetry the effect in plan is to create an apparently irregular form. While the vertical edges are rounded, those around the top are bevelled to prevent chipping. Characteristically, the sides of the sculpture curve in towards the bottom to give the effect of lightening the work by releasing the block from the base. Concave circles are sunk into two adjacent faces: towards the top of one and near the bottom of that to its left. The surface of the black stone is punctuated by the white speckles of fossils. At one point towards the top edge these congregate as a cloud-like form and on one of the chamfered bottom corners the process of carving has exposed an especially large section of a single fossil. There are several fine cracks, most noticeably beneath one of the concavities, which were in the original block.

As with many of Hepworth's sculptures, this work can be related to a painting of the same title (dated May 1966), though there is no other evident link between them.[4] The term touchstone has three definitions all of which may be relevant to the sculpture.[5] It is simply a general term for a black stone such as black marble or basalt, but this meaning

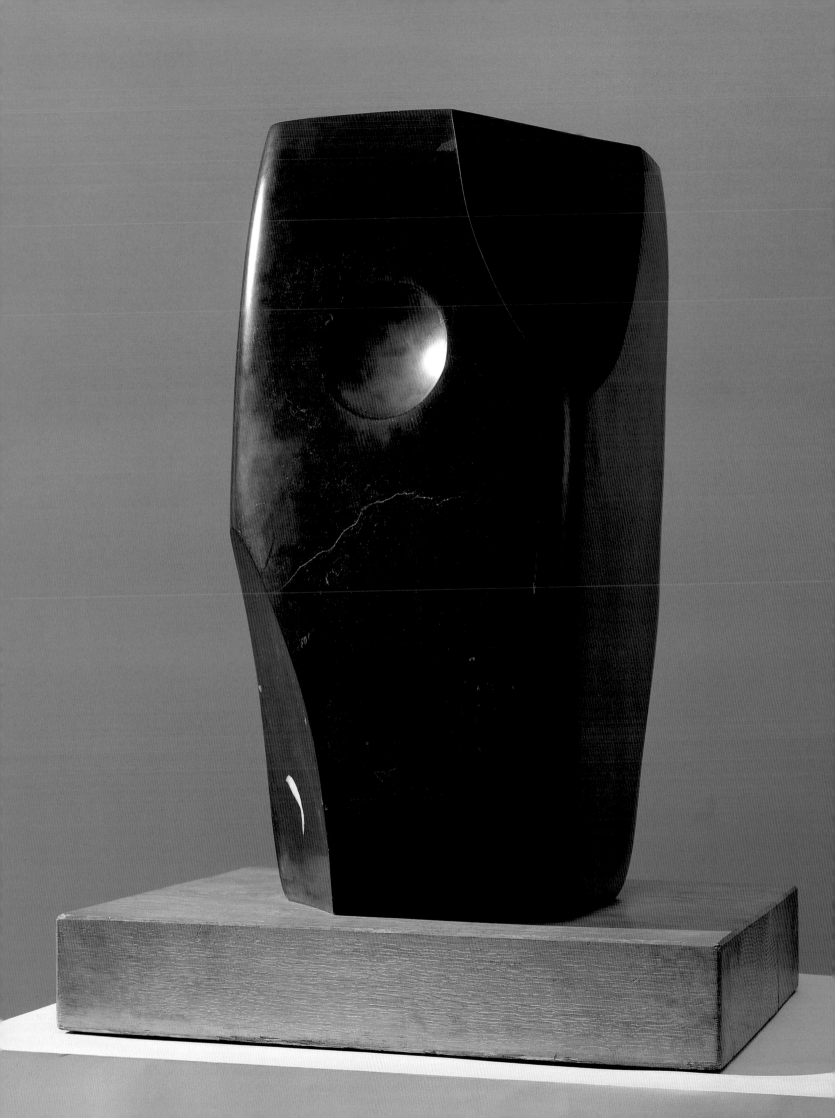

derives from its more specific application to a variety of black quartz or jasper used to test the quality of gold and silver. It was this function that gave rise to the third definition of touchstone as a test of quality in general. It would seem, by her own account, that Hepworth alluded to this in the title. In 1968, she said that she wanted her work to be 'a totem, a talisman, a kind of touchstone for all that is of lasting value … something that would be valid at any time or that would have been valid 2,000 or even 20,000 years ago'.[6] This idea had been reflected a decade earlier, with pieces with titles such as *Talisman* and *Totem*.[7] The elevation of the abstract art object as the embodiment of resistance to the materialism of the modern world had been a mainstay of Hepworth's theory since the 1930s, when its currency amongst a variety of artists was exemplified in projects such as *Circle* (1937). As the artist told Alan Bowness in 1970, 'I called that marvellous piece of Irish black marble "Touchstone" and that is what sculpture is all about. It's something you experience through your senses, but it's also a life-giving purposeful force.'[8]

71 Makutu 1969, cast 1970

T03151 BH 505; cast 0/9

Bronze 67.5 × 24.5 × 24.3 (26⅝ × 9⅝ × 9½)
on bronze base 8 × 38 × 38 (3⅛ × 15 × 15)

Cast inscription on top of base 'Barbara Hepworth | 1969
CAST 1970 0/9' r. and cast foundry mark on back of base
'Morris | Singer | FOUNDERS | LONDON' t.l.

*Presented by the executors of the artist's estate, in
accordance with her wishes, 1980*

*Displayed in the artist's garden, Barbara Hepworth
Museum, St Ives*

Exhibited: *Autumn Exhibition 1970*, Penwith Gallery, St Ives,
Sept.– Oct. 1970 (sculpture 2†); *Winter Exhibition 1970–1*,
Penwith Gallery, St Ives, Dec. 1970 – Feb. 1971 (sculpture
2†); AC tour 1970–1: Cardiff, Cambridge, Eastbourne,
Southampton (not in cat.‡); New York 1971 (22†, repr.);
St Ives Group 3rd Exhibition, Austin Reed Gallery, Aug. 1971
(2†); AC Scottish tour 1978 (26†); Bretton Hall 1980 (25†,
repr. p.28); Wales & Isle of Man 1982–3 (26†)

Literature: Bowness 1971, p.50, no.499; *Tate Gallery
Acquisitions 1980–2*, 1984, pp.123–4, repr.; W.J. Strachan,
Open Air Sculpture in Britain: A Comprehensive Guide,
1984, p.78, no.141, repr. p.79

Cast from an original carving in lignum vitae of the same name, *Makutu* takes its title from Maori.[1] According to an earlier Tate Gallery catalogue entry, the word means 'to bewitch; a spell or incantation; and also a variety of sweet potato'.[2] It is probable that Hepworth would have chosen it for the more abstract and mysterious definitions. In 1966 she had given a slate carving the title *Two Forms (Maori)*.[3] In answer to an enquiry from a Tate curator, the artist's executor, Alan Bowness, suggested that the title *Makutu* might have been taken from a book that was sent to the artist and was now in his own collection. 'Finding names was often a bit of a problem', he explained.[4] The title's allusion to magic and mystery may be compared to a metaphysical quality suggested by many of Hepworth's works. Several titles include references to religious themes – Christian, non-Christian and pagan – and to ritualistic activity in general, such as *Three Forms Vertical (Offering)* 1967 and four separate works with the subtitle 'amulet', meaning a charm.[5]

The hollow-cast bronze is typical of Hepworth's work in a number of ways. Its basic form is that of the original log with the edges rounded. It is pierced once and, while the exterior is dark bronze, the internal surfaces have a pale green patination that becomes heavier towards the bottom. The hole narrows to a tilted, more regular oval shape at the back. After its acquisition by the Tate, the sculpture was cleaned of marks resulting from its display out of doors, such as bird lime, and wax-polished. The original bolts holding it to the base were replaced with stainless steel.[6]

Other casts of *Makutu* are in the collections of the Midtown Gallery, Atlanta (2/9), and of the Morris Singer Sculpture Association (4/9).

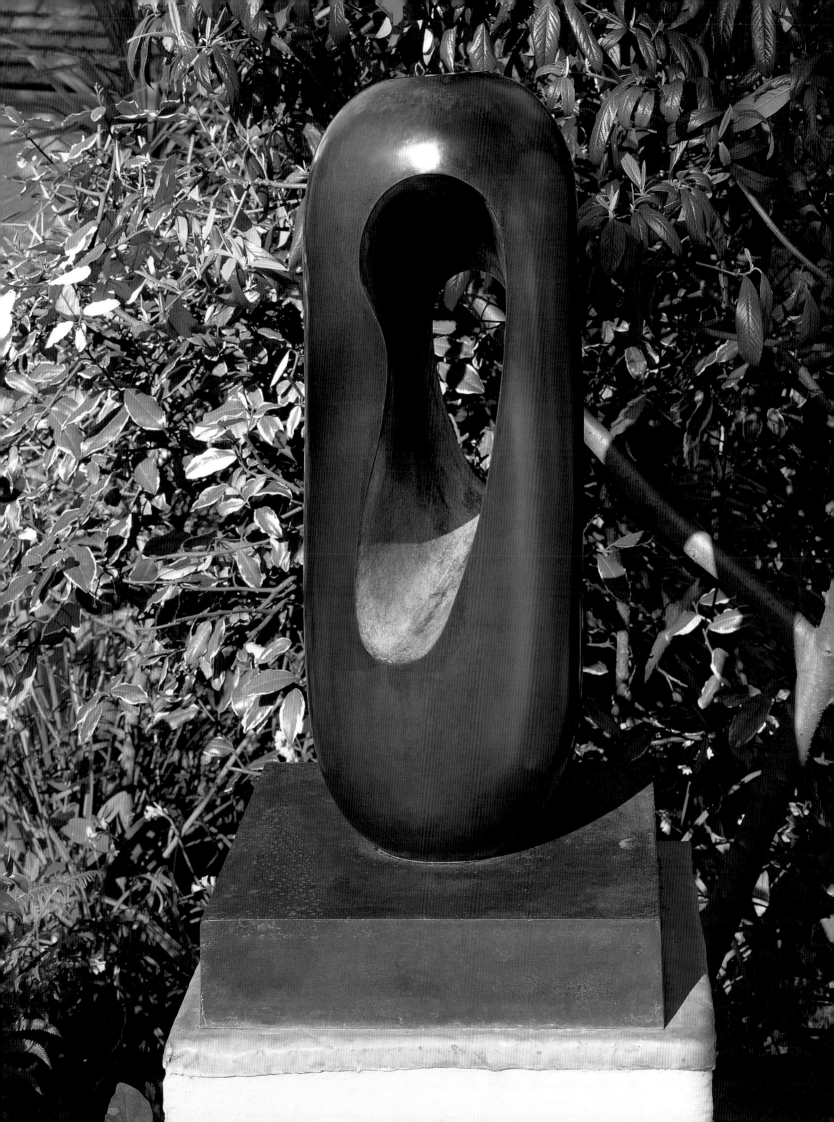

72 Oval with Two Forms 1971

TO3152 BH 525

Marble and slate 28 × 39 × 33 (11 × 15⅜ × 13)
on a slate base 5.5 × 30 × 30.1 (2 × 11¾ × 11⅞)

*Presented by the executors of the artist's estate, in
accordance with her wishes, 1980*

Exhibited: Marlborough 1972 (14, repr. in col.); *Spring
Exhibition 1973*, Penwith Gallery, St Ives, April–May 1973
(sculpture 13); *Summer Exhibition 1973*, Penwith Gallery, St
Ives, June–Aug. 1973 (sculpture 4); *Autumn Exhibition 1973*,
Penwith Gallery, St Ives, Sept.–Nov. 1973 (sculpture 3);
Zurich 1975 (16, repr. in col.)

Literature: Jenkins 1982, p.20, repr. p.40; *Tate Gallery
Acquisitions 1980–2*, 1984, p.124, repr.

The three elements of *Oval with Two Forms* are carved from different stones. Though distinct from each other, the two white forms are both marble: the main 'bowl' is a grey-veined variety, possibly Carrara, while the smaller one is warmer in colouring and has a more crystalline appearance. It is possible that the latter is Hepworth's preferred Serravezza, a whiter marble from the same area of Italy as Carrara. The black form is slate and was probably quarried locally at Delabole. Dowels attach the two smaller elements to the main oval, which is fastened to the base with bolts. The sculpture's asymmetrical form is emphasised by its location towards the front and left of the base, which gives it a sense of leftward movement. Hepworth produced many works consisting of triangular slate pieces, and her assistants have recalled that they originated from her reuse of the off-cut corners of larger slabs. She would, they said, 'pebble' them – round off the edges and polish – to produce the desired form.[1]

The polychromatic aspect of Hepworth's work had re-emerged with her use of a range of different stones during the 1960s. Here, or in *Two Opposing Forms (Grey and Green)* 1969 for example, the combination of stones of different colours and patterning makes the material the main focus.[2] The highly coloured aspect of many of the sculptures of the period was further accentuated by her painting of stone, a practice she had used in the 1940s. It first reappeared with the large *Marble with Colour (Crete)* 1964 and she employed it in several of the pieces in green and grey marble. Hepworth used paint in *Pierced Hemisphere with a Cluster of Stones* 1969, the work most closely comparable to *Oval with Two Forms*.[3] The artist said she enjoyed making the former, which consists of white marble, Hoptonwood stone, slate, and green Irish marble, because 'all the materials are such personal loves'.[4] She noted that *Apolima* 1969 combined white marble and slate and anticipated that she would be 'led into using various opposing forms and materials' in the future.[5] *Oval with Two Forms* confirms that prediction.

The contrasting colours were part of an increasing opulence in Hepworth's small-scale sculptures, stimulated by the success which encouraged the use of lavish materials and such larger works as *Two Forms (Divided Circle)* 1969 (no.69 q.v.). A wider range of exotic stones with rich colours and patterning, a greater use of polished bronze and slate and even the casting of works in gold expanded her repertoire. It seems this adjustment was, in part, to meet a growing demand. The polished bronze version of this work, cast in 1972 in an edition of 9+0, would also be consistent with this tone.[6]

The theme of small forms resting in a larger one had been a recurring feature of Hepworth's work since the 1930s. It was first seen in *Forms in Hollow* 1936, a plaster work consisting of three flat pebble-like elements lying in a shallow bowl.[7] However, the roots of the motif may be traced to her two-form sculptures of the early 1930s in which a maternal form enwraps a separate 'child', in particular *Mother and Child* 1934.[8] This comparison is validated by Hepworth's discussion of her long-standing interest in 'the relationship of inner and outer form … of a nut in a shell – or of a child in the womb'.[9] It is characteristic, however, that the title of this work stresses its abstract qualities.

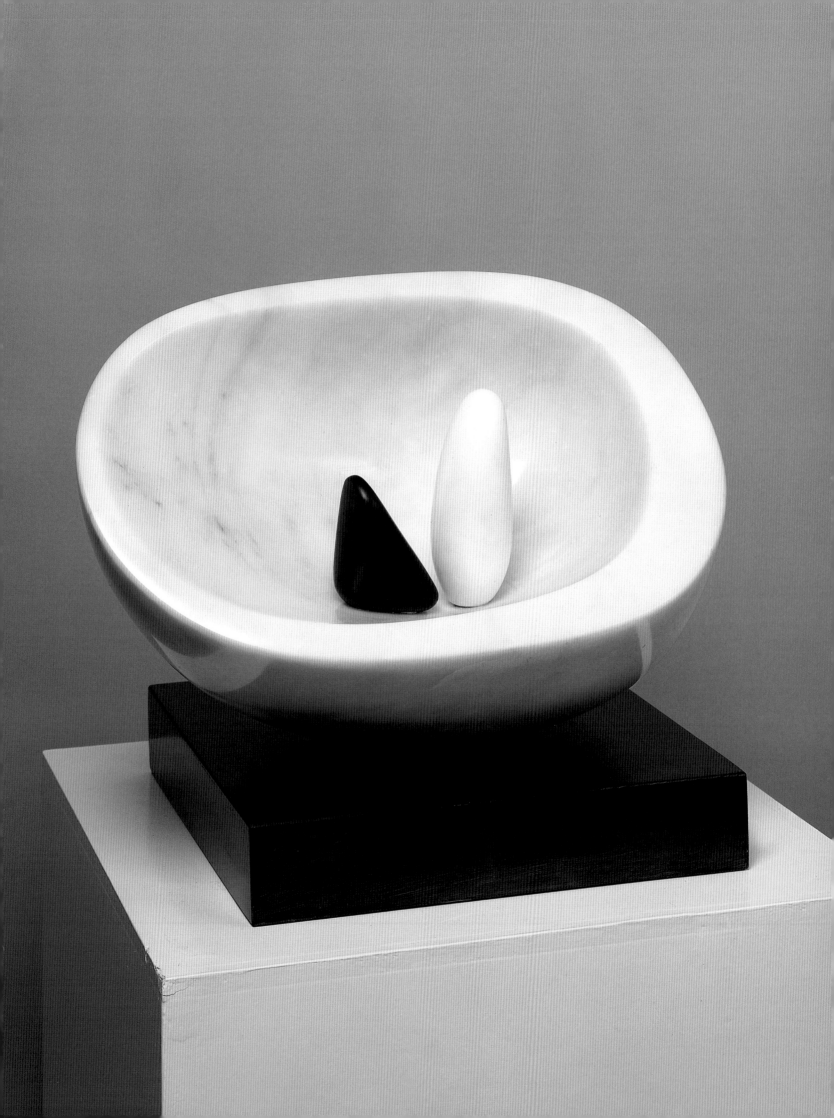

73 Shaft and Circle 1972, cast 1973

L00941 BH 572; cast 0/9

Bronze 114.3 × 29 × 15 (45 × 11⅜ × 5⅞)
on bronze base 7.4 × 47 × 30.5 (3⅞ × 18½ × 12)

Cast inscription on top of base 'Barbara Hepworth' and '0/9'
back right; cast foundry mark on back of base 'Morris |
Singer | FOUNDERS | LONDON' t.l.

*On loan from the artist's estate to the Barbara Hepworth
Museum, St Ives*

*Displayed in the artist's garden, Barbara Hepworth
Museum, St Ives*

Exhibited: *Spring Exhibition, 1974*, Penwith Gallery, St Ives,
April–June 1974 (sculpture 1†); Zurich 1975 (23, repr. p.48†);
Marlborough 1979 (58†, repr. p.36); New York 1996 (no
number‡, repr. in col. p.87)

Highly reflective surfaces were favoured in Barbara Hepworth's late works. This treatment was found, for instance, in the gilded openings of *Two Forms (Divided Circle)* 1969 (no.69 q.v.), but with the bronze version of *Shaft and Circle* the whole surface is maintained at a high polish. The cast was made from the Irish marble carving *Shaft and Circle* 1972.[1] The complex graining of the stone asserted the material quality of the sculpture, but this was completely transformed by the polishing of the bronze so that it melts into its surroundings. A similar inversion was achieved with the inscribed lines which were painted white on the stone but are dark in the bronze.

Dore Ashton saw the incision on *Shaft and Circle* 'as an open allusion to the ancients, whether the ancient graffiti draftsmen, or the ancient animal-stone carvers, or the old Anglo Saxon cross-or-round-shaft builders. Often Hepworth's allusions to ancient motifs are highly sublimated, tinctured with the values of our century, yet emergent wherever we look'.[2] The linear forms had appeared in Hepworth's drawings and prints over the preceding years, often associated with the sun and the moon to which the sculpture's title may be linked.

In plan *Shaft and Circle* is an irregular triangle of which the hypotenuse serves as the main face. The corners have been chamfered along the full height, and all sides taper towards the horizontal top. The sculpture is off-set to the right of the base. On the bronze the sides of the base are patinated green, and the top is a contrasting warm red. The cast in the artist's garden (0/9) is polished daily, but this process has revealed faults in the casting.[3] A fine pitting of the surface is now visible, especially in the region of the circle, having the appearance of frothing. The artist's correspondence with the Morris Singer foundry shows that they were aware of various other problems. Two casts were ordered in October 1973, one of which was to go to Hepworth's New York exhibition.[4] This cast (1/9) caused the sculptor to write to the manager, her friend Eric Gibbard: 'No doubt you heard that I was very upset over the cheap commercial finish on the one that came to go to America. It took three days very hard work for all of us to lick it into shape by just sheer hand rubbing.' For his part, Gibbard had been 'very disturbed' about the sculpture, and explained that instead of continued hand rubbing with 'wet and dry emery … a polishing mop [was] used'.[5] He added that the 0/9 cast was 'nearly ready when I noticed a poor colour match on the weld of the core bearer'. Under the double pressure from the sculptor of maintaining standards and producing the edition promptly, *Shaft and Circle* continued to cause difficulties; in February 1974, Gibbard wrote that he had 'scrapped two in the process'. The artist's copy was only ready at the end of the month.[6] Further casts were made over the following year, with 6/9 and 7/9 being ordered in early February 1975. The edition was cut short by the artist's death.

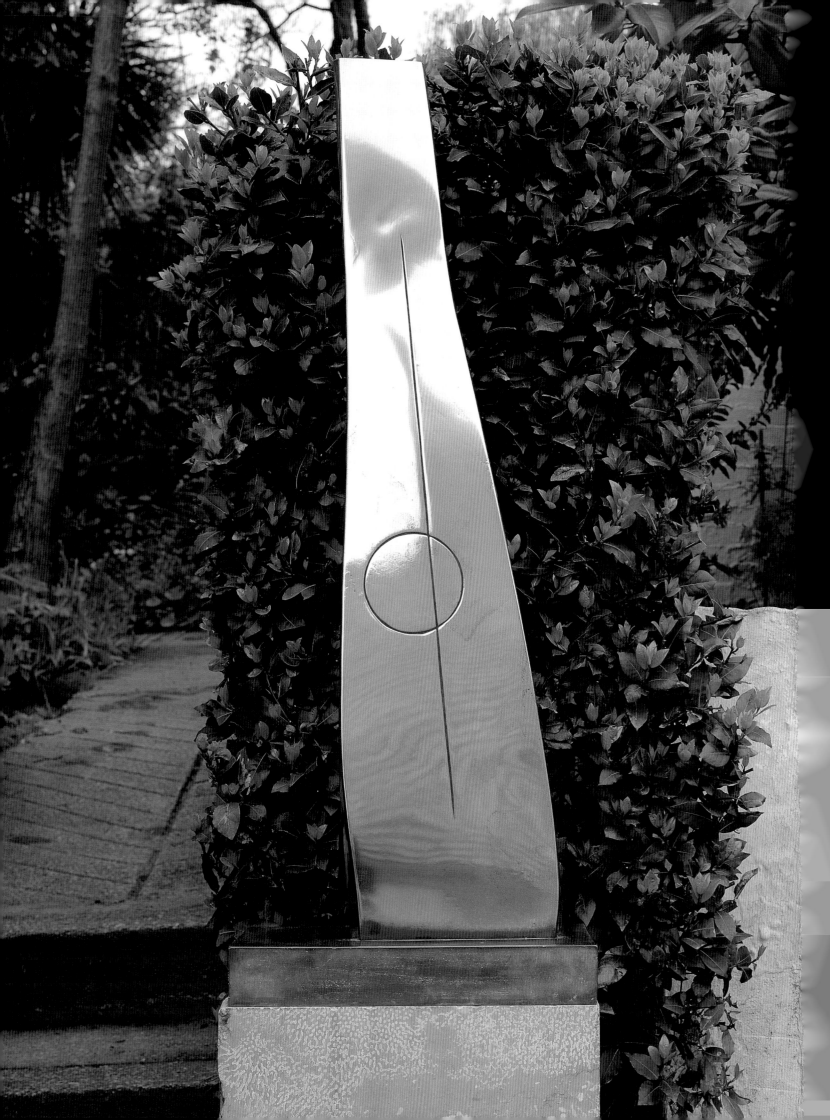

74 Rock Face 1973

TO2017 BH 560

Ancaster stone 102 × 47 × 23 (40¼ × 18⅝ × 9)
on beechwood base 3.6 × 64.5 × 25.5 (3 × 25⅜ × 10¹⁄₁₆);
weight 185 kg

Bequeathed by the artist 1975 and acquired 1976

Exhibited: New York 1974 (15, repr. in col.); *Retrospective*
1994–5 (83, repr. p.135)

Literature: Jane Bell, 'Barbara Hepworth at the
Marlborough', *Arts*, vol.48, 1974, p.75, repr.; *Tate Gallery
Acquisitions 1974–6*, p.107, repr.; Jenkins 1982, p.19, repr. p.40

Carved from a block of shelly limestone (Ancaster), *Rock Face* is most obviously characterised by its two-tone colouring. While the stone is predominantly grey, it has been cut so that a sandy brown layer spreads across the lower section of the front, reaching to the back edge of the side faces. The rounded-square holes reveal that this secondary colouring does not run the full depth of the block. The artist had used a similar piece of Ancaster stone twenty years earlier for *Hieroglyph* 1953.[1] The front of the sculpture is flat and the two sides recede obliquely to a curved back. The stone has been rubbed to give it a reflective polish, but has no coating. Its edges, including that around the bottom, are bevelled. There are several blemishes – chips and matt areas – which were probably caused while the stone was being worked. The base is of a single piece of timber and the stone is held on to it by two threaded bolts.[2]

Hepworth's choice of material reflects the revival of colour in her later work. The static verticality resulting from the artist's economy of carving is off-set by the surface pattern of the two colours of the block intermingling in a manner suggestive of wood grain. This effect is maximised by the characteristic carving out of the frontal concavity. The flatness of the faces and the simplicity of the two holes is in marked contrast to the complex forms of her early work and reflects a general tendency towards the simplification of stone forms as seen in such works as *Touchstone* 1969 (no.70 q.v.).

As the title of that work intimates, Hepworth saw these late monolithic pieces in terms of ritual and spiritual significance. 'You can't make a sculpture without it being a thing – a creature, a figure, a fetish,' she said in 1970.[3] The title of *Rock Face* suggests the duality of figure and landscape that had been a dominant aspect of her work for over thirty years. While the sculpture's frontality is suggestive of a face, it may also allude to the cliffs that are such prominent features of the landscape of west Cornwall; such a theme provided the basis for the earlier wood carving *Figure (Nanjizal)* 1958 (no.44 q.v.). As she explained to Alan Bowness, Hepworth saw the late carvings 'as objects which rise out of the land or the sea, mysteriously'.[4]

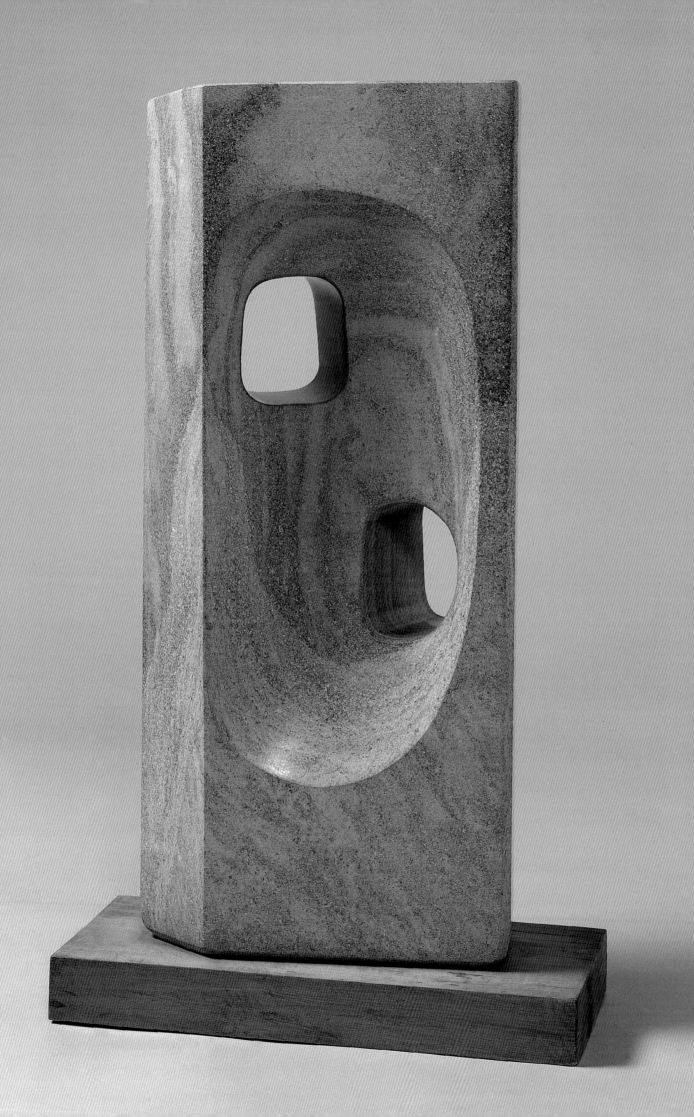

75 Conversation with Magic Stones 1973

T03851 BH 567; cast 0/2

Six bronze forms on bronze bases, approx. 480 × 410 (189 × 162) overall

Figure 1: 269.2 × 63.5 × 45.7 (106 × 25 × 18)
Figure 2: 274.3 × 58.4 × 47 (108 × 23 × 18)
Figure 3: 282 × 48.2 × 53.3 (111 × 19 × 21)
each on a bronze base 76.2 × 61 (30 × 24)
weight 430 kg each

Magic stone 1: 80 × 130.8 × 91.4 (31½ × 51½ × 36)
Magic stone 2: 86.3 × 106.6 × 121.9 (34 × 42 × 48)
Magic stone 3: 92.7 × 121.9 × 60.9 (36½ × 48 × 24)
each on a bronze base 61 x 61 (24 × 24)
weight 320 kg each

All but the figure on the left as viewed from the garden (Figure 3): cast inscription on side of base 'Barbara Hepworth 2/2' r. and cast foundry mark 'Morris | Singer | FOUNDERS | LONDON' l.
Left-hand figure (Figure 3): cast inscription over another on side of base '<Barbara Hepworth> Barbara Hepworth 2/2' t.r.

Accepted by the Commissioners of the Inland Revenue in lieu of tax and allocated 1984

Displayed in the artist's garden, Barbara Hepworth Museum, St Ives

Provenance: Trustees of Dame Barbara Hepworth

Exhibited: New York 1974 (3‡, repr. in col. and black and white); *Twentieth Century Monumental Sculpture*, Marlborough Gallery, New York, Oct.–Nov. 1974 (7‡); Edinburgh 1976 (13†, repr. in col.); *A Silver Jubilee Exhibition of Contemporary British Sculpture*, Greater London Council, Battersea Park, June–Sept. 1977 (22); Regents Park contemporary sculpture exhibition (catalogue not traced); Marlborough 1979 (152–5†, 'figures' 1 & 2, 'stones' 1 & 2 only, repr. pp.52–3, not NY); Bretton Hall 1980 (28†, four parts only, repr. p.32)

Literature: Hammacher 1968/1987, p.203, repr. p.2, pl.1; Dore Ashton, 'Barbara Hepworth: An Appreciation', New York 1974, exh. cat., pp.5–6; Malcolm Quantrill, 'London Letter', *Art International*, vol.21, no.4, July–Aug. 1977, p.72, repr. p.71; *Pictorial Autobiography* 1970/1978, p.129; 'Perspective: Birk's Special', *Building Design*, no.379, 20 Jan. 1978, p.11, repr.; Wales & Isle of Man 1982–3, exh. cat., [p.7]; W.J. Strachan, *Open Air Sculpture in Britain: A Comprehensive Guide*, 1984, p.228, no.535, repr. p.229; *Tate Gallery Acquisitions 1984–86*, 1988, pp.167–9, repr.; Alan G. Wilkinson, 'Cornwall and the Sculpture of Landscape: 1939–1975' in *Retrospective* 1994–5, exh. cat., p.113; Festing 1995, p.303; Curtis 1998, p.48, repr. p.64, fig.59 (col.)

*C*onversation with Magic Stones was the culmination of Hepworth's recurrent treatment of the theme of human interaction by means of multi-part sculpture. It consists of six discrete elements: three vertical, which the artist described as 'figures', and three horizontal called 'stones'. With *The Family of Man* 1970 (fig.7), it is one of two such large bronze groups intended for display in the landscape from Hepworth's last years. The Tate's cast in the Barbara Hepworth Museum was arranged by the artist (fig.79). Brian Smith, her secretary, told the Gallery that George Wilkinson, who assisted in the siting of the work, recalled the figures being positioned first and the stones arranged between them. They 'required a number of moves before Barbara was happy with the results'. He added that, 'although in poor health', Hepworth 'was able to get out into the garden, and the final results were as she wanted them'.[1] Another set, in the Scottish National Gallery of Modern Art, Edinburgh, is deployed in the same configuration.

The three vertical 'figures' combine curving and rectilinear profiles in irregular forms. That on the right, as viewed from the garden (identified as *Figure 1*), presents a flat face with three horizontal recesses and is a curved triangle in plan, the top of which slopes down towards the back. The 'figure' at the rear (*Figure 2*) has a face similarly divided into sections, but its back is also flat, with a single recessed horizontal section and the whole tapers towards the top. While these two appear to face the same way, the left-hand figure (*Figure 3*) does not have an obvious front; its slightly convex sides define a stepped form, in which one of the recessed sections is curved and two protruding steps are triangulated. The 'magic stones' are three identical irregular eight-sided polyhedrons, with distinct surface decoration. Each of the faces of the solid is a different shape; two are parallel and, of the other six, four have a single right-angled corner. Each 'stone' is orientated so that it sits on a different face, making it difficult to recognise them as the same form. The stone on the left as seen from the garden (*Magic stone 3*) has five sides which are marked by a highly textured recessed area. This was achieved by the swirling agitation of the surface of the plaster when it was still wet. The middle stone (*Magic stone 1*) has three sides with similar indentations and one with an uneven oval recess, up to 2.7 cm (1⅛ in) deep, which at some stage caused the face of the solid to bow slightly. Circles are incised into two faces of the last stone (*Magic stone 2*), as if a hollow cylinder had been pressed into the plaster.

Brian Smith has confirmed that the work was executed by Hepworth's assistants under her direction.[2] In keeping with her standard practice, each form was hollow-cast from a plaster original. The plaster of Paris was laid onto expanded aluminium sheets wrapped around an aluminium armature; it was worked while wet and carved later. Those corners of the 'stones' where four planes intersect are slightly imperfect as two of the planes do not reach the apex of the angle. This disjunction suggests that the plaster was assembled from flat panels, the thickness of which equated to the discrepancy in the join (approx. 5 mm / ⅜ in). In addition to the recessed areas of the

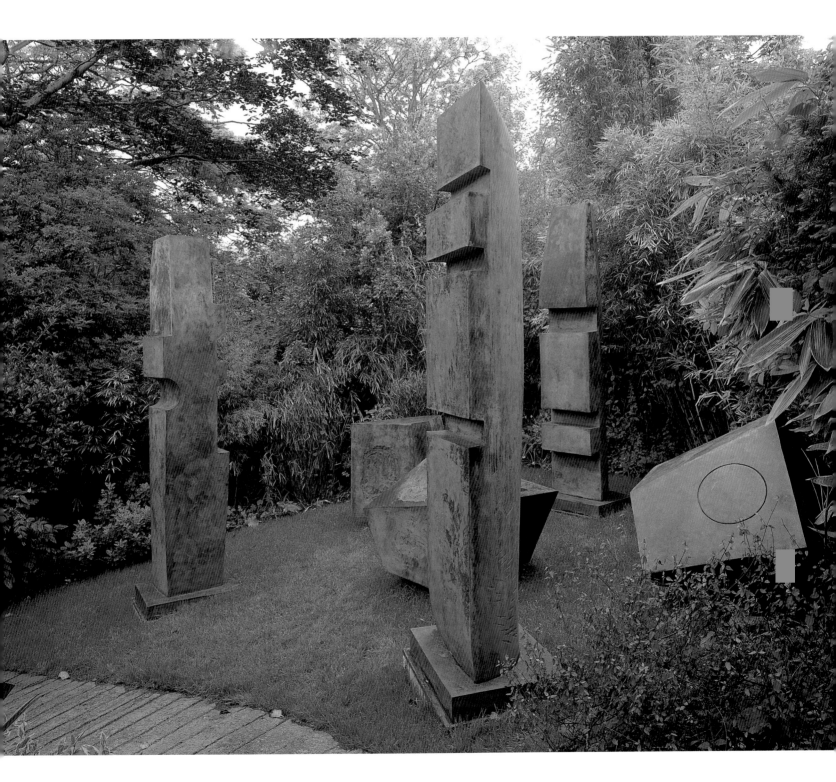

'stones', the surface of the original plaster 'figures' was textured with a regular but apparently random pattern of small and longer linear marks. The appearance is consistent with Hepworth's 1970 description of working the plaster of her *Single Form* 1961–4 (fig.6): 'I used axes, rakes, hatchets – different kinds in a different rhythm. You can see the axe marks where I wanted extra vitality'.[3] The edges were also distressed in places, suggesting a desire to soften them in a way that would distinguish the 'figures' from the geometrical sharpness of the 'stones'.

Conversation with Magic Stones was issued in two editions. Of the first edition of two sets (+0), which were to remain complete, the first (1/2) is in the collection of Trinity University, San Antonio, Texas and the second (2/2) in a private collection in Switzerland. The artist's copy (0/2) is that owned by the Tate Gallery, but was wrongly stamped '2/2' by the foundry. There were also to be a further four casts from which the different elements were to be sold individually. Of these, only two sets were cast; two pieces from the first set were sold to an American collector (1/4) and the whole second set is in the Scottish National Gallery of Modern Art (2/4).

The artist told the bronze founders that the plasters of four of the pieces would be ready by the beginning of August 1973 and that 'the other two nine ft. figures will follow'.[4] They assured her that they would be moulded and the first set cast in bronze by November, and would be patinated and finished ready for shipping to New York at the end of the year.[5] The plasters were painted as a guide for the foundry, to whom she wrote: 'As regards the colouring of "Conversation with Magic Stones"; I indicated all this with a thin wash of brown, indicating very thin liver of salts [potassium sulphide] and blue on the surfaces, that I want to be blueish-white'.[6] She felt that the first set cast was too dark and asked for the liver patination to be lightened in order to bring out the green-blue areas. The deliberately varied patina is readily apparent on the Tate's work, which, despite prolonged display out of doors, is in good condition. The grass between the forms is persistently heavily worn by the number of museum visitors moving around the sculpture (fig.79) but, in keeping with the wishes of the artist's trustees, the ability to enter the group is considered essential.

The concept of *Conversation with Magic Stones* was reworked in two related smaller sculptures. The group of six forms was cast in bronze in a reduced form (30.5 cm/12 in high) with slightly modified proportions; though entitled *Maquette for Conversation with Magic Stones*, it was made a year after the large sculpture.[7] Labelling a subsequent, smaller version of a work 'maquette' had been a regular feature of Hepworth's practice since the production of multiple versions of works such as *Orpheus* 1956 (no.38 q.v.). She also commissioned Breon O'Casey and Brian Ilsley to produce an edition of six sets of three small-scale 'magic stones' in sheet silver.[8] These were dated 1973 and exhibited, as *Three Magic Forms*, in 1974 alongside *Conversation with Magic Stones*.[9]

Hepworth related her major late sculptures to earlier ideas. Over the years, she explained to Bowness in 1970, 'I kept on thinking of large works in a landscape … And in the last ten years I've had the space and time and money for materials, so I've been able to fulfil many ideas that were around for a long, long time'.[10] The roots of *Conversations with Magic Stones* may be identified at two earlier moments in her career. In the right-hand 'figure' there are echoes of works originated in the 1930s, such as *Single Form (Eikon)* 1937–8 (no.12 q.v.), as both are a rounded triangular form with a sloping top. However, the three 'figures' appear to be specifically related to two earlier alabaster groups. One of these, *Three Figures – Conversation* 1951–2 (fig.77) was shown at the Lefevre Gallery in October 1952 and, having been purchased by the British Council, was irreparably damaged in 1962–3. Though previously dated to the early 1950s, it has been suggested that the other group might have been made in response to that loss.[11] This second set of three 'figures' was found with no base in Hepworth's studio after her death and may be considered unfinished. Its unpolished stones appear to have served as patterns for the vertical elements in the small bronze version of

268

Conversation with Magic Stones. In both of the bronzes and this surviving alabaster group, the forms of two of the figures are very similar, but the one on the left is more complex in its larger version.

The figures of the destroyed alabaster group were more intimately arranged and, though still closely related, are less like those of *Conversation with Magic Stones.* However, all these works echo the forms of Hepworth's series of 'group' sculptures of 1951–2, most particularly *Group II (people waiting)* 1952 (fig.55). They share a common rectilinear figure style that, in a Tate Gallery catalogue entry on another 'group' piece, has been compared to the form of the prow of a gondola.[12] The style may also be seen in relation to Hepworth's paintings of the late 1940s and early 1950s, such as *Family Group – Earth Red and Yellow* 1953 (no.30A q.v.), in which figures are defined by interlocking straight lines.

Conversation with Magic Stones reflects similar concerns to the works of twenty years earlier, most especially the theme of social interaction. Hepworth related *Group I* 1951 (no.27 q.v.) and its two successors to her experience of watching the crowds in the Piazza San Marco, Venice, and the way people responded bodily to each other and to the architecture. This was consistent with the predominance in her thinking of a concern with social formations and the relationship between individuals, the artist and society. *Conversation with Magic Stones* reflects a synthesis of that theme of human interaction with the more metaphysical aspect that had developed in her thinking in the intervening period. In the viewer's ability to interact physically with the work, Hepworth developed this theme to its grandest and most literal representation.

The origin of the form of the 'magic stones' lies in her most purely abstract work of the mid-1930s. The irregular polyhedron appears to have been based upon the left-hand element of her *Two Forms* 1934–5 (fig.78), one of the geometrical pieces that followed the birth of her triplets in October 1934. In common with similar works of the period, this may be related to the cubistic head sculptures of Giacometti, such as *Cube* 1934, which Hepworth would have seen in reproduction in the fifth issue of *Minotaure* in May 1934.[13] Such crystalline forms recurred in her paintings of the 1940s; her *Drawing for Sculpture* 1941 (fig.37), in particular, incorporates two-dimensional images which are especially close to the 'magic stones'.

It has also been pointed out that the 'magic stones' are similar to the mysterious rhombohedron that appears in Dürer's engraving *Melancholia I*, possibly as a symbol of Geometry.[14] Associated with melancholy through the contemplation of the hidden significance of numbers, Geometry 'epitomised man's attempt to understand the world around him' and had alchemical associations; as such, Hepworth's solid may be thought to embody this esoteric and alchemical pursuit. Giacometti cited Dürer's print as an inspiration and, though there is no record of Hepworth's conscious reference to it, it may be significant that her small silver *Three Magic Forms* was known as 'Geometria' while in the collection of Priaulx Rainier, a close friend.[15] Such esoteric symbolism is consistent with the reference to magic in the title of Hepworth's sculpture.

The work thus establishes a tension between human presences and the symbolic embodiment of metaphysical, magical forces within a landscape setting. The totemic character of the 'figures' had also been seen in *The Family of Man* and had featured in the work of other British sculptors, such as Henry Moore and William Turnbull. The 'magic stones' were anticipated by a number of small monolithic carvings to which Hepworth applied such abstract, esoteric terms as *Touchstone* 1969 (no.70 q.v.). The title *Conversation with Magic Stones*, the arrangement of its figures and their situation all invite comparison with the Neolithic stones in the landscape west of St Ives. In particular, it may be significant that a number of such groups have been seen in figurative terms, such as 'The Merry Maidens' and the 'The Pipers' near St Buryan in West Penwith. Hepworth's work had been specifically associated with such sites as the Men-an-Tol (fig.32) by J.D. Bernal in the 1930s and, after her relocation to Cornwall, she

fig.78
Two Forms, 1934-5, base 29.2 × 15.2 (11½ × 6), alabaster, BH 65, Barbara Hepworth Estate

cited 'the remarkable pagan landscape' as a major source of inspiration.[16] The title and the forms of the 'stones' may also be thought redolent of Paul Nash's depictions of abstract solids in the countryside of the 1930s and 1940s (fig.26).

Specifically, when *Conversation with Magic Stones* was first exhibited in New York, Dore Ashton discussed it in relation to primitive cultures, asserting that 'Hepworth has closely pondered the simple configurations of magical societies'. She described the 'figures' in terms of 'the static majesty of totems … the Cycladic … [and] a memory of menhirs'. She observed that the 'stones' 'carry messages: the eternal circle scratched on one; scarab-like textures on another; ambiguous imprints (a fossilized foot? hand?) on another'. She saw in them 'two ancient themes – the earth and upright man' and identified in the sculpture the theme of natural origin:

In so many origin myths, the horizontal is the earth, the female principle, the Earth Mother. For many cultures, the stones are the bones of the Earth Mother, and in the Navajo language, Earth means 'recumbent woman'. The stones I find in Hepworth – whether the bronze analogies in 'Conversation', or real stones – are nearly always the bones of the Earth Mother, carrying their ineffable message of origin. They subsume all of our longings for beginnings; for truths that escape pragmatics.[17]

fig.79
Conversation with Magic Stones, another view

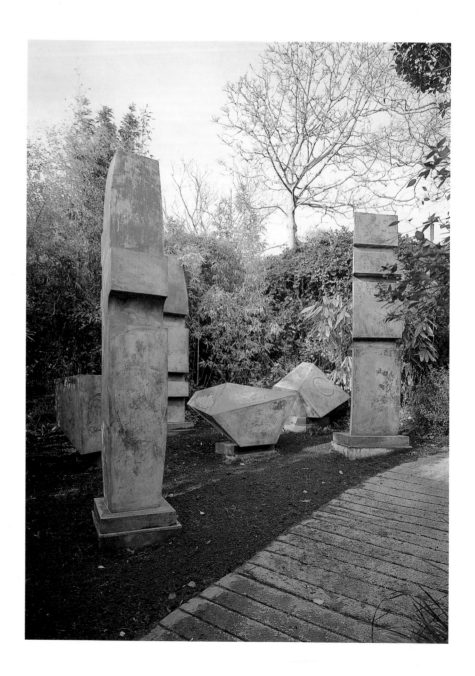

76 Fallen Images 1974–5

TO3153 BH 574

Marble on constructed wooden base 121.9 × 130.2 × 130.2
(48 × 51¼ × 51¼)

*Presented by the executors of the artist's estate, in
accordance with her wishes, 1980*

*Displayed in the artist's studio, Barbara Hepworth Museum,
St Ives*

Exhibited: Zurich 1975 (24, repr.); *St. Ives: Twenty Five Years
of Painting, Sculpture and Pottery*, Tate Gallery, Feb.–March
1985 (216, repr. p.216); *Retrospective* 1994–5 (86, repr. p.110)

Literature: Susan Bradwell, 'Barbara Hepworth', *Arts
Review*, vol.27, no.11, 30 May 1975, p.308; Jenkins 1982, p.20,
repr. p.41; *Tate Gallery Acquisitions 1980–2*, 1984, pp.124–5,
repr.; Alan G. Wilkinson, 'Cornwall and the Sculpture of
Landscape: 1939–1975' in *Retrospective* 1994–5, exh. cat.,
p.115; Alan G. Wilkinson, exh. cat., New York 1996, pp.30–1,
repr.; Curtis 1998, p.48

Reproduced: *Pictorial Autobiography* 1970/1978, p.134,
pl.354

Hepworth's last major work, *Fallen Images* consists of six free-standing marble forms assembled on a circular platform. In its arrangement of discrete geometrical marble elements it can be seen both to typify her last works and to recall her first non-figurative carvings of 1934–5. Of a material with which she was especially associated, it may be seen as her final artistic statement.

The sculpture is recorded in the artist's album as the first work of 1974, though its catalogue number – BH 574 – locates it in 1973 in the sequence.[1] The contradiction between this and the dating of 1974–5 may be explained by the later production of the circular base. Susan Bradwell recorded that, when she interviewed the artist a week before her death, *Fallen Images*, which she described as Hepworth's 'latest work', was on display in her studio.[2] An earlier Tate Gallery catalogue entry has noted that Hepworth arranged for the work's inclusion in the 1975 Zurich exhibition which proved to be posthumous.[3] A photograph in the exhibition catalogue shows the marble forms arranged on the artist's carving turntable approximately as they are now but still sitting on their 'bankers' – the small palettes used for carving – and surrounded by sculptor's tools. As it is unlikely that the stones were carved in such close proximity, the photograph was presumably taken while the configuration was being established. It is possible that the base was made for the exhibition after the artist's death, though a circle, drawn on the turntable and discernible in the photograph, may mark its proposed circumference; similar straight lines appear to fix the locations of the individual elements. George Wilkinson, Hepworth's assistant, recalled that there had been a small plaster maquette of the work and believed it to be one of the only times that such a model had been used for a carving.[4] He also said that the artist had wanted to set the pieces of *Fallen Images* on a reflective aluminium surface but the cost proved prohibitive and a wooden one was made by him. A precedent existed in a comparable multi-part marble sculpture, *Assembly of Sea Forms* 1972, which incorporates a Brancusi-like polished stainless steel circular base (diameter 183 cm / 72 in) set on castors so that the work can revolve.[5]

The elements of *Fallen Images* seem to have been carved from several types of white marble.[6] Veining in the smaller vertical element gives it a cloudy grey appearance, while the larger of the two hemispheres is imbued with a warm orange colouring. The large cone, the oval and the smaller hemisphere are all marked with small orange flecks, caused by the oxidation of iron particles. The purer white sphere is deeply incised with a circle. The top edges of the two vertical elements are bevelled in a manner typical of Hepworth's later carvings.

When *Fallen Images* was acquired by the Tate, filler repairs to small pitted areas in the larger cone were found to have discoloured and were replaced with white alabaster dust in a clear embedding resin. Paint smears around the bottom of all of the forms were removed and the marble was cleaned. The current base of MDF and timber was made in 1993 to replace the less substantial plywood and timber one made

*c.*1979. The stones are attached by stainless steel bolts through the wooden members.[7]

While the late 1960s had seen her use a variety of coloured stones – black, green, grey and sepia – Hepworth made a number of white marble carvings in her last years. There was a considerable increase in the production of these: of the seven works dated 1974–5, two were bronzes and five were in white marble. As well as *Assembly of Sea Forms*, *Fallen Images* was preceded by *Cone and Sphere* 1973 and followed by *One, Two, Three (Vertical)* 1974–5.[8] Hepworth had been associated with the quintessentially classical material since the 1920s when she learnt to carve it in Italy. Later, she explained that she loved it for 'its radiance in the light, its hardness, precision and response to the sun'.[9] She listed white marble carvings from different periods as her favourite works and, in 1964, claimed to be 'one of the few people in the world who knows how to speak through marble'.[10]

To the eight individual elements in *Assembly of Sea Forms* Hepworth had applied names: 'Sea King', 'Sea Form' and 'young', 'Embryo', 'Sea Mother' and so on. This followed the precedent of *The Family of Man* 1970 (fig.7), though in that case the bronze cast figures were sold individually as well as in a set. Though there is no indication that she saw its forms as having individual identities, such an idea of a mythic narrative may also be identified in *Fallen Images*. Alan Wilkinson has suggested that 'by association with her earlier work, the two truncated cones suggest, on an almost subliminal level, two standing figures – a man and a woman'.[11] One may also discern an echo of Neolithic stones – a quality that recurred in Hepworth's work from the 1930s' carvings typified by *Three Forms* 1935 (no.9 q.v.) to the late bronze groups such as *Conversation with Magic Stones* 1973 (no.75 q.v.). The title of *Fallen Images* is also reminiscent of Paul Nash's 1930s' paintings of abstract forms in the landscape as substitutes for megaliths. Specifically, his *Mineral Objects* 1935 depicts two flat-topped cones, similar to those in *Fallen Images*, set on a Dorset beach.[12]

The geometric forms of *Fallen Images* are close to those of works such as *Cone and Sphere* 1973 in which the spherical element is similarly incised, and contrast with the irregularity of *One, Two, Three (Vertical)* 1974–5. Such simple marble shapes had been a feature of her carving for some years, being seen in such works as *Four Hemispheres* 1969.[13] That they would have persisted is demonstrated by the presence of three marble spheres in Hepworth's workshop at the time of her death. The formal purity that associates *Fallen Images* with the simple morphology of earlier carvings reveals an aspect of her late work in general. In keeping with the revival of interest in pre-war British modernism reflected in exhibitions such as the Marlborough Gallery's *Art in Britain 1930–40 Centred Around Axis, Circle, Unit One* in 1965, Hepworth's work had taken on a marked retrospective aspect during the 1960s. Symbolised by the publication of her *Pictorial Autobiography* in 1970, this was clearly demonstrated by *Conversation with Magic Stones* 1973 in which forms from the 1930s and the 1950s were reworked. The artist associated this quality with the 'liberation … [of] space and money and time to work on a much bigger scale … to fulfil many ideas that were around for a long, long time',[14] but it may also have been prompted by a heightened awareness of her own mortality. In 1965 she was diagnosed with cancer of the tongue and two years later Herbert Read, one of Hepworth's closest and oldest associates, died from the same complaint. That her renowned vitality was compromised by an ever-present awareness of death is illustrated by her comment to Ben Nicholson in 1969 that she did not 'expect to live for more than a week at a time'.[15] The effects of continued illness left Hepworth increasingly weak and by 1974–5 she was largely bed-ridden and dependent on the help of her assistants. It has been suggested that in *Fallen Images* 'Hepworth seems, quite possibly with a sense of finality, to be looking back to the serene abstract carvings of the mid-1930s'.[16] The elegiac tone of the work's title supports such a reading.

In 1969, Hepworth had told Nicholson that she had 'deliberately studied the photos of my early dreams of large works done in 1938–9 … This is not retrograde – it is for me,

a fulfilment of my life long ideas'.[17] Indeed, while the arrangement of white marble elements of *Fallen Images* recalls *Three Forms* 1935, the shapes and the scale of the work are closer to the lost *Project (Monument to the Spanish War)* 1938–9 (fig.8). Through a similar comparison, Hepworth had related her *Three Forms Vertical (Offering)* 1967 to the Vietnam War and it may be that *Fallen Images* was associated with the end of that conflict in January 1973.[18] In light of her nostalgic perspective, the pathos of the work may have a more personal dimension as well. In the recovery of the moment of 1930s, one may also see a reflection of her long-running sadness over the collapse of her relationship with Nicholson. Though divorced in 1951, the two had remained close friends until his remarriage in 1957 and departure for Switzerland the following year; they re-established contact in 1966 but, despite Nicholson's permanent return to Britain in 1971, they did not see each other before Hepworth died in May 1975. That her work was influenced by such a nostalgia is suggested by A.M. Hammacher shortly before she died; he wrote:

she was living in the past in a way that I had not seen in her before. She yielded unrestrainedly to unreal longings, their origins locked away in memories, and tried to imagine them as having a future. I can of course consider the output of those seven years (1968–75) in itself, but it is hard all the same to disregard that hidden struggle against the fatal process that was threatening her creative powers.[19]

Though highly emotive, it is unlikely that the title *Fallen Images* was intended as a specific allusion and it should probably not be interpreted literally. It does, nevertheless, imbue the sculpture with a melancholy tone, its conjunction hinting at disillusionment. It is noteworthy that the motif of the sphere echoes a similar object in the foreground of Dürer's *Melancholia I*, which, it has been suggested, may have influenced the form of the 'stones' in *Conversation with Magic Stones* 1973.[20] Despite the title's implication of randomness, the elements are carefully arranged. In this, the recovery of past formats and the use of a favourite material, one may also see *Fallen Images* as an assertion of Hepworth's continued belief in idealist values embodied in pure, carved abstract form.

Appendix A
Barbara Hepworth prints

Untitled 1958
P06249
Lithograph on handmade Barcham Green paper
image size 43.5 × 29.8 (16¾ × 11¾)
sheet size 65.4 × 44.3 (25¾ × 17½)
not inscribed
proof only
Published by St George's Gallery

Presented by Curwen Studio through the Institute of
Contemporary Prints 1975

Europaeische Graphik VI
Mixed suite of prints by various artists
Published by Galerie W. Ketterer for Felix Mann's
Europaeische Graphik VI, Munich
edition of 100, of which 1–35/100 on Japanese paper

Three Forms Assembling 1968–9
P06250
Lithograph on Japanese paper
image size 58.7 × 45.7 (23⅛ × 18)
sheet size 69.6 × 50.4 (27⅜ × 19⅞)
inscribed in pencil 'Barbara Hepworth' b.r.

Presented by Curwen Studio through the Institute of
Contemporary Prints 1975

12 Lithographs by Barbara Hepworth 1969
Suite of 12 lithographs on handmade Barcham Green
paper watermarked 'BH', some embossed 'CP' for
Curwen Prints
sheet size c.58.4 × c.81.3 (23 × 32)
Published by Curwen Prints 1969
'home' edition of 1– 60/60
'overseas' edition of x1 – x30/30
Tate Gallery copies unnumbered

Three Forms 1969
P06261
image size 45.7 × 59.7 (18 × 23½)
inscribed in pencil 'Barbara Hepworth' b.r.
sheet embossed 'CP' monogram b.l.

Oblique Forms 1969
P06255
image size 55.6 × 73 (21⅞ × 28¾)
inscribed in pencil 'Barbara Hepworth' b.l.
sheet embossed 'CP' monogram b.l.

Genesis 1969
P06253
image size 72.4 × 53.7 (28½ × 21⅛)
inscribed in pencil 'Barbara Hepworth' b.r.

Sun and Moon 1969
P06260
image size 74 × 55.6 (29⅛ × 22¼)
inscribed in pencil 'Barbara Hepworth' b.r.

Two Marble Forms (Mykonos) 1969
P06262
image size 73.7 × 48.3 (29 × 19)
inscribed in pencil 'Barbara Hepworth' b.r.
sheet embossed 'CP' monogram b.l.

Mycene 1969
P06254
image size 81 × 58.4 (31⅞ × 23)
inscribed in pencil 'Barbara Hepworth' b.r.
embossed quadrilateral enclosing image

Pastorale 1969
P06256
image size 71.1 × 51.1 (28 × 20⅛)
inscribed in pencil 'Barbara Hepworth' b.r.

Sea Forms 1969
P06258
image size 59.1 × 82.2 (23¼ × 32⅜)
inscribed in pencil 'Barbara Hepworth' b.r.
embossed diagonal lines

Squares and Circles 1969
P06259
image size 53.3 × 70.8 (21 × 27⅞)
inscribed in pencil 'Barbara Hepworth' b.r.

Argos 1969
P06251
image size 81.6 × 58.7 (32⅛ × 23⅛)
inscribed in pencil 'Barbara Hepworth' b.r.

Porthmeor 1969
P06257
image size 72.4 × 54 (28½ × 21¼)
inscribed in pencil 'Barbara Hepworth' b.r.

Autumn Shadows 1969
P06252
image size 76.5 × 56.2 (30⅛ × 22⅛)
inscribed in pencil 'Barbara Hepworth' b.r.

Presented by Curwen Studio through the Institute of
Contemporary Prints 1975

Opposing Forms 1970
Suite of 12 screenprints on Saunders mould-made
paper
sheet size c.58.4 × c.77.5 (23 × 30½)
Printed by Kelpra Studio Ltd., published by Marlborough
Graphics 1970
edition of 72, 1–60 and boxed set with watercolour
numbered I–XII
Tate Gallery copies unnumbered

Two Opposing Forms 1970
P04262
77.2 × 58.3 (30⅞16 × 22¹⁵⁄₁₆)
inscribed in pencil 'Barbara Hepworth' b.r.
stamped on back 'Chris and | Rose Prater | collection'
b.r., 'K' and '7376' b.r.

Winter Solstice 1970
P04264
77.4 × 58.5 (30½ × 23)
inscribed in pencil 'Barbara Hepworth' b.r.
stamped on back 'Chris and | Rose Prater | collection'
b.r., 'K' and '7374' b.r.

Two Ancestral Figures 1970
P04267
77.5 × 58.3 (30½ × 22¹⁵⁄₁₆)
inscribed in pencil 'Barbara Hepworth' b.r.
stamped on back 'Chris and | Rose Prater | collection'
b.l., 'K' and '7381' b.r.

November Green 1970
P04261
77.3 × 58.4 (30⁷⁄₁₆ × 23)
inscribed in pencil 'Barbara Hepworth' b.r.
stamped on back 'Chris and | Rose Prater | collection'
b.l., 'K' and '7378' b.l.

Rangatira I 1970
P04268
77.5 × 58.2 (30 1/2 × 22¹⁵⁄₁₆)
inscribed in pencil 'Barbara Hepworth' b.r.
stamped on back 'Chris and | Rose Prater | collection'
b.r., 'K' and '7380' b.r.

High Tide 1970
P04260
77.3 × 58.4 (30⁷⁄₁₆ × 23)
inscribed in pencil on image 'Barbara Hepworth' b.r.
stamped on back 'Chris and | Rose Prater | collection'
b.r., 'K' and '7383' b.r.

Rangatira II 1970
P01414
77.5 × 58.3 (30½ × 22¹⁵⁄₁₆)
inscribed in pencil 'Artists copy' b.l. and 'Barbara
Hepworth' b.r.; stamped on back 'K' and '7379' b.r.

Assembly of Square Forms 1970
P04257
77.3 × 58.4 (30⁷⁄₁₆ × 23)
inscribed in pencil 'Barbara Hepworth' b.r.
stamped on back 'K' and '7377' b.r.

December Forms 1970
P04258
77.7 × 58.3 (30⅝ × 22¹⁵⁄₁₆)
inscribed in pencil 'Barbara Hepworth' b.r.
stamped on back 'Chris and | Rose Prater | collection'
b.l., 'K' and '7384' b.r.

Forms in a Flurry 1970
P04259
77.4 × 58.5 (30½ × 23)
inscribed in pencil 'Barbara Hepworth' b.r.
stamped on back 'Chris and | Rose Prater | collection'
b.r., 'K' and '7382' b.r.

Orchid 1970
P04263
58.2 × 77.5 (22¹⁵⁄₁₆ × 30½)
inscribed in pencil 'Barbara Hepworth' b.r.; stamped on
back 'Chris and | Rose Prater | collection' t.l., 'K' and
'7373' b.r.

Three Forms 1970
P04266
77.5 × 58.0 (30½ × 22⅞)
inscribed in pencil 'Barbara Hepworth' b.r.
stamped on back 'Chris and | Rose Prater | collection'
b.r., 'K' and '7375' b.r.

Rangatira II presented by the artist through the Institute
of Contemporary Prints 1975; the remainder presented
by Rose and Chris Prater through the Institute of
Contemporary Prints 1975

Winter Solstice 1971
P04269
Screenprint on paper
30.5 × 25.4 (12 × 10)
inscribed in pencil 'Barbara Hepworth' b.r.
Edition of 150, issued with the de luxe edition of Alan
Bowness (ed.), *The Complete Sculpture of Barbara
Hepworth 1960–69*, 1971
Published by Marlborough Graphics 1971

Presented by Rose and Chris Prater through the
Institute of Contemporary Prints 1975

The Aegean Suite 1971
Suite of 9 lithographs on handmade
Barcham Green paper watermarked 'BH'
sheet size c.58.4 × c.81.3 (23 × 32)
Published by Curwen Prints 1971
'home' edition of 1– 60/60
'overseas' edition of x1 – x30/30
Tate Gallery copies unnumbered

Cool Moon 1971
P06263
image size 81.4 × 58.2 (32¹/₁₆ × 22¹⁵/₁₆)
inscribed in pencil 'Barbara Hepworth' b.r.

Delos 1971
P06264
image size 76.7 × 54.5 (30³/₁₆ × 21½)
inscribed in pencil 'Barbara Hepworth' b.r.

Desert Forms 1971
P06265
image size 76.9 × 54.3 (30¼ × 21⅜)
inscribed in pencil 'Barbara Hepworth' b.r.; sheet
embossed 'CP' monogram b.l.
semi-circles of image embossed from behind

Sun and Marble 1971
P06271
image size 76.8 × 54.3 (30¼ × 21⅜)
inscribed in pencil 'Barbara Hepworth' b.r.

Sun and Water 1971
P06269
image size 76.5 × 54.6 (30⅛ × 21½)
inscribed in pencil 'Barbara Hepworth' b.r.

Itea 1971
P06267
image size 54.4 × 76.5 (21⁷/₁₆ × 30⅛)
inscribed in pencil 'Barbara Hepworth' b.r.

Fragment 1971
P06266
image size 77.6 × 51.5 (30⁹/₁₆ × 20¼)
inscribed in pencil 'Barbara Hepworth' b.r.

Sun Setting 1971
P06270
image size 75.6 × 54.5 (29¾ × 21½)
inscribed in pencil 'Barbara Hepworth' b.r.

Olympus 1971
P06268
image size 76.4 × 54.3 (30⅛ × 21⅜)
inscribed in pencil 'Barbara Hepworth' b.r.

Presented by Curwen Studio through the Institute of
Contemporary Prints 1975

Green Man 1972
P04270
Screenprint on paper 76.4 × 56.7 (30⅛ × 22⅜)
image size 67.3 × 49.8 (26½ × 19 5/8)
inscribed in pencil 'Barbara Hepworth' b.r.
stamped on back 'Chris and | Rose Prater | collection'
b.l., 'K' and '8015' b.r.
Published by Cercle Graphic Européen for the Erasmus
Foundation, The Netherlands
Edition of 200

Presented by Rose and Chris Prater through the
Institute of Contemporary Prints 1975

Moon Plan 1972
P04271
Screenprint on paper 76.2 × 56.2 (30 × 22⅛)
inscribed in pencil 'Barbara Hepworth' b.r.
Published by Cercle Graphic Européen for the Erasmus
Foundation, The Netherlands
Edition of 200

Presented by Rose and Chris Prater through the
Institute of Contemporary Prints 1975

Kestor Rock, Gleaming Stone 1973
P01415
Two lithographs on paper 32 × 41.1 (12⅝ × 16³/₁₆)
each image size 31.8 × 20.3 (12½ × 8)
inscribed under each image 'Barbara Hepworth' b.l.
Published by Rougemont Press, Exeter, as illustrations
for Paul Merchant, Stones, Exeter 1973
Edition of 150, 1–75 signed by both artist and author

Presented by the artist through the Institute of
Contemporary Prints 1975

Penwith Portfolio 1973
Mixed portfolio of 11 lithographs on paper in aid of the
Penwith Gallery, St Ives
other artists: Robert Adams, Alan Davie, Merlyn Evans,
Duncan Grant, Peter Lanyon, Bernard Leach, F.E.
McWilliam, Henry Moore, Ben Nicholson, Michael
Rothenstein
Edition of 90, 12 hors commerce
Published by Penwith Society 1973

Moon Landscape 1973
P01416
Lithograph on Saunders mould-made paper
sheet size 58.6 × 81.4 (23⅛ × 32¹/₁₆)
image size 51.4 × 47.3 (20¼ × 18⅝)
inscribed 'Artists copy' b.l. and 'Barbara Hepworth' b.r.

Presented by the artist through the Institute of
Contemporary Prints 1975

The impetus for Barbara Hepworth to
experiment with printmaking came from
outside. In 1958, in a collaborative venture
between Robert Erskine of the St George's
Gallery and the Curwen Press – which, as the
Curwen Studio, was establishing printmaking
facilities for artists – Stanley Jones started a
'pilot scheme' in a studio in St Ives. This
encouraged experiments by artists including
Ben Nicholson, Peter Lanyon and Patrick
Heron.[1] It was there that Hepworth made her
lithograph Untitled 1958. Jones recalled her
'making two small editions of prints' and
another lithograph is known in proof form.[2] It
was not until 1966 that this activity was
resumed. Curwen's manager Herbert Simon
wrote to the sculptor of printmaking as a way
for 'people of modest means to own
something by Barbara Hepworth', adding of
lithography in particular: 'I suspect you would
enjoy working on stone'.[3] In late 1968, Stanley

Jones spent a fortnight working with
Hepworth in St Ives; he recalled
experiments ranging from 'a novel
combination of drawn zinc plates with "blind
embossing" to the use of painted washes
done on a grained film'. Plastic films remain in
the artist's studio. Embossing is evident on
Mycene, where the image is contained within
a quadrilateral, and Sea Forms, which has
embossed diagonals crossing the whole
sheet. Jones prepared the plates in London
and proofed them for the artist's adjustments
before publishing the edition in 1969 as 12
Lithographs by Barbara Hepworth.[4] The
single print, Three Forms Assembling, dates
from the same moment. Their success was
such that a similar exercise for the Aegean
Suite soon followed; Jones travelled to
Cornwall in October 1970 and took the edition
in June 1971. This second suite explored
'ideas on which she was currently working in
sculpture'.[5]

In the period between the two suites of
lithographs, Hepworth made a set of
screenprints – Opposing Forms – with Chris
Prater which was published by Marlborough
Fine Art, her new dealers. It has been
acknowledged that the nuances were better
suited to lithography and demanded
laborious and ingenious transformation by
Prater, as 'it required ten printings in green,
seven in brown, and three greys to interpret
just the uneven pressure of a pencil line'.[6]
Further isolated screenprints – Winter
Solstice, Green Man and Moon Plan –
emerged from this project. Three years later,
Hepworth also contributed the lithograph
Moon Landscape to the portfolio published in
aid of the Penwith Gallery, St Ives.

Appendix B
John Skeaping
Fish c.1930

T 06548

Brown iron stone on green serpentine base 14.4 × 27.4 × 4.1 (5¹¹⁄₁₆ × 10¾ × 1⅝); weight 2.1 kg

Purchased from Nicholas Skeaping 1992

Provenance: F.W. Bravington, 1930s, given to Ruben Lall, c.1960; from whom purchased by R.J. Smith, c.1960–5; by whom sold to Nicholas Skeaping, 1991

Exhibited: *Carving Mountains: Modern Stone Sculpture in England 1907–37*, Kettle's Yard, Cambridge, March–April 1998, De la Warr Pavilion, Bexhill-on-Sea, May–June (46, repr. p.68)

*F*ish was acquired as a work by Barbara Hepworth but has since been attributed to her first husband John Skeaping. Such confusion exemplifies the stylistic and technical proximity of the artists' work at the time. The material in which it was carved links it to holidays spent at Happisburgh, Norfolk, in the summers of 1930 and 1931. Henry Moore was among those who joined Hepworth and Skeaping on both occasions. As the latter recalled:

> Henry, Barbara and I used to pick up large iron-stone pebbles on the beach which were ideal for carving and polished up like bronze. … Henry accompanied me on one of my fishing trips but he couldn't leave sculpture alone for long and took with him a piece of iron-stone and a rasp. Sitting at one end of the boat he filed away continuously.[1]

The pebbles were free, and were suitable for direct carving while away from the studio. In late 1931, Hepworth indicated the quantity collected when she told Ben Nicholson that she had gathered 'all the brown stones up from the beach of mine and Harry's, and packed up 4 large crates' to be sent to London.[2]

Iron stone is so called because of its colour rather than its hardness and, as Skeaping's account suggests, it is relatively easily worked. The comparatively rare sculptural subject of *Fish* may have derived from simple association with the seaside, but it is notable that Skeaping and Hepworth had visited Jim Ede on 21 June 1928 who had just bought Brancusi's *Poisson d'Or* 1924.[3] As distinct from Brancusi's streamlined brass, the organic form of the pebble remains perceptible in the slight undulation through the length of the iron stone. Other details were largely confined to the profile. The ripples of the fins were carried into the body by filing into the mass and through the incision of lines, four on the upper fin on the left side and seven on the lower fin on the right. The left side of the tail and the right gill also have defining lines. A notch was cut for the mouth and extended as a slit on the right side. While the left eye has a shallow but crisply incised circle, the right circle is broader, deeper and less precise. This asymmetry is consistent with a prevalent abstraction still rooted in nature.

Fish has suffered from extensive damage. A major break across the area of the gills was

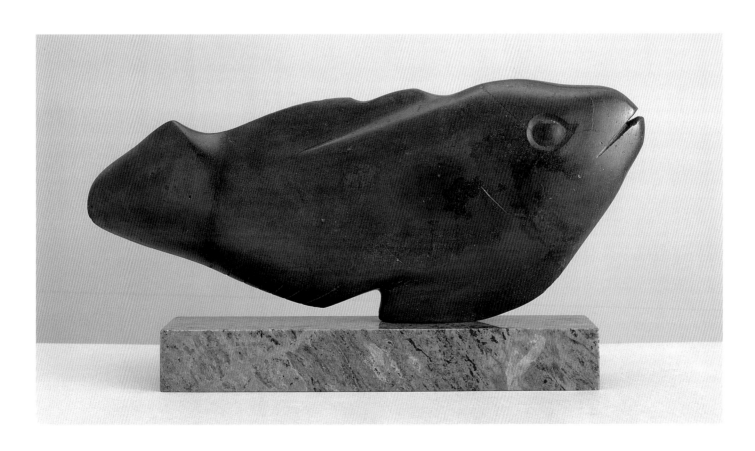

associated with a network of cracks. A crude repair left the head and body slightly misaligned. When examined in 1992, it was found that the epoxy adhesive – applied sometime between 1959 and 1980 – had bonded into the structure of the stone and resisted efforts to dissolve it. As physical removal threatened to damage the already delicate edges, this area was overfilled with pigmented resin. The tail had also been broken off but not repaired. It was fixed with adhesive and filled with the same resin. Smaller blemishes to the body – chips at the mouth and off the top fin, a scratch along the right side – were similarly treated; the surface, discoloured by the adhesive, was coated with wax.[4]

Its condition testifies to the sculpture's long period of neglect. It resurfaced in the wake of the Skeaping retrospective and was bought by the sculptor's son.[5] At that time it was attributed to Barbara Hepworth, and acquired by the Tate as her work.[6] The attribution rested on the fact that she showed an iron stone *Fish* both in her exhibition with Skeaping in 1930 and that with Nicholson two years later.[7] That work was listed – without a photograph, but noted as '9 inches long' – as BH 31 in her catalogue of works, and subsequently noted as lost.[8] In 1995, research amongst her papers revealed that the dealer Thomas Gibson had contacted both sculptors in 1973 in an effort to identify the author of the *Fish* then owned by R.J. Smith. Although made hesitant by the Tooth's listing, Hepworth had 'a strong feeling that this is John Skeaping's work' and vaguely recalled hers as 'quite a smooth carving at the top and underneath'.[9] For his part, Skeaping – who kept no records of his work – replied that she was 'right in suggesting that the work was one of mine'.[10] This was apparently unequivocal and Smith retained the work. The family of the first owner have only been able to confirm that F.W. Bravington collected work by both sculptors.

The stone compounded the confusion. Skeaping 'worked quite a lot in iron stone at that period' and four examples were exhibited in 1930, including *Stag* and *Duck*.[11] As well as her *Fish*, Hepworth included in the 1930 joint exhibition a half figure *Carving* in iron stone which flattened and reversed the pose of *Figure of a Woman* 1929–30 (no.3 q.v.).[12] Moore also made iron stone figures, including *Mother and Child* 1930 and, like Hepworth, would use the stone again for incised abstract pieces in 1934.[13] The styles and themes shared by all three in 1930–1 prove difficult to disentangle, especially within the confines of this particular material. However, the divergence between Hepworth's and Moore's inclination towards abstraction from the human figure and Skeaping's reputation as an animalier serves to reinforce his recognition of *Fish* as his work.

Abbreviations

Exhibitions and publications are listed chronologically.

Exhibition venue and place of publication is London unless otherwise stated.

AC Arts Council

AIA Artists International Association

BC British Council

CAS Contemporary Art Society

HRA Sir Herbert Read Archive, McPherson Library, University of Victoria, British Columbia

ICA Institute of Contemporary Arts

MOMA Museum of Modern Art, New York

RA Royal Academy

TGA Tate Gallery Archive

One-Person and Joint Exhibitions

Beaux Arts 1928: *Sculpture, Engravings and Drawings by Barbara Hepworth, William Morgan, John Skeaping*, Beaux Arts Gallery, June 1928

Glasgow 1928: *Sculpture, Drawings and Drypoints by John Skeaping and Barbara Hepworth and Engravings and Drawings by William E.C. Morgan*, Alex Reid and Lefevre, Glasgow, Sept. 1928

Tooth's 1930: *Sculpture by John Skeaping and Barbara Hepworth*, Arthur Tooth & Sons, Oct.–Nov. 1930

Lefevre 1933: *Barbara Hepworth, Ben Nicholson*, Alex Reid and Lefevre, Oct.–Nov. 1933

Lefevre 1937: *Sculpture by Barbara Hepworth*, Alex Reid and Lefevre, Oct. 1937

Leeds 1943: *Exhibition of Paintings, Sculpture and Drawings by Paul Nash and Barbara Hepworth*, Temple Newsam, Leeds, April–June 1943

Wakefield & Halifax 1944: *Sculpture and Drawings by Barbara Hepworth*, Wakefield City Art Gallery, Feb.–March 1944, Bankfield Museum, Halifax, March–April 1944

Lefevre 1946: *Barbara Hepworth: Sculpture and Drawings*, Lefevre Gallery, Oct. 1946

Lefevre 1948: *Paintings by Barbara Hepworth, Paintings by L.S. Lowry*, Lefevre Gallery, April 1948

New York 1949: *Barbara Hepworth*, Durlacher Bros, New York, Oct. 1949

Lefevre 1950: *New Sculpture and Drawings by Barbara Hepworth*, Lefevre Gallery, Feb. 1950

Venice Biennale 1950: *John Constable, Matthew Smith, Barbara Hepworth*, British Pavilion XXV Venice Biennale, June–Oct. 1950

Wakefield, York & Manchester 1951: *Barbara Hepworth: Sculpture and Drawings*, Wakefield City Art Gallery, May–July, York City Art Gallery, July–Aug., Manchester City Art Gallery, Sept.–Oct.

Lefevre 1952: *New Sculpture and Drawings by Barbara Hepworth*, Lefevre Gallery, Oct. 1952

Whitechapel 1954: *Barbara Hepworth: A Retrospective Exhibition of Carvings and Drawings from 1927–1954*, Whitechapel Art Gallery, April–June 1954

North American tour 1955–6: *Barbara Hepworth: Carvings and Drawings 1937–54*, North American tour organised by Martha Jackson Gallery, New York, 1955–6, Walker Art Center, Minneapolis, April–May 1955, University of Nebraska Art Galleries, June–Aug., San Francisco Museum of Art, Sept.–Oct., Albright Art Gallery, Buffalo, Nov.–Dec., Art Gallery of Toronto, Jan.–Feb. 1956, Montreal Museum of Fine Arts, March, Baltimore Museum of Art, April–June 1956

Gimpel Fils 1956: *Recent Works by Barbara Hepworth*, Gimpel Fils, June 1956

Newcastle 1956: *Barbara Hepworth, Ben Nicholson*, Hatton Gallery, Newcastle upon Tyne, Dec. 1956

New York 1956–7: *Barbara Hepworth: Sculpture, Paintings, Drawings*, Martha Jackson Gallery, New York, Dec. 1956–Jan. 1957

Gimpel Fils 1958: *Recent Works by Barbara Hepworth*, Gimpel Fils, June 1958

São Paolo Bienal 1959: *Paintings by Francis Bacon, Paintings & Etchings by S.W. Hayter, Sculpture & Drawings by Barbara Hepworth*, V Bienal do Museu de Arte Moderna São Paolo, Sept.–Dec. 1959

New York 1959: *Hepworth*, Galerie Chalette, New York, Oct.–Nov. 1959

BC South American tour 1960: *Barbara Hepworth*, BC tour of South America, Comisión National de Bellas Artes, Montevideo, Apr.–May 1960, Museo Nacional de Bellas Artes, Buenos Aires, May–June, Instituto de Arte Moderno, Santiago, Sept.–Oct., Museo de Bellas Artes, Viña del Mar (Chile), Oct., Museo de Bellas Artes, Caracas, Nov. 1960

Zurich 1960: *Barbara Hepworth*, Galerie Charles Lienhard, Zurich, Oct. 1960

Gimpel Fils 1961: *Barbara Hepworth*, Gimpel Fils, May–June 1961

Belfast 1962: *'Abstract Form and Life': Sculpture by Barbara Hepworth and Biological Models*, Queens University of Belfast, April 1962

Whitechapel 1962: *Barbara Hepworth: An Exhibition of Sculpture from 1952–1962*, Whitechapel Art Gallery, May–June 1962

John Lewis 1963: *Barbara Hepworth: Sculpture and Drawings*, John Lewis Partnership, Oxford Street, April 1963

Zurich 1963–4: *Barbara Hepworth: Sculpture and Drawings*, Gimpel & Hanover Galerie, Zurich, Nov. 1963–Jan. 1964

Toronto 1964: *Barbara Hepworth*, Toronto Art Gallery, March 1964

Gimpel Fils 1964: *Barbara Hepworth: Sculpture and Drawings*, Gimpel Fils, June 1964

BC European tour 1964–6: *Barbara Hepworth*, BC European tour, 1964–6, Kunstforeningen, Copenhagen, Sept.–Oct. 1964, Moderna Museet, Stockholm, Nov.–Dec., Ateneum, Helsinki, Jan.–Feb. 1965, Utstilling I Kunstnernes Hus, Oslo, March, Rietveld Pavilion, Rijksmuseum Kröller-Müller, Otterlo, May–July (expanded version), Kunsthalle, Basel, Sept.–Oct., Galleria Civica d'Arte Moderna, Turin, Oct.–Nov., Badischer Kunstverein, Karlsruhe, Feb.–March 1966, Museum Folkwang, Essen, April–June

Gimpel Fils 1966: *Barbara Hepworth*, Gimpel Fils, May–June 1966

New York 1966: *Barbara Hepworth*, Marlborough-Gerson Inc., New York, April–May 1966

Tate 1968: *Barbara Hepworth*, Tate Gallery, April–May 1968

Conferment 1968: *Exhibition on the Occasion of the Conferment of the Honorary Freedom of the Borough of St Ives on Bernard Leach and Barbara Hepworth*, St Ives Guildhall, public library and parish churchyard, Sept.–Oct. 1968 (no cat.)

New York 1969: *Barbara Hepworth*, Gimpel Gallery, New York, April–May 1969

Marlborough 1970: *Barbara Hepworth: Recent Work: Sculpture, Paintings, Prints*, Marlborough Fine Art, Feb.–March 1970

Plymouth 1970: *Barbara Hepworth*, Plymouth City Art Gallery, June–Aug. 1970

Hakone 1970: *Barbara Hepworth Exhibition, 1970*, Hakone Open-Air Museum, Japan, June–Sept. 1970

AC tour 1970–1: *Barbara Hepworth: Sculpture and Lithographs*, AC tour 1970–1, Abbotsholme, Uttoxeter, Jan.–Feb. 1970, Ashmolean Museum, Oxford, Feb.–March, Castle Museum, Nottingham, March–April, Manor House Art Gallery and Museum, Ilkley, April–May, Scottish National Gallery of Modern Art, Edinburgh, May, Belgrade Theatre, Coventry, June, Shrewsbury Art Gallery, July, Letchworth Museum and Art Gallery, Aug., Kettering Art Gallery, Aug.–Sept., National Museum of Wales, Cardiff, Sept.–Oct., Ede Gallery, Cambridge, Oct.–Nov., Towner Art Gallery, Eastbourne, Nov.–Dec., Southampton Art Gallery, Dec. 1970–Jan. 1971

New York 1971: *Barbara Hepworth*, Gimpel Gallery, New York, March–April 1971

Austin 1971: *Barbara Hepworth*, University of Texas Art Museum, Austin, Sept. 1971

Gimpel Fils 1972: *Barbara Hepworth*, Gimpel Fils, Oct.–Nov. 1972

Marlborough 1972: *Barbara Hepworth: The Family of Man – Nine Bronzes and Recent Carvings*, Marlborough Fine Art, April–May 1972

Folkestone 1974: *The Artist and the Book in France from Matisse to Vasarely and Barbara Hepworth Sculpture and Lithographs*, New Metropole Arts Centre, Folkestone, Dec. 1974–Feb. 1975

New York 1974: *Barbara Hepworth: 'Conversations'*, Marlborough Gallery, New York, March–April 1974

Zurich 1975: *Barbara Hepworth 1903–1975*, Marlborough Galerie, Zurich, Aug.–Oct. 1975

Gimpel Fils 1975: *Barbara Hepworth 1903–75*, Gimpel Fils, Oct.–Nov. 1975

Edinburgh 1976: *Barbara Hepworth: Late Works*, Edinburgh Festival Society, Royal Botanic Gardens, Edinburgh, Aug.–Sept. 1976

New York 1977: *Hepworth*, Gimpel and Weitzenhoffer, New York, March–April 1977

AC Scottish tour 1978: *Barbara Hepworth: A Selection of Small Bronzes and Prints*, Scottish Arts Council tour, Scottish College of Textiles, Galashiels, April–May 1978, Inverness Museum and Art Gallery, June, Dundee Museum and Art Gallery, Sept., Lillie Art Gallery, Milngavie, Sept.–Oct., Hawick Museum and Art Gallery, Oct.–Nov., Maclaurin Art Gallery, Ayr, Nov.–Dec. 1978

Osaka 1978: *Barbara Hepworth*, Gallery Kasahara, Osaka, Feb.–March 1978

Marlborough 1979: *Barbara Hepworth: Carvings and Bronzes,* Marlborough Gallery, London and Marlborough Gallery, New York, May–June 1979

Bretton Hall 1980: *Barbara Hepworth*, Yorkshire Sculpture Park, Bretton Hall, Wakefield, July–Oct. 1980

Washington 1981: *Barbara Hepworth from the Museum Collection*, Hirshhorn Museum and Sculpture Garden, Smithsonian Institution, Washington DC, April–July 1981

Wales & Isle of Man 1982–3: *Barbara Hepworth: A Sculptor's Landscape 1934–74*, Glynn Vivian Art Gallery and Museum, Swansea, Oct.–Nov. 1982, Bangor Art Gallery, Nov.–Dec., Wrexham Library Art Centre, Dec. 1982–Jan. 1983, Manx Museum, Isle of Man, Feb. 1983

New Art Centre 1987: *Barbara Hepworth: Ten Sculptures 1951–73*, New Art Centre, Nov. 1987–Jan. 1988

Canada 1991–2: *Barbara Hepworth: The Art Gallery of Ontario Collection*, tour of Canada, Art Gallery of Algoma, Sault Ste. Maria, Aug.–Sept. 1991, Thunder Bay Art Gallery, Oct.–Nov., Thames Art Gallery, Chatham Cultural Centre, Dec. 1991–Jan. 1992, Rodman Hall Arts Centre, St Catherine's, Feb.–March, Art Gallery of Northumberland, Cobourg, April–May 1992

Retrospective 1994–5: *Barbara Hepworth: A Retrospective*, Tate Gallery Liverpool, Sept.–Dec. 1994, Yale Center for British Art, New Haven, Feb.–April 1995, Art Gallery of Ontario, Toronto, May–Aug. 1995

New York 1996: *Barbara Hepworth: Sculptures from the Estate*, Wildenstein, New York, Oct.–Nov. 1996

Publications

Unit One 1934: Herbert Read (ed.), *Unit One: The Modern Movement in English Architecture, Painting and Sculpture*, 1934

Circle 1937: J.L. Martin, Ben Nicholson and Naum Gabo (eds.), *Circle: International Survey of Constructive Art*, 1937, reprinted 1971

Gibson 1946: William Gibson, *Barbara Hepworth: Sculptress*, 1946

Read 1952: Herbert Read, *Barbara Hepworth: Carvings and Drawings*, 1952

Hammacher 1959: A.M. Hammacher, *Barbara Hepworth*, 1959

Hodin 1961: J.P. Hodin, *Barbara Hepworth*, Neuchâtel and London 1961

Shepherd 1963: Michael Shepherd, *Barbara Hepworth*, 1963

C, F & B 1964: Mary Chamot, Dennis Farr and Martin Butlin, *Tate Gallery: The Modern British Paintings, Drawings and Sculpture*, I, 1964

Bowness 1966: Alan Bowness, *Barbara Hepworth: Drawings from a Sculptor's Landscape*, 1966

Hammacher 1968/1987: A.M. Hammacher, *Barbara Hepworth*, 1968, rev. ed. 1987

Pictorial Autobiography 1970: *Barbara Hepworth: A Pictorial Autobiography*, 1970, rev. ed. 1978

Bowness 1971: Alan Bowness (ed.), *The Complete Sculpture of Barbara Hepworth 1960–69*, 1971

Gardiner 1982: Margaret Gardiner, *Barbara Hepworth: A Memoir*, Edinburgh 1982

Jenkins 1982: David Fraser Jenkins, *Barbara Hepworth: A Guide to the Tate Gallery Collection at London and St Ives, Cornwall*, 1982

Festing 1995: Sally Festing, *Barbara Hepworth: A Life of Forms*, Harmondsworth 1995

Thistlewood 1996: David Thistlewood (ed.), *Barbara Hepworth Reconsidered*, Liverpool 1996

Curtis 1998: Penelope Curtis, *St Ives Artists: Barbara Hepworth*, 1998

Tate Gallery Acquisitions: *Tate Gallery* [years]; *Illustrated Catalogue of Acquisitions*

Tate Gallery Report: *Tate Gallery* [years]; *Illustrated Biennial Report*

Notes

Introduction

1 Letter to Ben Nicholson, n.d. [?July/ Sept. 1932], TGA 8717.1.1.97.

2 See Penelope Curtis, 'Barbara Hepworth and the Avant Garde of the 1920s' in *Retrospective* 1994–5, exh. cat., pp.11–28; see Abbreviations for the key to texts and exhibitions to which reference has been made.

3 Read 1952, section 1.

4 Curtis 1944–5, p.12; Prix de Rome entry, location unknown, maquette repr. *British Artists in Italy 1920–80*, exh. cat., Herbert Read Gallery, Canterbury 1985, p.7, ill.3.

5 John Skeaping, *Drawn from Life: An Autobiography*, 1977, p.70; their relationship is placed earlier and in England in Leo Walmsley, *So Many Loves*, 1944, 2nd ed. 1947, pp.269–70.

6 Read 1952, section 1; see also Skeaping 1977, pp.69, 71–2.

7 Beaux Arts 1928; Glasgow 1928; Tooth's 1930.

8 John Grierson, 'The New Generation in Sculpture', *Apollo*, vol.12, no.71, Nov. 1930, p.349.

9 They contributed to *London Group Exhibition of Open-Air Sculpture*, Selfridge's Roof Garden, June–Aug. 1930, and *London Group*, New Burlington Galleries, Oct. 1931.

10 Jeremy Lewison, *Ben Nicholson*, exh. cat., Tate Gallery, 1993, p.36 n.21.

11 Letter to Ben Nicholson, postmarked 14 Aug. 1931, TGA 8717.1.1.46.

12 *Carvings by Barbara Hepworth, Paintings by Ben Nicholson*, Arthur Tooth and Sons', Nov.–Dec 1932; Lefevre 1933

13 Letter to E.H. Ramsden, 4 April 1943, TGA 9310.

14 Letter to Nicholson, postmarked 27 Dec. 1932, TGA 8717.1.1.125.

15 Alan G. Wilkinson, 'The 1930s: "Constructive Forms and Poetic Structure"' in *Retrospective* 1994–5, exh. cat., p.45.

16 Lewison 1993, p.241; their work appeared in the 1934 and 1935 issues of *Abstraction-Création: art non figuratif*.

17 Lewison 1993, pp.242–3.

18 *Unit One* 1934.

19 *Abstract and Concrete: An Exhibition of Abstract Painting and Sculpture, 1934 & 1935*, 41 St Giles, Oxford, Liverpool, Cambridge, Alex Reid & Lefevre, London, Feb.–June 1936.

20 'Editorial', *Circle* 1937, p.v.

21 Lefevre 1937.

22 Leeds 1943; Wakefield & Halifax 1944.

23 Gibson 1946; Lefevre 1946; 'Approach to Sculpture', *Studio*, vol.132, no.643, Oct. 1946, pp.97–101.

24 Letter to Herbert Read, 12 Jan. [1943], HRA; see also Penelope Curtis, 'What is Left Unsaid' in Thistlewood 1996, p.158.

25 New York 1949; Lefevre 1950.

26 Wakefield, York & Manchester 1951; Whitechapel 1954; *Electra*, Old Vic Theatre, 1951; *The Midsummer Marriage*, Royal Opera House, Covent Garden, 1955.

27 Read 1952, Preface, p.vii.

28 'Geometry of Fear' in Herbert Read, 'New Aspects of British Sculpure', *Works by Sutherland, Wadsworth, Adams, Armitage, Butler, Chadwick, Clark, Meadows, Moore, Paolozzi, Turnbull*, exh. cat., British pavilion, XXVI Venice Biennale, 1952.

29 Various artists worked for her on an ad hoc basis, and it has been suggested that Peter Lanyon was an early assistant. More permanent assistants were: John Wells (?1949–1950–1), Denis Mitchell (1949–59), Terry Frost (1950–2), Owen Broughton (1951), John Milne (1952–4), Roger Leigh (1952–4, 1957), Brian Wall (1955–60), Keith Leonard (1955–9), Tom Pearce (1959–61), Breon O'Casey (1959–62), Michael Broido (1959–62), Dicon Nance (1959–71), Tommy Rowe (1958–62 as student, 1962–4), Norman Stoker (1962–75), Angela Conner (1963), George Wilkinson (1964–75).

30 Bowness 1971, p.7.

31 North American tour 1955–6; New York 1959; Zurich 1960.

32 Hodin 1961.

33 Whitechapel 1962; BC European tour 1964–6.

34 See Penelope Curtis, 'A Chronology of Public Commissions' in *Retrospective* 1994–5, exh. cat., p.152.

35 Bowness 1966.

36 Letter to Herbert Read, 29 June 1965, HRA.

37 Hammacher 1968/1987; Bowness 1971.

38 Hammacher 1968/1987, p.193.

39 The display includes preparatory plasters which are not included in the present catalogue. In the greenhouse: the plaster for the bronze *Sea Form (Porthmeor)* 1958, BH 249 (no.48 q.v.), the aluminium and plaster model for the bronze *Square Forms (Two Sequences)* 1963–4, BH 331, the plaster for the bronze

The Family of Man: Figure 8, The Bride 1970, BH 513; in the plaster studio: the plaster for *Variation on a Theme* 1958, BH 248 and related to *Garden Sculpture (Model for Meridian)* 1958 (no.46 q.v.), the plaster for the bronze version of the wooden *Oval Sculpture (Delos)* 1955, BH 201 (unfinished).

40 Statement, *Unit One* 1934, pp.19,20.

41 Kineton Parkes, *The Art of Carved Sculpture*, I, 1931, p.13.

42 E.g. Herbert Read, *Art and Society*, 1936, 2nd ed. 1945

43 'Sculpture', *Circle* 1937, p.116.

44 Letter to J.D. Bernal, undated [1937–9], Bernal Archive, University of Cambridge, Add: 8287/384.

45 Brian Wall, interview with the authors, 3 May 1996.

46 On Moore's membership: Gardiner 1982, p.50, though see denial in Roger Berthoud, *The Life of Henry Moore*, 1987, p.144.

47 Gardiner 1982, p.51.

48 Dartington School archive.

49 Statement, *Unit One* 1934, p.20.

50 J.P. Hodin, 'Barbara Hepworth and the Mediterranean Spirit', *Marmo*, no.3, 1963, p.65.

51 Winifred Nicholson, 'Paris in the 1920s and 1930s', Andrew Nicholson (ed.), *Unknown Colour: Paintings, Letters, Writings by Winifred Nicholson*, 1987, p.105.

52 *World Review*, from June 1941; twenty-one of the early articles republished as J.R.M. Brumwell (ed.), *This Changing World*, 1944.

53 William Beveridge, *Social Insurance and Allied Services*, 1942.

54 Herbert Read, 'A Nest of Gentle Artists', *Apollo*, vol.76, no.7, Sept. 1962, pp.536–8.

55 Letter to Read, 8 April [1942], HRA.

56 Adrian Stokes, 'Miss Hepworth's Carving', *Spectator*, 3 Nov. 1933, reprinted in Lawrence Gowing (ed.), *The Critical Writings of Adrian Stokes*, I, 1978, pp.309–10; Alex Potts, 'Carving and the Engendering of Sculpture: Adrian Stokes on Barbara Hepworth' and Anne M. Wagner, 'Miss Hepworth's Stone *Is a Mother*' in Thistlewood 1996, pp.43–74.

57 See Phyllis Bottome, *Alfred Adler: Apostle of Freedom*, 1939.

58 Letters to Herbert Read, HRA; Herbert Read, 'Psychoanalysis and the Critic', *Criterion*, vol.3, 1932, pp.214–30; *Education Through Art*, 1943; Read was the editor of *The Collected Works of C.G. Jung*, 1953–75.

59 *Gumfrey*, Royal College of Art student magazine, 1925.

60 Herbert Read, *Art and Society*, 1936, rev. ed. 1945.

61 Most famously in W.G. Hoskins, *The History of the English Landscape*, 1955.

62 Read 1952, section 4.

63 Ibid.

64 See, for example, Introduction to Rainer Maria Rilke, *Duino Elegies*, trans. J.B. Leishman and Stephen Spender, 1939, p.18.

65 Bowness 1971, pp.14–15.

66 Read 1952, section 6.

67 d'Arcy Wentworth Thompson, *On Growth and Form*, 1911, 2nd ed. Cambridge 1942; Rudolf Arnheim, *Art and Visual Perception*, 1954.

68 Recorded in Edwin Mullins, Hakone 1970, exh. cat., unpag.; Eugen Herriger, *Zen and the Art of Archery*, trans. R.F.C. Hull, 1953.

69 Membership papers, TGA 965.

70 Letter to Herbert Read, 4 Dec. [1956], HRA.

71 Bowness 1971, p.13.

72 Tom Greenwell, 'Barbara Hepworth: Talking Freely', *Yorkshire Post*, 13 Nov. 1962, p.3.

73 Letter to E.H. Ramsden, n.d. [1944], TGA 9310.

74 *Madonna and Child* 1954, BH 193, St Ives parish church, repr. *Pictorial Autobiography* 1970/1978, p.64, pl.176.

75 Bowness 1966, p.10; Ben Nicholson, *Unit One* 1934, p.89.

76 Letter to Helen Sutherland, 6 Feb. 1966, on loan to TGA.

77 Bowness 1971, p.12.

78 *Single Form* 1937–8, BH 103, Dag Hammarskjöld Museum, Backakra, Sweden, repr. Hodin 1961, pl.103; 'Single Form' in *Markings*, trans. by Leif Sjöberg and W.H. Auden, 1964, p. 145.

79 Letter to Herbert Read, 24 Dec. 1962, HRA.

80 Interview with Cindy Nemser, *Art Talk: Conversations with 12 Women Artists*, New York 1975, p.16.

81 Barbara Hepworth, 'Sculpture', *Circle* 1937, p.113.

82 Adrian Stokes, 'Miss Hepworth's Carving', *Spectator*, 3 Nov. 1933, republished in Lawrence Gowing (ed.), *The Critical Writings of Adrian Stokes*, I, 1978, pp.309–10; 'Introduction', Marlborough 1970, exh. cat., p.6.

83 Read 1952, section 3.

84 Letter to Herbert Read, 12 Jan. [1943], cited above n.24, HRA.

85 Henry Moore, *Madonna and Child* 1943–4, St Matthew's, Northampton, repr. David Sylvester (ed.), *Henry Moore, I, Sculpture and Drawings 1921–48*, rev. ed. 1957, p.140, LH 226; letter to Herbert Read, [30 Dec. 1946], HRA.

86 Read 1952, section 6.

87 Edouard Roditi, *Dialogues on Art*, 1960, p.100.

88 Nemser 1975.

89 Penny Florence, the Odd Man Out? Pre about a Public Artist' in 1996, pp.23–42; Wagner

Katy Deepwell, 'Hepworth and her Critics', ibid., pp.75–93; Claire Doherty, 'The Essential Hepworth? Re-reading the Work of Barbara Hepworth in the Light of Recent Debates on "the Feminine"', ibid., pp.163–72.

90 Wagner in Thistlewood 1996, p.60.

91 Doherty, ibid., p.166.

1 Torso

1 Stanley Casson, *Sculpture of Today*, 1939, p.9.

2 John Skeaping, *Drawn from Life: An Autobiography*, 1977, p.72; Read 1952, section 1.

3 Read 1952, section 1.

4 Anne M. Wagner, '"Miss Hepworth's Stone *Is* a Mother"' in Thistlewood 1996, pp.53–74.

5 Henri Gaudier-Brzeska, *Torso* 1914, Tate Gallery, repr. Evelyn Silber, *Gaudier-Brzeska: Life and Art*, 1996, pls.76–7, no.61.

6 John Skeaping, *Torso* 1928, Hiscox Holdings Ltd., repr. as Hepworth BH 14c, *Retrospective* 1994–5, exh. cat., p.23, no.4, reattributed by Sophie Bowness, 'Modernist Stone Carving in England and "the big view of sculpture"' in *Carving Mountains: Modern Stone Sculpture in England 1907–37*, exh. cat. Kettle's Yard, Cambridge 1998, p.43 n.47.

7 Read 1952, p.ix.

8 *Contemplative Figure* 1928, BH 15, private collection, repr. Read 1952, pl.4 and Penelope Curtis, 'Early Hepworth: New Images for Old', *Burlington Magazine*, vol.137, no.1113, Dec.1995, p.848, fig.80.

9 *Limestone Statue of a Woman* c.1073–1056 BC, British Museum, BM WA 124963.

10 Louvre postcard of Apollo from Actium cited in Bowness 1998, p.43 n.47; John Skeaping, *Torso of a Boy in Detached Relief* 1928, Snape Maltings, Suffolk, repr. exh. cat., Glasgow 1928, no.1.

11 Ibid.

12 *Torso*, repr. Read 1952, pl.8.

2 Infant

1 Hammacher 1968/1987, p.32.

2 *Pictorial Autobiography* 1970/1978, p.17.

3 Barbara Hepworth 'Statement' in the series 'Contemporary English Sculptors', *Architectural Association Journal*, vol.45, no.518, April 1930, p.384.

4 Anne M. Wagner, '"Miss Hepworth's Stone *Is* a Mother"' in Thistlewood 1996, p.54.

5 Henry Moore, *Suckling Child* 1927, location unknown, repr. David Sylvester (ed.), *Henry Moore, I, Sculpture and Drawing 1921–48*, rev. ed. 1957, p.27, LH 42; Wagner in Thistlewood 1996, p.69.

6 Gertrude Hermes, *Baby* 1932, Tate Gallery, repr. *Retrospective* 1994–5, exh. cat., p.18.

7 *Standing Figure* 1930, BH 26, private collection, repr. Read 1952, pl.11.

8 'The Aim of the Modern Artist: Barbara Hepworth, Ben Nicholson', *Studio*, vol.104, no.477, Dec. 1932, p.332.

9 Tate Gallery conservation files.

10 John Grierson, 'The New Generation in Sculpture', *Apollo*, vol.12, no.71, Nov. 1930, p.350.

11 Letter to Ben Nicholson, postmarked 22 July 1932, TGA 8717.1.1.82.

12 *Mask* 1928, BH 14, Wakefield City Art Gallery, repr. Hodin 1961, pl.14; *Sleeping Mask* 1928, BH 11, location unknown, not reproduced.

13 F. G[ordon] R[oe], 'Let's be Modern', *Connoisseur*, vol.86, no.352, Dec. 1930, p.413.

14 John Grierson, 'The New Generation in Sculpture', *Apollo*, vol.12, no.71, Nov. 1930, pp.350, 351.

15 Hepworth 1930, p.384.

3 Figure of a Woman

1 Barbara Hepworth, 'Statement' in the series 'Contemporary English Sculptors', *Architectural Association Journal*, vol.45, no.518, April 1930, p.384.

2 'The Aim of the Modern Artist: Barbara Hepworth, Ben Nicholson', *Studio*, vol.104, no.477, Dec. 1932, p.332.

3 *Figure* 1931, BH 34, Pier Gallery, Stromness, repr. Read 1952, pl.16a.

4 Kineton Parkes, *The Art of Carved Sculpture*, I, 1931, p.130; John Grierson, 'The New Generation in Sculpture', *Apollo*, vol.12, no.71, Nov. 1930, p.349.

5 Tate Gallery conservation files.

6 Hammacher 1968/1987, p.34, pl.19.

7 Hepworth albums, TGA 7247.1.

8 *Mother and Child* 1929 in brown Hornton stone, BH 18, location unknown, repr. Penelope Curtis, 'Early Hepworth: New Images for Old', *Burlington Magazine*, vol.137, no.1113, Dec.1995, p.848, fig.75.

9 Parkes I 1931, p.48; Michelangelo, *Brutus* c.1538, Museo Nazionale di Bargello, Florence, repr. Umberto Baldini, *The Complete Sculpture of Michelangelo*, 1982, pl.184.

10 Jacob Epstein, *Night* and *Day* 1928–9, London Underground Electric Railway, 55 Broadway, repr. Evelyn Silber, *The Sculpture of Epstein*, Oxford 1986, pls.18–19.

11 Pablo Picasso, *Women at the Fountain* 1921, MOMA, New York, repr. Christian Zervos, *Pablo Picasso: vol.4, Oeuvres de 1920–22*, Paris 1951, p.119, pl.322.

12 *Musician* 1929, BH 19, private collection, repr. *Retrospective* 1994–5, exh. cat., p.20, no.5.

13 *Statue of Kurlil* c.2500 BC, British Museum, WA 114207, repr. Geoffrey Grigson, *Art Treasures of the British Museum*, 1957, pl.9.

14 Charles Harrison, *English Art and Modernism 1900–1939*, London and Bloomington, Indiana, 1981 and London and New Haven 1994, p.229; Henry Moore, 'Mesopotamian Art', *Listener*, vol.13, no.334, 5 June 1935, pp.344–5.

15 Alan Wilkinson, 'The 1930s: "Constructive Forms and Poetic Structures"' in *Retrospective* 1994–5, exh. cat., pp.31–2; Henry Moore, *Girl with Clasped Hands* 1930, British Council, repr. David Sylvester (ed.), *Henry Moore, I, Sculpture and Drawing 1921–48*, rev. ed. 1957, p.45, LH 93.

16 Penelope Curtis, 'British Modernist Sculptors and Italy', *British Artists in Italy 1920–1980*, exh. cat., Herbert Read Gallery, Canterbury 1985, pp.12–14.

17 Frank Dobson, *Cornucopia* 1925–7, Hull University Art Gallery, repr. Neville Jason and Lisa Thompson-Pharoah, *The Sculpture of Frank Dobson*, 1994, p.65, no.51 (col.).

4 Sculpture with Profiles

1 Barbara Hepworth, 'Statement' in the series 'Contemporary English Sculptors', *Architectural Association Journal*, vol.45, no.518, April 1930, p.384.

2 Letter to Ben Nicholson, postmarked 2 Oct. 1931, TGA 8717.1.1.56; letter to E.H. Ramsden, 28 April [?1943], TGA 9310.

3 *Head* 1930, BH 32, Leicestershire Museums, Arts and Records Service, repr. Hodin 1961, pl.32; Read 1952, section 1.

4 Herbert Read, 'Foreword', *Carvings by Barbara Hepworth, Paintings by Ben Nicholson*, exh. cat., Arthur Tooth and Sons, 1932.

5 *Kneeling Figure* 1932, BH 42, Wakefield City Art Gallery, repr. Hodin 1961, pl.42.

6 Robert Melville, 'Creative Gap', *New Statesman and Nation*, vol.75, no.1935, 12 April 1968, p.494.

7 Anne M. Wagner, '"Miss Hepworth's Stone *Is* a Mother"' in Thistlewood 1996, p.63.

8 *Profile* 1932, BH 40, private collection, repr. Hodin 1961, pl.40; *Figure* 1933, BH 48, former collection Lady Bliss, repr. Hodin 1961, pl.48.

9 Letter to Ben Nicholson, postmarked 26 Nov. 1933, TGA 8717.1.1.148.

10 *Pictorial Autobiography* 1970/1978, p.24, fig.58, as 1932.

11 Ben Nicholson, *1932 (profile – Venetian red)*, private collection, repr. Jeremy Lewison, *Ben Nicholson*, exh. cat. Tate Gallery, 1993, p.119, no.23.

12 Ben Nicholson, *Profile* 1933, Kettle's Yard, University of Cambridge, repr. ibid., p.129, no.36.

13 Wagner 1996, p.60.

14 Ben Nicholson, letter to Hepworth, [4] Jan. 1933, Hepworth papers, quoted in Sophie Bowness, 'Modernist Stone Carving in England and "the big view of sculpture"' in *Carving Mountains: Modern Stone Sculpture in England 1907–37*, exh. cat., Kettle's Yard, Cambridge 1998, p.40.

15 Alan G. Wilkinson, 'The 1930s: "Constructive Forms and Poetic Structure"' in *Retrospective* 1994–5, exh. cat., p.43.

16 Read 1952, section 2.

17 Ibid.

18 Wilkinson in *Retrospective* 1994–5, exh. cat., p.45; Arp, *Head with Annoying Objects* 1930–2, Kunstmuseum, Silkeborg, repr. ibid.

19 'The Aim of the Modern Artist: Barbara Hepworth, Ben Nicholson', *Studio*, vol.104, no.477, Dec. 1932, p.332.

20 *Two Heads* 1932, BH 38, Pier Gallery, Stromness, repr. Read 1952, pl.20b; *Profile* 1932, BH 40, private collection, repr. Hodin 1961, pl.40.

21 *Figure* 1933, BH 48, whereabouts unknown, repr. Hodin 1961, pl.48; *Reclining Figure* 1932, BH 44, private collection, repr. ibid., no.44.

22 *Saint-Rémy* 1933, private collection, repr. Hammacher 1968/1987, p.46, fig.26, as '1931'.

23 Hodin 1961; Henry Moore quoted in *Tate Gallery Acquisitions 1976–8*, 1979, p.117.

24 See Appendix B.

5 Seated Figure

1 *Kneeling Figure* 1932, BH 42, Wakefield City Art Gallery, repr. Hodin 1961, pl.42; *Torso* 1932, BH 41, City of Aberdeen Art Gallery and Museums, repr. ibid. pl.41.

2 Letter to Ben Nicholson, postmarked 16 May 1932, TGA 8717.1.1.68.

3 Tommy Rowe, interview with the authors, 16 Oct. 1996.

4 Tate Gallery conservation files.

5 Derek Pullen and Sandra Deighton, 'Barbara Hepworth: Conserving a Lifetime's Work' in Jackie Heuman (ed.), *From Marble to Chocolate: The Conservation of Modern Sculpture*, 1995, p.140.

6 *Figure* 1933, BH 48, whereabouts unknown, repr. Hodin 1961, pl.48; *Reclining Figure* 1932, BH 44, private collection, repr. ibid., pl.44; *Figure* 1933, BH 50, destroyed, repr. Hammacher 1968/1987, p.60, pl.37.

7 *Studies for Sculpture (Profile Heads)* c.1932, artist's estate, repr. *Retrospective* 1994–5, exh. cat., p.50, no.92.

8 Letter to Ben Nicholson, postmarked 3 Sept 1932, TGA 8717.1.1.103.

9 John Grierson, 'The New Generation in Sculpture', *Apollo*, vol.12, no.71, Nov. 1930, p.351.

10 Penelope Curtis, 'Barbara Hepworth and the Avant Garde of the 1920s' in *Retrospective* 1994–5, exh. cat., p.25.

11 Read 1952, section 2.

12 Henry Moore, *Figure* 1931, Henry Moore Foundation, repr. David Sylvester (ed.), *Henry Moore, I, Sculpture and Drawing 1921–48*, rev. ed. 1957, p.77, LH 102; *Composition* 1932, former collection Sir Kenneth Clark, repr. ibid. p.72, LH 128; *Unit One* 1934, pp.33, 34.

13 Alex Reid & Lefèvre invoice 3 Nov. 1933 as 'Carving by Barbara Hepworth "Composition" (Lignum vitae)', Sadler papers, TGA 8221.1.3.

14 Michael Sadleir, *Michael Ernest Sadler*, 1949, pp.388–9; John Skeaping, *Blood Horse* 1929, Tate Gallery, repr. Penelope Curtis, *Modern British Sculpture from the Collection*, Tate Gallery Liverpool, 1988, p.41.

15 *Selected Paintings, Drawings and Sculpture from the Collection of the late Sir Michael Sadler*, Leicester Galleries, Jan.–Feb. 1944.

16 Mark Harvey, letter to Hepworth, 7 April 1970, TGA 965.

17 Letter to Mark Harvey, 28 April 1970, TGA 965.

6 Two Forms

1 Tate Gallery conservation files.

2 Festing 1995, p.117.

3 John Skeaping, *Woman and Bird* c.1928, private collection, repr. *John Skeaping 1901–1980: A Retrospective*, exh. cat., Arthur Ackermann & Son Ltd., 1991, p.31; Maurice Lambert, *Man with a Bird* 1929, Tate Gallery, repr. *V & A Annual Review*, 1930, p.6, fig.3.

4 Constantin Brancusi, *Poisson d'Or* 1924, destroyed, formerly Museum of Fine Arts, Boston, repr. Sidney Geist, *Brancusi: The Sculpture and Drawings*, New York 1975, p.130, no.181 (col.); see Appendix B.

5 Alan G. Wilkinson, 'The 1930s: "Constructive Forms and Poetic Structure"' in *Retrospective* 1994–5, exh. cat., p.47.

6 *Carving* 1933, BH 49, destroyed, repr. Read 1952, pl.24b; *Standing Figure* 1934, BH 62, Hillman Periodicals, New York, repr. Hodin 1961, pl.62.

7 Letter to Ben Nicholson, postmarked 3 Sept. 1932, TGA 8717.1.1.98.

8 Ben Nicholson, *1933 (composition in black and white)*, Swindon Museum and Art Gallery, repr. Jeremy Lewison, *Ben Nicholson*, exh. cat., Tate Gallery, 1993, p.134; *1933 (painting – hibiscus)*, Ohara Museum of Art, Kurashiki, repr. ibid. p.135.

9 Letter to Ben Nicholson, postmarked 22 July 1932, TGA 8717.1.1.82.

10 *Unit One* 1934, p.19.

11 'The Aim of the Modern Artist: Barbara Hepworth, Ben Nicholson', *Studio*, vol.104, no.477, Dec. 1932, p.332.

12 Adrian Stokes, 'Miss Hepworth's Carving', *Spectator*, 3 Nov. 1933, republished in Lawrence Gowing (ed.), *The Critical Writings of Adrian Stokes*, I, 1978, pp.309–10; Hepworth, letter to Ben Nicholson, postmarked 8 Dec. 1933, TGA 8717.1.1.157.

13 *Unit One* 1934, p.20.

14 Anne M. Wagner, '"Miss Hepworth's Stone *Is* a Mother"' in Thistlewood 1996, p.64.

15 Letter to Ben Nicholson, postmarked 14 Dec. 1933, TGA 8717.1.1.161.

16 Letter to Ben Nicholson, postmarked 31 Dec. 1932, TGA 8717.1.1.131.

17 Salvador Dalí, *The Enigma of William Tell* 1933, Moderna Museet, Stockholm, repr. Dawn Ades, *Dalí*, 1982, p.90, pl.70.

18 Wilkinson in *Retrospective* 1994–5, exh. cat., p.47.

19 Arp, *Head with Annoying Objects* 1930–2, Kunstmuseum, Silkeborg, repr. *Retrospective* 1994–5, exh. cat., p.47; *Axis*, no.1, Jan. 1935, p.16.

20 Read 1952, section 2.

21 Lewison 1993, p.241; *Retrospective* 1994–5, exh. cat., p.45.

22 Alberto Giacometti, *Disagreeable Object* 1931, private collection, repr. *Alberto Giacometti*, exh. cat., Scottish National Gallery of Modern Art, Edinburgh 1996, no.69, pl.18; *Le Surréalisme au service de la révolution*, no.3, Dec. 1931, pp.18–19.

23 Read 1952, section 2; Pablo Picasso, *Figures by the Sea* 1931, Musée Picasso, repr. Christian Zervos, *Pablo Picasso, vol.7 Oeuvres de 1926 à 1932*, Paris, 1955, p.134, pl.328; *Drawings for a Monument* 1928, *Cahiers d'Art*, vol.4, no.8–9, 1929, pp.342–53.

24 J.B. Frankfort, conversation with Richard Morphet, 21 Sept. 1995; Festing 1995, p.119.

25 H[enri] Frankfort, 'New Works by Barbara Hepworth', *Axis*, no.3, July 1935, p.16.

7 Mother and Child

1 Letter to Ben Nicholson, postmarked 2 Oct. 1931, TGA 8717.1.1.56.

2 *Mother and Child* 1927, BH 6, Art Gallery of Ontario, repr. *Retrospective* 1994–5, exh. cat., p.21.

3 *Two Heads* 1932, BH 38, Pier Gallery, Stromness, repr. Read 1952, pl.20b.

4 *Two Forms* 1933, BH 54, former collection L. Grahame-Wigan, repr. Hodin 1961, pl.54.

5 *Mother and Child* 1934, BH 57, private collection, repr. ibid., pl.57.

6 Tate Gallery conservation files.

7 Henry Moore quoted in *Tate Gallery Acquisitions 1976–8*, 1979, p.117.

8 Henry Moore, *Four-Piece Composition: Reclining Figure* 1934, Tate Gallery, repr. David Sylvester (ed.), *Henry Moore, I, Sculpture and Drawing 1921–48*, rev. ed. 1957, p.91, LH 154.

9 Tate Gallery conservation files.

10 Hepworth albums, TGA 7247.7.

11 Lefevre 1933; Adrian Stokes, 'Miss Hepworth's Carving', *Spectator*, 3 Nov. 1933, republished in Lawrence Gowing (ed.), *The Critical Writings of Adrian Stokes*, I, 1978, pp.309–10.

12 Letter to Ben Nicholson, postmarked 8 Dec. 1933, TGA 8717.1.1.157.

13 Adrian Stokes in Gowing I 1978, pp.309–10.

14 Letter to Ben Nicholson, postmarked 6 Dec. 1933, TGA 8717.1.1.156.

15 Alex Potts, 'Carving and the Engendering of Sculpture: Stokes on Hepworth' in Thistlewood 1996, pp.43–52; Anne M. Wagner, '"Miss Hepworth's Stone *Is* a Mother"', ibid., pp.57–9.

16 Melanie Klein, 'Early Stages of the Oedipus Conflict', *International Journal of Psycho-Analysis*, vol.9, 1928, reprinted in Juliet Mitchell (ed.) *The Selected Melanie Klein*, Harmondsworth 1986, pp.69–83; 'Infantile Anxiety Situations Reflected in a Work of Art and the Creative Impulse', *International Journal of Psycho-Analysis*, vol.10, 1929, reprinted ibid., pp.84–94.

17 Wagner in Thistlewood 1996., pp.60, 66.

18 E.H. Ramsden, 'Barbara Hepworth: Sculptor', *Horizon*, vol.7, no.42, June 1943, pp.418–21.

19 Letter to E.H. Ramsden, 4 April 1943, TGA 9310.

8 Three Forms (Carving in Grey Alabaster)

1 Henry Moore quoted in *Tate Gallery Acquisitions 1976–8*, 1979, p.117.

2 *Axis*, no.3, July 1935, p.16; *Tate Gallery Acquisitions 1980–2*, 1984, p.112.

3 Ibid.; list c.1939, copy Tate Gallery cataloguing files.

4 Dicon Nance, letter to the Tate Gallery, 27 March 1981.

5 Tate Gallery conservation files.

6 Dimensions:
small sphere diam. 6.5 cm (2⁹⁄₁₆ in); middle element 7.7 × 12.1 × 7.7 cm (3 × 4¾ × 3 in); large element 24.4 × 15.2 × 6 cm (9⅝ × 6 × 2⅜ in).

7 H[enri] Frankfort, 'New Works by Barbara Hepworth', *Axis*, no.3, July 1935, p.16.

8 Read 1952, section 3.

9 Letter to Ben Nicholson, postmarked 21 Dec. 1934, TGA 8717.1.1.197.

10 Gardiner 1982, p.38.

11 Letter to E.H. Ramsden, 4 April 1943, TGA 9310.

12 Hodin 1961, pl.66.

13 Alan Bowness, Tate Gallery cataloguing files; Frankfort 1935, p.16;

Moore, I, Sculpture and Drawing 1921–48, rev. ed. 1957, p.91, LH 154.

9 Tate Gallery conservation files.

10 Hepworth albums, TGA 7247.7.

11 Lefevre 1933; Adrian Stokes, 'Miss Hepworth's Carving', *Spectator*, 3 Nov. 1933, republished in Lawrence Gowing (ed.), *The Critical Writings of Adrian Stokes*, I, 1978, pp.309–10.

12 Letter to Ben Nicholson, postmarked 8 Dec. 1933, TGA 8717.1.1.157.

13 Adrian Stokes in Gowing I 1978, pp.309–10.

14 Letter to Ben Nicholson, postmarked 6 Dec. 1933, TGA 8717.1.1.156.

15 Alex Potts, 'Carving and the Engendering of Sculpture: Stokes on Hepworth' in Thistlewood 1996, pp.43–52; Anne M. Wagner, '"Miss Hepworth's Stone *Is* a Mother"', ibid., pp.57–9.

16 Melanie Klein, 'Early Stages of the Oedipus Conflict', *International Journal of Psycho-Analysis*, vol.9, 1928, reprinted in Juliet Mitchell (ed.) *The Selected Melanie Klein*, Harmondsworth 1986, pp.69–83; 'Infantile Anxiety Situations Reflected in a Work of Art and the Creative Impulse', *International Journal of Psycho-Analysis*, vol.10, 1929, reprinted ibid., pp.84–94.

17 Wagner in Thistlewood 1996., pp.60, 66.

18 E.H. Ramsden, 'Barbara Hepworth: Sculptor', *Horizon*, vol.7, no.42, June 1943, pp.418–21.

19 Letter to E.H. Ramsden, 4 April 1943, TGA 9310.

Geoffrey Grigson, 'Painting and Sculpture', *The Arts Today*, 1935, facing p.106.

14 *Unit One*, Mayor Gallery, April 1934.

15 Letter to E.H. Ramsden, 4 April 1943, TGA 9310.

16 Read 1952, section 3.

17 *Abstraction-Création: Art Non Figuratif*, no.2, 1933, p.6; Ben Nicholson, *1932 (painting)*, repr. Jeremy Lewison, *Ben Nicholson*, exh. cat., Tate Gallery, 1993, p.121, no.26 (col.).

18 *Abstraction-Création: Art Non Figuratif*, no.3, 1934, p.35; *Reclining Figure* 1932, BH 44, private collection, repr. Hodin 1961, pl.44.

19 Letter to Ben Nicholson, postmarked 3 April 1934, TGA 8717.1.1.182.

20 Letter to Ben Nicholson, postmarked 8 Dec. 1933, TGA 8717.1.1.157.

21 Letter to E.H. Ramsden, 4 April 1943, TGA 9310.

22 *Unit One* 1934, p.20.

23 *Three Forms* 1935, cast 1971, polished bronze, BH 521, repr. Wales & Isle of Man, 1982–3, exh. cat., [p.8], no.1.

9 Three Forms

1 Hodin 1961; letter to Ben Nicholson, postmarked 21 Dec. 1934, TGA 8717.1.1.197.

2 H[enri] Frankfort, 'New Works by Barbara Hepworth', *Axis*, no.3, July 1935, p.16.

3 Read 1952, section 3.

4 Letter to E.H. Ramsden, 4 April 1943, TGA 9310.

5 *Tate Gallery Report 1964–5*, 1966, p.39.

6 Dimensions: medium size element 8.5 × 18 × 12 cm (3⅜ × 7⅛ × 4¾ in), larger oval 18 × 25.5 × 12 cm (7¹⁄₁₆ × 10 × 4¾ in).

7 Distance of large element from the front 20.8 cm (8 3/16 in), distance from the right edge 18 cm (7 1/8 in).

8 Frankfort 1935, p.16.

9 Adrian Stokes, 'Miss Hepworth's Carving', *Spectator*, 3 Nov. 1933, republished in Lawrence Gowing (ed.), *The Critical Writings of Adrian Stokes*, I, 1978, p.309.

10 Katy Deepwell, 'Hepworth and her Critics' in Thistlewood 1996, p.82.

11 Frankfort 1935, p.16.

12 Read 1952, section 3.

13 Ben Nicholson, *1935 (white relief)*, Tate Gallery, repr. Jeremy Lewison, *Ben Nicholson*, exh. cat., Tate Gallery, 1993, p.149, no.64.

14 Hammacher 1968/1987, p.74.

15 Henry Moore, *Three-piece Carving* 1934, destroyed, repr. David Sylvester (ed.), *Henry Moore, I, Sculpture and Drawing 1921–48*, rev. ed. 1957, pp.38–9, LH 149.

16 Richard Morphet, *Art in One Year:1935*, display broadsheet, Tate Gallery, 1977, [p.3].

17 *Two Segments and Sphere* 1935–6, BH 79, private collection, repr. Hodin 1961, pl.79; *Conoid, Sphere and Hollow II* 1937, BH 100, Government Art Collection, repr. Read 1952, pl.53.

18 Theo van Doesburg, 'Vers la Peinture Blanche', *Art Concret*, April 1930, translated in Joost Baljeu, *Theo van Doesburg*, New York 1974, p.183; Lewison 1993, p.44.

19 H.S. Ede, letter to Ben Nicholson, postmarked 30 Mar. 1933, TGA 8717.1.2.883.

20 Letter to Ben Nicholson, undated [Dec. 1934], TGA 8717.1.1.203.

21 Charles Harrison, *English Art and Modernism 1900–1939*, London and Bloomington, Indiana, 1981, rev. ed. London and New Haven, Conn. 1994, p.264.

22 Read 1952, section 3.

23 Ibid., section 2.

24 J.D. Bernal, 'Foreword', exh. cat., Lefevre 1937.

25 Letter to J.D. Bernal, undated [1937–9], Bernal Archive, University of Cambridge, Add:8287/384.

26 Marcus Brumwell, note to the Tate Gallery, March 1965, Tate Gallery cataloguing files.

27 Tate Gallery conservation files.

10 Discs in Echelon (version 4)

1 *Discs in Echelon* 1935, BH 73, version 1, MOMA, New York, repr. Read 1952, pl.40.

2 *14th 7&5 exhibition*, Zwemmer Gallery, Oct. 1935; J.M. Richards, 'London Shows: Ben Nicholson at the Lefevre: 7&5 at Zwemmer's', *Axis*, no. 4, Nov. 1935, p.22.

3 *Discs in Echelon* 1936, plaster, BH 73, version 2, artist's estate, repr. *Un Siècle de Sculpture Anglaise*, exh. cat., Galerie nationale de Jeu de Paume, Paris 1996, p.95 (col.); Lefevre 1937.

4 *Discs in Echelon* 1936, aluminium, BH 73, version 3, Gimpel Fils, not reproduced.

5 *Discs in Echelon* 1935, hollow bronze cast 1964, BH 73, version 5, repr. Hodin 1961, pl.73.

6 Letter to Herbert Read, 29 Oct. 1961, HRA.

7 Brian Wall, interview with the authors, 3 May 1996.

8 Breon O'Casey, interview with the authors, 16 Oct. 1996.

9 Ibid.

10 Derek Pullen, Tate Gallery conservator, note to the authors.

11 W. Holman, letter to Hepworth, 27 April 1959, TGA 965.

12 Derek Pullen, ibid.

13 Repr. New York 1966, exh. cat.

14 Hepworth albums, TGA 7247.8.

15 Letter to W. Holman, 29 April 1959, TGA 965.

16 Janet Leach, in conversation with the authors, 8 Jan. 1997.

17 Silvie Nicholson, in conversation with the author, 11 March 1997.

18 *Sculptures in the Rijksmuseum Kröller-Müller*, Otterlo, 3rd English edition, 1970, p.75.

19 *Tate Gallery Acquisitions 1980–2*, 1984, p.112; Sotheby's 4 Dec. 1963, lot 174, repr.

20 Gimpel Fils gallery records.

21 Janet Leach, letter to Hepworth, 16 Nov. 1964, TGA 965.

22 Tate Gallery conservation files.

23 Alun R. Graves, 'Casts and Histories: Material Evidence and Hepworth's Sculptures' in Thistlewood 1996, p.180.

24 *Two Forms* 1935, BH 67, formerly collection of Mark Tobey, repr. Hodin 1961, pl.67.

25 Read 1952, section 3.

26 J.D. Bernal, 'Foreword', exh. cat.,Lefevre 1937.

27 J.M. Richards, 'London Shows: Ben Nicholson at the Lefevre: 7&5 at Zwemmer's', *Axis*, no.4, Nov. 1935, p.24.

28 Hugh Gordon Porteus, 'New Planets', *Axis*, no. 3, 1935, p.22.

29 'Sculpture', *Circle* 1937, p.113.

30 Herbert Read, 'L'Art contemporain en Angleterre', *Cahiers d'Art*, vol.13, 1938, p.32, repr. p.38, 'something in the English temperament not ... our puritanism, but rather our transcendentalism'.

31 Katy Deepwell, 'Hepworth and her Critics' in Thistlewood 1996, pp.75–93.

32 Claire Doherty, 'Re-reading the Work of Barbara Hepworth in the Light of Debates on "the Feminine"', ibid. 1996, p.171.

11 Ball, Plane and Hole

1 *Discs in Echelon* 1935, BH 73, version 1, MOMA, New York, repr. Read 1952, pl.40.

2 Tate Gallery conservation files: base thickness: 16 mm (⅝ in); warp across width: 7 mm (%₂ in); warp along length: 10 mm (⅜ in) at the left and 5.5 mm (%₆ in) at the right.

3 Ibid.

4 Sir Leslie Martin, letter to the Tate Gallery, 21 July 1986.

5 Alan G. Wilkinson, 'The 1930s: "Constructive Forms and Poetic Structure"' in *Retrospective* 1994–5, exh. cat., p.56; Jeremy Lewison, *Ben Nicholson*, exh. cat., Tate Gallery, 1993, p.41.

6 Roger Berthoud, *The Life of Henry Moore*, 1987, p.26.

7 Ben Nicholson, letter to Herbert Read, 24 Jan. [1936], HRA; Alberto Giacometti, *Woman* 1928, Giacometti Foundation, Zurich, repr. Yves Bonnefoy, *Alberto Giacometti: A Biography of his Work*,

Paris 1991, p.162, pl.154 and *Man*, Musée national d'art moderne, Paris, repr. ibid., p.148, pl.139; *Abstract and Concrete: An Exhibition of Abstract Painting and Sculpture, 1934 & 1935*, 41 St Giles, Oxford, Feb. 1936.

8 Alberto Giacometti, *Circuit* 1931, Musée national d'Art Moderne, Centre Georges Pompidou, Paris, repr. Reinhold Hohl, *Giacometti, Sculpture, Painting, Drawing*, 1972, p.60.

9 Festing 1995, p.117; Wilkinson in *Retrospective* 1994–5, exh. cat., p.56.

10 *International Exhibition of Surrealism*, New Burlington Galleries, June 1936; *Circle* 1937.

11 'Sculpture', *Circle* 1937, p.116.

12 *Two Forms (Two Figures)* 1935, BH 69, destroyed, repr. Hodin 1961, pl.69.

13 *Monumental Stela*, repr. *Circle* 1937, sculpture section, pl.2.

14 Hodin 1961, p.163, Bernard Meadows, interview with the authors, 8 Oct. 1998.

15 *Pictorial Autobiography* 1970/1978, p.44, pl.120, mistakenly identified as '*New Movements in Art Exhibition* at the London Museum'.

16 Sir Leslie Martin, letter to the Tate Gallery, 21 July 1986; interview with the authors, 27 Nov. 1996.

17 J.D. Bernal, 'Foreword', exh. cat., Lefevre 1937.

12 Single Form (Eikon)

1 *Single Form* 1937–8, plaster, BH 104, artist's estate, not reproduced.

2 Hepworth albums, TGA 7247.37.

3 *Single Form (Stela)* 1937, BH 91, artist's estate, repr. Hodin 1961, pl.91; *Single Form in Lignum Vitae* 1937, BH 92, Laing Galleries, Toronto, repr. exh. cat., Lefevre 1937.

4 *Single Form in Sycamore* 1937, BH 97, whereabouts unknown, repr. Hepworth albums, TGA 7247.37; *One Form in Plane* also known as *One Form (Single Form)*, BH 94, destroyed, repr. Gibson 1946, pl.31.

5 Constantin Brancusi, *Bird in Space* 1925, MOMA, New York, repr. Sidney Geist, *Brancusi: The Sculpture and Drawings*, New York 1975, p.132; *Circle* 1937, p.102, pl.26.

6 J.D. Bernal, 'Foreword', exh. cat., Lefevre 1937.

7 *Single Form* 1937, BH 103, Dag Hammarskjöld Museum, Backakra, Sweden, repr. Hodin 1961, pl.103.

8 William Gibson, 'Barbara Hepworth', *London Mercury*, vol.37, no.217, Nov. 1937, pp.57–8, reprinted in *Circle: Constructive Art in Britain 1934–40*, exh. cat., Kettle's Yard, Cambridge 1982, p.69.

9 Anthony Blunt, 'Specialists', *Spectator*, no.5704, 22 Oct. 1937, p.683, reprinted ibid.

10 Bruce Laughton, *The Euston Road School: A Study in Objective Painting*, Aldershot 1986, p.187.

11 'Sculpture', *Circle* 1937, p.116.

12 Ibid., p.115.

13 Ibid.

14 Letter to E.H. Ramsden, 28 April [1943], TGA 9310.

15 J.D. Bernal 1937.

16 *Circle* 1937, p.117.

17 Letter to Ben Nicholson, 12 Oct. 1937, TGA 8717.1.1.243; John Piper, 'Prehistory from the Air', *Axis*, no.8, early winter 1937, pp.4–9.

18 'Sculpture', *Circle* 1937, p.115.

19 Letter to Herbert Read, 7 Feb. [1940], HRA.

20 Katy Deepwell, 'Hepworth and her Critics' in Thistlewood 1996, pp.78–83.

21 Letter to E.H. Ramsden, 'Wednesday' [?March 1943], TGA 9310; *Figure* 1933, BH 48, former collection Lady Bliss, repr. Hodin 1961, pl.48.

22 *Art in Britain 1930–40 Centred around Axis, Circle, Unit One*, Marlborough Fine Art, March–April 1965.

23 Tate Gallery conservation files.

24 Ibid.

13 Forms in Echelon

1 *Pictorial Autobiography* 1970/1978, p.41.

2 'Art Out-of-Doors', *Architectural Review*, vol.85, no.509, April 1939, p.201, pl.1.

3 'House near Halland, Sussex', *Architectural Review*, vol.85, no.507, Feb.1939, pp.63–78.

4 'Art Out-of-Doors', April 1939, p.200.

5 Dudley Shaw Ashton, *Figure in a Landscape*, 1953 reported in Reyner Banham, 'Object Lesson', *Architectural Review*, vol.115, no.690, June 1954, repr. p.404.

6 *Two Forms (Two Figures)* 1935, BH 69, destroyed, repr. Hodin 1961, pl.69.

7 e.g. Hodin 1961, pl.107.

8 *Abstract and Concrete Art*, Guggenheim Jeune Gallery, *London Bulletin*, no.14, 1 May 1939, pp.2–4, 21–2.

9 Copy, Tate Gallery cataloguing files.

14 Sculpture with Colour (Deep Blue and Red)

1 Tate Gallery conservation files.

2 Barbara Hepworth, albums of photographs, 1940, private collection and MOMA, New York.

3 Hodin 1961, p.165.

4 Read 1952, section 4.

5 Gibson 1946; exh. cat., Leeds 1943; exh. cat., Wakefield & Halifax 1944.

6 *Impressionist, Modern and Contemporary Paintings, Sculpture and Drawings, Part II*, Sotheby's, 24 March 1983, lot 259, repr.

7 Letter to E.H. Ramsden, 7 May 1940, TGA 9310.

8 Leeds 1943, no.101; Wakefield & Halifax, 1944, no.26; Gibson 1946, p.9.

9 Letter to E.H. Ramsden, 4 April 1943, TGA 9310.

10 Ibid.

11 Read 1952, section 4.

12 Ben Nicholson, *1940–42 (two forms)*, repr. Jeremy Lewison, *Ben Nicholson*, exh. cat., Tate Gallery, 1993, p.159 (col.).

13 Read 1952, section 3.

14 *Sculpture with Colour, White, Blue and Red Strings* 1939, BH 113, repr. Read 1952, pl.60a.

15 Read 1952, section 4.

16 *Stringed Relief*, private collection, repr. David Sylvester (ed.), *Henry Moore, I, Sculpture and Drawing 1921–48*, rev. ed. 1957, p.125, LH 182; *Bird Basket*, private collection, repr. ibid. p.129, LH 205 (col.).

17 Colin Sanderson and Christina Lodder, 'Catalogue Raisonné of the Constructions and Sculptures' in *Naum Gabo: Sixty Years of Constructivism*, exh. cat., Dallas Museum of Art, 1985, p.229.

18 Hammacher 1968/1987, p.76.

19 Martin Hammer and Christina Lodder, 'Hepworth and Gabo: A Creative Dialogue' in Thistlewood 1996, p.117.

20 Republished in Lawrence Gowing (ed.), *The Critical Writings of Adrian Stokes, II, 1937–58*, 1978, p.24.

21 Ibid., p.36.

22 Edouardo Roditi, *Dialogues in Art*, 1960, p.97.

23 Hammacher 1968/1987, p.92; Read 1952, section 4.

24 *Tate Gallery Report and Acquisitions 1972–4*, 1975, p.255.

25 Letter to E.H. Ramsden, 4 March 1943, TGA 9310.

26 Hepworth albums, TGA 7247.13.

27 Letter to E.H. Ramsden and Margot Eates, n.d., TGA 9310.

28 Letter to Nicholson, n.d. [11 Oct. 1941], TGA 8717.1.1.261.

29 Naum Gabo, *Spiral Theme* 1941/1942, Barns-Graham version: Scottish National Gallery of Modern Art, Edinburgh.

30 Wilhelmina Barns-Graham, conversation with the authors, 10 May 1997; Hepworth albums TGA 7247.12.

31 *Sculpture with Colour*, BH 459, repr. Hepworth albums, TGA 7247.38.

15 Drawing for 'Sculpture with Colour' (Forms with Colour)

1 'Approach to Sculpture', *Studio*, vol.132, no.643, Oct. 1946, p.101.

2 Letter to Ben Nicholson, n.d. [26 Sept. 1941], TGA 8717.1.1.252.

3 Letter to Ben Nicholson, n.d. [13 Oct. 1941], TGA 8717.1.1.263.

4 *Pictorial Autobiography* 1970/1978, p.42.

5 Notes made by Richard Calvocoressi from Barbara Hepworth's letter to Alastair Morton, April 1940, TGA 9322.

6 Letter to E.H. Ramsden, n.d. [1943], TGA 9310.

7 *Oval Form* 1942, private collection, repr. Read 1952, pl.66a.

8 Gibson 1946, p.8.

9 'Approach to Sculpture', 1946, p.101.

10 Read 1952, section 4.

11 Tate Gallery conservation files.

12 Ibid.

13 Letter to Ben Nicholson, n.d. [13 Oct. 1941], TGA 8717.1.1.263.

14 Colin Sanderson and Christina Lodder, 'Catalogue Raisonné of the Constructions and Sculptures' in *Naum Gabo: Sixty Years of Constructivism*, exh. cat., Dallas Museum of Art, 1985, p.229.

15 Naum Gabo, *Construction in Space with Crystalline Centre*, 1938–40, repr. Herbert Read and Leslie Martin, *Gabo: Constructions, Sculpture, Paintings, Drawings, Engravings*, 1957, unpag., pl.74.

16 Herbert Read, 'Vulgarity and Impotence: Speculations on the Present State of the Arts', *Horizon*, vol.5, no.28, April 1942, p.269.

17 *Forms in Movement*, formerly in the collection of Helen Sutherland, repr. *St. Ives: Twenty Five Years of Painting, Sculpture and Pottery*, exh. cat., Tate Gallery, 1985, p.165.

18 *Red in Tension* 1941, private collection, repr. *Retrospective* 1994–5, exh. cat., p.73 (col.).

19 *Drawing for Stone Sculpture* 1946, private collection, repr. *Retrospective* 1994–5, exh. cat., p.74 (col.).

20 *Landscape* 1946, location unknown, repr. Hodin 1961, pl.b.

21 *Axis*, no.7, autumn 1936, p.21.

22 Letter to E.H. Ramsden, 8 Jan. 1942, TGA 9310.

23 See, for example, Jeremy Lewison, *Ben Nicholson*, exh. cat., Tate Gallery, 1993.

24 Ben Nicholson, 'Notes on Abstract Art', *Horizon*, vol.4, no.22, Oct. 1941, pp.272–6; *New Movements in Art: Contemporary Work in England: an Exhibition of Recent Painting and Sculpture*, London Museum, March–May 1942.

25 G.L.K. Morris, 'English Abstract Painting', *Partisan Review*, vol.10, no.3, May–June 1943, pp.224–6.

26 Herbert Read, 'Vulgarity and Impotence', 1942, p.267.

27 Read 1952, section 4.

28 Ben Nicholson, letter to Herbert Read, 16 Jan. [1940], TGA 8717.1.3.33.

29 Ben Nicholson, letter to Herbert Read, 6 Sept. 1944, TGA 8717.1.3.50.

30 Kathleen Raine, *Stone and Flower: Poems 1935–43*, 1943.

31 *Forms in Red: Drawing for Sculpture with Colour* 1941, private collection, repr. Gibson 1946, pl.43; letter to Herbert Read, 12 Jan. [1943], HRA.

16A & B Oval Sculpture (No.2)

1 Brian Wall, interview with the authors, 3 May 1996.

2 *Oval Sculpture* 1943, cast 1959, BH 121.3, artist's estate, repr. Tate 1968, exh. cat., p.16 (col.).

3 Tate Gallery conservation files.

4 Gibson 1946, p.8.

5 Letters to Ben Nicholson, n.d. [Sept. 1943], TGA 8717.1.1.277 & 278.

6 Sven Berlin, *A Coat of Many Colours: An Autosvenography*, Bristol 1994, pp.107–8.

7 Letter to E.H. Ramsden, n.d. [1946], TGA 9310.

8 Martin Hammer and Christina Lodder, 'Hepworth and Gabo: A Creative Dialogue' in Thistlewood 1996, p.128.

9 *Conicoid* 1939, BH 112, Leeds City Art Gallery, repr. Read 1952, pl.57a; *New Movements in Art: Contemporary Work in England: an Exhibition of Recent Painting and Sculpture*, London Museum, March–May 1942.

10 'Approach to Sculpture', *Studio*, vol.132, no.643, Oct. 1946, p.98.

11 Letter to E.H. Ramsden n.d. [1946], TGA 9310.

12 'Approach to Sculpture', 1946, p.97.

13 Herbert Read, *Henry Moore*, 1944, p.xxiii.

14 Alan G. Wilkinson, 'Cornwall and the Sculpture of Landscape: 1939–1975' in *Retrospective* 1994–5, exh. cat., pp.81–2.

15 Letter to E.H. Ramsden, n.d. [Dec. 1946] TGA 9310.

16 E.H. Ramsden, 'The Sculpture of Barbara Hepworth', *Polemic* 5, Sept./Oct. 1946, p.34.

17 Letter to Herbert Read, 6 March [1947], HRA, repr. Thistlewood 1996, p.11.

18 Herbert Read, *Education Through Art*, 1943.

19 Melanie Klein, 'Infantile Anxiety Situations Reflected in a Work of Art and the Creative Impulse', *International Journal of Psycho-Analysis*, vol.10, 1929, reprinted in Juliet Mitchell (ed.), *The Selected Melanie Klein*, Harmondsworth 1986, pp.84–94.

20 Cindy Nemser, 'Barbara Hepworth', *Feminist Art Journal*, vol.2, no.2, spring 1973, p.5.

21 *Large and Small Form* 1945, BH 128, private collection, USA, repr. Read 1952, pls.79a–b.

22 *Sculpture with Colour (Eos)* 1946, BH 141, private collection, USA, repr. Hodin 1961, pl.141.

23 Letter to E.H. Ramsden, n.d. [1946], TGA 9310.

17 The Artist's Hand

1 Bowness 1971, p.44.

2 Robert and Nicholas Robins, 'Hands and the Artist: Barbara Hepworth', *Journal of Hand Surgery*, vol.13-B, no.1, Feb. 1988, p.104, repr.

3 Hepworth albums, TGA 7247.37.

4 *Hand I (vertical)* 1949–50, BH 162, destroyed, not reproduced.

5 *Hand II (horizontal)* 1949–50, BH 163, repr. Hepworth albums, TGA 7247.19.

6 John Wells, interview with the authors, 15 Oct. 1996.

7 A.D.B. Sylvester, 'ICA: 1950 Aspects of British Art', *Art News and Review*, vol.2, no.24, 30 Dec. 1950, p.5.

8 *Concentration of Hands No.1* 1948, British Council, repr. Bowness 1966, pl.30; *Hands Operating* 1949, New Art Centre, repr. ibid., pl.28.

9 *Pictorial Autobiography* 1970/1978, p.51.

10 Tom Pearce, interview with the authors, 1 Nov. 1996.

11 *Pictorial Autobiography* 1970/1978, p.53.

12 *Hand Sculpture* 1944, BH 123, private collection, repr. *Retrospective* 1994–5, exh. cat., p.75 (col.); Lázló Moholy-Nagy, *The New Vision* (1928), 1939.

13 David Lewis, 'A Personal Memoir, 1947–55' in *St. Ives: Twenty Five Years of Painting, Sculpture and Pottery*, exh. cat., Tate Gallery, 1985, p.18.

14 Repr., Robins 1988, p.105.

15 *Pictorial Autobiography* 1970/1978, p.79.

16 Gardiner 1982, pp.33–4.

18A & B Landscape Sculpture

1 'Approach to Sculpture', *Studio*, vol.132, no.643, Oct. 1946, p.100.

2 Ibid.

3 Read 1952, section 4.

4 Letter to E.H. Ramsden, 28 April [1943], TGA 9310.

5 Hodin 1961, pl.127.

6 E.H. Ramsden, *Sculpture: Theme and Variation*, 1953, p.42.

7 Read 1952, section 4.

8 *Tate Gallery Report and Acquisitions 1972–4*, 1975, p.254.

19 Tides I

1 'Approach to Sculpture', *Studio*, vol.132, no.643, Oct. 1946, p.98.

2 Letter to Ben Nicholson, n.d. [early 1946], TGA: 8717.1.1.304.

3 Hodin 1961, p.166.

4 Tate Gallery conservation files.

5 Ibid.

6 David Lewis, 'St Ives: A Personal Memoir 1947–55' in *St. Ives: Twenty Five*

Years of Painting, Sculpture and Pottery, exh. cat., Tate Gallery, 1985, p.36.

7 Letter to Ben Nicholson, 26 Feb. 1966, TGA 8717.1.1.363.

8 Ben Nicholson, letter to Norman Reid, 6 Nov. 1975; Norman Reid, letter to Ben Nicholson, 18 Nov. 1975, Tate Gallery acquisition files.

9 Letter to E.H. Ramsden, n.d. [1944], TGA 9310.

20 Pelagos

1 David Lewis, 'Sculptures of Barbara Hepworth', *Listener*, vol.44, no.1122, 27 July 1950, p.122.

2 Shepherd 1963, [p.38].

3 *Studio*, vol.132, no.643, Oct. 1946; Tate 1968; *Retrospective* 1994–5.

4 Hammacher 1968/1987, p.105.

5 David Lewis, 'The Sculptures of Barbara Hepworth', *Eidos*, no.2, Sept.–Oct. 1950, p.28.

6 Quoted as if about *Wave* in Alun R. Graves, 'Casts and Continuing Histories: Material Evidence and the Sculpture of Barbara Hepworth' in Thistlewood 1996, p.176; actually in reference to *Figure (Ascending Form)* 1956, BH 219, private collection, repr. Hodin 1961, pl.219.

7 Ronald Alley, 'Barbara Hepworth's Artistic Development', Tate 1968, exh. cat., pp.16–21.

8 Read 1952, section 4.

9 Ibid.

10 Edouard Roditi, *Dialogues on Art*, 1960, p.93.

11 Claire Doherty, 'Re-reading the Work of Barbara Hepworth in the Light of Debates on "the Feminine"' in Thistlewood 1996, p.168.

12 Letter to Herbert Read, 6 March [1947], HRA, repr. Thistlewood 1996, p.11.

13 Read 1952, pp.x–xi.

14 Herbert Read, *Education Through Art*, 1943; letter to Herbert Read, n.d. [1943], HRA.

15 Letter to Herbert Read, 15 Jan. 1941, HRA.

16 David Thistlewood, 'Contested Significance in the Work of Barbara Hepworth: Absolutist and Relativist Interpretations' in Thistlewood 1996, p.5.

17 Read 1952, p.x.

18 G.S. Whittet, 'London Commentary', *Studio*, vol.148, no.736, July 1954, p.28.

19 Letters to Herbert Read, 14 May [1944], 8 April [1941], HRA.

21 Projects for Waterloo Bridge

1 London Metropolitan Archive: LCC/PP/HIG/215.

2 LCC press release, 9 May 1942, London Metropolitan Archive: LCC/CL/HIG/2/151.

3 Sir Charles Wheeler, sketches for *The Four Winds*, Wolfsonian, Miami Beach,

repr. *Sculpture in Britain Between the Wars*, exh. cat., Fine Art Society, 1986, p.153, no.109.

4 London Metropolitan Archive: LCC/MIN/11, 584.

5 Ibid., 214, p.84.

6 Ibid.

7 Frank Dobson, *Four Freedoms*, repr. Neville Jason and Lisa Thompson-Pharoah, *The Sculpture of Frank Dobson*, 1994, p.150, nos. 155–7; Eric Kennington, *Four Saints*, Wolfsonian, Miami Beach, repr. *Sculpture in Britain Between the Wars*, exh. cat., Fine Art Society, 1986, pp.97–9, nos. 65–8.

8 London Metropolitan Archive: LCC/MIN/11, 597.

9 Ibid.

10 Ibid., 214, p.273.

11 *Models for Sculpture for Waterloo Bridge* 1947, BH 144.1, Hirshhorn Museum and Sculpture Garden, Smithsonian Institution, Washington DC, not repr.; BH 144.2, private collection, not repr.

12 Read 1952, section 5.

13 Nicholson, letter to Helen Sutherland, postmarked 27 Nov. 1947, on loan to TGA.

14 London Metropolitan Archive: LCC/MIN/11, 214, p.84.

15 Read 1952, section 5.

16 London Metropolitan Archive: LCC/MIN/11, 214, p.84.

17 *Drawing for Stone Sculpture* 1947, private collection, repr. Bowness 1966, pl.33; ibid. p.21.

18 Read 1952, section 5.

19 Letter to E.H. Ramsden, n.d. [June 1947], TGA 9310.

20 Nicholson, letter to Helen Sutherland, postmarked 27 Nov. 1947.

21 *Involute* 1946, BH 135, whereabouts unknown, repr. Hodin 1961, pl.135.

22 *Pendour* 1947, BH 145, Hirshhorn Museum and Sculpture Garden, Smithsonian Institution, Washington DC, repr. Hodin 1961, pl.145.

23 J.P. Hodin, 'Portrait of the Artist, No. 27: Barbara Hepworth', *Art News and Review*, vol.2, no.1, 11 Feb. 1950, p.6.

24 Hodin 1961, p.20.

25 Letter to E.H. Ramsden, n.d. [1946], TGA 9310.

26 'Approach to Sculpture', *Studio*, vol.132, no.643, Oct. 1946, p.98.

27 Letter to Ben Nicholson, 1 May [1948], TGA: 8717.1.1.328.

22 Two Figures with Folded Arms

1 Bowness 1966, p.20.

2 Nicholson, letter to Helen Sutherland, postmarked 27 Nov. 1947, on loan to TGA.

3 Letter to Herbert Read, 6 March 1948, HRA.

4 Tate Gallery conservation files.

5 Bowness 1966, p.20.

6 Herbert Read, 'Barbara Hepworth: A New Phase', *Listener*, vol.39, no.1002, 8 April 1948, p.592.

7 *Seated Nude* 1947, private collection, repr. Hodin 1961, pl.f.

8 Letter to Herbert Read, n.d. [1948], HRA.

23A & B Fenestration of the Ear (The Hammer) & The Scalpel 2

1 Ben Nicholson, letter to Helen Sutherland, postmarked 26 Oct. 1948, on loan to TGA; the canvas was presumably never completed.

2 Tate Gallery conservation files.

3 R.A.C. Cobbe, 'Examination of Modern Paintings: Technical Information Received from Artists', *Studies in Conservation*, vol.21, no.1, Feb. 1976, p.27.

4 Letter to Herbert Read, 8 Dec. [1940], HRA.

5 Herbert Read, 'Barbara Hepworth: A New Phase', *Listener*, vol.39, no.1002, 8 April 1948, p.592.

6 Read 1952, section 5.

7 Chris Stephens, 'From Constructivism to Reconstruction: Hepworth in the 1940s' in Thistlewood 1996, pp.140–2.

8 *Tate Gallery Acquisitions 1976–8*, 1979, pp.80–4.

9 Science Museum, Inv. No.1977–500; Pictorial Collection Ref. No.PC1500.

10 Letter to Mrs Barbara Passe, 14 Sept. [1952], Science Museum, ibid.

11 Stephens in Thistlewood 1996, p.147.

12 *Barbara Hepworth: 'Fenestration of the Ear'*, Tate St Ives study display broadsheet, 1993.

13 Margaret Moir, letter to Tate Gallery, 13 June 1978.

14 Letter to Herbert Read, 6 March [1948], HRA.

15 Philip Hendy, 'Art: New Subjects for Old', *Britain Today*, no.146, June 1948, p.37.

24 Seated Woman with Clasped Hands

1 Bowness 1966, p.20.

2 *Biolith* 1948–9, BH 155, Jonathan Clark, repr. Hodin 1961, pl.155.

25 Bicentric Form

1 Letter to Tate Gallery, 7 Feb. 1958, Tate Gallery cataloguing files.

2 Read 1952, section 5.

3 Bowness 1966, p.20; *Interlocking Forms* 1950, private collection, repr. ibid., pl.18.

4 *Biolith* 1949, BH 155, Jonathan Clark, repr. Hodin 1961, pl.155; *Three Groups (Blue and Yellow Ground)* 1949, private collection, repr. Read 1952, pl.127a.

5 *Two Figures* 1943, BH 120, Art Gallery of Ontario, Toronto, repr. Hodin 1961,

pl.120; Chris Stephens, 'From Constructivism to Reconstruction: Hepworth in the 1940s' in Thistlewood 1996, p.151.

6 Festing 1995, p.183.

7 David Lewis, 'The Sculptures of Barbara Hepworth', *Eidos*, vol.2, Sept.–Oct. 1950, p.30.

8 Angela Vanhaelen, 'Barbara Hepworth's *Contrapuntal Forms*: Conflicting Visions of Utopia in the Post-War Period', *Collapse: The View from Here*, no.1: *Ideologies of Britishness in Post-War Art and Culture*, 1995, p.108.

9 Ibid.

10 Lewis 1950, p.30.

11 Herbert Read, 'Barbara Hepworth', *La Biennale di Venezia*, no.3, Jan. 1951, pp.13–14.

12 Patrick Heron, 'The Return of the Image', *New Statesman and Nation*, vol.39, no.989, 18 Feb. 1950, p.187.

13 John Berger, 'Sculptural Vacuum', *New Statesman and Nation*, vol.47 no.1206, 17 April 1954, p.498.

26 Apollo

1 Repr. *Pictorial Autobiography* 1970/1978, p.61, pl.169; cf. another view, repr. *Retrospective* 1994–5, exh. cat., p.95.

2 Repr. *Pictorial Autobiography* 1970/1978, p.62, pl.172.

3 Tommy Rowe, interview with the authors, 16 Oct. 1996.

4 Pablo Picasso, *Design for a Monument to Guillaume Apollinaire* 1928, Musée Picasso, Paris, repr. Werner Spies, *Picasso Sculpture with a Complete Catalogue*, 1972, p.78.

5 Gjon Mili, 'Speaking of Pictures …', *Life*, vol.28, no.5, 30 Jan. 1950, pp.10–12.

6 Letter to Herbert Read, 13 May 1952, HRA.

7 Herbert Read, 'New Aspects of British Sculpture', *Works by Sutherland, Wadsworth, Adams, Armitage, Butler, Chadwick, Clark, Meadows, Moore, Paolozzi, Turnbull*, exh. cat., British pavilion, XXVI Venice Biennale, 1952.

8 Tate Gallery conservation files.

9 New Art Centre 1987, no. 3, repr.

10 Tommy Rowe, interview with the authors, 16 Oct. 1996.

27 Group I (concourse) February 4 1951

1 Denis Mitchell, letter to Tate Gallery, 8 June 1978, Tate Gallery cataloguing files.

2 Ibid.

3 J.P. Hodin, 'Barbara Hepworth and the Mediterranean Spirit', *Marmo*, no.3, Dec. 1964, p.59.

4 Mitchell 1978.

5 *Tate Gallery Acquisitions 1976–8*, 1979, pp.84–9.

6 Read 1952, pls.149 a–b.

7 *Tate Gallery Acquisitions 1976–8*, 1979, p.88.

8 Terry Frost, letter to Tate Gallery, 13 Jan. 1978, Tate Gallery cataloguing files.

9 Alan Bowness, letter to Tate Gallery, 5 Aug. 1978, Tate Gallery cataloguing files.

10 Ibid.

11 Read 1952, section 3.

12 Ibid.

13 *Concourse*, private collection, repr. Read 1952, pl.107; *Concourse (2)*, Royal College of Surgeons, repr. *Pictorial Autobiography* 1970/1978, p.51.

14 'Concourse', *Annals of the Royal College of Surgeons of England*, vol.45, July 1969, p.49.

15 Read 1952, section 6.

16 Gentile Bellini, *Processione in Piazza San Marco* 1496, Galleria Accademia, Venice, repr. John Steer, *Venetian Painting*, 1985, p.64, pl.44 (col.).

17 Alberto Giacometti, *Piazza* 1947–8, Peggy Guggenheim Collection, Venice, repr. Angelica Zander Rudenstine, *Peggy Guggenheim Collection, Venice*, 1985, pp.70–2.

18 Read 1952, section 6.

19 Alan G. Wilkinson, 'Cornwall and the Sculpture of Landscape: 1939–1975' in *Retrospective* 1994–5, exh. cat., p.97.

20 *Pictorial Autobiography* 1970/1978, p.60.

21 Alan Bowness, letter to Tate Gallery, 5 Aug. 1978, Tate Gallery cataloguing files.

22 Ibid.

28 Poised Form

1 Alan Bowness, answers to a Tate Gallery questionnaire, 30 Sept. 1983, Tate Gallery cataloguing files.

2 Hepworth albums, TGA 7247.21; Hodin 1961, pl.172.

3 Tate Gallery conservation files.

4 Letter to Herbert Read, 13 May 1952, HRA.

5 *Maquette for Garden Sculpture* 1951, BH 170, Kettle's Yard, University of Cambridge, repr. Hepworth albums, TGA 7247.21.

6 *Apollo* was also made from a bent-wire maquette.

7 *2a Rassegna Internazionale di Scultura all'Aperto*, Villa Mirabello, Varese, Aug.–Sept. 1953; Read 1952, pl.156.

8 Matthew Gale, unpublished catalogue of the Kettle's Yard Collection, Cambridge 1995.

9 Ibid.

29 Image

1 *Contemporary British Sculpture*, exh. cat., AC open-air tour 1958, p.12.

2 Letter to E.H. Ramsden, 28 April [1943], TGA 9310.

3 *Sculpture in the Open Air*, exh. cat., Holland Park, 1954, unpag.

4 J.D. Bernal, 'Introduction', exh. cat., Lefevre 1937.

30A & B Family Group – Earth Red and Yellow & Two Figures (Heroes)

1 *Drawing for Stone Sculpture* 1947, private collection, repr. Bowness 1966, pl.33; *Figures (Sunion)* 1956, private collection, photograph in the artist's estate.

2 Ben Nicholson, letter to Helen Sutherland, postmarked 26 Oct. 1948, on loan to TGA.

3 George Wilkinson, interview with the authors, 14 Oct. 1996.

4 Tate Gallery conservation files.

5 Georges Braque, *La Musicienne* 1918, Kunstmuseum, Basle, repr. Nicole S. Mangin, *Catalogue de l'oeuvre de Georges Braque, vol.6: Peintures 1916–23*, 1973, unpag., pl.20; *Art d'Aujourd'hui*, May 1953.

6 Robert Adams, *Figure* 1949, Tate Gallery, repr. Alastair Grieve, *Robert Adams*, 1992, p.156, pl.79; Henry Moore, *Time-Life Screen*, Time-Life Building, Bond Street, London, repr. Alan Bowness (ed.), *Henry Moore: Sculpture and Drawings, II, Sculpture 1949–54*, rev. ed. 1965, pl.74, LH 344.

7 *Tate Gallery Acquisitions 1976–8*, 1979, pp.89–90.

8 Read 1952, section 3.

9 Chris Stephens, 'From Constructivism to Reconstruction: Hepworth in the 1940s' in Thistlewood 1996, p.147.

10 Ben Nicholson, letter to J.R.M. Brumwell, 27 Jan. 1953, copy in TGA (no number).

11 John Skeaping, *Drawn from Life: An Autobiography*, 1977, p.207.

12 Gardiner 1982, p.18; *Madonna and Child* 1954, BH 193, repr. *Pictorial Autobiography* 1970/1978, p.64.

31 Two Forms (White and Yellow)

1 Kasimir Malevich, *Red Square and Black Square* 1914–16, MOMA, repr. Alfred H. Barr, *Cubism and Abstract Art*, New York 1936, p.123.

2 Piet Mondrian, *Composition No.2 with Red and Blue* 1937, Musée national d'art moderne, Paris, repr. *La Collection du Musée national d'art moderne*, Paris 1985, p.441 (col.); *Composition with Blue* 1937, Gemeentemuseum, The Hague, repr. John Milner, *Mondrian*, 1992, p.199 (col.).

32 Corinthos

1 Letter to the Tate Gallery, 19 July 1962, Tate Gallery cataloguing files.

2 Margaret Gardiner, interview with the authors, 26 Feb. 1997.

3 *Pictorial Autobiography* 1970/1978, p.73.

4 Letter to Nicholson, n.d. [shortly before 26 Oct. 1954], TGA 8717.1.1.347.

5 Hodin 1961 and Bowness 1971.

6 Denis Mitchell, *Oracle* 1955, artist's estate, repr. *Denis Mitchell*, exh. cat., Glynn Vivian Art Gallery and Museum, Swansea 1979, pl.42.

7 *Pictorial Autobiography* 1970/1978, p.73.

8 Tate Gallery conservation files.

9 Dicon Nance, interview with the authors, 12 Oct. 1996.

10 Letter to Norman Reid, 7 Feb. 1964, Tate Gallery acquisition files.

11 Letter to Norman Reid, 10 Jan. 1964, Tate Gallery conservation files.

12 Ibid.

13 Letter to Norman Reid, 7 Jan. 1965, Tate Gallery conservation files.

14 Letter to Norman Reid, 19 March 1965, Tate Gallery conservation files.

15 Tate Gallery conservation files.

16 Hammacher 1968/1987, p.115; letters to Herbert Read, 10 Oct. and 21 Dec. 1954, HRA.

17 Letter to Tate Gallery, 19 July 1962, Tate Gallery cataloguing files.

18 Bryan Robertson, 'Preface', Whitechapel 1962, exh. cat., [p.8].

19 *1954, May (Delos)* 1954, private collection on loan to Whitworth Art Gallery, Manchester, repr. Norbert Lynton, *Ben Nicholson*, 1993, p.269 (col.).

20 Letter to Nicholson, n.d. [Aug. 1954], TGA 8717.1.1.345.

21 'Greek Diary 1954–1964', in Walter Kern, (ed.) *J.P. Hodin: European Critic*, 1965, pp.19–24.

22 Hammacher 1968/1987, pp.115–17.

23 'Greek Diary 1954–1964', 1965, p.24.

24 Bowness 1966, p.12.

25 Herbert Read, 'Barbara Hepworth: A New Phase', *Listener*, vol.39, no.1002, 8 April 1948, p.592.

26 Bowness 1966, p.12.

27 Letter to Tate Gallery, 19 July 1962, Tate Gallery cataloguing files.

28 David Lewis, 'The Sculpture of Barbara Hepworth', *Eidos* 2, Sept.–Oct. 1950, p.28.

29 Hammacher 1968/1987, p.115.

30 Claire Doherty, 'Re-reading the Work of Barbara Hepworth in the Light of Debates on "the Feminine"' in Thistlewood 1966, p.168.

31 *Curved Form with Inner Form (Anima)* 1959, BH 265, Rijksmuseum Kröller-Müller, Otterlo, repr. Hammacher 1968/1987, p.136.

32 Edwin Mullins, 'Barbara Hepworth', Hakone 1970, exh. cat., unpag.

33 Ibid.

33 Coré

1 Letter to Herbert Read, 1 Dec. 1959, HRA.

2 *Hand II (horizontal)* 1949–50, BH 163, repr. Hepworth albums, TGA 7247.19.

3 Letter to Herbert Read, 29 Oct. 1961, HRA.

4 *Marble Form (Coré)* 1955–6, BH 208, Pierre Schlumberger, Houston, Texas, repr. Hodin 1961, pl.208.

5 *Pastorale* 1953, BH 192, Rijksmuseum Kröller-Müller, Otterlo, repr. ibid., pl. 192.

6 'Greek Diary 1954–64', Walter Kern (ed.), *J.P. Hodin: European Critic*, 1965, p.23.

7 Hepworth album, TGA 7247.25.

34 Curved Form (Trevalgan)

1 Letter to Herbert Read, 29 Oct. 1961, HRA.

2 Herbert Read, letter to Hepworth, 6 Dec.1951, TGA 965.

3 Penelope Curtis, 'The Artist in Post-War Britain', *Retrospective* 1994–5, exh. cat., p.142.

4 Letter to Herbert Read, 29 Oct. 1961, HRA.

5 Brian Wall, interview with the authors, 3 May 1996.

6 Bowness 1971, p.7.

7 Tate Gallery conservation files.

8 *Sculpture 1850–1950*, exh. cat., Holland Park, 1957, p.[15].

9 Letter to the Tate Gallery, 15 May 1961, Tate Gallery cataloguing files.

10 Read 1952, section 4.

11 Notes from a meeting between the artist and Kay and Peter Gimpel, 14–16 Jan. 1960, TGA 965.

35 Involute II

1 *Involute* 1956, 24 cm (9½ in) high, BH 214, private collections, repr. Hepworth albums, TGA 7247.26.

2 *Involute I*, 1946, BH 135, private collection, repr. Hodin 1961, pl.135; *Involute II* 1946, BH 138, Pier Arts Centre, Stromness, repr. *Pier Gallery, Stromness, Orkney*, 1978, p.28, no.20.

3 Hepworth albums, TGA 7247.26.

36 Forms in Movement (Pavan)

1 Edwin Mullins, 'Barbara Hepworth', Hakone 1970, exh. cat., unpag.

2 *Curved Form (Pavan)* 1956, 91.4 cm (36 in), BH 210, Wakefield City Art Gallery, repr. Hodin 1961, pl.210.

3 Gimpel Fils 1956.

4 *Conferment* 1968, St Ives parish churchyard; formerly Tom Slick version on loan to Marion Koogler McKay Art Institute, San Antonio, Texas.

5 *Forms in Movement (Pavan)* 1956–9, BH 211, destroyed, repr. Hodin 1961, pl.211.

6 Dicon Nance, letter to the Tate Gallery, 27 March 1981, Tate Gallery cataloguing files.

7 Tate Gallery conservation files.

8 Mullins 1970.

9 Ibid.

10 Alan G. Wilkinson, 'Cornwall and the Sculpture of Landscape: 1939–1975' in *Retrospective* 1994–5, exh. cat., p.99.

11 *Monolith – Pavan* 1953, private collection, repr. Bowness 1966, fig.35.

12 e.g. Gabo, *Model for 'Spheric Theme "with Centre"'*, c.1937, Tate Gallery, repr. *Naum Gabo: Sixty Years of Constructivism*, exh. cat. Dallas Museum of Art, 1985, p.224, no.42.1.

37 Stone Sculpture (Fugue II)

1 'Statement by the Artist', Whitechapel 1962, exh. cat., [p.15].

2 Hodin 1961.

3 *Wood and Strings (Fugue)* 1956, BH 209, Fitzwilliam Museum, Cambridge, repr. Hodin 1961, pl.209.

38 Orpheus (Maquette 2), Version II

1 Mullard House, see *Retrospective* 1994–5, exh. cat., p.114; *Theme on Electronics (Orpheus)* 1956, BH 223, Philips Electronics, Dorking, repr. Hodin 1961, pl.223.

2 *Orpheus (Maquette 1)* 1956, BH 221, Gimpel Fils, repr. Gimpel Fils 1975, exh. cat., no.13; *Orpheus (Maquette 2)* 1956, BH 222, Detroit Institute of Art, repr. *Barbara Hepworth 1903–75*, exh. cat., William Darby, 1975, no.6.

3 Gimpel Fils 1958.

4 Gimpel Fils gallery records.

5 Brian Wall, interview with the authors, 3 May 1996.

6 Ibid.

7 *Curved Form (Orpheus)* 1956, private collection, repr. Bowness 1966, pl.40.

8 *Turning Forms* 1950, BH 166, Marlborough School, St Albans, repr. Hodin 1961, pl.166.

9 *The Midsummer Marriage* 1954, repr. *Pictorial Autobiography* 1970/1978, p.68.

10 *Broadsheet*, no.1, May 1951.

11 *Statements: A Review of British Art in 1956*, ICA, Jan.–Feb. 1957; *Winged Figure I*, BH 228, private collection, repr. Hodin 1961, pl.228; *Dimensions: British Abstract Art 1948–57*, O'Hana Gallery, Dec. 1957.

12 Lynn Chadwick, *Inner Eye (Maquette III)* 1952, Tate Gallery, repr. Dennis Farr and Eva Chadwick, *Lynn Chadwick: Sculptor*, Oxford 1990, p.67, no.75.

39 Stringed Figure (Curlew), Version II

1 *Theme on Electronics (Orpheus)* 1956, BH 223, Philips Electronics, Dorking, repr. Hodin 1961, pl.223.

2 *Stringed Figure (Curlew) (Maquette I)*, BH 224, private collections, not repr.; *Stringed Figure (Curlew) (Maquette II)*, BH 225, Gimpel Fils, repr. Hodin 1961, pl.225.

3 Gimpel Fils gallery records.

4 Brian Wall, interview with the authors, 3 May 1996.

5 Hodin 1961, pl.225.

6 *Stringed Figure* 1956, private collection, repr. Bowness 1966, pl.39.

7 Naum Gabo, 'An Exchange of Letters between Naum Gabo and Herbert Read', *Horizon*, vol.10, no.53, July 1944, reprinted in Herbert Read and Leslie Martin, *Gabo: Constructions, Sculpture, Paintings, Drawings, Engravings*, 1957, p.172.

8 John Wells, *Sea Bird Forms* 1951, Tate Gallery, repr. David Brown (ed.), *St. Ives: Twenty Five Years of Painting, Sculpture and Pottery*, exh. cat., Tate Gallery, 1985, p.188, no.127.

9 Claire Doherty, 'Re-reading the Work of Barbara Hepworth in the Light of Debates on "the Feminine"' in Thistlewood 1996, p.169.

40 Spring, 1957 (Project for Sculpture)

1 Letter to the Tate Gallery, 3 March 1965, Tate Gallery cataloguing files.

2 *Figures (Summer) Yellow and White* 1957, private collection, repr. Bowness 1966, pl.41; *Wind Movement No.2* 1957, private collection, repr. ibid., pl.42.

3 *Group (Dance) May* 1957, artist's estate, repr. *Retrospective* 1994–5, exh. cat., p.138, no.111.

4 *Single Form (Antiphone)* 1953, BH 187, artist's estate, repr. Hodin 1961, pl.187.

41 Torso II (Torcello)

1 *Winged Figure I* 1957, BH 228, private collection, USA, repr. Hodin 1961, pl.228.

2 *Figure (Archaean)* 1959 also known as *Archaic Form*, 217 cm (85 1/2 in), BH 263, Rijksmuseum Kröller-Müller, Otterlo, repr. Hammacher 1968/1987, p.131, pl.107.

3 Brian Wall, interview with the authors, 3 May 1996.

4 Letter to Herbert Read, 29 Oct. 1961, HRA.

5 Letter to Kay Gimpel, 10 April 1960, TGA 965.

6 Letter to Ben Nicholson, 2 Oct. 1966, TGA 8717.1.1.368.

7 Letter to Peter Gimpel, 24 Sept 1959, TGA 965.

8 Letter to Kay Gimpel, 4 May 1960, TGA 965.

9 Tate Gallery conservation files.

10 Shepherd 1963, [p.39]; Edwin Mullins, 'Barbara Hepworth', Hakone 1970, exh. cat., unpag.

11 Ibid.

12 Shepherd 1963, [p.39]; Hammacher 1968/1987, p.138.

13 Ibid., pp.137–8.

14 Henri Matisse, *Back I* c.1909–10, cast 1955–6; *Back II* c.1913–14, cast 1955–6; *Back III* c.1916–17, cast 1955–6; *Back IV* 1930, cast 1955–6, Tate Gallery, repr. Wanda E. Guébriant, *Matisse: Catalogue raisonné de l'oeuvre sculpté*, Paris 1997, pp.243–6.

15 Richard Calvocoressi, 'Public Sculpture in the 1950s', Sandy Nairne and Nicholas Serota (eds.), *British Sculpture in the Twentieth Century*, 1981, pp.137–8.

16 Letter to Herbert Read, 4 Dec. [1956], HRA.

42 Forms (West Penwith)

1 *Three Reclining Figures (Prussian Blue)* 1951, private collection, repr. Bowness 1966, pl.19 (col.).

2 Letter to Herbert Read, 6 March [1948], HRA.

3 *Winged Figure I* 1957, BH 228, private collection, repr. Hodin 1961, pl.228; letter to Tate Gallery, 3 March 1965, Tate Gallery cataloguing files.

4 *Figure (Oread)* 1958, BH 237, Art Gallery of Ontario, Toronto, repr. Hodin 1961, pl.237; *Reclining Figure* 1958, BH 238, private collection, repr. ibid., pl.238.

43 Reclining Figures (St Rémy)

1 *Three Reclining Figures (Prussian Blue)* 1951, private collection, repr. Bowness 1966, pl.19 (col.).

2 *Saint Rémy* 1933, private collection, repr. Hammacher 1968/1987, p.46, fig.26, as '1931'.

3 Read 1952, section 2.

4 *St Rémy, Mountains and Trees* 1933, artist's estate, repr. *Retrospective* 1994–5, exh. cat., p.41, pl.95.

44 Figure (Nanzijal)

1 Bowness 1971, p.9.

2 Brian Wall, interview with the authors, 3 May 1996.

3 Dicon Nance, interview with the authors, 12 Oct. 1996.

4 Letter to Tate Gallery, 15 May 1961, Tate Gallery cataloguing files.

5 *Figure (Requiem)* 1957, BH 230, Aberdeen Art Gallery and Museums, repr. Hodin 1961, pl.230.

6 Denis Mitchell, *Turning Form* 1959, Tate Gallery, repr. *St. Ives: Twenty Five Years of Painting, Sculpture and Pottery*, exh. cat., Tate Gallery, 1985, p.204, no.179.

7 Henry Moore, *Upright Motive No.1 Glenkiln Cross* 1955–6, repr. Alan Bowness (ed.), *Henry Moore: Sculpture and Drawings, III, Sculpture 1955–64*, 1965, pls.18-20, LH 377; William Turnbull, *Janus 2* 1959, Tate Gallery, repr. *The Alistair McAlpine Gift*, exh. cat., Tate Gallery, 1971, no.46.

45 Cantate Domino

1 Brian Wall, interview with the authors, 3 May 1996.

2 Art Bronze Foundry, invoice, 10 March 1959, TGA 965.

3 Brian Wall, interview with the authors, 3 May 1996.

4 Letter to Peter Gimpel, 24 Sept. 1959, TGA 965; Margaret Moir (Hepworth's secretary), letter to Peter Gimpel, 27 April 1961, TGA 965.

5 Tate Gallery conservation files.

6 Shepherd 1963, [p.39].

7 Edwin Mullins, 'Barbara Hepworth', Hakone 1970, exh. cat., unpag.

8 Albrecht Dürer, *Praying Hands* 1508, Albertina, Vienna, repr. Walter L. Strauss, *The Complete Drawings of Albrecht Dürer, II, 1500–1509*, New York 1972, p.1033.

9 Letter to Herbert Read, 18 Jan. 1953, HRA.

10 Mullins 1970.

11 Psalm 98:7–9.

12 Hodin 1961, pl.244.

13 Letter to Norman Reid, 27 Nov. 1967, Tate Gallery acquisitions files.

14 *Figure (Requiem)* 1957, BH 230, Aberdeen Art Gallery and Museums, repr. Hodin 1961, pl.230.

15 *Madonna and Child* 1954, BH 193, St Ives parish church, repr. ibid., pl.193.

16 Henry Moore, *Madonna and Child* 1943–4, St Matthew's, Northampton, repr. David Sylvester (ed.), *Henry Moore, I, Sculpture and Drawings 1921–48*, rev. ed. 1957, p.140, LH 226; Hepworth, letter to Herbert Read, [30 Dec. 1946], HRA.

17 Mullins 1970.

18 Ossip Zadkine, *The Destroyed City* 1946–53, Leuvesluis, Rotterdam, repr. Gaston-Louis Marchal, *Ossip Zadkine: La Sculpture…Toute la vie*, Rodez 1992, p.121; Auguste Rodin, *Prodigal Son*, c.1889, Musée Rodin, Paris, repr. Herbert Read, *The Art of Sculpture*, 1956, pl.189.

19 Naum Gabo, *Bijenkorf Construction* 1956–7, N.V. Magazijn De Bijenkorf, Coolsingel, Rotterdam, repr. *Naum Gabo Sixty Years of Constructivism*, exh. cat. Dallas Museum of Fine Art, 1985, p.42, fig.50, no.67.5; Gabo, *Model for a 'Monument to the Unknown Political Prisoner'* 1952, Tate Gallery, repr. ibid., p.127, pl.45, no.61.2.

20 Festing 1995, p.238.

21 Letter to Tate Gallery, 27 Nov. 1967, Tate Gallery acquisition files; Festing 1995, p.305.

46 Garden Sculpture (Model for Meridian)

1 Lilian Somerville, letter to Hepworth, 10 Oct. 1958, BC Archive GB/652/25, quoted in Penelope Curtis, 'A Chronology of Public Commissions' in *Retrospective* 1994–5, exh. cat., p.155.

2 *Tate Gallery Acquisitions 1980–2*, 1984, p.116.

3 Harold Mortimer, interview with David Fraser Jenkins, 18 Aug. 1981, Tate Gallery cataloguing files.

4 Bowness 1971, p.10.

5 Harold Mortimer, interview ibid.

6 British Council transcript, quoted in *Retrospective* 1994–5, exh. cat., p.155.

7 Bowness 1971, p.10.

8 Ben Nicholson 1953, *August 11 (meridian)*, private collection, repr. Norbert Lynton, *Ben Nicholson*, 1993, p.268, pl.254 (col.).

9 Brian Wall, interview with the authors, 3 May 1996; *Maquette for State House (Meridian)* 1958, BH 245, private collections, repr. Hodin 1961, pl.245; *Maquette (Variation on a Theme)* 1958, BH 247, Art Gallery of Ontario, Toronto, repr. ibid., pl.247.

10 *Variation on a Theme* 1958, BH 248, artist's estate, not reproduced.

11 Hepworth albums, TGA 7247.28.

12 *Tate Gallery Acquisitions 1980–2*, 1984, p.116.

13 Hodin 1961, p.22.

14 Letters to Herbert Read, 5 Nov. [1959], 1 Dec. 1959, HRA.

15 Letter to Gimpel Fils, 20 Jan. 1960, quoted in *Retrospective* 1994–5, exh. cat., p.155.

16 Letter to Ben Nicholson, 25 Dec. 1958, TGA 8717.1.1.361.

17 Peter Gimpel, letter to Hepworth, 18 Aug. 1959, TGA 965.

18 Letter to Charles Gimpel, 17 Nov. 1959, TGA 965.

19 Kay Gimpel, letter to Hepworth, 29 March 1960, TGA 965.

20 Letter to Kay Gimpel, 16 May 1960, TGA 965.

21 Letter to Morris Singer Founders, 20 Feb. 1961, TGA 965.

22 Eric Gibbard, letter to Hepworth, 31 July 1961, TGA 965.

23 Tate Gallery conservation files.

24 Interview 1958, British Council transcript, quoted in *Retrospective* 1994–5, exh. cat., p.155.

25 Bowness 1971, p.7.

47 Sea Form (Porthmeor)

1 Art Bronze Foundry, invoice 10 March 1959, TGA 965.

2 Tate Gallery conservation files.

3 *Sea Form (Porthmeor)*, plaster, artist's estate, on loan to Barbara Hepworth Museum, St Ives; *Conferment* 1968 (no cat., Guildhall).

4 Letter to Herbert Read, 29 Dec. 1961, HRA.

5 *St. Ives: Twenty Five Years of Painting, Sculpture and Pottery*, exh. cat., Tate Gallery, 1985, p.192.

6 Shepherd 1963, [p.39].

7 *Pictorial Autobiography* 1970/1978, p.76.

8 Terry Frost, *Green, Black and White Movement* 1951, Tate Gallery, repr. David Lewis, *Terry Frost: A Personal Narrative*, Aldershot, 1994, p.51 (col.); Bryan Wynter, *Mars Ascends* 1956, Tate Gallery, repr. Michael Tooby, *An Illustrated Companion to the Tate St Ives*, 1993, p.65 (col.).

9 *Pictorial Autobiography* 1970/1978, pp.76–7.

10 Claire Doherty, 'Re-reading the Work of Barbara Hepworth in the Light of Debates on "the Feminine"' in Thistlewood 1996, pp.169, 171.

11 Ibid. p.171.

48 Périgord

1 Letter to Tate Gallery, 3 March 1965, Tate Gallery cataloguing files.

2 *Wind Movement No.2*, artist's estate, repr. Bowness 1966, pl.42.

3 Letter to Tate Gallery, 3 March 1965.

4 *Figures (Summer) Yellow and White* 1957, private collection, repr. Bowness 1966, pl.41; *Group (Dance) May 1957*, artist's estate, repr. *Retrospective* 1994–5, exh. cat., p.138, no.111.

5 Ben Nicholson, *1955 (Périgord)* 1955, private collection, repr. Norbert Lynton, *Ben Nicholson*, 1993, p.280, pl.266 (col.).

6 J.P. Hodin, 'Barbara Hepworth: A Classic Artist', *Quadrum*, no.8, 1960, p.80.

7 Letter to Herbert Read, [Dec. 1958], HRA.

49 Corymb

1 Brian Wall, interview with the authors, 3 May 1996.

50 Figure (Nyanga)

1 Shepherd 1963, [p.40].

2 Crack: *c*.26 cm (10¼ in) × 1 cm (⅜ in).

3 Letter to Tate Gallery, 8 May 1969, Tate Gallery cataloguing files.

4 Dicon Nance, interview with the authors, 12 Oct. 1996.

5 Letter to Tate Gallery, 8 May 1969, Tate Gallery cataloguing files.

6 See Bowness 1966, pls. 43–6, 50–2.

7 Bryan Robertson, 'Introduction', Whitechapel 1962, exh. cat., p.10; letter to Tate Gallery, 8 May 1969, Tate Gallery cataloguing files.

8 Ibid.

9 Letter to Herbert Read, 8 Oct. 1961, HRA.

10 Naum Gabo, *Linear Construction No.2* 1970–1, repr. *Tate Gallery Report 1968–70*, 1970, p.21; Ben Nicholson, *March 63 (artemission)* 1963, repr. ibid., p.22 (col.); Henry Moore, *Upright Form (Knife Edge)* 1966, repr. Alan Bowness (ed.), *Henry Moore: Sculpture and Drawings, IV, Sculpture 1964–73*, 1977, pls.44–5, LH 551; Patrick Heron, *Portrait of Herbert Read* 1950, National Portrait Gallery, repr. *Herbert Read: A British Vision of World Art*, exh. cat., Leeds City Art Galleries, 1993, p.140, pl.159, no.112.

51 Image II

1 Edouard Roditi, *Dialogues on Art*, 1960, p.99.

2 J.P. Hodin, 'Barbara Hepworth and the Mediterranean Spirit', *Marmo*, no.3, Dec. 1964, p.62.

3 New York 1959; Zurich 1960.

4 Assistants: Denis Mitchell (1949–59), Brian Wall (1955–60), Tommy Rowe (intermittently 1958–64), Breon O'Casey (1959–62) and Tom Pearce (1959–61).

5 Tom Pearce, interview with the authors, 1 Nov. 1996.

6 Brian Wall, interview with the authors, 3 May 1996.

7 Tommy Rowe and Breon O'Casey, interview with the authors, 16 Oct. 1996.

8 Tom Pearce, interview with the authors, 1 Nov. 1996.

9 Bowness 1971, p.9.

10 Letter to Peter Gimpel, 29 March 1961, TGA 965.

11 Tommy Rowe, interview with the authors, 16 Oct. 1996.

12 Letter to Peter Gimpel, 11 April 1961, TGA 965.

13 Tate Gallery conservation files.

14 Letter to Herbert Read, 30 May 1959, HRA.

15 *Icon II* 1960, BH 275, Ferens Art Gallery, Kingston-upon-Hull, repr. Bowness 1971, pl.18; *Talisman II* 1960, BH 276, artist's estate, repr. ibid., pls.20, 21.

16 Herbert Read, 'A Letter of Introduction', New York 1959, exh. cat., [p.4].

52 Figure for Landscape

1 Edouard Roditi, *Dialogues on Art*, 1960, p.92.

2 Ibid., p.101.

3 Bowness 1971, p.13.

4 Ibid., p.14.

5 Edouard Roditi, 1960, p.100.

6 Anne M. Wagner, 'Miss Hepworth's Stone *Is* a Mother' in Thistlewood 1996, pp.65–8.

7 Henry Moore, *Reclining Figure (External Form)* 1953–4, Art Institute of Chicago, repr. Alan Bowness (ed.), *Henry Moore, II, Sculpture and Drawings 1949–54*, rev. ed. 1965, pl.28, LH 299.

8 Herbert Christian Merillat, *Modern Sculpture: The New Old Masters*, 1974, p.113.

9 Arp, *Ptolemy I* 1953, Fondation Arp, Clamart, repr. Herbert Read, *The Art of Sculpture*, 1956 [p.iv].

10 *Sea Form (Atlantic)* 1964, BH 362, Museum of Fine Arts, Dallas, repr. Bowness 1971, pls.103, 104; *Rock Form (Porthcurno)* 1964, BH 363, Cornwall County Council, repr. ibid., pls.105, 106.

11 Brian Wall, interview with the authors, 3 May 1996; Tommy Rowe, interview with the authors, 16 Oct. 1996.

12 Letter to Herbert Read, 29 Oct. 1961, HRA.

13 Angela Connor, interview with the authors, 16 July 1997.

14 Zurich 1960.

15 Letters to Morris Singer Ltd., 21 Sept. 1959 and 2 Dec. 1959, TGA 965.

16 Letter to Read, 1 Dec. 1959, HRA.

17 Letter to Morris Singer Ltd., 20 Sept. 1961, TGA 965.

18 Gimpel Fils 1961, no.18; Kay Gimpel, letter to Hepworth, 7 March 1961, TGA 965; Gimpel Fils gallery records.

19 Tate Gallery conservation files.

20 Ibid.

53 Pierced Form (Epidauros)

1 *Curved Form (Oracle)* 1960, BH 288, artist's estate, repr. Bowness 1971, pl.31.

2 Letter to Herbert Read, 1 Dec. 1959, HRA.

3 Henry Moore, *Reclining Figure* 1957–8, Travertine marble, UNESCO, Paris, repr. Alan Bowness (ed.), *Henry Moore: Sculpture and Drawings, III, Sculpture 1955–64*, 1965, pls.43–8, LH 416; *Upright Figure* 1956–60, elm, Solomon R. Guggenheim Museum, New York, repr. ibid., pls.33–6, LH 403; *Reclining Figure* 1959–64, elm, Henry Moore Foundation, repr. ibid., pls.74–5, LH 452.

4 *Two Forms in Echelon* 1961, BH 301a, artist's estate, not reproduced.

5 'Greek Diary 1954–64', Walter Kern (ed.), *J.P. Hodin: European Critic: A Symposium*, 1965, pp.19–20.

6 Tommy Rowe, interview with the authors, 16 Oct. 1996.

7 David Lewis, 'The Sculpture of Barbara Hepworth', *Eidos* 2, Sept.–Oct. 1950, p.28.

8 *Oval Form (Penwith Landscape)* 1955, BH 202, MOMA, repr. *Retrospective* 1994–5, p.85.

9 Tate Gallery conservation files.

10 *Epidauros II* 1961, BH 303, St Ives Borough Council, repr. Bowness 1971, pl.43.

11 *Winged Figure I* 1957, BH 228, private collection, repr. Hodin 1961, pl.228.

12 Norbert Lynton, 'London Letter', *Art International*, vol.6, no.7, Sept. 1962, p.47.

54A & B Maquette, Three Forms in Echelon

1 *Winged Figure I* 1957, BH 228, private collection, repr. Hodin 1962 pl.228.

2 John Lewis Partnership Archive, selectively copied for the Tate Gallery cataloguing files; *Tate Gallery Acquisitions 1980–2*, 1984, pp.118–19.

3 Press release, JLP Archive.

4 *Mural Art Today*, Victoria and Albert Museum, Oct.–Nov. 1960.

5 Geoffrey Clarke, *Spirit of Electricity*, 1961, Thorn House, St Martin's Lane, London, repr. Sandy Naire and Nicholas Serota (eds.), *British Sculpture in the Twentieth Century*, 1981, p.148.

6 O.B. Miller, letter to Hepworth, 24 May 1961, JLP Archive.

7 Chris Stephens, 'From Constructivism to Reconstruction: Barbara Hepworth in the 1940s' in Thistlewood 1996, pp.135–53.

8 Letter to O.B. Miller, 5 June 1961, JLP Archive.

9 Letter to O.B. Miller, 2 Oct. 1961, JLP Archive.

10 Letter to O.B. Miller and 'Specification', 10 Oct. 1961, JLP Archive.

11 *Tate Gallery Acquisitions 1980–2*, 1984, p.118.

12 *Maquette, Three Forms in Echelon* 1961 plaster, artist's estate, not reproduced.

13 Letter to O.B. Miller and 'Specification', 10 Oct. 1961, JLP Archive.

14 Ibid.

15 Penelope Curtis, 'A Chronology of Public Commissions' in *Retrospective* 1994–5, exh. cat., p.155.

16 Letter to O.B. Miller, 11 Oct. 1961, JLP Archive.

17 *Tate Gallery Acquisitions 1980–2*, 1984, p.119.

18 O.B. Miller, letter to Hepworth, 16 Oct. 1961, JLP Archive.

19 Letter to O.B. Miller, 17 Oct. 1961, JLP Archive; *Tate Gallery Acquisitions 1980–2*, 1984, p.119.

20 Letter to O.B. Miller, 19 Oct. 1961, JLP Archive.

21 O.B. Miller, letter to Hepworth, 25 Oct. 1961, JLP Archive.

22 Letter to O.B. Miller, 17 Oct. 1961, JLP Archive.

23 Letter to O.B. Miller, 10 Oct. 1961, JLP Archive.

55 Single Form (September)

1 *Stringed Figure (Churinga)* 1960, 81.5 cm (32 in) high, BH 280, private collection, Switzerland, repr. Bowness 1971, pl.26.

2 Tate Gallery conservation files.

3 Breon O'Casey and Tommy Rowe, interview with the authors, 16 Oct. 1996.

4 Bowness 1971, p.10.

56 Square Forms

1 Tate Gallery conservation files.

5 *Curved Form (Bryher II)* 1961, BH 305, Hirshhorn Museum and Sculpture Garden, Smithsonian Institution, Washington DC, repr. ibid., pl.47; *Single Form (Chûn Quoit)* 1961, BH 311, private collections, repr. ibid. pl.55.

6 *Tate Gallery Acquisitions 1980–2*, 1984, p.120.

7 Alan G. Wilkinson, 'Cornwall and the Sculpture of Landscape: 1939–1975' in *Retrospective* 1994–5, exh. cat., p.104.

8 Bowness 1971, p.10.

9 Bryan Robertson, 'Introduction', Whitechapel 1962, exh. cat., [p.6].

10 Bowness 1971, p.10.

11 Ibid.

12 *Retrospective* 1994–5, exh. cat., p.155; Festing 1995, p.254.

13 Roger Lipsey, *An Art of Our Own: The Spiritual in Twentieth Century Art*, Boston and Shaftesbury 1988, pp.444–60.

14 *Single Form* 1937–8, BH 103, Dag Hammarskjöld Museum, Backakra, Sweden, repr. Hodin 1961, pl.103; New York 1956–7; *Markings*, trans. Leif Sjöberg and W.H. Auden, 1964, see also Penelope Curtis, 'The Artist in Post-War Britain' in *Retrospective* 1994–5, exh. cat., pp.128–9.

15 *Hollow Form (Churinga III)* 1960, BH 292, Dag Hammarskjöld Museum, Backakra, Sweden, repr. Bowness 1971, pl.36.

16 Hepworth quoted in Lipsey 1988, p.458.

17 Bowness 1971, p.10.

18 Penelope Curtis, 'A Chronology of Public Commissions' in *Retrospective* 1994–5, exh. cat., p.155.

19 James King, *The Last Modern: A Life of Herbert Read*, 1990, p.296.

20 Henry Moore, *Reclining Figure* 1957–8, UNESCO, Paris, repr. Alan Bowness (ed.), *Henry Moore: Sculpture and Drawing, III, Sculpture 1955–64*, 1965, pls.43–8, LH 416, *Retrospective* 1994–5, exh. cat., p.155.

21 Ibid.

22 Bryan Robertson 1962; *Sculpture: Open-Air Exhibition of Contemporary British and American Works*, Battersea Park, May–Sept. 1963.

23 Angela Connor, interview with the authors, 16 July 1997.

24 Edwin Mullins, 'Barbara Hepworth', Hakone 1970, exh. cat., unpag.

25 Dore Ashton, 'Barbara Hepworth, An Appreciation' in New York 1974, exh. cat., [p.5].

26 Ibid. [p.3].

27 Penny Florence, 'Barbara Hepworth: the Odd Man Out? Preliminary Thoughts about a Public Artist' in Thistlewood 1996, p.31.

2 Breon O'Casey, interview with the authors, 16 Oct. 1996.

3 Bowness 1971, p.7.

4 *Square Forms with Circles* 1963, BH 326, artist's estate, repr. ibid., pl.74.

5 *Square and Circle* 1963, private collection, repr. Bowness 1966, pl.55.

6 Ben Nicholson, *1957, April (Lipari)* 1957, private collection, repr. Jeremy Lewison, *Ben Nicholson*, exh. cat., Tate Gallery, 1993, p.186, no.111 (col.).

57 Bronze Form (Patmos)

1 Plaster version, Bowness 1971, pl.65; *Autumn Exhibition 1968: Past and Present*, Penwith Gallery, St Ives, Sept.–Nov. 1968, sculpture 10.

2 Tate Gallery conservation files.

3 *Oval Form (Trezion)* 1961–3, BH 304, British Museum, repr. Bowness 1971, pl.46.

4 *Hand Sculpture (Turning Form)* 1953, BH 189, private collection, repr. Hodin 1961, pl.189.

5 *Curved Form (Patmos)* 1960, BH 284, Art Gallery of Ontario, Toronto, repr. Bowness 1971, p.31.

6 *Epidauros II* 1961, BH 303, St Ives Borough Council, repr. ibid., p.43.

7 *Tate Gallery Acquisitions 1980–2*, 1984, p.121.

8 'Greek Diary 1954–64', Walter Kern (ed.), *J.P. Hodin: European Critic: A Symposium*, 1965, p.21.

9 Edouard Roditi, *Dialogues on Art*, 1960, p.101.

58 Sphere with Inner Form

1 J.P. Hodin, 'Barbara Hepworth and the Mediterranean Spirit', *Marmo*, no.3, Dec. 1964, p.62.

2 Anne M. Wagner, 'Miss Hepworth's Stone *Is* a Mother' in Thistlewood 1996, pp.53–74.

3 *Curved Form with Inner Form (Anima)* 1959, BH 265, Rijksmuseum, Kröller-Müller, Otterlo, repr. Hammacher 1968/1987, p.136, fig.115.

4 Warren Forma, *5 British Sculptors (Work and Talk)*, New York 1964, p.17.

5 Letter to Art Bronze Foundry, 2 Feb. 1965, TGA 965.

6 Letter to Art Bronze Foundry, 21 April 1965, TGA 965.

7 Tate Gallery conservation files.

8 S.M. Bradley, letter to Derek Pullen, 28 Jan. 1985, Tate Gallery conservation files.

9 *20th Century Paintings, Drawings and Sculpture presented to the Institute of Contemporary Arts for sale on behalf of the Carlton House Terrace Project*, Sotheby's, 23 June 1966 (lot 25), p.37, repr. on front cover.

59 Squares with Two Circles

1 *Tate Gallery Report 1964–5*, 1966, p.41.

2 Nan Rosenthal, 'Sculpture in the Constructivist Tradition', in Steven A. Nash (ed.), *A Century of Modern Sculpture: The Patsy and Raymond Nasher Collection*, exh. cat., Dallas Museum of Art, 1987, p.161.

3 *Maquette for Monolith* 1963, BH 349, private collections, repr. Bowness 1971, p.37.

4 Ibid., p.12.

5 Rosenthal in Nash 1987, p.161.

6 Bowness 1971, p.12.

7 Ibid., p.13.

8 Ibid.

9 Warren Forma, *5 British Sculptors (Work and Talk)*, New York 1964, p.15.

10 Penelope Curtis, 'A Chronology of Public Commissions' in *Retrospective* 1994–5, exh. cat., p.152.

11 Tate Gallery conservation files.

60 Pierced Form

1 Letter to Norman Reid, 7 Nov. 1964, Tate Gallery acquisitions files.

2 J.P. Hodin, 'Barbara Hepworth and the Mediterranean Spirit', *Marmo*, no.3, Dec. 1964, p.59.

3 Tommy Rowe, interview with the authors, 16 Oct. 1996.

4 *Marble with Colour (Crete)* 1964, BH 360, Museum Boymans-van Beuningen, Rotterdam, repr. Bowness 1971, pl.360.

5 Tate Gallery conservation files, 1992.

6 *Pierced Form (Amulet)* 1962, BH 316, private collections, repr. Bowness 1971, pl.62.

7 *Reclining Solitary Form (Amulet)* 1961, BH 307, private collections, repr. ibid., pl.48; *Upright Solitary Form (Amulet)* 1961, BH 308, private collections, repr. ibid., pl.49.

8 *Pierced Hemisphere* 1937, BH 93, Wakefield City Art Gallery, repr. Hodin 1961, pl.93; *Head (Icon)* 1959, BH 251, formerly collection Tom Slick, repr. ibid., pl.251.

9 Letter to Mary Chamot, 3 March 1965, Tate Gallery cataloguing files.

10 *Head (Chios)* 1958, BH 242, private collection, USA, repr. Hodin 1961, pl.242.

11 Hodin, 1964, p.60.

12 Ibid., p.59.

13 Ibid., p.65.

61 Two Figures (Menhirs)

1 Tate Gallery cataloguing files.

2 Dimensions: narrower slate 73.6 × 19 × 7.6 cm (29 × 7½ × 3 in), broader slate 75.5 × 26.7 × 7 cm (29¾ × 10½ × 2¾ in).

3 *Tate Gallery Report 1964–5*, 1966, p.41.

4 Tommy Rowe, interview with the authors, 16 Oct. 1996.

5 Tate Gallery conservation files; steel rods 1.3 cm (½ in), wooden base 7.2 × 63.8 × 32 cm (2¾ × 25⅛ × 12⅝ in).

6 Tom Pearce, interview with the authors, 1 Nov. 1996.

7 Dicon Nance, interview with the authors, 12 Oct. 1996.

8 H.C. Gilbert, conversation with the authors, Oct. 1996.

9 Bowness 1971, p.8.

10 Edwin Mullins, 'Barbara Hepworth', Hakone 1970, exh. cat., [p.32].

11 Carving (Mylor) 1962–3, 84.5 cm (33¼ in), BH 322, private collection, repr. Bowness 1971, pl.75.

12 Three Standing Forms 1964, BH 365, Albright-Knox Art Gallery, Buffalo, repr. ibid., pl.102; Two Figures 1964, BH 366, Rijksmuseum Kröller-Müller, Otterlo, repr. ibid., pl.100.

13 Two Figures 1943, BH 120, Art Gallery of Ontario, Toronto, repr. Hodin 1961, pl.120.

14 Two Figures (Menhirs) 1954–5, BH 197, Chicago Art Institute, repr. ibid., pl.197.

15 'The Sculptor Speaks', British Council recorded lecture, 1970, TGA TAV524.

16 Menhirs 1964, BH 340, artist's estate, repr. Bowness 1971, pl.90.

17 Two Personages (Menhirs), 1965, BH 377, private collection, USA, repr. ibid., pl.115.

18 Circle 1937, p.117.

19 Penelope Curtis, Modern British Sculpture from the Collection, Tate Gallery Liverpool, 1988, p.54.

20 Bowness 1971, p.13.

62 Hollow Form with White

1 Letter to Norman Reid, 7 May 1969, Tate Gallery acquisition files.

2 Dicon Nance, interview with the authors, 12 Oct. 1996.

3 Elegy III 1966, BH 429, Rijksmuseum Kröller-Müller, Otterlo, repr. Bowness 1971, pl.158; Elegy 1945, BH 131, McCrory Corporation, New York, repr. Hodin 1961, pl.131; Elegy II 1946, BH 134, Carnegie Institute, Pittsburgh, repr. ibid., pl.134.

63 River Form

1 River Form 1965, BH 401, artist's estate, repr. Bowness 1971, pls.137–8; Oval Form with Strings and Colour 1965, BH 382, artist's estate, repr. ibid., pl.125.

2 St. Ives: Twenty Five Years of Painting, Sculpture and Pottery, exh. cat., Tate Gallery, 1985, p.193.

3 Arthur Markwell, letter to the artist, 11 June 1973, TGA 965.

4 Dore Ashton, 'Barbara Hepworth: An Appreciation' in New York 1974, exh. cat., p.6.

64 Spring

1 Oval Form with Strings and Colour 1965, BH 382, artist's estate, repr. Bowness 1971, pl.125.

2 'Approach to Sculpture', Studio, vol.132, no.643, Oct. 1946, p.97.

3 Oval with Black and White 1965, BH 387, private collection, Bowness 1971, pl.127.

65 Four-Square (Walk Through)

1 Edwin Mullins, 'Barbara Hepworth', Hakone 1970, exh. cat., unpag.

2 Three Obliques (Walk In) 1968, BH 473, University College, Cardiff, repr. Bowness 1971, pls.183–4.

3 Bowness 1971, pp.6–7.

4 Fabio Barraclough, 'Editorial', Sculpture International, no.4, 1967, p.10.

5 Anthony Caro, Early One Morning 1962, Tate Gallery, repr. Dieter Blume, Anthony Caro Catalogue Raisonné, III, Steel Sculpture 1960–80, Cologne 1981, p.49; David Smith, Cubi XXVII 1965, Solomon R. Guggenheim Museum, New York, repr. Rosalind E. Krauss, Terminal Iron Works: The Sculpture of David Smith, Cambridge, Mass. and London 1971, p.142.

6 Edwin Mullins, 'Scale and Monumentality: Notes and Conversations on the Recent Work of Barbara Hepworth', Sculpture International, no.4, 1967, p.21.

7 Maquette for Large Sculpture: Four-Square (Four Circles) 1966, BH 407, private collections, repr. Bowness 1971, pl.145; Four-Square (Four Circles) 1966, BH 416, private collection, USA, repr. ibid., pl.142; Four-Square (Four Circles) 1966, BH 428, Royal College of Art, repr. ibid., p.43.

8 Mullins 1967, p.20.

9 Entrance: 33.5 × 198.8 × 157.8 cm (13¹³⁄₁₆ × 78¼ × 62⅛ in); interior area: 111 × 157.8 cm (43¹¹⁄₁₆ × 62⅛ in).

10 Bottom left-hand upright measures 196.4 × 212.5 × 26 cm (77⁷⁄₁₆ × 83⅝ × 10¼ in); bottom right-hand upright: 196.4 × 221.4 × 25.2 cm (77⁷⁄₁₆ × 87⅛ × 9¹⁵⁄₁₆ in).

11 Upper front element measures 195 × 186 × 25 cm (76¾ × 73¼ × 9⅜ in); upper back element: 229 × 195 × 25 cm (90⅛ × 76¾ × 9⅜ in).

12 Pictorial Autobiography 1970/1978, p.128.

13 Horizontal oval on lower left-hand element measures 85 × 86.2 cm (33½ × 34 in); interior circle: 82 × 82 cm (32¼ × 32¼ in).

14 35.5 cm (14 in) down and from the edge.

15 Oval on lower right-hand element measures 96.6 × 96 cm (38 × 37¹⁵⁄₁₆ in) diminishing to 81.7 × 78.3 cm (32³⁄₁₆ × 30¹³⁄₁₆ in).

16 40 cm (15¾ in) down and 54.5 cm (21½ in) from the edge.

17 Tate Gallery conservation files.

18 Derek Pullen and Sandra Deighton, 'Barbara Hepworth: Conserving a Lifetime's Work' in Jackie Heuman (ed.), From Marble to Chocolate: The Conservation of Modern Sculpture, 1995, p.143, photographs before and after weathering repr. p.142 (col.).

19 Bowness 1971, p.12.

20 Mullins 1967, p.20.

21 Mullins 1970, unpag.

22 Ibid.

23 Norbert Lynton, 'Hepworth at the Tate', Guardian, 3 April 1968, p.12.

24 Bowness 1971, p.12.

25 Ibid. pp.13–14.

26 Margaret Gardiner, conversation with the authors, 27 Feb. 1997.

27 Ben Nicholson, Wall 1964, destroyed, repr. Norbert Lynton, Ben Nicholson, 1993, p.446.

28 Letter to Ben Nicholson, 16 May 1966, TGA 8717.1.1.365.

66 Vertical Form (St Ives)

1 Vertical Wood Form 1968, BH 464, private collection, repr. Bowness 1971, pl.178.

2 Repr. ibid., p.50.

3 Four Hemispheres 1970, BH 517, private collection, repr. Zurich 1975, exh. cat., p.37; Sun and Moon 1966, BH 417, H.M. the Queen, repr. Bowness 1971, pl.140.

4 Letter to Peter Gimpel, 19 May 1960, TGA 965.

5 Tate Gallery conservation files.

6 Horizontal Form 1968, BH 462, private collection, repr. Bowness 1971, pl.177.

7 John Grierson, 'The New Generation in Sculpture', Apollo, vol.12, no.71, Nov. 1930, p.351.

8 Pictorial Autobiography 1970/1978, p.119.

9 Letter to Herbert Read, 8 April 1942, HRA.

10 Pictorial Autobiography 1970/1978, p.55.

67 Six Forms (2 × 3)

1 Bowness 1971, pl.13.

2 Letter to Eric Gibbard, 2 Aug. 1968, TGA 965.

3 Tate Gallery conservation files.

4 Three Forms Vertical (Offering) 1967, BH 452, private collection, USA, repr. Bowness 1971, pl.169.

5 Ibid., p.13.

6 Edwin Mullins, 'Barbara Hepworth', Hakone 1970, exh. cat., unpag.

7 Bowness 1971, p.10.

8 Curved Form (Bryher II) 1961, BH 305, Hirshhorn Museum and Sculpture Garden, Smithsonian Institution, Washington DC, repr. ibid., pl.2 (col.);

Single Form (Chûn Quoit) 1961, BH 311, private collection, repr. ibid., pl.55.

9 Ibid., pl.67.

10 Ibid., p.11.

11 Letter to Eric Gibbard, 10 Dec. 1963 and Gibbard's reply, 11 Dec. 1963, TGA 965.

68 Hollow Form with Inner Form

1 Single Form 1963–8, BH 471, McCrory Corporation, New York, repr. Bowness 1971, pl.198; Hollow Form 1963–8, BH 330, destroyed Aug. 1971, repr. ibid., p.35.

2 Dicon Nance, interview with the authors, 12 Oct. 1996.

3 Single Form (Aloe) 1969, BH 482, Poole Technical College, repr. Bowness 1971, p.49.

4 Tate Gallery conservation files.

5 Reclining Figure I (Zennor) 1955–6, BH 204, private collection, repr. Gimpel Fils 1975, exh. cat., no.10; Reclining Figure II 1955–6, BH 205, private collection, repr. Barbara Hepworth, exh. cat., William Darby, 1975, unpag.; Oval Form (Penwith Landscape) 1955–6, BH 203, Marlborough Fine Art, repr. Retrospective 1994–5, exh. cat., p.85; Three Forms: The Seasons 1956, repr. Gimpel Fils 1956, exh. cat., no.7, repr.

69 Two Forms (Divided Circle)

1 Bowness 1971, p.7.

2 Three Obliques (Walk In) 1968, BH 473, University College, Cardiff, repr. ibid., pl.183.

3 Hammacher 1968/1987, p.200.

4 J[ackie] Heuman, 'Perspectives on the Repatination of Outdoor Bronze Sculptures' in Phillip Lindley (ed.), Sculpture Conservation: Preservation or Interference?, Aldershot 1997, pp.124–5, repr. [p.221], pls.XXVIII (before weathering), XXIX (col.).

5 Tate Gallery conservation files.

6 Edwin Mullins, 'Scale and Monumentality', Sculpture International, vol.4, no.1, 1967, p.20.

7 Bowness 1971, p.12.

8 Letter to Ben Nicholson, 22 Dec. 1967, TGA 8717.1.1.371.

9 Bowness 1971, p.12.

10 Mullins 1967, p.21.

11 Maquette for Divided Circle 1969, BH 478, private collections, repr. Bowness 1971, p.49.

12 Theme and Variation 1970, BH 511, Cheltenham & Gloucester Building Society, repr. Pictorial Autobiography 1970/1978, p.130.

13 Quoted in Retrospective 1994–5, exh. cat., p.156.

14 See Appendix A.

15 Breon O'Casey, interview with the authors, 16 Oct. 1996.

16 Maquette, Theme and Variations 1970, BH 512a, artist's estate, repr. Retrospective 1994–5, exh. cat., p.129.

17 Terry Frost, *Green, Black and White Movement*, Tate Gallery, repr. David Lewis, *Terry Frost: A Personal Narrative*, Aldershot 1994, p.51 (col.).

70 Touchstone

1 *Torso* 1927, BH 8, whereabouts unknown, repr. Hodin 1961, pl.8; *Tate Gallery Acquisitions 1974–6*, 1976, p.106.

2 Irish Marble Ltd. brochure, TGA 965.

3 Letter to Irish Marble Ltd., 12 Sept. 1966, TGA 965.

4 *Touchstone*, 1966, artist's estate, not reproduced.

5 *Oxford English Dictionary*.

6 Susan Puddefoot, 'A Totem, a Talisman, a Kind of Touchstone', *Times*, 2 April 1968, p.13.

7 *Talisman* 1959, BH 253, private collection, USA, repr. Hodin 1961, pl.253; *Totem* 1960–2, BH 278, private collection, repr. Bowness 1971, pls.22–3.

8 Ibid., p.14.

71 Makutu

1 *Makutu* 1969, BH 499, artist's estate, repr. Bowness 1971, p.50.

2 *Tate Gallery Acquisitions 1980–2*, 1984, p.123.

3 *Two Forms (Maori)* 1966, BH 405, artist's estate, repr. Bowness 1971, pl.117.

4 Alan Bowness, answers to Tate Gallery questionnaire, 28 Sept. 1983, Tate Gallery cataloguing files.

5 *Three Forms Vertical (Offering)* 1967, BH 452, private collection, repr. Bowness 1971, pl.169; *Small Form (Amulet)* 1960, BH 282, Curt Burgauer, Zurich, not reproduced; *Reclining Solitary Form (Amulet)* 1961, BH 307, artist's estate, repr. Bowness 1971, pl.48; *Upright Solitary Form (Amulet)* 1961, BH 308, artist's estate, repr. ibid., pl.49; *Pierced Form (Amulet)* 1962, BH 316, artist's estate, repr. ibid., pl.62.

6 Tate Gallery conservation files.

72 Oval with Two Forms

1 Breon O'Casey and Tommy Rowe, interview with the authors, 16 Oct. 1996.

2 *Two Opposing Forms (Grey and Green)* 1969, BH 492, private collection, repr. Bowness 1971, pl.193.

3 *Marble with Colour (Crete)* 1964, BH 360, Museum Boymans-van Beuningen, Rotterdam, repr. Bowness 1971, pl.98; *Pierced Hemisphere with a Cluster of Stones* 1969, BH 481, private collection, repr. ibid., pls.187–8.

4 Ibid., p.14.

5 *Apolima* 1969, BH 493, private collection, Los Angeles, repr. ibid., p.203.

6 *Oval with Two Forms* 1971, cast 1972, polished bronze, BH 538, repr. Wales & Isle of Man 1982–3, exh. cat., [p.23], no.31.

7 *Forms in Hollow* 1936, BH 71, destroyed in war, repr. Gibson 1946, pl.29.

8 *Mother and Child* 1934, BH 56, Wakefield City Art Gallery, repr. Hodin 1961, pl.56.

9 'The Sculptor Speaks', British Council recorded lecture, 1970, TGA TAV524.

73 Shaft and Circle

1 *Shaft and Circle* 1972, BH 546, private collection, repr. New York 1974, exh. cat., pp.10, 28, no.8.

2 Dore Ashton, 'Barbara Hepworth: An Appreciation' ibid., p.7.

3 Tate Gallery conservation files.

4 New York 1974.

5 Letter to Eric Gibbard, 28 Jan. 1974 and Gibbard's reply, 31 Jan. 1974, TGA 965.

6 Eric Gibbard, letters to the artist, 13 Feb. 1974 and 25 Feb. 1974, TGA 965.

74 Rock Face

1 *Hieroglyph* 1953, BH 188, Leeds City Art Gallery, repr. Hodin 1961, pl.188.

2 Tate Gallery conservation files.

3 Bowness 1971, p.14.

4 Ibid.

75 Conversation with Magic Stones

1 Brian Smith, letter to Tate Gallery, 22 Sept. 1987, Tate Gallery cataloguing files.

2 Ibid.

3 Bowness 1971, p.15.

4 Letter to Morris Singer, 19 July 1973, TGA 965.

5 Morris Singer, letter to Hepworth, 20 July 1973, TGA 965.

6 Letter to Morris Singer, 4 Oct. 1973, TGA 965.

7 *Maquette for Conversation with Magic Stones*, BH 575, artist's estate, repr. Wales & Isle of Man 1982–3, exh. cat., [p.22], no.29.

8 Breon O'Casey, interview with the authors, 16 Oct. 1996; Brian Ilsley, interview with the authors, 4 March 1998.

9 *Three Magic Forms* 1973, BH 569, Kettle's Yard, Cambridge, repr. *Retrospective* 1994–5, exh. cat., p.131; New York 1974, no.18.

10 Bowness 1971, p.7.

11 1950s dating: *Tate Gallery Acquisitions 1984–86*, 1988, p.168; 1960s: Sir Alan Bowness, in conversation with the authors, 17 April 1998.

12 'Group I (concourse) February 4th 1951', *Tate Gallery Acquisitions 1976–8*, 1979, p.84.

13 Alberto Giacometti, *Cube* 1934, Alberto Giacometti Foundation, Zurich, repr. Reinhold Hohl, *Giacometti: Sculpture, Painting, Drawing*, 1972, pl.68; *Minotaure*, May 1934, p.42, as *Pavillon Nocturne*.

14 Matthew Gale, unpublished catalogue of the Kettle's Yard Collection, Cambridge 1995.

15 Ibid.

16 J.D. Bernal, 'Introduction', *Sculpture by Barbara Hepworth*, exh. cat., Alex. Reid & Lefevre, 1937; Read 1952, section 4.

17 Dore Ashton, 'Barbara Hepworth: An Appreciation' in New York 1974, exh. cat., p.6.

76 Fallen Images

1 Hepworth albums, TGA 7247.44.

2 Susan Bradwell, 'Barbara Hepworth', *Arts Review*, vol.27, no.11, 30 May 1975, p.308.

3 *Tate Gallery Acquisitions 1980–2*, 1984, p.125.

4 George Wilkinson, interview with the authors, 14 Oct. 1996.

5 *Assembly of Sea Forms* 1972, BH 555, Norton Simon Museum of Art, Los Angeles, repr. Hammacher 1968/1987, front cover (col.).

6 The large cone measures 91.1 × 37.5 cm (35⅞ × 14¾ in); smaller cone, 59.5 × 30 cm (23⁷⁄₁₆ × 11¹³⁄₁₆ in); larger hemisphere, 32.5 × 35.5 × 26.8 cm (12¾ × 14 × 10½ in); smaller hemisphere, 28.5 × 30.5 × 23.5 cm (11¼ × 12 × 9¼ in); sphere, 29.5 cm (11⅝ in); oval, 28.8 × 51 × 26 cm (11⅜ × 20¹⁄₁₆ × 10¼ in).

7 Tate Gallery conservation files.

8 *Cone and Sphere* 1973, BH 571, artist's estate, repr. *Retrospective* 1994–5, exh. cat., p.120; *One, Two, Three (Vertical)* 1974–5, BH 577, artist's estate, repr. Hepworth albums, TGA 7247.45.

9 J.P. Hodin, 'Barbara Hepworth and the Mediterranean Spirit', *Marmo*, no.3, 1964, p.59.

10 Letter to Norman Reid, 7 Nov. 1964, Tate Gallery acquisition files.

11 Alan G. Wilkinson, New York 1996, exh. cat., p.31.

12 Paul Nash, *Mineral Objects* 1935, private collection, repr. Andrew Causey, *Paul Nash*, Oxford 1980, p.140, pl.VI, no.815.

13 *Four Hemispheres* 1969, BH 483, private collection, repr. Bowness 1971, pls.191–2.

14 Ibid., p.7.

15 Letter to Ben Nicholson, 16 Feb. 1969, TGA 8717.1.1.378.

16 Wilkinson 1996, p.31.

17 Letter to Ben Nicholson, 21 Jan. 1969, TGA 8717.1.1.377.

18 *Three Forms Vertical (Offering)* 1967, BH 452, private collection, repr. Bowness 1971, pl.169.

19 Hammacher 1968/1987, pp.193–5.

20 Matthew Gale, unpublished catalogue of the Kettle's Yard Collection, Cambridge 1995.

Appendix A

1 Pat Gilmour, *Artists at Curwen: A Celebration of the Gift of Artists' Prints from the Curwen Studio*, exh. cat., Tate Gallery, 1977, pp.95, 97.

2 Stanley Jones, *Barbara Hepworth: Lithographs made at Curwen Studio 1969 and 1971*, exh. cat., Curwen Gallery, 1994; *Untitled lithograph* 1958, repr. Robin Garton (ed.), *British Printmakers 1855–1955: A Century of Printmaking from the Etching Revival to St Ives*, Aldershot 1992, p.309, pl.572.

3 Herbert Simon, letter to Hepworth, 30 Aug. 1966, Curwen Studio records, quoted in Pat Gilmour 1977, p.103.

4 Stanley Jones 1994.; *12 Lithographs by Barbara Hepworth*, Curwen Gallery, 1969.

5 Stanley Jones, *The Aegean Suite*, Curwen Gallery, 1971.

6 Pat Gilmour, *Kelpra Studio: The Rose and Chris Prater Gift, Artists' Prints 1961–1980*, exh. cat., Tate Gallery, 1980, p.21.

Appendix B

1 John Skeaping, *Drawn from Life: An Autobiography*, 1977, pp.91–2.

2 Letter to Ben Nicholson, postmarked 29 Sept. 1931, TGA 8717.1.1.52.

3 H.S. Ede, Diary 1928, Kettle's Yard Archive, University of Cambridge; Constantin Brancusi, *Poisson d'Or* 1924, destroyed, formerly Museum of Fine Arts, Boston, repr. Sidney Geist, *Brancusi: The Sculpture and Drawings*, New York 1975, p.130, no.181.

4 Tate Gallery conservation files.

5 *John Skeaping 1901–1980: A Retrospective*, exh. cat. Arthur Ackermann & Son Ltd, 1991.

6 *Tate Gallery Report 1992–4*, 1994, p.54; Penelope Curtis, 'Early Hepworth: New Images for Old', *Burlington Magazine*, vol.137, no.1113, Dec. 1995, p.847, Appendix 1.

7 Tooth's 1930, no.46; *Carvings by Barbara Hepworth and Paintings by Ben Nicholson*, Arthur Tooth & Sons, Nov.–Dec. 1932, extra no.13.

8 Hepworth albums, TGA 7247.1; Hodin 1961, no.31.

9 Letter to Thomas Gibson, 18 Jan. 1973, copy Tate Gallery cataloguing files.

10 John Skeaping, letter to Thomas Gibson, 8 Feb. 1973, copy Tate Gallery cataloguing files.

11 Ibid.; *Stag*, location unknown, repr. Tooth's 1930, exh. cat. no.18; *Duck*, private collection, repr. Ackermann 1991 exh. cat., p.35, no.31 (col.).

12 *Carving*, private collection, repr. *Retrospective* 1994–5, exh. cat., p.33.

13 Henry Moore, *Mother and Child* 1930, private collection, repr. Herbert Read (ed.), *Henry Moore*, 1944, no.18a.

Selected Bibliography

In addition to the monographs on Barbara Hepworth, all of which are listed under 'Abbreviations', the following selection of the artist's writings and other major articles are of interest.

Place of publication is London unless otherwise stated. A comprehensive bibliography has been compiled by Meg Duff and published in David Thistlewood (ed.), *Barbara Hepworth Reconsidered*, Liverpool 1996.

Artist's Writings:

Statement in the series 'Contemporary English Sculptors', *Architectural Association Journal*, vol.45, no.518, April 1930, p.385

'The Aim of the Modern Artist: Barbara Hepworth, Ben Nicholson', *Studio*, vol.104, Dec. 1932, pp.332-3

Statement in Herbert Read (ed.), *Unit One: The Modern Movement in English Architecture, Painting and Sculpture*, 1934, pp.17-25

'Sculpture' in J.L. Martin, Ben Nicholson, N. Gabo (eds.), *Circle: International Survey of Constructive Art*, 1937, pp.113-16

'Approach to Sculpture', *Studio*, vol.132, no.643, Oct. 1946, pp.97-101

Autobiographical text in six sections in Herbert Read, *Barbara Hepworth: Carvings and Drawings*, 1952

Notes in *Barbara Hepworth: A Retrospective Exhibition of Carvings and Drawings from 1927 to 1954*, exh. cat., Whitechapel Art Gallery, 1954

Statement in *Barbara Hepworth, Ben Nicholson*, exh. cat., Hatton Gallery, Newcastle upon Tyne, 1956

Edouard Roditi, 'Barbara Hepworth', in *Dialogues in Art*, 1960, pp.90-102

'Two Conversations with Barbara Hepworth: Art and Life; The Ethos of Sculpture' in J.P. Hodin, *Barbara Hepworth*, Neuchâtel and London 1961, pp.23-4

'Statement by the Artist' in *Barbara Hepworth: An Exhibition of Sculpture from 1952-1962*, exh. cat., Whitechapel Art Gallery, 1962

'A Sculptor's Landscape' in Alan Bowness (ed.), *Barbara Hepworth: Drawings from a Sculptor's Landscape*, 1966

'Conversations with Barbara Hepworth' in Alan Bowness (ed.), *The Complete Sculpture of Barbara Hepworth: 1960-69*, 1971

Cindy Nemser, 'Conversation with Barbara Hepworth', *Feminist Art Journal* (USA), vol.2, no.2, spring 1973, pp.3-6, 22, republished in Cindy Nemser, *Art Talk: Conversations with 12 Women Artists*, New York 1975, pp.12-33

Articles:

John Grierson, 'The New Generation in Sculpture', *Apollo*, vol.12, no.71, Nov. 1930, pp.347-51

Herbert Read, 'Introduction', *Carvings by Barbara Hepworth, Paintings by Ben Nicholson*, exh. cat., Arthur Tooth & Sons' Galleries, 1932

Paul Nash, 'A Painter and a Sculptor', *Week-end Review*, 19 Nov. 1932, p.613

Adrian Stokes, 'Miss Hepworth's Carving', *Spectator*, 3 Nov. 1933, p.621, republished in Lawrence Gowing (ed.), *The Critical Writings of Adrian Stokes: Vol.1 1930-37*, 1978, pp.309-10

H. Frankfort, 'New Works by Barbara Hepworth', *Axis: A Quarterly Review of Contemporary 'Abstract' Painting and Sculpture*, no.4, Nov. 1935, pp.21-4

J. D. Bernal, 'Introduction', *Catalogue of Sculpture by Barbara Hepworth*, exh. cat., Alex Reid & Lefevre, 1937

E.H. Ramsden, 'Barbara Hepworth: Sculptor', *Horizon*, vol.7, no.42, June 1943, pp.418-22

Herbert Read, 'Introduction', *Sculpture and Drawings by Barbara Hepworth*, exh. cat., Wakefield City Art Gallery, 1944

David Lewis, 'Barbara Hepworth', *Exhibition of Works by John Constable, Matthew Smith, Barbara Hepworth*, exh. cat., British pavilion, XXV Venice Biennale, 1950

Herbert Read, 'Barbara Hepworth', *La Biennale di Venezia*, no.3, Jan. 1951, pp.12-14

Patrick Heron, 'Introduction', *Barbara Hepworth: Sculpture and Drawings*, exh. cat., Wakefield City Art Gallery, 1951

John Berger, 'Sculptural Vacuum', *New Statesman and Nation*, vol.47, no.1206, 17 April 1954, p.498

J.P. Hodin, 'Barbara Hepworth', *Paintings by Francis Bacon, Paintings and Etchings by S.W. Hayter, Sculptures and Drawings by Barbara Hepworth*, exh. cat., Bienal de São Paulo, 1959

J.P Hodin, 'Barbara Hepworth: A Classic Artist', *Quadrum*, no.8, 1960, pp.75-84

Bryan Robertson, 'Introduction', *Barbara Hepworth: An Exhibition of Sculpture from 1952-1962*, exh. cat., Whitechapel Art Gallery, 1962

J.P. Hodin, 'Barbara Hepworth and the Mediterranean Spirit', *Marmo*, no.3, Dec. 1964, pp.58-65

Ronald Alley, 'Barbara Hepworth's Artistic Development', *Barbara Hepworth*, exh. cat., Tate Gallery, 1968

Edwin Mullins, 'Introduction', *Barbara Hepworth Exhibition 1970*, exh. cat., Hakone Open-Air Museum, 1970

Dore Ashton, 'Barbara Hepworth: An Appreciation', *Barbara Hepworth: 'Conversations'*, exh. cat., Marlborough Gallery, New York 1974

Penelope Curtis, 'Early Hepworth: New Images for Old', *Burlington Magazine*, vol.137, no.1113, Dec. 1995, pp.846-9

General Books:

Carola Giedion-Welcker, *Modern Plastic Art*, Zurich 1937, rev. ed. *Contemporary Sculpture: An Evolution in Volume and Space*, London 1956

Herbert Read, *A Concise History of Modern Sculpture*, 1964

A.M. Hammacher, *Modern English Sculpture*, 1967

Charles Harrison, *English Art and Modernism*, London and Bloomington, Indiana 1981, rev. ed. London and New Haven, Conn. 1994

Sandy Nairne and Nicholas Serota (eds.), *British Sculpture in the Twentieth Century*, 1981

David Brown (ed.), *St Ives 1939-64: Twenty Five Years of Painting, Sculpture and Pottery*, exh. cat., Tate Gallery, 1985

Susan Compton (ed.), *British Art in the 20th Century: The Modern Movement*, exh. cat., Royal Academy of Arts, 1987

Daniel Abadie (ed.), *Un Siècle de Sculpture Anglaise*, exh. cat., Galerie national du Jeu de Paume, Paris 1996

Index